The Definitively Unfinished Marcel Duchamp

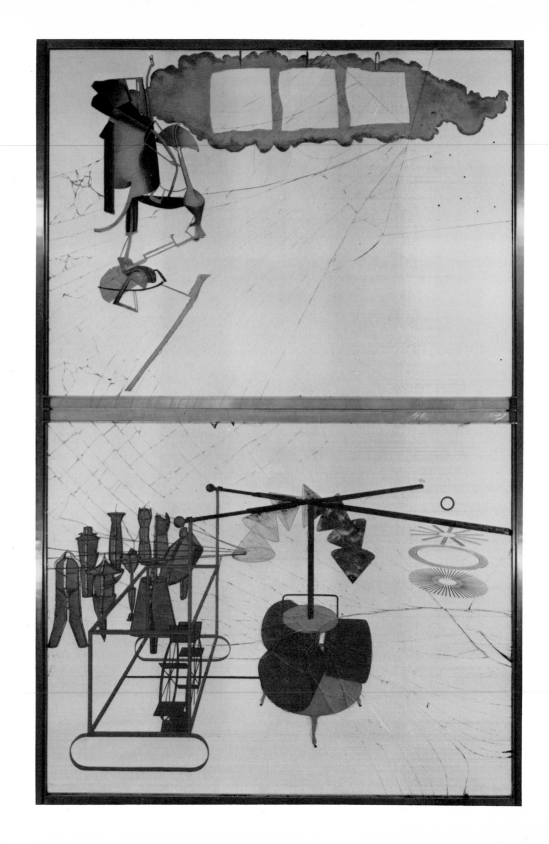

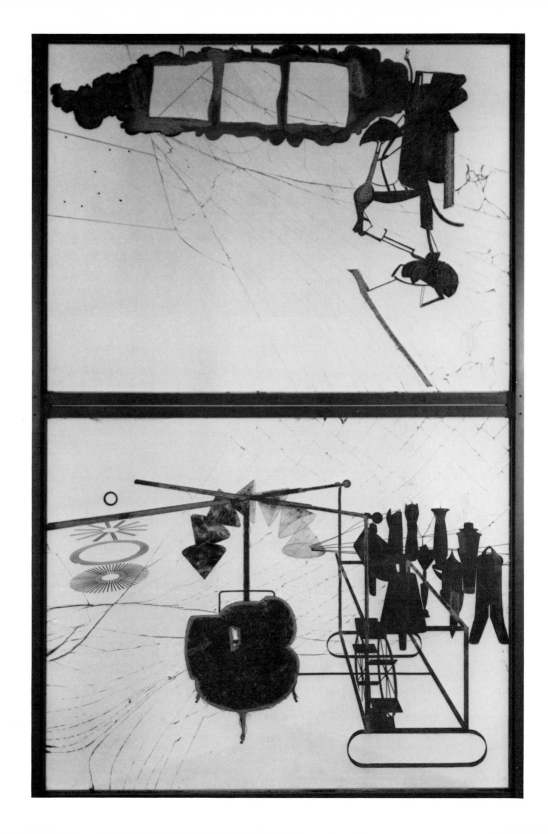

La Mariée mise à nu par ses célibataires,
même (Le grand verre) [*The Bride*
Stripped Bare by Her Bachelors, Even
(The Large Glass)], 1915–1923. Oil, var-
nish, lead foil, lead wire, and dust on
two glass panels, 109¼ × 69¼ in. Recto
and verso. (Philadelphia Museum of Art;
Katherine S. Dreier Bequest, 1953.)

edited by **THIERRY DE DUVE**

The Definitively Unfinished Marcel Duchamp

Nova Scotia College of Art and Design
Halifax, Nova Scotia

The MIT Press
Cambridge, Massachusetts
London, England

Second printing, 1992

Details of *La Mariée mise à nu par ses célibataires, même (La boîte verte)* [*The Bride
Stripped Bare by Her Bachelors, Even (The Green Box)*] appear opposite the chapter titles by
courtesy of the Rosa Esman Gallery, New York, reproduced from a photograph by Nicholas
Walster.

This book was set in Bodoni Book by DEKR Corporation and was printed and bound in the
United States of America.

Library of Congress Cataloging-in-Publication Data

The Definitively unfinished Marcel Duchamp / edited by Thierry de
 Duve.
 p. cm.
 Includes bibliographical references and index.
 ISBN 0-262-04117-0
 1. Duchamp, Marcel, 1887–1968—Criticism and interpretation.
 I. Duve, Thierry de.
 N6853.D8D44 1991
 709′.2—dc20 91-10177
 CIP

Contents

Foreword

The eleven essays that compose the body of this book were first presented at a bilingual colloquium at the Nova Scotia College of Art and Design, Halifax, Nova Scotia, in October 1987. Three, originally written in French, are here offered in translation, and those parts of the debates that took place in French have also been translated. The colloquium was one of a series of events that marked the one-hundredth anniversary of the foundation of the Nova Scotia College of Art and Design by the legendary Anna Leonowens. Marcel Duchamp was not the only artist to have been twinned with the college: Archipenko, Arp, O'Keeffe, and Schwitters, among others, were born in 1887 too, but the college's own recent history—particularly the way in which it had so readily embraced the legacy of Duchamp in its days as a stronghold of conceptualism—left no doubt about the choice of subject for this colloquium. The Nova Scotia College was aware, too, of the ten years that had elapsed since the monumental events of 1977 organized in Paris and at Cerisy-la-Salle: new scholars and new approaches had emerged (seven of the authors represented here had in the interim published books devoted wholly or in part to Duchamp), and the opportunity to assemble many of them in Halifax seemed the more compelling with the possibility of reciprocal public discussions of the papers. It is hoped that by the transcription of those discussions we have not only enhanced the comprehension of the texts but also caught at least some of the kaleidoscopic flow of wit, erudition, and good humor that was enjoyed by the 130 members of the colloquium, and of which Marcel Duchamp himself would undoubtedly have approved.

Among many who made contributions to the successful outcome of the colloquium, I am especially grateful to Thierry de Duve, then of the University of Ottawa, Programme Director of Le Collège International de Philosophie, who gave much valuable advice, chaired seven of the sessions, and undertook to edit the present publication, and to Heather McKean, secretary of the Art History Division of the Nova Scotia College of Art and Design, whose tireless energy and assiduous attention to detail ensured its success. The college also benefited greatly from the support, both moral

and financial, of the Canada Council, and from grants from the Social
Sciences and Humanities Research Council and the Cultural Division of
the Department of External Affairs of the Government of Canada. To these
agencies I express grateful thanks.

H. Dennis Young
Organizer of the Colloquium

Introduction

"A guest plus a host equals a ghost," Marcel Duchamp once said. When Dennis Young invited me to help him organize the conference whose proceedings you are about to read, adding that he would be very pleased if I could preside over its course as well as contribute a paper, I didn't realize how mischievous he had been. Flattery is the sweetest trap and vanity the most consenting victim. But Dennis is too accomplished a "Duchampologist" and too fine a psychologist not to have been aware of the trap he had set. I was cast in the role of the ghost, only to realize it too late.

It was, in retrospect, a very enjoyable role, and I shall be forever thankful to Dennis for his mischief. For in true modesty he cast himself in the role of the host and did all the work. He initiated the project and got it onto its feet; he presented the Nova Scotia College of Art and Design with a wonderful opportunity to associate its own centennial celebration with that of its most revered artist; he wrote dozens of letters, organized the logistics, and, above all, secured the funding without which the conference would have remained a dream. In his inconspicuous and genial manner, he also curated a small Duchamp exhibition with replicas of replicas and tables where visitors could consult the Duchamp literature and immerse themselves in the scholarly atmosphere of those three days. On display were the books all of us guests had written on the old man. The books were neither glued nor chained nor attached in any way to the tables, but the tables were painted all around the books so that, if pinched, *une teinture de persistance dans la situation* would be left behind. It was pure Dennis, this mild deterrent, and a beautiful symbol of his hospitality.

A conference celebrating *the* transatlantic artist of the century, and to be held in Canada, to boot, had to be bilingual. Françoise Longhurst and James Crombie did the simultaneous translation, and I want to thank them for having spent hours working their way through Duchamp's virtually untranslatable puns and idiosyncrasies. For the publication, of course, other translations were needed. I express my thanks to the translators of Jean Suquet's, Herbert Molderings's, and André Gervais's papers, and I am especially grateful to Tamara Blanken who transcribed and helped edit

the discussions, translated those exchanges that took place in French, put her thorough knowledge of the Duchamp literature to the best of use, and assisted me throughout this project.

Before the papers were delivered and translated, they had of course to be written. In the course of editing this book, I have had many opportunities to ponder the staggering diversity of scholarly approaches that the work of Marcel Duchamp has spawned. My pleasure in trying to absorb those of my colleagues and fellow participants in this conference grew with each reading, and I am indebted to them for having enlightened me and taught me how relative my own approach was. Finally, there is someone to whom all of us, I am sure, are equally thankful, and this is of course Marcel Duchamp himself. None of the eleven papers you are about to read would ever have seen the light of day, none of the animated exchanges—which we tried to keep as lively on paper as they were in the heat of the debate— would ever have occurred, had it not been for him and his work.

Thierry de Duve

The Definitively Unfinished Marcel Duchamp

Given

In his essay "The Creative Act," written late in his life, Marcel Duchamp made a direct quotation from T. S. Eliot's "Tradition and the Individual Talent." As far as I am aware, this was the only time Duchamp ever quoted the opinion of a critic word for word. I will return to the passage cited by Duchamp later. I want to take my point of departure from another section of that same essay of Eliot's:

The existing monuments form an ideal order among themselves, which is modified by the introduction of the new (the really new) work of art among them. The existing order is complete before the new work arrives; for order to persist after the supervention of novelty, the whole existing order must be, if ever so slightly, altered; and so the relations, proportions, values of each work of art toward the whole are readjusted; and this is conformity between the old and the new.[1]

What is conspicuously absent from this account and from the rest of the essay is any unifying sense of purpose, any statement of common objectives underlying the different manifestations of art at different times and places. Instead, the dependency of the artist and poet on a historical sense of the past is emphasized at the same time as the need for novelty. The promise is that juxtaposition will create meaning for the new and new meaning for the old. Meanwhile, the living artist must make a continual self-sacrifice, "a continual extinction of personality," in order to achieve a place among "the dead." The word "dead" reverberates like a refrain throughout the essay, with only a weak reassurance that the immortality of poetry will survive the extinction of its author.

On first hearing, Eliot's statement about the ideal order of art and about conformity between the old and the new sounds a far cry from the declared iconoclasm of Marcel Duchamp, who, while "Tradition and the Individual Talent" awaited publication in *The Sacred Wood*, added a moustache, a goatee, and a cryptically suggestive inscription to a reproduction of the *Mona Lisa*. The gap narrows when we turn from Eliot the critic to Eliot the poet, who himself at this time was about to begin work on *The Waste Land*. To quote Spenser's "Sweet Thames run softly till I end my song" and then

immediately conjure up the image of "empty boxes, sandwich papers, silk handkerchiefs, cardboard boxes, cigarette ends" might well be compared with drawing a moustache on the Mona Lisa. If this was what Eliot meant by the supervention of novelty, it comes across in his poetry as a much more diametrical confrontation than we might expect from his tentative suggestion that "the whole existing order must be, *if ever so slightly* altered," and whereas Duchamp's defacing of Leonardo's masterpiece was a unique gesture, Eliot goes on to draw moustaches on Dante, Shakespeare, Sophocles, St. Augustine, and a host of other writers, old and new, from East and West, in no less than half a dozen different languages.

Eliot introduced the theme of "Tradition and the Individual Talent" with a complaint that "In English writing we seldom speak of tradition, though we may occasionally apply its name in deploring its absence." What I would argue with here is his suggestion that the absence of tradition is a peculiarly English phenomenon. Three quarters of a century before, another poet and critic, writing in France, and also in one of his earliest essays, had lamented the absence of tradition as a phenomenon of the age: "The great tradition has been lost, and the new one is not yet established."[2] I would be inclined to push the event of its loss back another century before Baudelaire, and I would point to a correlation between the demise of tradition and the emergence of art history.

What marks Winckelmann as the first art historian is not just the fact that he was "the first writer to use the phrase 'history of art' on a title page,"[3] nor even that with him the claim to authoritative opinion on the art of the past shifted definitively from artists to scholars, but rather that he was the first to perceive, if not absolutely clearly, that particular works by particular artists are locked into place by impersonal forces that circumscribed their production. By comparison with Winckelmann, Xenocrites of Sicyon and Giorgio Vasari alike are not so much historians as recorders of tradition, and this distinction implies primarily not so much that they may have checked some of their facts less carefully, but that they perceived the past from the standpoint of a present that had its own values, which they accepted as absolute. Winckelmann's contribution has partly to do with the internal logic of the development of style—and this may be the area in which he has contributed most to the methodology of art historical scholarship—but it also has to do with his recognition that the achievements of

art grow out of the conditions of their time and place; and this idea, as it has been disseminated in the writings of his successors, has had incomparably more influence on the practice of art from his day to ours.

For Winckelmann himself, the determinants of artistic achievement were finally meteorological, and though he advocated imitation of the art of that place, Greece, that had been blessed with ideal climatic conditions for the engendering of ideal beauty, there is no suggestion that any amount of copying of antique statues will make the climate of Halifax, England, Halifax, Nova Scotia, or Calgary, Alberta, more like that of Athens or the Peloponnesus. Among the artists of the generations that follow him I would distinguish two kinds of response, the distinction hinging on whether or not cause and effect are perceived to be reversible. With the classicism of David and the French Revolution, the imitation of the stern masculine style of certain aspects of the Greco-Roman period is associated with a perception of moral severity that is to be inculcated in the present through its artistic imitation of the past. With the Nazarenes, the Pre-Raphaelites, and others, the adoption of medievalizing styles is likewise associated with an aspiration to revive the Christian piety of a bygone age. I would characterize this kind of response as "romantic," even though it overlaps the style of neoclassicism, and I would contrast it with a response I would consider specifically "modern," even though it begins with the ironic echoes of Velazquez's *Las Meninas* in Goya's *Family of Charles IV* and continues down to our own day where it is sometimes considered specifically "postmodern"—and of course, it includes Eliot and Duchamp along the way. The notion of "modern," as we apply it to art and poetry, implies before anything else a separateness from that which is traditional. If, for the romantic, the ideals of the past had become remote, for the modern they are inaccessible. References to the past serve only to emphasize its inaccessibility, to deny the applicability of its values to a new age, and to underline their ephemerality in their own time and place. In default of a positive sense of purpose, tradition may have become more of an issue than it was in the age that possessed it, but as artists turn to the past for guidance, they find only solutions that are no longer applicable, and, in default of any other guide, they can often only attest their nonapplicability. The development of modern art is characterized—in its modifications of style and structure as much as in its imagery—by a succession of denials. Through time, as the books of

modern poetry huddle together with the works of the dead poets on an ideal bookshelf, the "supervention of novelty" may itself be superseded by a process of assimilation, but, through such meager continuities as are necessary to identify that which is denied, what emerges is a negative dependency, which is, of course, a dependency nonetheless, not merely a "tradition of the new."

I would not wish to hold art history entirely responsible for the negativity of the situation I have described, or to have the weight of blame fall entirely upon the shoulders of Winckelmann or Dennis Young. Art history, like the art it addresses, is a product of its time and place, and its emergence belongs among a complex of events that have also affected the arts directly. Wilhelm Dilthey, the better part of a century ago, identifying Winckelmann as part of a larger movement of "developmental history based on national politics, religion, law, customs, language, poetry and literature," goes on to make the following points: "The evolutionary theory . . . is necessarily linked to the knowledge of the relativity of every historical form of life. . . . The contradiction between the increasing historical consciousness and philosophy's claim to universal validity has hardened."[4] As with philosophy, so with art. I also noted the words "renewed skepticism."

In even broader terms than those employed by Dilthey, we might very reasonably associate the emergence of art history with the burgeoning of science; only, in the case of science, the result is not just a body of information on the workings of natural process, but also, through its application, an altered world and an altered way of life that evidently result from the harnessing of the mechanisms of natural process more than through human choice or divine intervention.

Thumbing through the pages of *Bartlett's Dictionary of Quotations* I came across the statement: "True science teaches, above all, to doubt and be ignorant." That came from Miguel de Unamuno's *The Tragic Sense of Life*, written in 1913. Four years later T. S. Eliot would write:

The vast accumulations of knowledge—or at least of information—deposited by the nineteenth century have been responsible for an equally vast ignorance. When there is so much to be known, when there are so many fields of knowledge in which the same words are used with different meanings, when

everyone knows a little about a great many things, it becomes difficult for anyone to know whether he knows what he is talking about or not.[5]

Elsewhere, Eliot echoes Matthew Arnold's opinion of Byron, Shelley, and Wordsworth: "the English poetry of the first quarter of the nineteenth century, with plenty of energy, plenty of creative force, did not know enough."[6] Again, I would have to challenge Eliot's and Arnold's view that this was a peculiarly English phenomenon. Walter Benjamin makes essentially the same complaint of Baudelaire.[7]

In 1934, in the period after his conversion, Eliot the poet took up the theme again in "Choruses from *The Rock*":

All our knowledge brings us nearer to our ignorance,
All our ignorance brings us nearer to death,
But nearness to death no nearer to God,—
Where is the Life we have lost in living?
Where is the wisdom we have lost in knowledge?
Where is the knowledge we have lost in information?

For Eliot the poet, it is not just the quantity of information that is the problem, but also the way the kind of information our age has elicited supersedes the kind of knowledge that had once been supposed to give a sense of purpose to life and to secure our place in the order of things.

The correlation between the accumulation of information about the world and the development of skepticism can be tested in an earlier period. Pyrrho founded his school in Elis scarcely five years after Aristotle opened his school, the Lyceum in Athens. If the name of the one has become synonymous with the investigation of concrete and particular things and situations, the other's is equally the epitome of skepticism. In a footnote to *The Complete Works of Marcel Duchamp*, Arturo Schwarz reports: "When reading the manuscript of this book Duchamp recollected that he had had the chance, when he was librarian at the Bibliothèque Sainte-Geneviève, of going through the works of the Greek philosophers once more, and that the one which he appreciated most and found closest to his own interests was Pyrrho."[8] I know of nowhere in Duchamp's writings or recorded statements that any mention is made of Pyrrho, and the footnote itself is hardly enough to justify any suggestion that Pyrrho was a major influence, but it

is interesting to know that Duchamp was aware of the proximity of his own thought.

The parallels are striking. For myself, I am intrigued by the possibility that Pyrrho may have started out as a painter, and by the fact that his teacher in philosophy Anaxarchus considered the world of experience to be a realm of phantoms, like those of dreams or madness, comparable to a stage set.[9] It occurs to me to wonder if Pyrrho's painting belonged to the more illusionistic side of Greek art?

Pyrrho's philosophical views are reported by his pupil Timon via the late second-century AD writer Aristocles: "His [Pyrrho's] pupil Timon says that the man who is to be truly happy must pay regard to these three questions: (1) What is the nature of things? (2) What attitude ought we to adopt with respect to them? (3) What will be the net result for those so disposed?"[10] Pyrrho's answers to Timon's first and second questions were (1) that the nature of things cannot be known; and (2) that "we ought not to put our trust in them, but be without beliefs." And what does Duchamp believe? Pierre Cabanne put the question.

Cabanne: *What do you believe in?*
Dechamp: *Nothing, of course! The word "belief" is another error. It's like the word "judgment," they're both horrible ideas, on which the world is based. I hope it won't be like that on the moon!*
Cabanne: *Nevertheless, you believe in yourself?*
Duchamp: *No.*
Cabanne: *Not even that?*
Duchamp: *I don't believe in the word "being." The idea of being is a human invention.*[11]

This would seem to be in direct contradiction of what Duchamp had told James Johnson Sweeney a year earlier: "I like the word 'belief.' I think in general that when people say 'I know,' they don't know, they believe. . . . To live is to believe; that's my belief, at any rate."[12]

There is no denying a tension between these two statements, but in this instance, I think, it is worth trying to squeeze in a distinction between the "horrible idea" and the likable word. What seems to be involved is, in the

one case, a strong sense of the word "belief" that implies a grounding in more solid conviction than simple knowledge. Such belief, even in himself, "egomaniac" as he claims to be, is anathema to Duchamp. In the other case, what is involved is a weak sense of the word "belief" that implies some uncertainty about the facts stated. In each case Duchamp's arguments opt for the lesser level of certainty about the being of things in the world. When he says "To live is to believe" what I think he means is that our day-to-day activity in the world implies certain assumptions without which life becomes impossible, beliefs of the order that the refrigerator in the kitchen contains food that will alleviate my feelings of hunger and that there is a kitchen and a refrigerator and that food exists. When he finally asserts "That's my belief, at any rate," he has returned to a strong sense of "belief" in regard to the necessity for such weak beliefs. There may, however, still be more to it.

In 1971 Robert N. Bellah contributed a paper on "The Historical Background of Unbelief" to a conference in Rome on "The Culture of Unbelief." Bellah, too, found a precedent for modern skepticism—and perhaps even the roots of it—among the Greeks, and he finds it in the somewhat surprising context of the writings of Plato. What is significant, in my present context, is a distinction he draws about the use of words: "Where the word 'belief' is used to translate biblical Hebrew and Greek, it means not the 'belief that' of Plato, but 'belief in,' a matter not of cognitive assent but of faith, trust and obedience."[13] The distinction is helpful in relation to the first and second questions of Timon and also in relation to Pyrrho's replies: (1) "Things are by nature indeterminable" and (2) "We ought not to put our trust in them." With Duchamp the two senses tend to elide or, perhaps more precisely, the answer to the question regarding "belief that" tends by implication to carry the answer to the question about "belief in." When Pierre Cabanne later asks "Do you believe *in* God?", Duchamp's negative reply does not indicate primarily a withholding of "faith, trust and obedience," but a denial of the existence of God. He uses the same turn of phrase with which he dismissed the notion of "being": "God is a human invention."[14] Only when Cabanne pursues Duchamp's denials in relation to himself can we discern a sense of biblical "belief in"—or rather a *denial* of biblical "belief in"—from Duchamp's reply.

Cabanne: *Nevertheless you believe* in *yourself?*
Duchamp: *No.*

Even here Duchamp's denial of "faith, trust and obedience" in himself can be seen to be dependent on "belief that." He observed to Cabanne: "Despite yourself, when you're an atheist, you're impressed by the fact that you're going to completely disappear."[15]

So what, taking up Timon's final question, will be the result for those who follow these precepts? Timon's twofold answer was, first, a disinclination to make assertions and, second, that state of psychic quietude which the Greeks called "ataraxia." Pyrrho, who according to reports had been originally somewhat irascible, never thereafter showed impatience or disdain but, on the contrary, made humility and gentleness the standards of his personal conduct. In spite of being a teacher, he made a firm resolution not to exert any pressure on the minds of others, and he took this resolution so seriously that he never wrote anything, and was so unconcerned with the impact his spoken words were making that, if his listener were suddenly to leave, he would go on talking to himself without giving any indication of discomfiture.

Pyrrho's reasons for not committing his thoughts to writing have echoes of the argument of Plato's *Phaedrus*, but also, in our own time, of Lawrence Weiner's reasons for preferring to communicate his artworks in the "non-impositional" form of spoken words rather than as fabricated objects; but I can find no hint of a suggestion that such considerations might have had anything to do with the diminution in Duchamp's output after *The Large Glass*. On the contrary, he repeated frequently that art ought to shock; but he did nonetheless establish a reputation for tranquility of spirit. Harriet and Sidney Janis refer to "the depths of the serenity that surrounds and the quiet that informs his life and person."[16] Arman saw him as "above all the fights . . . nobody even had the smallest chance to fight with Marcel."[17]

As to Timon's promise that happiness will ensue from adherence to his precepts: Pyrrho's gentleness and naive good humor inspired affection and respect on all sides, which lasted till the end of his long life. As for Duchamp: his last answer to Cabanne's questions was: "I am very happy."

A self-proclaimed Pyrrhonian of the generation of Winckelmann was Julien Offray de La Mettrie.[18] He was a doctor by profession, reminding us of the

one case, a strong sense of the word "belief" that implies a grounding in more solid conviction than simple knowledge. Such belief, even in himself, "egomaniac" as he claims to be, is anathema to Duchamp. In the other case, what is involved is a weak sense of the word "belief" that implies some uncertainty about the facts stated. In each case Duchamp's arguments opt for the lesser level of certainty about the being of things in the world. When he says "To live is to believe" what I think he means is that our day-to-day activity in the world implies certain assumptions without which life becomes impossible, beliefs of the order that the refrigerator in the kitchen contains food that will alleviate my feelings of hunger and that there is a kitchen and a refrigerator and that food exists. When he finally asserts "That's my belief, at any rate," he has returned to a strong sense of "belief" in regard to the necessity for such weak beliefs. There may, however, still be more to it.

In 1971 Robert N. Bellah contributed a paper on "The Historical Background of Unbelief" to a conference in Rome on "The Culture of Unbelief." Bellah, too, found a precedent for modern skepticism—and perhaps even the roots of it—among the Greeks, and he finds it in the somewhat surprising context of the writings of Plato. What is significant, in my present context, is a distinction he draws about the use of words: "Where the word 'belief' is used to translate biblical Hebrew and Greek, it means not the 'belief that' of Plato, but 'belief in,' a matter not of cognitive assent but of faith, trust and obedience."[13] The distinction is helpful in relation to the first and second questions of Timon and also in relation to Pyrrho's replies: (1) "Things are by nature indeterminable" and (2) "We ought not to put our trust in them." With Duchamp the two senses tend to elide or, perhaps more precisely, the answer to the question regarding "belief that" tends by implication to carry the answer to the question about "belief in." When Pierre Cabanne later asks "Do you believe *in* God?", Duchamp's negative reply does not indicate primarily a withholding of "faith, trust and obedience," but a denial of the existence of God. He uses the same turn of phrase with which he dismissed the notion of "being": "God is a human invention."[14] Only when Cabanne pursues Duchamp's denials in relation to himself can we discern a sense of biblical "belief in"—or rather a *denial* of biblical "belief in"—from Duchamp's reply.

Cabanne: Nevertheless you believe in *yourself?*
Duchamp: No.

Even here Duchamp's denial of "faith, trust and obedience" in himself can be seen to be dependent on "belief that." He observed to Cabanne: "Despite yourself, when you're an atheist, you're impressed by the fact that you're going to completely disappear."[15]

So what, taking up Timon's final question, will be the result for those who follow these precepts? Timon's twofold answer was, first, a disinclination to make assertions and, second, that state of psychic quietude which the Greeks called "ataraxia." Pyrrho, who according to reports had been originally somewhat irascible, never thereafter showed impatience or disdain but, on the contrary, made humility and gentleness the standards of his personal conduct. In spite of being a teacher, he made a firm resolution not to exert any pressure on the minds of others, and he took this resolution so seriously that he never wrote anything, and was so unconcerned with the impact his spoken words were making that, if his listener were suddenly to leave, he would go on talking to himself without giving any indication of discomfiture.

Pyrrho's reasons for not committing his thoughts to writing have echoes of the argument of Plato's *Phaedrus*, but also, in our own time, of Lawrence Weiner's reasons for preferring to communicate his artworks in the "non-impositional" form of spoken words rather than as fabricated objects; but I can find no hint of a suggestion that such considerations might have had anything to do with the diminution in Duchamp's output after *The Large Glass*. On the contrary, he repeated frequently that art ought to shock; but he did nonetheless establish a reputation for tranquility of spirit. Harriet and Sidney Janis refer to "the depths of the serenity that surrounds and the quiet that informs his life and person."[16] Arman saw him as "above all the fights . . . nobody even had the smallest chance to fight with Marcel."[17]

As to Timon's promise that happiness will ensue from adherence to his precepts: Pyrrho's gentleness and naive good humor inspired affection and respect on all sides, which lasted till the end of his long life. As for Duchamp: his last answer to Cabanne's questions was: "I am very happy."

A self-proclaimed Pyrrhonian of the generation of Winckelmann was Julien Offray de La Mettrie.[18] He was a doctor by profession, reminding us of the

close association between the empirical branch of medicine and Pyrrhonism in antiquity. It is recorded that "La Mettrie was born with a fund of natural and inexhaustible gaiety; he had a quick mind, and such a fertile imagination, that it made flowers grow in the field of medicine. Nature had made him an orator and a philosopher; but a yet more precious gift which he received from her, was a pure soul and an obliging heart."[19] Unfortunately, the unhappy course of his life refuted the predictions of Timon. His successes in the field of medicine incurred the jealousy of his colleagues, and one of them, abusing his easy friendship, enticed him to lend "the volubility of his pen" to a scurrilous work on *The Politics of Physicians*. Meanwhile an attack of fever had caused him to become aware of the correlation between his physical symptoms and his state of consciousness, and the metaphysical works that ensued from this realization brought down the wrath of the clergy in addition to that of the physicians. He retreated first to Holland, then to Prussia where he received the protection of Frederick the Great, but died of a renewed attack of fever at the age of forty-one.

I know of no reference to La Mettrie by Duchamp and hardly more than a mention in the literature on Duchamp. Nonetheless, La Mettrie's major work *L'homme-machine* [*Man a Machine*] of 1748 is interspersed with metaphors that provide a real precedent for the imagery of *The Large Glass*:

The human body is a machine which winds its own springs. It is a living image of perpetual movement. Nourishment keeps up the movements which fever excites. Without food, the soul pines away, goes mad, and dies exhausted. The soul is a taper whose light flares up the moment before it goes out. But nourish the body, pour into its veins life-giving juices and strong liquors, and then the soul grows strong like them, as if arming itself with proud courage, and the soldier whom water would have made flee, grows bold and runs joyously to death to the sound of drums.[20]

Elsewhere there are references to the influence of climate that seem to anticipate Winckelmann. In one place the soul is compared to a soft screen on which "images of the objects painted in the eye are projected as by a magic lantern." Other comparisons with the processes of ceramics, baking, and fermentation get jumbled up together, but the pervading metaphor is

that of the mechanisms of clocks and watches, just as for Duchamp in the early twentieth century it is that of the automobile. Eliot the poet likewise compared the human engine to "a taxi throbbing waiting."[21]

If La Mettrie reinforces the links between Duchamp and Pyrrhonism, the example of his life and some of his stated opinions intensify certain logical and ethical doubts that Pyrrhonism raises. In the first place, his beliefs about the mechanistic nature of human beings seem at variance with Pyrrho's injunction that we should be without beliefs. If they are not to be judged inconsistent with Pyrrhonism, they raise the question: when is a belief not a belief? The answer, in this instance, would seem to be not so much a simple distinction between "belief that" and "belief in" but a matter of whether the latter can grow out of the former, whether our understanding of the world in which we live is such as to form a basis for faith, trust, and obedience and hence provide a guide to moral judgments and a virtuous life. What becomes significant now is the sequence of Timon's three questions and the way the answers to the second and third grow out of the first. Pyrrho's negative answers to all three tend to weaken the force of their interconnectedness, but if we supply answers from almost any system of religious belief, or from many other systems of philosophy among the Greeks, the urgency of that interconnectedness becomes rapidly apparent. What breaks down with La Mettrie is not so much that his Pyrrhonism fails to fulfill Timon's promise of happiness in the material sphere, but that, with him, moral problems tend to get lost in medical solutions. As a medical man he was prepared, for instance, to relieve criminals of the "disease"[22] of guilt and remorse, and we may well wonder what virtue attaches to the courage of the soldier who would have run away except for the influence of strong liquor.

What is disturbing about La Mettrie is the possibility that his perception of the human condition may be right. And if it is, what do we do about it? What do we do about it as people, and what do we do about it as artists? In practice, I know for myself that there comes a point when ethical questions loom so large that I cannot sit perpetually on the fence, nor do I admire those who do. There comes a point at which conviction cannot be denied, regardless of the logic of its grounding. But is such conviction a sufficient basis for the artist to commit his or her art to the ethics of human affairs, regardless of the logic of its grounding? In this instance, conviction,

and the evidence of my experience of that art of the past to which conviction directs my attention, tells me that the higher path for art must be grounded in our profoundest intimation of the order of things, and if that implies an art beyond the domain of ethical questions, so be it.

In approaching an artist like Duchamp, whose total output may be small but whose range within that limited number of pieces is vast, a question arises as to where to center one's attention. Fortunately, Duchamp has been extraordinarily considerate in that regard, leaving us in *Etant Donnés* a work that is, in effect, his last will and testament (figs. 1.1 and 1.2). As his final work, intended to be viewed only after his death, the piece itself carries a unique authority, but its title, which is a direct quotation from the notes for *The Large Glass*, conveys the unmistakable intention of singling out that particular piece, from among all of the earlier work, to be associated with the final work; that each should be perceived in relation to the other, as complement and commentary, each directing the interpretation of the other; and that the two together, in the hindsight (and foresight) of the artist's maturely considered opinion, should be accorded a uniquely significant place within the artistic legacy he was to bequeath us. If further confirmation were needed, the evidence of the way Duchamp used his time should be overwhelming. In the period of sixty-six years from his first dated work in 1902 to his death in 1968, he was engaged with one or other of these pieces for almost half that time, a total of some thirty years. If we allow for the fact that, according to his own account,[23] he had largely given up art in 1923, the place of these two pieces looms even larger.

It is not a little surprising that it should have been Duchamp, of all artists, who would choose to provide this kind of orientation toward the understanding of his art. One of the most persistent themes in his recorded statements is that the artist is not aware of "what he is doing or why he is doing it," that "the spectator [who "later becomes the posterity"] brings the work in contact with the external world by deciphering its inner qualifications and thus adds his contribution to the creative act."[24] In 1915, he had related the argument to Rembrandt: "It is just because Rembrandt is none of the things that posterity has given him that he remains."[25]

Perhaps, however, we should not be surprised; perhaps it was just because Duchamp recognized the importance of "the spectator who later becomes

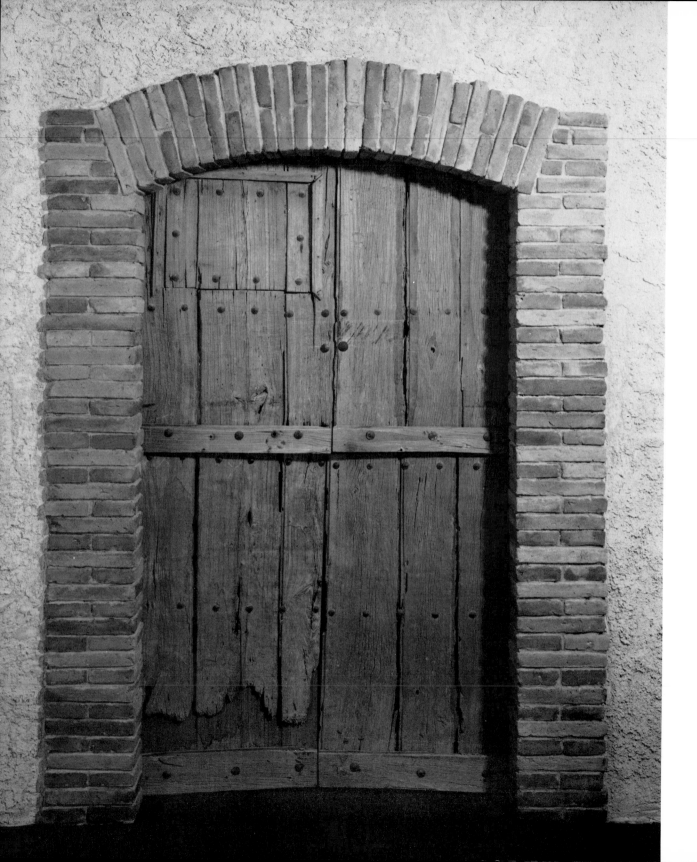

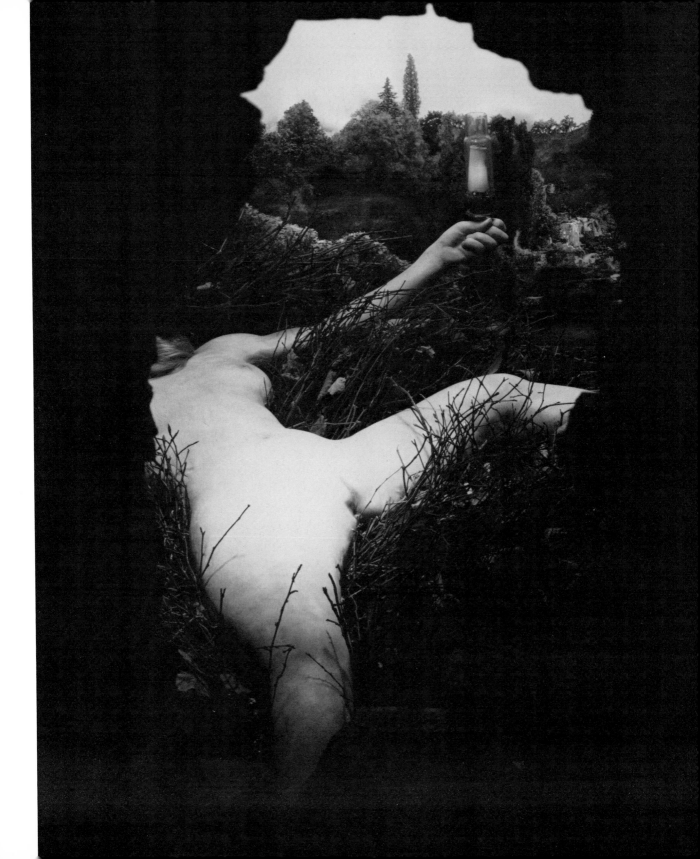

1.1
Etant donnés 1° la chute d'eau, 2° le gaz d'éclairage [Given: 1. the Waterfall, 2. the Illuminating Gas], 1946–1966, the door. Mixed media, approx. 95½ × 70 × 49 in. (Philadelphia Museum of Art; gift of the Cassandra Foundation.)

1.2
Etant donnés, the peep show.

the posterity" that he also saw the need to play posterity to himself in order to realize the meaning of his work most completely. The gesture is, in any case, unique to Duchamp, which may explain why its implications for the assessment of his art as a whole have not everywhere been recognized.

Without adding to the speculation as to the interpretation of particular allegorical mechanisms depicted in the lower sections of the *Large Glass*, I think it would be fairly safe to say that (paraphrasing Duchamp's own words)[26] it refers to an autocognizance, real or imagined, registered in the region of the groin. "The waterfall" and "the illuminating gas" are part of what *The Green Box* calls "the bachelor machine," and the meaning of *Etant Donnés* seems to follow thus: If you are a bachelor, and given that your waterfall and illuminating gas are in good working order, the image of the nude woman with legs spreadeagled will follow as a necessary consequence behind the door and the brick wall. There is no possibility of contact, only a perception that belongs exclusively to the beholder. Similarly, the bride section of the *Large Glass* is rendered in the vocabulary of Cubism, which will not admit of tangible objects or the kind of space that can contain them but only what Clement Greenberg would call an "optical" space that can be entered "only with the eye."[27] I would suggest that the inaccessibility of the woman in each case should be interpreted allegorically, that the experience of "other" in a sexual relationship belongs within the perceptions of the person experiencing. To that extent, heterosexual intercourse, masturbation, and real or imagined brother-sister incest are all equally onanistic.

What may be difficult to adjust to is that the uniquely high level of seriousness revealed by these two works (*Etant Donnés* and the *Large Glass*) should be developed around such subject matter. Alice Goldfarb Marquis in her biography of Duchamp reveals her own difficulty almost inadvertently. Discussing Duchamp's humor, she refers to an interview with Alain Jouffroy: "As he told Jouffroy in 1961, humor 'is indispensable . . . because the serious is something very dangerous.' *Then he canceled out the genuine profundity of that remark with a joke:* 'The only thing I can consider seriously is eroticism.' "[28] It scarcely seems credible that Marquis should have responded in that way, that she should have thought Duchamp was joking about the seriousness of eroticism. As the subtitle for her book, she

had herself chosen to give the name of Duchamp's female alter ego, not in the form in which he always wrote it, but—in order to elicit its punning reference to eroticism—as "Eros, c'est la vie." Could anything be more explicit than the statement that physical love or sexual desire is life? To be fair, it is true, as she was observing, that Duchamp's conversation is pervaded with humor. A word that crops up over and over again in the interviews with Pierre Cabanne is "amusing." The bulb of "Paris Air" was amusing;[29] "It amused me to bring the idea of happy and unhappy into ready-mades, and then the rain, the wind, the pages flying, it was an amusing idea";[30] "These people were very amusing because they were unexpected";[31] "[pure chance] amused me";[32] "It's always the idea of 'amusement' which causes me to do things";[33] "[the word 'swift'] amused me"; "As a formula [the idea of elementary parallelism] seems very pretentious, but it's amusing";[34] "When you're a kid . . . you simply follow a line that amuses you";[35] "[Stieglitz] didn't amuse me much";[36] "The idea is amusing because they are molds."[37] Alternatively: "It's fun to do things by hand";[38] "the movies were fun."[39] But such expressions could also carry negative connotations: "This Neo Dada which now calls itself New Realism, Pop Art, Assemblage etc. is cheap fun living off what Dada did."[40]

By contrast Duchamp uses the antonym "serious" very sparingly, and this lends added significance to his statement to Jouffroy. Even in relation to the *Large Glass* he felt the need "to introduce 'hilarity' or at least humor into such a 'serious' subject"[41]—"an *amusing* physics."[42] I can cite only three other places[43]—there may well be more—where Duchamp uses the word "serious." What it boils down to is that Duchamp is prepared to take only two things seriously, chess and eroticism.

Perhaps I can approach an explanation by first recalling not Baudelaire's notion of the "heroism of modern life" but the actual heroic age of the *Iliad*. Alasdair MacIntyre in his book *After Virtue* devotes a chapter to "The Virtues in Heroic Societies." "The heroes of the *Iliad*," he writes, "do not find it difficult to know what they owe one another. . . . There is indeed in the vocabulary available to Homer's characters no way for them to view their own culture as if from the outside. The evaluative expressions which they employ are mutually interdefined and each has to be explained in terms of the others. . . . The rules which govern both action and evaluative

judgment in the Iliad resemble the rules and precepts of a game such as chess."[44]

That this should be the case, that chess should embody the rules and precepts of life in the heroic age, is understandable enough, since the game derives historically from the schematized conflicts of just such an age, albeit from India rather than Greece, and notwithstanding the transformation of war elephants into bishops. What is interesting in MacIntyre's analysis is that it draws attention not to the emotional facade of heroism but to the underlying principles of order that make heroic acts admirable in the eyes of reasonable people. According to MacIntyre this has to do primarily with the cohesive power of kinship obligations, but the world of nonhuman nature is controlled by anthropomorphic gods whose conduct is susceptible of similar evaluative judgments. What was important was not that the gods were particularly virtuous. Indeed, Xenophanes could claim that "Homer and Hesiod have imputed to the gods all that is blame and shame for men."[45] Rather it was the fact that it was possible to apply such judgments to the forces that controlled the universe. Faith, trust, and obedience were grounded in the order of things.

The problem is not that our age lacks exemplars of heroic behavior, as Baudelaire and Balzac pointed out, but that the criteria that validate the propriety of heroic acts have become increasingly relative to shifting patterns of social organization, and that they are, even then, constantly eroded by the scientific reinterpretation of virtue as the outcome of mechanical causes, or adrenalin if not of alcohol.

Whereas for Balzac, for Baudelaire the critic, and for many later existentialists what was of interest was the display of heroic courage whether in personal or public or cosmic sphere, what engaged Duchamp's serious attention was the possibility of mechanical order. It was not the competitive or combative aspect of chess that interested him—had it been, he might have been a better chess player—but the kind of enclosed order to which MacIntyre alludes. Duchamp told Cabanne: "A game of Chess is a visual and plastic thing, and if it isn't geometric in the static sense of the word, it is mechanical, since it moves; it's a drawing, it's a mechanical reality."[46] These were precisely the same terms in which Duchamp perceived erotic experience in the *Large Glass*. If his interest in chess had little to do with

its emotional aggressive aspects, so his interest in eroticism is greatly distanced from any hint of sensuality—just as any lingering interest in painting is distanced from its optically sensuous aspect. Whether the analogy is to the codes of conduct in heroic society, to geometrical theorems, or to mechanical processes, it is essentially the enclosed sense of order that engages Duchamp's serious attention. He once told an interviewer, "I've never read Descartes to speak of. . . . I am not a Cartesian by pleasure. I happen to have been born a Cartesian. The French education is based on a sequence of strict logic. You carry it with you."[47]

Duchamp is Cartesian not only in his logical cast of mind, but also in his emulation of the reductive method of the *Meditations,* seeking a basis of certain order beneath the amusing diversity of experience. That this process did not lead him to the same conclusions as Descartes may have to do not only with the general disintegration of the Baroque synthesis, but also with two specific weak points that had revealed themselves in Descartes's own system. The first had to do with the nature of human being and the second with the nature of the world. In the former area Descartes invites the undermining of his own position by his arguments both that animals are purely mechanical creatures and also that the human body operates according to mechanical principles subject to the control of the mind.[48] Even the analogy with clocks and watches, adopted and extended to its logical conclusion by La Mettrie in *Man a Machine,* was already present in Descartes. In regard to the nature of the world, the *Meditations* had pointed to, then drawn back from, the possibility that the world in which Descartes thought he lived was no more than a dream or a painted illusion.[49] The notion of the world as picture was revived with a vengeance by Kant, set in historical context by Dilthey, and has become almost a commonplace in the twentieth century. The decomposition of pictorial structure in Duchamp's early paintings is one outcome of the questioning of the objective validity of our picturing of the world to ourselves. If the possibility of sustaining the being of self on the basis of thought, and the reality of the world as an extension of mind, were therefore denied Duchamp, what he could not doubt was the logic of "Given: (1) the waterfall (2) the illuminating gas."

But in Duchamp's case, the logic is an experiential logic, not an objective analysis of the contents of experience. Just as his art's scientific traits do

not deal with the actual findings of science but convey the experiential character of a world dominated by science, so too if his art forsakes the sensuous optical qualities of painting like Matisse's for more cerebral content, it continues to deal experientially with things in the mind. He told Laurence D. Steefel his artistic goal was "to grasp things with the mind the way the penis is grasped by the vagina."[50]

Once the central place of the eroticism of *Etant Donnés* and the *Large Glass* is recognized in Duchamp's art, other works find their own place more securely in relation to it, while still others fall away into lesser levels of significance. The iconoclasm of moustache, goatee, and suggestive inscription added to the image of the *Mona Lisa* now reveals itself as a means of access to the experience of sexual identity in a human face. Duchamp explained in a 1961 interview: "The curious thing about that moustache and goatee is that when you look at it, the *Mona Lisa* becomes a man. It is not a woman disguised as a man; it is a real man."[51] These remarks take on added interest in relation to the possibility raised recently that the *Mona Lisa* is based on Leonardo's own features. Since Freud, the question of Leonardo's sexual orientation has been a necessary aspect of the study of his art, but what now becomes an issue is not so much orientation as identification, and this is evidently of primary consequence to Duchamp who was to invent a female alter ego for himself, Rrose Sélavy. If there is a further complication in Duchamp's own case, it would have to do with the depth of his affection for his sister Suzanne. Beyond the obvious traits that identify the human species and the more subtle ones that distinguish male from female features, there come into play the still more subtle cues of family resemblance that counter the recognition of sexual object through the invocation of taboos on incest.

Similarly with the *Nude Descending a Staircase* (fig. 5.9) and the Readymades. From the point of view of eroticism the *Nude Descending a Staircase* is shocking, not as an "explosion in a shingle factory" but because nakedness, which should be kept politely out of sight in the bedroom, is seen to be descending into the public domain of downstairs. Duchamp told Cabanne "basically [eroticism] is really a way to try to bring out in the daylight things that are constantly hidden—and that aren't necessarily erotic—because of the Catholic religion, because of social rules. To be able to

reveal them, and to place them at everyone's disposal—I think it is important because it's the basis of everything and no one talks about it."[52]

With the Ready-mades, there are some obvious erotic suggestions like the multi-phallic form of the *Bottle Dryer*, whose sexual connotations become even more explicit if it is imagined with the bottles mounted on it (fig. 6.5). *"Fountain"* even more so: the analogies between urination and copulation hardly need to be specified in detail. But there is also a more general if indirect relationship to the theme of eroticism that I can get at by way of an understanding of the term Duchamp used to designate these works and its relationship to the forms of the *Large Glass*.

Primarily the term "Ready-made" indicates that the objects were "already made," but about half the contemporary quotations cited for the term in the *Oxford Dictionary* relate to ready-made clothing, and I am always surprised that this innuendo is not taken up in the studies of Duchamp, when so much of his art has to do with dressing up (as Rrose Sélavy) or stripping bare (like the bride in the *Large Glass*). Duchamp himself stipulated that *Traveller's Folding Item* (fig. 1.3) should be displayed like a skirt with a wooden support underneath to confirm for the sake of prying eyes the promise of "Underwood" on the typewriter cover itself.[53]

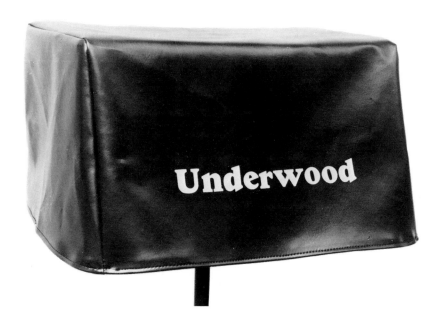

1.3
Pliant . . . de voyage [*Traveller's Folding Item*], readymade, 1964. Replica by Arturo Schwarz with the authorization of Duchamp after lost original of 1916, 9¹/₁₆ in. high (Galleria Schwarz, Milan.)

At the time of the first Ready-made, Duchamp had not long completed the drawing *Cemetery of Uniforms and Liveries,* which was to feature in the *Large Glass* as the "malic molds" (fig. 1.6). These have much more the look of objects from the hardware store than of clothing, so it would be reasonable to pick up a suggestion of clothing in items that really do come from the hardware store. Uniforms and liveries provide standardized identification in relation to the role the individual fulfills professionally; ready-made clothing has more far-reaching implications in that it offers the purchaser the image of his private self, already made, off the rack (figs. 1.4 and 1.5). Through all the extraordinary variety of forms in the nine malic molds there runs a single connecting plane, "the plane of sex cutting them at the point of sex."[54] The metaphor of a level of sameness despite variety of social roles is unmistakable, and it is consistent that each equally receives the illuminating gas that passes thence from each equally through the "capillary tubes," where it solidifies and is cut into spangles. A similar reading of the Ready-mades is indicated, except that it is primarily as metonym rather than as metaphor that each signifies its contact with life, which is to say with "eros."

In relation to this universal erotic theme, other works are relegated to a lesser level of significance. Duchamp himself dismissed the optical experiments of 1934.[55] In their way, the optical illusions of these works are akin to the verbal illusions of puns that also at times amused Duchamp. They belong with the incoherent profusion of contingencies and chance effects in the world of everyday activity, which may provide amusement but in which he refuses to become involved. Duchamp told James Johnson Sweeney: "There are two kinds of artists: the artist that deals with society, is integrated into society; and the other artist, the completely freelance artist, who has no obligations."[56] Duchamp considered himself lucky that he never had to work for a living, had no interest in politics or politicians, and was disdainful of heroes. What was "above all" important to him in chess was that "there is no social purpose."[57] Whether his stance of indifference should properly cause us to label him a Pyrrhonist or a dandy in the tradition of Baudelaire, his aloofness is justified not because social and political issues are unimportant, still less because he provides an example the rest of us ought to follow, but because it was necessary for him to disentangle himself from those issues so as to gain an uninhibited view of

the order of things in a world of mechanical law that supersedes, along with the other illusions, the illusion of moral judgment. If there were lapses from this principle of aloofness, they came about negatively through his attempts to shock, like the *Tzanck Check* and the Monte Carlo bonds, which both belong to the Dada period of the *L.H.O.O.Q.* As the former is anchored through a relationship of negative dependency to a past Duchamp wished to wipe right out, so the latter owe the obligations of negative dependency to the world of commerce from which Duchamp wished to set himself free. Likewise dependent are the many later artists who would "deconstruct" the commercial system or the gallery system while anchored to that which they profess to disdain.

If then the posthumous directive of *Etant Donnés* gives an orientation to Duchamp's art around the theme of eroticism, this is not necessarily to say this was Duchamp's intention all along. If Duchamp could tell Cabanne that he believed in eroticism a lot, "because it's truly a rather widespread thing throughout the world, a thing that everybody understands,"[58] we may wonder how far this concern that everybody should understand, expressed when he was seventy-nine, reflects the mood in which the artist approached his first explicitly erotic works in his twenties. What interests me is not so much the relationship that must have existed between the eroticism of Duchamp's art and the sexuality of the man but, rather, the relationship, in his art, between its eroticism and its iconoclasm.

In his later years, Duchamp's attitude toward iconoclasm and anti-art certainly changed. He told Francis Roberts in 1963, "The years change your attitude and I couldn't be very iconoclastic any more. . . . If I have been blamed for anti-art, I am delighted to be blamed, because that was my intention in the first place, to do something that would not please everybody, to do something iconoclastic."[59] By 1963, however, the notion of anti-art annoyed him because—recognizing the principle of negative dependency—he saw that "whether you're anti- or for, it's two sides of the same thing." He still objected to art as a gratification of taste, and he still objected to the elevation of art as a human activity because he felt that "art has no biological source."[60] A page before, Duchamp had been talking about eroticism; and there is no escaping the innuendo that, if art itself has no biological source, eroticism certainly does: namely, (1) the waterfall and (2) the illuminating gas.

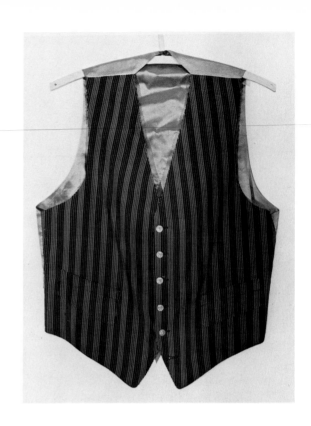

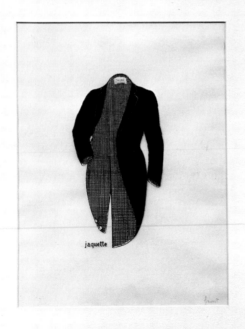

jaquette

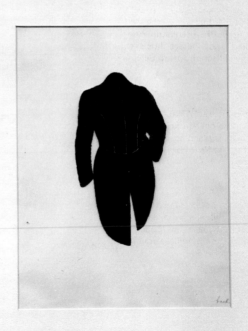

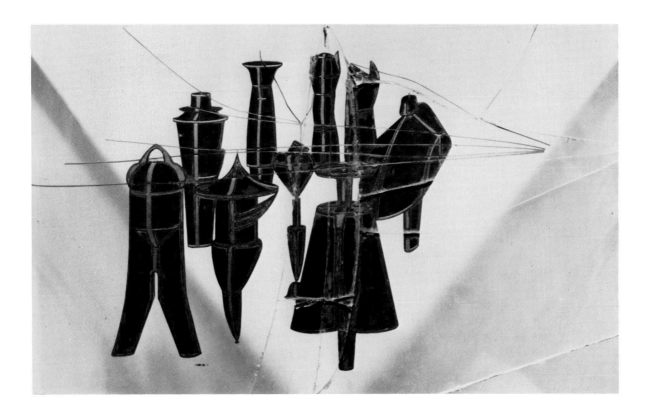

1.4
Gilet [*Waistcoat*], 1958. Rectified ready-made: green wool waistcoat, 23⅝ in. long. The five buttons on the vest bear the letters PERET (Benjamin Péret) in 24-point lead type, and are thus seen in reverse. (Collection Arturo Schwarz, Milan.)

1.5
Jacquette [*Jacket*], 1956. Two parts, gouache and collage on paper, each 10¾ × 8 in. (Collection Carroll Janis, Conrad Janis, New York; photo Geoffrey Clements.)

1.6
Neuf Moules Mâlic [*Nine Malic Molds*], 1914–1915. Oil, lead wire, and sheet lead on glass, 26 × 39¹³⁄₁₆ in. (Collection Mme Alexina Duchamp, Villiers-sous-Grez.)

Even now, in the aftermath of so-called "sexual liberation"—regardless of the ebb and flow of social tides of permissiveness and repression—sex continues to be a difficult, delicate topic in life and in art. Sex may be talked about more, but we are fortunate indeed if we can negotiate those conversations without ever feeling twinges of personal anxiety. If Duchamp's desire was to shock for shocking's sake, no subject could be better calculated to bring about that end. Of course, one must not forget that the early years leading up to the *Large Glass* also produced the notes that speak of "possibilities authorized by . . . laws,"[61] as if the laws of human behavior could be calculated with the precision of a problem in geometry. But there could be a shift of emphasis there too. Apart from sex, it would be hard to imagine anything better calculated to shock than such a mechanistic interpretation of human behavior. If these things shock, we must ask why. The answer is inescapable: they shock because of the intensity of pressure we have to exert to deny them. It would be fully consistent with Duchamp's own theorizing about the artist's lack of awareness, and about the emergence of meaning through subsequent interpretation, if the "serious" eroticism of Duchamp's later years could be shown to have come about partly as a by-product of his iconoclasm, his desire to shock. It would be interesting if we could know precisely when Duchamp first began to muse on the transformation of the face of the moustached Mona Lisa into that of an actual man. The interview in which he made the observation took place more than forty years after the iconoclastic gesture against the work of art.

At this stage, Eliot's essay "Tradition and the Individual Talent" may again come to my help, this time by providing a metaphor: "The mind . . . of the poet . . . [is] a . . . medium in which special, or varied, feelings are at liberty to enter into new combinations."[62] This process is what Eliot understands by his "impersonal" theory of poetry, that the mind of the poet is not so much a store of personal experiences to be expressed but a vehicle or medium within which what I will call an intuition of the order of things (I am uncomfortable with his emphasis on *feelings*) can precipitate out into an order of words formed by the poet. Duchamp's one verbatim quotation from Eliot's essay takes up this "impersonal" theme: "The more perfect the artist, the more completely separate in him will be the man who suffers and the mind which creates; the more perfectly will the mind digest and transmute the passions which are its material."[63] It is revealing that

Duchamp should have developed his mature theoretical position around Eliot's theory of poetry. The medium of poetry, as Clement Greenberg observed, is psychological, but the two great works of Duchamp's early and late years are quite massive physical objects. The medium of the painter, as Clement Greenberg also observed—and Duchamp always remained essentially a painter—is physical.[64] For Duchamp there necessarily has to be an intermediate stage in which the intuition is precipitated out as idea in the artist's mind before Duchamp the craftsman translates it into material form. If, however, one were to set out to devise a literal equivalent of Eliot's theory for the painter, this would not by any means necessarily be the case.

For Eliot, the critic of poetry, the notion of "medium" is a metaphor, but the painter works with material substances suspended in what is literally just such a medium. If he or she can find a way of disengaging himself or herself, the possibility presents itself not just that an intuition or intimation of the order of things in a material universe may be engendered in signs and symbols, but that the order of its "itness" may be manifest directly through the activity of the artist's "passive attending upon the event."[65]

At this stage I am now going to contradict Eliot the critic one last time—which I might feel uncomfortable about, had not Eliot the poet already contradicted him so very much more assertively. "The Three Voices of Poetry" of 1953 must be one of Eliot's weakest essays. He defines the three voices as those of "the poet talking to himself or to nobody . . . the poet addressing an audience . . . [and] the poet when he attempts to create a dramatic character speaking in verse."[66] It seems to me inconceivable that anyone, even a poet, should ever speak in the way that poetry is written. The justification of its utterly improbable turns of phrase and form is that what speaks to us always in great poetry and art and music is not a person, a poet, artist, or musician, but, regardless of grammatical syntax, the voice of that order of things beyond human perception and control. Although Eliot may present his impersonal theory as an explanation of poetry through the ages, the impersonality of his own work gains its poetic justification in relation to the impersonal order of things presented by the world of science. That, too, is why the impersonal forms of Pollock's dripped paint and of Duchamp's Ready-mades (which he described as works of art without an

artist)[67] carry such enormous authority. What is not really at stake is belief in God. Even La Mettrie had an open mind on that subject. What is at stake is the kind of entity God could conceivably be in relation to the kind of world that science reveals to us and the kind of relationship or nonrelationship that human beings could conceivably have to God (given such a world), if He, She, or It exists. At the beginning of Schoenberg's opera *Moses and Aaron,* Moses calls on "Only one, infinite, omnipresent, unperceived, and inconceivable God!" Departing from the Bible story, Schoenberg has Moses smash the tablets of stone when Aaron demonstrates that even the words they contain are "images, just part of the whole idea."[68] It might be possible to find precedents in traditional theology for some aspects of the thought of the libretto; what is more significant and quite without precedent is the uncenteredness of the music to which these words are set.

If the purpose of art in such a world, as I have argued elsewhere, is "to justify the inevitability of its particular forms,"[69] the word "justify" carries little connotation of demonstrating fair play between God and men. Rather it is a matter of making perceptible the resoluteness of the world's otherness. If there yet remains some semblance of a bridging role of the sort that Kant envisaged between the realm of ethical judgment and that of our understanding of the order of things, the supports of that bridge must be set farther apart than Kant set them, not merely an internal reconciliation of cognitive and imaginative spheres, but a bringing into relationship—or nonrelationship—of that reality beyond the realm of our experience, which Kant calls the "suprasensible substrate," and that aspect of our humanity that can feel the chill of its indifference. I would not quarrel with the logic of Kant's arguments regarding the inaccessibility of the suprasensible substrate, but would rather assert that the role of the artist has always entailed a mystical revelation beyond the logic of argument, albeit, in the present, this must imply a material mysticism.

Duchamp's beauty of indifference, if indeed it may in any meaningful sense be said to be "beautiful," is justified not as a manifestation of unfeelingness within the human sphere, but as a reflection of that impersonal otherness that lives our lives for us, through the functioning of processes indifferent to life and nonlife. In the reality of whatever they may actually be, these processes may not be capable of being given in human awareness. But they are "Given" in the stronger sense of a difficult truth that cannot be attested on the basis of evidence and yet stares us in the face.[70]

Notes

1 T. S. Eliot, "Tradition and the Individual Talent," *Selected Essays 1917–1932* (London: Faber and Faber, 1932), 15.

2 Charles Baudelaire, "The Salon of 1846," *Art in Paris 1845–1862,* trans. Jonathan Mayne (London: Phaidon, 1965), 116.

3 David Irwin, "Introduction," *Winckelmann: Writings on Art* (London: Phaidon, 1972), 57.

4 Wilhelm Dilthey, "The Types of World-view and Their Development in the Metaphysical Systems," *Selected Writings,* trans. H. P. Rickman (Cambridge: Cambridge University Press, 1976), 135.

5 T. S. Eliot, "The Perfect Critic," *The Sacred Wood,* 2d ed. (London: Methuen, 1928), 9.

6 T. S. Eliot, "Introduction," *The Sacred Wood,* xii.

7 Walter Benjamin, "Modernism," *Charles Baudelaire: A Lyric Poet in the Era of High Capitalism,* trans. Harry Zohn (London: NLB, 1973), 71.

8 Arturo Schwarz, *The Complete Works of Marcel Duchamp* (New York: Abrams, 1969), 38.

9 Léon Robin, *Pyrrhon et le Scepticisme Grec* (New York: Garland, 1980), 7–8.

10 Charlotte L. Stough, *Greek Skepticism* (Berkeley: University of California Press, 1969), 17.

11 Pierre Cabanne, *Dialogues with Marcel Duchamp,* trans. Ron Padgett (New York: Viking Press, 1971), 89.

12 James Johnson Sweeney, "Regions Which Are Not Ruled by Time and Space . . . ," *Salt Seller: The Writings of Marcel Duchamp,* ed. Michel Sanouillet and Elmer Peterson (New York: Oxford University Press, 1973), 137.

13 Robert N. Bellah, "The Historical Background of Unbelief," *The Culture of Unbelief* (Berkeley: University of California, 1971), 39.

14 Cabanne, *Dialogues,* 106.

15 Ibid., 107.

16 Harriet and Sidney Janis, "Marcel Duchamp, Anti-Artist," in Joseph Masheck, ed., *Marcel Duchamp in Perspective* (Englewood Cliffs: Prentice-Hall, 1975), 30.

17 Alice Goldfarb Marquis, *Marcel Duchamp: Eros, c'est la vie* (Troy, N.Y.: Whitston, 1981), 308.

18 Julien Offray de La Mettrie, *Man a Machine* (La Salle, Illinois: Open Court, 1953), 127.

19 "Frederick the Great's Eulogy on Julien Offray de la Mettrie," in La Mettrie, *Man a Machine,* 9.

20 La Mettrie, *Man a Machine,* 93.

21 T. S. Eliot, *The Waste Land,* line 217.

22 "Man-Machine from the Greeks to Computer," *Dictionary of the History of Ideas* (New York: Scribner, 1973), III, 140.

23 Cabanne, *Dialogues,* 87.

24 "The Creative Act," *Salt Seller,* 138.

25 "A Complete Reversal of Art Opinions by Marcel Duchamp, Iconoclast," *Studio International* 189, no. 973 (January-February 1975), 29.

26 "We always reduce a gravity experience to an auto-cognizance, real or imagined, registered inside us in the region of the stomach." "A l'infinitif," *Salt Seller,* 87.

27 Clement Greenberg, "Modernist Painting," in Gregory Battcock, ed., *The New Art,* (New York: Dutton, 1973), 73.

28 Marquis, *Duchamp,* 331.

29 Cabanne, *Dialogues,* 63

30 Ibid., 61.

31 Ibid., 46.

32 Ibid., 47.

33 Ibid., 47.

34 Ibid., 34.

35 Ibid., 21.

36 Ibid., 54.

37 Ibid., 48.

38 Ibid., 106.

39 Ibid., 68.

40 Letter to Hans Richter, dated November 11, 1962, quoted in Werner Hofmann, "Marcel Duchamp and Emblematic Realism," in Masheck, ed., *Marcel Duchamp in Perspective,* 64.

41 Marquis, *Duchamp,* 314.

42 William Rubin, "Reflexions on Marcel Duchamp," in Masheck, ed., *Marcel Duchamp in Perspective,* 50.

43 (1) In "Regions Which Are Not Ruled by Time and Space," interview with James Johnson Sweeney, in *Salt Seller,* 136: "I took [chess] very seriously and enjoyed it because I found some common points between chess and painting." (2) Cabanne, *Dialogues,* 18 (of Duchamp's passion for chess): "It's not a serious matter, but it does exist." (3) Marquis, *Duchamp,* 309: "Discounting the notion of a joke, Duchamp insisted he was serious when he painted *Nude Descending a Staircase.*"

44 Alasdair MacIntyre, *After Virtue* (Notre Dame: University of Notre Dame Press, 1981), 118.

45 Katherine Everett Gilbert and Helmut Kuhn, *A History of Esthetics* (Bloomington: Indiana University Press, 1953), 1.

46 Cabanne, *Dialogues,* 18.

47 Marquis, *Duchamp,* 112.

48 René Descartes, *Traité de l'homme* (1664), quoted in *Dictionary of the History of Ideas,* III, 136.

49 Rene Descartes, *Les Méditations,* in *Oeuvres Philosophiques de Descartes* (Paris: Garnier Frères, 1967), II, 407.

50 Marquis, *Duchamp,* 311.

51 Ibid., 176

52 Cabanne, *Dialogues,* 88.

53 Marquis, *Duchamp,* 161.

54 "The Green Box," *Salt Seller,* 51.

55 Cabanne, *Dialogues,* 87.

56 *Salt Seller,* 133.

57 Cabanne, *Dialogues,* 19.

58 Ibid., 88.

59 "I Propose to Strain the Laws of Physics," interview with Francis Roberts in *Art News* 67, no. 8 (December 1968), 62. N.B. The order of the sections preceding and following the ellipses has been reversed.

60 Cabanne, *Dialogues,* 100.

61 These words occur in both "Preface" and "Notice" in "The Green Box," *Salt Seller,* 28.

62 Eliot, "Tradition and the Individual Talent," 18.

63 Ibid., quoted in "The Creative Act," *Salt Seller,* 138.

64 Clement Greenberg, "Towards a Newer Laocoon," *Partisan Review,* 7 (Fall 1940), 305.

65 Eliot, "Tradition and the Individual Talent," 21.

66 T. S. Eliot, "The Three Voices of Poetry," *On Poetry and Poets* (New York: Noonday Press, 1969), 89.

67 Interview with Francis Roberts, 47.

68 Arnold Schoenberg, *Moses and Aaron,* Act II, Scene V.

69 Eric Cameron, *Bent Axis Approach* (Calgary: Nickle Arts Museum, 1984).

70 I would like to acknowledge my indebtedness at more points than I could possibly specify to lectures on Duchamp given by the two organizers of this colloquium, Thierry de Duve and Dennis Young; also to many conversations with them. It goes without saying that the shortcomings of this paper are all my own work.

Discussion

Moderated by Thierry de Duve

ROSALIND KRAUSS

I would like some clarification about the parallel you are suggesting between Eliot and Duchamp. How seriously were we to take that connection?

ERIC CAMERON

I think the parallel fits where it touches. There is an obvious distinction there. Eliot said later that his period of doubt was a kind of belief. And I think there is always somewhere in the region of Eliot's thought, before his conversion even, the possibility of a religious position, so that a distinction has to be drawn between Duchamp and Eliot in that way. But I am not sure precisely which points you were concerned with.

ROSALIND KRAUSS

I suppose my own experience is that it doesn't touch at all. That's why I'm asking this question. Eliot's conception of tradition, his idea of high culture, his notion that art is redemptive, seems to me to be so far from my understanding of Duchamp. I just don't know where to look in Duchamp to find anything that would connect to this.

ERIC CAMERON

I think that there are two things perhaps I can reply in relation to this. And the first is that I would draw a distinction between Eliot the critic and Eliot the poet, particularly in that early period of "Tradition and the Individual Talent" and of the *Waste Land*. Think of the constant juxtaposition of images throughout the *Waste Land,* in which the lowest side of London life is contrasted with the sense of an elevated aristocratic context, whether it's the Oedipus story with Tiresias being the major character, whether it's the people swarming across a bridge in London compared with Dante, or whether it's the Spenser instance that I quoted. There are many of those instances: the juxtaposition, for instance, in "A Game of Chess," between the part that paraphrases *Anthony and Cleopatra* and the part that shifts to a London pub with the woman who hasn't looked after herself and has lost her teeth and is afraid of her husband coming back from the wars and what he's going to think of her. I would

think that is what I meant by the equivalent of drawing a moustache on the Mona Lisa. Now toward the end of the poem, it does all resolve itself because he talks about "these fragments I have shored against my ruins." And he quotes, in the final passage, the Sanskrit phrase which comes down as "peace which passeth understanding." Out of that repetition of negatives there comes, really in the same breath, for Eliot, the sense of solace and of a religious salvation. I think that the sense of some order coming out of Duchamp's iconoclasm really comes rather later in his life. But there is a parallel. I was saying that there was going to be a second point to this, and I have forgotten it.

HERBERT MOLDERINGS

At the beginning, you outlined two currents of artistic approach, a modern one and a traditional one. As I understood it, you related Duchamp to the modern current. This has been happening in relation to Duchamp's work for fifty years or more, and it has prevented, for a long time, a larger approach to his work. For me, Duchamp's unique contribution to contemporary artistic activity was to have understood, as early as 1912–13, that the opposition between academic art and vanguard art was no longer valid. What he stressed and practiced was the negation of the conception of *peinture pure*—of *peinture pour la peinture*—and the development of an art which was "at the service of the mind," like the old academic art still active at the time. I think he was able to develop new forms of expression in vanguard art because he referred back to the traditional conception of literary, allegoric painting. And so, I think all these attempts to push Duchamp and his work into either traditional or modernist conceptions of art prevent a full understanding of what he was doing. He combined the two.

ERIC CAMERON

Well, that helps me remember the second half of the answer I was going to give to Rosalind Krauss a second ago. That had to do with the question of Eliot's commitment to tradition and Duchamp's iconoclasm, his desire—he says at one time—to wipe the past right out. I think both equally represent a paying of attention to the past—as he eventually came to recognize. And I think of a parallel case in the way Joseph Kosuth a long time ago wrote his essay "Art after Philosophy."[1] The pivot

of his argument was that he linked together, on the one hand, Ad Rein-
hardt, who wanted to perpetuate, to distill the essence of art, to the stage
that got him to saying "Art in art is art as art"—it becomes as tautologi-
cal as that—and, on the other, Duchamp's denial of the past. And both
equally were addressing the subject of art. I have stressed in my paper
the process of negative dependency, and, in a way, I am trying to equate
negative and positive dependency as both being dependencies, not deny-
ing, however, that there is a distinction between positive and negative
dependency. Now, that isn't quite the same answer that I'd want to give
to Herbert Molderings's question, because what is at stake there is a
narrower definition of "modern" versus a much broader definition of
"modern." I think that when we speak of "modernism," what we tend to
think of is the very limited definition of what's taken place in the twen-
tieth century that Clement Greenberg particularly has been responsible
for formulating. And I was really applying the term "modern" to a much
broader development: the earliest work I quoted that would fit in with
that definition would be Goya's portrait of the *Family of Charles IV*,
which goes back to 1800. What I was thinking of there was a different
sense of relationship to the past and to its ideals, to its ideas, to the sort
of systems of authority on which art had depended, rather than to the
forms which art takes. I certainly think you're right to point out that
Duchamp (as he says in the Cabanne interviews) insists that art had
previously, for the last two hundred years and before, been at the service
of religion and also had been literary. Even though his subsequent
remarks clearly stress the aspect of the literary, what I would emphasize
is his reference to art's having been religious in the past. In the end,
what for me is important is that he comes to address questions which
have, in our own time and given our own beliefs, equivalent answers that
we can provide in our own age. But what interests me is the process of
negation by which he arrives at them. I certainly can't deny the things
that you're saying about his returning to some aspects of academic
work—the extraordinary display of perspective virtuosity in the *Oculist
Witnesses*, for instance. It must show a fuller command of perspective
than that of any of the academic artists of the nineteenth or the twentieth
century. So, I agree with the point that you're making but would qualify
that my own sense of "modern" certainly implies something very much

broader than Greenbergian modernism, which I think I dismissed in one phrase when I said that modern art, in its changes of structure as well as in its imagery, represents a denial of the past. I was using the word "modern," oddly enough, in a way which is so broad that most of what I've read of as "postmodern" simply gets absorbed into it.

DENNIS YOUNG

Perhaps I can focus on the moment just before both Duchamp and Eliot began to produce, that is to say on the Symbolist epoch, in order to remind us that even though Eliot ends the *Waste Land* with that line about "These fragments I have shored against my ruins," he begins with a quotation which addresses the predicament of the Cumaean Sibyl in her cage. However, what he doesn't tell us is that the practice of the Cumaean Sibyl was to throw down from her cave, in answer to supplicants, leaves upon which were written the answers to their requests for knowledge, some of which would be snatched away by the wind. The supplicant would thereby receive only fragments of the reply. I have always been struck by the relation between that practice and Duchamp's practice in the various notes which are never chronologically ordered and which seem very much like fragments of a greater message, parts of which are missing: a method which resonates with the Symbolist notion that if we want to apprehend something more profound behind material existence, then we might best do so by picking up these fragments and having them resonate within us. And this is in fact what Duchamp scholarship has produced. When I read the writings of all of you, what impresses me is how they always raise the question of whether Duchamp could have actually intended us to see these things in such a way or whether he simply had a profound intuition that we would develop them and interpret them in ways that he could not predict.

ERIC CAMERON

Regarding Symbolism, I'd like to say that Duchamp talked of Laforgue— who must be made the main connecting point between Eliot and Duchamp—as a way out of Symbolism. Laforgue's *Hamlet*, I think, was a key.

ROSALIND KRAUSS

I understand Dennis Young to be addressing all of us on the panel when

he just said that we have all made interpretations of Duchamp by relating Duchamp's work to larger systems of knowledge, systems of an esoteric kind. I wish to exempt myself from such a group and to say that I am enormously hostile to such a move. I think it is a betrayal of Duchamp. The idea that he was involved in systems of elaborate, esoteric research, that he would have supported interpretations that referred his work to neoplatonism, to a revival of belief systems supported by classical perspective, to the whole baggage that Duchamp scholarship has produced, seems misguided to me. And what may develop (at least I hope so) over the course of these three days is a battle between those who hold that position and those who find themselves attacking it, as I do. I would also like to say I believe that Eric Cameron has misunderstood what Herbert Molderings was saying. He was not saying that Duchamp had returned to, or supported, anything like academic art, but that Duchamp had bought out of an opposition between modernism and the academic to show it as a dead end; and that he was trying to find some other ground on which to operate. So the idea that he was welcoming the academy, or academic forms like perspective, just seems wrong to me.

ERIC CAMERON

Well, I hope I didn't say that. What we were talking about specifically in that context were certain forms used in academic art and certain forms that have been in a Greenbergian sense referred to as modern. And I accepted that Duchamp's area of activity was in relation to both.

HERBERT MOLDERINGS

But I don't start from Greenberg because I don't start from theory. The oppositions between traditional art and modern art weren't theoretical oppositions. They were social and institutional oppositions. We could discuss at length the role of Goya in relation to the development of that which happened in painting after 1850. In a general sense, after the revolution of 1848, the material, social, and institutional oppositions between traditional academic art and modern art established themselves. And on the basis of the development of these real social oppositions, theory developed to the point where, in 1912–13, the vanguard art milieu in which the young Duchamp lived with his elder brothers was completely involved with a certain conception which was, in my opinion, best

expressed by Apollinaire when he radicalized the studio talk of the time into a theory of *peinture pure, peinture pour la peinture*. Now, I think the young Duchamp was already fed up with all these empty discussions among his brothers and the Gleizes and Metzingers, with all these theoretical questions. He tried to find a way out, and he found it by leaving aside all the so-called antitraditional ideas of modernist talk. But he did not go back to academicism. He went back to a very, very old tradition of art. He talked about Renaissance art. He talked about the role of the monks in medieval art. He simply wanted to express his ideas by art. What keeps interesting me in his art, for the present situation, is that his position is for me, today, the only viable, workable one for continuing, because there is no academy any longer, there are no modern artists any longer; all the modern artists are in the academy, they are professors. There is only business. And so the opposition between academic art and modern art no longer works. But I think what still works is this conception of putting art at the service of the mind.

ERIC CAMERON

There are two points in response to that. First, there are a considerable number of statements by Duchamp about his professed iconoclasm, about his anti-art, about his desire to wipe the past right out, that have to be somehow accommodated into what you're saying. And the second is to clarify the matter, that I hinted at, of the echoes of *Las Meninas* in Goya's portrait of Charles IV. What I meant there was that it had to do with the changed status of monarchy after the French Revolution. And the comparison of what that can mean as Goya perceives it, with the echoes of the way Velasquez perceived the court of Philip IV, comes through very clearly. That has to do with a real live situation in the world.

HERBERT MOLDERINGS

I want to make only one more point, on iconoclasm. Duchamp's art was iconoclastic not only in relation to traditional art, the *Mona Lisa* and so on. On the contrary, he was iconoclastic in relation to the modernist painting of his time. That was his advanced position. The moustachioed *Mona Lisa*, *L.H.O.O.Q.*, is iconoclastic in relation to all *peinture pure*. It revitalized this very old *Mona Lisa* picture. Mondrian—I'm sorry to

tackle him here—would never have been able to revitalize the message and the experience formalized in the *Mona Lisa* picture.

ERIC CAMERON

That was precisely my point about negative dependency.

ROSALIND KRAUSS

I'd also like to address negative dependency because it is possible to include everything in one word if you find a description that will do that. I think Duchamp was aware of the problem of negative dependency and therefore tried to escape it. Take the whole move, for instance, of the *Rotoreliefs*, the attempt to make something that would really exist at the level of an industrial product, or toy, or optical game, something that would have nothing to do with the system of art distribution or marketing or evaluation. It would finally get out of the art system. It seems to me we're talking about someone who was aware of what it means to be trapped in a situation where whatever he did would always end up seeming to fall within the terms of aesthetic discourse and suffer a kind of sublimation. Duchamp is one of the few artists in the twentieth century who really did think through the problem of negative dependency.

ERIC CAMERON

Yes, I would agree with that, but it seems to me that the contrasts appear in the statements, a couple of pages apart in Cabanne, where he talks both about art having been elevated unduly because it had no biological source and then about the fact that eroticism does have a biological source. I think that in the end, in his final considered opinion, he was looking for that which would have the deepest rooting in life—not simply to escape from dependency. It was to claim and grasp a dependency, which was at a deeper level than the cultural, that the final statement came—not simply for the negative sense of freeing himself from those cultural entrapments.

WILLIAM CAMFIELD

I'd like to probe around more in the anti-art iconoclastic issue. It really is double-edged. No one defaces a nobody. When one chooses a *Mona Lisa* or one erases a Willem de Kooning there's always, on the back side of that, a compliment and a tribute to whomever one defaces. As I lis-

tened, it seemed as though you were unsure about the later Duchamp's position on iconoclasm and anti-art, as though there were some change, some difference between Duchamp in the twenties and Duchamp in the seventies. Would you rake through that again?

ERIC CAMERON

Yes. I have forgotten the name of the person with whom the later interview was . . .

WILLIAM CAMFIELD

Francis Roberts?

ERIC CAMERON

Francis Roberts, that's right. To him he said that he had been credited with anti-art and was pleased to have been because that was his intention at the time, and that through the years one's ideas change, and he really couldn't be iconoclastic any longer. I also picked up on Duchamp's justification of eroticism as something that everybody would understand. To use something that everybody would understand seemed very much at variance with the desire to shock of the earlier years. You're right, I haven't really completely worked through that transformation. I tried to construct the way in which those things which shock might have an importance in human life precisely because they are revealing things that we try to repress. But if you can discover something that really shocks people, the chances are that you have discovered something really fundamentally important about people at the same time.

WILLIAM CAMFIELD

I would say that if one surveys the literature on Duchamp, in the sixties, the emphasis would seem to be on his anti-art or iconoclastic comments, not on that which you cite in the interview with Francis Roberts. In fact, the dependency on anti-art comments was so heavy in the sixties and seventies that Robert Lebel, in a very interesting interview with Duchamp dated 1967 (and published then), does his best to draw Duchamp into explaining why he had denied that there is anything of ethical or transcendental significance to the *Large Glass* or to anything else. Lebel seems to think that in the sixties Duchamp took a distressingly negative attitude in his comments.

ERIC CAMERON

I wonder if some of that has to do with Duchamp's feelings about neo-Dada and Pop artists and the fact that he perceived them as having a rather easy time by advocating negative positions which were immediately accepted, became socially respectable and sold very well—as compared to the real challenge, the real situation that he had endured in his early years and the consequences that it had had for his lifestyle and his very limited financial success.

THIERRY DE DUVE

Are there any questions from the floor?

TAMARA BLANKEN

Looking at the larger issue of belief, I think we have to distinguish among the contradictory statements made by Duchamp those taken as facts by Duchamp. I find it very difficult to adhere to all statements by Duchamp because of his inherent contradiction. Duchamp was amused by contradictory ideas, and I believe that he presented them as givens but not as beliefs.

ERIC CAMERON

I certainly have to agree with that, that there is a complexity to the things that he said. Even though my original sources are used in English all the time, when I eventually went back to the French it did occur to me, for instance in a place where I was contrasting the statement he made to James Johnson Sweeney about liking the word "belief" with the statement he made to Cabanne, that he, in fact, hadn't said anything about the word "belief" to Cabanne, but had talked rather about "*croyance*." There may be an additional overlay there; there are in fact statements in two languages which never quite say the same things. Obviously, I've attempted the task of going through Duchamp and trying to elicit from the hindsight of his late years a serious thread which brings some order to the multiplicity of his art through his life. I'm not going to go back on that, we'll let the arguments stand as they can. But I certainly wouldn't want to deny that in making that case I have selected the material and still hold that some of it, especially the fact of the posthumous work, presents evidence that I find pretty strong.

1 Joseph Kosuth, "Art after Philosophy," *Studio International,* October and November 1969.

FRANCIS M. NAUMANN

Marcel Duchamp:
A Reconciliation of Opposites

Any attempt to establish a formula, a key, or some other type of guiding principle by which to assess or in other ways interpret the artistic production of Marcel Duchamp would be—in the humble opinion of the present author—an entirely futile endeavor. Of course, this is due largely to the fact that by the time he had reached his twenty-fifth birthday, after a few years of experimenting in a variety of prevailing artistic styles—from Intimism and Fauvism to Futurism and Cubism—Duchamp adopted a highly individualistic approach to the art-making process, one wherein each creative effort was conceived with the intention of consciously defying convenient categorization. "It was always the idea of changing," he later explained, of "not repeating myself." "Repeat the same thing long enough," he told an interviewer, "and it becomes taste," a qualitative judgment he had repeatedly identified as "the enemy of Art," that is, as he put it, art with a capital A.[1]

Although Duchamp generally accepted whatever anyone had to say about his work—in accordance with his belief that the artist played only a "mediumistic" role between the art object and the public—we cannot help but suspect that he would not willingly have lent his approval to the more arcane and convoluted interpretations of his work. When asked once for his opinion about the various analyses that had been suggested for the *Large Glass*, for example, he responded that each writer "gives his particular note to his interpretation, which is interesting," he added, "but only interesting when you consider the man who wrote the interpretation."[2]

If Duchamp felt this way about the interpretation of a single work, we can only assume that he would not have lent his enthusiastic support to any artist, critic, or art historian who wished to establish a systematic approach to an understanding of his complete oeuvre. Indeed, a few years before his death, he told Pierre Cabanne that his approach differed from that of his contemporaries because he steadfastly refused to accept any form of systematization. "I've never been able to contain myself enough," he said, "to accept established formulas, to copy, or to be influenced."[3] Yet for those

who feel they still need some kind of formula to unlock the mysterious message underlying the enigmatic productions of this highly provocative and influential artist, Duchamp provided a few comforting words of advice: "There is no solution," he has often been quoted as saying, "because there is no problem."[4]

As often as I have personally sought solace in those very words, I cannot help but regard Duchamp's systematic avoidance of repetition as a system in and of itself, an ideological commitment to the art-making process that inevitably results in certain philosophical contradictions—or another way of putting it, a system that by its very nature creates problems with no apparent need for solutions. It may have been Duchamp's instinctive quest for an alternative method of expression that led him to develop a body of work that can be seen to parallel a series of essentially opposing themes— themes that, when carefully analyzed, reveal a consistent duality of compatible opposition. Whether consciously or unconsciously, by the early 1920s he had already established the major tenets of this working method, exploring and reexploring themes of opposition that would prevail in his work for the rest of his life. Before investigating the possible philosophical origins of this approach, let us examine a few selected examples from Duchamp's work and determine, if possible, exactly when and why this method became so thoroughly entrenched at the very root of his artistic sensibilities.

The most outstanding example from Duchamp's work is the creation of Rose Sélavy, a compatible fusion, or, to employ the term used in the title of this essay, a reconciliation of opposing sexual identities. Rose—or Rrose, as Duchamp would soon begin calling her—was born fully mature in New York in 1920. She was not created by Duchamp's hands, in the fashion that an academic sculptor might carve an Olympian goddess. Rather, like Athena, who sprang forth fully formed from the head of Zeus, Rrose came from Duchamp's forehead, or, to be more accurate, she emerged directly from his cerebral facilities. Unlike the Greek deity, however, Duchamp's creation was not designed to exhibit her beauty (although perhaps it is no coincidence that Athena served as the ancient patroness of learning and the arts). But this, of course, was not the reason why Duchamp invented a female alter ego. "I wanted to change my identity," he told an interviewer. Initially, as he later explained, he simply wanted to change his religious

background, and searched for a Jewish name, but found none that tempted him sufficiently. Then, he claims, the idea suddenly came to him: "Why not change sex? It was much simpler."[5] So, he took on the name "Rose," which, he explained, was a particularly awful name in 1920, to which he added the punning surname "Sélavy," and had himself—or, rather, herself—photographed by Man Ray on several occasions, posed in a rather affected manner, sporting samples of the fashionable, though perhaps somewhat conservative clothing of the day (fig. 2.1).

Although it has not been previously noted in the vast literature on Duchamp, Rrose's appearance may have been styled after that of a character played by his favorite film personality in these years, Charlie Chaplin. I am here specifically referring to Chaplin's *A Woman*, a film Duchamp may very well have seen shortly after his arrival in America in the summer of 1915.[6] In the most famous scene of the film (fig. 2.2), Chaplin impersonates a woman in order to gain entrance to the boardinghouse where his girlfriend lives, and most of the comic routines that follow are based on the predicaments that arise as a result of his male-female identity. Of course the idea of men dressing up as women in order to set up comic situations had been explored in the theater on many earlier occasions, from Shakespearean times to the Comédie Française. While these sources may help to explain Rrose's affected manner and poorly disguised identity, they do not really help to reveal why Duchamp chose to adopt a female personage in the first place. If we should wish to explore the possible psychological motivations behind this role-playing identity—as many already have for Duchamp— we could readily base our studies on a number of complicated Freudian and Jungian theories, from an unconscious expression of bisexuality to man's primordial desire to combine and unify the sexes. Rather than investigate the possible significance of such universal principles, however, let us for the moment look briefly to Duchamp's earlier work, where, to a certain extent, themes of sexual identity and opposition had already been explored.

Long before the concept of opposition can be understood as a factor that may have contributed to the theoretical foundation of Duchamp's unique *modus operandi*, it can be seen to have emerged from its more literal employment in his early work. Themes of sexual opposition, for example, are sharply juxtaposed in a number of drawings he prepared in his early

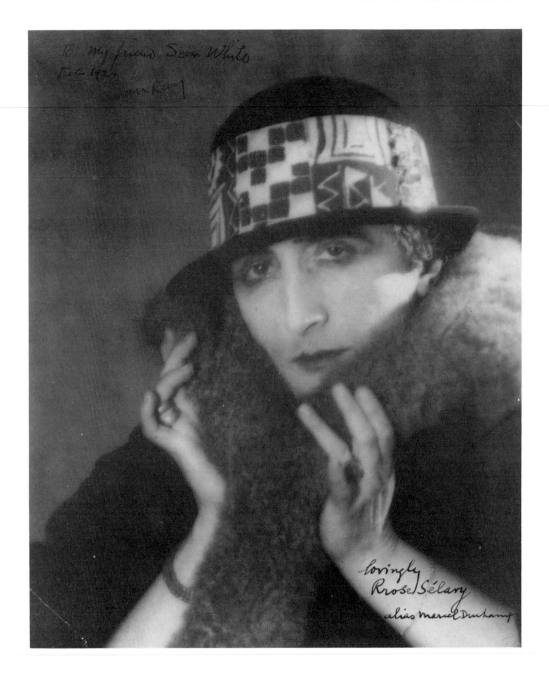

2.1
Man Ray, *Marcel Duchamp as Rrose
Sélavy*, ca. 1921. Gelatin silver print,
8½ × 6¹³⁄₁₆ in. (Philadelphia Museum
of Art; Samuel S. White 3rd and Vera
White Collection.)

2.2
Charlie Dressed as a Woman, film still
from Charles Chaplin, *A Woman*, 1915.
(Photo Francis Naumann.)

twenties to serve as humorous illustrations for popular French journals. In several of these drawings, men and women are cast in stereotypical roles, guises that are meant to emphasize their opposing sexual and sociological identities. The man appearing in a drawing entitled *Conversation* (fig. 2.3), for example, is shown leaning longingly over a partition, in quest of the woman seated at the table, while she (even though we cannot see her face) maintains an erect posture, indicating, perhaps, that her pretense to dignity prevents her from warmly accepting the man's advances. In another drawing from this period (fig. 2.4), a dejected husband pushes a baby carriage in the company of his melancholic, bored, and somewhat disheveled wife, who is quite obviously pregnant for at least a second time. The inscription— *Dimanches* [*Sundays*]—was likely derived from a series of poems by Jules Laforgue bearing the same title, wherein Sunday is a day of the week characterized by its monotony and boredom.[7]

These stereotypical models of male and female behavior are provided with even more specific, symbolic identities in a painting of 1910 entitled *Paradise* (fig. 2.5), where, judging from the title, the nude figures of a man and woman were meant to represent Adam and Eve, *the* archetypical models of male and female identity. In the following year, this nude couple reappears, forming the prominent figurative motif in a painting entitled *Young Man and Girl in Spring* (fig. 2.6), a highly provocative image that has been the subject of numerous speculative interpretations. The work was painted in the spring of 1911, at a time when Duchamp's favorite sister, Suzanne, was preparing to marry a Rouen pharmacist, Charles Desmares. When the couple married in that year, Duchamp presented this small canvas as a wedding gift. Since the painting was given to the couple but dedicated only to Suzanne, Arturo Schwarz sees the painting as an affirmation of Duchamp's "unconscious incestuous love," an interpretation he then extends to the hidden symbolism of the *Large Glass*.[8]

Schwarz's interpretation relies on the assumption that Suzanne's marriage was an unconscious betrayal of her brother's incestuous affection. Duchamp, on the other hand, may very well have regarded the marriage of his sister as a welcome event. In this light, the two outstretched nude figures could have been intended to represent Suzanne and her future husband, seen in nothing less than the guise of the world's first lovers,

Adam and Eve, who in the painting appear to be frolicking in the Garden of Eden, leaping upward toward the lower branches of a tree located in the center of the composition, which, in this context, would represent the newlyweds reaching for the forbidden fruit. Once this interpretation has been accepted, a far less esoteric symbolism can be seen to emerge from the abstract forms in the painting's complex landscape; the form of a child encased in a circular orb in the center of the composition, for example, may have been intended as a reference to successful procreation, while the pink tonality given to the various circular forms in the background may refer to the cherry blossoms of spring—the traditional season of lovers—a subject suggested by the painting's title and explored by Duchamp in an earlier landscape. Moreover, this tonality may have been designed in order to invoke an association with the most conventional and age-old symbol of love: a large, geometrically simplified human heart, its upper lobes defined by the outspread branches of the centrally placed tree and its lower portion formed by the two semicircular arching black lines that converge at the base of the picture.[9]

During the fall and winter of 1911–1912, Duchamp appears to have fully absorbed the stylistic dictates of Cubism, the emergent artistic movement he later claims to have accepted more "as a form of experiment, than conviction."[10] With some variation, however, the complex fragmentation and indeterminate spatial structure common to Analytic Cubism dominates the general appearance of the majority of paintings from this period, a stylistic progression that culminates in the production of his most famous painting, *Nude Descending a Staircase* (fig. 5.9). As important as this particular work may have been in helping to establish Duchamp's reputation on both sides of the Atlantic, it was not the painting itself but rather its subsequent history that can now be seen to have had the most significant impact on the future development of his work, a development that would not only represent a radical departure from his own earlier work, but would also represent a definitive break from the previously established and accepted conventions of the art-making process.

It should be noted, of course, that I am not the first to notice that a major transition took place in Duchamp's work during this period. Walter Arensberg, for example, the poet and wealthy collector who befriended Duchamp during his first trip to America and went on to assemble the single largest

2.3
Conversation, 1909. Pen and ink and wash on paper, 12 × 9⅞ in. (The Museum of Modern Art, New York; gift of Mary Sisler; photo Geoffrey Clements.)

2.4
Dimanches [*Sundays*], 1909. Conte pencil, brush, and "splatter" on paper, 24 × 19⅛ in. (The Museum of Modern Art, New York; gift of Mary Sisler; photo Geoffrey Clements.)

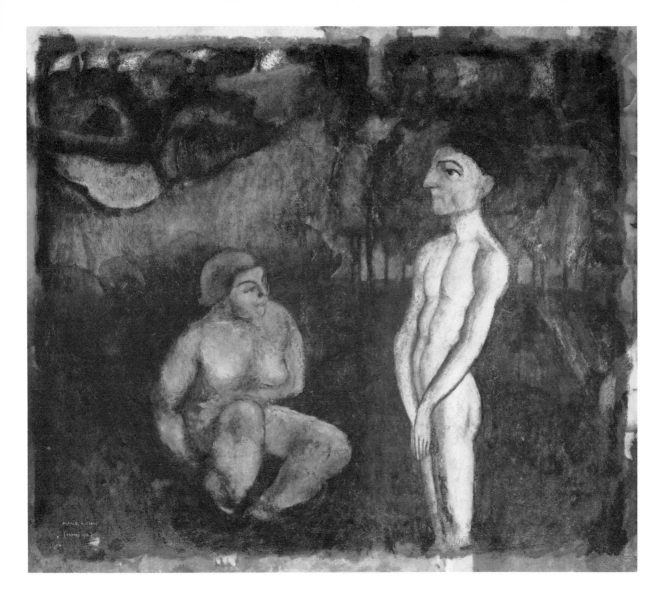

2.5
Paradis [*Paradise*], 1910–1911. Oil on
canvas, 45 1/16 × 50 9/16 in. (Philadelphia
Museum of Art; The Louise and Walter
Arensberg Collection.)

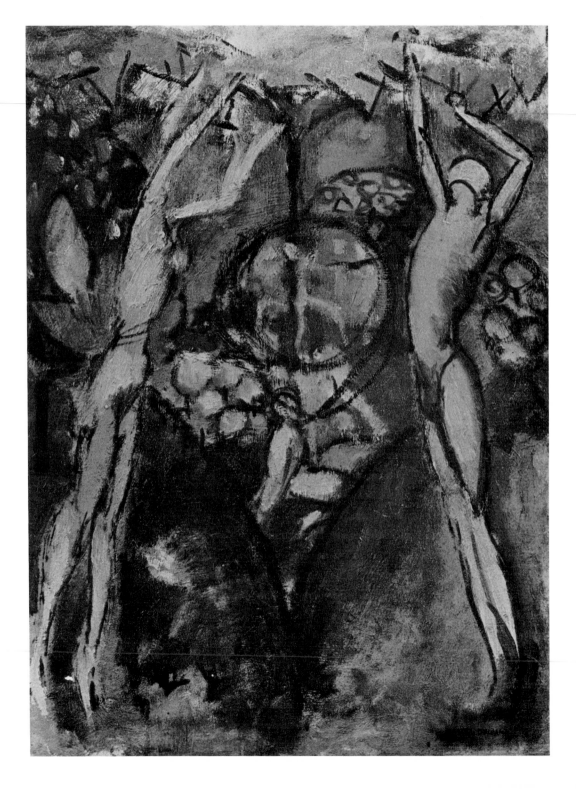

2.6
Jeune homme et jeune fille dans le prin-temps [*Young Man and Girl in Spring*], 1911. Oil on canvas, 25⅞ × 19¾ in. (Collection Vera and Arturo Schwarz, Milan.)

collection of his work, was often puzzled by this abrupt departure and at least on one occasion addressed the question directly to his old friend. "I have been meaning for a long time," he queried in a letter to Duchamp written from his California home in 1937, "to write you about those early paintings. To me, in view of your later work, they remain your greatest mystery. In the whole history of painting I know of no such complete and abrupt transition as these paintings show in relation to the work with which you immediately follow them. Can you remember at all," he asked, "anything that happened that would account for the change? Some autobiographical record of that period would be invaluable to the understanding of your work."[11]

Unfortunately, Duchamp's response to Arensberg—if there ever was one—does not survive. But on several subsequent occasions he responded to essentially the same inquiry, asked, as it frequently was, by a host of inquisitive well-wishers, who, in the late 1950s and '60s, flocked to Duchamp's side during the last decade of his life, in a period of renewed interest in his work. When Cabanne asked Duchamp why he quit painting—which the critic considered the "key event" in the artist's life—Duchamp explained that it was due primarily to the rejection of his *Nude Descending a Staircase* from the Independents Exhibition of 1912.[12] The very people Duchamp had regarded as his friends and fellow painters, including his very own brothers, found the painting objectionable, out of line with their established notions of what Cubism should be. Duchamp immediately thought their attitude abhorrent; later he called it "naively foolish." The event "gave him a turn," as he put it, and from that time onward he would consider such conservative and overtly dogmatic behavior an aberration, particularly for artists who purport to be more open-minded than the general public. Rather than allow himself to be subjected to any compromising situations in the future, Duchamp's "solution" to this "problem"—to turn his own words around—came in the form of employment he accepted at the Bibliothèque Sainte-Geneviève in Paris. "I wanted to be free of any material obligation," he explained, "so I began a career as a librarian, which was a sort of excuse for not being obliged to show up socially [as an artist]."[13] Moreover, with the modest income provided by this job, Duchamp would no longer be under pressure to produce paintings and other works of art for the sole purpose of exhibition and sale. This situation liberated

him from having to conform to the accepted styles of the day, allowing him to pursue his individual interests, in whatever direction they might take him.

It was in April of 1912, the very month when Duchamp withdrew his *Nude* from the Independents Exhibition, that he completed two drawings featuring a king and queen surrounded by animated nudes, a theme drawn from the principal components of a chess game and the movement of its pieces. The drawings culminated in the production of a major work painted during the course of the next month, *The King and Queen Surrounded by Swift Nudes*. In July, Duchamp traveled to Munich, where he developed the theme of *The Bride Stripped Bare by the Bachelors*, a subject that would be retained in the *Large Glass* (frontispiece), a work whose central iconographic motif— as the complete title acknowledges—is devoted to the mechanical movements of a bachelor in quest of his disrobing bride. It was during the summer of 1912, then, in Munich, that Duchamp had replaced the identity of a chess "king" and "queen" with their more familiar and domestic counterparts: an alluring "Bride" and her sexually aroused "bachelors." But whether Adam or Eve, king or queen, Bride or bachelor, these exclusively male and female identities represent established polarities of opposition, like the black and white pieces in a chess game, a theme Duchamp had already investigated in an earlier series of drawings and paintings. More than simply concentrating on subjects of thematic opposition, however, the works produced in Munich mark the beginning of Duchamp's first systematic efforts to develop an iconographic content unique to his own work, one that harbored meaning only within the narrowly established confines of an extremely personal, highly individualistic and self-reflexive narrative context.

Whereas it may be relatively easy to rationalize the artist developing a completely new attitude toward his work immediately after the rejection of his *Nude*, it has been more difficult to explain exactly why this important transition took place three months later in Munich. It may have been that the physical separation from his brothers and Parisian colleagues provided the necessary detachment required for the freedom of mind to develop his own ideas. It may also have been, as some have suggested, that the paintings and aesthetic theories of Kandinsky and the Blaue Reiter group, centered as they were then in Munich, influenced Duchamp's thoughts

about the potential of abstraction as both a thematic and stylistic component in his work. Whatever his sources, the Bavarian capital seems to have provided the ideal atmosphere in which Duchamp succeeded in severing all artistic ties, not only with concurrent stylistic trends but also with his own earlier work. "My stay in Munich," he later reported, "was the scene of my complete liberation."[14]

This statement, combined with the fact that he had immersed himself in the center of a German-speaking environment, may be enough to suggest that it was during the time of his stay in Munich that Duchamp first discovered the writings of Max Stirner (1806–1856), an obscure nineteenth-century German philosopher whose anarchistic theories may have provided the most extensive theoretical basis for Duchamp's newfound artistic freedom.[15] When he was asked later in life to identify a specific philosopher or philosophical theory that was of special significance to his work, he cited Stirner's only major book—*Der Einzige und sein Eigentum*—which was originally published in 1845 but appeared in a French edition in 1900 under the title *L'unique et sa propriété*, and later in English as *The Individual and His Own*.[16] In this highly provocative book, Stirner outlined a controversial treatise in defense of philosophic egoism, wherein, based on his observation that all people possess unique qualities unto themselves, he championed the right of the individual to assume a superior position in society. To this end, he rejected all systematic philosophies and launched a bitter attack on all levels of social and political authority. Stirner regarded the state as the supreme enemy of the individual, and he supported its destruction by rebellion rather than revolution, a position that has linked his philosophical beliefs to existentialism and nihilism.

The one work Duchamp produced that he said was specifically influenced by Stirner's philosophy was his *Three Standard Stoppages* of 1913–1914 (fig. 2.7), a box containing three separate measuring devices that were individually formed by identical systems of chance operation: held horizontally from the height of one meter, a meter-long length of string was allowed to fall freely onto a canvas surface. The resultant impressions were then more permanently affixed to glass plates, from which were prepared three wood templates, duplicating the subtle twists and curves of their chance configuration. Duchamp later explained that this work was made as "a joke about the meter,"[17] making it clear that his central aim was to

2.7
Trois Stoppages-Etalon [*Three Standard Stoppages*], 1913–1914. Assemblage, 11⅛ × 50⅞ × 9 in. (overall). (The Museum of Modern Art, New York; Katherine S. Dreier Bequest, 1953.)

2.8
Standard meter, Pavillon de Breteuil, Sèvres, France. (Photograph courtesy French Embassy, New York.)

throw into question the accepted authority of the meter, the standard unit of measurement adopted by Europeans and officially established as precisely the distance between two scratches on a platinum-iridium bar housed in a temperature-controlled chamber in the Academy of Science just outside Paris (fig. 2.8). Thus, just as Stirner rejected all systems of authority and championed the supreme rights of the individual, Duchamp conceived of the *Three Standard Stoppages* as a unique system of measurement that was determined by the chance of a given individual, and which was to be utilized exclusively within the framework of his own personal requirements.

In this context, it is important to emphasize that Duchamp chose to repeat this operation three separate times. "For me the number three is important," he later explained: "one is unity, two is double, duality, and three is the rest." Or, as he put it on another occasion: "1 a unit / 2 opposition / 3 a series."[18] In other words, creating a single new "meter" would only result in producing an entirely new system of measurement, with no more (or less) claim to authority than the old. Creating two new meters would only compound the problem by setting up polarities of opposition (one "meter" vs. the other). Creating three meters results in a self-sustaining system, one that does not present a simple alternative, nor a choice between two variants, but a complete system that must be comprehended and utilized in its entirety. Three, then, introduces a factor of reconciliation, serving to unite the two elements of opposition while simultaneously producing a compatible and comprehensive fusion of all three.

Although Duchamp may not have been aware of it at the time, this system of reconciliation very closely duplicates a philosophical system that is nearly as old as philosophy itself. Heraclitus, for example, the fifth-century BC Greek philosopher, believed that unity in the world was only formed through the combination of opposing extremes. With some variation, this same idea is used to help explain theories of immortality by a number of other Greek philosophers, including Socrates and Plato. But as far as I have been able to determine, it was not until the writings of Bishop Nicholas Cusanus, the fifteenth-century German scientist, statesman, and philosopher, that these theories of opposition would begin to approach an organized system of logical discourse. Cusanus criticized previous philosophical systems where contradictories were not allowed, maintaining that a "coincidence of opposites," or what he called the *coincidenta oppositorum*, clearly

existed in God, the infinite being wherein all extremes of opposition are reconciled in perfect unity.[19] Of course, the best-known application of this system formed the basis of Hegel's famous dialectical method, wherein the truth of a given proposition could be clarified and established on the basis of triadic divisions: a *thesis* (the thing), an *antithesis* (its opposite), and *synthesis* (the process of their unification). Hegel's dialectical method profoundly influenced the development of German philosophical thought in the nineteenth century. Max Stirner, for example, came under Hegel's influence while studying philosophy at the University of Berlin, and later he became associated with a group of young Hegelians known as *Die Freien* (The Free Ones), which included such notable figures as Karl Marx and Friedrich Engels, whose socialist inclinations Stirner would come to strongly reject, as he would, for that matter, philosophical systems of any kind.[20]

It should of course be noted that theories of opposition and reconciliation are not restricted exclusively to the realm of philosophy, but can be found in varying forms in a number of diverse areas of intellectual and scientific thought. Today, for example, they can be detected as a prevalent factor in disciplines as diverse as structuralist theory and molecular biology. In literature, the concept was already well established in the Renaissance, particularly as it pertained to the "conceit" or metaphor; the concept was elaborated upon and refined by literary critics and rhetoricians of the seventeenth century to such a degree that some historians believe it formed the theoretical basis for the style of metaphysical poetry in the period.[21] More relevant as a possible source for Duchamp, however, would have been the efforts made by French poets and literary critics from the Romantic to Symbolist periods to reconcile concepts of the real and the imaginary and, in the late nineteenth and early twentieth centuries, of the conscious and unconscious. As the inheritor of this tradition, Apollinaire, for example, sought a completely new method by which to free himself from the restrictions of metaphor, approaching a poetical form that could be appreciated directly for what it was, rather than for whatever it might represent.[22]

While Duchamp was of course familiar with the writings of Apollinaire, as well as those of the French Symbolist poets, there is yet one other source that utilized at the very basis of its operations a reconciliation of opposing entities, and that is the art of alchemy. In ancient and medieval times,

alchemy was traditionally understood to be a craft devoted exclusively to finding a universal elixir of life, and to the transmutation of base metals into silver or gold (in this respect, it is generally considered the historical forerunner of the science of chemistry). More recently, the practice of alchemy has been studied for its symbolic significance, or, as Carl Jung utilized it, as a metaphor for various psychological processes that form the basis of life's inherent contradictions. Jung's thorough study of this subject resulted in a massive compilation of material in a book entitled *Mysterium Coniunctionis: An Inquiry into the Separation and Synthesis of Psychic Opposites in Alchemy.*[23] Here, as the title suggests, Jung traces the duality of opposites and their reconciliation (the *coniunctio oppositorum*), identifying Mercurius as the unifying agent in alchemical texts, while the process of what he calls "individuation" accomplishes this reunion in the realm of psychotherapy. As compelling as the comparisons might be with specific works by Duchamp, or with his working method—as I have outlined it here—it is doubtful that alchemy had anything to do with the formation of his approach to art. "If I have ever practiced alchemy," Duchamp told the French critic Robert Lebel, "it was in the only way it can be done now, that is to say, without knowing it."[24]

It is my feeling that Duchamp's disclaimer should not be treated lightly. No matter what his sources may have been—if any—his exploration of opposites and their reconciliation seems to have been motivated more by his unwillingness to repeat himself than by any possible willingness to conform to the dictates of a previously established system—philosophical, literary, alchemical, or otherwise. His working method involved a constant search for alternatives—alternatives not only to accepted artistic practice, but also to his own earlier work. It was perhaps with this in mind that in 1913 he asked himself the provocative question: "Can one make works which are not works of 'art'?"—a question he answered within a year by his invention of the Readymade, "a work of art," as he later described it, "without an artist to make it."[25] In strictly Hegelian terms, a work of art could be seen to represent the *thesis;* an object that is not a work of art, its opposite or *antithesis;* while the Readymade succinctly combines these ideas in a single artifact, bringing about their reconciliation, or *synthesis*.

The most literal and abstract manifestation of this approach in Duchamp's work can be found in his lifelong devotion to chess, a game that in itself

2.9
Marcel Duchamp and Vitaly Halberstadt, *L'opposition et les cases conjuguées sont réconciliées* [*Opposition and Sister Squares Are Reconciled*], 1932. Book cover, 11 × 9⅝ in. (Private collection; on extended loan to Philadelphia Museum of Art.)

has often been compared to Hegel's dialectical triad. In 1932, Duchamp published a book on pawn and king endings entitled *Opposition and Sister Squares Are Reconciled*, which he wrote in collaboration with the German chess master Vitaly Halberstadt (figs. 2.9 and 2.10).[26] Accompanying a series of parallel texts in French, German, and English, the authors included an abundance of carefully designed diagrams, many of which were printed on both sides of translucent paper in order to fully explicate the various nuances of their complex treatise. "But the end games in which it works," Duchamp later explained, "would interest no chess player. . . . Even the chess champions don't read the book," he said, "since the problems it poses really only come up once in a lifetime."[27] In agreement with its author, most of the individuals who have bothered to assess this book have repeated these very aspects of its impracticality, but none (so far as I know) have noted the significance of its central treatise, clearly announced by its title: to reconcile the alleged differences that had developed over the years between positions of opposition and the concept of sister squares. The opening sentences of this study make its purpose abundantly clear (emphasis added):

2.10
Marcel Duchamp and Vitaly Halberstadt,
*L'opposition et les cases conjuguées
sont réconciliées* [*Opposition and Sister
Squares Are Reconciled*], 1932. Interior
of book, 11 × 9⅝ in. (Private collection;
on extended loan to Philadelphia
Museum of Art.)

Curiosity has impelled us to elucidate a question which, for twenty years, has periodically given rise to bitter articles in chess literature.

Opposition or "sister squares."

Let us simplify: Opposition and "sister squares."

In other words, Duchamp and his coauthor have set about to prove that theories of opposition and theories of "sister squares" (usually referred to as "related squares" in modern chess terminology) are actually one and the same, and that they represent only variant methods by which to solve essentially the same end game situation.[28]

Perhaps the purest example from Duchamp's artistic production to illustrate the reconciliation of contradictory or opposing entities is a work simply known as *Door, 11 rue Larrey*, a construction that was nothing more than a door he had designed for the main room of a small apartment he moved into in 1927 on the rue Larrey in Paris (fig. 2.11). This door was located in a corner of the main living area, positioned in such a way as to close the entrance either to the bedroom or to the bathroom, but not to both at

the same time. In opposition to the axiom implicit in the common French adage—"Il faut qu'une porte soit ouverte ou fermée" ["A door must be either open or closed"][29]—Duchamp has ingeniously managed to defy the assumption of mutual exclusivity, uniting these contradictory themes into a compatible totality, or as he might have preferred to describe it, "a reconciliation of opposites."

In conclusion, it should be acknowledged that my remarks about Duchamp's work and working method are *not* made with the intention of establishing yet another method by which to view or interpret his artistic production. Rather, my comments are submitted with the intention of simply pointing out a recurrent theme, a casual observation about the artist and his work, about which he himself may very well have been aware. Indeed, it has been convincingly demonstrated that various concepts of polarity and their ultimate unity—light/darkness; life/death; good/evil—form the basis of virtually all myths and folkloric traditions: from the Taoist, Buddhist, and Hindu religions in the East to the dualism of Heaven and Hell in the Christianized West.[30] If we should wish to believe that Jung was correct, and we have all somehow managed to inherit a storehouse of archaic images and ideas from the past (as part of what he called our "collective unconscious"), then we can just as easily assume that in his exploration of opposing identities, Duchamp was simply echoing a basic human concern: to unify or in other ways reconcile the conflicting dualities of life.

Yet, we might ask ourselves, just exactly how aware—or unaware—was Duchamp of the operation of this psychic phenomenon in his work? Was he not aware of the fact that the construction of puns and other word games—literary activities that delighted him, and at which he excelled—involved the formation of intentionally alternate readings, their precise meaning or humorous content understood (reconciled in the mind) only when both their literal and suggested meanings were fully comprehended? Moreover, when he conceived of the realistic, near-*trompe l'oeil* figure in the *Etant Donnés*, was he not immediately aware of the fact that, in stylistic terms, this figure represented the virtual antithesis of the abstract elements in the *Large Glass*? And by implication, with the important role he realized for the spectator, was he not also aware of the fact that any viewer who tried to comprehend the totality of his work would be placed in the position of having to reconcile these differences? It would seem implausible that

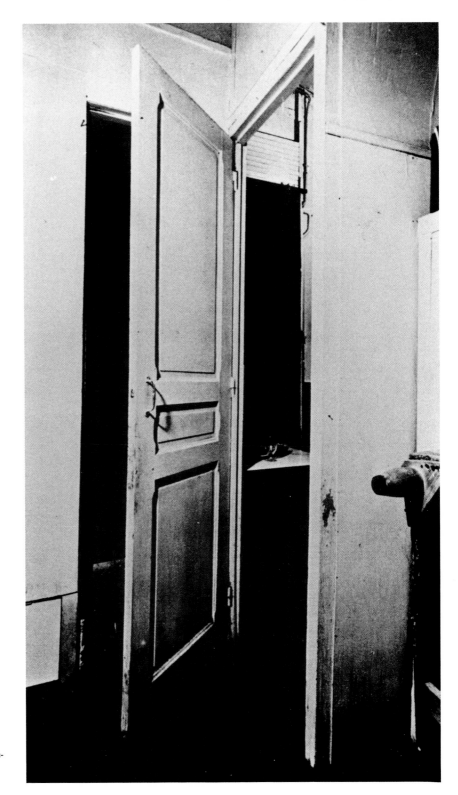

2.11
Porte, 11 rue Larrey [Door, 11 rue Larrey], 1927. Wooden door (made by a carpenter following Duchamp's instructions), 86⅝ × 24¹¹⁄₁₆ in. (*In situ* photograph by Arturo Schwarz.)

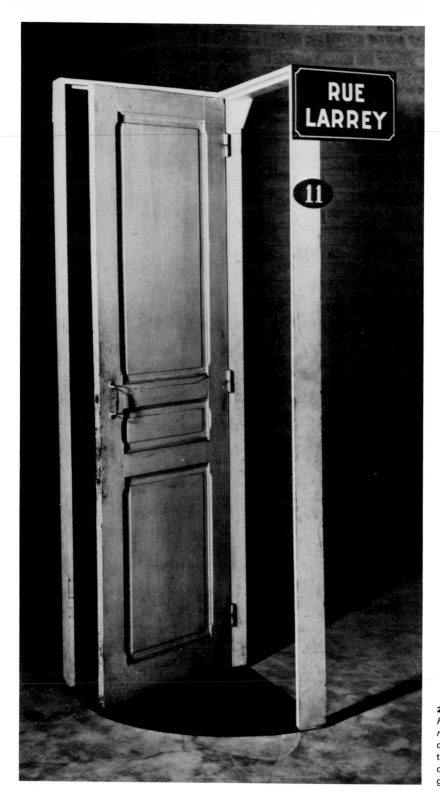

2.12
Porte, 11 rue Larrey [*Door, 11 rue Larrey*], 1927. Wooden door (made by a carpenter following Duchamp's instructions), 86⅝ × 24¹¹⁄₁₆ in. (Detached from original location; collection Fabio Sargentini, Rome.)

such a profound thinker as Duchamp did not—at least momentarily—reflect upon the possible sources and operational motivations for his work.

We know that at least once—in conversation with the French existentialist philosopher and critic Denis de Rougemont—Duchamp discussed the notion of cause and effect, emphasizing the inevitable contradictions that result when one attempts to apply such a tautological system of reasoning in a proof for the existence of God:

Leurs prétendues démonstrations dépendent de leurs conventions. Tautologies que tout cela! On en revient donc évidemment aux mythes. Je le prévoyais. Prenez la notion de cause: la cause et l'effet distingués et opposés. C'est insoutenable. C'est un mythe dont on a tiré l'idée de Dieu, considéré comme modèle de toute cause. Si l'on ne croit pas en Dieu, l'idée de cause n'a plus de sens. Je m'excuse, je crois que vous croyez en Dieu. . . . Remarquez l'ambiguïté du mot croire, dans cette phrase.

Their supposed demonstrations depend on their conventions. All this is tautologies! One returns consequently to myths. I anticipated it. Take the notion of cause: cause and effect, different and opposite. It's indefensible. It's a myth from which one has drawn the idea of God, considered as the model for all causes. If one doesn't believe in God, the idea of cause has no meaning. Excuse me, I think that you believe in God. . . . Note the ambiguity of the word believe, in this sentence.[31]

So far as I have been able to determine, Duchamp specifically addressed a theory of opposition on only one occasion: in a note he wrote in 1914 entitled "Principle of Contradiction," wherein he hints that any such formulation would, by its very process, invalidate itself. But through a series of wonderfully illogical though remarkably convincing suppositions, he goes on to develop a theory of "literal nominalism," wherein the conceptual content of words is to be discarded, replaced only by an understanding of their plastic and abstract qualities.[32] Even though in this very note, Duchamp reminds himself that this theory should be developed, he never really carries it beyond this point. Outside of chess—which he took quite seriously—the only ideological construct he might have considered a possible metaphor for his work was his own concept of "Infra-thin," a detailed investigation he began in the late 1930s that concerned itself with the nearly imperceptible nuances that exist between things: from the warmth

left by a recently occupied seat, to the sound made by velvet trouser legs rubbing together.[33] Even though this theory involves a study of many of the same concerns Duchamp investigated in his earlier work—the differences between objects and their shadows, mirrors and their reflection, originals and copies, etc.—the reasons for his preoccupation with such tenuous, nearly immeasurable factors can, I suspect, be more accurately traced to his quiet, unaggressive, and comforting personality.

It may have been these very aspects of Duchamp's persona that once led the composer John Cage to compare his old friend to a Zen master. And the sculptor Arman, who saw quite a bit of Duchamp in the 1960s, characterized the artist as a King Arthur presiding over the Round Table: "above all the fights," he recalled, "nobody ever had the smallest chance to have a fight with Marcel." In fact, among the people who knew him well, no one seems to be able to recall having quarreled with Duchamp. Beatrice Wood, a lifelong friend and admirer who knew the artist for over fifty years, recalls that his very presence was a calming force. "We had wonderful moments of silence," she remembers. "There are times when we would spend the entire evening together, exchanging only a few words. I just assumed we were on the same wavelength. Marcel was not the kind of person you would argue with. Whenever an issue came up, he would simply say 'Cela n'a pas d'importance.' " And Paul Matisse, the artist's stepson, explained that Duchamp rarely disagreed with whatever you had to say: "For him," he recalled, "agreement was the way he kept his freedom. He felt arguing was just falling into a trap, and for him to argue against another's idea was to get caught up in it just as surely as if he had promoted it himself."[34] In short, it would appear that throughout his life, Duchamp successfully avoided situations that might have resulted in the possibility of a confrontation—reconciling, one could say, polarities of opposition even before they were given the opportunity to establish themselves.

Notes

This article is based on a lecture of the same title presented at the international conference "Avant-Garde Art and Literature: Toward a Reappraisal of Modernism," organized by Barbara Lekatsas and Pellegrino D'Acierno at Hofstra University, Hempstead, Long Island, November 1985. I am indebted to Professor D'Acierno for having drawn my attention to a number of the literary sources identified in the accompanying notes. I am particularly indebted to Teeny Duchamp, who kindly read this paper in manuscript form and graciously offered her encouragement for its publication.

1 James Johnson Sweeney, "A Conversation with Marcel Duchamp," television interview, NBC, January 1956; published in James Nelson, ed., *Wisdom: Conversations with the Elder Wise Men of Our Day* (New York: W. W. Norton & Company, 1958), 92, 94–95; quoted here in the variant transcription published by Michel Sanouillet and Elmer Peterson, eds., *Salt Seller: The Writings of Marcel Duchamp (Marchand du Sel)* (New York: Oxford University Press, 1973) (130, 133–134; see also the interview with Francis Roberts, "I Propose to Strain the Laws of Physics," *Art News* 68, no. 8 (December 1968), 62; and Duchamp's interview with Otto Hahn, *Art and Artists* 1, no. 4 (July 1966), 10.

2 Interview with Pierre Cabanne, *Dialogues with Marcel Duchamp,* trans. Ron Padgett (New York: Viking Press, 1971), 42.

3 Cabanne, *Dialogues,* 26.

4 As quoted, for example, in Arturo Schwarz, *The Complete Works of Marcel Duchamp* (New York: Harry N. Abrams, 1969; 2d rev. ed., 1970), 201.

5 Cabanne, *Dialogues,* 64.

6 This film was produced by Essanay Company and released on July 12, 1915 (see *Circulating Film Library Catalogue* [New York: Museum of Modern Art, 1984], 47); Duchamp arrived in America about a month earlier, on June 15, 1915.

7 Both of these drawings were discussed at greater length in Francis M. Naumann,

The Mary and William Sisler Collection (New York: Museum of Modern Art, 1984), 126–127, 130–131.

8 See Schwarz, "The Alchemist Stripped Bare in the Bachelor, Even," in Anne d'Harnoncourt and Kynaston McShine, eds., *Marcel Duchamp* (New York: Museum of Modern Art; Philadelphia: Philadelphia Museum of Art, 1973), 81–98.

9 This is essentially the interpretation provided in Naumann, *Sisler Collection,* 138–139.

10 Cabanne, *Dialogues,* 27.

11 Walter Arensberg to Marcel Duchamp, August 26, 1937 (Francis Bacon Library, Claremont, California).

12 Cabanne, *Dialogues,* 17.

13 Ibid., 41.

14 Notes for a lecture, "Apropos of Myself," delivered at the City Art Museum of St. Louis, St. Louis, Missouri, November 24, 1964; published in d'Harnoncourt and McShine, eds., *Marcel Duchamp,* 263. For an analysis of Duchamp's stay in Munich and its implications, see Thierry de Duve, "Resonances of Duchamp's Visit to Munich," *Dada/Surrealism,* no. 16 (1987), 41–63.

15 Max Stirner was the pen name of Kaspar Schmidt. On Stirner and his philosophy see James Hunecker, "Max Stirner," *Egoists: A Book of Supermen* (New York: Scribner's Sons, 1910), 350–372; Sir Herbert Edward Read, "Max Stirner," *The Tenth Muse* (New York: Books for Libraries Press, 1958), 74–82; James J. Martin, introduction to Stirner, *The Ego and His Own: The Case of the Individual Against Authority* (New York: Libertarian Book Club, 1963), xi–xxii; and S. A. Grave, "Max Stirner," *The Encyclopedia of Philosophy* (New York: Macmillan, 1967), VIII, 17–18.

16 Duchamp recalled the title of Stirner's book as "Le Moi et la Propriété" (in a questionnaire about *The Three Standard Stoppages,* artist's files, Museum of Modern Art, New York; undated, but probably

written shortly after the work was acquired by the museum in 1953). Later, when Duchamp was asked by the Swiss artist and critic Serge Stauffer if there was a particular philosopher or philosophical theory that had captured his attention, he again identified Stirner and his book (see Stauffer, "Hundert Fragen an M. Duchamp," in *Marcel Duchamp: Die Schriften* (Zurich: Regenbogen-Verlag, 1981), I, 290.

17 From the Museum of Modern Art questionnaire (see previous note).

18 Cabanne, *Dialogues,* 47; and the Museum of Modern Art questionnaire (see note 16); the foregoing analysis closely follows my earlier reading of this work (see Naumann, *Sisler Collection,* 168–171).

19 See Armand A. Maurer, "Nicholas of Cusa," in *The Encyclopedia of Philosophy* (New York: Macmillan Company, 1967), V, 496–498, as well as other works cited in Maurer's extensive bibliography.

20 Marx and Engels denounced Stirner's philosophy in their book *Die deutsche Ideologie* [*The German Ideology*], written in 1845–1846 but not published in its entirety until 1965 (in simultaneous English and Russian editions: London: Lawrence & Wishart; Moscow: Progress Publishers). Nearly the entire second part of this monumental tome is devoted to a line-by-line attack on Stirner and his book (for a concise summary of these comments, see C. J. Arthur, "Introduction: The Critique of Stirner," in *The German Ideology: Part I* [New York: International Publishers, 1970], 24–32).

21 See, for example, R. L. Colie, "Some Paradoxes in the Language of Things," in J. A. Mazzeo, ed., *Reason and the Imagination: Studies in the History of Ideas: 1600–1800* (New York: Columbia University Press, 1962), 93–128; and Joseph Anthony Mazzeo, "A Seventeenth-Century Theory of Metaphysical Poetry," chapter 2 in *Renaissance and Seventeenth-Century Thought* (New York: Columbia University Press, 1964), 29–59.

22 See Marcel Raymond, *From Baudelaire to Surrealism* (New York: Wittenborn, Schultz, 1950), 221–225; and Jean Pierrot, *The Decadent Imagination: 1880–1900* (Chicago: University of Chicago Press, 1981), passim.

23 Originally published in German, in two volumes, by Rascher Verlag (Zurich) in 1955 and 1956; trans. R. F. C. Hull as vol. 14 of *The Complete Works of C. G. Jung* (Princeton: Princeton University Press, 1963).

24 Duchamp's words recalled by Robert Lebel in André Breton and Gérard Legrand, eds., *L'Art magique* (Paris: Club Français de l'Art, 1957), 98; quoted in Lebel, *Marcel Duchamp* (New York: Grove Press, 1959), 73, and Schwarz, "The Alchemist Stripped Bare," 81. Unfortunately, Duchamp's denial has not deterred a host of insistent scholars who continue to investigate his possible alchemical sources; see, for example, Maurizio Calvesi, *Duchamp invisibile: La costruzione del simbolo* (Rome: Officina, 1975), and the writings of John Moffitt, who is preparing a book-length study on the subject of Duchamp and alchemy (see his "Marcel Duchamp: Alchemist of the Avant-Garde," in *The Spiritual in Art: Abstract Painting 1890–1985* [Los Angeles: Los Angeles County Museum of Art; New York: Abbeville Press, 1986], 257–271).

25 From the interview with Francis Roberts, "I Propose to Strain the Laws of Physics," 47; Duchamp's question to himself was preserved in a note dated on its verso "1913" (published in facsimile in the collection *A l'infinitif* [New York: Cordier & Ekstrom Gallery, 1966]).

26 This book was released in both paperback and deluxe, hardbound editions (published by L'Echiquier, Edmond Lancel, Brussels). The original notes for this book are preserved in the so-called *Box of 1932* (currently in the collection of the Philadelphia Museum of Art; on extended loan from Richard Feigen Inc., New York).

27 Cabanne, *Dialogues,* 77–78.

28 Until recently, few Duchamp scholars have taken this chess treatise seriously, most choosing to echo the relatively simplistic description of the book provided by Duchamp's lifelong friend Henri-Pierre Roché ("Vie de Marcel Duchamp," *La Parisienne* [January 1955], 3–4; "Souvenirs," trans. George Heard Hamilton, in Lebel, *Marcel Duchamp,* 83–84). A notable exception is the analysis of Hubert Damisch, "The Duchamp Defense," *October,* no. 10 (Fall, 1979), 22–24.

29 This saying originates from the play *Le Grondeur* (act IV, scene I), a comedy written in 1691 by Jean Palaprat (1650–1721) and David Augustin de Brueys (1640–1723); see Maurice Maloux, *Dictionnaire des Proverbes, Sentences et Maximes* (Paris: Librairie Larousse, 1986), 16. This citation was kindly drawn to my attention by Billy Kluver. On *Door, 11 rue Larrey,* see Naumann, *Sisler Collection,* 210–212.

30 See the excellent and comprehensive study on this subject by Alan W. Watts, *The Two Hands of God: The Myths of Polarity* (New York: George Braziller, 1963); see also Mircea Eliade, *The Two and the One,* trans. J. M. Cohen (New York: Harper & Row, 1965).

31 Denis de Rougemont, *Journal d'une époque* (Paris: Gallimard, 1968), 563–564; see also Rougemont, "Marcel Duchamp, mine de rien," *Preuves* [Paris] 18, no. 204 (February 1968), 43–44.

32 See *Marcel Duchamp, Notes,* arrangement and translation by Paul Matisse (Paris: Centre National d'Art et de Culture Georges Pompidou, 1980), notes 185 and 186. It is interesting to note that, coincidentally, Paul Matisse cited this very note as the principle document that led him to a greater understanding of the meaning and value of Duchamp's "illogical logic" (see "Some More Nonsense about Duchamp," *Art in America* 68, no. 4 [April 1980], 81–82).

33 See *Marcel Duchamp, Notes,* notes 1 through 46.

34 See "John Cage on Marcel Duchamp," an interview with Moira and William Roth, *Art in America* 61, no. 6 (November-December 1973), 74; Arman is quoted from a taped interview with Moira Roth, February 26, 1973, quoted in Alice Goldfarb Marquis, *Marcel Duchamp: Eros, c'est la vie: A Biography* (Troy, New York: Whitston Publishing Company, 1981), 308; Beatrice Wood is quoted from a telephone interview with the author, November 10, 1987 (see also Wood's "Marcel," *Dada/Surrealism,* no. 16 [1987], 12–17); and Paul Matisse, "Some More Nonsense about Duchamp," 77.

Discussion

Moderated by Thierry de Duve

CAROL JAMES

Could you tell us about this last slide, the sort of construction of the rue Larrey door?

FRANCIS NAUMANN

A good and easy question. I showed the door twice: in a photograph taken by Arturo Schwarz, attached in its original setting (fig. 2.11), and then after it had been removed from its original location in the early 1960s, at Duchamp's request (fig. 2.12). The person who moved into Duchamp's studio, and who still lives there, the daughter of Patrick Waldberg, told me this summer that the door was replaced at the time of its removal. Meanwhile, what happened to the original door makes an amusing story. A couple of years ago it was owned (and perhaps still is) by a man named Fabio Sargentini, an Italian collector. In 1976 it was sent to the Venice Biennale. Since it was the only major object this collector owned, he asked if he could personally oversee its installation. So, the night before the opening, the door was removed from its crate and the director of the Biennale ordered workmen to clean the room into which it was to be placed. They installed the door in a corner of the room, literally nailing it to the wall, and then they proceeded to paint it! So there's that story, and the famous one about the shovel being actually used by a guard in a museum—the only two times I am aware of when a Duchamp readymade was mistaken for the original. It sounds like an Italian joke, I know. But the story is absolutely true.

CRAIG ADCOCK

Francis, I was interested in your comments about Max Stirner. I agree with you, I don't see much alchemy in Duchamp; but when I looked at Stirner, I didn't see much Stirner in Duchamp either. Or if you prefer, I didn't see any Duchamp in Stirner's book, much as I didn't see any Duchamp in books like Gaston de Pawlowski's. I am just curious if casual references on Duchamp's part to those kinds of mystical sources may have been intended to mislead us a little bit or to put scholars onto the wrong track.

FRANCIS NAUMANN

I am inclined to think that he knew of Stirner early on, because he specifically cites the French edition of the book, which is a translation published around 1900. And more important than this book was the work of a French philosopher, Victor Basch, who published a long critical treatise on Stirner and celebrated him as one of the most important of the forgotten philosophers of the past. Indeed, Stirner was very popular in the early years of this century.

WILLIAM CAMFIELD

Francis, I want to follow the alchemy thread. You have a good point, because I have never been a believer in the alchemy issue myself. I have been a befuddled disbeliever for many years. But more recently I have been having second thoughts about that, not in the sense that alchemy could be applied as a system or that Duchamp ever looked at it that way. But certainly there was a lot of that around in the epoch of Symbolism, and we know that Duchamp was interested in some of those artists like Redon—who, he claimed once, was one of his favorite artists—or Mallarmé and others. I'm wondering if you think there might not be a possibility for a much more reasoned discovery of alchemical matters, in 1912 and earlier. It seems to me that that's really an unexplored area of Duchamp scholarship.

FRANCIS NAUMANN

My only hesitancy in using that kind of an approach is that in the end I'm not sure that you learn anything more about the artist, nor about the art object. You see, my idea is that Duchamp simply sat back and asked himself certain basic questions, really important questions about life and about art. People who think in such a profound way have a habit of coming up with universal truths that are enclosed in virtually every discipline. I think all universal systems of interpretation give the appearance of somehow enhancing methods or procedures that incorporate certain universalist principles in their conception. But when you get to the point where you know more about the method you've discovered than the object or situation you're trying to analyze, then I think you've gone too far. Alchemy is a universal system. So are linguistics, semiology, formalism,

Freudian and Jungian analysis, whatever. The more you know about a particular discipline, the easier it is to discover tangential relationships.

ROSALIND KRAUSS

My question is for Bill, really. Why is it that an interest in Mallarmé leads one to alchemy? In other words, I don't understand why the connection to Symbolism is license to make the next step.

WILLIAM CAMFIELD

That was a sort of casual reference, just a name that came to the top, thinking of people in the Symbolist epoch. I wouldn't really pursue Mallarmé, and I'm not a specialist in that subject. But alchemy was a subject of interest to people in the nineties, the epoch of Symbolism. To some extent Duchamp came out of that.

ROSALIND KRAUSS

But it's too fast to say that since there was an interest in "A," therefore "B." That's just not rigorous. Just because there were some Symbolist poets who were interested in alchemy, does that make Duchamp interested in alchemy?

WILLIAM CAMFIELD

No. But I say that I came as a disbeliever. It strikes me that alchemy is one aspect of Duchamp studies which has not been subjected to rigorous study. And I ask the question of whether really rigorous historical study, there, might not yield something which is more useful than what has come up? Now, that's a question, not a statement.

HERBERT MOLDERINGS

Since Schwarz, there has been this discussion on alchemy.[1] Linde had already brought it up, but Schwarz interpreted Duchamp's work as entirely based on alchemy only on the basis of one painting, *Jeune homme et jeune fille dans le printemps*. Everything then follows from there and, above all, from the circle in the middle of the painting (fig. 2.13, top). I don't think that any knowledge of alchemy is necessary to understand the iconography of that painting, since its elements lose their mystery if situated in the Symbolist tradition, very strong about 1900, of painting spring precisely in such a way. Böcklin for example painted half a dozen pictures of spring which feature a ring of dancing amoretti as an

2.13
Top: *Jeune homme et jeune fille dans
le printemps* [*Young Man and Girl in
Spring*], 1911. Oil on canvas, 25⅞ × 19¾
in., detail. (Collection Vera and Arturo
Schwarz, Milan.) Bottom: Mercurius in
the bottle. Woodcut illustrating J. C.
Barckhausen's *Elementa Chemiae*, Ley-
den, 1718. (Courtesy Arturo Schwarz.)

attribute of spring. I want to suggest that the figures within the central circle around the tree represent just such a ring of four dancing amoretti. How is it possible to see only one single figure in this circle as Schwarz does? Then there is a marvelous painting by Hodler of 1901 called *Spring*. And what do you see? On the left side, a young woman dressed in white and on the right side, a nude young man. This was the Symbolist metaphor for youth and awakening of sexuality. As you have shown, in 1911 Duchamp displays a very strong concern with the subject of male-female paradise. And in the same year he paints *Spring*. I see no reason to push away this Central European tradition of Symbolist painting in order to reach for alchemy. But I didn't understand exactly how you explained the circle.

FRANCIS NAUMANN

I didn't, not in this talk. But I have an idea. Schwarz makes a compelling comparison between that little circle and Mercurius in a bottle, because the little figure is nearly in the same position as an illustration he cites from some obscure eighteenth-century alchemical treatise (fig. 2.13, bottom). But I'm inclined to agree with you that in paintings from this period, the circle in the middle is usually a ring of dancing, oftentimes nude female figures. There is a tradition: for example, a painting by Maerten van Heemskerck, as well as an engraving by Marcantonio Raimondi, are just two examples of a standard classical vision continued by a host of academic painters in the nineteenth century, and perpetuated by one artist at the turn of the century, Pierre Paul Girieud, who often showed in the Salon des Indépendants exhibitions, and whom Duchamp specifically said he admired.[2] I analyzed *Young Man and Girl in Spring* as being some kind of reference to Adam and Eve jumping up, but, at the same time, a reference to Suzanne and her happy union with the pharmacist from Rouen. If the result of that union is to produce an infant, then the figure in the center of this circle could be interpreted as a reference to the end product of a successful marriage. I have no reason to see it as an alchemical symbol.

JEAN SUQUET (F)

I'd like to return to the question of Duchamp's lack of involvement with alchemy. An alchemical interpretation of the *Large Glass* can be made, providing that it is rigorous, but an attempt to make Duchamp into an

adept who has found the Philosopher's Stone is pure delirium. Did he or
didn't he read any hermetic treatises? There is an indication that he had
read something, as has been drawn to our attention by Ulf Linde whose
insight I respect.[3] There is a picture by Duchamp entitled *Glissière en
métaux voisins* [*Glider in Neighboring Metals*], a very strange title indeed.
What could possibly be a "glissière en métaux voisins?" Well, in what
was the bible for alchemists around 1900, a book by Albert Poisson
entitled *Théories et symboles des alchimistes*, one finds the expression "le
cuivre, l'étain et les métaux voisins" ["copper, tin, and neighboring
metals"]. Now, you might say to me: "these are two uses of words only
coincidentally related; that's not proof." If one is familiar with the
source, within the technical alchemical expression "copper, tin, and
neighboring metals," "neighboring metals" doesn't come as a surprise, as
it is quite a natural appellation. Whereas when one rediscovers this
expression "métaux voisins" in the title of a painting, it no longer means
anything. Consequently, it is very tempting to believe that Duchamp bor-
rowed this term from the alchemical book that Charcornac was spreading
throughout Paris during that time.

ANDRÉ GERVAIS (F)

One small yet appropriate detail about "métaux voisins": During the
same time there was a manufacturer who was the first to begin replacing
the cloth on airplane fuselages with metal plating. This company was
called Voisin.

JEAN SUQUET (F)

Right.

ANDRÉ GERVAIS (F)

The *Glider* in question, which is on glass, suggests a water mill with
metal plates for paddles. These metal plates are also those mounted onto
airplanes. So, métaux Voisin becomes "métaux voisins" by a simple play
on words.

JEAN SUQUET (F)

That's possible, but the other hypothesis is not to be rejected.

HERBERT MOLDERINGS

Even if Duchamp read that alchemy book and he found "cuivre, étain,

métaux voisins," the question is: what did he take from this? In 1952 Marcel Jean wrote to him, sent him a questionnaire, and asked him, "What are these 'métaux voisins'?" And Duchamp answered in his letter, "I don't know what these metals are but I know that they are neighbors."[4] So it seems that what interested him was really this funny word combination and how it stimulated the imagination. It was, I think, a kind of poetic language, but nothing alchemical. I'm not open to that.

JEAN SUQUET (F)

I am not willing to defend at any price an alchemical interpretation, but when you say, "it's poetic language, he wrote 'métaux voisins' because it seemed funny or surprising," you are jumping to conclusions. The fact that the same expression is found in two different texts doesn't absolutely imply a cause and effect relationship between them. It is rather like a manifestation of what Breton described as objective chance [le hasard objectif]. Even though separated from Duchamp by thousands of kilometers and many decades, in 1852 Melville wrote "The Paradise of Bachelors" wherein a fraternity of nine bachelors wander through a factory sprinkled with splashes and are seen out of the corner of the eye of a prankish child. And so, by an extraordinary stroke of objective chance, there is this coincidence between the imagination of Duchamp, who had never read Melville, and Melville's story which says the same things not only with the same words but with the same numbers: nine bachelors, a machine, slopes, splashes, the Mad Maid's Bellows-pipe, and so on.[5]

FRANCIS NAUMANN

Maybe Melville got it from Duchamp!

JEAN SUQUET (F)

Perhaps Duchamp didn't find "métaux voisins" in Albert Poisson's book, but there is the fact that two unrelated works spoke of métaux voisins at the same time. Here we have one of those coincidences upon which, I believe, poetry is based.

HERBERT MOLDERINGS

I think we have a lot of these combinations in Duchamp's writings, many of them combinations of a physical word and a psychological word. I would say that one of the structures determining his writings is the interpenetration of physics and psychology. This was rather widespread about 1900.

JEAN SUQUET (F)

I agree that a mixture of the physical and the psychological is commonly found in Duchamp. But whereas "metals" could pass as being physical, I don't see how "neighboring" could be interpreted as psychological, except if you think of a squabble among neighbors.

THIERRY DE DUVE

For the sake of a squabble among neighbors, could we get closer to the idea of the reconciliation of opposites which Francis Naumann had defended in his thesis?

JEAN SUQUET (F)

Allow me one remark. Francis Naumann has shown that Duchamp's declaration of faith was to never repeat himself. But what did he do throughout his life? He did nothing but repeat himself. He made the *Chocolate Grinder* three times, the *Malic Molds* four times, and the *Bride* two times. Furthermore, when he began again to work on something, forty years later, it was on the *Etant donnés*. With Duchamp there is a fundamental contradiction which is always active. Though he claims, "I want to never repeat myself," he always repeats himself. The proof of this repetition exists in the title of his major work, which ends with the word "même." "Même" is the verbal symbol of repetition.

THIERRY DE DUVE (F)

Moreover, "même" repeats the same syllable twice.

FRANCIS NAUMANN

That's not much of a contradiction. He's talking about two different things here: not repeating himself, and repeating in the sense of making multiple examples of a given object in an edition. To remake readymades is, in my opinion, a variation on the idea of what a readymade is supposed to be (although I know Duchamp was heavily criticized when he made these editions). I mean, you see, making the very same thing again is simply another way of not repeating yourself.

ERIC CAMERON

Maybe I can offer something that may help in the reconciliation of this contradiction that doesn't seem to be a contradiction. What I'm thinking of is the book that Nelson Goodman wrote in the sixties, *Languages of*

Art, in which he distinguishes between two kinds of art: one which he calls "autographic" and the other which he calls "allographic."[6] The "autographic" normally is things like painting and sculpture when they're made in one unit. And "allographic" is normally things like music or theater or literature where there are multiple copies. Every performance of a Beethoven symphony is an authentic Beethoven. If you see the work of art as essentially existing at the service of the mind, in the mind, then it becomes an allographic art in which all of the different manifestations equally represent the work, just as the performance of a Beethoven symphony always is the authentic Beethoven even though there are several copies of them.

FRANCIS NAUMANN

I agree.

THIERRY DE DUVE

Maybe I'll butt in with a few philosophical quibbles that I have with your talk. Let's say, in a nutshell, that I would question your Hegelian model. You presented it in oversimplified terms: thesis, antithesis, synthesis; that is, an affirmation (A), a negation (B = −A), and the double negation bringing us to the "reconciliation of the opposites" (C = −−A). Let's leave Hegel aside. Whether that is Hegel's notion of reconciliation of the opposites (or his notion of dialectics, rather), or not, is another topic. But I don't think it applies to Duchamp at all. That's my point. And here is just one example of why: the Halberstadt-Duchamp chess book. Its title is *L'opposition et les cases conjuguées sont réconciliées*. So, we've got a reconciliation which appears, to me at least, to be a second-degree reconciliation: not the reconciliation of an opposition, but one between, on the one hand, a theory of opposition in general (opposition being already the conflict of two things) and, on the other hand, another theory resting on "les cases conjuguées." I'm not familiar with chess, and I haven't read Halberstadt's and Duchamp's treatise on this particular end game, so I don't know what this theory actually is, let alone what it would be if we were to translate it into an art theory, which I think we are allowed to do with Duchamp. In any case those two theories in turn are shown to be one and the same. Would you care to react to this comment?

FRANCIS NAUMANN

You may very well be right. I'm not versed well enough in Hegelian philosophy to make any confident statement about how these things related. I mentioned this only in the context of Stirner, who was a Hegelian, suggesting only the possibility that his ideas might have run parallel to Hegel's. As for the chess book, on its very first page Duchamp emphasized the fact that its subject was "opposition and sister squares," not "opposition or sister squares." Opposition is a system where, in an end game situation, you move your pawns and king only in response to your opponent's moves, a system that will determine whether you win, lose, or draw in a particular position. "Sister squares" is a bit more complicated, but it involves an understanding of this same concept of opposition based on the position of your pawns in relation to the color of the surrounding squares. These two systems are, as Duchamp points out, simply different ways of looking at the same end game situation.

THIERRY DE DUVE

If I understand you well, the first theory would say, "whatever the opponent is doing, do the contrary," or something similar . . .

FRANCIS NAUMANN

Yes . . .

THIERRY DE DUVE

I mean, "do a particular move that keeps you in a straight or diagonal opposition to your partner," or something like that.

FRANCIS NAUMANN

No. Well . . .

THIERRY DE DUVE

We need a chess expert.

FRANCIS NAUMANN

There are probably some here.

HERBERT MOLDERINGS

I will try only if there's nobody who feels qualified in the audience.

MOLLY NESBIT

I have a simple way of getting back to your thesis, Francis, which is this:

if we take the reconciliation of opposites in theory, then maybe we are stuck with a philosophical problem. But if we take it in practice, don't we get a way of making humor by combining two things, two different, maybe opposite things, that don't go together? So we get, say, Chaplin in drag and we laugh. Right? It's a mechanism.

FRANCIS NAUMANN

Definitely. You know, this whole paper could have been just an analysis of the puns, which are, in most cases, things that you take to mean one thing and actually mean something else. In deciphering their meaning, you flip-flop, as in an illusion, but as in a compatible illusion. The correct response is a smile, not a laugh. Anyway, I've always wondered why there has never been a detailed study of the puns.

THIERRY DE DUVE

If I may say so, André Gervais has produced what is to this day, I think, *the* book on Duchamp's puns, aphorisms, and so on.[7] But I believe the floor is eager to intervene?

JAKE ALLERDICE

I'm not sure exactly how to phrase the question, but I'm going to give it a try. It bears on the question of puns, in that a pun is one word which is two or more. And it bears on Duchamp's idea of using that little bit of energy that's wasted. Can the reconciliation of opposites, whereby something is either on or not on, be brought down to this very slight idea of the "*infra-mince*," the very slight line that seems to separate things by no more than a quantum?

FRANCIS NAUMANN

I think I know what you're getting at, and I sense something similar. One among many very pleasant aspects of Duchamp's personality was to effectively reconcile opposition between people. This tendency, some have claimed, might have been the result of outright laziness. Rather than argue, he claimed the argument itself wasn't worth the time and effort. Expending as little energy as possible seems to have been an integral part of his personality. I don't know whether or not you can work this observation into a general theory of opposition. But I should emphasize the fact that I began this paper by saying that I do not believe there is a

single theory which completely and adequately covers all aspects of Duchamp's method. Even though I have, in effect, explored the possibilities of such a theory, I shall never look at a specific work by Duchamp with the intention of finding an expression of this theory; I mean, a theory in the stylistic sense. Frankly, I don't think I've discovered anything special, nothing beyond what Duchamp himself said. No big deal. I'll rip up the paper on the spot if somebody thinks I found something.

ROSALIND KRAUSS

I was anxious because Herbert Molderings never got to his chess explanation.

HERBERT MOLDERINGS

Could you switch off the microphone? As a poor practitioner of chess, to me the question of opposition seems to be a very simple thing. Because, by "opposition," you name in chess the relation between your king and the opponent's king in an end game involving king/pawn: what remains on the board is king/pawn on either side, or two pawns and the king on either side. Then, by saying "I shall win because I have the opposition," you mean that you immediately see that you will block your opponent's king. You move your king, and the opponent is forced to move his king in order to defend his pawns. So, saying "I have the opposition" means, "I have the move which will block, in the end, the opponent's king by separating him from his pawns. And if I take the pawn, I'll win." That's all.

THIERRY DE DUVE

What then is "sister squares"?

HERBERT MOLDERINGS

That is too complicated. I've never played that. As far as I know, that's a series of moves in a field around the pawns: deferred moves, a delay of opposition. But I can't explain it in detail.

FRANCIS NAUMANN

Well, it's exactly that. I know that you move your pawn in such a way as to establish opposition. That's why opposition is the same thing as sister squares.

HERBERT MOLDERINGS

This you should never do. If your opponent has the opposition you will lose.

FRANCIS NAUMANN

No, it's the other way around. If you have opposition, there's a way of moving to avoid giving your opponent opposition, so that you win. But what I'm trying to say is that in the end, it's the same thing as sister squares.

HERBERT MOLDERINGS

Now, when I thought about these moves in chess, I thought about your general sketch of his method of reconciliation of opposites. And I asked myself, what does this mean in his work? When seeing the opposites in the *Large Glass*, the bachelors and the Bride, where is the reconciliation? They are separate, absolutely, and there is reconciliation only in projection, in the mind. Duchamp separates the opposites. And when he unites them, it's only in the imagination. So I think his theory of dialectics is very idealistic, like Stirner's. You talked about the young Hegelian school, and you touched on Marx's and Engels's critique of Max Stirner's book. I get a bit tired, I guess, of trying to use the holy family of Marx and Engels, the critics of Stirner's book, in order to deal with the idealist notion of dialectics in Duchamp's work. But, you know, I think there is no real reconciliation of opposites. It sometimes makes me very sick when dealing with the *Large Glass*. It's all coming down to what? Voyeurism? One never touches anything, and . . . Well, you know what these chocolate grinders are occupied with . . .

FRANCIS NAUMANN

Well, in the case of his ideas for the *Large Glass*, I don't see why we cannot envision its theme in terms of a bride and a bachelor. What, in the end, is the purpose of a bride and a bachelor, if not their ultimate physical union, an act which results in a change of their identities? He could have given them numerous other identities that never merge.

HERBERT MOLDERINGS

I'm sorry. The bachelors are the bachelors.

FRANCIS NAUMANN

Yes, I know, but only in respect to their identities.

HERBERT MOLDERINGS (F)

There is no question of "la mariée" and "le marié."

THIERRY DE DUVE

Ladies and gentlemen, this is precisely going to be the topic of Jean Suquet's talk, and after we have heard him we can resume this conversation as to whether or not the Bride and the bachelors ever mate or whether they remain separated.

1 Arturo Schwarz, *The Complete Works of Marcel Duchamp.*

2 Pierre Cabanne, *Dialogues with Marcel Duchamp,* 23.

3 Ulf Linde, "L'ésotérique," *Abécédaire,* 60–85.

4 Marcel Duchamp, *Letters to Marcel Jean* (trilingual edition, German translation by Herbert Molderings, Munich: Verlag Silke Schreiber, 1987), 74.

5 Suquet's memory may have carried him a bit too far. "The Paradise of Bachelors" is the first part of a short story in two parts, entitled "The Paradise of Bachelors and The Tartarus of Maids," which Herman Melville wrote and published in magazines somewhere between 1853 and 1856. It was first published in book form in *The Complete Stories of Herman Melville* (New York: Random House, 1949). Although the narrator of "The Tartarus of Maids" is indeed led through a factory (a paper mill, actually) by a prankish child and encounters the Mad Maid's Bellows-pipe as well as many machines, there is no mention of slopes and splashes in Melville's story. As to the nine bachelors, they are a modern reincarnation of the medieval Templars and their "paradise" is simply a men's club by the Thames in the middle of the City. They never get to wander through the paper mill of "The Tartarus of Maids."

6 Nelson Goodman, *Languages of Art* (2d ed., Indianapolis: Hackett, 1976).

7 See André Gervais's contribution to the conference, where he refers to his book *La raie alitée d'effets.*

Par la perspective (ou toute autre moyen tout aussi canons...) les lignes, le dessin sont forcés... perdent à peu près du "toujours possi... avec en plus l'ironie d'avoir choisi le corps... ~~primitif~~ ... qui devient inévitablement selon cette...

Possible

Translated by Tamara Blanken
and Thierry de Duve
Translation revised by Dennis Young

Everyone knows that he scribbled a moustache on the *Mona Lisa*, baptized a urinal "Fountain," spun a bicycle wheel with its fork in the air, and fabricated puns from the crudest obsession. I don't want to dilute the salty taste of these healthy snickers. Throughout his life, with obvious pleasure, Marcel Duchamp said "No"—a "no" that brought glory to his name, and rightly so. But what if these negations were really only shadows cast by the sun of a "yes," whose rays sparkle through the splinters of the *Large Glass?* This hermetic window, to whose crystallization the glorious naysayer almost secretly devoted between fifteen and twenty years of work, will be the object of our questions. This *thing*—I lean upon Marcel Duchamp's own words[1]—is truer to me as reproduced in the slide you see here (frontispiece) than in its material reality at the Philadelphia Museum of Art, where it appears as two steel-framed glass plates almost three meters high, a strange window indeed—one with no wall around it—veiled by a network of cracks and fortified in its isolation by its sacred character as a museum object. In the slide, the thing becomes a ghost of light and cast shadows: an image relieved of its original matter that has rediscovered the airy transparency of the ideas from which it was born. Fascinated by the screen like the spectators in Plato's cave—except that we are not chained— we look at it, and when we move closer, pointing out some detail, we enter the cone of projection; we cast our own shadows onto the screen; the image catches us in its net. May the enmeshment become an embrace!

But in order for this ghost of light to take shape, it must be fired by our feverish questions, irrigated with our blood, and animated by our breath, but also, let's not forget, sprinkled with our laughter. Marcel Duchamp made this thing called the *Large Glass* in New York between 1915 and 1923. With enigmatic patience and the care of a scribe copying a sacred text, he drew fiercely repulsive mechanical figures—not at all beautiful and apparently devoid of meaning—with lead wire, and stuck them onto the surface with varnish. Visual joy and retinal pleasure are nowhere to be found; rising up before us, rather, is the blueprint for a machine. And what does this machine do? What is its use? Where does it take us? To answer these questions, the best we can do is to make it run. If it has a meaning,

it is in its running. But how are we supposed to make it work since it appears inexorably stopped?

When Duchamp crystallized his scheme for the *Large Glass* (not yet having lost interest in someday unveiling it to onlookers), he considered accompanying it—as if with a manual of instructions—with a brief and dry text that would set his frozen machinery in motion. And here I want to make the point that I will be hammering to the end: the machine runs only on words. For Duchamp very carefully retained the notes, scraps, and sketches that, made in 1912–1915 in Paris, preceded the actual construction of the *Large Glass;* but not until the *Large Glass,* "definitively unfinished" in 1923, broke while confined to a crate in the back of a jolting truck on a Connecticut road, not until then did the words, firing from the cracks, start the engine. Instead of repairing the shattered *Large Glass* as soon as he was informed of its breakage, Duchamp decided to publish, at the cost of more very meticulous work, the corpus of writings that recorded his plans—resurrecting the imaginary flesh: the fabric of words that would drape again this *skeleton* of rods and gears. Only then did he restore the image between two new plates of glass, now to be read through the foundational grid of his writings. In Paris, in 1934, an edition of a hundred or a hundred and fifty copies of the *Green Box* was published—so named because of its green flocked cardboard cover and the assonance between "vert" [green], "verre" [glass], and "ouvert" [open]. Ninety-four scraps of paper bearing plans, drawings, hastily jotted notes, and freely drawn rough drafts were delivered in bulk. It was up to the reader to shuffle these cards as he or she pleased. There was no author's name on the cover; the work appeared anonymous and as if offered to the blowing winds. In light of this, I had not the least scruple, when opening it for the first time in 1949 at the request of André Breton, in making it speak (with Marcel Duchamp's consent) in my own voice; and out of its sparkling randomness, I began fishing words that resonated with something I felt deep inside me, something obscure yet promising illumination. One should refrain from saying "I." One should say "we." It is indecent and pretentious to appropriate body and soul, blood and sweat, the work of another. If an interior journey goes deep enough, at some point it arrives where all roads meet. I was twenty. I dreamt—with due reverence—of taking up the journey where the previous traveler had left off. Since then, other trails have appeared for us to follow.

In 1967, Duchamp put together another box, white this time, entitled *A l'infinitif*. Then, in 1980, Teeny Duchamp, Paul Matisse, and Pontus Hulten published another bundle of handwritten *Notes* foreshadowing the *Large Glass*. These additions have generously enriched the exegesis, but they have not bent the roads radiating from the *Green Box*, which contains all we need—were it only the outline of a lacuna, the tail of a comma—to articulate in detail our interpretations. The legend to the *Large Glass* lies in the *Green Box;* Duchamp put it there for us to read. Although I shall, of course, take into account everything that is known today about the *Large Glass*, whether from the *Green Box* or not, I believe that his first choice should be trusted. Manuscripts in hand, we must oscillate between the *orders* and the *authorizations* that will lead us to the heart of the *dazzle*. I only hope everybody marvels as I did when I first opened this green case that spilled out over my table like a treasure chest.

The legend begins with the title, inscribed on the box's lid from top to bottom: *La Mariée mise à nu par ses célibataires même* [*The Bride Stripped Bare by Her Bachelors Even*]. "Même" is in the singular and without the comma that would later isolate it from the gentlemen, in the plural, preceding it. This phrase, boasting an irony of discord, must be analyzed down to its grammatical undergarments and undressed word by word, letter by letter—but only through the prism of the *Large Glass*. All discourse on the stripping bare is vain and doomed if not hinged on the setting in motion of its machinery, on the machination it represents. Is this assembly of gears a joke? If you wish! But a functioning machine was what Duchamp really wanted when he set out on his journey.

One of the very first manuscripts puts two actors in place: the *Bride above* and the *bachelors below*. One is in heaven, the others are on earth. Between them, an opaque iron hinge straddling the center line seals them from each other hermetically. But such was not always the case. Here is the only photograph we have of the *Large Glass* before it was broken (fig. 3.1). It was taken, perhaps without Duchamp's knowledge, at the Brooklyn Museum where it was exhibited in 1926—the one and only time it was shown intact. Let us appreciate the first of a string of surprising contradictions that we will continuously come up against. Duchamp didn't even bother to have an excellent photograph made before abandoning the work he loved so much and that cost him thousands of hours of effort and rewarded him with

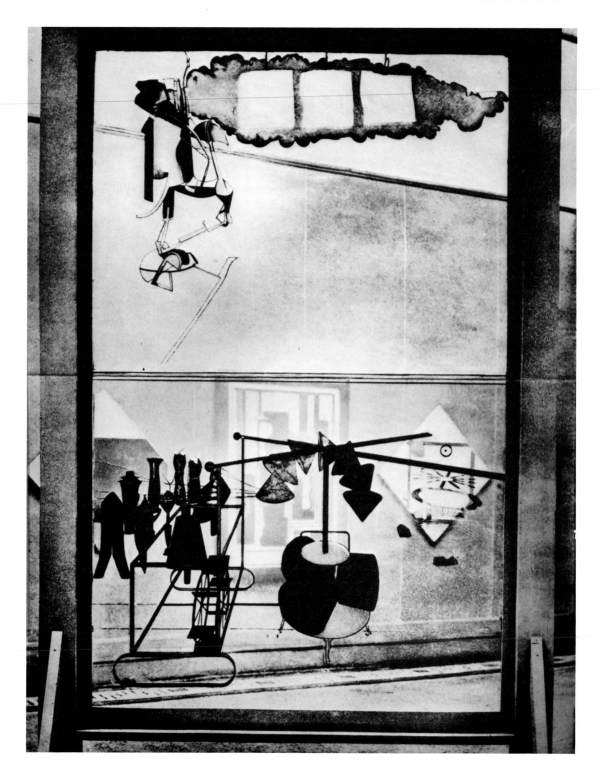

thousands of hours of pleasure. After being slightly cropped, this casual print, with a glimpse of the walls and pictures of the Brooklyn Museum behind the *Large Glass*, thus became the only photo to receive prominence among the loose leaves of the *Green Box*. It is the same photo that Duchamp used to illustrate André Breton's "Phare de la Mariée" ["Lighthouse of the Bride"]. It shows us how, originally, the transparency of the *Glass* in its monumental wooden frame was not blocked by a thick opaque beam that, although needed to reinforce the 1936 repairs, unfortunately accentuated the separating effect of the three thin horizontal lines leading from the lower to the upper half like rungs of a ladder. These lines are three long and narrow glass plates seen edgeways. By extending the obliques of the *Glass*'s perspective construction until they intersect, we find that the vanishing point pierces the middle of the highest of the lines, which is therefore the horizon line. Duchamp designated it *the Bride's garment*. The allegory is admirable: the horizon is an imaginary line that the gaze cannot pass, and just as the horizon limits the view of the traveler, garments limit the gaze of the voyeur. Even better: when one moves toward the horizon, it recedes at the same rate that one advances. Duchamp represented the Bride's dress slipping from her shoulders as the horizon slipping away. She will be stripped bare, but we will never see her nude.

Now, for the horizon to slip away, one must move forward. After a good four pages of my paper, we haven't moved an inch and the *bachelor machine* has yet to run. Still, we can see its cogwheels, its mills, its gears. Take the triple roller sitting in the middle of the first blueprint, the *chocolate grinder* on its *Louis XV chassis*. Does it even budge? Sure, it turns! A manuscript verifies that it turns without any mechanical assistance but by virtue of the repetition of the *adage of spontaneity: the bachelor grinds his chocolate himself*. A machine moved by a proverb! Could one hope for a more convincing demonstration of my act of faith? It is words that make the machine run. And what does a machine do when it runs? It endlessly does again that which it just did, it repeats itself forever: it turns, it turned, it will turn, around and around, and will return always to the *same* [même]. "Même" is the word-engine of repetition. (Perhaps I should sketch the psychological portrait of this moody creature, evoke its childhood air, its dubious color, but I don't have the time—and who cares about the moods of nuts and bolts when trying, monkey wrench in hand, to unlock move-

ment?) To the left, between the blades of the *large scissors* that form an iron "X" above the grinder, the *chariot* raises its shafts. "Chariot," because according to the first plans this cage was to be rolling and jolting on four wheels rather than gliding on two runners. It is pulled forward by a noria of *lead-bottomed bottles* driven by the *mill wheel*. They cascade from the ceiling of the bachelor space onto a *pedal* in the *basement* that the floor hides from view. Since the lead of these bottles has an *oscillating density*, now heavy, now light as a feather, they fall at times hard and fast and at times idly, giving the chariot a jolting gait. None of these mechanisms actually appears in the *Large Glass*, and nothing but words, once again, can make them move. Because of the nature of its metal rods, the chariot has a characteristic that remains unknown until revealed by the legend: it is *emancipated from gravity*, if only horizontally. Its momentum is not restricted by friction. At the end of its run, its unaltered force has lost none of its vigor, and the best it can do is to *invert itself into a reverse force equal to the forward force:* the chariot/glider returns to its point of departure as though pulled back by the memory of its ruts. I won't harp on its moods which it chants in *litanies*, word after word, verse after verse, except to say I want them cleansed, washed away by the *waterfall*—also invisible— that activates the paddlewheel that gives the chariot its initial flick. So everything is not as frozen as it appears. The grinder chases its tail. The chariot comes and goes. Duchamp wanted his cogwheels to be lubricated by the oil of laughter, and he engaged them tooth for tooth, eye for eye, with the stirring of his emotions. What strange perversion might motivate a man to imagine his body becoming a machine, to instruct it even to carry out the fundamental act during which each of us bumps and grinds to pleasure? Man is master of the machine; he invented it; he built it; it obeys domesticated laws. Instead of being confined to opaque, tired, suffering flesh, nerve impulses spark along rods of nickel, platinum, fine copper, and *gold*—stable and immortal metals that mental and sentimental rust will not corrode. When all is thrown into gear, one way or another, the machine works. It has to work.

But are we finally going to see something move behind this foreground of wanton machines? Well, the nine red gentlemen standing behind the chariot—nine strongmen daubed with red lead compound, entrenched behind this hardware of ironic iron and wily wheels—do not budge. But their name

slips and skids on its own meaning. Duchamp gathered this *meeting*, this *farandole*, this *wardrobe* of nine *uniforms and liveries* frozen at attention, first under the name *Eros' matrix* and finally under that of *cemetery*. Womb and tomb are conflated and confined to one place! What a stride, what a leap it takes to pass from entry to exit in this way! Subtle mobility, quasi-spiritual fluidity must inhabit these males reduced to their habit. Indeed, the bachelors are full of wit, inflated as they are with *illuminating gas*. "Gas" comes from "geest," a Flemish word meaning spirit. This ultimate transparent being is going to appear as the soul of the machination. But does it ever appear? Gas is invisible by nature; painting can only show the molds that contain it, the pipes that channel it. Yet in this plumbing pinned to the ground there is a flux: time flies, and gas flows. If I have tracked the traces imprinted on the *Large Glass* for almost twenty years, it has been to catch up with brother gas and accompany him, as far as possible, on his *voyage*. Before I set out by his side in order better to acquaint myself with him, I would like to free him from the culinary bondage to which our time has relegated him. In 1912, at the time when Duchamp conceived of the *Large Glass*, domestic gas was not doomed only to burn under saucepans. It was not called *gaz d'éclairage* for nothing, being the blood of the city's lights, the "hydrogène clarteux," the spirit of lamps that needed only a match to shine out. In the *Large Glass* the gas leaks along the *capillary tubes* tangled above the bachelors' heads. These lead ducts condense it, solidify it, stretch it, cut it, and break it up into a myriad of droplets of frosty fog. It then jumps from filter to filter, following the arch of funnel-shaped *sieves* that hover above the grinder. It rambles in the *labyrinth of the three directions* until it loses its sense of up and down. It breaks down, it dissolves, it *liquefies*, but nevertheless remains absorbed in its dearest childhood memory: its *determination to rise*. In the *Large Glass*, as elsewhere, there is no shadow without light. Sloppy, liquefied, having become *a drip*, the gas, for all that, remains red, the color of blood and fire. Frothing like lava from the mouth of the last funnel, it flows like molten sulphur into a spiral gutter that catches it and directs it down to the earth. A drawing on tracing paper, the very first sketch for the *Large Glass* (fig. 9.1), shows only the spine of this gutter. If it had been transferred onto the *Glass* itself, perspective would have narrowed it here and widened it there, giving it an amusement park *toboggan* look (fig. 3.2). Above this toboggan, the large stammering scissors don't offend heaven in the least,

3.2
Fête foraine, Le Toboggan [Funfair, the
Toboggan], French postcard, ca. 1905.
(Courtesy Jean Suquet.)

since their blunt squared blades cannot be closed any further. These scissors have never cut anything, except in the bachelors' fantasies. On the contrary, they establish a liaison by way of two pieces of *string* tied to the tips of their blades, and by extending upward the two double oblique lines passing through the drawing on carbon paper entitled *Oculist Witnesses* (fig. 3.4), we can determine exactly where these strings are attached. By extending them downward, we form a triangle whose apex is plumb with the end of the toboggan. As another drawing from the *Green Box* shows (fig. 3.5), there hangs a *weight* suspended by two hooks, about to slip off and threatening to fall at any minute into a puddle of gas, liquefied but as explosive and inflammable as ever. Here is the result of this montage (fig. 3.3).

Let us go over the story again. A waterfall activates the mill. Falling bottles cause the chariot to jerk and, consequently, the scissors to jolt. The suspended weight, held by the hooks and the strings, threatens to fall. All these falls and crashes motorizing the bachelor commotion follow one other in a counterpoint of traps and trips, beating the drum to the same song whose chorus resonates again and again throughout the *Large Glass:* it sings the will to be emancipated from gravity. A fall is the way that chance ordinarily chooses to manifest itself: a flowerpot falling on the head, a throw of the dice. In a world ruthlessly subject to laws, chance is a leap beyond law, an event independent of what precedes it, a missing link in the chain of cause and effect. Falling from the sky like a gift of grace, chance is the shadow of *free will*. Let us open a little philosophical digression—especially appropriate here, since we will only be repeating point by point what Duchamp argued with strings, bottles, and gas lamps. Man uses free will when he chooses, as he pleases, to fall left or right with nothing pushing him to either side. He falls, no doubt, but maintains his composure. The *freedom of indifference*—a term that Duchamp borrowed word for word from Middle Age scholastics—has its forerunner in the itch for emancipation that thrills the bachelor machine. The chariot escapes gravity at the level of its ruts. The lead of the bottles sparkles with the bubbles of oscillating density. Our traveling companion, the condensed, congealed, and liquefied gas, counters all his burdens with his unwavering determination to rise. All these characters down below have only one

3.3
Detail of the *Large Glass* with superim-
position of the drawing *Oculist Wit-
nesses* and of *Note 153*. (Montage and
photo Jean Suquet.)

3.4
Témoins oculistes [*Oculist Witnesses*],
1920. Verso. Stylus on reverse of carbon
paper, 19⅝ × 14¾ in. (From the *Green
Box*, collection Régine Pietra; photo
Jean Suquet.)

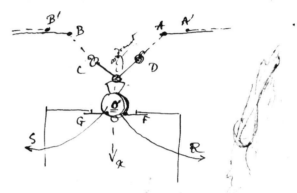

en A et B. points de tirage (écartement des ciseaux
jusqu'en A'B'). le mobile o est retenu par F
et G. les crochets c et D cèdent. — 3 solutions
1ᵉ le mobile o abandonne en même temps c et
D et tombe suivant x — en déterminant
par sa chute un fracas à exposer
2ᵉ le mobile abandonne c seulement et la
traction cessant en A', il est entraîné
suivant la trajectoire R (autre fracas)

3.5
Schema from *Note 153*. (Photo Jean
Suquet.)

obsession: to climb up there in order to see from where the flowerpot of free will falls on their heads.

Luckily, up there, there's no super strongman who spits lightning or dictates his law. Up there, thankfully, is a woman. Up there, there is the Bride. That atrocious arrangement of angular forms hanging at the zenith of the *Large Glass*, that hiccuping rack suspended on a hook sunk in a lintel— is that the Bride? If only she had remained invisible like the illuminating gas or the waterfall! Didn't she have a less grimacing appearance in her younger years? The faintly recognizable silhouette of a young veiled bride can be seen on a freehand pen drawing in the margin of one of the early notes (fig. 3.6). Yet on the 1912 canvas where she first appeared, kneaded in fleshy colors, no one could see a bride in the illegible muddle of viscera portrayed. Certainly we see no bride either in the black and white skeleton that Duchamp abstracted from this painting, the structure that he projected onto the *Large Glass* like an enlarged X-ray (fig. 3.7). The riddle remains. However, we can unravel the logic of this disincarnated apparition. The Bride, Duchamp explains, proceeds from an imaginary four-dimensional entity projected into our three-dimensional world and then reprojected onto a two-dimensional surface. Four, three, two . . . one is next and zero is soon to appear. Whereas the bachelors are plural, fragmented, and, being so multiplied, can be cast in several roles, the Bride tends to become ONE. Here, French is infinitely more poetic: UNE is an anagram of NUE [nude]. One and nude, the Bride no longer knows any boundaries. Her appearance evaporates into transparency. She and her four dimensions can no longer be seen; only her ephemeral imprint is left on the two dimensions of the picture, like a footprint in the sand.

Running parallel to the trail of this fleeting creature is the water of a river with which we are all familiar. In spite of the mathematical affectations with which the best scientists have dressed it up, the fourth dimension is time. At the beginning of this century, while the theory of the fourth dimension was entertaining the keenest of modern minds, the physicist Einstein, the metaphysicist Bergson, and the pataphysicist Jarry sought it nowhere else but in time. So did the mathematician Jouffret, from whom Duchamp borrowed the notion of *instantaneous crossing*—certainly one of the least clumsy ways of *giving the idea* of this dimension, perpendicular to all three others, whose perspective had never been mastered by a painter.

3.6
Drawing from the *Green Box*. (Photo Jean Suquet.)

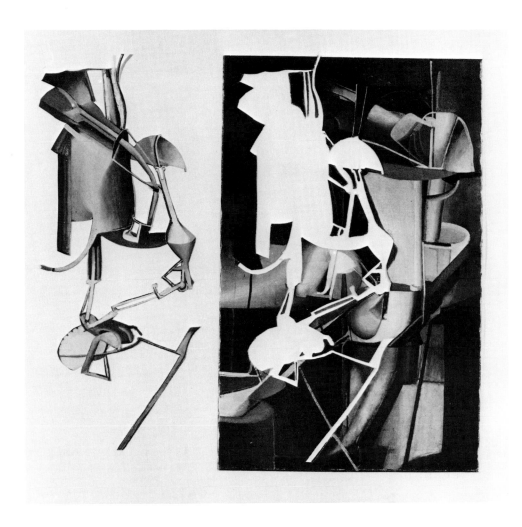

3.7
Schema showing the Bride appearing in
the *Large Glass* as a cut-out from the
painting *Mariée* [*Bride*] (1912). (Schema
Jean Suquet.)

If I plunge into the river of time it is in order to collect a verbal nugget. Duchamp curiously baptized the Bride as the *Pendu Femelle*. Making "pendu" feminine in this way is strange: "une pendue" comes readily to mind. But how trivial an appellation for the Bride! "Une pendule" certainly suits her better. "Une pendule" is a clock. Duchamp didn't overexert himself representing time's unseizable flight by the subterfuge of a trajectory, like that of an arrow. He suggested it between the lines, he integrated it into the very structure of the machine. Why are there three rollers on the grinder, six sieves (according to the first texts), and nine bachelors? Because the *number three* equals *duration*. Time's passage is counted out in threes: yesterday, today, tomorrow; before, during, after. It is from this "during" [pendant] that the Bride is hung [pendue]. She embodies—in the carnal sense of the word, for she is organized around a *life-center*—the present, the instant without breadth, the only point where the crushing weight of time meets the fourth dimension flying by. Her heart beats. Her *pulse* exacerbates a convulsive staccato. The warm *dew* that she secretes nourishes a *wasp* that regulates the sudden mood changes of a *barometer* that measures the weather [temps], just as a clock measures time [temps]. Released from this physiological fermentation is an *interior draft*, a *breath*, a *wind* that rushes the "pendue-pendule," spreads and tears her up into a oriflamme of viscera and meninges, and sets her swaying from all *four cardinal points*. Carried away by the pleasure that she feels overcoming her, the Bride strips herself of the limits of her flesh and escapes all contour. The spasms, the quakes, the gasping "yes" of an approaching climax, multiply into a *meteorological extension*, shaken by *storms* and embellished by *fine weather*, which passes across the sky like a tongue of *flame* until the tempest of orgasm arches the woman's body above the horizon into *milky way flesh*.

What a pity it is to have to reduce to a mere three phrases the prodigious play of metaphors and metamorphoses with which Duchamp describes the birth, the rise, and the acme of pleasure. Nothing short of a river of words, a verbal cascade, can describe this beautiful takeoff. Rather than the nickel, platinum, or gold dust with which some notes wanted to crown the *Large Glass* in a flood of light, it is a buoyant celebration, a feast of words that is going to prove capable of differentiating *the married divinity from*

the celibate human. Divine! Who are you then, you who blossom into a milky way, you whose train sways with the mathematics of love and the cries of "noli me tangere"? What do your eclipses hide? What do your absences conceal? I believe, dear *Mariée*, that the legs of your capital M stride to infinity to be at one with Mother. In a note, Duchamp himself named you the *mother-machine*, the *machine-mother*. Let's not forget that the first and most famous of all pendus femelles, the arch-mother, was Jocasta, mother of Oedipus. Must we climb even higher or recede even deeper in time to reach this divinity, who longs to be nude [nue] so as to be one [une], offers her own flesh and supplies her milk to the entire universe, as Magna-Mater, eternal lady of the night, celestial whore? If so, fine! She's more accessible at last! She has fallen from heaven and into bed with French popular culture (fig. 3.8). For where are we going to rediscover the *commands of the Bride*, her explosion in the sky, the comet of her tousled hair, and the galaxy of her breasts, if not at the amusement park?

At an early stage of the project, the breath of the enraptured Bride was to have been suggested by *transparent paper filaments* that unroll and recoil with each puff, like a party whistle. Some time later, her breath became a draft of air, carrying letters like leaves in the wind, and the paper filaments, previously transparent, vanished entirely so that only the letters remained. If we use the arched silhouette of the Bride to scale the drawing of the paper filaments (fig. 3.9) to the *Large Glass*, we can see that this draft runs through the entire region of the *milky way*. We cannot see the air itself, but we do see three squares of gauze, called the *draft pistons*, crowning the *Large Glass*, rippling like laundry pinned to a line, and swelling and flapping in the wind (fig. 3.11). Or rather, we see only the imprint of this animated linen after it has spent three months in the mysterious matter of the *flesh-like milky way*—a blue and pink outflow, undulating and tormented, which resembles more than anything the convolutions of gray matter: the Bride blows her letters from the *head*. In other words, she speaks, she murmurs, she shouts the *blossoming imagined by her, Bride desiring*. The nubile young woman longs to be nude [nue], a cloud [nue], a nebula. She herself unfastens her dress, which falls onto the horizon and drapes around the world, while the waves of her pleasure weave words in the fabric of the sky.

3.8
Commandements de la mariée [The
Bride's Commands], French postcard,
ca. 1910. (Courtesy Jean Suquet.)

Pleasure? Yes, Duchamp handwrote this exact word, *jouissance*, letter by letter. These letters fly from left to right, from one end of the milky way to the other, and then instantly return as though they could not part with the lips that have pronounced them, as though the Bride were alone when rushing to the peak of pleasure. She is married, yes, but only to some bachelors. Yet they are *her* bachelors. Whoever finds the key to this possession solves the riddle. The waterfall, falling from who knows where—from the sky, of course!—flicks the mill wheel in motion. A bottle tumbles onto a pedal. The chariot thrusts forward. The scissors open. The strings tighten. The hooks jump. The suspended weight drops at the foot of the toboggan and strikes the liquefied gas. The gas explodes miraculously, as if in the barrel of a cannon, bottom on the ground and mouth open toward the sky. Fire! Propelled by the blast, a *combat marble* shoots up, attacking the horizon. But, like everything moving toward this inaccessible line, it cannot reach it. It is content to release two metal *rams* that the bachelors brandish above their heads, like musclemen, to hold up the horizon-garment of the Bride. The rams fall. The dress slips off—or at least begins to. For the combat marble communicates to the rams that it knocks down the illuminating gas's dearest childhood memory: the determination to rise. And the rams move up again, slowly but surely. And the dress is pulled back up.

Soon Duchamp would repudiate these sideshow musclemen and their rigged *boxing match*. He had found a less clumsy denouement to the story of the illuminating gas. Our brother the gas lies flattened into a puddle—*what a drip!*—at the foot of the toboggan. Suddenly the crash of the falling weight jolts him out of his sleep and sets him on fire. He has discovered the best way to satisfy his desire for wings, having realized that his destiny was predicted by his name. Called illuminating gas, he should illuminate: let light proceed from his own enlightenment. Born in the darkness of the *malic molds*, having suffered through the sieves, having fallen into disgrace down the toboggan, the gas now ignites, burns with desire, and, emitting his own *interior illumination*, sets out to declare his passion to the Bride. *"After the three crashes: Splash"* [*"Après les 3 fracas: Eclaboussure"*], Duchamp writes to describe the flash of inspiration that sets the gas on fire. Carried by a flight of assonances, he also writes: *éblouissement de l'éclaboussure* [*dazzling of the splash*]. There's no need for lightning to

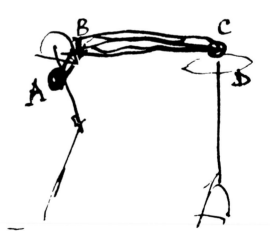

A

B boule

filaments
en papier
transparent
allant en épanouissement suspendu
jusqu'à la boule du jongleur et
revenant alternativement comme
certains soufflets
de fête à Neuilly.

Épanouissement ABC.

Enfaire une **Inscription** (titre,)
Inscription mourante.

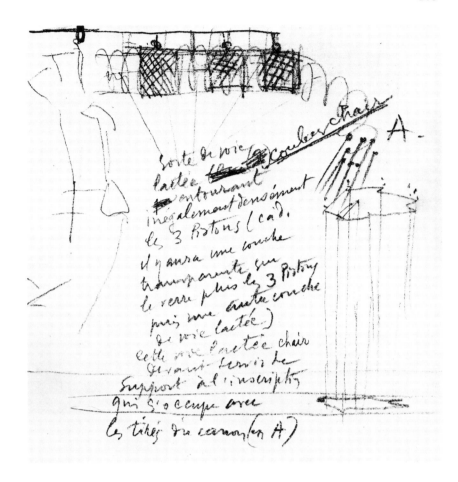

3.9
Drawing from *Note 152*. (Photo Jean
Suquet.)

3.10
Drawing from the *Green Box*. (Photo
Jean Suquet.)

3.11
Note from the *Green Box*. (Photo Jean
Suquet.)

shatter the window! True explanation seeks clarity within its own folds. It is from within the *Large Glass* that light is thrown upon the riddle: the gas is dazzled by its own burning reflection in the mirror of the three *oculist charts* radiating plumb with the end of the toboggan. Like a child catching the sun in a pocket mirror in order to bounce it into the eyes of the one it wants to dazzle, the oculist mirrors concentrate and direct the blaze of the illuminating gas toward the sky. They send up, Duchamp says, *not the drops themselves but their image*. This is the exact physiological definition of the gaze. A beam of photons penetrates the eye and is focused by the crystalline lens. In the retina, chemical substitutes register these grains of light. Beyond the retina, electrical impulses take over and generate mental images, soon followed by words concluding this chain of exchanges. In 1918, Duchamp integrated *oculist charts* into his picture in order to test the acuteness of the bachelors' gaze and especially in order to refine it, to sharpen it, and to cure it of its earthly shortsightedness. Up there in the sky, the Bride has been nude for a long time, indeed, from time immemorial. I believe that there will never be enough emphasis placed on the defect in construction—or is it its most perfect feature?—that determines the profound meaning of the *Large Glass:* the Bride's garment is suspended from the horizon line. If the bachelors don't see her nude, totally nude, it's because they bear the horizon within their own gaze, projecting it as far as their eyes can see. They fantasize and wave, far ahead of themselves, the dress that they are burning to undo. As long as they themselves remain enveloped in the perspective folds pulling them down to earth, the vanishing point will keep vanishing . . .

Thus the two energies at work in the *Large Glass* flow together: a flow of light below, a flow of words above. At the end of the journey, the gas has become a dazzled gaze, and the Bride effervescent writing. As to the *stripping bare*, Duchamp instructed us, word for word, to read it as a *poème*,. (The comma was put in by Duchamp himself.) The time has come to entrust a troubadour with the task of reading this poem on our behalf. He's an inconspicuous minstrel and, not surprisingly, performs at the fair. He appears in the guise of a *guéridon*, like the tipsy bistro table—his altar—that Matta built under Duchamp's direction for the 1947 Surrealist Exhibition (fig. 3.12). Its three or four legs, depending on the model, rest on the horizon line while its round tabletop touches the milky way. There's

no need for a giant to make contact. The milky way hugs the vault of heaven and bows until it touches the horizon. Duchamp points out that within the higher world forms *no longer have mensurability in relation to their destination*. Such is the case with the letters of the alphabet which, whether in capitals or lower case, equally inform their receiver. And it just so happens that this guéridon is the Bride's letter scales. Well, why wouldn't it also show some kinship with those acrobats so popular at the turn of the century? Indeed, prancing about on the Bride's garment that the rams undulate, hopping over the splashes directed by the mirrors, it *DANCES*. Its central rod, wrapped in a coiled spring, transmits the blows and counterblows of the bachelor commotion to the upper tabletop. Rolling on this tabletop, a *black ball* translates into twirls the *waves of unbalance* coming from below. But it never falls, for the Bride, flicking it with her moving letters, sends it *orders of new balance* thwarting its swerves. Duchamp first gave this ballet master, this star dancer, the deus ex machina of this boisterous meeting of above and below, the name *jongleur de centre de gravité* [*juggler of center of gravity*]. Juggling with the three meanings of the word gravity, he then called it the *manieur de gravité* [*handler of gravity*] and finally the *soigneur de gravité* [*tender of gravity*] (fig. 3.13). We must join the One in the sky, the Bride, to the others on earth, the bachelors. Gravity comes down tails, and the *jongleur* heads it off. The horizon cuts earth from sky, leaving an extremely grave gash. The *soigneur* seals the lips of this wound and tends to the scar that Duchamp allowed to form in the first draft of his preface: *Etant donné que . . . ; si je suppose que je sois souffrant beaucoup . . .* [*Given that . . . ; if I suppose I'm suffering a lot . . .*]. And what balm, what alcohol, what liquor sits on the guéridon at the Bride's bedside? Humor is the answer. Just call this guéridon's name out loud and bite the pun: "Guéris, donc!" ["So, heal!"] "Et si tu es gai, ris donc!" ["And if you're happy, then laugh!"] To recover from gravity is to laugh. By laughing, by dancing, the *manieur* now joins the *horizontal blossoming of the Bride desiring* to the *blossoming of the vertical stripping bare by the bachelors*. He compares them, matches them, conciliates them, and unifies them in the *blossoming without causal distinction* that *crowns* the *Large Glass* with *splendid vibrations*. I quote Duchamp: *There is no question of symbolizing this happy ending by an exalted painting . . . There is the need to express this blossoming graphically in a completely different way from the rest of the painting*. How did Duchamp

3.12
L'autel du Soigneur de gravité [*The Altar of the Tender of Gravity*], 1947. Assemblage built by Matta under Duchamp's supervision for the exhibition *Le Surréalisme en 1947*, Galerie Maeght, Paris, 1947. (Photo Denise Bellon.)

3.13
Note from the *Green Box*. (Photo Jean Suquet.)

express graphically the milky way streaming with writing, the flesh made word that enraptures the black ball and conveys the Bride's commands down to the splash? He spelled it out: *(Epanouissement) ABC. En faire une INSCRIPTION (titre,)* [*(Blossoming) ABC. To make an INSCRIPTION of it (title,)*] (fig. 3.10). Long live the comma, forged from this imperious resolution. Pure and free, it leaves "titre" dangling in its parentheses, already reigning over the title that it ends, *even*—already the master of the title that ends with "même." Scratched for the sake of pleasure, the comma dances to the flow of the pen as the most svelte, the most flighty, the most mocking cast shadow of the tender of gravity. The French word for comma, "virgule," comes from the latin "virgula," the diminutive of "virga," which means small branch, magic wand: "virga," in other words, hints at the male organ. The inscription, the news that Duchamp saw flashing back and forth on the billboard crowning the *Large Glass*, articulates, to begin with, *le titre*, comma, of his *poëme*, comma: *The Bride Stripped Bare by Her Bachelors*, comma, *Even*.

At the beginning of my paper, I claimed that this phrase titling the *Green Box* was not signed. But, of course, this was to be deaf to the two major sonorities between which its syntax is organized: "Mariée" and "céliba-taires"—in short, *Mar, cel*. Duchamp obviously punched his first name into the surface of the airy flesh of the milky way! The Bride has risen to the sky in order to proclaim Marcel himself the *child God* of the machine-mother. Duchamp wanted to be the *son* of his own work. Consistently he pursued that rift in the chain of cause and effect which would allow him to insert into it the lever by which he would become his own cause. He punctuated causality with the fleeting and insignificant sign that would make him the master of his own identity—identity simply expressed by the word "même." Duchamp dreamt of his name—his first name, the name by which he first heard himself called—written in giant letters across the entire horizon. Hence the very little concern he had for his worldly repu-tation. He needed no less than the fourth dimension to take the measure-ments of his signature, as boundless as the universe. This might be seen as absolute narcissism, but it also calls for pure self-effacement in front of heaven's mirror. Where the black ball was to have united the Bride's kindled flame with the dazzled splash, Duchamp preferred to drill nine *holes*. Just as he had reduced canvas to glass, just as he had transmuted

the lead of painting not into gold but into words—flying words—just as he had evaporated clear paper into volatile writing, so he opened up in transparency an even deeper transparency, the pure light of a void, the soul of *"Nothing, perhaps"* already promised in the *Preface*. This constellation of holes, both the *target* riddled with the bachelors' gazes and the riddle sifting the Bride's letters, delimits *images of the target* where the road *finds its hole toward the infinite* . . .

Infinity, by definition—to expand on one of the tautologies that Duchamp loved—is that which has no end. Consequently, and most logically, the *Large Glass* remained *definitively unfinished:* neither the toboggan, nor the zigzag of the strings and marble, nor the stammering rams, nor the spring of the tender, nor the exalted black ball—not a rung of this ladder, not a step on this path leading from bottom to top and top to bottom—was ever transferred onto the *Large Glass*. The scissors have snapped. They have cut through the hyphen in "machine-mother": "noli me tangere." Mister Phallus, the tender of gravity, the *guéridon*, has been told to pay more discrete homages. The endlessly spiraling screw has swallowed up his black ball. And the spring of the cosmic clock has vanished into the transparency opened up by the nine holes. Mister Phallus lived too fast a life, his rendering would have taken up too much space, one wouldn't have seen anybody else! Unable to draw the bow of the *large comma,* with which Duchamp wanted to enrich punctuation, he had to make do with the *throbbing jerk* of the *small comma*. It is precisely because this tiny comet of black ink means nothing that it now twinkles in the title as a sign. He whom we are given to contemplate only by his absence has left no more than a trace of his passing: the comma in the title.

Why? Even if the *Large Glass* cannot be completely finished, why doesn't the illuminating gas illuminate it with its fireworks, and why doesn't the *Inscription* crown it with splendid vibrations? The explanation is simple, lying from the very first day in the very first drafts. One glimpse at the *Large Glass* is enough: it represents the instant before, it is a *delay in glass*. The chariot is drawn back. The scissors are closed. When they open (in a minute? soon? tomorrow? never?), they are going to spread the strings which are going to liberate the weight which is going to fall into the liquefied gas which is going to rebound as a splash which is going to be dazzled by the oculist mirrors which are going to direct drops to the tender of gravity

who is going to . . . Well, but nothing is going anywhere in the *Large Glass*. None of this is shown. Here we are at the heart of the contradiction. In clear sketches and with sentences that don't stop along the way, Duchamp imagined the plan for a picture that would strip the Bride bare. And when the moment came to realize it, he chose a point of view that held the last veil in suspense. However much the jolting chariot comes and goes—as the Bride's letters come and go, as the weight falls, as the gas runs and the ball rolls—however much time runs with both legato and staccato movement, the *Large Glass* cuts through it all. It represents an *instantaneous state of rest*, it is an *allegorical appearance*, exalting above all a single moment. This moment, which Duchamp struggled hard to freeze on crystal, is not the moment of expansion, or of explosion, or of the setting on fire; it is, on the contrary, the moment of contraction, of shrinkage, when everything is *possible* but in suspense. Note 82 perhaps provides the key. I want to avoid distorting it, and I know very well that separated from its context its meaning is altered, yet I will quote from it two major propositions: *le tableau est impuissant . . . le langage peut* [*the picture is impotent . . . language can*].

Note

1. All words first appearing in italics are those of Duchamp and come from either the *Box of 1914,* the *Green Box,* the *White Box,* or the *Notes* published in 1980 by Paul Matisse (Paris: Centre Georges Pompidou, 1980).

Discussion

Moderated by Thierry de Duve

FRANCIS NAUMANN

I have only one very quick question. When Schwarz asked Duchamp to complete the *Large Glass*, in 1965 I think, for the engraving *The Large Glass Completed* (fig. 3.14), do you know why he did not include the juggler of gravity?

JEAN SUQUET (F)

No, I have no answer to give you. I don't know what Schwarz asked Duchamp nor how Duchamp replied. In the notes, on the sketches, and in the freely drawn plans, the Soigneur de gravité [the tender, or juggler, of gravity] is there. But how could it be shown in the *Large Glass*, when the *Large Glass* represents the instant just before? The splash only splashes when the scissors open and when the chariot moves forward: while the chariot remains pulled back, the scissors are closed. Hence, there is no splash. Nor is there, consequently, an ignition of the gas. The *Large Glass* is an "allegorical appearance" of the instant preceding the explosion. When you see the *Large Glass* at the museum you are confronted with a plate of glass divided by a horizon fortified with heavy metal braces, and you say to yourself, "There is no contact between the Bride and her bachelors." But this is to forget the *Green Box*, wherein contact does take place. The *Large Glass* is only a map which helps you chart an itinerary but, of course, doesn't embark you on the journey. Nothing moves without the notes, without the Bride's speech. All the elements of the interpretation are in the *Green Box*. Everything can be deduced from it, including the height of the Soigneur de gravité. By 1949, in my tentative first writing, I had said this.[1] I return now to the sketch that Schwarz published and to which your question referred. This sketch is strictly impossible, in a mechanical sense. Although it is signed by Duchamp—we have to admit that Duchamp gave his approval—this montage, in making the cogwheels click, in fitting together the pieces of the puzzle, is not possible because it contradicts not only the drawings that have appeared in the *Notes*—the juggler with his black ball—but also those which had already appeared in the *Green Box*—the "Blossoming ABC." The boxing match should occupy, it

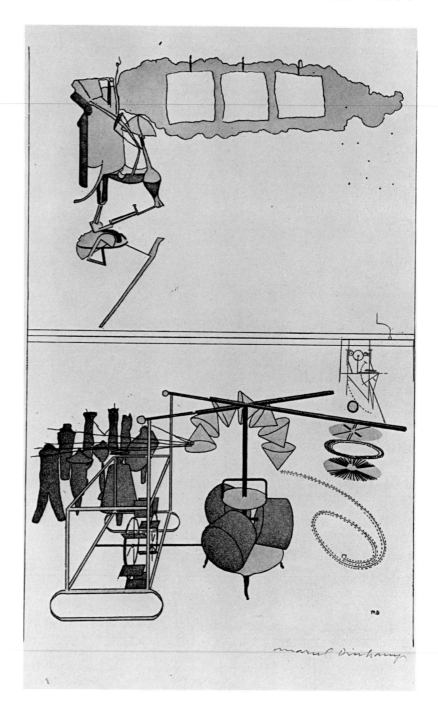

3.14
Le grand verre complété [*The Large Glass Completed*], 1965. Colored etching on japan vellum, 19¹¹/₁₆ × 13 in. (Collection Vera and Arturo Schwarz, Milan.)

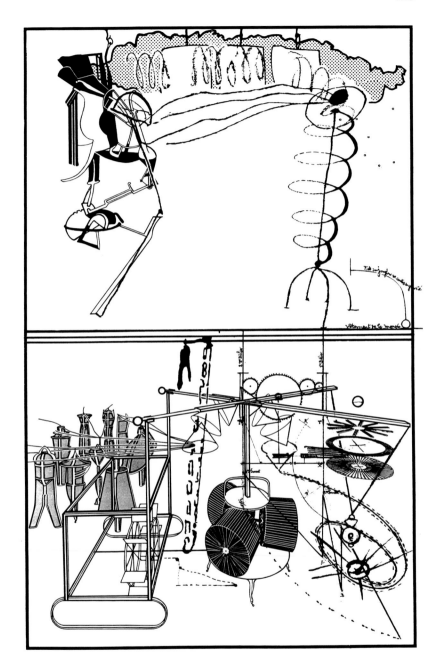

3.15
Jean Suquet's schema of the *Large Glass* as if it were completed according to Duchamp's notes. Suquet states:
The drawing Boxing Match *was certainly not intended to be transferred as such onto the* Large Glass. *It is an elevation, and nothing indicates that it is on a 1:1 scale. In order to validly integrate it, one would have to redraw it in rigorous perspective from the same viewpoint that rules over the bachelor space. The red steel spring and the matching cogwheels, seen from above, would appear in the form of ellipses, figures that Duchamp multiplied in the lower part of the machine. The large cogwheel would also have been elliptical if the boxing match had been introduced as seen at an angle like the chariot. The rams, replacing the grinder's bayonet in order to support the horizon, would have been equal to it in force and thickness instead of remaining reduced to a line. And the combat marble would resurrect from invisibility instead of remaining reduced to the mere outline of its trajectory. Moreover, for reasons of visual balance, it is probable that the large cogwheel would have had a diameter equivalent to those of the mill wheel, the flanks of the grinder, and the oculist charts. However, there is little chance that the boxing match, planned in 1913, could coexist with the oculist charts appearing around 1917–1918. Sublimation opened up another path. At the beginning, in 1913, the gas exploded in the barrel of a cannon. Later, in 1916, it ignited into a dazzled splash. But the Soigneur de gravité always* DANCED. *Duchamp's letter to Serge Stauffer of August 18, 1960, attests it: "The Oculist Witnesses are like a visual barrier between the end of the toboggan's operations and the Soigneur de gravité." In the schema above, the* curved foot of the juggler of centers of gravity, *belonging to the drawing of the boxing match and scaled to the size of the other feet belonging to figure 3.9, determines the scale of the boxing match as shown here.*

seems, the entire lower half of the bachelor apparatus. This is understandable. Otherwise, it would be too small an element alongside large apparatuses like the grinder. As it is given in *The Large Glass Completed,* of course this montage cannot work. But, if it is assembled according to a different scale (fig. 3.15), if its directions for use are applied word-for-word, it works. Or it can work. It is "possible."

CAROL JAMES

I have just a couple of questions about the nine shots. First of all, mechanically where do you place them? Could you clarify to which part of the itinerary they belong? And then, why do you think they are there—although they are the most invisible thing on the *Glass*—when many of the other elements are not there?

JEAN SUQUET (F)

Ah, the nine shots! I forgot to say in my presentation that to visual perspective, with its vanishing point piercing the horizon, Duchamp added a "perspective in duration." It is most probable that out of all the drawings that succeed each other as on a continuous path, certain ones were preferred over others. That of the nine shots is one of the most difficult drawings to explain. They represent, by "subsidized symmetry" [symétrie commanditée], as Duchamp said, the nine outlets through which the gas escapes from the heads of the nine malic molds. They are also symmetrical with respect to this intermediate passage: the gas clears the horizon through nine holes which are in the image of the nine molds. The nine holes drilled at the top of the *Large Glass* (not actually resulting from the impact of nine shots but of three times three shots) open, within its transparency, an even deeper transparency: the *Large Glass* is transparent, but when a hole is drilled in glass it is made even more transparent. Through these nine holes, the ignited splashes of gas, or their images, penetrate the Bride's domain, whether they reach her or not. These nine holes are located at the same place where the tabletop of the Soigneur de gravité would have been. Following the "perspective in duration," did Duchamp's idea of the Soigneur de gravité come before that of the nine holes? I don't believe so, because the nine holes are already represented in the one-to-ten-scale plan drawn out as early as 1913. From the very outset Duchamp envisioned the nine shots at the same time as the Soigneur, perhaps a little before.

THIERRY DE DUVE (F)

I can add something which reinforces this interpretation of the nine holes. I think, indeed, that the fact that there are not nine shots but rather three times three shots repeats or transposes, by subsidized symmetry, as you have stressed, the experience of the *Stoppages*. Don't forget that the "plane of sex," which cuts through the malic molds at the height of their sex, represents the projection, at this height, of the *Network of Stoppages* hovering in perspective over their heads. The *Network* was achieved by drawing three times each of the three *Standard Stoppages* with the help of rulers especially conceived to that effect. And so with the nine shots: Duchamp made them with a toy cannon and some matches. From three different angles he fired a match dipped in paint three times at the same target. But the target is not represented on the *Large Glass*, nor is it represented in the notes.

JEAN SUQUET (F)

Agreed.

THIERRY DE DUVE (F)

Because it subsists only as "a coefficient of displacement which is nothing but a souvenir," if I remember correctly.[2]

JEAN SUQUET (F)

That's it.

THIERRY DE DUVE (F)

I would like to pick up on what Francis Naumann pointed out very well this morning, namely, that Duchamp said, "one is unity, two is double, and three is the rest"—"a series," he said elsewhere. In other words, one's an individual, two's a couple, and three's a crowd. Now, in the first version of the nine malic molds there were eight.

JEAN SUQUET (F)

There were eight.

THIERRY DE DUVE (F)

So, I have the impression that there is a whole reflection going on about the indexation of the series or the crowd—possibly the crowd of potential viewers—by the couple. Ultimately there were two possible solutions: $2^3=8$ or $3^2=9$.

JEAN SUQUET (F)

Yes, that's right. You said that matches were fired from a cannon. And with what does one ignite gas? With matches. At the last stage of the illuminating gas's journey, when it touches the Bride (one of the matches does actually touch the Milky Way), a match becomes a star, a bit of light returning to the flood. When it is matches that one shoots at the target, and when the one who aims is an emanation of the illuminating gas, you don't need to be a great detective in order to conclude that these matches serve to set the gas on fire.

THIERRY DE DUVE (F)

To me that is the most materialist reading of the *Large Glass* but also the most utopian one, which shows that these things are not incompatible.

ANDRÉ GERVAIS (F)

In another note, published in 1980, Marcel Duchamp talks about the Bride's garment [le vêtement de la Mariée] as being a well-waxed plat-form ["une estrade encaustiquée"] where the Soigneur de gravité actually dances.[3] Can you comment on this?

JEAN SUQUET (F)

Yes, with a childhood memory. When I was about seven or eight, in 1935 or 1936, I saw such a fairground attraction in the small town of Gramat, in southern France. There was a platform, appropriately made of wood and well-waxed, under which tarpaulins hid the strongmen, the musclemen, who held it up. Now and then the men would kneel, making the platform tip, and then stand up again, lifting it up. The barker roared to the crowd: "Who wants to climb up there and try to remain standing?" There was always some big shot who rode the platform, holding his arms out like a tightrope walker, but who ultimately fell on his face amidst laughter. When I read Duchamp's note it reminded me of his statement to Schuster that he was inspired by a fairground stall.[4] Had he seen this attraction? I don't know. But I was not at all surprised that he called the place where the Soigneur de gravité dances a "platform."

ANDRÉ GERVAIS (F)

One last point, regarding the word "même." "Même," as it was men-tioned a while ago, is the repetition of the same syllable, which, read as

if it were English, says "me, me." It is a way to be reminded of Mar [Mariée] on the one hand and Cel [célibataires] on the other. In the 1964 interview with Otto Hahn, Duchamp said that "même" is just like "ha ha" in Alfred Jarry's *Gestes et opinions du docteur Faustroll, pataphysicien*.[5] In both cases there is a consonant and a vowel, a consonant and a vowel. It's a word that only designates what it says. But it can also be interpreted as Schwarz has: "m'aime" [loves me].

J E A N S U Q U E T (F)

Of course. But I am going to be very categorical. When Duchamp says that a word means nothing, that's not true, because while Duchamp mastered his brushes and his paintings, words mastered him. He played with words, but words played with him. The words were quicker [plus vites], they passed him by. For Duchamp words were not disincarnated signs. They were visceral, sanguine. "Même" isn't an adverb drawn by chance out of the hat of an illiterate. Duchamp chose it for all its innuendos of repetition, of return to the same. That it also means "m'aime," why not? But first it's "même."

A N D R É G E R V A I S (F)

One particularly sees that "même" can mean "m'aime" when considering the work METRO (or "aimer tes héros" [love your heroes]) of fifty years later. I think that now is the occasion to insist on the delay which gives a word as banal as "même" its overdetermination in the sense of Ricardou (or its poetic function in the sense of Jakobson). This is as intertextually essential inside Duchamp's work as is indetermination outside the work, which addresses the fact that a delay is constantly present between the author (or writer) and the viewer (or reader).

J E A N S U Q U E T (F)

Yes.

A N D R É G E R V A I S (F)

There is an incommensurable delay, with which one cannot catch up, a chasm more or less filled, so to speak, according to the times, the languages, and the theories utilized.

J E A N S U Q U E T (F)

Yes.

ANDRÉ GERVAIS (F)

There is as much internal overdetermination as there is external indetermination: in this sense, Duchamp will have only replotted, in an almost violent manner as the works accumulated, the notion of nonreconciliation.

JEAN SUQUET (F)

I don't agree. I would like to recall this note by Duchamp: "le tableau est impuissant . . . le langage peut." Words speak, I have confidence in them. There are two Duchamps: there's Duchamp who made *Etant donnés,* which I frankly detest, and there's Duchamp, still adolescent somehow, who made the *Large Glass* in great solitude, but in carnal contact with that which first expressed itself through words. This Duchamp isn't a totally negative creator. Of course, I'm not saying this against you, I'm reaffirming my will to have Duchamp say "yes," without neglecting the "no," without removing the bite from his erotic acid. It's fine to exhibit a urinal in a salon—in 1917. In 1987 who cares? Everybody's doing it. Therefore, I want to return to the yes-Duchamp, to the Sun-Lion who doesn't eclipse the Moon-Scorpion. He is double, he is tremendously ambiguous. He was always saying "no" in order to ward off those who would approach, except sometimes when, all the same, he would say "yes."

THIERRY DE DUVE

This brings us back, I guess, to the theme of opposition and reconciliation, and to whether there is such a thing. Maybe some people in the audience or at the table have ideas about this, or maybe they would like to ask Jean Suquet for more details from his demonstration of how the *Large Glass* functions.

ERIC CAMERON

I wonder if I can ask a different question about a different point, and that was your interpretation of the fourth dimension as time. I'm thinking of Linda Dalrymple Henderson's book in which she says that Einstein, whom you mentioned, certainly wasn't known much before 1919.[6] I'm thinking also of the diagrams illustrating the fourth dimension that Duchamp himself gives, which have to do with planes disappearing into lines and which all seem to be spatial. And also there's the fact that he

refers not only to the fourth dimension but also to "n" dimensions, which couldn't be reconciled on the basis of time. Finally, there's the fact that a lot of those things which represent movement occur in the lower section of the *Glass*, whereas it is the upper section that he refers to as time, so that the "delay in glass" therefore doesn't necessarily refer to the fourth dimension. I wonder if you could comment on that, please.

JEAN SUQUET (F)

It's difficult for me to talk about the fourth dimension because I'm not a mathematician. On the first point, Einstein before 1919: I believe that as early as 1909 Minkowski's space-time was popularized in magazines like *La Nature*. Did Duchamp read that? Did he read articles in 1911–1912 which referred to the theory of relativity? It's probably doubtful. On the other hand, a sure source for Duchamp was Jouffret's *Traité de géometrie en quatre dimensions*. In Jouffret the notion of time intervenes. One of the features that he attributes to the fourth dimension is that one can move into it thanks to a "traversée instantanée" [instantaneous traversal], an expression which Duchamp would borrow word for word. With Jarry, the intervention of time is even more evident: with marvelous humor, his Doctor Faustroll comments on H. G. Wells's *The Time Machine* by simply constructing the machine. With Bergson, there is yet another instance where time enters into the work. I agree that there's a purely spatial fourth dimension, and I surrender to the mathematicians. But in order to suggest this fourth dimension which is perpendicular to the three others, linear duration is a facility that Jouffret, Bergson, and Pawlowski have used—I leave Einstein aside because there I lack breadth of knowledge. Thus, I don't believe that it's a heresy to say: "the fourth dimension is time."

THIERRY DE DUVE (F)

Can I ask Craig Adcock if he has a comment about the world in four or in *n* dimensions?

CRAIG ADCOCK

I would just add a couple of points. It's difficult to determine how much relativity theory Duchamp could have known. I think Linda Henderson is probably right that he wouldn't have known much about Einstein, but I think he could have known something about the theory of relativity

through his reading of Poincaré. Almost all of Duchamp's *n*-dimensional notes and interpretations have to do with a spatial fourth dimension. But there are some particular notions like the "clock in profile," where you have something like a relativistic modification of a measuring device. Also, I think that the *instantané*—the idea of a frozen temporal moment, a slice or a cut in time—was also very important to Duchamp. This photographic metaphor, the momentary freezing of passing time, was critical to his method.

THIERRY DE DUVE

May I jump on this photographic metaphor to ask Rosalind if she cares to comment? Because you, Rosalind, have interpreted the instantaneous traversal, etc., as connected to photography.[7] Do you care to say anything about this?

ROSALIND KRAUSS

About what? About the fourth dimension?

THIERRY DE DUVE

"L'exposition extra-rapide," "l'apparence allégorique," and "le repos instantané." Suquet links them to the fourth dimension. You once linked them to snapshot photographs. Does this have anything to do with the interpretation of the fourth dimension as time? You may dismiss my question.

ROSALIND KRAUSS

Well, I've always been fascinated by this reconstruction Jean Suquet has made, which I've followed in his books. But there are certain aspects of the *Glass* which that reconstruction omits, interestingly enough. One of them is the idea Duchamp had of putting an emulsion over the top half of the *Glass* and of making it literally into a photographic plate. This, I think, doesn't figure in your discussion, Jean, but certainly reinforces the notion of the *instantané*, of the snapshot, of a photographic record of this orgasmic event. And another aspect missing from your reconstruction, another form of lens that Duchamp projected in the notes is the Wilson-Lincoln system. So, there are various optical devices that have aspects of impression rather than inscription, which Duchamp seemed to have indicated and which certainly raise the issue of photography and seem cru-

cially important to me. They don't necessarily open onto the issue of the fourth dimension, but . . .

JEAN SUQUET (F)

It's true. I didn't talk about the project of coating the top of the *Large Glass* with bromide and making a photographic impression there. I'm a photographer, and I would have to envision the thing from a technical, artisanal point of view, which is out of the question here. But you are right, there was an attempt to make a black and white photograph of the painting on canvas, *Mariée*, in order to reproduce it on the *Large Glass*. That was hardly possible with the methods of his time (and not even easy with ours). Your second objection was that I omitted certain parts of the *Large Glass*. That's true. I didn't talk about the prisms under the horizon, the Wilson-Lincoln system. Perhaps that was in order to move along more quickly or because they interfered with my demonstration. But what I especially avoided due to lack of time was the glass entitled *A regarder (l'autre côté du verre) d'un oeil, de près, pendant presque une heure* [*To Be Looked at (from the Other Side of the Glass) with One Eye, Close To, for Almost an Hour*] (fig. 8.8), which is situated at a place in the *Large Glass* that I left empty. I left it empty because it doesn't exactly fit within my journey, my will to travel.

THIERRY DE DUVE (F)

I'd like to know more about your envisioned transfer of the small glass *A regarder* to the *Large Glass*, and I'd also like to ask Rosalind if she wants to comment on what seems to me to be a new and very convincing interpretation of the *Oculist Witnesses*, where the illuminating gas is interpreted as the gaze itself. There, I use the allegorical bundle, which isn't that allegorical, of photons penetrating the eye, etc. So, I have two questions. Do you want to play ping-pong with them?

JEAN SUQUET (F)

I realized the integration of the small glass *A regarder* into the *Large Glass* photographically. The vanishing point of the *Large Glass* rigorously controls the vanishing lines of the small glass. Hence it's certain that Duchamp had thought of integrating it. I don't know what the pyramid floating in the air represents. That's why I didn't use it.

ROSALIND KRAUSS

And what about the Wilson-Lincoln system (fig. 3.16)?

JEAN SUQUET (F)

Ah, Wilson-Lincoln! Why should we cross the horizon between Wilson and Lincoln, this portrait which when seen from the left shows Wilson and from the right shows Lincoln? After all, they are the guardians of the Star Spangled Banner, and above them is the Milky Way; so the two guardians of the Star Spangled Banner become the guardians of the stars of the *Large Glass*. I venture this quick and easy explanation because I know you're gracious. I'm not proposing it as an interpretation that I feel viscerally. As to the bromide, it can easily be integrated into the operation. It doesn't matter that Duchamp reproduced the *Bride* at the top of the *Large Glass* by painting instead of projecting it onto a bromide emulsion; in any case he wanted it to resemble an "imitation of photography," a snapshot.[8]

ROSALIND KRAUSS

It's certainly possible to integrate it into this mechanism you have constructed. But what drops out, just as the Wilson-Lincoln prisms drop out, is the mirror surface of the oculist witnesses and the various surfaces of optical impression. That aspect of the material/optical existence of the *Glass* seems not to function—to be rendered irrelevant to a machine which, in your projection, works mechanically and linguistically but not optically. I guess what I'm saying is that there is another system we find evidence for, both in the notes for and in the realization of the *Glass*, which seems to exist alongside the one you're describing.

JEAN SUQUET (F)

I'm very surprised to hear it said to me that mechanically it functions, linguistically it functions, but optically it doesn't function. I have spent most of my time photographing, if not the *Large Glass*, which I've never seen, at least the manuscripts and drawings of the *Boxes*—since I made the reproductions which were used to illustrate *Duchamp du signe*, published by Flammarion. You say, "You've neglected the optical part of the Bride," and I reply, "I've been steeped in it for hours and hours, absorbed in the precise gestures of my trade." Is this still an evasion? When it's a matter of stripping bare, evasion goes without saying.

3.16
Note from the *Green Box*.

FRANCIS NAUMANN

This is the first time I have ever heard that Duchamp had intended the upper part of the *Glass* to be an emulsion. I know he wanted to project the image of the Bride photographically, but I had no idea that he wanted the whole thing prepared in the fashion of a photographic plate.

ROSALIND KRAUSS

He says it in the *Notes*. He said he wanted to coat it with emulsion.

FRANCIS NAUMANN

That's a surprise to me . . .

JEAN SUQUET (F)

No, it's not in the *Notes*.

HERBERT MOLDERINGS (F)

No.

FRANCIS NAUMANN

I've read the *Notes* carefully, and I've never noticed this. I'd just like to know where exactly it appears.

ROSALIND KRAUSS

I can show you.

JEAN SUQUET (F)

It's the Milky Way which should have been printed photographically. He didn't talk about it in the *Notes* but in the *Green Box*.[9]

FRANCIS NAUMANN

I had another question for Rosalind: How do you see the Wilson-Lincoln system as photographic?

ROSALIND KRAUSS

It's not photographic but, insofar as it's a system of prisms, it certainly works like a lens. It's part of an optical system of which photography is also a part.

THIERRY DE DUVE

I don't think so. I don't believe that.

FRANCIS NAUMANN

Neither do I, although it would have had to be created photographically, if it's what I think it is. The Wilson-Lincoln system is just a series of vertical, wedge-shaped slices inserted down the length of two portraits, one of Lincoln and the other of Wilson. When you look at it from one angle you see Wilson, and from the other you see Lincoln.

ROSALIND KRAUSS

It is a system through which he describes these drops passing not as material things but as images, a system of prisms which transform the drops into their image. He refers to the system "as in those portraits," but he projects it in the *Glass* as actual prisms. How do you think it is, Jean?

JEAN SUQUET (F)

In fact, this Wilson-Lincoln portrait is only an "example" suggested by Duchamp. The gas should pass through the horizon between a square

seen in a plan and a square seen in perspective, like, Duchamp said, those portraits which seen from one side show Lincoln and from the other Wilson. The splash which shoots up toward the sky should cross the horizon—the Bride's clothes—between a figure seen in a plan and the same figure seen in perspective: that is to say, between "le géométral" and "le perspectif," about which Jean Clair has often spoken.[10] Perspective is the quasi-carnal, material, and tactile appearance, whereas "le géométral" is the abstract, the plan seen through the mind's eye. Thus, the gas escapes the terrestrial world by passing through the Bride's veil between, on the one hand, sentient appearances, and, on the other, the mental scheme drawn from them.

ROSALIND KRAUSS

And he talks about a "miroirique" aspect. What is it?

THIERRY DE DUVE

Renvoi miroirique.

ROSALIND KRAUSS

You know, if we're going to take the diagrams you've shown us seriously, we can take that other diagram seriously. It's a system of the optical breaking-up of an image. We each have our own way of reading these neologistic words Duchamp throws at us, and I am content to hear everyone's interpretation. I just think we have to be careful about imposing it as the only reading, because these systems multiply in Duchamp, and they exist side by side quite frequently.

JEAN SUQUET (F)

I probably presented my way of seeing things too passionately, for you're making me into someone who wants to impose his views and who has come here in order to celebrate mass. It's because I have called the Soigneur de gravité a deus ex machina, isn't it? There have been two large Duchamp exhibitions. The first, in Philadelphia in 1973, assembled EVERYTHING by Duchamp, or so they said (in capitals); and the second, in Paris in 1977, strove to assemble "almost everything." I saw the list of the works sent to Philadelphia. The photograph of the *Autel du Soigneur de gravité* [*Alter of the Juggler of Gravity*] was to have been among those coming from France. It was not shown in Philadelphia. As

for the show at the Pompidou Center, when I saw Jean Clair I said to him: "I hope you're going to include the Soigneur de gravité." The Soigneur de gravité was not included. Yet this photo of the Soigneur de gravité, of the altar that Breton devoted to him at the 1947 Surrealist Exhibition, well and truly exists—I showed it to you a short while ago (fig. 3.12). Nobody speaks about it. So, I was forced to show my passion, crying out in turn that there were blind spots. No mention was made of the Soigneur de gravité, this deus ex machina, this phallus—it's the Lacanian phallus, that much is obvious. You tell me: "It's conspicuous by its absence, it exists because it's not talked about." Agreed! All the same, when all the data of the *Large Glass* are taken into account, there is contact between top and bottom, and it's the Soigneur de gravité who establishes it. Maybe there's Wilson, maybe there's Lincoln, they're the strongmen who wriggle under the platform. But above them is the Soigneur de gravité, he who dances without falling! There is my declaration of faith, formulated with passion. I can't help it, words speak for me.

HERBERT MOLDERINGS (F)

One question about the Soigneur de gravité in the 1947 Surrealist Exhibition. Wasn't it Matta who thought up the altar of the Soigneur de gravité: the white ball on the tipped table, the enlargement of *L'idée de la fabrication* [the Idea of the Fabrication], the flatiron, the fork, and all the rest?

JEAN SUQUET (F)

Matta didn't think it up. He constructed it, but under the direction of Duchamp. Absolutely. I heard that from Matta himself.

HERBERT MOLDERINGS (F)

Really?

JEAN SUQUET (F)

Oh yes. It was Duchamp who told him, "You'll do this, this, this, and this." And he did exactly what Duchamp said.

HERBERT MOLDERINGS (F)

That's strange. I talked to Matta some years ago and he told me that the combination of the stoppages, the "guéridon," and so on, was his own invention. That's interesting.

JEAN SUQUET (F)

Excuse me, but he told me . . . It's always very touchy intervening in a discussion where there is an inconsistency and quoting someone: "Matta told me" . . . "Duchamp told me," and so on. It's not fair to use hearsay as proof. The point can only be validly discussed with tangible proof or with testimonies that have been confirmed by others. I can't provide them. I simply want to insist that I saw Matta in 1973 and consulted him about the Soigneur de gravité altar, and that he told me it was Duchamp who told him to do this and that. I can't give you any proof other than my word. Then, Matta added: "I myself wanted to do something else. I wanted to set up a red salt prop upon which an alarm clock would have shook, but in the void, so that it wouldn't be heard. 'Roux' and 'sel' ['red' and 'salt'] would have made 'Roussel'. I wasn't able to do it because Duchamp wanted me to make the other one." That was my conversation with Matta. I'd like it better if he were among us and able to settle this, but I cite him as precisely as possible. In any case, even if it was Matta who conceived of the Soigneur de gravité altar, on his own or according to what Duchamp told him, it nevertheless remains that the Soigneur de gravité altar that he fabricated corresponds exactly to the Soigneur de gravité that Duchamp had drawn in his *Notes*, which Matta couldn't have known at the time. A round tabletop, a central leg, four feet. The Soigneur de gravité at the Surrealist Exhibition has four feet, just like it has four feet on Duchamp's sketch. The two images are not superimposable within a millimeter, but they both show a "guéridon."

HERBERT MOLDERINGS

One more question. The mechanism you have reconstructed functions perfectly; I admire it very much. But don't you think that during the ten years taken over the development of the erotical mechanism there was one major shift, around 1918, which resulted in the final incompleteness of the *Glass?* If one considers what Duchamp did besides the *Glass* between 1913 and 1917–1918, on the level of readymades, one can see that he was very much occupied with mechanics, gravity problems. But then, in 1918, he turned to a new technical-scientific system which was optics, in order to find a metaphor for the meeting of Bride and bachelors. In 1918 you have *A regarder*, in 1920 you have the *Oculist Witnesses,* and soon thereafter the optical machines. I believe that the whole

set of mechanical metaphors is disrupted by this new approach. It ceases to function and the *Glass* becomes more complicated because Duchamp throws out everything mechanical from the Bride's domain. Nothing mechanical is allowed there. Machines, engineering, mathematical measuring are all in the lower part, in the bachelors' domain. I think that when he introduced, instead of the juggler of gravity, the oculist charts and the Kodak lens as the transitional zone between the Bride and the bachelors, the thing opened up. So, however much I admire your machine, I am reminded of the "choice of possibilities" in the "Preface" of the *Green Box* (fig. 5.1). One possible reading of the notes has a large blank field between the Bride and the bachelors, which is still visible in the final picture.

J E A N S U Q U E T (F)

I perfectly agree with you. It's true that in 1918, perhaps even a little before, the way the machine ran slackened. After 1918 Duchamp took four or five years to complete the *Tableaux d'oculiste* [*Oculists' Charts*], whereas six years earlier it had taken him a mere few months to execute the chocolate grinder on the *Large Glass*. Hence, time slowed down and it all ended up in the incompletion of the *Large Glass*. I grant you that I've deduced the machine I've described and the road I've followed from the notes of 1912–1913. And I agree that as soon as I run up against the later figures that Rosalind Krauss has called to our attention, things such as the Wilson-Lincoln system, or especially *A regarder* . . . , it doesn't run as well. But I haven't kept silent about them because of a desire to fake my demonstration. I've taken Duchamp at his word and gone back to the source of his emotion, the verbal source. And so the machine I've made run is related to the *Bride* of 1912, 1913, and 1914. Thereafter— understand me well—everything is thrown out of gear, begins to break down and continues to break down until this "cochonnerie" which is *Etant donnés*.

H E R B E R T M O L D E R I N G S

I think that that "cochonnerie" exactly starts in this optical, in this new point of . . .

J E A N S U Q U E T (F)

All the same, I'm going to justify the word "cochonnerie" that I just

used. You interpreted it very well, as I meant it. Quite simply, the headless doll in Philadelphia is bagged in a pig's skin. That's it. I've justified my statement. It's a visceral affair for me to make the machine run. If it doesn't run, I don't want to know about it.

THIERRY DE DUVE

"But it does move."

1 Jean Suquet is here referring to the forty-page draft of what would become, twenty-five years later, *Miroir de la mariée,* which he sent to Duchamp on December 19, 1949. Duchamp's response came in a letter dated December 25, 1949, which ended with this sentence: "Après tout, je vous dois la fière chandelle d'avoir mis à nu ma mise à nu." ["After all, I really owe it to you to have stripped bare my stripping bare."].

2 *Salt Seller,* 35. The translation of "cote de distance" by "coefficient of displacement" is poor, to say the least. "Distance mark" would be better but would still fail to convey the very precise meaning of the French "cote," which is the notation of the dimensions of an object on a sketch or a plan, as in a "croquis coté."

3 *Notes,* notes 151 verso and 152.

4 Jean Schuster, "Marcel Duchamp, vite," *Le Surréalisme, même,* 2 (Paris, 1957).

5 Otto Hahn, [interview with] "Marcel Duchamp," *L'Express,* 684 (Paris, July 1964).

6 Linda Darlymple Henderson, *The Fourth Dimension and Non-Euclidian Geometry in Modern Art* (Princeton: Princeton University Press, 1983).

7 Rosalind Krauss, "Notes on the Index," *October,* 3 (Spring 1977).

8 *Notes,* note 147.

9 Referring to the *Milky Way* or *Top Inscription,* Duchamp wrote: "Representation of this inscription: Photographic method." And he added: "With the negative of the enlargement: have prepared with silver bromide—the large plate glass and make a print, directly on the back (ask a photographer for information)." *Salt Seller,* 38.

10 Jean Clair, "Marcel Duchamp et la tradition des perspecteurs," *Abécédaire,* 124–159.

Marcel Duchamp's Fountain: Aesthetic Object, Icon, or Anti-Art?

Duchamp's *Fountain* (fig. 4.1) has become one of the most famous/infamous objects in the history of modern art. The literature on it—counting references imbedded in broader considerations of Duchamp's work—is staggering in quantity, and one might suppose that little more of consequence could be discovered. However, an examination of this literature reveals that our knowledge of this readymade and its history is riddled with gaps and extraordinary conflicts of memory, interpretation, and criticism. We are not even able to consult the object itself, since it disappeared early on, and we have no idea what happened to it. Duchamp said Walter Arensberg purchased *Fountain* and later lost it. Clark Marlor, author of recent publications on the Society of Independent Artists, claims it was broken by William Glackens.[1] Others reported it as hidden or stolen. We do not even know with absolute certainty that Duchamp was the artist—he himself once attributed it to a female friend—and some of Duchamp's comments raise fundamental questions regarding his intentions in this readymade. But most critics have not been troubled by these conflicting comments from Duchamp or by the lacunae in our knowledge. Some deny that *Fountain* is art but believe it is significant for the history of art and aesthetics. Others accept it grudgingly as art but deny that it is significant. To complete the circle, some insist *Fountain* is neither art nor an object of historical consequence, while a few assert that *Fountain* is both art and significant—though for utterly incompatible reasons.

Those who perceive *Fountain* as anti-art or as an object of aesthetic indifference overwhelm all others in number, and they base their view on statements by Duchamp himself. However, their views represent a *selective* reading of Duchamp's statements—statements, moreover, made in the 1960s, forty-five to fifty years after he first presented *Fountain*. I propose to return to the beginning, to study *Fountain* in the original context of 1917, and then to reconsider the history of its critical reception.

When I first encountered *Fountain* as a college student, I do not remember how it was presented to me or how I responded to it. But I do know that I

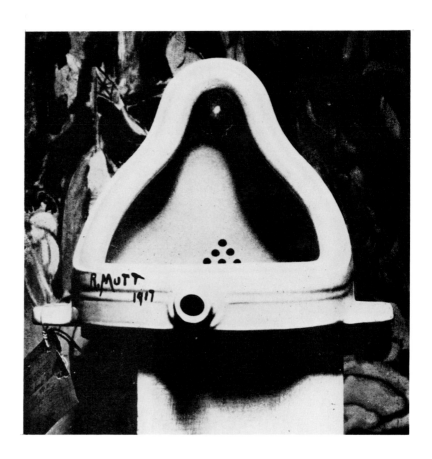

4.1
Fountain, readymade, 1917 (lost). Origi-
nal 1917 photograph by Alfred Stieglitz,
silver gelatin print, 9⅝₁₆ × 7 in.

did not really look at it or think about it critically until the mid-1960s when I began to teach the history of modern art. Within a couple of years I became convinced that *Fountain* was a masterpiece—that the object was of intrinsic importance in itself, that it was representative of its culture, expressive of Duchamp, and so characteristic of his work that he could not have made from scratch anything more effective than this readymade object.

Fountain was a product of Duchamp's first sojourn in New York (1915–1918) and the organization of the American Society of Independent Artists established there in 1917. Duchamp settled in New York in 1915, a refugee from the depressing wartime condition of Paris. Owing to his notorious *Nude Descending a Staircase* (1912) exhibited at the Armory Show in 1913, he arrived with a readymade aura. Given his rapid progress in English, his intelligence, charm, and good looks, he was soon a person of consequence on the art scene. He developed an important friendship with Walter and Louise Arensberg, who hosted the most stimulating intellectual salon of the city, and he was also close to several young French and American artists and writers, among them Man Ray, Charles Demuth, the actress Beatrice Wood, Henri-Pierre Roché, Francis Picabia, and Jean Crotti.

Duchamp's apartment/studio became a gathering place of some curiosity for them—sparsely and eccentrically furnished with a few pieces of furniture, several readymades, and sections of the *Large Glass* reclining against the wall or resting on sawhorses.

Two readymades frequently visible in photographs of his apartment were the *Bicycle Wheel* and *Trap*. The latter was a coat hanger, appropriated in New York during 1917, nailed to the floor and literally transformed by Duchamp's mind and maneuver from a coat hanger into a trap. The *Bicycle Wheel*—actually the fork and front wheel of a bicycle mounted upside down on a wooden stool—was a work produced in 1915 to replace the first version of the *Bicycle Wheel* made during 1913 but left behind in Paris.

Duchamp adopted the English word "readymade" for such objects while he was in New York, and he also exhibited them there as sculpture for the first time. Two readymades were included in an exhibition at the Bourgeois Gallery in 1916, although they passed almost unnoticed.[2] *Fountain* was to be the first readymade that engaged public attention.

Fountain entered the history of art in April 1917 on the occasion of the first exhibition of the American Society of Independent Artists.[3] That Society—like its French model—was to be a liberal, democratic society open to all artists.[4] It aimed to present to the American public—via large annual exhibitions—the status of art in America without the intervention of a jury or any sort of screening process. *Anyone* could join for $6 ($1 initiation fee and annual dues of $5). That automatically assured each member the exhibition of two works. In principle and in practice the Society of Independent Artists was to be the epitome of democracy, and it was so publicized. Shortly before the opening exhibition on April 9, 1917, the organizers advertised over 2,500 items by 1,200 artists stretching over two miles of panels.[5]

Duchamp had become a founding member of the Society of Independent Artists, and he was to render that Society a variety of services. He became a member of the Board of Directors and chairman of the hanging committee. In collaboration with Roché and Beatrice Wood, he also planned a magazine, *The Blindman*, to record the critical and public response to the exhibition, and, finally, he undertook a testing of the fundamental principles of the Society. Duchamp had already experienced the failure of the French Society of Independent Artists to live up to its principles when, in 1912, some Cubist friends asked him to withdraw his *Nude Descending a Staircase*.[6] In 1917 he seems to have decided to test the mettle of the American Independents.

During a conversation with Arturo Schwarz in the 1960s, Duchamp said that the idea for *Fountain* came up in a conversation with Arensberg and the American artist Joseph Stella not long before the opening of the Independents' exhibition.[7] They went immediately to look for an object, and according to Duchamp, he chose a urinal from the showroom of the J. L. Mott Iron Works, a major manufacturer of bathroom fixtures. Mott's plant was in New Jersey, but there were showrooms from coast to coast including a major one in New York.[8] The urinal did not hang around Duchamp's apartment long, but there are photographs showing it doing exactly that (fig. 4.2). Before this urinal appeared at the Independents, however, some changes were made.

Duchamp rotated the urinal 90 degrees from its men's-room position, inscribed it "R. Mutt," and provided it the title *Fountain*. To my knowledge he never explained the 90-degree rotation or the title, but he did comment much later on the inscription "R. Mutt." "Mutt," he says, came from Mott, but to use "Mott was too close so I altered it to Mutt, after the daily strip cartoon 'Mutt and Jeff' which appeared at the time. . . . And I added Richard [French slang for money-bags]. . . . Get it? The opposite of poverty. But not even that much, just R. MUTT."[9]

According to contemporary newspaper reports, the forms that accompanied *Fountain* identified Mutt as an artist from Philadelphia. Duchamp was never asked to explain his use of a fictitious name, but he stated later that he did not wish to compromise his test of the Independents' principles by revealing that *Fountain* had been submitted by a member of the Board of Directors.[10]

Duchamp's friend Beatrice Wood has provided a recollection of what happened next.

Two days before the Exhibition opened, there was a glistening white object in the storeroom getting readied to be put on the floor. I can remember Walter Arensberg and George Bellows standing in front of it, arguing. Bellows was facing Walter, his body on a menacing slant, his fists doubled, striking at the air in anger. Out of curiosity, I approached.

"We cannot exhibit it," Bellows said hotly, taking out a handkerchief and wiping his forehead.

"We cannot refuse it, the entrance fee has been paid," gently answered Walter.

"It is indecent!" roared Bellows.

"That depends upon the point of view," added Walter, suppressing a grin.

"Someone must have sent it as a joke. It is signed R. Mutt; sounds fishy to me," grumbled Bellows with disgust. Walter approached the object in question and touched its glossy surface. Then with the dignity of a don addressing men at Harvard, he expounded: "A lovely form has been revealed, freed from its functional purpose, therefore a man clearly has made an aesthetic contribution." . . .

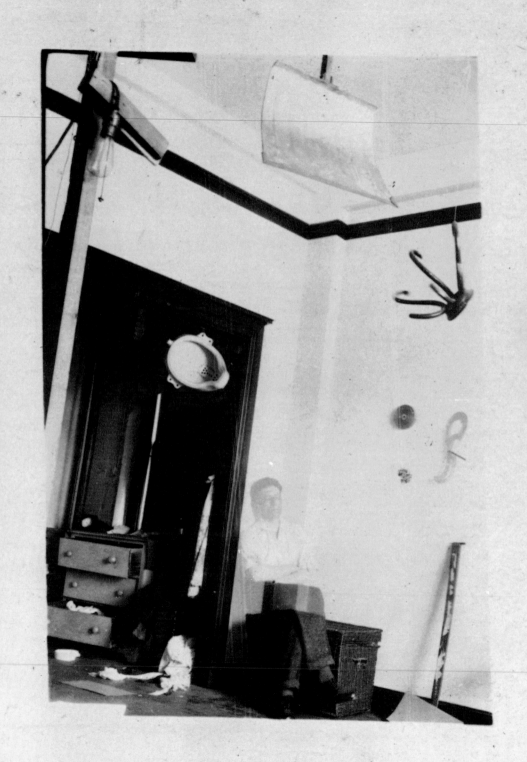

4.2
Duchamp's studio at 33 W. 67th St., New York, 1917–1918. Photographer unknown. (Philadelphia Museum of Art; private collection.)

"It is gross, offensive! There is such a thing as decency."

"Only in the eye of the beholder. You forget our bylaws."[11]

Arensberg's argument did not prevail. A meeting was called of all the directors who could be quickly assembled, and, after a heated debate that continued almost to the opening hour, *Fountain* was excluded from the exhibition by a close vote.[12] As reported in the press, the directors claimed Mutt's sculpture was not art and, moreover, it was indecent. Duchamp resigned immediately. Regrettably, no official records of this episode remain following a fire in the Society's offices around 1930.[13]

The *Fountain* disappeared temporarily—evidently concealed behind a panel—and the opening occurred on schedule with rousing success save for the much-publicized breach of principles and Duchamp's resignation. The astonishing feature of all the publicity was the fact that *Fountain* was never reproduced in the press and never described as anything except a "bathroom fixture." Accordingly, only a handful of people had actually seen the object and fewer still knew who had really made *Fountain*. Duchamp concealed his identity as Mutt throughout the duration of the exhibition. Indeed, so determined was he to maintain his anonymity as the artist that he lied to his sister Suzanne when he wrote her in Paris one day after the opening:

One of my female friends under a masculine pseudonym, Richard Mutt, sent in a porcelain urinal [to the Independents] as a sculpture; it was not at all indecent—no reason for refusing it. The committee has decided to refuse to show this thing. I have handed in my resignation.[14]

At least I think this was a "white lie" to conceal his authorship, but two other possibilities should be considered. We might have a forerunner of Duchamp's female alter ego, Rrose Sélavy, who appeared in 1920. He had his friend Man Ray photograph him in drag as Rrose (alias Marcel Duchamp), and some of his works were signed by Rrose. Although one might take this as an act on the level of a college fraternity prank, the ambivalence and reversibility of male/female forms, functions, and identities was a matter of profound importance for Duchamp. The second possibility is that *Fountain* really was sent to the Independents by a female friend of Duchamp's. But he did not say she *made* it, only that she *sent* it.

Might she have acted only as a shipping agent to provide additional cover for Duchamp, and, if so, who was she? Press accounts referred to Mutt as a Philadelphian, but so far no female from Philadelphia has been identified and no documents have been found that would implicate Duchamp's two male friends from Philadelphia, Morton Schamberg and Charles Sheeler. However, a female friend in New York was implicated by another of Duchamp's American artist friends, Charles Demuth. Demuth wrote to Henry McBride—normally a sympathetic critic of modern art—about the rejected *Fountain*, urging McBride to pursue the topic and indicating that more information could be obtained either through Duchamp or Richard Mutte [sic] at telephone number 9255 Schuyler.[15] That was the number of Louise [McC.] Norton, estranged wife of the publisher of an avant-garde journal and a close friend of Duchamp, who is further implicated by the tag attached to *Fountain* (fig. 4.1)—legible only since the recent discovery of the original photograph—that bears her address at 110 West 88th Street.[16] Letters and conversations with Mrs. Norton (later Mme Edgar Varèse) have yielded no additional information, but I submit that the tag on *Fountain* and this reference to her as Richard Mutte indicates she was a member of Duchamp's inner circle who knew all about *Fountain*. This merits attention because much of the contemporary information *published* on *Fountain* occurs in an article by Louise Norton.

That article appeared in the second and last issue of *The Blind Man*, in May 1917, an issue devoted to the suppression of *Fountain* at the Independents. It was only then—one month after the opening of the Independents—that one could see that *Fountain*, the piece of "bathroom furniture," was a urinal. There, too, alongside the photograph of *Fountain* by the distinguished photographer Alfred Stieglitz, were two articles that constitute the critical statements of the day—an editorial entitled "The Richard Mutt Case" and Louise Norton's article on "The Buddha of the Bathroom." Among the many interesting observations in her article, I wish to underscore one related to that curious title, "Buddha of the Bathroom": "to any 'innocent' eye how pleasant is its chaste simplicity of line and color! Someone said, 'Like a lovely Buddha.' "[17]

Among the many accounts of *Fountain*, no comments have been more neglected than this reference to a simple, chaste form "like a lovely Buddha." But recall that Beatrice Wood had attributed to Arensberg (in

his argument with Bellows) comments about a "lovely form," and as one explores private correspondence during April 1917, such comments on the aesthetic and anthropomorphic properties of *Fountain* emerge as the rule, not the exception.

To this day some accounts of the Independents' exhibition claim that *Fountain* was stolen, smashed, or lost forever before the opening, but we know it was only concealed and found a few days later by Duchamp, possibly in the company of Man Ray. According to Beatrice Wood, Duchamp suggested they carry *Fountain* to Stieglitz's studio, and after Duchamp and Stieglitz talked for some time, Stieglitz agreed to photograph it "to fight bigotry in America. He took great pains with the lighting, and did it with such skill that a shadow fell across the urinal suggesting a veil. The piece was renamed: 'Madonna of the Bathroom.' "[18]

We now have two references to *Fountain* as an anthropomorphic form— one as a Buddha; one as a Madonna.

In a letter to Gertrude Stein, the writer and music critic Carl Van Vechten affirmed both associations:

This porcelain tribute was bought cold in some plumber shop (where it awaited the call to join some bath room trinity) and sent in. . . . When it was rejected Marcel Duchamp at once resigned from the board. Stieglitz is exhibiting the object at "291" and he has made some wonderful photographs of it. The photographs make it look like anything from a Madonna to a Buddha.[19]

Stieglitz himself verified these anthropomorphic and aesthetic views in a letter to Georgia O'Keefe in which he remarked about the "*fine lines* of the urinal" and his photograph which suggested a "buddha form."[20]

For over fifty years hardly anyone paid the slightest attention to these comments about pleasing aesthetics and anthropomorphic references in *Fountain*. In the wake of Dada, attitudes expressed in those private letters became as inaccessible as the letters themselves, while published references of this sort were given no credibility whatsoever. In the context of 1917, however, it becomes impossible to ignore the positive and anthropomorphic perceptions of *Fountain* by so many of Duchamp's friends. And, indeed, a comparison of *Fountain* with selected images of both seated

Buddhas and half-length Madonnas reveals striking parallels in their simple, frontal, iconic forms with broad bases and narrower tops contained within a simple, flowing contour (figs. 4.3 and 4.4).

These anthropomorphic forms were highlighted by a previously unpublished photograph that turned up in the Arensberg files during research for this paper (fig. 4.5). It is the same Stieglitz photograph but cropped so that a Madonna- or Buddha-like form is made more emphatic by elimination of the base.[21]

Stieglitz's letter to Georgia O'Keeffe also provided another fascinating bit of information. For years Duchamp scholars have wondered what was in the background of Stieglitz's photograph of *Fountain*. Stieglitz wrote that he photographed *Fountain* in front of a painting by Marsden Hartley. That painting turns out to have been a work of 1913 called *The Warriors* (fig. 4.6).[22] The similarity between *Fountain* and the simple, iconic form at the center of Hartley's painting is too obvious to be coincidental. Indeed, Hartley even employed a similar form as a frame for a seated Buddha in his 1913 *Portrait of Berlin*, and I am also tempted to see the theme of *The Warriors* as relevant to *Fountain*, that is, mounted warriors headed off to battle as a reference to battles Duchamp and Stieglitz were waging against bigoted, conservative forces in American art.

In these references to Madonna- and Buddha-like forms, I wish to underscore that we are dealing with aesthetics. I am using the term aesthetics both with its connotation of beauty and pleasure *and* in a broader sense of visual properties whether or not they are perceived as beautiful. But without exception in this circle of friends around Duchamp, visual properties counted. A year earlier, Duchamp's studio companion Jean Crotti had astounded a newspaper reporter by describing Duchamp's snow shovel readymade (*In Advance of the Broken Arm*) as "the most beautiful object I have ever seen."[23] Years later Duchamp's close friend Roché looked back at 1917 and claimed that Duchamp was saying in the urinal that "Beauty is around you wherever you choose to discover it."[24]

Up to this point I have focused on less known, private comments on *Fountain*, but perhaps the most important commentary is the widely publicized account of "The Richard Mutt Case" published in *The Blind Man*.[25]

4.3
Amida Nyorai, Amida Triad in East Section of Dempodo, ca. AD 740–760. (Collection of Horyuji Temple, Nara, Japan.)

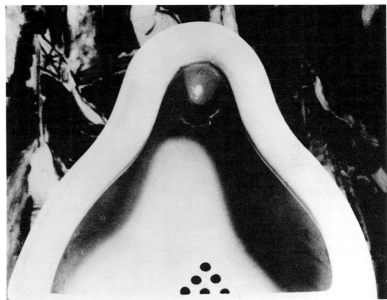

4.4
Pimen, *The Virgin of Pimen*, ca. 1380.
(Tretyakov Gallery, Moscow.)

4.5
Photograph of *Fountain* (cropped). Origi-
nal 1917 photograph by Alfred Stieglitz,
4¼ × 7 in. (Philadelpia Museum of Art;
The Louise and Walter Arensberg
Collection.)

4.6
Marsden Hartley, *The Warriors*, 1913. Oil
on canvas, 47¾ × 47½ in. With overlay
showing placement of *Fountain* in Stieg-
litz's photograph. (The Regis Collection,
Minneapolis.)

It merits quotation in full:

The Richard Mutt Case

They say any artist paying six dollars may exhibit.

Mr. Richard Mutt sent in a fountain. Without discussion this article disappeared and never was exhibited.

What were the grounds for refusing Mr. Mutt's fountain:—

1 *Some contended it was immoral, vulgar.*

2 *Others, it was plagiarism, a plain piece of plumbing.*

Now Mr. Mutt's fountain is not immoral, that is absurd, no more than a bath tub is immoral. It is a fixture that you see every day in plumbers' show windows.

Whether Mr. Mutt with his own hands made the fountain or not has no importance. He CHOSE it. He took an ordinary article of life, placed it so that its useful significance disappeared under the new title and point of view—created a new thought for that object.

As for plumbing, that is absurd. The only works of art America has given are her plumbing and her bridges.

The authorship of this editorial is not precisely known, but it was probably written by Beatrice Wood with the assistance and approval of Duchamp and Roché—and it speaks clearly to the issues.[26]

I wish to explore further the elements of choice and transformation raised in "The Case of Richard Mutt." Photographs of the J. L. Mott showroom (fig. 4.7) indicate that Duchamp had to make a selection when he went there, because the showroom would have been filled with an assortment of fixtures, including real fountains and a variety of urinals. Mott catalogues are scarce, but examples from 1902, 1908, 1912, 1914, and 1918 reproduce scores of urinals, among which only two seem to offer a profile similar to the model used for *Fountain* (figs. 4.8 and 4.9). The Mott catalogues and trade publications indicate that the perception of anthropomorphic forms in machines and manufactured objects wasn't peculiar to Duchamp's circle of friends. The manufacturers and advertisers did their own anthropomorphizing, as is evident in reproductions of Goulds

4.7
J. L. Mott Iron Works, New York City
showroom, 1914.

4.8
Heavy Vitro-adamant Urinal 839-Y. From
the J. L. Mott Iron Works, *Marine Depart-
ment Catalogue "Y"*, volume II (New
York, 1902).

4.9
Porcelain Lipped Urinal, Panama model.
From the J. L. Mott Iron Works, *Mott's
Plumbing Fixtures Catalogue "A"* (New
York, 1908). Courtesy Henry Francis du
Pont Winterthur Museum Library; Col-
lection of Printed Books.

4.10
J. L. Mott Iron Works, Shower, 1912.

Pumps (1917) and Speakman Showers (1909), both carried by the J. L. Mott Company (figs. 4.10 and 4.11). The perception of machines in the image of man was "in the air" during that early stage of what Reyner Banham and Sigfried Giedion have called "The Machine Age."[27]

So much for Duchamp's exercise of choice. How about his transformation of readymade objects? Comparing *Fountain* with ordinary, functioning urinals (fig. 4.1 versus figs. 4.8 and 4.9) makes evident what he has done visually and conceptually. He has removed "an ordinary article of life" from the context in which one normally encounters it—a men's room or plumbing shop—and placed it in a new "art context," with a new title or identity and a new physical point of view, namely rotated 90 degrees and placed on a pedestal near our eye level. And the transformation is profoundly imbued with the ironic spirit of Duchamp. *Fountain* is an inanimate, machine-made product, yet it appears to be a living form that quietly exudes sexuality. A masculine association cannot be escaped because the original identity of the urinal remains evident, yet the over-riding image is that of a generic female form—a smooth, rounded, organic shape with flowing curves. Ironic dualities continue as a hard, chilly surface belies the sensuousness of the form; as a receptacle for waste fluid is renamed as a dispenser of life-giving water; as an object associated with "dirty" biological needs comes to bear association with the serene, spiritual forms of a seated Buddha or a chaste, veiled Madonna.

These elements of mechanomorphic forms, sexuality, and irony are familiar to us in Duchamp's work. They are the basis of the *Large Glass*. Moreover, *Fountain* was not the first time a urinal had figured in Duchamp's thought. Three years earlier, in a note from 1914, he wrote: "one only has: for 'female' the public urinal and one 'lives' by it."[28] I do not know exactly what Duchamp meant by that, but it involves the association of a female form and/or function with a male object and the male injection of fluid into a uterine shape. Furthermore, as early as 1911 Duchamp also produced a seated Buddha-like figure in a painting entitled *Draft on the Japanese Apple Tree*.

The selection of *Fountain* seems less and less the product of an impulsive desire merely to goad or challenge the Independents. Of course Duchamp relished the opportunity to provoke the Independents. Surely

he would have been surprised and disappointed had *Fountain* been accepted without comment and exhibited without creating a furor. But it seems evident that *Fountain* was more than a simple affront to the Independents. It was an integral part of his work, including other readymades as well as the *Large Glass*.

One event that must have contributed to Duchamp's concept of readymades was his visit to the 1912 Salon de la Locomotion Aérienne in the company of Léger and Brancusi. Léger later recalled that Duchamp "wandered amidst engines and propellers, keeping silent. Then all of a sudden he addressed Brancusi: 'Painting is over. Who'd do better than this propeller? Tell me, could you do that?' "[29]

Within a year Duchamp did, in fact, almost cease to paint, turning instead to studies for the *Large Glass* and to his first readymades. The early readymades selected in Paris, for example the *Bicycle Wheel* (fig. 4.12) and the *Bottle Dryer*, did not possess the sleek lines of airplane propellers, but neither of these two examples appears to have been motivated by visual indifference or anti-art.

In Duchamp's earliest known reference to these two objects, he calls them simply "sculpture already made."[30] Duchamp's later comments on the *Bicycle Wheel* vary from interview to interview, but none sustain an anti-art argument. To the contrary, he told Arturo Schwarz:

It had more to do with the idea of chance. In a way, it was simply letting things go by themselves . . . to help your ideas come out of your head. To see that wheel turning was very soothing, very comforting, a sort of opening of avenues on other things than material life of every day. . . . I enjoyed looking at it, just as I enjoy looking at the flames dancing in a fireplace.[31]

Schwarz also elicited from Duchamp the acknowledgment that "the wheel must have had a great influence on my mind, because I used it almost all the time from then on, not only there, but also in the *Chocolate Grinder*, and later on in the *Rotoreliefs*."[32] Still more links to Duchamp's oeuvre have been suggested by other authors,[33] and to all those views I wish to add that the *Bicycle Wheel*—consciously or not—is effective from a visual or aesthetic perspective. Though composed of two distinct parts (the bicycle wheel and the stool), it exists as a well-proportioned whole, human in its

4.11
J. L. Mott Iron Works, Goulds Force Pump, 1918.

4.12
Roue de bicyclette [*Bicycle Wheel*], 1951.
Assisted readymade. Third version after
lost original of 1913, 50½ in. high. (The
Museum of Modern Art, New York; The
Sidney and Harriet Janis Collection.)

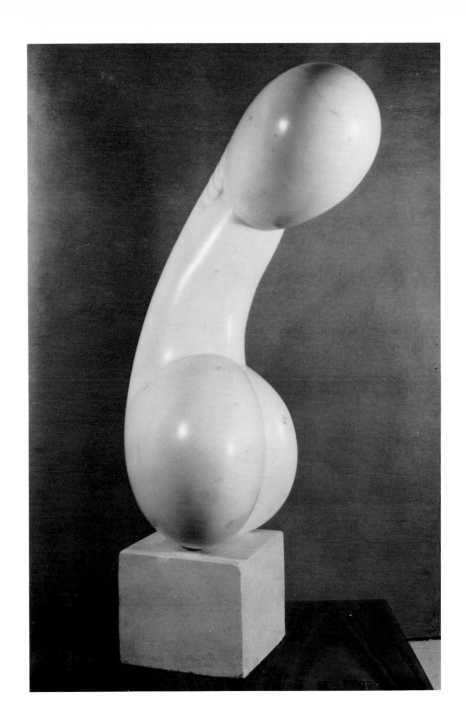

4.13
Constantin Brancusi, *Princess X*, 1916.
Marble. (Sheldon Memorial Art Gallery,
University of Nebraska, Lincoln; gift of
Mrs. A. B. Sheldon.)

scale and uprightness and Brancusi-like in the dialogue between "base" and "object," which share such features as light, taut, open constructions based on circles and spokes. Could it have been merely by chance, convenience, or practicality that Duchamp selected such a stool for the "base" of the *Bicycle Wheel*? Can any more appropriate "base" be conceived for it—whether designed by the artist or selected from the world of tables, chairs, benches, and what not?

Having mentioned Brancusi, I wish to propose that he might be more involved in all of this. An exhibition of his sculpture was held at the Modern Gallery in New York in the fall of 1916 that included two versions of *Princess X*, one in marble (fig. 4.13) and another in brass. Both were purchased by friends of Duchamp—the brass version by Arensberg; the marble one by the lawyer and art collector John Quinn. Arensberg's version was also shown at the 1917 Independents show.[34] Accordingly, Duchamp was surely familiar with both sculptures. Brancusi's sensuous abstraction of the *Princess* into a featureless face, long curving neck and full-rounded breasts was too abstract for most critics, although one was offended by the artist's sly incorporation of a phallic form:

We are not of the class that favors drapery for the legs of the piano stool, but phallic symbols under the guise of portraiture should not be permitted in any public exhibition hall, jury or no jury. . . . America likes and demands a clean art.[35]

It is most unlikely that Duchamp missed the female/male fusion of forms in Brancusi's *Princess X*. Indeed the affinities between these works is sufficient to raise the possibility that *Princess X* contributed to the conception of *Fountain*.

Yet another artist must be considered as having possibly contributed something to *Fountain*, namely Alfred Stieglitz. Our visual image of the original *Fountain* is based on his photograph. To what extent did he control the photograph—hence our image of *Fountain*—and to what extent did Duchamp? Curiously, no negative or print has ever been found in the Stieglitz estate, and *Fountain* has not figured in publications on Stieglitz—while it always appears in publications on Duchamp. I think we have come to think of this photograph as Duchamp's work, not Stieglitz's. And surely Duchamp had a role in it. He asked Stieglitz to do it and talked to him a

long time about it. Also the Buddha-Madonna references seem to have been part of the experience of those around Duchamp before he went to see Stieglitz. Yet in the final analysis it remains a superb Stieglitz photograph. It was probably Stieglitz who elected to place *Fountain* in front of a Marsden Hartley painting with fortuitous visual and intellectual links to Duchamp's readymade. It also seems likely that Stieglitz chose to place *Fountain* exactly at our eye level, bringing it close, magnifying its presence, rotating it slightly on axis to set up just a touch of tension, and lighting it from above so that it is dramatically isolated against its setting yet also softly veiled, moody and mysterious. Moreover, through his friendship with Picabia, Stieglitz was familiar with the symbolic use of common manufactured items in art, and during that very spring of 1917 he was championing a young photographer, Paul Strand, whose dramatic close-up photographs of common objects were to make a substantial impression on Stieglitz and on photography in America. It is generally believed that Picabia and Duchamp were instrumental in the development of Strand's vision, but much is still unknown about the interchange of Duchamp, Picabia, Stieglitz, and Strand, and I suspect that Stieglitz's photo of the *Fountain* will prove to be a significant piece to that puzzle whenever it is worked out.

The impact of Duchamp's readymades, machine forms, and machine aesthetic was too extensive to survey here, but in addition to a role they had in stimulating Strand's photography, Duchamp's readymades provided the stimulus for Man Ray's objects and for such singular constructions as the assemblage entitled *God* by Morton Schamberg and the Baroness Elsa Freytag von Loringhoven.[36] It is remarkable, however, that the furor *Fountain* ignited in April 1917 vanished almost as suddenly as it had erupted. Though *Fountain* was supposedly purchased by Arensberg, there is no witness that it was ever on exhibit in his apartment, and, to date, I have not found a single reference to it in the archives of the Arensbergs or anyone else linked to this affair![37] I do not know how to account for this surprising silence. In the public realm we know that America was preoccupied with mobilization for entry into the war. And there was the matter of prudery. But how to account for that silence in the private realm of Duchamp's friends?

So far as is known, *Fountain* was never exhibited and eventually lost, perhaps around the time of the Arensbergs' permanent move from New

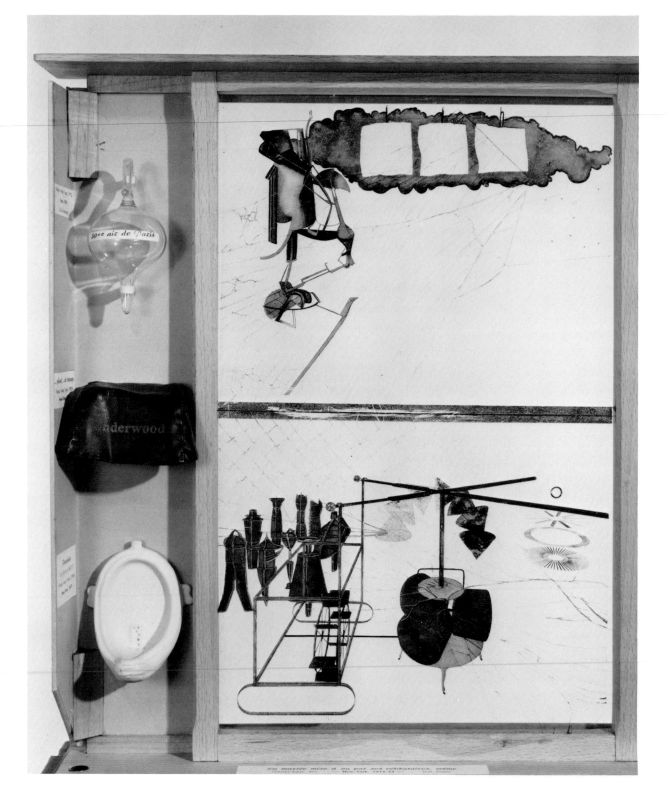

4.14
Centerpiece detail of *Box-in-a-Valise* (fig. 7.1), 1961 version; initial version, 1936–1941.

York to Hollywood in 1923.[38] Moreover, *Fountain* was rarely mentioned in the 1920s and 1930s, and, to my knowledge, was not even reproduced again until the Duchamp issue of *View* in 1945—28 years after the Independents controversy![39]

This remarkable silence precluded any substantial debate over the issues *Fountain* had raised. That debate came instead in the 1960s, and it has been lively from then to now. In the final section of this paper, I will deal with that debate, pausing first to consider later versions and replicas of *Fountain*. The Stieglitz image we have been looking at continued to be a primary document for *Fountain*, but the later versions have influenced our perception and our thinking.

Duchamp initiated the first of the later versions of *Fountain* in a miniature form for his *Box-in-a-Valise* (1936–1941) (figs. 4.14 and 4.15), literally a valise containing a box filled with photographs, color reproductions, and miniatures of sixty-nine of his favorite works—a veritable portable museum.[40] *Fountain* appears there, mounted right-side-up in a frame containing the *Large Glass* and two other miniaturized readymades, *Traveller's Folding Item* (1916) and *Paris Air* (1919).

Another version of *Fountain* appeared in 1950, this time a full-scale example that is traditionally identified as the second version of the 1917 original (fig. 4.16). Duchamp had agreed to participate in an exhibition being organized by Sidney Janis on the theme "Challenge and Defy." *Fountain* must have seemed like the ideal representative, and Duchamp searched for a satisfactory substitute for the lost original. Finding none, he asked Janis to look for one as close to the original as possible during his summer trip in Europe. Janis purchased a urinal at a flea market in Paris; Duchamp approved it, inscribed it "R. Mutt 1917," and entered it in the exhibit.[41]

Comparison of this object with Stieglitz's photograph of the original urinal indicates a basic similarity of shape and size, but the differences strain the accuracy of the word "replica" to describe the Janis version of *Fountain*. The design of the drain holes is different; the signature is less bold; detailing of the putty connection and flushing rim is not crisply defined, and the entire surface is irregular, imparting almost a hand-made quality in contrast

to the flawless perfection of the J. L. Mott urinal. Photographs of it also differ from the initial version of Stieglitz and Duchamp. The mysterious lighting and background of Stieglitz's photograph have been replaced by a concern for clarity. And though photographs of the Janis version present *Fountain* isolated in a space removed from its original functional context, it is presented in a three-quarter view below eye level—a perspective that recalls the original male function of the urinal and sacrifices the 1917 confrontation with an iconic, anthropomorphized Madonna- or Buddha-like form.

Duchamp's installation of this version of *Fountain* was also distinctive, namely right-side-up and low on the wall "so little boys could use it" (fig. 4.17).[42] And for a second exhibition at the Janis Gallery in 1953, Duchamp installed *Fountain* in yet another manner, this time suspending it in a doorway and attaching a sprig of mistletoe to it—suggesting the coming together of male and female within the aura of *Fountain* (fig. 4.18).[43]

What is one to make of these two installations which differ so markedly from each other and from the 1917 presentation of *Fountain?* Do they imply that *any* installation is satisfactory, or at least any specified by Duchamp? Is each installation of equal merit, or does special merit adhere to the initial concept—or to the most recent? In my opinion, Duchamp's decisions were deliberate and significant. He exercised the three basic installations for sculpture, utilizing floor, wall, and ceiling, and each solution featured different elements: a stress on the anthropomorphic icon and aesthetics in 1917, provocative reference to the original (and always potential) function of a urinal in the 1950 exhibition, and reference to a hanging female thing in 1953. I suspect, moreover, that duplication of the 1917 image and installation was no longer a viable option for Duchamp in the 1950s. Not only was he averse to repeating himself, but both he and the culture had changed. The image produced by Duchamp and Stieglitz in 1917 embodied aesthetic and anthropomorphic qualities that were no longer of central importance in the 1950s. In that respect the original image was "special," linked to the artist and culture in ways that could not be repeated. If the later versions of *Fountain* are enriched by a comparable intellectual and cultural context, that context must be sought in the 1950s and 1960s, not in 1917.

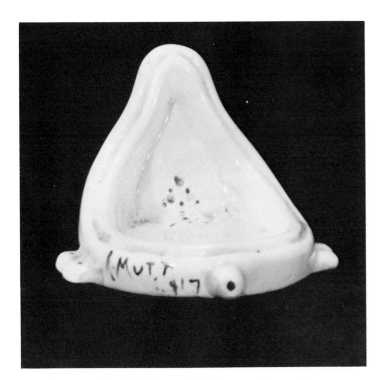

4.15
Fountain, miniature replica for the *Box-in-a-Valise*. From the second miniature edition, 1938. Glazed porcelain and paint, 1$\frac{13}{16}$ × 2$\frac{3}{8}$ × 3$\frac{1}{4}$ in. (Collection Tokoro Gallery, Tokyo.)

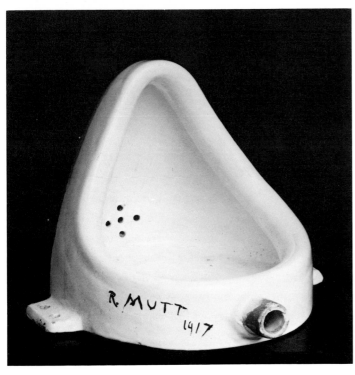

4.16
Fountain, 1950. Readymade. Second version selected by Sidney Janis after lost original of 1917. Requested and signed by Duchamp, 12 × 15 × 18 in. (Collection Carroll Janis, Conrad Janis, New York.)

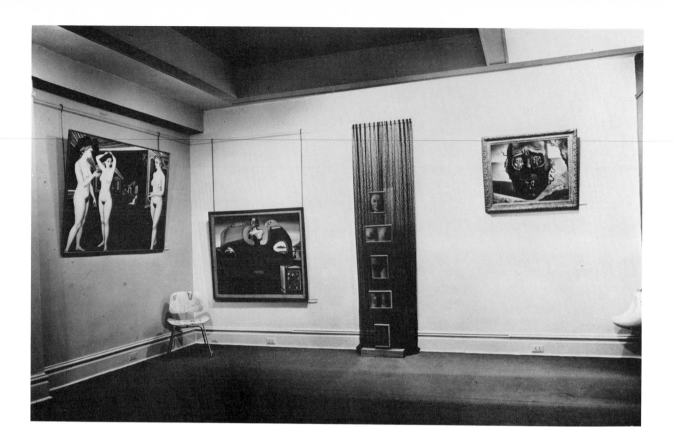

4.17
"Challenge and Defy" installation view,
Sidney Janis Gallery, New York, Septem-
ber 25–October 21, 1950. (Courtesy Sid-
ney Janis Gallery, New York.)

Duchamp was not the only artist faced with decisions about later versions
of readymade objects. Man Ray produced a second version of the *Gift* in
1949 (fig. 4.21) to bring it up to date for reproduction in Robert Mother-
well's anthology on *The Dada Painters and Poets*—and how changed is his
concept of the object.[44] In the 1921 original (fig. 4.19) we look up at a
towering, starkly simple and threatening form suggestive of some missile,
shield, or instrument of torture. In the later version, we look down on a
squat, softer, and somewhat fussy form that looks like an iron with carpet
tacks glued to it.

The Swedish writer Ulf Linde was responsible for the next full-scale version
of *Fountain*. Working with the sculptor Per Olof Ultvedt in 1960, Linde
made replicas of two readymades and the *Large Glass* for an exhibition in
Stockholm.[45] He did so without Duchamp's authorization and without having
seen the originals, working instead from published photographs and dimen-
sions. Nevertheless, Duchamp accepted and signed those objects during a

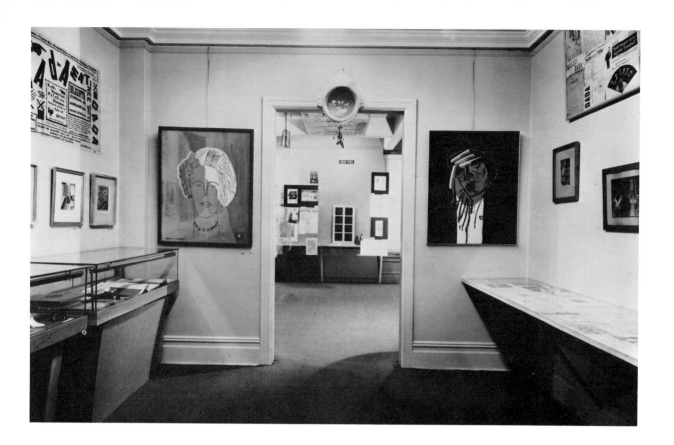

4.18
"Dada, 1916–23" installation view, Sidney Janis Gallery, New York, April 25–May 9, 1953. (Courtesy Sidney Janis Gallery, New York.)

visit to Sweden later in 1961. In 1963, Linde made replicas of other readymades including *Fountain* (fig. 4.20). This time he operated with Duchamp's permission, but again he worked without knowledge of the originals, relying on photographs and talking directly with the craftsmen—save for *Fountain*, which he purchased out of a men's room in a Stockholm restaurant. Though similar in appearance to the original version of *Fountain*, this third version of Linde's is slightly larger, different in details, and generally reproduced without the mysterious, iconic qualities of the Stieglitz photograph.

In the following year Duchamp authorized the fourth full-scale version of *Fountain*, in this instance an edition of ten (eight numbered and two hors commerce) produced by Arturo Schwarz of the Galleria Schwarz in Milan (fig. 4.22).[46] According to Schwarz, Duchamp sought exact replicas of the originals in this edition instead of copies of contemporary objects, and to this end Duchamp was involved in every stage of the process—approving each blueprint before craftsmen were authorized to proceed with production

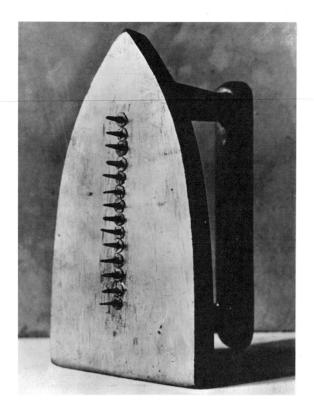

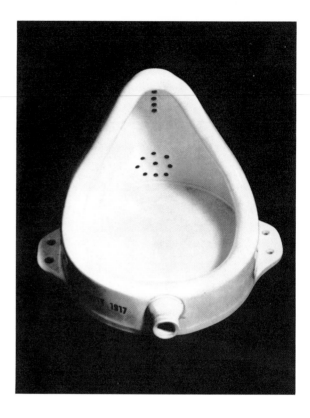

4.19
Man Ray, *The Gift*, 1921 (lost). Assemblage. Photograph by Man Ray. (Private collection. Man Ray Trust/A.D.A.G.P., 1987.)

4.20
Fountain, 1963. Readymade. Third version selected by Ulf Linde after lost original of 1917. Signed by Duchamp. (Moderna Museet, Stockholm.)

and specifying the size of the edition, the price of the readymades, and their public presentation.

Regarding the accessibility of Duchamp's work, we must bear in mind that there was no way to see the sweep of his production until after the opening of the Arensberg Collection in the Philadelphia Museum of Art in 1954. Moreover, the first book on Duchamp was not published until Robert Lebel's monograph of 1959; popular editions of Duchamp's notes were not available until 1958/1960, and his first solo exhibition did not occur until 1963 at the Pasadena Art Museum.[49] Duchamp was then in his seventies.

The accessibility of Duchamp's work coincided with a stunning change of the avant-garde. Duchamp had not been prominent on the art scene during the 1950s. The debate in that decade had been dominated by Abstract Expressionism, that is by an intensely subjective, painterly art similar in some respects to the art against which Duchamp had reacted in 1912–1914. He still did not care much for such art, and his own work looked

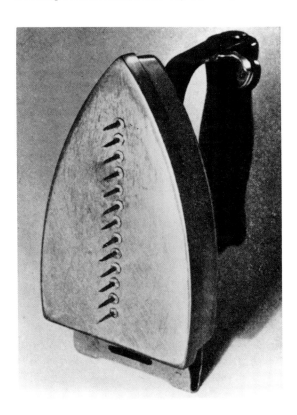

4.21
Man Ray, *The Gift*, 1949 (lost). Assemblage. (Photograph by Man Ray.)

eccentric in its midst. But from the late 1950s to the early 1960s a sea change occurred. The Abstract Expressionists were as good as ever, but they were no longer the avant-garde. A radically different-looking avant-garde was emerging composed of the New Realists in Europe (Jean Tinguely, Yves Klein, Arman, and others) and such Americans as Robert Rauschenberg, Jasper Johns, Ed Kienholz, Claes Oldenburg, Andy Warhol, Roy Lichtenstein, and others—artists who some critics loosely described as neo-Dadaists until distinct personalities and directions became more evident.[50] Warhol's painted plywood boxes based on Brillo Pad cartons are representative of this new avant-garde and, in this instance, of its link to Duchamp's readymades. But almost everything in the late 1960s and early 1970s seemed to have roots in Duchamp's work—not only what came to be called Pop Art, but Op Art, Minimal or Reductive Art, Conceptual Art, Performance and Body Art. In the course of a decade, Duchamp and Dada were transformed from secondary, aberrant phenomena in the history of modern art into the most dynamic forces in contemporary art.

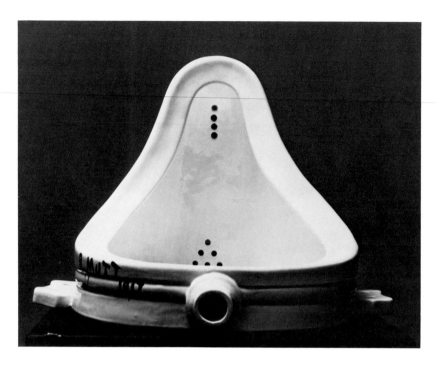

4.22
Fountain, 1964. Fabricated replica of readymade. Fourth version by Arturo Schwarz with the authorization of Duchamp after lost original of 1917. (Galleria Schwarz, Milan.)

Duchamp was pleased with the results, and the *Fountains* in the Galleria Schwarz edition do appear to approach the original object more closely than the Janis and Linde versions. Nevertheless, the *Fountains* in this edition are also distinctive in their contours, drain holes, and modulations of the surface, and in their general appearance as sparkling, new objects devoid of the qualities of Stieglitz's photograph.

Clearly I am stressing the unique visual properties of each of these later versions of *Fountain*, including how they are photographed and presented in exhibitions. Few spectators have paid much attention to the later versions of the readymades and many dislike them, charging that Duchamp sold out to commerce after disdaining it so long, or lamenting his confusion of values in accepting copies of all kinds. Duchamp responded deftly to every criticism. He was not about to become a de facto member of the Independents by acting as judge or censor. For the most part, he pointed out positive aspects of all later versions of the *Large Glass* and the readymades.[47] However, Duchamp also made it absolutely clear that the copies were not meant to replace the originals. In a 1967 conversation with his friend and biographer Robert Lebel, Duchamp said that despite everything,

"a copy remains a copy." The Linde and Richard Hamilton replicas, he said, possessed more authentic character than photographs, but as for "the rest, the little aesthetic plumage, they don't have it—and I am pleased about that. . . . All that goes without saying for those who know, but there are very few of them."[48]

To my knowledge, this statement has never been quoted in the vast literature on Duchamp, whereas his remarks about aesthetic indifference have been quoted countless times and employed as the cornerstone for elaborate critiques of his work, some of which will be considered briefly later in this paper.

The proliferation of these readymades in the early 1960s contributed to an incredibly expanded interest in Duchamp, but two other factors were even more significant for the prominence of Duchamp—the accessibility (at long last) of his work and the obvious relevance of that work to heady developments in avant-garde art of the 1960s.

In the context of the lively, controversial avant-garde art of the 1960s, *Fountain* finally received the critical airing denied it in 1917—an airing tinted, however, by the context of the 1960s. The opinions and interpretations regarding *Fountain* were remarkably diverse, but those that characterized it as anti-art or as an object of aesthetic indifference overwhelmed all others. In a telling reflection of the new context, however, the critics of the 1960s who perceived *Fountain* as anti-art were not counterparts of those conservative, philistine folk of 1917. More often than not, they were notable figures in the artworld who respected Duchamp and who viewed the anti-art nature of *Fountain* as praiseworthy or as a significant historical fact. William Rubin is one example. Throughout the 1960s, his writings characterized Duchamp's readymades and *Fountain* as his "signal contribution" to a form of "anti-art."[51] Rubin's comments do not seem to have been intended as a negative comment, but as recognition of an important historical fact.

For Hans Richter, Duchamp's friend and old Dadaist colleague, *Fountain*'s ringing virtue—and only virtue—had been its shocking, anti-art nature. Once done, it could not be repeated and had no lingering value.[52] This view led Richter to attack the neo-Dadaists for trying to revive the shock

value of common, readymade objects and for placing those objects into the mainstream of the commercial art world.

These 1960s advocates of *Fountain* as anti-art, Richter and Rubin, based their opinions (in part, at least) on statements by Duchamp himself. In his widely read 1965 book *Dada: Art and Anti-Art*, Richter quoted a letter from Duchamp that has been cited countless times:

When I discovered the readymades I thought to discourage aesthetics. In Neo-Dada they have taken my readymades and found aesthetic beauty in them. I threw the bottle-rack and the urinal into their faces as a challenge and now they admire them for their aesthetic beauty.[53]

Perhaps still more numerous were those critics who viewed *Fountain* not as anti-art but as an object of aesthetic indifference. They, too, could cite the authority of Duchamp himself and frequently quoted his comment to Pierre Cabanne: "The choice of the ready-mades is always based on visual indifference as well as the total absence of good or bad taste."[54] Octavio Paz, Mexican poet and ardent admirer of Duchamp, has been an influential advocate of this view:

The Readymades are not anti-art . . . but rather "an-artistic". Neither art nor anti-art, but something in between, indifferent, existing in a void. . . . Their interest is not plastic but critical or philosophical. It would be senseless to argue about their beauty or ugliness, firstly because they are beyond beauty and ugliness, and secondly because they are not creations but signs, questioning or negating the act of creation. The Readymade . . . is a jibe at what we call valuable. It is criticism in action.[55]

On the face of it, Duchamp's statements about readymades that stress anti-art and aesthetic indifference challenge my insistence on the significance of visual properties. The importance of Duchamp's statements cannot be denied, but I wish to underscore that those statements present a limited "truth"—even a misleading "truth"—if left simply at that, because Duchamp had much more to say about his readymades, some of it thoroughly at odds with comments about anti-art and aesthetic indifference. If we are going to base our theories or interpretations of the readymades on Duchamp's statements, then it is essential to consider *all* of the statements rather than ignoring any that do not fit a particular point of view.

The contradictory nature of Duchamp's comments about his readymades is abundantly clear in an interview with Francis Roberts.[56] At one point Duchamp said that he did not even consider the readymades to be art, but later in the same interview he stressed that the readymades were not "trivial" but, to the contrary, represented "a much higher degree of intellectuality." And in his closing comment, Duchamp allowed: "I'm nothing else but an artist, I'm sure, and delighted to be."

Another example exists in Duchamp's 1964 interview with Otto Hahn, who observed: "From the considerable documentation on the *Large Glass*, one is led to think that all your work, even the Readymades, are the fruit of lengthy development." Duchamp responded: "The Readymades are completely different from the *Large Glass*. I made them without any object in view, with no intention other than unloading ideas."[57] Two contradictions are involved, one of which is evident, namely the remark that the readymades were done "without any object in view"—except for "unloading ideas." The other contradiction derives from Duchamp's remark about the readymades being "completely different from the *Large Glass*." One year earlier Duchamp had encouraged Ulf Linde to pursue ideas Linde had presented on that very issue of the relation of the readymades to the *Large Glass*. In Duchamp's *Box-in-a-Valise*, Linde had noted the alignment of three readymades with the *Large Glass*, and for an exhibition installation in Stockholm in 1963 Linde repeated that alignment. He suspended the container of *Paris Air* alongside the Bride; he placed *Fountain* parallel to the bachelors' realm, and he installed the typewriter cover (*Traveller's Folding Item*) at the division between the realms of the Bride and the bachelors, the position in the *Large Glass* that—according to Duchamp's "notes"—was to contain the clothes of the Bride.[58]

Independent of Linde, Walter Hopps had also pondered the juxtaposition of those three miniature readymades with the *Large Glass* in the *Box-in-a-Valise*. While working on the installation of Duchamp's first solo exhibition at the Pasadena Art Museum in 1963, Hopps asked Duchamp about that particular aspect of the installation, and Duchamp indicated that *Paris Air*, *Traveller's Folding Item*, and *Fountain* should be placed in a vertical stack in proximity to the *Large Glass* because they were "readymade talk" about what was going on in the *Glass*.[59] Hopps could understand the association of *Fountain* with the bachelor realm and *Paris Air* with the Bride as a

"hanging female thing" [le pendu femelle], but he was puzzled by *Traveller's Folding Item* and asked about it. Duchamp responded to the effect that "Oh, it is removed from its machine"—confirmation, it would seem, that the typewriter cover (cover for a machine) was related to the clothes for the Bride.

I offer Duchamp's comments in an interview with Katherine Kuh as a concluding challenge to simple-minded readings of the readymades as objects limited to anti-art or aesthetic indifference:

The curious thing about the Ready-Made is that I've never been able to arrive at a definition or explanation that fully satisfies me. There's still magic in the idea, so I'd rather keep it that way than try to be exoteric about it. But there are small explanations and even certain general traits we can discuss. Let's say you use a tube of paint; you didn't make it. You bought it and used it as a ready-made. Even if you mix two vermillions together, it's still a mixing of two ready-mades. So man can never expect to start from scratch; he must start from ready-made things like even his own mother and father. . . . I'm not at all sure that the concept of the Ready-Made isn't the most important single idea to come out of my work.[60]

If the concept of "readymades" is extended to anything in life which is a given, from tubes of paint to parents, then we are on the threshhold of religious or spiritual issues, and that dimension exists indeed in several interviews. In a 1961 interview with Herbert Crehan, Duchamp commented on art as "the only thing left today that has a religious tendency or status" and "the only activity of man today that is individualistic. It is individualistic and religious at the same time."[61]

The final section of this paper will be devoted to a selective survey of interpretations and critical opinions regarding *Fountain* in the years following Duchamp's death in 1968. As in the 1960s, most authors discounted any aesthetic content in *Fountain* and the readymades, but for reasons that frequently reflected the cultural and intellectual conditions of the 1970s and 1980s. Peter Bürger, for example, viewed the readymades from a sociological/political perspective and reproduced *Fountain* as an example of "Duchamp's provocation" that "unmasks the art market where the signature means more than the quality of the work" and "radically questions the very principle of art in bourgeois society."[62] As far as Bürger was

concerned, "Duchamp's Ready-Mades are not works of art but manifestations."

The formalist art critic Clement Greenberg grudgingly accepted the ready-mades as art but deprecated their visual properties because Duchamp had not expanded the range of art with the readymades—he had only called public attention to something that already existed, namely "bad" art.[63]

Noted aesthetician-philosopher Arthur C. Danto not only rejected any meaningful role for aesthetics in Duchamp's readymades, but established that presumed absence of visual significance as a cornerstone for publications that have influenced aesthetic theories since the early 1970s. Danto's viewpoint emerged from a 1964 encounter with Warhol's *Brillo Boxes*, which seemed to him indistinguishable from actual Brillo cartons. He concluded then:

To see something as art requires something the eye cannot descry—an atmosphere of artistic theory, a knowledge of the history of art: an artworld. . . .

What in the end makes the difference between a Brillo Box and a work of art consisting of a Brillo Box is a certain theory of art. It is the theory that takes it up into the world of art, and keeps it from collapsing into the real object which it is. . . . It is the role of artistic theories, these days as always, to make the artworld, and art, possible.[64]

In my opinion, the fact of the matter is exactly the opposite, that is, artists and art generate the artworld and art theory, not vice versa. Nevertheless, Danto's ideas triggered a prominent development in aesthetics that came to be known as the Institutional Theory.[65] By the end of the 1970s, Duchamp and his readymades—above all *Fountain*—displaced Warhol's *Brillo Boxes* as the primary example in Danto's arguments. Undiscerning in visual matters and satisfied with the "art-historical fact" that "Duchamp seized upon his readymades precisely because they were in his view aesthetically indifferent,"[66] Danto has continued to elaborate his concept of the philosophical essence of art. Why, he asks, is something a work of art when something exactly like it is not? Why should this urinal "be an artwork when something else exactly 'like' this, namely 'that'—referring now to the

class of unredeemed urinals—are just pieces of industrial plumbing?"[67] Danto credits Duchamp with genius for raising the question in that form. He views the question as corresponding precisely to the form of all philosophical problems, that is, cases where we have indiscernibles belonging to different philosophical kinds, where there is a difference but not a natural one. By raising this philosophical question on the nature of art from within art, Danto claims that Duchamp's work implies that "art already is philosophy in a vivid form, and has now discharged its spiritual mission by revealing the philosophical essence at its heart. The task may now be handed over to philosophy proper. . . . So what art finally will have achieved as its fulfillment and fruition is the philosophy of art."[68]

About the same time that *Fountain* and the readymades were serving the theses of various aestheticians, other authors found them susceptible to occult interpretations.[69] Jack Burnham, the most prolific of those authors, believed that art had reached a crisis stage previsioned by Duchamp and detectable through hints of occult knowledge in his work.[70] According to Burnham, Duchamp had discovered the secret keys to that occult knowledge around 1912, and though he could not betray the secrecy of that knowledge, it became the driving force of his work. Burnham's arguments are too complex to examine here, *Fountain* alone being engulfed in a freewheeling interpretation that stirs together aspects of alchemy, the Cabala, Freud, Tarot cards, and all the gods of structural linguistics from Ferdinand de Saussure to the present.

The extravagant subjectivity of some occultist interpretations was counterbalanced later in the 1970s and 1980s by the probing scholarship of authors who sought to reexamine Duchamp through his own writings, particularly the "new" notes in *A l'infinitif* (1967) and the *Notes* of 1980 with their passages on perspective, photogrpahy, *n*-dimensional geometry, and the concept of *infra-mince*.[71]

Ulf Linde had pioneered this approach in the 1960s and is still contributing. There is not space to explore his method except to observe that he did not necessarily view the visual properties of *Fountain* (and other readymades) as important in themselves. Instead, the readymades were deemed significant insofar as their form, function, and associations seemed to participate in Duchamp's larger oeuvre, particularly the *Large Glass* and the notes.

Yoshiaki Tono has suggested that the concept of *infra-mince* may yield the greatest insight into the readymades, while Jean Clair has explored issues of perspective and photography in Duchamp's work, indicating the special relationships between photography and the readymades.[72] Craig Adcock has reconsidered the readymades as a consequence of his preoccupation with Duchamp's interest in *n*-dimensional geometry.[73] Although Adcock began with the conventional concept of the "aesthetic indifference" of the readymades, he observed that many of them had a repetitive, "geometrical look"; this prompted him to look again, since geometry was demonstrably important to much of Duchamp's work and thought. Adcock observed that *Fountain* was symmetrical and "geometric-looking," and he allowed that "if one disassociates the urinal from its useful significance—not easy— then its purely geometrical qualities become quite important and suggest alternative meanings."[74] The 90-degree rotation of *Fountain* in the 1917 Stieglitz photograph reminded Adcock of 90-degree rotations and reversals basic to *n*-dimensional geometry in Duchamp's work, that is, such reversals as the flip-flop of left and right, of inside and outside, which could be taken as analogues for aesthetic flip-flops and the male/female reversals in *Fountain*.

Despite their substantial differences, none of the authors considered in this section was fundamentally concerned with the visual properties of *Fountain*. However, there were a few individuals in the 1970s and 1980s for whom the visual properties of *Fountain* were indeed significant, and I choose to conclude this paper with their witness.

The American sculptor Robert Smithson provided a strong voice for the artist as shaman and the readymades as magical objects:

> [*Duchamp's*] *objects are just like relics, relics of the saints or something like that. It seems that he was into some kind of spiritual pursuit that involved the commonplace. He was a spiritualist of Woolworth, you might say. . . . At bottom I see Duchamp as a kind of priest of a certain sort. He was turning a urinal into a baptismal font.*[75]

A similar note was struck by historian of science George Basalla in his discussion of *Fountain* in an article entitled "Transformed Utilitarian Objects."[76] Basalla underscores our emotional attachment to utilitarian objects and claims that such objects acquire an aura when they are trans-

formed by bestowing a new function upon them. For this aura to exist, the beholder must experience both his emotional bond to the original form and function of the object *and* his bonding to a new function in what is still recognizably the old form. The spectator, driven to resolve the dissonance between old and new functions, generates an aura about the transformed object—it becomes a "transfiguration."

Kermit Champa offers brief but provocative commentary to which I am very partial. He remarks that the spectator of *Fountain* is made to realize

with a mixture of humor and discomfort, its rather outlandish eroticism— an eroticism bred by the object itself but heightened enormously by its removal from the men's room and its introduction into the art gallery. Whatever the viewer's reaction to the urinal, the artist, Duchamp, could not be held fully responsible. . . . What the Fountain *finally constituted more than anything else was the brilliant discovery within the world of the Readymade and the everyday of the perfect Freudian symbol, flagrantly obvious and stimulating once it was discovered, but utterly untranslatable and, as a result, perversely pure. Phallic? Vaginal? It was a man-made female object for exclusive male functions. Yet who could characterize it precisely?*[77]

At this point I have indicated interpreters of *Fountain* who:

1 tremble before the magic of this fetish-like object
2 disdain it as bad art
3 caress its sensuous form
4 reject it as anti-art
5 view it as a revelation of occult mysteries
6 perceive it as a political/sociological manifestation
7 hail it as an ingenious revelation of art-as-philosophy.

It seems appropriate to observe that if Duchamp excelled at appropriating objects to serve as readymades, then we have excelled no less at appropriating his readymades to serve our objectives. One might wonder what Duchamp thought of all these interpretations—about half of which emerged before his death. Several observations may be made. First, he rarely commented on anything said or written about him. There are suggestions that he found some interpretations more interesting or relevant than others—but only suggestions. Second, Duchamp never rejoined the so-called

Independents, that is, he never became a judge or censor. In his gentle, wise way he accepted all interpretations as they came along, realizing it would have been a wasteful, perhaps even foolish use of his time to explain and defend his work from us. In fact, he incorporated us in the creative act. In a talk entitled "The Creative Act," Duchamp said:

All in all, the creative act is not performed by the artist alone; the spectator brings the work in contact with the external world by deciphering and interpreting its inner qualifications and thus adds his own contribution to the creative act.[78]

Duchamp even went so far as to say that the place of an artwork in history is dependent upon us, the spectators.

Duchamp exaggerated our importance, but we do have something to say about the place of a work of art in history, and *Fountain*'s place in history is still evolving because it still possesses magic; it continues to offend, mystify, and generate ideas. Those ideas carry their own measure of validity, but a validity marked by their time and authors, and more or less removed from the original conditions of 1917 when Duchamp referred to *Fountain* simply as "sculpture," and his friends—reflecting, I think, his own attitude—spoke of *Fountain's* pleasing form and anthropomorphic associations.

On the face of it, the attitudes, documents, and historical conditions of 1917 deserve to reenter our consideration of *Fountain*—including our continued search for *Fountain*'s "readymade talk" of what is going on in the *Large Glass* and in those tantalizing notes on infra-thin, *n*-dimensional geometry, photography, molds, and mirrorical returns. Moreover, the relevance of those original conditions extends beyond *Fountain* itself into our consideration of the whole of Duchamp's work—providing historical ballast against the shifting winds of contemporary criticism and reminding us that visual properties are significant, even for the readymades.

Notes

1 For the claims of Duchamp and Marlor see Pierre Cabanne, *Entretiens avec Marcel Duchamp* (Paris: Belfond, 1967), 99, and Clark S. Marlor, "A Quest for Independence: The Society of Independent Artists," *Art and Antiquities* (March-April 1981), 77.

2 Bourgeois Gallery, New York, *Exhibition of Modern Art,* April 3–29, 1916, no. 50. Two unidentified readymades were mentioned by an unnamed critic, "Exhibitions Now On," *American Art News* 14, no. 27 (April 8, 1916), 3. Duchamp later said the two readymades were exhibited in an umbrella stand at the entrance (*Marcel Duchamp, Letters to Marcel Jean* [Munich: Verlag Silke Schreiber, 1987], 77). Duchamp also exhibited the readymade *Pharmacy* at the Montross Gallery, New York, *Exhibition of Pictures by Jean Crotti, Marcel Duchamp, Albert Gleizes, Jean Metzinger,* April 4–22, 1916, no. 27.

3 For the most thorough and reliable account of the first exhibition of the Society of Independent Artists, see Francis Naumann, "The Big Show: The First Exhibition of the Society of Independent Artists," parts I and II, *Artforum 17* (February 1979), 34–39, and (April 1979), 49–53. Naumann has provided photographs, friendly criticism, and numerous references regarding the Independents' exhibition and *Fountain.* See also Clark S. Marlor, *The Society of Independent Artists: The Exhibition Record 1917–1944* (Park Ridge, New Jersey: Noyes Press, 1984).

4 The program and principles of the Society were proclaimed in a widely distributed announcement entitled "The Society of Independent Artists, Inc.," undated, copy in the Archives of the Société Anonyme, Beinecke Rare Book and Manuscript Library, Yale University, New Haven, Connecticut.

5 For extensive clippings on the Independents' exhibition see Katherine S. Dreier's scrapbook, vol. I (1915–1917), in the Archives of the Société Anonyme. See also Naumann, "The Big Show."

6 For an account of Duchamp's removal of *Nude Descending a Staircase* from the 1912 Salon des Indépendants, see Robert Lebel, *Marcel Duchamp* (New York: Grove Press, 1959), 8–11. Duchamp's continued contempt for the censorship of the two Cubist painters who requested the *Nude*'s removal, Albert Gleizes and Jean Metzinger, was evident in an interview with this author on April 4, 1961.

7 Arturo Schwarz, *The Complete Works of Marcel Duchamp* (New York: Abrams, 1970), 466.

8 The main plant of J. L. Mott Iron Works (founded 1828) was located in Trenton, New Jersey, but Mott had outlet stores from coast to coast, including major showrooms in Philadelphia and in New York at Fifth Avenue and 17th Street. See the J. L. Mott Iron Works catalogues, *Modern Plumbing for Schools, Factories, etc.* (New York, 1912), and *Marine Plumbing, Catalogue "M"* (New York, 1918).

9 Otto Hahn, "Passport No. G255300," *Art and Artists* 1, no. 4 (July 1966), 10.

10 Arts Council of Great Britain, unpublished interview with Marcel Duchamp conducted by William Coldstream, Richard Hamilton, R. B. Kitaj, Robert Melville, and David Sylvester, London, June 19, 1966, 28–29. I am grateful to Prof. H. Dennis Young for bringing this interview to my attention.

11 Beatrice Wood, *I Shock Myself* (Ojai: Dillingham Press) 29–30. Beatrice Wood is the only eyewitness to this event who has published an informative account of the argument between Bellows and Arensberg. She has, in fact, contributed several accounts, published and unpublished, which vary in some details but remain consistent in the essentials. The earliest version known to this author appears in Wood's letter to Louise Arensberg on August 10, 1949, in the Beatrice Wood Papers, Archives of American Art, Smithsonian Institution, Washington, D.C., roll no. 1236, frames 989–990. A similar version, transformed into a dialogue between Bellows and Arensberg, was sent to this author in June 1962. Another version substituting Rockwell Kent for George Bellows was published by Francis Naumann, "I Shock Myself: Excerpts from the Auto-

biography of Beatrice Wood," *Arts* 51 (May 1977), 134–139.

12 Anonymous review, "His Art Too Crude for Independents," *The New York Herald,* April 14, 1917, 6.

13 At the time the Society's files were destroyed by fire, they were being housed in the studio of A. S. Baylinson (1882–1950), a Russian-born artist who became a student of Robert Henri and an early member of the Independents. Clark S. Marlor, letter to the author, December 2, 1986.

14 Marcel Duchamp to Suzanne Duchamp, April 11, 1917 (Archives of American Art, Smithsonian Institution, Washington, D.C.). This letter and others from Duchamp to his sister and his brother-in-law, Jean Crotti, have been published in English translation with commentary by Francis M. Naumann, "Affectueusement, Marcel: Ten Letters from Marcel Duchamp," *Archives of American Art Journal* 22, no. 4 (1982), 2–19.

15 Charles Demuth to Henry McBride, undated (c. April 10–14, 1917), Archives of Henry McBride, Beinecke Rare Book and Manuscript Library, Yale University. The "e" added to Mutt in this letter could possibly have been intended to suggest a female identity or, if associated with the "R" of R. Mutt, "Mutter," the German word for "mother." For another possibility involving the Egyptian goddess Mut, see Meyer Schapiro, "Leonardo and Freud: An Art-Historical Study," *Journal of the History of Ideas* (April 1956), 148.

16 An original print of Alfred Stieglitz's photograph was discovered by Ecke Bonk and reproduced in his *Marcel Duchamp: The Box in a Valise de ou par Marcel Duchamp ou Rrose Selavy* (New York: Rizzoli, 1989), 205. Translated from the German by David Britt.

17 Louise Norton, "Buddha of the Bathroom," *The Blind Man,* no. 2 (May 1917), 5–6.

18 Wood, *I Shock Myself,* 30.

19 *The Letters of Gertrude Stein and Carl Van Vechten, 1913–1914,* edited by Edward Burns (New York: Columbia University Press, 1986), 58–59. This undated letter,

attributed by the editor to April 5, must date after April 13.

20 Alfred Stieglitz to Georgia O'Keeffe, April 19, 1917, Archives of Georgia O'Keeffe, Beinecke Rare Book and Manuscript Library, Yale University. Restrictions on these archives, recently placed at Yale, preclude access to this letter. Owing, however, to the forthcoming publication of this letter in the selected correspondence of Georgia O'Keeffe, Sarah Greenough and Juan Hamilton graciously informed me of some of its contents and authorized a brief paraphrase. I am grateful to be able to indicate some points in this important document. Stieglitz was also led to think that the urinal had been submitted by a young woman, probably at the instigation of Duchamp.

21 This photograph came to the Philadelphia Museum with the Arensberg Archives in 1950. It is described by the associate curator of photographs, Martha Chahroudi, as probably a photograph from the original negative. It is on photographic stock consistent with the period but not really consistent with Stieglitz's photographs. At one time it was mounted on a page from *291,* no. 3, May 1915. I am grateful to Ms. Chahroudi for making this information available, and to Naomi Sawelson-Gorse who told me of the existence of the cropped photograph.

22 Among several colleagues with whom I shared the reference to Marsden Hartley, Francis Naumann promptly identified *The Warriors.* I am grateful for his quick eye and for permission from the present owner of *The Warriors* to reproduce it with a diagram indicating as accurately as possible the portion of the painting covered by *Fountain* as originally photographed by Stieglitz. The shape of *Fountain* cannot be made to fit on a standard frontal reproduction of *The Warriors* without distortion, indicating that the camera lens, the urinal, and the painting were not aligned in parallel planes when Stieglitz made the photograph.

23 Nixola Greeley-Smith, "Cubist Depicts Love in Brass and Glass: 'More Art in Rubbers Than in Pretty Girl!' " *The Evening World* (New York, April 4, 1916), 3. Reprinted in Rudolf E. Kuenzli, ed., *New York Dada,* no. 14 (New York: Willis Locker & Owens, 1986) 135–137.

24 H[enri] P[ierre] Roché, "Souvenirs of Marcel Duchamp," in Robert Lebel, *Marcel Duchamp* (New York: Grove Press, 1959), 87.

25 *The Blind Man,* no. 2 (May 1917), 5. Edited by P[ierre] Roché], B[eatrice Wood], T[otor, nickname for Marcel Duchamp]. In her diary, Beatrice Wood records the appearance of this last issue of *The Blind Man* on May 5, 1917. Wood's father warned her she might go to jail if such "filth" was sent through the mail. Although the editors saw no grounds for such concern, they decided to distribute *The Blind Man* by hand in order not to risk bad publicity for such distinguished backers as Mrs. Harry Payne Whitney.

26 Beatrice Wood claims she wrote this editorial in *I Shock Myself,* 31. In response to questions posed by Serge Stauffer (*Marcel Duchamp, Die Schriften,* vol. 1 [Zurich: Regenbogen-Verlag, 1981], 280), Duchamp said "The Richard Mutt Case" was by the eidtors of *The Blind Man.* Duchamp identified Louise Varèse as the author in his interview for the Arts Council of Great Britain, June 19, 1966, 27. Alice Goldfarb Marquis thinks Arensberg was probably the principal author (*Marcel Duchamp: Eros, c'est la vie. A Biography* [Troy, New York: Whitson Publishing Company 1981], 164).

27 Reyner Banham (*Theory and Design in the First Machine Age* [New York: Praeger, 1960], 9–12) and Sigfried Giedion (*Mechanization Takes Command* [New York: Oxford University Press, 1948], 41–44) set the "machine age" in the second decade of the twentieth century, and characterize it as a stage of mechanization in which an abundance of machines that altered everyday life (typewriters, telephones, electrical appliances, and automobiles) came to be owned and operated by the middle class.

28 Marcel Duchamp, *Salt Seller: The Writings of Marcel Duchamp (Marchand du sel)* ed. Michel Sanouillet and Elmer Peterson (New York: Oxford University Press, 1973), 23.

29 Dora Vallier interview with Fernard Léger, "La vie dans l'oeuvre de Fernand Léger," *Cahiers d'Art* 29, no. 3 (1954), 140; trans. by author. Schwarz cites other versions of the event and remarks that Duchamp did not remember the episode (Schwarz, *The Complete Works of Marcel Duchamp,* 595).

See also Dickran Tashjian, "Henry Adams and Marcel Duchamp: Liminal Views of the Dynamo and the Virgin," *Arts* 51 (May 1977), 103.

The Salon de la Locomotion Aérienne was held in the Grand Palais, Paris, October 26–November 10, 1912. Guillaume Apollinaire was expressing similar views at about the same time: "je pense que le style moderne existe, mais ce qui caractérise le style d'aujourd'hui on le remarquerait moins dans les façades des maisons ou dans les meubles que dans les constructions de fer, les machines, les automobiles, les bicyclettes, les aéroplanes." ("La Renaissance des Arts Décoratifs," *L'Intransigeant* [Paris, June 6, 1912]). See Guillaume Apollinaire, *Chroniques d'Art,* ed. L. -C. Breunig (Paris: Gallimard, 1960), 250–251.

30 Marcel Duchamp, letter to Suzanne Duchamp, January 15, 1916 (Archives of American Art, Smithsonian Institution, Washington, D.C.), translated with commentary by Francis M. Naumann, "Affectueusement, Marcel," *Archives of American Art Journal* 22, no. 4 (1982), 5.

31 Schwarz, *The Complete Works of Marcel Duchamp,* 442.

32 Ibid.

33 Some of the more interesting analyses have been published by Ulf Linde, "La Roue de bicyclette," in *Marcel Duchamp abécédaire* (Paris: Centre Georges Pompidou, 1977), 35–41; Jean Clair, *Duchamp et la photographie* (Paris: Editions du Chêne, 1977), 64–74; and Craig Adcock, *Marcel Duchamp's Notes from the "Large Glass"* (Ann Arbor, Michigan: UMI Research Press, 1983), 102–103. For a summary and commentary on several viewpoints, see Francis M. Naumann's catalogue *The Mary and William Sisler Collection* (New York: Museum of Modern Art, 1984), 160–165, and John Moffit's text "Marcel Duchamp: Alchemist of the Avant-Garde" in Maurice Tuchman, ed., *The Spiritual in Art: Abstract Painting 1890–1985,* (exh. cat., Los Angeles County Museum of Art, November 23, 1986–March 8, 1987), 257–271.

34 For Brancusi's exhibition at the Modern Gallery (New York, October 23–November 11, 1916), see Marius de Zayas, "How, When, and Why Modern Art Came to New York," *Arts* 54, no. 8 (April 1980), 107,

introduction and notes by Francis M. Nau-
mann. For the exhibition of the brass ver-
sion see The Society of Independent
Artists, *First Annual Exhibition,* Grand
Central Palace, New York, April 10–May 6,
1917, no. 167; illus. in the catalogue.
Intriguing parallels and differences
between Brancusi and Duchamp are
explored in the excellent article of Edith
Balas, "Brancusi, Duchamp and Dada,"
Gazette des Beaux Arts 95 (April 1980),
165–174.

35 W. H. de B. Nelson, "Aesthetic Hysteria,"
The International Studio (June 1917),
ccxxi–ccxxv.

36 For additional commentary on *God* see
Robert Reiss, " 'My Baroness': Elsa von
Freytag-Loringhoven," in Rudolf E.Kuenzli,
ed., *New York Dada* (New York, 1986), 88,
and Jack Burnham, *Great Western Salt
Works* (New York: George Braziller, 1974),
86.

37 I am indebted to Naomi Sawelson-Gorse,
archivist for the Arensberg Archives at The
Francis Bacon Library, Claremont, Califor-
nia, for her thorough search in all collec-
tions of the Arensbergs' papers.

38 During the Arensbergs' extended vacation
in California, before settling in Hollywood,
Charles Sheeler lived in their New York
apartment and was responsible for both
the sale of some of their collection and the
packing of the contents of the apartment
for shipment to Los Angeles (Sawelson-
Gorse letter to this author, November 25,
1986). Beatrice Wood does not remember
seeing *Fountain* in the apartment of
Duchamp or the Arensbergs after the Inde-
pendents Exhibition (letter to this author,
July 26, 1984). She never saw *Fountain* in
their Hollywood home either, where she
visited several times before settling in
Hollywood herself in 1948.

39 *View* 5, no. 1 (March 21, 1945), 23. The
1917 photograph of a urinal hanging in
Duchamp's apartment (fig. 4.2) was also
reproduced in this issue (p. 20), and it had
been included by Duchamp in his *Box-in-
a-Valise* (1936–1941).

Breton's attention to Duchamp's ready-
mades in the 1930s merits consideration.
He did not write specifically about *Foun-
tain,* but he influenced generations with
his definition of the readymades as "man-
ufactured objects promoted to the dignity

of objects of art through the choice of the
artist" ("Phare de la Mariée," *Minotaure,*
2, no. 6 [December 1934], 45–49; quoted
here from Robert Lebel, *Marcel Duchamp*
[New York, 1959], 89). Breton discounted
the formal qualities of the readymades,
stressing instead that they were not an
end in themselves but a means to set
inventive powers free, to enable us to
transcend the limits imposed by conven-
tional life (André Breton, "Crise de l'ob-
jet," *Art and Artist* 1 no. 4 [July 1966], 13;
trans. Angus Malcolm; originally pub-
lished in Galerie Charles Ratton, Paris,
Exposition Surréaliste d'Objets, May 22–
29, 1936).

40 Duchamp initially conceived of an edition
of about 300 of these portable museums,
twenty-four of which would be deluxe
examples containing an original art work
in addition to the sixty-nine miniaturized
items. Duchamp went on to produce other
editions of this complex work, which is the
subject of an excellent study by Ecke
Bonk, *Marcel Duchamp: The Box in a Val-
ise de ou par Marcel Duchamp ou Rrose
Sélavy.*

41 Sidney Janis Gallery, New York, *Challenge
and Defy,* September 25–October 21, 1950,
cat. no. 10. The information in this para-
graph is based on Sidney Janis's letters to
the author (December 19, 1986; July 29
and August 18, 1987). Mr. Janis identified
the flea market as the Marché aux Puces
at the Marché Baron in Clignancourt.

Consistent numbering and nomenclature
for the various versions of *Fountain* was
established by Anne d'Harnoncourt and
Kynaston McShine (*Marcel Duchamp,*
Museum of Modern Art, New York, and
the Philadelphia Museum of Art, 1973).
That system has been continued here, that
is, the term "version" is employed instead
of "replica," and the original *Fountain* of
1917 is considered as the first version, the
urinal selected by Janis as the second ver-
sion, and so on in chronological order.
The 1963 version selected by Ulf Linde—
omitted in the d'Harnoncourt/McShine
sequence—is identified here as the third
version.

42 Sidney Janis, letter to this author, August
18, 1987.

43 Sidney Janis Gallery, New York, *Dada
1916–1923,* April 15–May 9, 1953, cat. no.
40.

44 According to Merry Foresta (letter to the author, August 5, 1987), Man Ray produced this version of *The Gift* around 1949 when Motherwell asked for a print to reproduce in his book *The Dada Painters and Poets* (New York: Wittenborn, Schultz, Inc., 1951, p. 100). The object was lost or destroyed and the photograph does not exist in Man Ray's studio. The absence of that photograph is confirmed by Juliet Man Ray and Jerome Gold, Administrative and Curatorial Assistant for the Man Ray Trust. Juliet Man Ray and Jerome Gold have contributed substantially to my research on Man Ray and Duchamp.

45 The exhibition organized by Linde and Ultvedt was held in the Bok-Konsum Gallery, Stockholm, May 1960. I am indebted to Linde for the information in this text regarding his version of *Fountain* (Ulf Linde, letter to the author, July 8, 1987).

46 Much of the information in this text on the Galleria Schwarz edition is based on Arturo Schwarz's letter to the author, January 26, 1987. See also Schwarz's text for the Neuen Berliner Kunstvereins, *Multiples,* May 8–June 15, 1974.

47 For Duchamp's defense of the replicas of his works see his interviews with Otto Hahn, "Passport No. G255300," 11; Robert Lebel, "Marcel Duchamp maintenant et ici," *L'Oeil,* no. 149. (May 1967), 77, and Dore Ashton, "An Interview with Marcel Duchamp", *Studio International* 171, no. 878 (June 1966), 246.

48 Robert Lebel, "Marcel Duchamp maintentant et ici," 77 trans. by author. Although Duchamp was referring to replicas of the *Large Glass,* his comments occur in a conversation that also incorporated the readymades.

49 Pasadena Art Museum, *Marcel Duchamp,* October 8–November 3, 1963, preface by Walter Hopps. Publications cited in the text include Robert Lebel, *Sur Marcel Duchamp* (Paris: Trianon Press, 1959) and *Marcel Duchamp* (New York: Grove Press, 1959); Marcel Duchamp, *Marchand du Sel*, ed. Michel Sanouillet (Paris; Le Terrain Vague, 1958); Marcel Duchamp. *The Bride Stripped Bare by Her Bachelors Even*, typographic version by Richard Hamilton, trans. by George Heard Hamilton (London: Percy Lund, Humphries & Co. Ltd., 1960).

50 Irving Sandler (*The New York School* [New York; Harper & Row, 1978], 146) notes the common use of the term "neo-dada" through 1961, particularly for works involving assemblage or junk sculpture.

51 William Rubin, "Reflexions on Marcel Duchamp," *Art International* 4, no. 9 (December 1, 1960), 49 and 52. Rubin's discussion of the readymades is not limited to aesthetics, but his position is clear and he repeats it in passages on Duchamp in *Dada and Surrealist Art* (New York: Abrams, 1968), 36–37.

52 Hans Richter, *Dada Art and Anti-Art* (New York: McGraw-Hill Book Company, 1965), 208.

53 Ibid., 207–208. Dieter Daniels recently brought to my attention a later publication by Richter (*Begegnungen von Dada bis heute* [Cologne, 1973], 155–56) which reveals that Richter made these comments, not Duchamp.

54 Cabanne, *Entretions avec Marcel Duchamp,* 84; trans. by author.

55 Octavio Paz, *Marcel Duchamp, Appearance Stripped Bare,* trans. Rachel Phillips and Donald Gardner (New York: Seaver Books, 1978), 22. This is an expanded version of Paz's essay "Marcel Duchamp o el Castillo de la Pureza" (Mexico City, 1968), translated as *Marcel Duchamp or the Castle of Purity* (New York and London, 1970).

56 Marcel Duchamp, " 'I Propose to Strain the Laws of Physics'," *Art News* 67, no. 8 (December 1968), 46–47, 62–64; interview conducted by Francis Roberts.

57 Otto Hahn, "Passport No. G255300," 10.

58 Walter Hopps, Ulf Linde, and Arturo Schwarz, *Marcel Duchamp, Readymades, etc. (1913–1964)* (Milan: Galleria Schwarz, 1964). In Linde's text entitled "MARiée CELibataire," see especially pp. 54, 60–63.

59 For information regarding installation of the Duchamp exhibition in Pasadena, I am indebted to Walter Hopps (conversation with the author, August 6, 1987).

60 Katherine Kuh, *The Artist's Voice* (New York: Harper and Row, 1960), 90–92.

61 Herbert Crehan, interview with Duchamp, WBAJ-FM Radio, New York, transcribed by

Robert Cowan; excerpts published in *Evidence,* no. 3 (Fall 1961), 36–38.

62 Peter Bürger, *Theory of the Avant-Garde* (Minneapolis: University of Minnesota Press, 1984), 51–52; trans. by Michael Shaw from original publication in 1974.

63 Clement Greenberg, "Counter-Avant-Garde," *Art International* 15, no. 5 (May 20, 1971), 18.

64 Arthur C. Danto, "The Artworld", *The Journal of Philosophy* 61, no. 19 (October 15, 1964), 580–581.

65 A principal figure in the development of the Institutional Theory has been George Dickie. See his *Aesthetics* (New York: Pegasus, 1971), 101–108. Other participants in this debate include: Richard J. Sclafani ("Artworks, Art Theory and the Artworld," *Theoria* 39 [1973], 18–34, and "Afterwords—What Kind of Nonsense Is This?," *The Journal of Aesthetics and Art Criticism* 33 no. 4 [Summer 1975], 455–458); Steven Goldsmith ("The Readymades of Marcel Duchamp: The Ambiguities of an Aesthetic Revolution," *The Journal of Aesthetics and Art Criticism* 42, no. 2 [Winter 1983], 197–208); T. J. Diffey ("On Defining Art," *The British Journal of Aesthetics* 19, no. 1 [Winter 1979], 15–23); Timothy Binkley ("Piece: Contra Aesthetics," *The Journal of Aesthetics and Art Criticism* 35 [1977], 265–277); Jack Glickman ("Creativity in the Arts," *Culture and Art,* ed. Lars Aagaard-Mogensen [Nyborg, 1976]), rpt. in Joseph Margolis, ed., *Philosophy Looks at the Arts* [Philadelphia, 1978], 155–161); Joseph Margolis ("The Ontological Peculiarity of Works of Art," *The Journal of Aesthetics and Art Criticism* 36 [1977], 45–50); and S. K. Wertz, " 'Toilet Paper' (a.k.a. Artificiality and Duchamp's *Fountain*)," *Southwest Philosophy Review* 3 [1986], 5–18).

66 Arthur C. Danto, *The Philosophial Disenfranchisement of Art* (New York: Columbia University Press, 1986), 33.

67 Ibid., 14.

68 Ibid., 16.

69 Occasional references to alchemy had appeared in the literature on Duchamp since the 1930s, but serious consideration of that theme arose simultaneously in the work of Ulf Linde and Arturo Schwarz in

the late 1960s. Nicolas Calas based an interpretation of the *Large Glass* on Tarot Cards ("The Large Glass," *Art in America* 57, no. 4 [July–August 1969], 34–35) and Maurizio Calvesi presented a synthesis of various occult theories in *Duchamp Invisibile—La costruzione del simbolo* (Rome: Officina Edizioni, 1975). For a survey of alchemical interpretations of Duchamp's work see Jean Clair, "La fortune critique de Marcel Duchamp," *Revue de l'Art,* no. 34 (1976), 92–100. Jack Burnham's occult interpretations are developed in several publications: *Great Western Salt Works* (New York: George Braziller, 1974); "Unveiling the Consort," parts I, and II, *Artforum* 9, no. 7 (March 1971), 55–60, and no. 8 (April 1971), 42–51; "The True Readymade?," *Art and Artist* 6, no. 2 (February 1972), 26–31; and *The Structure of Art* (New York: George Braziller, 1971).

70 This theory is developed most extensively by Burnham in *Great Western Salt Works,* 12–132 passim.

71 Marcel Duchamp, *Marcel Duchamp, Notes,* ed. and trans. Paul Matisse (Paris: Centre National d'Art et de Culture Georges Pompidou, 1980); Marcel Duchamp, *A l'infinitif* [The White Box] (New York: Cordier & Ekstrom, Inc., 1967); rpt. and trans. in *Salt Seller: The Writings of Marcel Duchamp (Marchand du Sel),* ed. Michel Sanouillet and Elmer Peterson (New York: Oxford University Press, 1973).

72 Yoshiaki Tono, "Duchamp and 'Inframince'," in *Duchamp* (exh. cat., Fundacio Caixa de Pensiones and Fundacio Joan Miro, Barcelona, May–June 1984), 55; Jean Clair, *Duchamp et la photographie* (Paris: Editions du Chêne, 1977), and "Duchamp and the Classical Perspectivists," *Artforum* 16, no. 7 (March 1978), 40–49.

73 Craig E. Adcock, *Marcel Duchamp's Notes from the "Large Glass": An n-Dimensional Analysis* (Ann Arbor: UMI Research Press, 1983). All studies regarding modern art and concepts of the fourth dimension are indebted to the excellent publications of Linda Dalrymple Henderson: "A New Facet of Cubism: 'The Fourth Dimension' and 'Non-Euclidean Geometry' Reinterpreted," *The Art Quarterly* 34 (Winter 1971), 410–433, and *The Fourth Dimension and Non-Euclidean Geometry in Modern Art* (Princeton: Princeton University Press, 1983).

74 Adcock, *Duchamp's Notes,* 167. Most of
 Adcock's observations regarding *Fountain*
 occur between pp. 159 and 173.

75 Robert Smithson, "Robert Smithson on
 Duchamp, an Interview," *Artforum* 12, no.
 2 (October 1973), 47; interview conducted
 by Moira Roth.

76 Georges Basalla, "Transformed Utilitarian
 Objects," *Winterthur Portfolio* 17, no. 4
 (Winter 1982), 183–201.

77 Kermit Champa, "Charlie Was Like That,"
 Artforum 12, no. 6 (March 1974), 58.

78 Marcel Duchamp, "The Creative Act," talk
 given for the meeting of the American
 Federation of Arts at the Museum of Fine
 Arts, Houston, April 3, 1957. Published in
 Art News 56, no. 4 (Summer 1957), 28–29;
 rpt. in Duchamp, *Salt Seller,* 138–140.

Discussion

Moderated by Dennis Young

R O S A L I N D K R A U S S

Perhaps I missed something, Bill, but in your discussion of the various alternatives in the post-1917 history of the reception of the *Fountain,* it seems to me you made a significant omission—at least from my point of view. The attitudes you were placing in opposition to the one you were describing as the right one—specifically an aesthetic consideration of the work, within a machine aesthetic—had to do with taking the work as an object of indifference, or as a piece of anti-art. But the possibility you left out, which to my mind plays a large role in the history of the reception of Duchamp's readymades, is the experience of seriality, and the position of the series within the discourse of modernism. The urinal factors into this discourse the issue of the replica, the mold, the cast, which is to say, the multiple without an original. There is ample evidence in the notes that Duchamp was tremendously interested in the matter of casting and that the mold played an important role in his own thinking. Obviously the *Malic Molds* are molds, and one of the notions of color he developed was a kind of color that had to do with molds. This idea of the replica has also been addressed by those, like Jean Clair or myself, who have analyzed the *Large Glass* by stressing the issue of its existence in the context of photography, buttressed by the fact that Duchamp himself specified this.[1] The publication of the *1914 Box* involved placing the notes in actual boxes for photographic glass plates. Photography is a striking instance of a form through which Duchamp thought about the case of the multiple without an original. Now, you cited many examples of people around Duchamp enunciating this machine aesthetic, but I don't remember you tying this to Duchamp himself. What I'm trying to get at is that your omission of the issue of the series allows you to continue to invoke the binary opposition original/not original that has always propped up the aesthetic discourse. And the aesthetic of uniqueness played a large role in your demonstration about the urinal itself: that it couldn't just be any urinal, that it had to be precisely this one. That stress on uniqueness tends to exclude a practice that turns on seriality. Could you respond to that?

WILLIAM CAMFIELD

I'll give it a try. Yes, your concern about the issue of replicas, molds, and photographs is very important and probably represents one of the most fruitful directions of research. Actually I had some commentary in my paper which I dropped because it was too long already. As to your second remark, about the machine aesthetic, which I stressed as circulating in the group around Duchamp without really pinning it down to him: I was simply responding to the conditions as I found them. There is only one comment from those days on the *Fountain* which is clearly attributed to Duchamp, and that's the letter he wrote on April 11 to Suzanne in Paris, in which he said that he had entered a porcelain urinal as a sculpture—"nothing indecent." Obviously there are lots of information that may yet turn up. I am hoping that Louise Norton Varèse is going to leave a batch of fascinating documents that one of these days will be made open to us, or that other things will come from who knows whom. Meanwhile that's all we have, and I think you're quite right in pointing out therefore that I tend to circle Duchamp. But I take the fact, that there is not one exception to the aesthetic reading of the urinal among Duchamp's close friends, to be important circumstantial evidence, even compelling. You can go to Louise Norton, or to Beatrice Wood, or to Carl Van Vechten, or to Alfred Stieglitz—anyone who has given us a specific testimony from that time and place. I feel that all those efforts to anthropomorphize the *Fountain* and to speak of its pleasing visual properties reflect something that they picked up from Duchamp. For example, Crotti, in 1916, living with Duchamp, refers to the snow shovel as the "most beautiful object I've ever seen." It just strikes me that when you get a dozen of these, and no exceptions, it must reflect the conversation going on at the café and in the studio, etc. Do you want to pursue that, or shall I go back to your other point which was very important?

ROSALIND KRAUSS

I would say that I don't agree.

DENNIS YOUNG

Can I cut across you because I see Eric Cameron wants to contribute to this?

ERIC CAMERON

Really it's simply to take up the point about the series of works, the replicas. In fact, you have a rather stronger case when you call the urinal a sculpture than when you relate it to photography because of the way in which nineteenth-century sculpture was practiced, with the final responsibility given to a *praticien* who would reproduce the work many times over, either in bronze or in marble. And this applies pretty universally to sculptural practice in the nineteenth-century.

ROSALIND KRAUSS

The *praticien* was also called, by the way, a *reproducteur*. So the notion that practice was taking place at the level of reproduction is there in traditional sculpture (even though it might have been repressed). I'm sorry, this is probably boring everybody, but I think that the banality of the Museum of Modern Art's position is to be found in the way it embraced a machine aesthetic. It was so easy. It was a kind of "okie doke" that American supporters of modernism fell for; it was the marriage between modernism and advertising, packaging—the idea that everything could be beautiful, that you would see beauty everywhere. I can't buy the idea that this is something Duchamp would go for. And so I think your argument, Bill, convicts him through circumstantial evidence. If I were part of a jury I would hold out for better proof than that.

WILLIAM CAMFIELD

I suppose my response is that it strikes me that you're speaking from a standpoint of the twenties and later. Whereas if you go back to 1912 and 1917, Duchamp wasn't falling for anything.

ROSALIND KRAUSS

What about the comb? Do you think the comb is beautiful?

WILLIAM CAMFIELD

Personally I have no strong aesthetic response to the comb, but I hope it will be clear that I think every one of those readymades has interesting visual properties. Whether or not you say it's beautiful, or gross, is to a large extent in your eye. You know, we have the old history of aesthetics problem: is beauty inherent in the object or is it in the eye of the beholder?

MOLLY NESBIT

Let's use common sense. If Duchamp's friends were going to express their approval of his work, would they do it in a language other than that of "beauty"? Probably not. They'd use the language that they'd been using to express their approval for works of art. So "beautiful" is normal, but it's not necessarily an aesthetic certification. And the same would be true for the flowing lines in the Madonnas and the Buddhas. Those are the kinds of things which that group of symbolist-modernist types in America noticed, which they pulled out of modern pictures to make them comprehensible and acceptable. If they were to look at the lines and say "geometric," that would be a problem. They would have to civilize the geometry somehow.

HERBERT MOLDERINGS

I have two questions. The Buddha-Madonna view depends very much on the *Fountain*'s position in the photograph taken by Stieglitz. But you also showed it to us floating in the air (fig. 4.2.) Do you have any explanation of why it's floating in the air and what relation this experience of the object might have to the Buddha-Madonna association? My second question is in relation to the pleasing visual properties. I agree with you that Duchamp was not indifferent to the plastic visual appearance of his objects (I shall try this afternoon to demonstrate that, from quite a different angle), but don't we have to relate the 1917 intervention to the Bourgeois Gallery exhibition of 1916? This would mean that the idea of ready-made sculptures was already tested out in public. Duchamp told interviewers that these two readymades weren't even noticed. You said that we don't know which readymades they were. I have just translated the correspondence between Duchamp and Marcel Jean, and there Marcel Jean quotes information from Man Ray according to which the Underwood typewriter cover and *In Advance of the Broken Arm* were exhibited.[2] Marcel Jean asks Duchamp whether this is right or not. In his reply Duchamp doesn't say specifically that it's right, he doesn't say it's not. So, could it be that a year after the Bourgeois Gallery test he had to choose a stronger piece, with provoking, even appalling rather than pleasing visual qualities, because a snow shovel and even a typewriter cover had proved to be too unremarkable for the American public?

WILLIAM CAMFIELD

First, for the hanging urinal: I have to say that I can't account for that. One can only guess. But the case I presented dealt a lot with Stieglitz's photograph, and frankly I must say that I can't be sure—or that we can't be sure—of who really controlled that photograph in the end. Was it Stieglitz or Duchamp? Obviously they had a long discussion. It's conceivable that Stieglitz had a heavier and Duchamp a lesser role. There are other arguments about other works which indicate that maybe Duchamp didn't have the idea, but that he simply accepted it and liked the interpretation. Duchamp often endorsed the spectator. My guess is that Duchamp had more of an input in this case, but I really don't know. It's the same with the urinal hanging in the studio. Is it related to the *Pendu femelle,* which would be a quick association? But if so, then why is he later associating it with a masculine object? It appears in the bachelor realm of the *Large Glass* (fig. 4.22).[3] In short, I think what we're left with is a very complicated situation with possible interchanges of male-female positions, or roles, which is bedazzling. And I don't purport to have the answers to that. Now, to address the issue of the previous exhibitions of the readymades and their possible intention to revolt: yes, I think that when he went after this *Fountain,* Duchamp must have been aware that he was going to provoke and challenge. As I said in my talk, I think he may still have had that 1912 Independents' exhibition in his mind. In the sixties when I talked to him he was still bitter about that. I think he wanted to test these Independents, and he found a way to do it. So I don't deny that, but I also maintain the position that he didn't pick just any urinal. If it were only that, then he could have picked other offensive objects. Why a urinal, why this particular one?

DENNIS YOUNG

Time is running out, and perhaps we should leave it at that, until we address ourselves to the paper given by Thierry de Duve, which is very much on the topic of Duchamp testing the Independents.

1 Jean Clair, *Duchamp et la photographie* (Paris: Chêne, 1977); Rosalind Krauss, "Notes on the Index."

2 Marcel Duchamp, *Letters to Marcel Jean,* 77.

3 As is clear from his contribution, William Camfield is actually referring to the *Box-in-a-Valise,* where a miniature replica of the urinal is put alongside the lower part of a reproduction of the *Large Glass,* and a small *Paris Air* vial alongside its upper part, with a miniature replica of the typewriter cover next to the horizon line, or Bride's garment. He may also be referring to Ulf Linde's installation of these three readymades for the 1963 Stockholm exhibition.

THIERRY DE DUVE

Given the Richard Mutt Case

Translated by the author
Translation revised by Judith Aminoff
and Lynne Cohen

Given, first, the waterfall, second, the lighting gas, in the dark, we shall determine the conditions for the instantaneous state of Rest—or extra-quick exhibition, or allegorical appearance—of a succession of news items—or of several collisions, or of several assaults—seeming to necessitate each other under certain laws, in order to isolate the sign of accordance between, on the one hand, this state of Rest, capable of all the innumerable eccentricities, and, on the other, a choice of possibilities legitimated by these laws and also occasioning them. Nothing perhaps.

In this collage of quotations, you may have recognized the *Preface* from the *Green Box* and the *Notice* (better translated as *Warning*) to the *Large Glass* (figs. 5.1 and 5.2).[1] They sound like a mathematical theorem, assigning a task to the reader: *we shall determine the conditions . . . in order to isolate the sign of accordance.* The starting point is given, yet it allows for alternative readings, since the invisible waterfall of the *Large Glass* is not the same as that which sparkles in the background of *Étant donnés*, and since the Bride's *oculist witnesses* are not dazzled by the same *bec Auer* when they are lost in transparency as they are when framed by a brick doorframe. Here is still another reading, prompted by the humorous cross-references among Duchamp's works: *given*, first, by way of *waterfall*, a certain famous *Fountain* in the guise of a urinal signed R. Mutt; second, by way of *lighting gas*, the name "art" that enlightens this fountain with its aura, *we shall determine the conditions for the instantaneous state of Rest—or extra-quick exhibition . . . ,* etc.

One by one, the terms of the theorem should be clarified. Duchamp's urinal, as we know, has vanished. All that remains are the replicas made by Sidney Janis in 1950, by Ulf Linde in 1963, and by Arturo Schwarz in 1964, and also, of course, the photograph taken by Alfred Stieglitz in 1917. For us, now, this photograph is the *instantaneous state of Rest* of the urinal, the proof that the title *Fountain* once had a referent. For the public, in 1917, this same photograph was the urinal's *extra-quick exposure*—and ultraconfidential exhibition—in the little magazine *The Blind Man*, where it appeared. *Instantaneous state of Rest* and *extra-quick exposure*, or *exhi-*

Préface

Etant donnés 1° la chute d'eau
2° le gaz d'éclairage,

~~on déterminera~~
nous déterminerons les conditions
du Repos instantané (ou apparence allégorique)
d'une succession [d'un ensemble] de faits divers
semblant se nécessiter l'un l'autre
par des lois, pour isoler le signe
de la concordance entre, d'une part,
ce Repos (capable de toutes les excentricités innombrables (?))
et, d'autre part, un choix de Possibilités
légitimées par ces lois et aussi les
occasionnant.

Par repos instantané = faire entrer
l'expression ~~extra rapide~~

On déterminera les conditions de [la] meilleure
exposition du Repos extra rapide [de la
pose extra rapide (= apparence allégorique)
d'un ensemble etc.

non peut être.

Avertissement

Étant donnés [dans l'obscurité] 1°- la chute d'eau
Soit, donnés ✳ 2°- le gaz d'éclairage, dans l'obscurité

? ⟷ ?

on déterminera les conditions de l'exposition
Reproduction allégorique
extra rapide (= apparence allégorique) de plusieurs
collisions semblant se succéder rigoureusement
[attentats]
chacune à chacune suivant des lois, pour
isoler le signe de la concordance entre cette
exposition extra-rapide (capable de toutes les
excentricités) d'une part et le choix des possi-
bilités légitimées par ces lois d'autre part.

Comparaison algébrique
$$\frac{a}{b}$$
a étant l'exposition
b " les possibilités

le rapport $\frac{a}{b}$ est tout entier non pas dans un
nombre
~~chiffre~~ c $\frac{a}{b}$=c mais dans le signe (—) qui sépare
a et b ; a et b dès que sont connus, ils deviennent
nouvelles relatives
des unités et perdent leur valeur numérique (ou de durée)
; reste le signe — qui les séparait (Signe de la
concordance ou plutôt de chercher)

bition, are also called, in Duchamp's *Preface* and *Warning*, *allegorical appearance*. The appearance of what? Of *a succession of news items . . .* With good Duchampian logic, to determine the conditions of an *appearance* is to explain the *apparition which is its mold*.[2] So the problem becomes more precise: *we shall determine the conditions of the allegorical appearance* (or look) of Stieglitz's photograph by explaining the *apparition* (or advent) of a *succession of news items*.

The Richard Mutt case didn't really make the news in 1917. But it is *a succession of news items* that we must explain rather than any one single item: *several collisions seeming strictly to succeed each other according to certain laws . . .* We are dealing with an organized series of events, each involving the random collision of two independent causal chains, like a succession of chance encounters: the readymade, Duchamp said elsewhere, is *a kind of rendezvous*.[3] *Fountain* is not the first of the readymades. On the contrary, it is one of the last "unassisted" ones. Nor was this the first time that a readymade had a rendezvous with its spectators. The succession of news items that needs to be explained thus recedes in time, preceding the *Fountain*. And since these items *seem to necessitate each other under certain laws*, we must look back in time in order to identify these laws, starting with the one whose appearance (or look) the Richard Mutt case dissipates and whose conditions of apparition (or advent), in April 1917, at the first exhibition of the Society of Independent Artists, Inc., it reveals.

The law in question, the one that *legitimates and occasions a choice of possibilities*, is simply stated: anyone can be an artist. It follows directly though perhaps unwittingly from the bylaws of the Society, founded in December 1916 in New York. Article II, section 3 of the bylaws stated that "Any artist, whether a citizen of the United States or of any foreign country, may become a member of the Society upon filing an application therefor, paying the initiation fee and the annual dues of a member, and exhibiting at the exhibition in the year that he joins."[4] Sections 4 and 5 specified that the initiation fee would be one dollar and the annual dues five dollars. Notice that the bylaws spoke of "any artist" without indicating how artists are recognized as such—probably by having paid their six dollars and by having exhibited in the year they join. Thus the Society seemed ready, *in advance*, to grant, *with all kinds of delays*, the status of artist to anyone fulfilling those two conditions. Being an artist was cheap

enough and exhibiting was no problem.[5] The famous rule—or no-rule rule— of "No jury, no prizes" was not in the bylaws, but it was commented upon at length in the Foreword to the catalogue of the first exhibition, which opened on April 10, 1917. This stated that the Society was founded "for the purpose of holding exhibitions in which all artists may participate independently of the decisions of juries."[6] This was of course intended to free artists from the extremely conservative juries of the National Academy of Design, until then the only institution in America handing out certificates of legitimacy to anyone seeking the status of professional artist. The Society had no social mandate other than the one with which it was endowed by its members, who, in return, had no proof that they were artists other than their membership card. Individually or as a group, the Independent Artists had only the legitimacy they gave themselves through self-proclamation.

The quantitative success of the Big Show in 1917 proves the theory of self-proclamation. Some 2125 works by 1235 artists were shown. There is no doubt that given such numbers, the majority of the participants were amateurs or would-be artists whom a jury or a commercial gallery would never have accepted.[7] The list of names tells us nothing, of course, since it consists mainly of names unknown and soon to vanish. But the fact that as many as 414 women were included, compared to 821 men, is a good indicator of the proportion of nonprofessionals among men and women alike, given the hardly advanced state of women's emancipation at the time.[8] So Richard Mutt was in good company, an unknown among all the unknowns who grabbed their chance to call themselves artists. But Richard Mutt was soon to become famous while all the others would revert to anonymity. And the paradox is that they had exhibited whereas Mr. Mutt's entry was censured, put behind a partition, surreptitiously stolen, rejected on a technicality by Rockwell Kent, broken by William Glackens or bought away by Walter C. Arensberg—we'll probably never know, among all equally fantastic versions of the facts, which is the right one.[9] In any case, *Fountain* was neither seen by the public nor listed in the catalogue. A press release was issued by the board of directors on the day following the opening, leaving no doubt as to the fate of the controversial object: "The *Fountain* may be a very useful object in its place, but its place is not an art exhibition and it is, by no definition, a work of art."[10] By no definition indeed, except the one following from the very principles that the Society

had set for itself and then immediately betrayed at the start of its career. The board of directors must have thought that art can be defined only through comparison, and that a urinal cannot be compared with anything known by the name of art.

In the *Green Box*, the *Preface* and the *Warning* are immediately followed by a note entitled *Algebraic Comparison*. Here it is: *a/b, a being the exhibition, b being the possibilities, the ratio a/b is in no way given by a number c (a/b = c) but by the sign (/) which separates a and b; as soon as a and b are known they become new units and lose their numerical relative value (or value in duration); what remains is the sign (/) which separated them (sign of the accordance or rather of . . . ? . . . look for it.)*[11]

A and *b* are known (*a being the exhibition, b being the possibilities*). For the multitude of nobodies who seized their chance to proclaim themselves artists, the ratio *a/b* represents the relation between what they exhibited— in principle, anything—and the possibilities of exhibition offered to anyone. The ratio *a/b* expresses that formula through which the Society performed its self-legitimation. It is the relation of the founding exhibition of 1917 to the "No jury, no prizes" statutory law that it gave itself. In short: *a/b* equals "anything to anybody." But, as we read in the "Algebraic Comparison," *as soon as a and b are known they lose their value in duration*. Indeed, this verdict is ironically confirmed by the fact that after the first exhibition of 1917, which was a great success, never again would the Society of Independent Artists, which remained in existence until 1944, produce an event worthy of remaining in the history books of modern art. By contrast, it is when *a* and *b* are unknown—unknown, that is, to their contemporaries, since to us they are given—that the ratio *a/b* retains its value in duration; *a*, this time, which I'll call *a′*, being the *extra-quick exhibition capable of all the eccentricities*—in this case that of exhibiting a urinal—and *b*, which I'll call *b′*, being *the possibilities* that the Society denied to the only individual who took the formula of its self-legitimation literally, the mysterious R. Mutt. Indeed, this verdict has been confirmed by history, with all the required *ironism of affirmation*.

I have just said "by contrast." I could have said "by comparison." In itself, the ratio *a/b* does not yet constitute an *algebraic comparison*, even in "amusing algebra."[12] But we know from other sources what the canonical

Duchampian formula is for the amusing algebraic comparison: *"Arrhe est à art ce que merdre est à merde."* (Arrhe is to art what shitte is to shit.)[13] Duchamp even put it in an explicitly algebraic form:

$$\frac{arrhe}{art} = \frac{merdre}{merde}$$

The general formula thus reads: $a/b = a'/b'$. And here is one concrete implementation of it: by way of "arrhe" any object shown at the Independents', for example *Nice Animals* by Rockwell Kent, Jr., aged eight;[14] by way of "art" the art institution called Society of Independent Artists when it respects the liberal principle legitimating it; by way of "merdre" *Fountain*, of course; and by way of "merde" the same institution when it fails to abide by the same principle. The relation a/b, which in 1917 was legitimate in the eyes of the Society, is equivalent to the relation a'/b', which was not but which has since become legitimate, *with all kinds of delays*. This now remains to be demonstrated.

Today everyone knows that the mysterious R. Mutt was none other than Marcel Duchamp, and that he enjoyed a prominent institutional position in the Society. His name is among those of the twenty founders, on whom he no doubt exercised a determining influence. He is said to have proposed that the works be hung in alphabetical order, starting with a letter drawn out of a hat, which earned him the nomination as chairman of the hanging committee, assisted by Rockwell Kent and George Bellows. Exactly one year before, Duchamp had exhibited two (unidentified) readymades in the "Exhibition of Modern Art" at the Bourgeois Galleries, and in the "Four Musketeers Show" at the Montross Gallery he had shown the assisted readymade *Pharmacie*, 1914. On the whole, the press had been silent and the readymades received no public notice. Bellows, Glackens, Kent, and company had probably not visited those shows; otherwise a year later they would have guessed who was the culprit. It seems that in April 1917 even the organizers of the Independents' show were unaware of who has hiding behind R. Mutt. Upon learning the fate of Mr. Mutt's entry, Duchamp

immediately resigned from the board of directors, but even his resignation aroused little or no suspicion among the organizers. He had resigned on a matter of principle and out of solidarity with an unjustly ostracized fellow artist. Perhaps he had embraced Mr. Mutt's cause with too quixotic an enthusiasm, but he had done so in good faith. In spite of the press release, the newspapers remained silent, by and large. The rare accounts of an inside scandal occurring at the Indeps—as the press familiarly called the Independents—mentioned an unspecified "bathroom fixture" or "a familiar article of bathroom furniture," with not even a hint at who its author might have been, even though Duchamp's resignation over it was taken up as juicy gossip by at least two reviewers.[15] If the journalists had known what exactly this "bathroom fixture" was, if they had learned or even guessed Mr. Mutt's identity, they would certainly have reveled in that *news item*. In fact, there was no public scandal. Duchamp himself took great care to see that nobody except his immediate accomplices would be informed, even to the point of writing to his sister Suzanne, on April 11: "One of my female friends under a masculine pseudonym, Richard Mutt, sent in a porcelain urinal as a sculpture."[16] Though some were shown in 1916, the readymades began their paradoxical public career only at the Independents' Show, where nobody saw R. Mutt's ready-made urinal. More subsequent *news items* would be necessary for that career to really surface. Meanwhile, there was another paradoxical effect: in spite of the urinal's invisibility, or rather thanks to it, the Society was able to retain its legitimacy. With the ready-mades' public appearance remaining underground—an *apparition*—the Society was spared open ridicule. And, more importantly, the betrayal of its principles was kept safe from public critique. Thus, the liberation of all the artists, known or unknown, serious or spurious, who were until then oppressed by the juries of the National Academy, was real. In the days following the United States' declaration of war, no troublemaker was going to cast doubt on the way America obeyed President Wilson's watchword, "The world must be made safe for democracy."

Duchamp's tact, here, was both exquisite and cruel. He graciously avoided posing as a martyr and provoking a "Salon *du* refusé."[17] But he made sure that others did it for him, at the denouement, when the show's success was secure and the organizers' righteousness was no longer in peril. His politeness was matched only by his revenge, and the coup was carefully planned.

On the day of the opening, or perhaps a few days later, the first issue of a small satirical magazine entitled *The Blind Man* came out. It was announced as the *Independents' Number* on the cover, and it was adorned with a caricature by Alfred Frueh representing a blind man guided through a painting exhibition by his dog (fig. 5.3).[18] The sarcasm is mild, yet the cover seems to say that the public is blind to modern art, an opinion echoed in the magazine by the poet Mina Loy, who stated (p. 7): "Only artists and serious critics can look at a greyish stickiness on smooth canvas." This opinion apparently reflected that of the professional critics, most of whom considered the general public incapable of making sound judgments and took the absence of a jury—even worse, the hanging in alphabetical order—as a denial of their mission. As Francis Naumann remarks, one of their frequent rationales in discrediting the Indeps was the following: what would happen if magazines accepted everything submitted to them for publication?[19] With this remark as background, R. Mutt's sweet revenge begins to appear. *The Blind Man, Independents' Number* had been concocted by a merry threesome nowhere identified as such:[20] Henri-Pierre Roché, Beatrice Wood, and Marcel Duchamp. Significantly, however, the readers were called upon to make the next number. This "notice" (or was it a "warning"?) was printed on the cover: "The second number of The Blind Man will appear as soon as YOU have sent sufficient material for it." And Roché's editorial explained what the procedure was to be (p. 4): "The Blind Man's procedure shall be that of referendum. He will publish the questions and answers sent to him. He will print what the artists and the public have to say. He is very keen to receive suggestions and criticisms. So, don't spare him." The editors would exert no selection on the articles. Just as anyone having paid his or her six-dollar dues would become an artist in the Society, so—as Beatrice Wood recalls in her memoirs—anyone having contributed four dollars toward the budget of *The Blind Man* would become an art critic.[21] The second issue came out around May 6, when the show closed, and this time its editors were identified on the cover, but with three initials as cryptic and pseudonymous as the "R" in R. Mutt: P.B.T., standing for (Henri-) Pierre (Roché), Beatrice (Wood) and Totor, diminutive of Victor, the nickname Roché had given to Duchamp (fig. 5.4). On the cover there was a reproduction of Duchamp's *Chocolate Grinder,* which the hanging committee would certainly have accepted, and inside the magazine (pp. 4–5) an unsigned contribution entitled "The Richard Mutt Case" revealed the

5.3
The Blind Man, no. 1, April 1917. Cover,
11¼ × 8³⁄₁₆ in. (Philadelphia Museum of
Art; The Louise and Walter Arensberg
Archives.)

mysterious R. Mutt's first name (fig. 5.5). Though it was probably Beatrice Wood who wrote the piece more or less under Duchamp's dictation (and rather more than less), it was supposed to have been written by "a reader" (thus, by a visitor to the show), who was blind, since he or she had not been able to see the urinal, but who nevertheless authenticated Mr. Mutt's signature by completing his first name, thereby making the hitherto unknown artist into an unrecognized artist.[22]

So someone apparently knew this R. Mutt from Philadelphia. The *Blind Man*'s readership learned that his name was not Ralph or Robert but Richard. Whereas very few people knew or even guessed that Mutt was in fact Duchamp, quite a few people had made the association with the famous cartoon characters Mutt and Jeff and had drawn the conclusion that the urinal must have been a joke. But now the joker became somebody, acquired an identity, proved that he had friends and defenders among the readers-writers of *The Blind Man*. More and more, his case resembled that of Louis Eilshemius, who was showing two paintings at the Independents, entitled *Supplication* and *The Gossips* (fig. 5.6).[23] Eilshemius was quite a character in the New York artworld. Born in 1864 into a wealthy family, this skilled painter in the Hudson River tradition, influenced by Corot, Innes, and Ryder, gradually fell into pathetic dementia and delusions of grandeur following a tragic love affair in his youth. In spite of promising debuts in 1887 and 1888, thereafter he was systematically turned down by the National Academy. By 1910–1912, he was poor; his style had become hallucinatory and repetitive, his subject matter obsessed with impotent eroticism, and his technique crude and uncontrolled. With sometimes surprisingly fresh directness, he began painting his deranged visions on roughly cut pieces of cardboard, lids of cigar boxes, and the like, unaware of the vague kinship of his work with the recent experiments of Fauvism and Cubism. After being rejected from the Armory Show in 1913, his previously mild paranoia took a more aggressive turn, and he soon became a celebrity of sorts, notorious for touring the New York galleries, hurling invectives at anything they were showing, especially modern art, and handing out extravagant pamphlets in which he claimed his unrecognized genius. Self-proclaimed "painter, poet, musician, inventor, linguist, mystic, educator, prophet, etc." (as one of those pamphlets stated), he was constantly bombarding the critics, especially Henry McBride at the *New York*

P · B · T

THE BLIND MAN

33 WEST 67th STREET, NEW YORK

BROYEUSE DE CHOCOLAT Marcel Duchamp

MAY, 1917 *No. 2* *Price 15 Cents*

5.4
The Blind Man, no. 2, May 1917. Cover,
11 1/16 × 8 1/16 in. (Philadelphia Museum of
Art; The Louise and Walter Arensberg
Archives.)

THE BLIND MAN

The Richard Mutt Case

They say any artist paying six dollars may exhibit.

Mr. Richard Mutt sent in a fountain. Without discussion this article disappeared and never was exhibited.

What were the grounds for refusing Mr. Mutt's fountain :—

1. *Some contended it was immoral, vulgar.*

2. *Others, it was plagiarism, a plain piece of plumbing.*

Now Mr. Mutt's fountain is not immoral, that is absurd, no more than a bath tub is immoral. It is a fixture that you see every day in plumbers' show windows.

Whether Mr. Mutt with his own hands made the fountain or not has no importance. He CHOSE it. He took an ordinary article of life, placed it so that its useful significance disappeared under the new title and point of view—created a new thought for that object.

As for plumbing, that is absurd. The only works of art America has given are her plumbing and her bridges.

"Buddha of the Bathroom"

I suppose monkeys hated to lose their tail. Necessary, useful and an ornament, monkey imagination could not stretch to a tailless existence (and frankly, do you see the biological beauty of our loss of them?), yet now that we are used to it, we get on pretty well without them. But evolution is not pleasing to the monkey race; "there is a death in every change" and we monkeys do not love death as we should. We are like those philosophers whom Dante placed in his Inferno with their heads set the wrong way on their shoulders. We walk forward looking backward, each with more of his predecessors' personality than his own. Our eyes are not ours.

The ideas that our ancestors have joined together let no man put asunder! In *La Dissociation des Idées*, Remy de Gourmont, quietly analytic, shows how sacred is the marriage of ideas. At least one charming thing about our human institution is that although a man marry he can never be *only* a husband. Besides being a money-making device and the *one* man that *one* woman can sleep with in legal purity without sin he may even be as well some other woman's very personification of her abstract idea. Sin, while to his employees he is nothing but their "Boss," to his children only their "Father," and to himself certainly something more complex.

But with objects and ideas it is different. Recently we have had a chance to observe their meticulous monogamy.

When the jurors of *The Society of Independent Artists* fairly rushed to remove the bit of sculpture called the *Fountain* sent in by Richard Mutt, because the object was irrevocably associated in their atavistic minds with a certain natural function of a secretive sort. Yet to any "innocent" eye

1916 Rose Marie Eilshemius

5.6
Louis Eilshemius, *Rose Marie Calling (Supplication)*, 1916. Oil on board, 61 × 40½ in. (Collection Roy F. Neuberger, New York; photo Geoffrey Clements.)

Sun, with complaint letters, of course to no avail. Everybody gossiped about him, nobody took him seriously, no gallery was showing him.[24] With the Independents, he was at last given a chance to proclaim himself an artist to the entire universe and to demonstrate his mighty talents. He grabbed it twice, since he participated in the show and since *Supplication* was reproduced in *The Blind Man.* Moreover, truthful to Roché's promise that *The Blind Man* "will print what the artists and the public have to say," the editors granted him an interview. He was at last vindicated.

But Eilshemius's interview in *The Blind Man* demands closer attention. It was published under the French title "Pas de commentaires! Louis M. Eilshemius," and it strikes a note quite different from everything else in the magazine. The "reader" who sent it in was Mina Loy, the poet, occasional painter (she had a piece in the Indeps), and mistress of Arthur Cravan. She was close to the editorial group P.B.T.—perhaps, after all, no closer than Louise Norton or Clara Tice, but still her role seems to have been more pointed than that of other "readers." She had been the only contributor to the first issue of *The Blind Man* besides P.B.T themselves: in a very interesting piece, she had protested against "Education . . . [which] demands an art that is only acknowledgeable by way of diluted comparisons," and she had advocated "pure uneducated seeing" as the only vital—alas only remotely probable—meeting point between "The Artist" and "The Public" (p. 7). In the second issue she conducted the interview with Eilshemius and wrapped it in some critical comments of her own, the title "Pas de commentaires!" notwithstanding. Not surprisingly, what she sees in Eilshemius is a true "naïf" blessed with "pure uneducated seeing." Yet the very construction of her text belies this seemingly genuine enthusiasm. Her flattering comments are abruptly interlarded with excerpts from the interview in such a way that Eilshemius, whom she compares to an American Douanier Rousseau, appears grossly naïve indeed. It is hard not to read Mina Loy's article as if her pen had been at times held by another hand, almost sarcastic in a deadpan fashion. Consider the following passage, in which Eilshemius's mad ambition is simply sandwiched between two admiring lines by Mina Loy as if nothing peculiar had happened: "Hopefully inspired by the granite simplicity of the painter's speech I asked him if he ever wrote. 'Don't you know who I am?', he gasped. 'Louis M. Eilshemius, M.A., Supreme Protean Marvel of the Ages. The Peer of all who create Painting, Literature and Music.' As I am used to do in reading

I found by intuition the finest passages while skimming the volumes handed to me: . . ." (p. 11). And she goes on to cite these "finest passages," one bland poem after another, until, with no transition whatsoever, she abruptly concludes her piece with this line: "Anyhow, Duchamp meditating the levelling of all values, witnesses the elimination of Sophistication" (p. 12).

This is quite a comment with which to end a piece entitled "Pas de commentaires," and there is little doubt in my mind as to whose very sophisticated hand was guiding Mina Loy's pen when she wrote it. She virtually acknowledged his identity in her conclusion. Eilshemius's reha-bilitation was the exclusive and cruel work of Marcel Duchamp, who had announced on opening night that, together with Dorothy Rice's *Claire Twins*, *Supplication* was the best painting in the show. Though Duchamp would develop sympathy for Eilshemius later on, in the context this was a rather ruthless and ironic compliment. One need only glance at the gro-tesque *Claire Twins* to be convinced of this (fig. 5.7). In the climate of worship surrounding him, Duchamp's verdicts were oracles, so that thanks to him Eilshemius got his fifteen minutes of fame and became a footnote in art history books. The poor Eilshemius was being manipulated, and it was Richard Mutt, alias Marcel Duchamp, who was pulling the strings.

In 1917, and only then, the Independents published two catalogues, one illustrated, the other not. For the price of four dollars—the same sum required for publication in *The Blind Man*—all members could have one of their works on view reproduced in the illustrated catalogue, and thereby make history. Sure enough, Eilshemius saw to it that *Supplication* was reproduced. Thus it was shown three times: in the show, where the painting was claimed to be art by the painter; in *The Blind Man*, where it was "selected" by the critics; and in the catalogue, where it was posing for posterity. *Fountain*, the work sent in by R. Mutt, was ushered out of the show and was not cited, let alone reproduced, in the catalogue. Everything was done to prevent it from making history. Word went around but the press didn't bother to really investigate, and the show ended without incident. Only with the epilogue did *The Blind Man* open "The Richard Mutt Case." But the party was over and a scandal at the Indeps would have been stale news, if it reached the press at all. The circulation of the little magazine was confidential and its distribution inefficient; its content smacked of jokes and its editors were not credible. Duchamp, who even

5.7
Dorothy Rice, *The Claire Twins*. Reproduced in *The New York Sun*, April 15, 1917. (Photo The Beinecke Rare Book and Manuscript Library, Yale University.)

then still concealed Richard Mutt's true identity, graciously remained aloof from the whole affair. He knew that his "bathroom fixture" would not land in the dustbin of history. He had arranged that "The Richard Mutt Case" be accompanied by a photographic reproduction that revealed what kind of bathroom fixture it actually was. To make sure the photograph referred to *Fountain by R. Mutt*, it was captioned as THE EXHIBIT REFUSED BY THE INDEPENDENTS and duly credited to its author: *Photograph by Alfred Stieglitz* (fig. 5.8).

The manipulation of Eilshemius was merely cruel, but that of Stieglitz was a stroke of genius. The Stieglitz gang and the Arensberg gang didn't mingle much at the time; Duchamp was not on such good terms with Stieglitz; and from Duchamp's circle, only Picabia was a close friend of the photographer. Nevertheless, not only did Stieglitz take a photograph of the *Fountain*, but he also contributed a letter to *The Blind Man*, dated April 13, where he maintained that all entries to the Independents should be anonymous, and on the 19th he wrote to Henry McBride, the *Sun's* critic: "I wonder whether you could manage to drop in at 291 Friday some time. I have, at the

request of Roché, Covert, Miss Wood, Duchamp & Co., photographed the rejected Fountain. You may find the photograph of some use. It will amuse you to see it. The Fountain is here too."[25] Apparently McBride didn't take his cue, nor did he react to a similar letter from Charles Demuth, who had tried to attract the critic's attention to the Society's betrayal of their principles and had given him other important clues, namely Duchamp's and Richard Mutt's (actually Louise Norton's) telephone numbers.[26] All this confirms that not only McBride but also Stieglitz were unaware of Richard Mutt's real identity.[27] Beatrice Wood recalls that Stieglitz agreed to photograph the *Fountain* "at Marcel's request," but it was probably thanks to her intervention, for she recorded in her diary entry for April 13: "See Stieglitz about 'Fountain'."[28] In any case, "Duchamp & Co." appear only last on the list of names Stieglitz mentioned in his letter to McBride. His complicity in the Richard Mutt Case is all the more startling when we remember that, at the time, he tended to consider Duchamp as a charlatan. But according to Beatrice Wood, again, he "was greatly amused" and "felt it was important to fight bigotry in America. He took great pains with the lighting, and did it with such skill that a shadow fell across the urinal suggesting a veil."[29] As William Camfield has demonstrated, he photographed the urinal in front of a painting by Marsden Hartley entitled *The Warriors*, setting its smooth curve against a similar ogival shape and flanking it by two flags in the painting, a mise-en-scène certainly meant to symbolize his fight against "bigotry in America."[30] The surprising thing with this photograph is not so much that Stieglitz annexed the urinal to his own aesthetics of symbolist correspondences—he did that even with the works he was showing at 291—but that Duchamp let him do it. And when, thanks to that photograph, the piece was redubbed "Buddha or Madonna of the Bathroom"—associations hardly congenial with Duchamp's own aesthetics and in any case quite alien to the testing of the Independents' liberalism, which was the real purpose of the urinal—he did not bat an eye. He could afford to let "the onlookers make the paintings" and Stieglitz turn a urinal into a Buddha, since his own strategy was of a very different nature. Stieglitz was to play a quite involuntary role in it.

Why did Duchamp go to the trouble of calling on Stieglitz for a photograph in the first place? If he simply wanted a photograph, he could have turned to just any photographer. In fact, the photographer had to be Stieglitz for

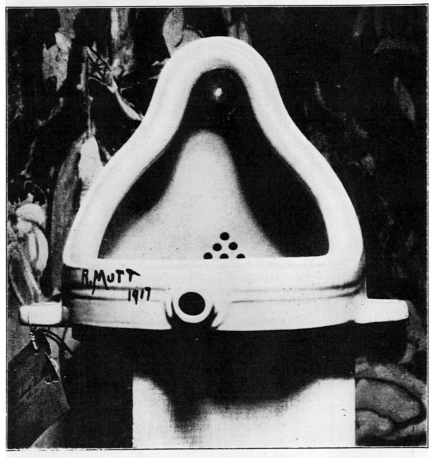

THE EXHIBIT REFUSED BY THE INDEPENDENTS

5.8
The Blind Man, no. 2, May 1917. Interior page, 11¼ × 8³⁄₁₆ in. (Philadelphia Museum of Art; The Louise and Walter Arensberg Archives.)

another reason: he was the owner of The Little Galleries of the Photo-Secession, otherwise known as Gallery 291. Stieglitz agreed to take the picture, and his defense of Richard Mutt proved to be absolutely candid. He was sincerely shocked that the Independents were betraying the principles they had set for themselves, and when he leaked the information to McBride, he enjoyed repaying them in their own coin. For Stieglitz believed in the independence of the Independents. He was participating in the show with two already famous photographs, *The Steerage* and *The Hand of Man*, and his complete gallery stable was accompanying him: John Marin, Charles Demuth, Arthur Dove, as well as Marsden Hartley and Georgia O'Keeffe, whose initiation fees he had paid himself. Stieglitz was elitist and purist when it came to his own gallery, but he was a libertarian when it came to

group shows. On the aesthetic level he didn't expect much from them, but he had already learned from the Armory Show that they were beneficial to the cause of modern art in America. The letter he contributed to *The Blind Man* one or two days before he was contacted by "Roché, Covert, Miss Wood, Duchamp & Co." (the only letter, by the way, that appears to have been a straight and earnest response to Roché's invitation to comment on the Indeps) is extremely telling. When he asked whether it wouldn't "be advisable next year during the exhibition, to withold the names of the makers of all work shown" (p. 15), he was stating his ethics, not defending his aesthetics. For the latter he had *Camera Work* and 291. In his gallery he was a dealer and the defender of a certain taste. Here he was a moralist: "In thus freeing the exhibition of the traditions and superstitions of names the Society would not be playing into the hands of dealers and critics, nor even into the hands of the artists themselves." In such an anonymous system, he seemed to imply, a Richard Mutt affair would not occur. An artist relying on pseudonyms and jokes in order to stir up a scandal would be as unlikely as an artist banking on his already acquired fame. Rather, "each bit of work would stand on its own merits. As a reality. . . . The Independent Exhibition should be run for one thing only: The independence of the work itself." And he concluded his piece by thus completing the Independents' motto: "NO JURY—NO PRIZES—NO COMMERCIAL TRICKS."

How ironic! This was written on April 13. The next day or the day after, Stieglitz fell prey to a particularly shrewd institutional (if not commercial) trick, one that, far from freeing the unknown R. Mutt's entry from the "superstition of names," would bestow on it the authority of the photographer's—and art dealer's—own name and fame. Stieglitz, any more than Eilshemius, didn't understand that Duchamp was using him. By photographing the *Fountain*, by inviting McBride to come to see it in his gallery, he was actually endorsing it in a roundabout way, as though it had been exhibited at 291, as though Duchamp had been among his protégés instead of compromising himself with minor artists such as Rockwell Kent or teaming up with clowns such as Arensberg and Man Ray.[31] Though Stieglitz was amused at the prospect of sanctifying the rejected *Fountain*, turning it into a Buddha or a Madonna, he didn't realize that in doing precisely that he was giving it the aura of a full-fledged work of art and that, by veiling the urinal with his own symbolist taste, he was shifting his defense of

Richard Mutt from ethical to aesthetic ground. Stieglitz didn't understand that the function of the urinal's photograph was not to feed an immediate press scandal but to put *Fountain*, whose very existence could be doubted were it not for this photograph, on the record for subsequent art history.

There it is, on the record, in art history books. Stieglitz's photograph concludes the transformation of the Richard Mutt case into a fait accompli. *A/b* and *a'/b'*, in and by themselves merely two *news items*, two *collisions* between an object and an institution, two encounters which in *appearance* cannot be equated to each other, are tied together in the equation of their *apparition: a/b = a'/b'*. This equation shows itself to be true, provided one notices that it is established only through the intervention of *a succession of news items seeming to necessitate each other under certain laws*, or rather, under a single law, which is nothing but the *algebraic comparison* itself. Let us envisage the following chain of encounters. Since the editorial board of *The Blind Man* mimics and parodies the democratic rule of the Independents' hanging committee, Eilshemius's painting, *Supplication*, as shown in the exhibition, is equivalent to its reproduction as shown in *The Blind Man*. Both relations are legitimate in the eyes of their respective committees. The formula of the first *news item* would thus read:[32]

$$\frac{Supplication}{\text{N.Y. Indeps}} = \frac{Reproduction\ of\ Supplication}{\text{The Blind Man}}$$

Since *The Blind Man* prints the reproduction of *Supplication* and the photograph of *Fountain* on equal footing, as well as, by the way, Joseph Stella's *Coney Island* and Marcel Duchamp's *Chocolate Grinder*, the respective relations of both reproductions to their medium are equivalent. Thus, the formula of the second *news item* would be:

$$\frac{Reproduction\ of\ Supplication}{\text{The Blind Man}} = \frac{Photograph\ of\ Fountain}{\text{The Blind Man}}$$

Since Stieglitz, who is the author of the photograph, falls into the trap and more or less unwittingly endorses Richard Mutt, the legitimation of the

object "Photograph by Alfred Stieglitz" by P.B.T., the editorial board of the magazine, is equivalent to that of the object that is its referent, *Fountain*, by Gallery 291. So we would have:

$$\frac{\textit{Photograph of Fountain}}{\text{The Blind Man}} = \frac{\textit{Fountain}}{291}$$

It follows, in algebra (even in "amusing" algebra, $a/b = a'/b'$ can be rewritten as $a/a' = b/b'$), that *Supplication* by Louis Eilshemius is to *Fountain* by Richard Mutt what the Society of Independent Artists is to Gallery 291:

$$\frac{\textit{Supplication}}{\textit{Fountain}} = \frac{\text{N.Y. Indeps}}{291}$$

Such is the *algebraic comparison* that, in the eyes of history, legitimates the difference between putative Art and provocative "non-art," between a self-proclaimed genius and the great *anartist* of the century, between Eilshemius, who claimed that "the artist . . . requires no instructor, no critic, no public, to certify that the result of his efforts is Art"[33] and Duchamp, who said, "it's the onlookers who make the paintings." Such a difference, however, is beyond formal or "retinal" appearances. Why would a urinal be better art than a fat nude, even clumsily painted? On its own it is not art at all. Only in its *allegorical appearance* is Richard Mutt's urinal art, and there is no allegory that does not refer formal appearance back to the *apparition which is its mold*. And there are differences in the "molds" too—the difference for example between a Society of independent, that is, self-proclaimed, artists and a small, very selective modernist gallery run by a man who is a prominent modernist artist himself. Yet this difference on its own is no guarantee either. Why would a democratic grouping of free individuals produce art of ipso facto inferior quality to that which has been screened by the trained eye of a dealer less interested in commerce than in purist aesthetics? The *algebraic comparison* requires that all four elements of the equation be balanced against each other, and this comparison is anything but "diluted," as Mina Loy had said in her diatribe against

education. To acknowledge *Fountain* as (good) art is not to compare it visually to the art of the past, and to reject *Supplication* as bad painting is not to despise "pure uneducated seeing." Rather, it is to take stock of differences in strategies: that of Eilshemius is wishful thinking blown up to the dimension of a social event from which it hopes to profit; that of Duchamp is cunning manipulation shrinking to the size of a ready-made photograph in which it finds a repository. The difference legitimated by the algebraic comparison is the split between tradition and the avant-garde, when the historical context (to which the institutions, but also the psychological destinies, belong) is such that tradition can only deteriorate and lay itself open to ridicule, and that the avant-garde can be significant only when it takes it upon itself to show precisely this. The algebraic comparison does not compare aesthetic objects to one another, and it does not simply switch contexts. It refers the objects to the contexts and vice versa, and it points to a difference that is one of objects in contexts, and that can be attributed neither to the objects (a and a') and their visual properties nor to the contexts (b and b') and their institutional determinations. Such a difference is beyond naming, yet it is articulated on either side of a pure signifier of difference, the one that the *Green Box* called *the sign (/) which separates a and b, the sign of accordance*. What is not beyond naming, or description, however, is the strategy through which the split between tradition and the avant-garde found its legitimation in the equal sign ($=$) that forces comparison between incomparable objects by contriving a substitution of institutional contexts. The foolish Eilshemius was made a fool and Stieglitz was fooled. As a result, *Fountain* became art. The presence of *Supplication* at the Indeps ridiculed tradition and made it look like a joke by contrast—or comparison—to that of *Fountain* at 291, which, conversely, entered a joke into tradition and made it look like art: $a/b = a'/b'$. Which was to be demonstrated.

Well, not quite yet. It is not logically correct that the enigmatic *sign of accordance* should be one of separation, and it is not morally right that it should be read out of a fool's bargain. One should distrust any fait accompli. It is always the result of a bid for power. Perhaps the law of the strongest is always the best, but it is not, for all that, the most legitimate. When written like this, the history of the avant-garde would merely be the history of the victors. How many smartasses in Duchamp's wake have not banked

on that, at the expense of how many Eilshemiuses who were deserving of better? Now, there's been a coup: Duchamp was all trick, guile, and irony. He put everyone in his pocket, and he could afford to. After all, he was not merely the anonymous R. Mutt, he was also Totor, or Victor, an institution unto himself. "Marcel Duchamp," as Henri-Pierre Roché recalled in his memoirs, "was at the time, in New York, the best known Frenchman along with Napoleon and Sarah Bernhardt."[34] All exaggeration aside, it remains that Duchamp enjoyed a reputation far out of proportion with what people knew of his work. It had actually preceded him: when he arrived in New York in June 1915, he was already, even for the general public who ignored his name, "the man who had painted the *Nude Descending a Staircase*."[35] The painting (fig. 5.9) raised a scandal and drew considerable success at the Armory Show in 1913: it was mocked and caricatured by the press (fig. 5.10); it was hailed and stigmatized as the last word in Cubism and Futurism combined; and it became the emblem of the extravagances of modern art as a whole. It is this celebrity that earned Duchamp an institutional position in the Society and from which the twenty founders hoped to benefit: John Sloan, Maurice Prendergast, and William Glackens brought to the Society the already stale prestige of the Ash Can School, to which Rockwell Kent, George Bellows, and Charles Prendergast could add reputations consolidated in its wake. The dedicated Walter Pach contributed, with his undisputed role as the great mediator in the organization of the Armory Show; John Covert had a modest fame as a Cubist and the privilege of being Arensberg's cousin; Joseph Stella held the prestige of being the only American Futurist; and John Marin was known for having shown at Stieglitz's from its very first day. Jacques Villon had been enrolled in his absence (if at all) by his brother, and Albert Gleizes, the only European with Duchamp and Picabia to have been actively involved in the foundation of the Society, represented the orthodox Cubism of the Puteaux group.[36] In fact only Duchamp and the friends under his influence, Picabia, Man Ray, and to some extent Morton Schamberg, held promise for the future.

At the root of the Society's creation, there are extremely ambiguous motivations. It was a coalition against the National Academy, and coalitions as always are fraught with all sorts of dissent. It was everyone's desire to perpetuate the Armory Show. But what this meant differed radically depend-

ing on the various factions involved. Arensberg, who had received the shock of his life there, and his circle, wanted to restage a big hullabaloo. Possibly they hoped that the Richard Mutt case would provide them with such an opportunity. Stieglitz and his circle wanted to give to American Cubism and Futurism the dignity of high art, in other words, of European art, on a par with Cézanne and Picasso. The Ash Can School alumni—and they formed the core of the Society's promoters; it is they who would reject the urinal—wanted to recuperate, institutionalize, academicize, and repatriate the Armory Show. In 1913, they had been caught unaware and outflanked on their left, so to speak, by the massive invasion of the European avant-gardes. They still resented it in 1916, and it was not without chauvinism that they sought to endow those artists who claimed a moderate and specifically American modernism with the platform denied to them by the even more conservative National Academy. In this context, Duchamp's presence among the founding members was obviously desirable as a token of avant-gardism and a guarantee of cosmopolitanism. There was no better way of perpetuating, i.e., neutralizing, the Armory Show than by trying to secure the imprimatur of the author of the *Nude Descending a Staircase*, presenting him with the presidency of the hanging committee, and hoping that he would honor the show with his participation. The founders, no doubt, expected him to come up with something that would send back an attenuated echo of the *Nude's* scandal at the Armory Show, something surprising but not really shocking, like the *Chocolate Grinder*, for instance.[37] Instead, there came a urinal.

Duchamp had shown cruelty in manipulating Eilshemius and genius in manipulating Stieglitz, and here he revealed himself to be diabolic. They wanted to trap him; he would make them trip on their own trap. Eilshemius was not the only one to practice wishful thinking. The whole mechanism of self-legitimation of the Society of Independent Artists, Incorporated, was a colossal wish, as if one could, even collectively, proclaim oneself an artist by decree. For the Society was still lacking true legitimation, that is, recognition by others besides its own members. It was torn between two desires that were also two necessities: to see itself legitimated by the past— tradition—but also by the future—the avant-garde. It sought to force the National Academy to recognize it or at least to acknowledge its existence. As with the Armory Show, the adopted strategy was numbers and publicity.

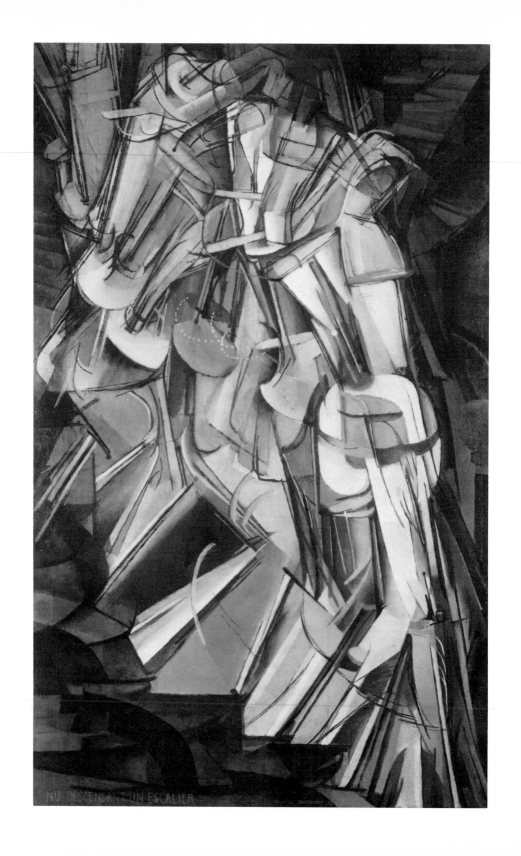

THE EVENING SUN, THURSDAY, MARCH 20, 1913.

SEEING NEW YORK WITH A CUBIST

The Rude Descending a Staircase
(Rush Hour at the Subway)

5.9
Nu descendant un escalier n° 2 [*Nude Descending a Staircase no. 2*], 1912. Oil on canvas, 58 × 35 in. (Philadelphia Museum of Art; The Louise and Walter Arensberg Collection.)

5.10
"The Rude Descending a Staircase: Rush Hour at the Subway," *The Evening Sun*, New York, Thursday, March 20, 1913.

But it was also seeking approval from the small purist avant-garde which did not expect anything either from the past or from exchange with the general public, the one on which Stieglitz for example conferred dignity. Here the founders made a gross miscalculation. They could have tried to get Stieglitz more deeply involved—we have seen that he had sympathy for their project—or to enlist Marius de Zayas, or perhaps Robert Coady. Instead, they turned to Arensberg and Duchamp. And in so doing, they laid their demand for legitimation at their feet. What did Duchamp do with this fearsome power? They wanted him to cover up an enterprise that smacked of conservative intentions. With his usual courtesy, he bowed to their demand. Even better, he graciously played the role of the eccentric but harmless troublemaker they expected him to play. As we remember, it was he who proposed that the works be hung in alphabetical order. There he was playing the eccentric. But it was also he, so it seems, who had first suggested the motto "No jury, no prizes," which he would soon submit to a drastic test. Here he was preparing his not so harmless revenge: they wanted him to be avant-garde; all right, his alter ego R. Mutt would be avant-garde. But—and here he was diabolically generous, yes, diabolic and generous—in suggesting the motto "No jury, no prizes," he offered to the Indeps the guarantee of tradition, rather, of a tradition. The Society's slogan did not appear out of thin air. Since 1884, "Ni récompense ni jury" had been the motto of the Paris Société des Artistes Indépendants, an institution that was no longer, to say the least, a temple of extravagance in 1917. And so the respectable legitimacy that the New York Independent Artists acquired is not the one they gave themselves but the one they received, through Duchamp, from the Paris Indépendants. The founders were reassured. Actually, they made a point of establishing their pedigree in their founding act, explicitly modeling the newborn institution on its French equivalent. The relation a/b, which was founding the Society (and which a while ago I expressed in short through the formula "anything to anybody"), was neither self-legitimated nor self-legitimating, it was inherited from a tradition which, by 1917, had grown more than venerable.

As always, art is legitimated solely by comparison: $a/b = a'/b'$. The substance of the founding act is this: anything that will be shown at the New York Independents is declared in advance to be on a par with everything that was shown at the Paris Indépendants throughout their career.

This time the equality of the two relations is blindingly obvious, since the denominator is common. In *b*, we have "No jury, no prizes," in *b'*, *"Ni récompense ni jury."* The guarantee of this common denominator, guaranteed in turn by the avant-garde personified by Duchamp, is precisely what led the founders of the Society to believe that they were allowed to conclude in advance that $a = a'$. Richard Mutt would prove them wrong. Comparison is not equality and *b* is in fact not equal to *b'*. Only in *appearance* do both slogans translate into one another, and then only if one fails to consider that between their *apparitions* (or advents) thirty-three years had passed, during which the Paris Indépendants had become a very academic institution. Duchamp could not have offered the founders of the Society a better vanguard alibi for their true conservatism. Token avant-garde is what they wanted, token tradition is what they got: the tradition of the avant-garde gone academic. Institutional legitimation is what they wanted, mere institutional legitimacy is what they got: on the aesthetic level the test lay ahead of them. Meanwhile, Duchamp had it behind himself. He knew from experience that, no matter how much the Independents, in Paris or in New York, had done or would do for the advancement of modern art, social liberalism is, for the true artist, just another aesthetic constraint. In other words he knew that, despite the maxim "No jury, no prizes," which seems to forbid aesthetic comparison, the true law of artistic legitimation remains the *algebraic comparison*, which he also knew should not be allowed to bypass the series of *collisions seeming strictly to succeed each other* that articulates it. We must now see this series regress in time in order to then see it fall back onto the Richard Mutt case, by *commissioned symmetries*.[38]

Had Duchamp not actually gone through the experience of the Richard Mutt case, but in a reversed chronological order? He knew better than anyone to what kind of circus he owed his nomination as chairman of the hanging committee. And he knew what scandal means, too. At the Armory Show, the crowd was pouring in to see his *Nude*. An even larger crowd knew the painting only from the press, from hearsay, from gossip. Never since Manet's *Olympia* had a painting been more reproduced, and above all more caricatured in the papers. Not only is it "the onlookers who make the painting," but in this case blind onlookers, who have never seen it! Duchamp knew all this and would remember it when the time would come for *The Blind Man*. There is also something else that he would remember

very well, for he had felt it as a bitter failure: the *Nude* had first been refused by the hanging committee of the Cubist room, which included his own brothers, at the Paris Indépendants in March 1912. The Independents had already betrayed their principles. The Richard Mutt case had already taken place. For Duchamp, when he arrived in New York, as for us today, it is *given*. And the demonstration may be taken up again from that vantage point.

Let $a/a' = b/b'$. In translation: *Fountain* is to *Nude Descending a Staircase* what Society of Independent Artists is to Société des Artistes Indépendants. Let $a/b = a'/b'$. In translation: the relation of *Fountain* to its real exhibition conditions at the New York Independents is equivalent to the relation of the *Nude* to its real exhibition conditions at the Paris Indépendants:

$$\frac{Fountain}{\text{N.Y. Indeps}} = \frac{Nude}{\text{Paris Indeps}}$$

Indeed the two works were rejected by institutions that had identical goals. The above formula now shows the negation wrought by the New York Indeps' legitimating principles, thus expressing the formula for their betrayal and their possible delegitimation.[39] They had declared that anything they would show would be on a par with everything their Paris counterpart had shown. It follows that the one thing they refused to show was also on a par with the one thing the Indépendants had rejected. But from the vantage point of December 1916, when the Society was founded, *Fountain* still lay in the future while the *Nude's* rejection was a thing of the past. It had already been triumphally rehabilitated at the Armory Show.[40] When Duchamp disembarked from the *Rochambeau* in June 1915, he was preceded by his scandalous success, *like a comet having its tail in front*.[41] And so the pissoir too was rehabilitated, but *in advance*. One only needs to fold the *commissioned symmetries* round their axis, the *Nude* at the Armory Show in 1913, to see everything fall into place and to understand that Duchamp's wager (for he didn't know yet what the fate of *Fountain* would be) was diabolically strategic on the aesthetic—not merely on the institutional—level, while on the ethical level it was strategically generous (for he was determined to eschew public scandal and not reveal the Society's

actual delegitimation). Just as the *Nude* was rejected in Paris in the spring of 1912, so *Fountain* would be rejected in New York in 1917:

$$\frac{Nude}{\text{Paris Indeps}} = \frac{(Nude)}{(\text{Armory Show})} = \frac{Fountain}{\text{N.Y. Indeps}}$$

At both ends of this chain of *algebraic comparisons* folded around a loud, successful scandal, there are two suppressed scandals. In 1912, out of affection for his brothers but also out of real bitterness, Duchamp withdrew his painting and hushed up. In 1917, out of courtesy but also out of a strategic calculation and supreme revenge, he got the "Richard Mutt Case" on the historical record but saw to it that it remained muffled. It is here that Duchamp's strategy proves inextricably diabolic and generous. The *Nude's* scandalous success at the Armory Show is precisely what the Ash Can School alumni among the Society's founders sought to repress with their desire to academicize and repatriate the Armory Show. Yet it is also precisely what they appropriated when they invited Duchamp to chair the hanging committee and begged him to bestow on them his perhaps dubious prestige. The coup of the urinal is the planned return of the repressed, and in order to be at once effective, significant, and just, in a way it had to be repressed too (hence the parentheses in the above formula). The absence of a scandal at the Indeps at once renders Duchamp's success with the Armory Show conspicuous and puts it into the background. For if R. Mutt had been an anonymous wisecracker, the Society could have afforded to censor him without risking open delegitimation. If on the other hand Duchamp had revealed the true paternity of the urinal, the Society might have been forced to endorse him, running the risk of letting the Big Show as a whole appear as a farce. In the end R. Mutt was censored, but not without Duchamp sticking his neck out by resigning from the board of directors, and not without his reputation as a troublemaker being whipped up again.

We can be sure that the coup was long fomented; it was, in any case, deadly on target, and it would prove to be just. It was ripened in workshop solitude, developed in bachelor chemicals, gently lit by the enlightening gas of meditation much more than it was concocted in the social fever of

the Arensberg Salon. From the very first day that Duchamp had set foot on American soil and Walter Pach drove him to the Arensbergs to become drunk with success, he knew that having its tail in front is not the normal anatomy of a comet. That is not how history is made. Success and scandal, success as scandal, are nothing. With the plans for the *Large Glass* tucked under his arm, he had already decided to *use "delay" instead of picture*.[42] Soon he would use "readymade" instead of delay too. Like the definitively unfinished *Large Glass* (called a *delay in glass* by Duchamp) in Jean Suquet's admirable demonstration, the "delay in porcelain" that he was fomenting represented the moment "before."[43] Before scandal, before success, before the moment when it would be proclaimed to be art by *The Blind Man*, or men.

The urinal's art status was obtained through impeccable, shrewd, and merciless strategy. Once on the record, the Richard Mutt case has proven impossible to erase. It has been written into the art history books, which means that it has been registered in the jurisprudence of modern art. The legal vocabulary is more than appropriate here, since we are dealing with legitimacy in general, with the legitimation of *Fountain* in particular, and with the possible delegitimation of a group of putative artists who could not cope with the test to which their own statutory law was submitted. On trial in 1917 was the Society of Independent Artists, whose members, all of them, Eilshemius as well as Stieglitz, Rockwell Kent, Jr., as well as Rockwell Kent, Sr., were acquitted with Richard Mutt's vindication. If *Fountain* is art, then *Supplication* is art and the little boy's *Nice Animals* is art too. But *Fountain* is still on trial. And so is *Supplication* for that matter, as is the product of the child's "pure uneducated seeing," his father's name notwithstanding. From institutional legitimation—or art status—it does not follow that aesthetic legitimacy—or art quality—is secured once and for all. The urinal is still awaiting further trial. Like the *Large Glass*, it ought to maintain itself in this expectation, definitively unfinished. And it is in relation to expectation, to the interplay of expectations, that we must take up the demonstration one last time and find the missing link tying together two chains of *algebraic comparisons*. The first chain, as we recall, was summarized by the following equation: *Supplication* by Louis Eilshemius is to *Fountain* by Richard Mutt what the Society of Independent

Artists is to Gallery 291. Or, if you prefer: *Supplication's* presence at the Indeps is equivalent to *Fountain's* presence at 291:

$$\frac{Supplication}{\text{N.Y. Indeps}} = \frac{Fountain}{291}$$

This chain is made of bids for power on the artists' part and disappointed expectations on the institutions' part. For *Supplication* is not exactly what the Society's founders were expecting or hoping for, as far as talent scouting goes. No more is *Fountain* what Stieglitz was expecting or fostering, as far as quality in modern art goes. If there is any kind of legitimation in this equation, it is forced: Richard Mutt's coup is equal to Eilshemius's self-promotion, only wittier. We may admire the ruse, we might even think we are laughing with Duchamp, but it would be at the expense of those who listened to him. Eilshemius paid that price, and it was high enough. We would endorse a conception of the avant-garde that sees art in terms of institutional strategy and nothing else; a sad conception, proud of deceiving all expectations and which depends on the delegitimation of tradition for its own legitimacy, as if Eilshemius could be called an artist only because he let the Hudson River tradition of landscape painting go crazy in his hands, as if Duchamp's manipulation of Stieglitz automatically meant that he was making fun of Georgia O'Keeffe and systematically practiced *negative ironism dependent solely on laughter*.[44] The second chain was summarized by this equation: *Fountain* by R. Mutt is to *Nude Descending a Staircase* by Marcel Duchamp what Society of Independent Artists is to Société des Artistes Indépendants. Or, if you prefer: *Fountain* being submitted to the New York Indeps is equivalent to the *Nude* being submitted to the Paris Indeps:

$$\frac{Fountain}{\text{N.Y. Indeps}} = \frac{Nude}{\text{Paris Indeps}}$$

This chain is made of betrayed expectations on both the artists' and the institutions' part. For the least we can say is that neither *Fountain* nor the

Nude met the expectations of the two societies, respectively. It's not that the works were not on the level; they were an act of treason, and as such they were rejected. What Gleizes, Le Fauconnier, and the Duchamp-Villon brothers expected from Duchamp in 1912 should rather have been entitled *Portrait of Chessplayers* or something similar; when they were met with a painting which, though Cubist in appearance, bore a title incompatible with the orthodoxy of the Puteaux group, they felt betrayed. And what Kent and Bellows expected from Duchamp in 1917 should rather have resembled the *Chocolate Grinder;* they were ready for a fancy title, this time, but not for an object whose appearance they could not compare with anything artistic. They felt their liberalism was taken advantage of and put to an unfair test. On the side of the artist, however, this symmetry is broken: the later event is *commissioned* by the earlier one. Whereas in 1912 Duchamp sincerely expected his *Nude* to be welcome in the Cubist room, in 1917 sincerity was no longer the issue: Duchamp knew he was putting the Indeps to a test when he fabricated an unknown self-proclaimed artist whose supposed expectations he expected to be betrayed. We may admire his gesture, we might even thumb our nose at the Indeps and think we are grinning with Duchamp, in 1917; we would soon be led to think that in 1912 the *Nude Descending a Staircase* was not a painting but also a gesture, whose avant-garde value was to force the hanging committee to betray either their taste or their principles. We would endorse an equally sad conception of the avant-garde, as if it were only satisfied with the far-out and relied on provocation and escalation, as if rejection were the only proof of artistic validity and nihilism the true source of creation, as if radicalism vis-à-vis the institution, not aesthetic quality, were the sole criterion of art. Both chains of *algebraic comparisons* leave us with strategy for the sake of strategy, success for the sake of success, or art for the sake of non-art. Following either of them leads to writing the history of the avant-garde as that of the victors, and what the victors have won is sheer negativity.

Another scenario ought to be envisaged, one in which the issue of the avant-garde's legitimacy would be dealt with—as it should be—in juridical rather than military terms. Let's take sides with the defeated for a brief moment and ask what the *algebraic comparisons* would have looked like if the Paris and the New York Independents had not been forced to betray their principles, if Duchamp had complied with their desire and respected

their sense of tradition. Let's thus replace the chain of betrayed expectations, as it actually happened, with the chain of fulfilled expectations, as it should have happened in order for the two institutions to have retained their self-respect. *Chocolate Grinder* being submitted to the New York Indeps would then be equivalent to *Portrait of Chessplayers* being submitted to the Paris Indeps:

$$\frac{Grinder}{\text{N.Y. Indeps}} = \frac{Chessplayers}{\text{Paris Indeps}}$$

Now the *Grinder* was reproduced on *The Blind Man*'s cover, whereas *Supplication* and the *Fountain*'s photograph were printed inside the magazine. Since, as we remember, the editorial board of the magazine parodies the hanging committee of the Independents, the former mimics the scale of preferences of the latter and shows where the latter's real desire for legitimation goes: that rather than attracting slightly paranoid individuals such as Eilshemius, the Big Show would be honored with Duchamp's presence. So we may substitute the *Grinder* for *Supplication* in the chain of bids for power and disappointed expectations, thereby nullifying not only Eilshemius's embarrassing claim to genius but also Duchamp's contemptuous declaration that *Supplication* was the best painting in the show. We would be bringing Eilshemius's participation down to the level where he is equal to all other participants, while elevating Duchamp's to the level where his prestige was eagerly awaited. We would thus ease out all coups and bids for power vis-à-vis the Society, while remaining sure that we would fulfill its desire:

$$\frac{Grinder}{\text{N.Y. Indeps}} = \frac{Fountain}{291}$$

The coup is now directed solely at Stieglitz. The Society might be more pleased with the *Grinder* than it was with *Supplication*, but Duchamp's offhand enlisting of Stieglitz still makes him a pawn in Richard Mutt's game. Yet in order to dissolve this last abuse, one need only let the *algebraic comparison* do the work. It is, after all, the law *legitimating a*

choice of possibilities and *occasioned* by them. The last equation and the one above are solved together in the following, which links the two chains:

$$\frac{Chessplayers}{Paris\ Indeps} = \frac{Fountain}{291}$$

This would be the new chain of fulfilled expectations, the one that shows where Stieglitz's true desire for legitimation goes. Stieglitz might now be satisfied that the presence of *Fountain* in his gallery is as legitimate as that of the *Chessplayers* would have been at the Paris Indépendants. He might be very surprised to learn that what was being forced into his avant-garde gallery with his involuntary blessing is now on a par with a European avant-garde (the orthodox Cubism of the Puteaux group) legitimized to the point of having become academic; but this is after all what he wanted for the art he was willfully promoting. In substituting *Fountain* for the *Grinder* which the Indeps expected, Duchamp also substituted, through *algebraic comparison*, one institution awaiting its legitimacy from the future (291) for one that had received its legitimacy from the past (the Indeps). In *using "delay" instead of picture*,[45] Duchamp would thus have understood and fulfilled in advance Stieglitz's true desire: to see the future receive the sanction of the past, to see modern art enter the museum. There it is, and as one historian of American art noticed: "It is also not too farfetched to consider the opening of the Museum of Modern Art in New York in 1929 as another outgrowth of the pioneering Stieglitz activity."[46]

Such is the way Victor, alias Duchamp, rendered unto Caesar what belonged to Caesar. He forced Stieglitz's hand, but Stieglitz—whose activity was declining in April 1917, and who would close down 291 two months later—was to enter history proudly, endowed not only with the prestige of having successfully supported his own protégés, but also with the more discrete fame of having lent his authority to the maxim "No jury, no prizes" in which the unknown R. Mutt found the authorization that led him to enlighten, with the gaslight of the name "art," the *allegorical appearance* of a waterfall. *Fountain by R. Mutt* is this waterfall's referent, *Photograph by Alfred Stieglitz* is its *extra-quick exposure* and its *instantaneous state of Rest*. But what happened to THE EXHIBIT REFUSED BY THE INDEPENDENTS?

It has vanished. The Independents too have vanished. They disappeared in 1944, but their prestige had waned long before. The "Richard Mutt Case" saves them from oblivion and generously restores to them the true legitimacy that they had betrayed and that they almost lost, and that they would have lost if *Fountain* had been conjured away for good. The true expectation of the French Indépendants and their American carbon copy is that history render them justice and legitimate this unheard-of principle, which was the bottom line of all the utopias of modern art but also their true condition of emergence: everyone and anyone can be an artist. Everything harks back to the year 1884 when the Société des Artistes Indépendants was founded around Seurat, whom Duchamp admired more than Cézanne. There and then we observe for the first time that an art institution claimed to found its own legitimacy on the mandate it had received from its members rather than on the continuity of a tradition guaranteed by a jury.

But this was also wishful thinking. The reality is that art is legitimated only through comparison and that comparison can be made only with what is already legitimate. Legitimation comes from the past alone. The moderns, those utopianists, those *comets having their tails in front*, asked that the future grant their demands. The avant-gardes wanted time, whose iron law is to be irreversible, to flow backward. The Richard Mutt case does not fulfill their wish but does them justice through *ironism of affirmation*. Making avant-garde art of true significance means anticipating a verdict that can only be retrospective. It means delivering the unexpected in lieu of the expected in such a way that betrayed and disappointed expectations show themselves, in the end, to have been fulfilled. Because it is in the nature of expectations not to depend on factual verification for their truth as expectations—that is, as projected scenarios—the scenario that I have described as the chain of fulfilled expectations proves to be the right one. Indeed, let's reestablish the facts: instead of the *Chessplayers*, the Paris Indépendants were presented with the *Nude Descending a Staircase*, and they rejected it; instead of going directly to Stieglitz in order to gain avant-garde legitimacy for *Fountain*, Richard Mutt went to the Independents, and they rejected it. The last formula, the one that happily linked the two chains of *algebraic comparisons*, translates back into one that is familiar:

$$\frac{Nude}{\text{Paris Indeps}} = \frac{(Nude)}{\text{(Armory Show)}} = \frac{Fountain}{\text{N.Y. Indeps}}$$

We may now remove those parentheses. The *Nude* at the Armory Show is the axis of *commissioned symmetries* around which the interplay between the expectations that are betrayed *in advance* and those that are fulfilled *with all kinds of delays* is being unfolded. Let's put ourselves in Duchamp's position in March 1912. He is already recognized as a Cubist painter, his work is already legitimated by the (immediate) past extending into the present. Yet he experiences rejection, and his decision, which is aesthetic, not to modify the *Nude Descending a Staircase* but to await future rehabilitation, has the shape of prospective, straightforward anticipation. It is as though he had wagered that the relation of the *Nude* to the Paris Indépendants, where it has just been rejected, would some day be equal to the relation of this same *Nude* to the Armory Show, where it would triumph. He is acting like an avant-garde artist and the future will prove him right. Let's now put ourselves in his position at the time of the Society's foundation, in December 1916, or a little later. He has already experienced both a kind of Richard Mutt case and its vindication, and it is as though he were wagering something quite different, which has the shape of anticipated retrospection: the relation of *Fountain* to the New York Independents, where it is most likely going to be rejected, will have been equal to the relation of the *Nude* to the Armory Show, where it has triumphed. Duchamp is still an avant-garde artist, projecting legitimation into the future, but with the awareness that such legitimation will have to come from comparison with the past. The comparison involved is not merely aesthetic in any formal sense: strategies intervene that address institutions. On the other hand, as a strategy, a move like Duchamp's anticipated retrospection is not merely institutional; it is aesthetic, for it allows the reconstitution of a chain—two chains, actually—of expectations that are aesthetic, the satisfaction and dissatisfaction of which are framed in an institutional context precisely made of what is already aesthetically legitimate in the eyes of the protagonists at any given moment. The comparison involved is the *algebraic comparison:* it is itself beyond the formal or "retinal." But it is also beyond the merely contextual. The *Nude* at the Armory Show is the missing link in the interplay of expectations and

satisfactions, the time and place of an immediate gratification, of an *instantaneous state of Rest*. It is fulfilling everyone's desires and wishes: those of Duchamp who erases a failure, those of the European artists whose flag the *Nude* has become, those of the American artists whom its audacity is liberating, those of the public which is bursting into healthy laughter. The Armory Show was everyone's business, and that is rare enough in the history of the avant-garde. A party was going on at the Armory, people were dancing round an *a/b* ratio that *is in no way given by a number c but by the sign (/) which separates a and b, the sign of accordance*. Scandal, usually a combat weapon, a pretext for repression, the locus of dissent and separation, was, for once, the *sign of accordance*. Which was to be demonstrated.

Well, not quite. Nothing is demonstrated. In art, one can show but not prove. One does not deconstruct the *allegorical appearance* in order to strip bare, once and for all, the *apparition which is its mold*. One errs between the appearance of apparitions and the apparition of appearances and one compares: *a* is to *b* what *c* is to *d*. One judges, one says, "this is art," and thus, again, one compares. And in order to judge, in order to know whether one has judged well, judged according to accordance, one has no law to rely upon, only signs. *Nothing perhaps*.

Notes

1 Marcel Duchamp, *The Green Box,* in *Salt Seller: The Writings of Marcel Duchamp (Marchand du sel),* ed. Michel Sanouillet and Elmer Peterson (New York: Oxford University Press, 1973), 27–28. (Throughout the text, italics indicate a Duchampian expression.) I have somewhat modified the translation and should explain why. The translation of *gaz d'éclairage* as *illuminating gas* is too esoteric, since *gaz d'éclairage* is a very common expression referring to the gas used in street lighting and other gas lamps, such as the *bec Auer,* before the advent of electricity. Hence *lighting gas* instead. *Exposition extra-rapide* contains a pun which the literal translation *extra-rapid exposition* fails to convey. In French, *exposition* means both "exhibition" and "exposure." I shall translate *exposition extra-rapide* by *extra-quick exhibition* when I want to refer to an art context and by *extra-quick exposure* when I want to stress its photographic connotations. The translation of *une succession de faits divers* by *a succession of various facts* is plainly wrong. *Faits divers* is a fixed expression referring to that section in newspapers sometimes called "Miscellaneous," where unimportant yet often dramatic events, mostly local, such as automobile accidents, are reported. Hence *news items.* The translation of . . . *les occasionnant,* by . . . *determining them* is not a slight but a philosophically crucial distortion. We are dealing with an artist who introduced chance and indeterminacy into the making of art. *Occasionner* cannot possibly mean "to determine." It merely means "to occasion, to give something the opportunity to exist or to happen." As to the *Notice,* I believe that *Warning* better conveys the idea of a threat contained in the French *Avertissement.*

2 *The White Box,* in *Salt Seller,* 84–85. In French, *apparition* only occasionally has the meaning of a ghostlike vision. It also, and more prosaically, means the simple fact of appearing, for which the English only cites *appearance* again. In order to maintain the contrast between *apparence* and *apparition,* I shall qualify the former as "appearance or look" and the latter as "apparition or advent."

3 *The Green Box,* in *Salt Seller,* 32.

4 Cited by Clark S. Marlor, *The Society of Independent Artists, The Exhibition Record 1917–1944* (Park Ridge, N.J.: Noyes Press, 1984), 81.

5 The press didn't fail to notice this. One journalist ironically commented on the *Big Show,* as the first exhibition of the Society got to be called: "Step up, ladies and gentlemen! Pay six dollars and be an artist— an independent artist! Cheap, isn't it? Yet that is all it costs. You and I, even if we've never wielded a brush, squeezed paint from a tube, spoiled good paint with crayon, or worked with a modelling tool, can buy six dollars worth of wall or floor space at the Grand Central Palace." Quoted by Francis Naumann, "The Big Show, The First Exhibition of the Society of Independent Artists, Part II, The Critical Response," *Artforum* 17 (April 1979), 49.

6 Marlor, *The Society of Independent Artists,* 7.

7 That in itself was enough to infuriate conservative critics such as Leila Mechlin, who wrote in the May 1917 editorial of the *American Magazine of Art:* "Naturally a great many of those who became exposed in this instance had not the smallest claim to the name artist." Quoted by Marlor, *The Society of Independent Artists,* 10.

8 Ibid., 9.

9 Most versions, including Duchamp's contradictory statements to Rudi Blesh and Pierre Cabanne, are discussed in William Camfield's essay "Marcel Duchamp's *Fountain:* Its History and Aesthetics in the Context of 1917," *Dada/Surrealism,* no. 16 (1987), 64–94. For a more expanded version, see William Camfield, *Marcel Duchamp, Fountain* (Houston: The Menil Foundation and Houston Fine Art Press, 1989). He does not mention, however, what I believe to be the most probable (in any case the least farfetched) version, that told by Rockwell Kent in his autobiography *It's Me, O Lord* (New York: Dodd, Mead & Co., 1955), 316, in which he says that after a heated discussion, the board of directors finally found a way to refuse

Fountain on the basis of a technicality: the entry card had not been filled in properly.

10 Quoted by F. Naumann, "The Big Show, The First Exhibition of the Society of Independent Artists, Part I," *Artforum* 17 (February 1979), 38.

11 *Salt Seller,* 28 (translation slightly modified).

12 It is most likely that in Duchamp's mind at the time the notion of *algebraic comparison,* which he invented, was his response to that of *arithmetical proportion,* then in favor with his brothers and Cubist friends, all members of the group *La Section d'Or.* When Duchamp maintains that *the ratio a/b is in no way given by a number c (a/b = c),* he is refuting a complete aesthetic theory, based on the mystique of the golden section. Indeed, the golden section formula, $a/b = b/(a + b) = c$, assigns a constant *numerical value* to *c:* 0.618 . . . In this case, the *numerical relative values* of *a* and *b* are *known:* if $a = 1$, then $b = 1.618$. . . ,etc.

13 *Boîte de 1914,* translation in *Salt Seller,* 24.

14 Rockwell Kent incited his family to participate: not only his son, Rockwell, Jr., but also his sister Dorothy, who was a violin player and an amateur watercolor artist. Cf. Rockwell Kent, *It's Me, O Lord,* 316.

15 See Camfield, "Marcel Duchamp's *Fountain,*" 67–68, and Naumann, "The Big Show, Part II," 50. One reviewer (*The New York Herald* [April 10, 1917]) even reported that "The Fountain" was "described by those who saw it, as a painting of the realistic school." I am indebted to Francis Naumann for having shared with me some of the press clippings he had collected in the course of his research.

16 F. Naumann, ed., "Affectueusement, Marcel: Ten Letters from Marcel Duchamp to Suzanne Duchamp and Jean Crotti," *Archives of American Art Journal* 22, no. 4 (1982), 8.

17 He considered doing it, but the prospect of being alone at his Salon des refusés and the ironic awareness that the Independents' Show already was one held him back. In his letter to Suzanne on April 11, he went on to say: "It was not at all indecent—no reason for refusing it. The committee has decided to refuse to show this thing. I have handed in my resignation, and it will be a bit of gossip of some value in New York. I would like to have a special exhibition of the people who were refused at the Independents—but that would be a redundancy! And the urinal would have been *lonely.*" Ibid.

18 *The Blind Man* (or *The Blindman,* depending on how one reads the graphic design on the cover), no. 1, is dated April 10, 1917, the day of the show's opening. Henri-Pierre Roché, Duchamp's writer friend from Paris who had arrived in New York in November 1916, signed the editorial, within which he enthusiastically embraced the cause of the Indeps, quoting at length from the Society's program: "The great need, then, is for an exhibition, to be held at a given period each year, where artists of all schools can exhibit together—certain that whatever they send will be hung and that all will have an equal opportunity." All contributions to *The Blind Man* sincerely rejoiced at the prospect of "equal opportunity" given to artists of all schools, even to those, as Roché said, "who might as well never have painted at all" (p. 5). The tone of sincerity that runs through the magazine is important, because it is precisely sincerity that was invoked to forgive in advance every possible extravagance and clumsiness, as it would still be, after the event, what might excuse Richard Mutt in the eyes of Katherine Dreier. (See Camfield's discussion of Dreier's letter to William Glackens, dated April 26, in "Marcel Duchamp's *Fountain,*" 74.) Roché made it very clear: "Never say of a man: 'He is not sincere.' Nobody knows if he is or not . . . Rather say: 'I do not understand him.' The Blind Man takes it for granted that all are sincere" (p. 6). However, given the irony implied by the magazine's title and Frueh's caricature, one wonders whether one should not apply to Roché himself the warning he gave to his readers: "Nobody knows if he is [sincere] or not." I think not. Like everybody else in his milieu, Roché was genuinely thrilled at the sudden freedom granted to artists. But he might have been ironic when, quoting from the Society's program again, he said: "For the public, this exhibition will make it possible to form an idea of the state of contemporary art." Whereas the artists were assumed to be sincere, the public was assumed to be blind.

19 Naumann, "The Big Show, Part II," 50.

20 No editor's name appeared on the cover. For reasons of legal liability, however, the last page mentioned: "Published by Henri Pierre Roché," in spite of the fact that Roché, not being an American citizen or an immigrant, was in no position to be legally liable. In the trio's initial project, Beatrice Wood was to stand alone as publisher but was forbidden to do so by her father, infuriated at the prospect that she would put her name onto "such filth."

21 F. Naumann, ed., "I Shock Myself: Excerpts from the Autobiography of Beatrice Wood," *Arts Magazine* 51, no. 9 (May 1977), 136.

22 The first name Richard was of course known to all the insiders who had seen the urinal, since it was written in full on the entry card attached to the object (and visible in Stieglitz's photograph); it had also made its way into a few of the press reports that had mentioned the existence of an inside scandal at the Indeps. However, not only were these reports rare in number, the majority of them had Mutt's identity misspelled altogether as "J. C. Mutt," one even as "Jeff Mutt." (See Camfield, "Marcel Duchamp's *Fountain*," 88, note 16.)

23 Both paintings are dated 1916. *The Gossips* was bought by the Musée du Jeu de Paume in Paris following Eilshemius's one and only European show at Durand-Ruel's in 1932. *Supplication* (which will come under discussion here) is an oil on cardboard, 61 x 40.5 in., presently in the collection of Mr. Roy R. Neuberger, New York. Its full title, *Rose Marie Calling (Supplication),* has an amusing Duchampian ring.

24 See Paul J. Karlstrom, *Louis Michel Eilshemius* (New York: Abrams, 1978); see also William Schack, *And He Sat among the Ashes* (New York: American Artists Group, 1939).

25 Quoted by Naumann, "The Big Show, Part I," 39, note 22.

26 "A piece of scultor [sic], called: 'a Fountain,' was entered by one of our friends for the Independent Exhibition now open at the Grand Central Palace. It was not exhibited. 'The Independents,' we are now told have a committee, or jury, who can decide, 'for the good of the exhibition . . . If you think you could do anything with

this material for your Sunday article we would appreciate it very much . . . P.S. If you wish any more information please phone, Marcel Duchamp, 4225 Columbus, or, Richard Mutte [sic], 9255 Schuyler." Demuth to McBride, quoted by Camfield, "Marcel Duchamp's *Fountain*," 72.

27 W. Camfield, citing an unpublished letter from Stieglitz to Georgia O'Keeffe, adds that "Stieglitz was also led to think that the urinal had been submitted by a young woman, probably at the instigation of Duchamp." (Ibid., 91, note 39.)

28 Ibid., 74. Wood's recollection that Stieglitz agreed to photograph the *Fountain* "at Marcel's request" is in *I Shock Myself,* 30.

29 Beatrice Wood, *I Shock Myself,* 30.

30 Though the question is open as to whether or not it also meant to convey indirectly Stieglitz's secret pro-German sympathies. A few days after America's entry into the war, the choice of a painting entitled *The Warriors,* done by Marsden Hartley—who had pro-German sympathies of his own (he had been homosexually involved with a German officer and had expressed his fascination with German insignia in his paintings)—hardly seems coincidental.

31 Carl Van Vechten went even further. In a letter to Gertrude Stein, he actually said that "Stieglitz *is exhibiting* the object at '291' and he has made some wonderful photographs of it." (Quoted by Camfield, "Marcel Duchamp's *Fountain*," 75, my italics.)

32 In the formulas, objects shall be in italics, institutions in roman characters.

33 L. Eilshemius, quoted by W. Schack, *And He Sat among the Ashes,* 222.

34 Henri-Pierre Roché, "Souvenirs sur Marcel Duchamp," in Robert Lebel, *Sur Marcel Duchamp* (Paris: Trianon, 1959), 79 (my translation).

35 Pierre Cabanne: "Did you think about what you represented at that period for Americans?" Marcel Duchamp: "Not very much. The tiresome thing was that every time I met someone, they would say: 'Oh! Are you the one who did that painting?' The funniest thing is that for at least thirty or forty years the painting was known, but

I wasn't. Nobody knew my name. In the continental American sense of the word, 'Duchamp' meant nothing. There was no connection between the painting and me." P.C.: "No one connected the scandal and its author?" M.D.: "Not at all. They didn't care. When they met me they said, 'Well fine!' but there were only three or four who knew who I was, whereas everyone had seen the painting or reproductions, without knowing who had painted it. I really lived over there without being bothered by the painting's popularity, hiding behind it, obscured. I had been completely squashed by the 'Nude'." P.C.: "Didn't that correspond perfectly to your idea of the artist?" M.D.: "I was enchanted." Pierre Cabanne, *Dialogues with Marcel Duchamp,* trans. Ron Padgett (New York: Viking Press, 1971), 45.

36 This is based on the list counting twenty founders published by Marlor, *The Society of Independent Artists,* 58. The list, published in the initial notice at the time of the Society's incorporation, counted seventeen founding members, to whom "the three French artists, Gleizes, Picabia and Villon, were added at Marlor's initiative because they were involved in the planning of the Society." (Camfield, "Marcel Duchamp's *Fountain,*" 87, note 10. Camfield cites the complete list and says that he owes this additional piece of information to Marlor himself.)

37 Or a painting entitled *Tulip Hysteria Coordinating,* according to a rumor possibly spread to mislead intentionally and compounded by the press. No entry by Duchamp is listed in the catalogue, and none at all under that title, by any artist (although a certain Ellen Anderson submitted a painting entitled *Tulips* and a certain Rosalie Clements a painting entitled *Early Tulips*). However, it seems that a painting indeed bearing the title *Tulip Hysteria Coordinating* was actually shown, since it was reviewed by Jane Dixon in the *New York Sun* as "the most hysterical tulips I ever saw in my life." (See Camfield, "Marcel Duchamp's *Fountain,*" 68 and 88, note 16, and Naumann, "The Big Show, Part I," 37 and 39, note 15.) It is possible that the rumor about *Tulip Hysteria Co-ordinating* was spread by Duchamp, but to me a title such as this one evokes Picabia much more than Duchamp.

38 The very complex notion of *symétries commanditées,* translated in *Salt Seller* as *subsidized symmetries* and for which I propose *commissioned symmetries,* can give way to several interpretations, not mutually exclusive, among them one that invites the reader to imagine a symmetry axis in time rather than in space, so that the flow of time would fold back on itself round this axis, *as if* time ran backward.

39 The risk for delegitimation was so real that, even to the present date, all the protagonists in the Richard Mutt affair more or less involved in the censorship of *Fountain* have cloaked the episode in embarrassed silence or downright travesty. In his autobiography *It's Me, O Lord,* Rockwell Kent did not give the affair more than ten lines; William Glackens's biography, written by his son Ira Glackens (*William Glackens and the Ashcan Group: The Emergence of Realism in American Art* [New York: Crown Publishers, 1957], 188), travestied the facts and tried to have the laughs on the censors' side; in 1937, John Sloan, president of the Society from 1918 to 1944, wrote an apologetic letter to Alfred Barr, Jr., then director of MoMA, in which he claimed that the hanging committee did not act as a jury, since a jury "is a body that passes on aesthetic merits," and that, therefore, the committee was not "in the position of rejecting an exhibit offered as a work of art when, as you know, we were dealing with a matter totally unrelated with art" (cited by Marlor, *The Society of Independent Artists,* 37–38). The taboo is apparently so strong that sixty-seven years after the events, and forty years after the disappearance of the Society, its "official" historian, Clark S. Marlor, still showed the greatest reluctance in recognizing the affair's historical importance and a rather disingenuous laziness in trying to establish the facts with the help of firsthand sources. (See F. Naumann's review of Marlor's book, *Archives of American Art Journal* 26, no. 2–3 [1986], 36–40.)

40 To be true to all the facts, it should be noted that when Walter Pach selected the *Nude* for the Armory Show in November 1912, it had just been rehabilitated already. It was shown in October at the Salon de la Section d'Or, organized by the very same orthodox Cubists, led by Marcel's brother, Jacques Villon, who had rejected it from the Indépendants in March and were now only too eager to amend. But this first rehabilitation remained, in more than one sense, a family affair

played out from within the Cubist brother-
hood. The "fathers" of Cubism, Picasso
and Braque, stayed away from all Salons
and showed only contempt for institu-
tional legitimation. Not so with the
"sons," Gleizes and Metzinger in particu-
lar, who attached great value to the incor-
poration of Cubism into the great tradition
and insisted on group discipline as a strat-
egy of penetration. Marcel, the "prodigal
son," would thus be reintegrated into the
coopted (i.e., self-proclaimed) avant-garde
of orthodox Cubism. The irony is that the
Duchamp family was split on this occa-
sion: while Raymond Duchamp-Villon
showed at the Salon d'Automne, Jacques
Villon, who was on its committee,
resigned in protest against their hostility
toward Cubism and replied with the Salon
de la Section d'Or, held simultaneously.
And Marcel, not surprisingly, showed in
both Salons but didn't care. He already
had the kind of "structuralist" understand-
ing of the issue of artistic legitimation that
is at the bottom of his *algebraic compari-
sons:* neither rejection from one Salon nor
admission into a counter-Salon is perti-
nent in isolation, since both Salons form a
couple leaving the public on the sidelines.
True legitimation—or, in the case of the
Nude, rehabilitation—would have to
involve the public. And this is what hap-
pened at the Armory Show. One more
fact, which seems to complete the inter-
play of *commissioned symmetries:* in
April 1912, right after the Indépendants
and months before the Salon de la Section
d'Or, the *Nude* was included in a Cubist
group show and sent to Barcelona where
it didn't raise an eyebrow, just as the first
readymades shown in 1916 at the Bour-
geois and Montross galleries would go
totally unnoticed. We would be pushing
our luck if, for the sake of *commissioned
symmetries,* the two readymades shown
at the Bourgeois proved to have been *In
Advance of the Broken Arm,* the snow
shovel, and *Emergency in Favor of Twice,*
a lost object whose title seems to have
been *symmetrically commissioned* by that
of the shovel.

41 *The Green Box,* in *Salt Seller,* 26. (Transla-
tion slightly modified.)

42 *The Green Box,* in *Salt Seller,* 26.

43 See Jean Suquet's contribution to the
present conference, as well as *Miroir de la
mariée* (Paris: Flammarion, 1974); *Le guér-
idon et la virgule* (Paris: Christian Bour-
gois, 1976); *Le Grand Verre rêvé* (Paris:
Aubier, 1990).

44 It is to this *negative ironism* that Duchamp
opposed the *ironism of affirmation* ("Gen-
eral notes for a hilarious Picture," *The
Green Box,* in *Salt Seller,* 30). Georgia
O'Keeffe was showing at 291 at the time
of the Independents' Show.

45 *"Employer 'retard' au lieu de tableau ou
peinture."* ["Use 'delay' instead of picture
or painting."] *"Retard"* has two meanings:
"delay" and "lateness." Just as the Indeps
are slow when they expect what has
already happened, so Stieglitz's true,
unconscious desire is running ahead of
the schedule set by his conscious expecta-
tions. From the vantage point of
Duchamp, the urinal is a "delay in porce-
lain" for everyone. But the Indeps will
always lag behind, whereas Stieglitz will
eventually compensate for his "lateness."
After 1920 he will change his mind about
Duchamp "the charlatan." But when he
asked Duchamp for his opinions on pho-
tography, probably expecting some sup-
port from this artist who had abandoned
painting, what he got for an answer was
another delay pinpointing his own late-
ness (*Salt Seller,* 165):
Dear Stieglitz,
*Even a few words I don't feel like writing.
You know exactly how I feel about pho-
tography. I would like to see it make peo-
ple despise painting until something else
will make photography unbearable. There
we are.*
Affectueusement,
Marcel Duchamp
(N.Y., May 22, 1922)

46 Sam Hunter, *American Art of the 20th
Century* (London: Thames & Hudson,
1973), 63–64.

Discussion

Moderated by Dennis Young

FRANCIS NAUMANN

Well, I have only one little comment to add to Thierry's paper, and to Bill's as well. I found about ninety reviews of the Independents' Exhibition, so it was talked about quite a bit in the press, even before the show opened. At some point, we know Duchamp released the information that he was planning to submit a painting entitled *Tulip Hysteria Co-ordinating*. I'd like to know what you make of that.

THIERRY DE DUVE

Well, I have a question in return: are you sure it was Duchamp who said that, or is it gossip?

FRANCIS NAUMANN

There are two reviews, I believe, both published before the exhibition opened, that report Duchamp planned to submit a painting by that title.

THIERRY DE DUVE

Very interesting. I think I'll make that into a footnote.[1] In including in my demonstration what was expected of Duchamp, I considered using that title instead of *Chocolate Grinder,* and decided against it because it doesn't seem likely to me that Duchamp would have invented a title such as *Tulip Hysteria Co-ordinating*. To me it's a title that sounds more like Picabia than Duchamp. But I may be wrong.

CRAIG ADCOCK

In your discussion of "the sign of the accordance," I have perceived this loop: you take works by Duchamp and have him spiral them back into the meaning of later works. There was a kind of recursion in your analysis, and I think it is something you can see in Duchamp's entire oeuvre, this turning back and reexamining things. I'm thinking in particular— just to keep the discussion on track with the *Fountain*—of the late work, *Mirrorical Return* (fig. 5.11), the etching connected with one of the sayings of Rrose Sélavy and the window design for Breton's *Arcane 17,* which in turn connect it with *Étant donnés*. Do you think that recursion is a general pattern that you can find in Duchamp's work?

UN ROBINET ORIGINAL REVOLUTIONNAIRE

"RENVOI MIRIORIQUE„?

"UN ROBINET QUI S'ARRETE DE COULER QUAND ON NE L'ECOUTE PAS"

33/100

5.11
Renvoi miroirique [*Mirrorical Return*],
1964. Etching, 10⁷/₁₆ × 7¹¹/₁₆ in. (Collec-
tion Francis Naumann, New York.)

THIERRY DE DUVE

I can think now of three expressions—but I could probably come up with a few more—that designate the recurrence of a particularly strategic ordering over time (whether conscious or not is a different thing). They all seem to indicate that one work has been ordered, commissioned, directed by another work. One expression is the one I used today, *symétries commanditées*. The *symétries commanditées* are symmetries in time, not in space. It is as though you had an axis around which time folded, although not in reality of course—nor in dream for that matter, there is nothing utopian in Duchamp. Time doesn't retrace its steps. But it is as though it did. And that's the *symétries commanditées*. Reciprocity is another way of expressing the same thing, as in the *reciprocal readymade:* "Use a Rembrandt as an ironing board."[2] *Mirrorical Return, Renvoi miroirique*, which you just used, is yet another. It is not by chance, indeed, that the etching called *Renvoi miroirique* represents the urinal as sketched from Stieglitz's photograph, exactly, and that it bears the caption, *"Un robinet qui s'arrête de couler quand on ne l'écoute pas."* So this urinal is a faucet that stops leaking when you don't listen to it. Of course another particularly significant example is the shaved Mona Lisa of 1965 (fig. 7.2) in relation to the mustachioed Mona Lisa of 1919. And I learned from Bill's paper today something I didn't know, that the replica made by Janis in 1950 was actually hung as a real urinal—that is, you could use it. That makes the urinal into a reciprocal readymade: it's just like using a Rembrandt as if it were a ironing board, because in the meantime *Fountain* had been recognized as art, on the level, so to speak, of Rembrandt. Don't forget that in "ironing board" there is "irony."

ANDRÉ GERVAIS (F)

Thierry, I would add that there is a 1961 aphorism by Duchamp, apropos Pierre de Massot, which brings back the *pissotière* once again.

THIERRY DE DUVE

"de Ma Pissotierre j'aperçois Pierre de Massot."[3]

ANDRÉ GERVAIS (F)

Right. And this evokes among other things the erotic context.

THIERRY DE DUVE

"J'avais l'habite en spirale."

ANDRÉ GERVAIS (F)

Right.

THIERRY DE DUVE

Yes, the spiral is another . . .

CRAIG ADCOCK

. . . sexual reference.

THIERRY DE DUVE

. . . recursion.

FRANCIS NAUMANN

There is one general question I have always thought about, but never really known how to address, and that concerns the degree to which Duchamp can be thought of as a manipulator. In both your and Bill's papers, it was suggested that he was a conscious manipulator, to the extent that you, Thierry, cited sheer cruelty as the motive for his having identified Eilshemius as a great painter. Personally, I can't see Duchamp operating in this fashion. I think he thought of Eilshemius as an American Douanier Rousseau, to be admired for his innocence and naïveté, rather than for any technical proficiency as a painter. Nevertheless, there can be little doubt that Duchamp took advantage of certain situations, some of which he himself helped to create. When he had to secure a photographic image of the *Fountain* for publication in the *Blind Man,* for example, he sought out the services of a skilled photographer. The most likely candidate would have been someone who understood what he was doing, like Man Ray, who was his close friend during these years and who had specialized in taking pictures of works of art. Instead, Duchamp went to Stieglitz. He must have made this decision for a reason. But exactly how far did he go in manipulating the situation? I can see him saying, "Let's pack this thing up and get a picture of it. Let's see if Stieglitz will help." I can see him going that far, but once the *Fountain* was at 291, I can't see him suggesting that the thing be placed in front of Marsden Hartley's painting because its form echoed the shape of a mountain. That must have been Stieglitz's idea. I once interviewed Gabrielle Buffet-Picabia and asked her if she could summarize the differences between Walter Arensberg and Alfred Stieglitz, between those individuals

in Duchamp's camp and those who gathered around the photographer. She said that, in her opinion, Arensberg was American while Stieglitz was European, still trying to preserve the ideals of the past, still trying to provide some kind of official sanction for the most recent expressions of modern art. Somehow, in securing a photograph of the urinal, Duchamp managed to force a merger of these two very different individuals. In this situation, if we want to see him as a manipulator, I suppose it's possible. But I simply cannot see him as being critically manipulative in the case of Eilshemius. I don't know if you are aware of this, but Duchamp purchased some works by Eilshemius, and so did Roché. They visited him a number of times in his studio, and, if anything, I think Duchamp was only trying to circumvent the art system that wouldn't allow Eilshemius to be shown—the same restrictive system, in fact, that wouldn't allow the *Fountain* to be shown.

WILLIAM CAMFIELD

I agree. I'm not sure that I'm prepared to go as far as Thierry does in Duchamp's manipulation, at least of Eilshemius. But that aside, one thing I'd like to pass on was that Duchamp did not tell Stieglitz that he was Mutt. Stieglitz made that photograph without knowing who Mutt was.

THIERRY DE DUVE

Thank you for the information. I'm very pleased to hear that. I surmised that without proof.

WILLIAM CAMFIELD

I thought you'd like that.

THIERRY DE DUVE

How do you know it for a fact?

WILLIAM CAMFIELD

It's in that same letter that I cited, Stieglitz to Georgia O'Keeffe, of August 19, 1917.

THIERRY DE DUVE

Great! Thank you.

FRANCIS NAUMANN

I have just one more comment about manipulation. The more I think

about it, the more I am hesitant to ascribe this tendency to Duchamp. I think he just let things take their own natural course. I can see him arranging to have the urinal brought to Stieglitz, but when someone associated its shape with that of a Madonna or a Buddha, I think he would have just gone along with the idea. People who made these formal observations, we have to remember, made them in defense of the urinal. Nevertheless, the iconoclastic implications of such an interpretation must have amused him, for it implies that if the device were put back into service, you would end up pissing into the mouth of a Madonna, a somewhat uncomfortable thought, we would all have to agree.

THIERRY DE DUVE

But what is much more funny and ironical is that if you piss in the *Fountain* in the position that it has in the Stieglitz photograph, you piss on yourself. *C'est l'arroseur arrosé*. That's very interesting because it becomes a fountain only if you use it.

ERIC CAMERON

I'd like to ask Thierry about the basis of his interpretation of the *Notice*, the *Preface*, and "appearance" and "apparition," and I hesitate here because I know those primarily through the English, even though I have looked at the French. But I've always assumed that the English translation in *Salt Seller* was right, and obviously . . .

THIERRY DE DUVE

Terrible translation, as usual.

ERIC CAMERON

Yes? What I'd like to ask though is—perhaps asking you to start from "appearance" and "apparition"—if you're producing one layer of an allegory which is multi-layered and will accommodate other things as well, bearing in mind that the waterfall and the illuminating gas do appear as part of the bachelor mechanism, therefore certainly having some other meaning. Then also what I'd like to get at is what "allegory" would mean at that time. I suppose I'm accustomed to the *real allegory* of Courbet, and then generally to "allegory" meaning something which points, from Prudentius through Dante through Bunyan, to things eternal. But how would the word "allegory" be understood at the time of Duchamp?

THIERRY DE DUVE

There are many questions in your intervention. As to the translations, I pointed out the few words that I think needed correcting; *"faits divers"* was one. The issue of appearance and apparition should be clarified. *L'apparition*, it's simply the fact of appearing, for which, unfortunately, English only has "appearance," again. It can also mean, of course, *une apparition*, like the Virgin appearing to Bernadette Soubirous in Lourdes. That's an apparition both in the English and in the French sense. But in French, the word has a double meaning.

ERIC CAMERON

Can I press you about what Duchamp specifically says about appearance and apparition in relation to the chocolate object which has different colors under different light but has the same substance?

THIERRY DE DUVE

The apparition is the mold of the appearance, Duchamp says. You can interpret that or, as you suggest, accommodate other works under the concept as if they filled it with meaning, but I want to make one thing very clear because that could be the source of a great misunderstanding. I am not interpreting Duchamp's work. I am not saying, "this is the true meaning of the text." I am not seeking to uncover what he intended to mean. I am mapping the text literally onto the description of some events from Duchamp's life and works, considering in this case that every appearance must have an apparition for its mold—that is, that the condition for something to have a look is that it has appeared. And I believe that I am far more faithful to Duchamp than if I had asked myself, "what does he mean when he says that the apparition is the mold of the appearance?" Similarly, since the "Preface" is formulated as a theorem starting, like most theorems, with the phrase "Etant donnés," I took it to be a theorem. Now, about allegory, I don't know. There are many theories of allegory, and I'm not a specialist at all. We are more or less familiar nowadays with, for example, Walter Benjamin's notion of the allegory. It would be a very interesting problem for scholars to see what concept of the allegory Duchamp would rely on, but my blind guess is that he would simply use the word in the way most people use it, that is, without knowing exactly what it means. Simply, you know, it's some kind of rhetorical figure: by saying something you say something else. We find

elsewhere (but I would rather leave this for another occasion) possibilities of building up on the notion that an allegory is a comparison, like a metaphor, but not a comparison between two things, rather a comparison between the relationships between two things. So that indeed the allegory has the structure, not of "A is compared to B" but of "A is to B what B is to C."

ERIC CAMERON

Can I ask you how one detail works out in relation to that translation? There is a place (I think it occurs in both the "Preface" and the "Notice") where he talks about "possibilities authorized by laws and also determining them."

THIERRY DE DUVE

Thank you for bringing it up. That's the worst mistranslation of the text. First of all, "Notice" is incorrect. It should be "Warning." It doesn't translate *avertissement, avertissement* is "warning." I mean, that's something: the guy starts with "Preface," and then he throws in "Warning," and then "Algebraic Comparison." As to "authorized" and "determining," let me read the text: *"un choix de Possibilités légitimées par ces lois et aussi les occasionnant."* To legitimate is not the same thing as to authorize, and *occasionner* is not "to determine." *Occasionner* means "to occasion," to give something the opportunity to appear or to happen. This is, I think, what any dictionary would give you for a definition. It's important because we all know that Duchamp undermines determinism wherever and whenever he can. He is absolutely antideterministic. Thus we have "possibilities that are legitimated by laws and are giving those laws an occasion, an opportunity, to appear." If you meditate this sentence it is quite bizarre because a law, as you would imagine it, would be some written text that is previous and transcendent to the things it legitimates and certainly not occasioned by them. But in Duchamp, we have a law which is actually unknown because when A and B are known they lose their "value in duration." If A and B are not known, then the law is not known either. And this law is legitimated by the appearance of a fact which is given the opportunity to appear by the same law. This is a definition of aesthetic judgment, inasmuch as you do judge without knowing the law or the criteria according to which you judge, but which

nevertheless appear after the fact as though they had been the ground for your judgment.

ERIC CAMERON

On the point of linguistic clarification, can I just ask why all the examples you've been giving have been drawn from a social context? I had always read "law" in relation to scientific context. In French, is *lois* equally "laws"?

THIERRY DE DUVE

Yes. The text has indeed the structure of a mathematical theorem, albeit of amusing mathematics. On the other hand, in the mathematical vocabulary you would never use the words "legitimacy" or "legitimate." Mathematical laws are proven, demonstrated, but not legitimated. Once you legitimate, you're in the ethical realm. You're not in the scientific realm.

DENNIS YOUNG

Is there anyone who would like to ask a question from the floor?

JOHN BENTLEY MAYS

This is a question that comes actually from within criticism and not art history. I would like to ask you to continue on with a criticism across time, attempting to create a symmetry at this end of time as opposed to the one where you started. You mentioned the way in which the gestures of Duchamp at the Independents' exhibition were a burlesque of certain ambitions within modernity at that particular moment. How do these works now, this many years later, enter the field of current discussion about modernity—whether "late," or "post," or whatever? I know this is a broad question, but can you lay out what you believe may be the impact of those gestures at this end?

THIERRY DE DUVE

Jesus Christ! The answer is no, I can't. But I can give you the hints that I am working on. My paper was entitled "Etant donné le cas Richard Mutt" and not simply "The Richard Mutt Case." It simply means this: what do we do with the given fact that even a urinal can be art? *Etant donnés* (i.e., given) first of all, *Fountain*, and second, the name of art that has been attributed to *Fountain*, where do we go from there? From the vantage point of 1987, it is a given fact that the modern avant-gardes

have allowed anything to be art. Although not everything is art, poten-
tially any kind of object, including shit, as we all know from Manzoni,
can be art. So there's no limit to that. What does it mean for our culture?
Has art really lost its meaning, or have we achieved that incredibly liber-
ated state where everybody has become an artist—which was, as you
know, *the* utopia of modernism? To have anticipated this "given" is
Duchamp's strength. He is our lever with which to lift the aesthetic world
again. That's how I see him. And the fulcrum is the readymade. Now,
are you going to explain why or justify how the urinal became art? It's
needless. It has been done. Whether the urinal is beautiful, significant,
meaningful, we have an excess of justifications for the blatant fact that
even a urinal can be art. Among those explanations there are those that
say, "Well, it's beautiful," and they rely on traditional aesthetics. That's
fine, I think it's valid. But it's only valid once the urinal has been called
art; to be a beautiful urinal doesn't account for its being art. There are
those that say, "It's art because an artist has chosen it." Then how do
you decide who is an artist? And there are those that say, "It's art
because it's in an art context." So, we are left with two questions: where
does the artist get his or her legitimacy from, and where does the art
context get its legitimacy from? The interesting thing about the Richard
Mutt case is that we have an encounter between an artist who is totally
unknown and has therefore no legitimacy, Richard Mutt, and an institu-
tion that has no legitimacy either, except the one it gives itself through
self-proclamation: "We are all artists." Of course things don't work that
way, so you have to demonstrate, first of all, that there was a ploy; there
was a trick, there is no magic. And second—but this you can't really
demonstrate—that if there had been only a trick, then we would fall, in
my opinion, into a very unethical situation. Then Duchamp's ploy would
have been mere strategy in the condemnable sense. There has to be a
"mediumistic" role, that is unconscious on the artist's part, to which
corresponds an aesthetic judgment on our part. So I've tried to show that
the Richard Mutt case was strategy all right, but not strategy simply in
order to enter the artworld, sell them shit and get away with it. Those
who conceive of art in terms of the art context and its power are either
true cynics or infantile leftists. If they were right the only artists would
be the art curators. I think that's a very unhealthy situation which unfor-
tunately we are going through and have gone through for some time. The

malaise issuing from that is called "postmodernism." As an art historian who is also an art critic, I'd say that it is the duty of art historians to reinterpret modernism in order to give some meaning to the word "post-modernism," which, of course, is mere wishful thinking today.

1 Thierry de Duve has done so. See footnote 37 of his paper.

2 *Salt Seller,* 32.

3 Duchamp distorted the spelling of "pissotière" and used an unusual capitalization in order to construct a perfect anagram of the name Pierre de Massot.

Objects of Modern Skepticism

In memory of Serge Stauffer

Translated from the German
by Helen Petzold and Gloria Meyerle

From the mid-nineteenth century the natural sciences and technology were the only fields that avant-garde writers and artists united to their class in one common perspective of history. It was the perspective of "Progrès": the enthusiasm for the advances in the control of nature, regardless of all retrogressive steps in the organism of society. It is in this context that bridges, railroads, steamships, factories, and city life appear in the painting of the Impressionist painters. By the time Duchamp turned to the natural sciences, far-reaching changes had taken place. While the new inventions spread euphoria and self-satisfaction among the public, Duchamp encountered the sciences in a state of crisis.

From the end of 1912 to May 1914 he worked as a library assistant in the Bibliothèque Sainte-Geneviève in Paris. From his writings we know that he must have made good use of this time studying historical treatises on perspective as well as the latest literature on geometry and dimension theory. More important for Duchamp's intellectual development than any single aspect of natural science, however, were the philosophical writings that the well-known French mathematician and physicist, Henri Poincaré, had published in the first decade of the century: *Science and Hypothesis* (1902), *The Value of Science* (1905), and *Science and Method* (1908), to mention the most significant.[1]

These works, wrote mathematician Ferdinand Lindemann, editor of the German editions, in 1914, "have had decisive influence on our ideas about the foundations of all exact knowledge. . . . Especially the book *Science and Hypothesis* almost brought popular fame to the author. His purely abstract mathematical works had perhaps been of greater significance to the development of science, but this particular work has carried the name Poincaré beyond the borders of his limited science."[2] How much this was indeed the case is revealed by the number of French editions alone. *Science and Hypothesis*, for instance, had run into twenty editions by 1912, only ten years after its first publication. *The Value of Science* was reissued sixteen times in the first six years and *Science and Method* as many as nine

times within only two years.[3] It was, therefore, not so much specific scientific literature but rather the philosophical fashion of his time that inspired Duchamp, when he began to develop new forms of art in 1912–1913.

In his philosophical books Poincaré popularly describes the newest discoveries in physics and their consequences for the physicist's concept of the world. The discovery of X-rays (1895), of the phenomenon of radioactivity (1896), of radium (1898), and especially of the electron (1897) and its laws of motion had shaken the foundations of Newton's classical mechanics, which had until then been considered absolutely unalterable. All views on matter, its structure and motion had to undergo a revision. Physics had entered a stage of development that Poincaré characterized as a "general collapse of the principles," a "period of doubts," and a "serious crisis" in science.[4] The essence of this crisis was not only the disintegration of old physical laws and axioms, as Poincaré himself assumed, but rather profound doubts about the existence of objective scientific knowledge. Materialism, which formed the basis of the sciences in the nineteenth century, was replaced by the philosophy of idealism and agnosticism.

"Does the harmony the human intelligence thinks it discovers in nature exist outside of this intelligence?," asks Poincaré at the opening of his book, *The Value of Science*. "No, beyond doubt a reality completely independent of the mind which conceives it, sees or feels it, is an impossibility. A world as exterior as that, even if it existed, would for us be forever inaccessible. But what we call objective reality is, in the last analysis, what is common to many thinking beings, and could be common to all."[5] For Poincaré the scientific laws of nature are pure symbols, mere conventions, which man creates for the sake of "convenience."[6] "The scientific fact is only the crude fact translated into a convenient language. . . . All these rules, all these definitions are only the fruit of an unconscious opportunism."[7] Mathematical and physical theorems cannot, therefore, fulfill the demand to be true. "The things themselves are not what science can reach . . . , but only the relations between things. Outside of these relations there is no knowable reality."[8] Immanuel Kant's old distinction between the thing in the appearance and the thing itself, unrecognizable to man, appears here once more in new terms.

Poincaré summarizes his point of view succinctly: "All that is not thought is pure nothingness."[9] He considers basic geometric and physical principles such as three-dimensional space, the law of gravity, and the theorem of the conservation of energy to be mere products of consciousness, arbitrary arrangements, which could be formulated otherwise. In physics, especially theoretical physics, epistemological confusion was so great that one spoke of a "physics for believers."[10]

The philosophy of agnosticism that began to dominate modern natural sciences, the very field in which the majority of people presumed knowledge to be secure, became the focus of Duchamp's artistic thinking around 1912–1913. Supported by the authority of one of the most significant mathematicians and physicists of his time, he made it his aesthetic goal to undermine faith in scientific thought. To this end he considered paint, canvas, and brushes to be hopelessly outdated tools. They seemed to him to be no longer adequate to express modern thought or to take up the artistic challenge presented by increasingly complicated realities. They had become intellectually blunt; even when they were applied in a new revolutionary way—as for example in Cubism and Futurism—they were from the outset categorized as "fine art," that is, labeled as the purely subjective matter of very peculiar individuals.

As Guillaume Apollinaire wrote in his "aesthetic meditations" in defense of Cubist painting in 1913: "To insist on purity is to baptize instinct, to humanize art, and to deify personality."[11] These notions of "instinct" and "deification of personality," which were central to the reception of modern art at that time, conflicted with the assumption of "objective statement," which, in social discourse, was entirely reserved for the natural sciences.

In order to enter this discourse Duchamp had to invent a pictorial method that could not be compared to anything that had been known as art until then. "Can one make works which are not 'works of art'?"[12] In this note from 1913 Duchamp accurately formulated the aesthetic problem with which he was confronted in view of his philosophical ambitions. He found the answer in commonplace objects that he transformed into hilarious pseudoscientific devices, carrying forward and transcending the literary example of Alfred Jarry's "pata-physics" into the field of the visual arts. It is, by the way, this pseudoscientific, philosophical function and point of

departure that differentiates the readymades from all other subsequent forms of object art, especially from the Constructivist spatial structures and the Surrealist "objets trouvés." The "works" that emerged from this concept appeared to be the exact opposite of what art was supposed to be at the time. Their external characteristics were impersonality and inexpressiveness as well as a peculiar kind of objectivity.

Duchamp introduced his playful, skeptical physics in 1913–1914 by inventing a new unit of length: *Trois Stoppages-Etalon* [*Three Standard Stoppages*] (fig. 6.1). The idea behind this work is noted in the *1914 Box*. "If a straight horizontal thread one meter long falls from a height of one meter straight on to a horizontal plane, twisting *as it pleases*, and creates a new image of the unit of length—3 patterns obtained in more or less similar conditions: *considered in their relation to one another* they are an *approximate* reconstitution of the measure of length."[13] Duchamp repeated the "experiment" three times, pasted the threads on dark blue-painted canvas just as chance and gravity had placed them, and mounted them on three narrow glass strips. In order to be able to use this personal measure of length for constructional drawings he cut wooden rulers with the profile of the curves of thread and arranged everything carefully in a box similar to the platinum standard meter that was kept in the International Bureau for Measures and Weights in Sèvres near Paris.

At first glance the *Three Standard Stoppages* appear to be utter nonsense or, in any event, a refined mockery of the scientist's ambitions. After all, had not Henri Poincaré stated in his treatise *Science and Hypothesis* that it would be "unreasonable to inquire whether the metric system is true or false"?[14] Regarding the standard measures (*les étalons*) used in physics and the possibility of experimentally testing their truth content, he wrote "Experience guides us in the choice of the *standard* [*l'étalon*] to which we shall refer natural phenomena without forcing it upon us; it tells us not which is the truest geometry, but which is the most *convenient*."[15]

In Poincaré's book Duchamp not only encountered the idea of all standards being relative but also may have found the stimulus that enabled him to visualize this idea artistically: the thread experiment. In a four-page passage in the chapter on classical mechanics, Poincaré presents a so-called "School of the Thread" ["L'Ecole du Fil"], which "tries to reduce everything

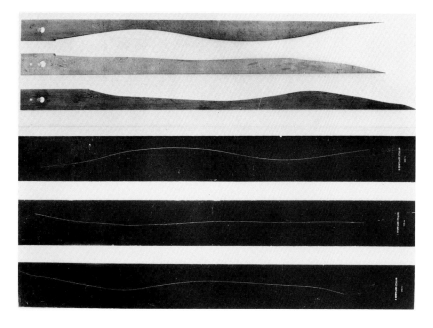

6.1
Trois Stoppages-Etalon [*Three Standard
Stoppages*], 1913–1914. Assemblage,
11⅛ × 50⅞ × 9 in. (overall). (The
Museum of Modern Art, New York;
Katherine S. Dreier Bequest, 1953.)

to the consideration of certain material systems of negligible mass . . . , systems of which the ideal type is the *thread*."[16] After the description of a few experiments with evenly tensioned threads, Poincaré summed up the procedure of the "School of the Thread" in an epistemological observation: "We see at the start a very particular and in sum rather crude experiment; at the finish, a law perfectly general, perfectly precise, the certainty of which we regard as absolute. This certainty we ourselves have bestowed upon it voluntarily, so to speak, by looking upon it as a convention."[17]

In the *Three Standard Stoppages* of 1913–1914 Duchamp radicalized Poincaré's thesis that scientific principles are pure arrangements to its logical conclusion, namely that all standards are equally valid, however personal, arbitrary, or capricious they may be. This, the first of Duchamp's non-paintings, is an image of relativism and subjectivism. It states that there is no necessity, no objective interrelation in nature and society. According to this work, scientific thought is nothing more than a human presumption, at best self-deception.[18]

In the form of a pseudoexperiment, the *Three Standard Stoppages* represent chance as the fundamental principle in Duchamp's idea of human life. In numerous works after 1913–1914 he used the rulers as a drawing aid. "Pure chance," he explained decades later, "interests me as a means to combat logical reality."[19]

The first sculptures Duchamp produced, which from 1915 he called readymades, also departed from the tradition of art and were modeled on experimental devices (fig. 6.2).[20] The first object of this sort was a bicycle wheel mounted on a kitchen stool. It was constructed in the same year as the *Three Standard Stoppages*. The idea of movement, the representation of which Duchamp struggled with for two years in his painting,[21] is continued here in an experimental setup. For the physicist the wheel of a bicycle with the fork secured to a support at the bottom is nothing unusual. In physics manuals we find similar devices to demonstrate the effect of angular momentum or to prove the effect of centrifugal forces on a free axis. However, Duchamp does not seem to have intended to associate any scientific proof with this arrangement nor to measure anything. The description of his perception of this "sculpture already made" emphasizes quite another

characteristic: "I enjoyed looking at it, just as I enjoy looking at the flames dancing in a fireplace. It was like having a fireplace in my studio, the movement of the wheel reminded me of the movement of the flames. . . . To see that wheel turning was very soothing, very comforting, a sort of opening of avenues on other things than material life of every day."[22]

Even with the aid of the notes he left behind, it is impossible to define accurately the comforting speculations on movement and standstill, on the transition from one dimension to another, or on space and time that Duchamp arrived at while meditating before the turning wheel. It does not seem particularly important to me. The aesthetic structure of this first readymade is characteristic: the combination of humor, pseudoscientific device, and a meditation object. We encounter this same structure in numerous other readymades.

Modern physics emphasizes the relativity of space. Poincaré had explained in his books that it is impossible for an observer in a moving system to ascertain where top and bottom or left and right are. Therefore, in his mind Duchamp turned his studio by 90 degrees and nailed the coatrack to the floor instead of to the wall. This arrangement, created in 1917 in New York, was titled *Trébuchet*. In French this word indicated a "trap"—the verb "trébucher" means "to trip, to stumble." *Trébuchet* is also a chess term for a pawn placed so as to "trip" an opponent's piece.

In scientific vocabulary, a *trébuchet* is a precision scale in a laboratory, a meaning that brings the notion of gravity into play. At that time there was hardly any other principle in classical mechanics that had been so shaken as the concept of gravity as an independent force. "If there is no longer a constant mass, there is no longer a center of gravity, we no longer know even what it is" (Poincaré).[23] As if to nurse the sick gravity, Duchamp invented the *Soigneur de gravité* (Tender of Gravity).

Most of the readymades in Duchamp's New York studio in 1917–1918 seem to have been associated with ideas regarding the location of objects in space. A counterpart to *Trap* on the ground is the readymade of a spiderlike hatrack, the upper part of a coatstand, which dangles on a cord (fig. 6.3). Both of these pieces of furniture move in countermotion: the coatrack, which is usually on the wall, falls and is fixed on the floor. The

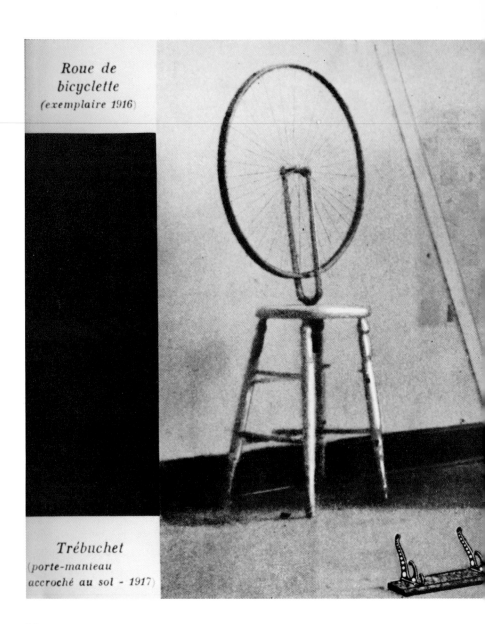

Roue de
bicyclette
(exemplaire 1916)

Trébuchet
*(porte-manteau
accroché au sol - 1917)*

6.2
Duchamp's studio, 33 W. 67th St., New
York, 1917–1918. Retouched photograph
from the *Box-in-a-Valise* showing *Tré-buchet* [*Trap*], 1917, and *Bicycle Wheel*,
second version, 1916.

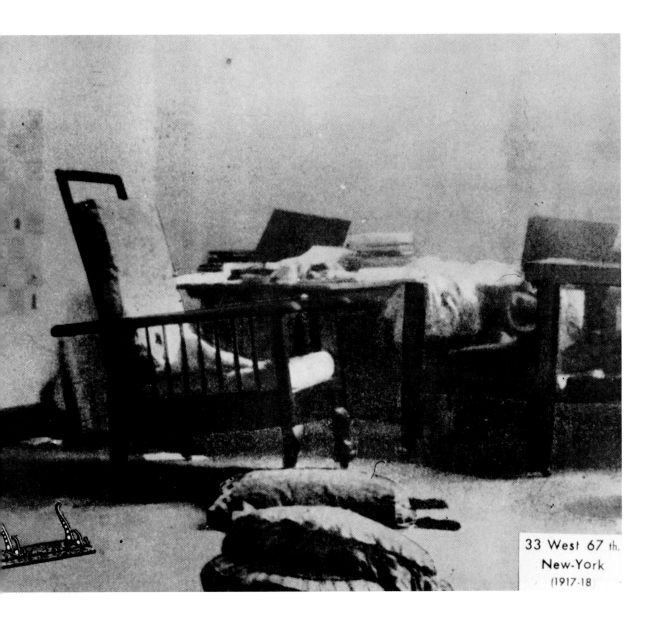

33 West 67 th.
New-York
(1917-18

6.3
Porte-chapeau [*Hatrack*], readymade,
1917 (lost). Wood, 9⅜ × 9⅜ × 5⅝ in.
Retouched photograph from the *Box-in-
a-Valise*, also showing *In Advance of the
Broken Arm* hanging from the ceiling in
the foreground and *Fountain* hanging in
the door opening in the background.

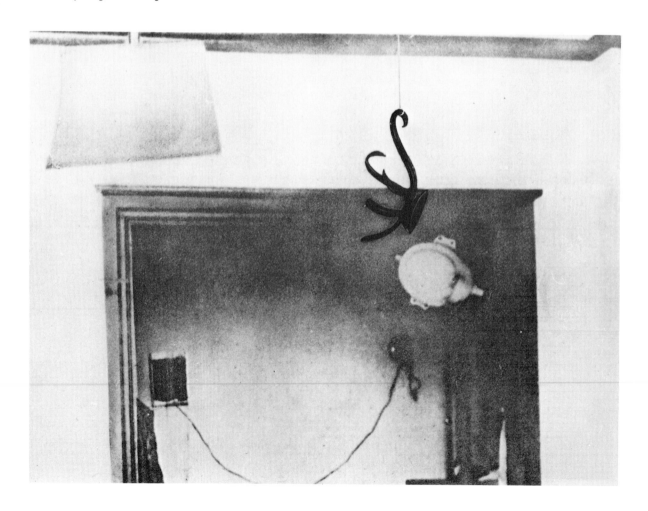

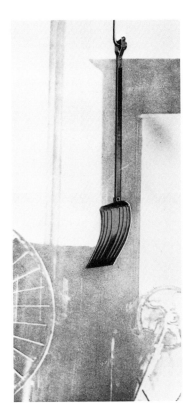

6.4
In Advance of the Broken Arm, ready-made, 1915 (lost). Wood and galvanized iron, approx. 48½ in. high. Retouched photograph from the *Box-in-a-Valise.*

hatrack rises, floats in the air. Like the coatrack, it can no longer countereffect gravity and define the position of hats in space.

A snow shovel is likewise displaced, hanging down from the ceiling (fig. 6.4). The choice of a snow shovel, too, does not seem to have been arbitrary, since it is also an object that conveys to man the physical feeling of heaviness. The inscription *In Advance of the Broken Arm* may refer to this sensation. This shovel now floats in the air. There is something wrong with the experience connected with it. The result is an object of everyday use as an image of the paradox.

"Right and left—two-dimensional plane. Top and bottom—three-dimensional space," Duchamp jots down twice on a slip of paper in the *White Box*.[24] In another jotting he explains, "Gravity and center of gravity make for horizontal and vertical in three-dimensional space. . . . Gravity is not controlled physically in us by one of the 5 ordinary senses. We always reduce a gravity experience to an autocognizance [*autoconstatation*], real or imagined, registered inside us in the region of the stomach."[25] The idea of reducing geometric-physical definitions to corporeal sensations is also inspired by Poincaré's approach. In *The Value of Science* he had pointed out that "it is to our own body that we naturally refer exterior objects; . . . we carry about everywhere with us a system of axes to which we refer all the points of space and . . . this system of axes seems to be invariably bound to our body."[26] Here, Poincaré summarizes what he had elaborated at length three years earlier in *Science and Hypothesis*. He derived the concept of geometric space from a synthesis of sensations of sight, touch, and "muscular sense." He considered this process of unifying corporeal sensations into a scientific definition of space to be the result of mere habit. "This habit itself results from very numerous *experiences*; without any doubt, if the education of our senses had been accomplished in a different environment, where we should have been subjected to different impressions, contrary habits would have arisen and our muscular sensations would have been associated according to other laws."[27]

It is as if Duchamp had wanted to simulate this different "education of the senses" by exposing himself and visitors to the crazy objects in his studio presenting totally new environmental conditions and object relations. In order to subvert the common belief in "top" and "bottom," "left" and "right," as absolutes, he had to disrupt, retard, paralyze the usual corporeal

thing-experience. The unexpected position of the coatrack, hatrack, and snow shovel in space serves this aesthetic purpose. Of course, these amusements bore no results for the sciences. But they had far-reaching consequences for the further development of the visual arts. Are all definitions of art and the beautiful not at least as relative as the so-called iron laws of nature? "These rules are not imposed upon us," Poincaré wrote on one of the most basic axioms of physics, the principle of cause and effect, "and we might amuse ourselves in inventing others."[28] Duchamp had fun doing exactly this, not only by inventing what he called *playful physics* and *ironical causality*,[29] but by blurring the line between works and artworks, between commonplace utensils and objects in the service of the mind. Thus he created a form of expression that forever denied the possibility of defining art metaphysically, i.e., basing aesthetics on absolute rules.

Duchamp's speculations on gravity could be pursued further with reference to a few other readymades, in particular *Pliant . . . de voyage, Air de Paris, Why Not Sneeze, Rrose Sélavy?*, as well as to *The Bride Stripped Bare by Her Bachelors, Even*.[30] However, I would like to leave this subject now and discuss another of his hobbyhorses—his dimension-theoretical fantasies.

One of the theoretical axes, if not the theoretical axis, on which Duchamp's writings and works are structured is the thought of the world as a projection problem. A great part of his texts from the years 1912 to 1920 (which appeared in the *White Box*) revolves around this question. Their point of departure is a conclusion by analogy: if a shadow is the projection of a three-dimensional object on a two-dimensional surface, Duchamp argues, then the three-dimensional object is the projection of a four-dimensional entity in the three-dimensional space.[31] Everything that exists in the three-dimensional world is only the "projection," the "representation," the "reflex" of invisible things existing in another world with a higher dimension. As our organs of perception are limited to three dimensions, that world remains closed to us forever. The concept of "four dimensions," a focus of Duchamp's pseudoscientific speculations, serves as an expression of this hypothetical reality. In the guise of an analogy taken from the geometric theory of dimension, Duchamp accepted the old proposition of Kantian agnosticism posing in Poincaré's philosophical writings as the most advanced position in modern thought.

All objects are images of other invisible objects, which are themselves again images. Then also, the world "in the fourth continuum" is not the real, true world. If the analogy for the transition from the second into the third and from the third into the fourth applies, then it should apply likewise to the transition from the fourth into the fifth dimension and so forth without end. In Duchamp's view the world is an endless tunnel comprised of mirrors, projections, and illusions.

In 1914 Duchamp chose the *Sèche-Bouteilles* [*Bottle Rack* or *Bottle Dryer*], a common domestic utensil to be found in the cellar of almost every French family, as a symbol of this agnostic world view (fig. 6.5). He notes: "Each ordinary 3-dim'l body, inkpot, house, captive balloon is *the* perspective projected by *numerous* 4-dim'l bodies upon the 3-dim'l medium."[32] Without base, the *Bottle Dryer* is represented on the print that Duchamp himself produced at great effort for his catalogue raisonné, the so-called *Box-in-a-Valise*. This print suggests that the object is seen hanging from the ceiling like the 1917 *Hatrack*. But there is no suspension visible either. Even with the help of the shadow, the approximate position of the object in space cannot be discerned clearly. A closer look reveals that there is something wrong with the shadow. It is the direct repetition of the figure of the *Bottle Dryer*, printed with the aid of a mask and transferred a few centimeters downward (fig. 6.6).

Can one demonstrate on a photograph, a two-dimensional plane, that plastic objects can be thought of as mirror-images of other higher-dimensional objects? Duchamp found an ingenious solution by negating the difference in form of the cast shadow and the object, so that the three-dimensional object could also be a shadow (of something else). The complicated process of printing that Duchamp used to achieve this effect[33] makes clear how much it meant to him to have the *Bottle Dryer* understood as a problem of projection: in the sense that each normal three-dimensional thing is the "apparition"[34] of invisible four-dimensional bodies.

In the objects and installations discussed so far, Duchamp ironizes particular aspects of the scientific world outlook: the concepts of the standard measure and the principle of causality, the idea of gravity and three-dimensional space. In the *Readymade malheureux* [*Unhappy Readymade*] of 1919, the general, fundamental character of his antiscientific skepticism

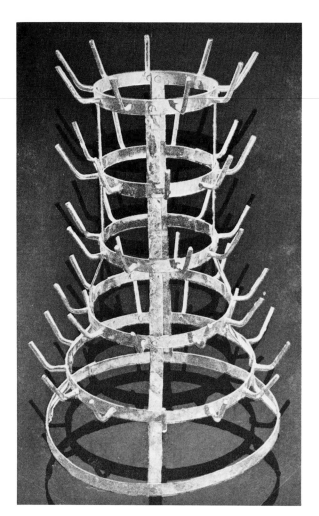

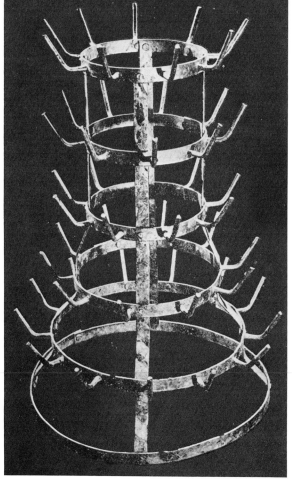

is revealed (fig. 6.7). In April of that year Duchamp's sister Suzanne married the painter Jean Crotti in Paris. As a wedding present he sent her (from Buenos Aires) the instructions for a "work" for the realization of which he required her cooperation.

It consisted of "a geometry book, which she had to hang by strings on the balcony of her apartment in the Rue de la Condamine; the wind had to go through the book, choose its own problems, turn and tear out the pages. Suzanne did a small painting of it, *Marcel's Unhappy Readymade*. That's all that's left, since the wind tore it up. It amused me to bring the idea of happy and unhappy into readymades, and then the rain, the wind, the pages flying, it was an amusing idea."[35]

Apart from Suzanne Duchamp's painting, the readymade was documented in a print that Duchamp incorporated in the *Box-in-a-Valise*. The geometric figures visible in the opened book have been sketched and completed by hand so that it was clear that the book dealt with geometry. Euclid's *Elements* did not withstand the elements of nature.[36] The readymade calls to mind Poincaré's statement that all scientific principles and laws are pure symbols, mere conventions, which man has created for the sake of convenience. "It is not nature which imposes [time and space] upon us, it is we who impose them upon nature because we find them convenient," reads one of the most clear-cut sentences in *The Value of Sciences*.[37] "There is no solution because there is no problem," Duchamp radicalized the epistemological idea contained in this proposition. "Problem is the invention of man—it is nonsensical."[38] The viewpoint of subjective idealism has seldom been formulated more openly.

The anesthesia of logical thought, the "cretinization" of reason, was Duchamp's lifelong artistic occupation. Although he was indebted to the sciences for his revolutionizing of the visual arts as hardly any other artist in this century, Duchamp was basically hostile to scientific rationalism, which had assumed the role of religion and philosophy as the principal means to explain reality.

Thirty years later, on the occasion of the exhibition "Le Surréalisme en 1947" in Galerie Maeght, Paris, which was dedicated to the theme "modern myth," Duchamp took the opportunity to address this issue directly. He did this in his usual inconspicuous, almost beside-the-point manner.

6.5
Sèche-bouteilles [*Bottle Dryer*], readymade, 1914 (lost). Second version, 1936 (lost). Galvanized iron, dimensions unknown. Retouched photograph from the *Box-in-a-Valise*.

6.6
Bottle Dryer. Proofprint (without the shadow) for fig. 6.5. (Private collection.)

6.7
Readymade malheureux [*Unhappy Readymade*], 1919 (lost). Retouched photograph from the *Box-in-a-Valise*.

Behind a circular hole cut into the green cloth with which the Salle de Superstition (Hall of Superstition) was hung, Duchamp, probably instructing the exhibition architect Frederick Kiesler, had a photo object installed that depicted the view of a vast, calm sea (fig. 6.8 and 6.9). Apparently, a narrow slit had been cut on the level of the horizon and, in it, a green ray of light flashed from time to time. The photo had been tilted slightly so that the slanted horizon suggested that the observer was on a boat at sea. It was described in the exhibition listing as follows: "Un hublot laisse passer le *Rayon Vert* de MARCEL DUCHAMP" ["through a porthole shines the *Green Ray* by Marcel Duchamp"].[39]

The arrangement referred to one of Jules Verne's *Voyages Extraordinaires* which had appeared in 1882 under the title *Le Rayon-Vert*.[40] The novel tells the story of a young woman who exposed herself to all possible dangers in order to see an extremely rare natural phenomenon: the green ray of light. According to the newspapers, it is supposed to appear for fractions of a second over the sea, presumably at the moment when the sun disappears behind the horizon, the air is absolutely still and there is neither dust nor cloud in the sky. During her adventure she is accompanied by two young men, one a geologist and one a painter, who are both in love with her.

In the image of the competition between the scientist and the artist for the woman's love, Jules Verne described the disenchantment of the world brought about by the advance of science. Therein lies the charm of this otherwise rather boring novel. The confrontation climaxes in a heated conversation between the three protagonists about the nature of the *Rayon Vert*. While the young woman wishes to interpret it on the basis of the mythology of the old Scottish singers as the "sash of the Valkyrie, whose hem floats on the waters of the horizon," the geologist analyzes the phenomenon as mere optical illusion—the result of afterimage effects and the mixing of complementary colors in the eye. The young woman, beside herself over this "physical argumentation," receives support from the artist who sarcastically recommends a few unsolved research themes to the geologist; for instance, the question regarding "the influence of fish tails on the breaking waves" or "wind devices on the formation of storms." After this debate the competition for eros was decided. The scientist lost the game, for he had "depoetized the heroine's ray of light, materialized her dream,

6.8
Le rayon vert [*The Green Ray*], 1947.
Installation at exhibition "Le Surréalisme
en 1947," Galerie Maeght, Paris, 1947.
(Photo Denise Bellon.)

transformed the sash of a Valkyrie into a brutal, optical phenomenon. She
would have perhaps forgiven anything else, but not that."[41]

The theme addressed here has been a focal point of modern literature and
art since the middle of the nineteenth century. Abstract-analytical thinking
backed up by its technological achievements penetrates more and more
into social reality and, by destroying the mythical traditions, expels the
poetic instincts of life. The position Duchamp takes in this conflict is clear.
All his life he had, indeed, dealt with optical illusions, not to further the
natural scientific world outlook but out of the conviction that all experi-
ences, scientific thought included, touch on mere appearance, on sense
illusions. Duchamp was as ironic as his colleague in the novel; they shared
the same attitude, namely, as Duchamp put it, "to discredit science mildly,
lightly, unimportantly"[42] and to give back to life a nonfunctional, playful
dimension.

6.9
The Green Ray next to Frederick Kiesler
and his sculpture, *La main blanche*. At
exhibition "Le Surréalisme en 1947,"
Galerie Maeght, Paris, 1947. (Photo
Denise Bellon.)

Notes

1 The original titles are *La science et l'hy-pothèse, La valeur de la science,* and *Science et méthode.* (English translations of all three are in *The Foundations of Science,* trans. George B. Halsted [Lancaster, Pa.: The Science Press, 1946]). The scientist François Le Lionnais, who was acquainted with Duchamp from about 1921, has indicated how extraordinarily important these works were for Duchamp: "Duchamp liked talking to people with a scientific background, and he asked them questions; he talked about mathematics. But until the end of his life he was stuck at Henri Poincaré—I managed to change his ideas quite a lot towards the end of his life. He had read a lot of books—not mathematical texts which he would have been unable to understand, but . . . philosophical works." Questioner: "Popular science . . . ?" FLL: "That's it, for instance *Science and Theory* [Le Lionnais probably means *Science and Hypothesis*]. That is the philosophical musings of a great mathematician, which combine philosophical and mathematical qualities. This influenced him a lot. And then when we ran into each other I surprised him by saying (I have no idea what influence this may have had): 'Poincaré—he's completely out of date'. That surprised him, shocked him." Quoted in "Marcel Duchamp as a Chess Player and One or Two Related Matters," *Studio International,* January/February 1975, 24.

2 Cf. Henri Poincaré, *Wissenschaft und Hypothese* (Leipzig, 1914), ix.

3 Cf. *Larousse mensuel illustré. Revue encyclopédique universelle,* 2, no. 69 (November 1912), 568.

4 *The Value of Science,* in *The Foundations of Science,* 314 and 297.

5 Ibid., 209.

6 Ibid., 255.

7 Ibid., 330 and 234.

8 *Science and Hypothesis,* in *The Foundations of Science,* 28.

9 *The Value of Science,* in *The Foundations of Science,* 355.

10 See Abel Rey, *La théorie de la physique chez les physiciens contemporains* (Paris, 1907), 160–162.

11 Guillaume Apollinaire, *The Cubist Painters: Aesthetic Meditations 1913* (New York: Wittenborn, 1962), 10.

12 "Peut-on faire des oeuvres qui ne soient pas 'd'art' ?" In Marcel Duchamp, *Duchamp du signe,* ed. Michel Sanouillet (Paris, 1975), 105.

13 *Duchamp du signe,* 36.

14 *Science and Hypothesis,* in *The Foundations of Science,* 124.

15 Ibid., 79–80.

16 Ibid., 104.

17 Ibid., 106.

18 Poincaré himself would never have drawn this conclusion. He quickly realized the dangers his epistemological argument held for experimental physics. In the introduction to *The Value of Science* of 1905 he tried to refute all those who had transformed the subjective idealist propositions in his earlier book *Science and Hypothesis* into complete skepticism, arguing that scientific laws are nothing but the inventions of the scholars, and that from now on science had to be thoroughly mistrusted. But the following statement, made by Poincaré as "clarification," was also not without ambiguity: "Some people have exaggerated the role of convention in science; they have even gone so far as to say that law, that scientific fact itself, was created by the scientist. This is going much too far in the direction of nominalism. No, scientific laws are not artificial creations; we have no reason to regard them as accidental, *though it be impossible to prove they are not.*" (My italics.) *The Value of Science,* in *The Foundations of Science,* 208–209.

19 Cf. Pierre Cabanne, *Entretiens avec Marcel Duchamp* (Paris, 1967), 81.

20 It appears that Duchamp's break with painting in 1913 began with his adventur-

ing into the field of sculpture, in which his elder brother Raymond Duchamp-Villon had already gained some recognition. That Duchamp had taken to viewing common-place objects as possible sculptures is established by a note in the *1914 Box:* "Le jeu de tonneau est une très belle *'sculp-ture' d'adresse"* (*Duchamp du signe*, 37). With reference to the readymades *Bicycle Wheel* and *Bottle Dryer* he wrote to his sister in January 1916: "I had purchased this as a *sculpture* already made." (Cf. Francis F. Naumann, "Affectueusement, Marcel," *Archives of American Art Journal* 22, no. 4, [1982], 5.) In a letter dated April 11, 1917, he wrote: "Richard Mutt sent in a porcelain urinal as a *sculpture"* (ibid., 8). The *Sculpture for Traveling* followed in 1918. An unrealized sculpture is outlined in the *White Box*: "Faire un tableau ou *sculpture* comme on enroule une bobine de film-cinéma" (*Duchamp du signe*, 107).

21 Here too, Duchamp had already made use of a scientific picture process, "chrono-photography" developed by the French physiologist Etienne-Jules Marey, in order to oppose Cubist theory with his own interpretation. See Herbert Molderings, "Film, Fotografie und ihr Einfluss auf die Malerei in Paris um 1910. Marcel Duchamp—Frank Kupka—Jacques Villon," *Wallraf-Richartz-Jahrbuch* 37 (1975), 247–286.

22 Cf. Arturo Schwarz, *The Complete Works of Marcel Duchamp*, 2d ed. (New York, 1970), 442. See also Duchamp's letter dated June 26, 1955, to Guy Weelen, then general secretary of AICA: "Je me rap-pelle seulement que l'ambiance créée par le mouvement intermittent avait quelque chose d'analogue à la danse d'un feu de bois; c'était comme une révérence au côté inutile d'une chose généralement utilisée pour d'autres buts. . . . J'ai probablement accepté avec joie le mouvement de la roue comme un antidote au mouvement habi-tuel de l'individu autour de l'objet contem-plé" (cf. *AICARC Bulletin*, no. 1 [1974], cover).

23 *The Value of Science,* in *The Foundations of Science,* 312.

24 *Duchamp du signe,* 123.

25 Ibid.

26 *The Value of Science,* in *The Foundations of Science,* 247.

27 *Science and Hypothesis,* in *The Founda-tions of Science,* 69.

28 *The Value of Science,* in *The Foundations of Science,* 234.

29 "Donner toujours ou presque le pourquoi du choix entre 2 ou plusieurs solutions (par causalité ironique)." Cf. *Duchamp du signe,* 46.

30 In the *Notes* (published posthumously) one can read the following on the *Large Glass*: "The picture in general is only a series of variations on the 'law of gravity,' a sort of enlargement, of relaxation of this law, submitting to it . . . extraphysical situ-ations or bodies less or not chemically conditioned." In *Marcel Duchamp, Notes,* ed. Paul Matisse (Paris, 1980), no. 104.

31 Cf. *Duchamp du signe,* 127–131. Here Duchamp paraphrases an idea outlined by Esprit Pascal Jouffret in his *Traité élémen-taire de Géométrie à quatre dimensions* (Paris, 1903), which is quoted explicitly by Duchamp. Duchamp's preoccupation with four-dimensional geometry is given detailed consideration in Linda D. Hender-son, *The Fourth Dimension and Non-Euclidean Geometry in Modern Art* (Princeton, 1983), and Gregory Adcock, *Marcel Duchamp's Notes from the Large Glass: An n-Dimensional Analysis* (Ann Arbor, 1983).

32 Ibid., 135.

33 The photograph of the *Bottle Dryer* that Duchamp used to make the print in the *Box-in-a-Valise* was taken by Man Ray. There is a full-page reproduction of it in *Cahiers d'art* 11, no. 1–2 (1936), 42 (as an illustration in the article "Coeurs volants" by Gabrielle Buffet). The original photo-graph is now in the collection of the Museum of Modern Art in New York. It was shown on loan from Christian Zervos, the director of *Cahiers d'art,* in the "Fan-tastic Art Dada Surrealism" exhibition in December 1936/January 1937 (cat. no. 221). After the exhibition it went into the collection of the museum. The base on which the *Bottle Dryer* stands and the original cast shadow are clearly visible on the original photograph. The light falls on the object from the top righthand side and throws a short shadow on the base. For his print in the *Box-in-a-Valise,* Duchamp had the base and the shadow masked. With the aid of a stencil that precisely

repeated the figure of the *Bottle Dryer,* a
new "shadow" was printed with a kind of
lacquer. Duchamp might have used the
plate that had been produced for the illus-
trations in *Cahiers d'art* for his print in the
Box-in-a-Valise, since both reproductions
have exactly the same dimensions, 27 ×
17 cm.

34 This concept is central to Duchamp's the-
ory. In French, *apparition* not only means
the process of appearing of a thing, but
also has a metaphysical meaning.

35 Cf. Cabanne, *Entretiens,* 90.

36 Linda D. Henderson has pointed out that
the diagram visible in the photograph
illustrates Theorem 36 of Book 3 of
Euclid's *Elements;* it demonstrates "'the
radical axis of two circles,' from which
tangents drawn to the two circles are
always equal" (*The Fourth Dimension,*
160).

37 *The Value of Science,* in *The Foundations
of Science,* 207.

38 Cf. Harriet and Sidney Janis, "Marcel
Duchamp. Anti-Artist," *View* 5, no. 1
(March 1945), 24.

39 The exhibition list is an unpaginated four-
page leaflet not to be confused with the
book *Le Surréalisme en 1947* that was
published for the exhibition by Galerie
Maeght (in which the *Rayon Vert* is only
mentioned in a footnote, p. 134).

The record of the *Rayon Vert* is confusing.
The work itself no longer exists. The
description given here is based on the
memories of the Surrealist painters Marcel
Jean, Matta Echaurren, and Mrs. Seigle,
who participated in installing the 1947
exhibition and recognized the *Rayon Vert*
on the two photographs reproduced here
when they were shown to them. The pho-
tographs were found in the negative
archives of Denise Bellon, who photo-
graphed almost every piece in the exhibi-
tion. Regarding the material and the
construction of this object, the recollec-
tions of the above-mentioned artists were
not very precise. Marcel Jean remembers
having held this work in his hands before
it was installed and speaks of it as "some-
thing like two superimposed photo-
graphs." Mrs. Seigle related: "On leaving
the Hall of Superstition most visitors
asked each other: 'Did you see the *Rayon
Vert?* I didn't.' Hardly anyone had seen it."

From this one may conclude that the light
did not flash very frequently. Marcel Jean
was probably the only one who talked
about the *Rayon Vert* after the exhibition
was closed and it disappeared. He men-
tions it in his *History of Surrealist Painting*
(London, 1960), 343: "Kiesler's *Totem of
Religions* stood next to Duchamp's object-
photograph *Le Rayon Vert.*" The sculpture
shown in figure 6.9 is not the *Totem of
Religions* (which according to the exhibi-
tion list was erected at the entry to the
next hall) but *La main blanche (figure anti-
tabou),* also by Kiesler.

In his book *L'art surréaliste* (Paris, 1969)
Sarane Alexandrian published a photo-
graph that supposedly shows Duchamp's
Rayon Vert (fig. 6.10). Arturo Schwarz
reproduced it in the second enlarged edi-
tion of *The Complete Works of Marcel
Duchamp* (New York, 1970) as number
419. Anne d'Harnoncourt and Kynaston
McShine did not include it in the cata-
logue of the Duchamp exhibition in the
Philadelphia Museum of Art and in the
Museum of Modern Art, New York, of
1973, but reproduced it in the "Chronol-
ogy" as the *Rayon Vert,* but as a work of
Frederick Kiesler who, as they explained,
executed it "on Duchamp's behalf" (p.
25). Marcel Jean and Matta stated that this
photograph does not show the *Rayon Vert*
at all. It remains uncertain which object of
the exhibition is documented on this
photo, also taken by Denise Bellon.
According to the number of the negative
and the register, the object on the photo
was part of the "object of the altars"
[*objets des autels*] and not of the *Hall of
Superstition* where the *Rayon vert* was
displayed. In stating that the *Rayon Vert*
was probably installed by Kiesler, Marcel
Jean and Matta confirm the information in
the Philadelphia catalogue. Unfortunately I
was unable to view the Frederick Kiesler
estate in New York, which could probably
throw more light on the collaboration
between Kiesler and Duchamp.

40 Editions Hetzel, Paris. Jules Verne's spell-
ing is *Le Rayon-Vert.*

41 Ibid., 115–117.

42 Cf. Cabanne, *Entretiens,* 67: "It was just
the idea that life would be more interest-
ing if you could stretch these things [the
laws of physics and chemistry] a little."
Thus Duchamp formulated his "program"
in retrospect. "After all, we have to accept
those so-called laws of science because it

makes life more convenient, but that doesn't mean anything so far as *validity* is concerned. Maybe it's all just an illusion. We are so fond of ourselves, we think we are little gods of the earth—I have my doubts about it, that's all. The word 'law' is against my principles. Science is so evidently a closed circuit, but every fifty years or so a new 'law' is discovered that changes everything. I just didn't see why we should have such reverence for science, and so I had to give another sort of pseudo explanation. I'm a pseudo all in all, that's my characteristic. I never could stand the seriousness of life, but when the serious is tinted with humour it makes a nicer colour." (Quoted in Calvin Tomkins, *Ahead of the Game: Four Versions of Avant-garde: John Cage, Marcel Duchamp, Jean Tinguely, Robert Rauschenberg* [London, 1968], 36–37.)

Discussion

Moderated by Dennis Young

F R A N C I S N A U M A N N

I have just one very quick question. I'd like to know what the other photograph of *Le rayon vert* is, the one that's published by Schwarz.

H E R B E R T M O L D E R I N G S

Le rayon vert was documented in a footnote of the book *Le Surréalisme en 1947*. In a separate four-page listing of the exhibits it was stated, under the heading *Salle de superstition*, that "un hublot laisse passer le Rayon vert de Marcel Duchamp." ["A porthole allows Marcel Duchamp's *Green Ray* to pass through."] That's all. From then on, nobody, as far as I know, talks about it, except for the painter and essayist Marcel Jean, who mentioned it in his 1959 book *The History of Surrealist Painting*. Talking about the arrangements in the Hall of Superstition, he said, "Kiesler's *Totem of Religions* stood next to Duchamp's object-photograph, *Le rayon vert*." Then all reference to it disappeared until after Duchamp's death, when Sarane Alexandrian, in his 1969 book *L'art Surréaliste*, published this photograph (fig. 6.10), calling it *Le rayon vert*. As you can see it's a box. He had found this photograph in the files of the photographer of the exhibition, Denise Bellon. I went through those files and I found the negative. Denise Bellon had no recollection of *Le rayon vert* and could not identify the work on the photograph. However, in the 1970 (second) edition of his catalogue raisonné, Arturo Schwarz included the photo found by Sarane Alexandrian and listed it as *Le rayon vert*, and the Philadelphia Museum and the MoMA, in their 1973–74 catalogue, also included it in the chronology. So I asked Marcel Jean, "Is this *Le rayon vert*?" And he said, no, that it had nothing to do with it. He said, "This is some object in relation to one of the altars which were built." That is what he presumed, but he couldn't say anything else about it. Then later I went through Denise Bellon's files again and found the two photographs you've seen (figs. 6.8 and 6.9), which confirm the 1947 listing, "Un hublot laisse passer le rayon vert de Marcel Duchamp." With these two photographs I went back to Marcel Jean and I asked him, "What is that?" And he said, "It's *Le rayon vert*." And I asked, "Who installed it?" As he remembered it, it was made of two "transparent" photographs

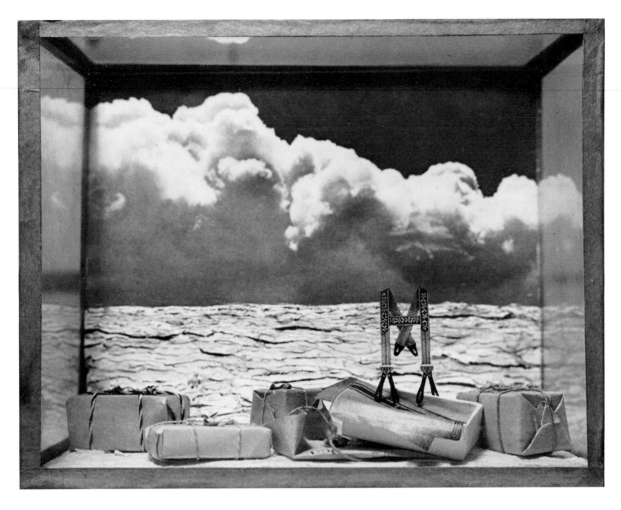

6.10
The Green Ray, 1947 (assemblage), as
identified by Sarane Alexandrian and
Arturo Schwarz. (Photo Denise Bellon.)

6.11
Frederick Kiesler, study for *The Green Ray*, 1947. Ink on paper. For the exhibition "Le Surréalisme en 1947," Galerie Maeght, Paris, 1947. (Frederick Kiesler Estate; photo Kevin Ryan.)

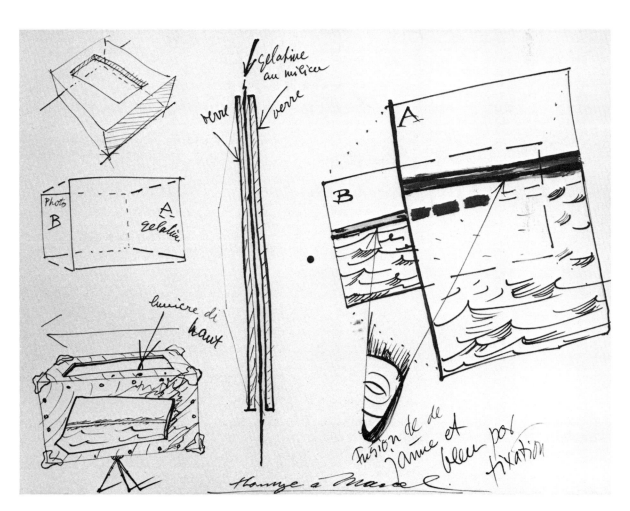

superimposed on one another, and he himself was to have installed it (being one of the artists who helped putting up the exhibition). But he didn't know what to do with it and, according to his recollection, he gave it to Matta. So, I went to see Matta and Matta said, "Yes, this is *Le rayon vert*, but I didn't install it, it was Frederick Kiesler who did." I have not yet checked out Kiesler's archives.[1] Now, what Jean Suquet said yesterday about these sayings of Matta has disturbed me a bit in relation to the precision of Matta's memory. But I rely on the memories of Marcel Jean and the fact that he was the only one who ever spoke about *Le rayon vert* and speaks very clearly about its position: it was beside Kiesler's *Totem of Religions*, he said. Actually, it was beside his sculpture, *La main blanche—figure anti-tabou*, and there (fig. 6.9) you see Kiesler beside his *Figure*. I am rather sure that this is the *Rayon vert* because of the exhibition listing saying, "A porthole allows Marcel Duchamp's *Green Ray* to pass through." However, this strange object with the suspenders, which Alexandrian and Schwarz published (fig. 6.10), doesn't let anything pass through.

FRANCIS NAUMANN

If you intensely light from behind the one that you refer to as the true *Rayon vert*, you won't see much of anything, except for the green ray projecting through the opening in the curtain.

HERBERT MOLDERINGS

Yes. There was the effect of a green ray of light. That is what Marcel Jean and Matta remembered. In the close-up photograph of the object (fig. 6.8) it seems that a light is flashing, so I suspect that there was a slit. But I don't know what it was that caused the flashing. In the photograph with Kiesler standing next to the piece you see the green cloth, and behind that you see a kind of panel, maybe made of wood. Can you see that?

FRANCIS NAUMANN

It's a cloth stretched across the surface of the wall. But I don't know whether or not someone recalled that the cloth was green.

HERBERT MOLDERINGS

Yes. It was Marcel Jean in his book. He says that the cloth in the Hall

of Superstition was green. They cut a hole in the cloth (you see it by the shadow), and the thing is positioned behind it. It was tilted, you know, and you have this porthole . . . And this item is the . . .

FRANCIS NAUMANN

. . . photograph of the green light?

HERBERT MOLDERINGS

No.

FRANCIS NAUMANN

It's a box or something, right?

HERBERT MOLDERINGS

Yes, it's a box. It must have been a kind of construction. And, if you look at the photograph with Kiesler, you get an idea of the dimension of the piece. Even if it's not by Duchamp, for me it's a great piece!

CRAIG ADCOCK

I'm curious to know if you have anything from Duchamp that leads you to believe that he meant to refer to Jules Verne's science fiction novel *Le rayon-vert*. Or could he perhaps have known something like Marcel Minnaert's *The Nature of Light and Colour in the Open Air*, where the phenomenon of the green flash is scientifically explained? Minnaert's book is a classic and was published first in the thirties, I think, and is still in print. Could Duchamp have read Minnaert and learned about the green flash there? Duchamp's work looks just like the actual phenomenon. The green flash occurs just as the sun goes down right at the horizon, a momentary blink of light.

HERBERT MOLDERINGS

I don't know Minnaert's book, and I would very much like to read it and see whether this is a more probable source than Jules Verne's *Le rayon-vert*. What impresses me about Duchamp's *Le rayon vert*, in connection with Jules Verne's, is the fact that the theme of the exposition and its accompanying book, published by Maeght, was modern myth. And that is also the theme of the novel, *Le rayon-vert*. We have often seen in the work of Duchamp that he took very ordinary common knowledge and, twisting it only very slightly, came up with something completely different.

JEAN SUQUET (F)

I'd simply like to say to Herbert Molderings that some of the people who participated in the hanging of the '47 exhibition are still alive. Sarane Alexandrian himself participated, as well as Seigle and others who perhaps knew more about the piece. That being said, I'll digress: it seems to me that *Le rayon vert* played quite a part in Duchamp's mythology, if only by its name. There's the *Green Box*, read in the light of a green ray. Next, I believe you're right to evoke a seascape with a horizon: we're on a boat and the horizon is therefore slanted. To me that sounds like a rather good explanation. In any case it confirms other illusionistic images that Duchamp has made: *Stéréoscopie à la main* [*Handmade Stereopticon Slide*] (fig. 8.6) from Buenos Aires shows a marine horizon; then there's the trespassing through the horizon of the *Large Glass*. So, it seems to me that this famous *Rayon vert*, of which all traces clearly have been lost, is also part of the Duchampian mythology. This is the first time I myself have seen this image. I never heard anything said about it when I joined the Surrealist group a short time after the 1947 exhibition, whereas the altar of the *Soigneur de gravité* was spoken about in great detail and very often. *Le rayon vert* has completely disappeared from my memory. As always, it's the missing things which bring everything around them into focus.

THIERRY DE DUVE (F)

Jean, would you go so far as to say that this is a new incarnation of the *Soigneur de gravité*?

JEAN SUQUET (F)

Oh no, not at all, I didn't say that. But I did say that, if only by its name, *Le rayon vert* was truly part of Duchamp's mythology, although—as Robert Lebel told me—Duchamp detested green. He had a deep horror of the color green. Why then did he choose green? It's perhaps due to the assonance of "vert" with "verre," but still . . .

HERBERT MOLDERINGS (F)

I'm certainly going to try to meet most of the people who participated in the exhibition in order to verify, by their recollections, that the object Marcel Jean talks about is really *Le rayon vert*.[2] I might add that there's yet another work that I believe can be put into the same basket, that's

Pharmacie [*Pharmacy*]. The red and green lights of anaglyphs have been mentioned in connection with it, but anaglyphs require special eyeglasses. *Pharmacy* would never work as an anaglyph because the distance between the two lights is too large. However, though in all of Duchamp's works there's always a very strong intellectual side, they're based on a plastic visual sensation. That's why I somewhat agree with the contribution that Bill Camfield made this morning. Passing in front of one of those pharmacies which has two illuminated bottles, there's the sensation of a lighthouse; it's extraordinary. I don't know if you've ever had this sensation: if you see the lights from afar, they are calm. But if you pass right in front, click, there's a flicker in the light, lasting a millisecond. And that's the ray. I believe that within *Pharmacy* there's the idea of the lighthouse, as Linde has observed: "Phares, ma cie."[3] And if you go to Paris, there's a pharmacy with red and green bottles in front of the Panthéon, where, at night, you will have this Duchampian sensation.

JEAN SUQUET (F)

I'm afraid that it's been demolished.

HERBERT MOLDERINGS (F)

No, no, the pharmacy was still there last summer.

ERIC CAMERON

I wonder if you could say something about the way Duchamp's response to Henri Poincaré's scientific theories and his mathematics might have changed in his later years. What I am thinking of is that Duchamp, in the later interviews, seems to talk of things like the fourth dimension as being very much in the past. I wonder how those things relate both to skepticism and to the mathematics of n dimensions.

HERBERT MOLDERINGS

I would say that the thinking and working on specific questions of rotations, passages from one dimension into another, gravity, and optics, ended around 1923–24, although they came back in the *Rotoreliefs*, in *Coeurs volants* [*Fluttering Hearts*], etc. Poincaré, as you said, was then a thing of the past. But what Duchamp kept from Poincaré's philosophical writings was his fundamentally skepticist world view. And I would like to add one or two things in order to take up what you said yesterday. You started by presenting Pyrrho from Elis as very important, and I agree

completely. But there are many differences between modern skepticism in the Poincaré sense and ancient skepticism. I will only stress one point: ancient skepticism, that of Pyrrho above all, was a philosophy which asked how one should live, how one should conduct one's life. It always ended in moral philosophy, whereas modern skepticism, since Descartes, and above all in the form of Poincaré's thinking, was a theoretical method. I think that when Duchamp said to Schwarz that the philosopher he appreciated most was Pyrrho from Elis,[4] he referred to this idea that the essence of skepticism lies in arriving at what Pyrrho called *ataraxia*, inner tranquility. And Duchamp called it in French "l'indifférence." Inner tranquility is happiness based on the absence of judgment. What I think Duchamp took over from Pyrrho's teaching was: no judgment because judgment is the beginning of dogma, and dogma is the beginning of fights, of quarrels. Such is the basis of happiness because it's the basis of ataraxia, indifference. This is the gist of Duchamp's Pyrrhonism. And as I understand it, it also somehow accounts for the influence he had on other artists. You see, when Julien Levy was asked about his admiration for Duchamp, the first thing he said was, "He taught us how to live."[5] And there is an article by Man Ray in *View*, 1943, "Photography Is Not Art," where in a whole chapter he is paraphrasing, almost word for word, this aphorism by Duchamp: "There is no solution because there is no problem."[6] There Man Ray too reflects on how Duchamp affected people by triggering them to find some different angle from which to make art.

WILLIAM CAMFIELD

This peace-making, serenity-invoking aspect of Duchamp is very important. It made me think of one very touching statement by Beatrice Wood, who admitted once in a letter to Louise Arensberg, in the forties, that frankly she had never really liked Marcel Duchamp's work that much but she loved him, not in a physical way but because he had taught her how to live. He had taught all of them how to live. That's all.

1 Since the Halifax conference, two major Kiesler exhibitions have taken place, the first in 1988 at the Museum moderner Kunst in Vienna, the second in 1989 at the Whitney Museum in New York. In both catalogues a sketch by Kiesler has been published, marked "Hommage à Marcel" and identified as a study for *Le rayon vert*. We reproduce it here too (fig. 6.11), as it leaves no doubt that it describes the same object as in figs. 6.8 and 6.9. (For a full account of the controversy about *Le rayon vert*, see footnote 39 of Herbert Molderings's paper.)

2 Since the conference, Herbert Molderings has been able to talk to Sarane Alexandrian, who could not remember having seen the *Rayon vert* in the 1947 exhibition. Surprisingly, it was not he but the research assistant of the publishing house who was working on the preparation of his book who found the photograph in the files of Denise Bellon and identified it as the *Rayon vert*.

3 Ulf Linde, "MARiée CELibataires," in *Marcel Duchamp: Readymades, etc. (1913–1964)* (Milan: Galleria Schwarz, and Paris: Terrain vague, 1964), 56.

4 Arturo Schwarz, *The Complete Works of Marcel Duchamp,* 38, note 23.

5 Julien Levy's exact statement is: "I first met Marcel when I was twenty and he was twice that, and found that he could teach me, teach us, how to exist—somewhere between the bonds of irony and the illusive liberty of chance." Quoted in "A Collective Portrait of Marcel Duchamp," *Marcel Duchamp* (Philadelphia: The Philadelphia Museum of Art, and New York: The Museum of Modern Art, 1973), 207.

6 Man Ray, "Photography Is Not Art," *View* 3, no.1 (1943).

Préface

Etant donné 1° la chute d'eau
2° le gaz d'éclairage,

... l'éclairage jusqu'aux plans d'écoulement ...

... terminerons ...
... instantané ...

Progrès (allégorique)
... (amélioration)
... du gaz d'éclairage

Moules mâlics.

An Original Revolutionary Messagerie Rrose, or What Became of Readymades

Late in life when he was giving retrospective slide shows and talks, Duchamp came to call the beginning of readymades "a happy idea" ["une heureuse idée"].[1] Even the attribution of the name "readymade" became part of what is more a process than a genre. What Duchamp did with things already made, be they everyday objects or "art" objects, actually physically extant or made for the occasion, constitutes the shifting history or definition of something that will always be marginal and uncategorizable, anasemic, virtually unnamable. The joy of this "happy idea" and its undeniably important role in the character of twentieth-century art lies, or rather floats, in the readymade's endless gaming on names, on the text/object confrontation, on the clash of the literal and the metaphoric, on the irony of artistic creation through reiteration of the already used.

Broadly speaking, the readymade and its changes correspond to the development in Duchamp's work generally chronicled in the names of three important works: *Nude Descending a Staircase*, *The Bride Stripped Bare by Her Bachelors, Even*, and *Given: 1. the Waterfall, 2. the Illuminating Gas*. The first readymades, especially those that precede the name, are the classic chosen everyday items with minimal alteration. Duchamp owes to the exposition at the Armory Show of the *Nude* (perhaps less a culmination than the *PASSAGE from the Virgin to the Bride* of his Cubist experiments) his bicontinental public and everlasting notoriety. The readymades related to the *Bride*'s construction, narrative, and erotics tended to be less easily recognizable as everyday objects than the *Bottle Rack*, *Comb*, or snow shovel because they were, indeed, already less readymade. That second wave of the readymade came with Rrose Sélavy, what we might call a heroinic period, and worked within an already altered sense of readymade. It now participated in the *Bride*'s widescale game of naming, where parts of the *Bride* such as "glider," "sieves," and "chocolate grinder" have a distinctly abstracted and nonrepresentational relation to objects of the same name or even to Duchamp's own earlier versions of them. When some dust-covered cone shapes can become "sieves," then an unknown, invisible

object enclosed in a ball of cord can become a "secret" readymade by the authority of naming, once a name exists. Rrose signals a deautobiographizing process in which the work is detached from the artist as a particular person or master, be it Duchamp or Leonardo. From *Mona/L.H.O.O.Q.* to widow/window, the readymades associated with Rrose became further distanced from the *tout fait* per se. Playing with pseudonyms, Duchamp created a *sujet d'art* with a different relation to the "artist" and the public or regardeur than that of the *objet d'art*. The nominalism of Rrose carried the readymade along, although it was becoming as much specially crafted as randomly chosen, as much part of an outer narrative for the Bride as lapidary captions on an object.

After the abandonment of the *Grand verre* and the subsequent publication of the *Boîte verte* and Rrose's puns, Duchamp turned to other projects, the grandest of which, *Etant donnés*, holds many secrets of a different order from those of the *Bride*. More and more Duchamp involved his own previous work, now part of the readymade world, in a dispersal and reinvestment of its terms. The forms were various: photographs of readymades as part of covers for catalogues or periodicals,[2] etchings, multiples of readymades, recombinations. I will here consider Duchamp's later work and its "readymades" principally to see what became of the readymade—the readymade as specific works and the readymade as an art category. I would like to place the readymade as a primary operator or *dispositif* in Duchamp's enterprise to bring the textual into the visual, to operate iterability or the delay, the identifying feature of writing, as part of the pictorial. Duchamp used his last work, which was already there but unveiled only posthumously, to demonstrate once again or once and for all the *retard* that adds the time dimension missing from the retinal, that is, the immediacy of the visual, its semiotic identification with presence. The holding off, putting off, off-putting that Duchamp played with his last activities was certainly motivated by the secrecy of *Etant donnés* and its calculated shock effect. I am not trying to rub out the quaint image of Duchamp's career as a kind of pyramid with the invention of the readymade and the elaboration of the *Large Glass* as a solid foundation after which he tapered off, played chess, did a bit of this and that, and ended up with *Etant donnés*, a pinnacle but also a *point de fuite*. Instead, the eyes peering into *Etant donnés* are forced to read back through all these Duchampian objects and their related texts, trying

to figure out why this freak figure preens before a lamp, what message of liberty she may proffer.[3]

My title borrows from the 1964 Milan exhibition etching where Duchamp put a drawing of the 1917 urinal *Fontaine* and a text previously used in several forms: "un robinet original . . ." Duchamp's own borrowing had begun long before with the readymades, objects themselves borrowed or made to look so from contexts other than art. "Original" is an in-joke on his own and modernism's quest of the new as well as a joke about plumbing's ordinariness. The revolution of this urinal lies in its topography that displaces common commercial hyperbole by putting the object where it's not supposed to be, where it is no longer hidden from at least half of the population. This readymade occupies Duchamp's usual place for ideas, somewhat off: off-center, off the subject, off-color. This unmentionable fixture begs to be called by its genre a *raidie merde* as the francophone would pronounce "readymade."

As readymades from language, both Rrose Sélavy and the new '80s generic category of the *messagerie rose* have roots in common parlance, in the trite phrase *la vie en rose* and the resemblance of *rose* to Eros and *ose* and their easy puns about having a good time daringly. These connotations of "pink" are, curiously, about the same as those of "blue" in English. The *messageries roses* are message-exchange services offered to clients of the French telephone service's computer-driven hardware-software monitor-modem Minitel system; the distracted and delayed user can indulge in verbal erotica without any danger of physical contact. The P.T.T. has indeed launched a revolutionary mode of lovemaking. What this has to do with Duchamp is not that Rrose Sélavy has been "used," but that once we know Duchamp and see a poster for a *messagerie rose*—a typical example would be a woman *mise à nu* drawn in bright pink on a black background—we read it through Duchamp who has changed our context by providing a readymade reference. We understand how he showed that art goes on talking, not as a voice of the past but as a "virus"[4] that modifies all subsequent messages. Minitel *messageries* (teletext) must always work with writing; messages are delayed, written, read, never telephonic. Fanciful spellings and other text games have become part of the subculture. Duchamp's *messagerie* uses exchanges of verbal and visual material in a way revolutionary for art and literature.

[handwritten note]

The "literal nominalism" Duchamp mentioned at the top of one recently published note, "1. Redo literal nominalism" ["1. Refaire nominalisme littéral"],[5] recalls the *"Pictorial nominalism"* [*"Nominalisme pictural"*] (*DDS*, 111) of the *White Box*, dated 1914. Nominalism, as a way of thinking that conceptualizes from the name, belongs to the abstract if not to metaphysics or idealism. "Literal," on the other hand, is most often a modifier designating the concrete, the direct. As part of the perennial pair describing verbal messages, "the literal and the figurative," the literal is the half valued for immediate clarity and devalued for lack of depth or eloquence. This rhetoric, with the implied visual metaphor of layering, the estimation that there is a figurative sense *behind* what one sees in art, is something Duchamp wanted to cut through, and one method was the readymade. At a time when the retinal painting of Impressionism, Postimpressionism, and Cubism dominated and had redefined both taste and theory, Duchamp understood that art had other motivations and that he could work with this rhetoric and its irony on the verbal implications of "literal," both to bring art back into the mental and to redirect the visual beyond aesthetics.

Nominalism suited him partly because it obviates the hierarchies of idealism and effaces the value boundaries between words and pictures. Duchamp willingly called himself a nominalist: "I don't believe in language, which, instead of explaining subconscious thoughts, in reality creates thought by and after the word. I declare myself willingly to be a nominalist. . . . As a good nominalist, I propose the word patatautological, which, after frequent repetition, will create the concept of what I am trying to explain."[6] The language he doesn't believe in is the stuff that believes in final explications. The words he does believe in are those that take on meaning rather than pretending to be its vehicle. It would be difficult even to speculate on Duchamp's familiarity with the philosophical and theological traditions of nominalism, and it is principally interesting that he chose the word in

exactly the sense he understands nominalism, as a possibility of playing with new categories.

So any word, even "readymade," after frequent repetition will take on the status of a concept. The word "readymade," which Duchamp seems to have picked up in New York (in American English it referred only to then-not-so-common-as-now mass-produced clothing) following the making of several objects subsequently baptized readymades, was like a fortuitous discovery rather than a creation because it fit a forming concept as a found cap fits your head. The definitions he wrote in his notes suggest that the readymade is, like a word, somewhat arbitrary, in that it is not predefined as such but a moment or *rendez-vous*.[7] When he wrote, "Also the exemplary side of the readymade" (*DDS*, 49), he was suggesting that the readymade is like a proper name, a one-of-a-kind. But once the name was found, the readymade as a genre could develop in any direction; in other words, the name itself permitted the concept to escape the confines of its own definition.

The first readymades had served to create the definition of a new genre, a genre that crossed the traditional borders between the visual and the textual, a genre that would refuse to be one in the usual sense of conformity to a set of formal rules. But as time passed, all of Duchamp's previous work became "readymade," first, in its simple anteriority, and second, in its availability for reuse as artistic material, that is, in a state of having been already changed into art. And so, Duchamp was able to ask sarcastically but literally, "Can we make works that are not 'art'?" ["Peut-on faire des oeuvres qui ne soient pas 'd'art'?"] (*DDS*, 105). Everything is now art and all art is non-art. Having been worked through pictorial nominalism, visual elements became recognizable icons in Duchamp's cosmology, while verbal elements, having been worked through literal nominalism, were deprived of their common figurative rhetoric of transcendence and set into punny play with each other.

The war sent Duchamp off to America, bag and baggage [*bagage plié*]. The *Boîte-en-valise* (1941) was a compilation, a summary in a different scale, and a new start (fig. 7.1). For an artist, it made living out of a suitcase in New York possible for the duration of the war. It corresponded somewhat to *Tu m'* which, as his last canvas, gathered images of readymades and served as a sort of "artist's studio" image. The *Boîte-en-valise* assembled

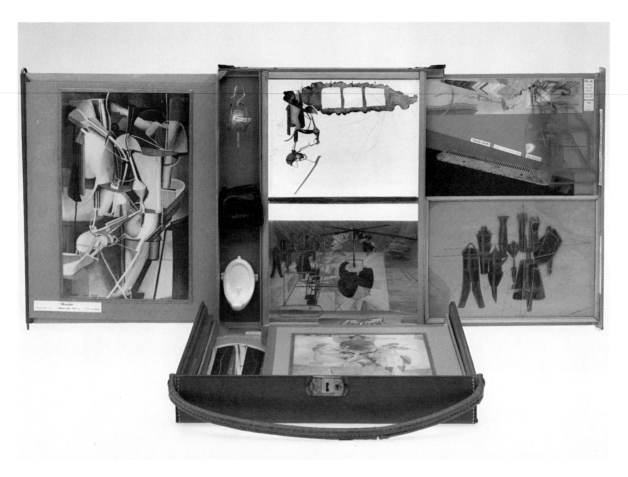

7.1
Boîte-en-valise [*Box-in-a-Valise*], deluxe edition, 1941. A box containing miniature reproductions of Duchamp's work, fit into a leather valise, 16 × 15 × 4 in.

three-dimensional models that could be moved about in ever-changing juxtapositions. The time to come would be that of literal nominalism that could take the names already conceptualized and renew them from a slightly different perspective. This *boîte à malices* (jack-in-the-box) is a surprise in its form and choice of presentation, not in its contents. Except for the puns calligraphed on music paper, these items are literally as we know them. The tiny model of the readymade Underwood typewriter cover called *Traveller's Folding Item* emblematizes the unfolding and refolding of all his work into this time capsule. The version here of *Why Not Sneeze?*, the first Rrose readymade, is a folded photograph pasted in the back of the box. It can't be lifted and Rrose's name is hidden. The *Boîte-en-valise* uses readymades as much as two-dimensional works like *La Mariée mise à nu* and the early paintings. The readymade process has here become one of cata-

loguing, and the task of gathering or finding readymades has lost its last traces of arbitrariness. These little copies turn the literalness of the copy into delight. The careful arrangement of the *Boîte* responds to the taxonomizing that Duchamp eventually accepted as part of the nomenclature. After Arturo Schwarz wrote a classification of readymades as assisted, aided, rectified, or modified,[8] Duchamp endorsed the scheme, surely enjoying the puns on "readymade *et D, A dead, et dé*," and so forth, and showing he was not imposing any artist-devised definitive categories on the regardeur. Any modification of the name is a joke, effectually denying its essence and giving it a new identity. But stripped of any essential quality, which is what Duchamp really approved of, the readymade is free to proliferate and redefine itself and only the remains (or ruins) of the name's trace are left over. Such traces are the moustache and beard of *L.H.O.O.Q.*, which appear alone as a frontispiece, and the playing card of Mona Lisa readymade into *L.H.O.O.Q. rasée* (1965), shaved (fig. 7.2).

These examples of self-repetition are typical of the late readymades and what becomes of nominalism literalized. The articles in the *Boîte-en-valise* are newly readymade, or readymades reasserted in a different time or material, a name they acquire after a delay or retain even if no longer as they were. After *L.H.O.O.Q.*, Mona Lisa is a readymade. Originality falls into a different plane and literal is now all turned around. As rewritten by Duchamp, the literal-figurative opposition doesn't hold up, or rather, fails to operate in the same way it had in visual art since painting had become the optimal expression of the human endeavor to translate experience into other dimensions, in particular the surface. With the readymade the representational function is simply chucked out. The bicycle wheel doesn't represent a bicycle wheel, it is one. The *Comb* is a comb or the later picture of it, both readymade. Finally the name is all that's left as literality is redefined, and a question like "is *Fresh Widow* a literal readymade?" remains undecidable.

In the fifties and sixties Duchamp produced mostly recognizable works— recognizable as versions of Duchamp, recognizable as works of classical art borrowed, recognizable as literalizations of words. Things like the *Safety Lock with a Spoon* [*Verrou de sûreté à la cuiller*] (1957) also remind us that literal is not necessarily clear or meaningful.[9] The strangeness of *Etant*

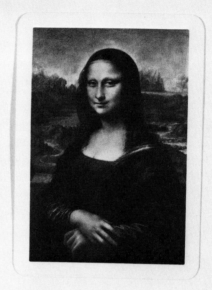

7.2
L.H.O.O.Q. rasée [*Shaved L.H.O.O.Q.*],
1965. Playing card, 3½ × 2⁷⁄₁₆ in.,
mounted on folded announcement,
8½ × 5½ in. (The Museum of Modern
Art, New York; gift of Philip Johnson,
1970.)

donnés (figs. 1.1 and 1.2) might be called the shock of the literal. Upon first looking into it, the regardeur is confronted with a *mise à nu* which, despite some previous hints, seems so different from the abstract *Bride*, the handwritten texts, and the readymades, which now by comparison seem all the more thingy, mechanical, impersonal. The scene is a jolt to all who are used to the esoteric, indifferent, chess-playing Duchamp. Another striking element of *Etant donnés* is its bizarre use of originality. Is there another major artwork set up as a peep show? The heavy wood door bears no resemblance to the other Duchamp works nearby in the Philadelphia Museum. The figure and landscape have a realist or even hyperrealist facture totally inconsistent with one's expectations and experience of Duchamp. The little framed Delvaux breast pasted on foil, *In the Manner of Delvaux* (1942), and the latex breast and text "Prière de toucher," from the 1947 catalogue *Le Surréalisme en 1947* (fig. 7.3), have a whimsy that the sight of *Etant donnés* erases. The little Delvaux ribbon plays against Delvaux's heaviness, and "Prière de toucher" was a little dirty joke on the museum. *Etant donnés* does not invite laughter. In fact it seems as out of touch figuratively as literally: the regardeur's space, sensibilities, and freedoms are disregarded if not mocked. The door holes seem like a cheap trick, a lure of the lowest sort, and the inside has a kitschy, low-life quality. It seems heavy, integrated, with nothing of the arbitrariness and mobility of the readymade left in it. To end his career for the time when he won't be here to know about it, Duchamp culminates in stark silence a denaming process started with the naming of the readymade.[10] But Duchamp being Duchamp, there has to be some connection, some remake of the *messagerie Rrose*.

The one item in the *Box-in-a-Valise* not reproduced from a previous form is the list of puns "Written Rotten" or "Morceaux moisis." The texts were familiar but their new names reinforce the fact that doing readymades had evolved from a process of making to one of repeating and naming, a nominalist course, not a contextualization. The readymades of subsequent years related to cloth and stuffing—the jacket, the vests, the rubber glove, the *Pair of Aprons*—are conceptually the clothing missing from the valise. The men's vests (1957–1961) were store-bought, the first readymades to really be readymade in the common American sense. He added to the vests letter buttons to spell out names, TEENY, SALLY, BETTY, PERET. The

7.3
Prière de toucher [*Please Touch*], 1947.
Velvet and foam rubber cover for the
deluxe catalogue, *Le Surréalisme en
1947*, 9¼ × 8¹⁄₁₆ × 2⁷⁄₁₆ in. (Collection
Musée d'Art Moderne, Paris; gift of Dan-
iel Cordier, 1976; photo Béatrice Hatala.)

letters used were typeset forms, so that the only person who could read the
name was the wearer looking in a mirror. Wearing a name only you can
read, you are renamed, changed in the same way a coatrack becomes a
Trap [*Trébuchet*], a readymade. Following the bachelor uniforms of the
Large Glass, which are also shapes and texts, the vests also point to the
continued nudity of Duchamp's female figures from the *Nude Descending*
to *Etant donnés*, a nudity that increases in realism. The women's names
on three of the vests androgynize the garments, but the mirror effect is the
odd thing, the aberration that really bestows the name on the gazer. As
long as the wearer cannot read the message he wears, the other is absent.
When only he can read it, when he is his only *regardeur*, the message is
cut off to others.

The *Pair of Aprons* (1959), the furry female and fleshy male, began as
potholders, *gants de cuisine* (fig. 7.4). The site of protection changes from
the hands to the genitals. The *inframince* slots where the hot handles would
go are now read as underwear references. The French *gant* is more clothing-
related than the English term. The English *apron*, often pronounced

a-pern, is a homophone for *epergne* from the text of *Apolinère Enameled* (1916–1917), the paint-advertising picture of a girl wearing a *tablier*. An *epergne* is a table centerpiece, an upright piece of decorative nonsense, an inedible pastry sculpture (*pièce montée*), such items as are associated with weddings. The bedroom/kitchen split of *Apolinère* persists in *Etant donnés* where the kitchen-type floor, the fluorescent lighting, and the cookie tin are all there on the edges like the *epergne* text. The only note turned into a readymade in the *Boîte-en-valise* was "Recette" [Recipe/Receipt] (*DDS*, 260). The aprons are soft sculpture versions of the *Coin de chasteté* (1954) and *Objet dard* (1951), readymades produced by the debris of the mold for the mannequin of *Etant donnés*. These accidental body parts were selected for their "improper art" quality, their obscene references. They work with complicated puns and self-reference but are as far from common manufactured objects as is the *Large Glass*.

From the cheap litho landscape of *Pharmacie* to the backdrop of *Etant donnés*, the problem of origin is finally flipped over. The drawing *Cols alités* ("bedridden mountain passes") from our M.D., medical doctor, superimposes landscape across the abstract forms of The Bride. We read these *cols*

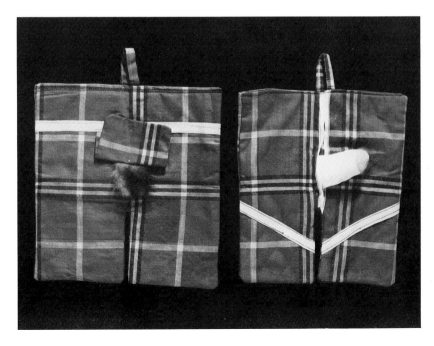

7.4
Couple de tabliers [*Pair of Aprons*], 1959. Assemblage, each approx. 8 × 7 in. (Collection Musée d'Art Moderne, Paris; gift of Daniel Cordier, 1976).

(crossing points), between valleys and between the *Bride* and *Etant donnés*, also as causality (*causalité*) or quizzes in bed (*colles alitées* [*DDS*, 255]). The cause of *Etant donnés* is the past naming of these landscapes and the name "readymade" that makes mandatory the rereading of forms and texts. The literalizing of the pun of *L.H.O.O.Q.* in *Etant donnés* violates not only common propriety more than the readymade with moustache, but the sense of propriety, the proprietary, of what is whose. The giggles provoked by Duchamp's version of *La Gioconda* are missing from *Etant donnés* because the relief of saying "It's only a pun, it's only a reproduction" is gone from the realistic mountain relief and what the voyeur-regardeur now must look at in the foreground. With *Etant donnés*, literalness signals the end, and things get serious. The headless figure really has no claim on propriety; she is observed and seeks to be observed but has no face, no individuality. Duchamp gives her to the regardeur, whether we want her or not. He sticks it to us and we do not much like it perceptively, aesthetically, or conceptually. What has he done to the regardeur?

Before concluding I would like to briefly consider just a few other pieces. Duchamp took a greeting card in Spanish with a fanciful landscape of trees, flowers, and parrots, signed it, named it *Pollyperruque* (1967), and sent it to an exhibition (fig. 7.7). Polly is the Fido of parrots, always cackling "Polly wants a cracker." A cracker is also a fire cracker (*un pétard*), a hotshot, a hot guy. Indeed, a male version, Pol, animated frequent television commercials for little girls' shoes at the time Duchamp put a wig in the name. This message for the artists' group the "Pollyimagists" has the usual double edge. A *polly-wig* is nearly a *pollywog*, a frog like Duchamp the signer. A wig is fake hair, so the polly-imagists are other fake-R's, *faussaires*. The salacious side of "Polly wants a cracker" is another hot ass (*L.H.O.O.Q.* / *chaud au cul*), a crazy Polly (*Paule folle*), Polly *verrückt*.

Two late checks refer to the *Tzanck Check*, a pseudo–bank check for his dentist in 1919 (fig. 7.5). The new *Czech Check* (1965) is John Cage's membership card for the Czech mycological association, signed by Duchamp. The *Chèque Bruno* (1965) is an ordinary blank check of the type provided to store clients in more trusting times (fig. 7.6). Duchamp's signature is his only change to *Czech Check*, whose title is motivated by a pun and its resemblance to the earlier title. The common currency of the

7.5
Chèque Tzanck [*Tzanck Check*], 1919. Ink
on paper, 8¼ × 5¹/₁₆ in. (Collection Vera
and Arturo Schwarz, Milan.)

7.6
Chèque Bruno [*Bruno Check*], 1965. Ink
on check blank, 3¼ × 8 in. (Collection
Mr. and Mrs. Philipp Bruno, New York;
photo courtesy Arturo Schwarz, Milan.)

territory has changed with the *Chèque Bruno;* Mona Lisa has diversified into a bank. The mushroom aficionado Cage wanted Duchamp to sign, to superimpose his creation on something beloved. For Cage it was an act of generosity. For Duchamp it was a token of worth in the exchange of signs. The *Chèque Bruno* is "made out" (*ordonné*) like that of 1919 but really more readymade, manufactured, than the early one marked "original." These two new checks imitate an imitation readymade.

Various house objects belong to the same architecture as the door Duchamp had installed at 11 rue Larrey in Paris (1927, replicated 1963) to disprove the adage that a door must be open or shut. One is the door spoon related to the pun "Du dos de la cuillère au cul de la douairière." The lock actualizes the rhetorical designator for *contrepèterie* in English, "spoonerism." This safety lock, *verrou de sureté*, echoing the *ceinture de chasteté* which locks in the virgin, locks out the regardeur: there's no keyhole. The readymade roof ventilator of 1915 was lost but redone as an engraving in 1964; this type of revolving tin exhaust ventilator is still common today (fig. 10.1). Its title, *Pulled at Four Pins*, varies only slightly the descriptive "pulled at four winds," but the phrase in English is both literally and figuratively nonsensical, a word-for-word-translation of the French "tiré à quatre épingles." That metaphor, inflated to "dressed to the nines" in English, is drawn (pulled), *tiré*, and printed, *tiré*, as a literal rendering with pins at the four corners pulling cloth (*Tiré à 4 épingles*, 1959) (fig. 10.7). The square is not free-floating like the veiling of the *Draft Piston* (1914, 1965). Where freedom is constricted in all these late closet items, each becomes a literal, single-minded premonition of the *Etant donnés* box.

The little item from the little room, the urinal, turned up as an etching for a catalogue cover in 1964 with the title above, "UN ROBINET ORIGINAL REVOLUTIONNAIRE / 'RENVOI MIRIORIQUE' [sic]" and, below, "UN ROBINET QUI S'ARRETE DE COULER QUAND ON NE L'ECOUTE PAS" (fig. 5.11). On the top line the letters U-R-I-N-O-I-R and on the bottom line U-R-I-N-E were printed in red to stand out, but not too obviously, still shuffled into the words. There is no water present as there is none for the waterfall of *Etant donnés*. The mirrorical return or reflection of one's look (*miroirique* quite appropriately misspelled as *miriorique*) centers on the vertically placed drain holes. In *Etant donnés* light comes through the waterfall holes to

create the water effect but there is no reflection. The regardeur actually sees his reflection in the *Large Glass*, in the properly angled glass and in shards in the mirror surface of the "oculist witnesses." The *Bouche-Evier* of 1964, a standard stopper made by Duchamp for his shower, combines drain holes with a blocking effect to let out liquid but keep back solids. The holes are dark; there is no reflection. The first urinal, named *Fontaine* like a garden sculpture, kept Duchamp out of an exhibition. The 1964 version for a show reflecting back on his career tells where the readymade has gone: into the mainstreams of art, bringing itself back with the reminder that *urinoir* equals "you're in R (art)" and "you are in Rr (error)."

In the sixties Duchamp was in demand for signatures, catalogue covers, dedications, in short, himself. People wanted from him more of the same, and he responded generously, always adding a little twist of the new. In 1967–1968 he made two sets of nine etchings for Arturo Schwarz[11] based on his own work and, for the second volume, on his own and that of several past masters. Of the five called "Morceaux choisis . . ." (chosen pieces or choice morsels), one, ". . . d'après Cranach," combines Cranach's Adam and Eve with Duchamp's 1924 *tableau vivant* appearance as Adam during Satie's *Relâche*. Another, ". . . d'après Ingres II," puts together figures from two different paintings. For ". . . d'après Rodin," he simply moved the man's hand that Rodin had coyly placed on the outside of the woman's thigh. These *morceaux* reread old works that had gone *moisis*, too familiar, and make us pay attention to something, the erotic side, that we had pretended was hidden. For the last ". . . d'après," next to Courbet's reclining woman he placed a voyeur bird so there is a pun pictured, as he said, "un faucon et un vrai" (fig. 7.8).[12] Using these stolen paintings to play with the tradition he called retinal painting, the precision detail of Ingres and the realism of Courbet, Duchamp showed how what we see masked as the beautiful body, the aesthetic object, is wrapped in worn-out repressions. To represent his own work in the series, Duchamp used a chess poster, the Auer gas lamp, and the title of the *Large Glass*. The female figure holding the gas lamp is precisely the truncated form of the *Etant donnés* mannequin along with a male figure from advertising. Here exposed for the first time, she turns the mannequin of *Etant donnés* into a copy. *The Bride Stripped Bare* is a known phrase, but the young nude at the altar is the first literal finish to the story.

7.7
Pollyperruque, 1967. Inscribed greeting
card, 5½ × 3½ in. (Collection Miriam
Keller, Baden-Baden.)

7.8
Morceaux choisis d'après Courbet
[*Selected Details after Courbet*], 1968.

M.D.

These etchings are something of the final avatar of the readymade, a version that comes around to using art as non-art, as familiar tokens of the "artworld" like something of a universal hardware store of gadgets and tools for *bricolage*. By the time *L.H.O.O.Q.* is *rasée*, art "quoting" and self-reference are the common material in need of demythologizing. Rrose started out as an alter-id or pata-name acting out the concept of the patatautological, and readymade is the patanym for masterpiece. The last readymades work to change both the work and the artist, to end up with literal nominalism.

The regardeur is still the creative component, working out the notion that the gap between creator and receiver is inevitable, instrumental, and indeed originary to the creative process. When Jacques Derrida noted why emitter and message separate, he also stated the function of the *messagerie* Rrose: "My communication must be repeatable—iterable—in the absolute absence of the receiver or of any empirically determinable collectivity of receivers. Such iterability . . . structures the mark of writing itself."[13] The regardeur remains imaginary, an indeterminate point of view. The possibility of the regardeur becomes the enabling condition of the work and not vice versa. The "mark of writing" is any mark lying between the *sujet d'art* and the regardeur. The late readymades show how iterability is different from *mere* repetition, that each instance is both new in time and a combination of all previous instances, that the regardeur is responsible for the ordering of the experiences. The regardeur occupies no space but has a crucial function. When *Etant donnés* seems to mock the poor regardeur looking through those holes, we must recall that the final job of the regardeur is to turn away, make the picture with something other than retinal, spatial.

Rrose too is in an indeterminable place and time. Duchamp's games with art and R the letter are part of his "little game between 'I and me,'"[14] as he called it, autobiographical exercises that ended up going from the name to anything called his own. And thanks to his epitaph, "It's always the others who die," which makes us wonder who's literally in his urn while we animate the *messageries roses*, he can continue with us as active regardeurs.

The text of *Why Not Sneeze?* could in 1921 be read by all as a reflection, but in the 1964 replica edition it worked mirrorically like the vest buttons. In 1941, the *Boîte-en-valise* hid the text completely. Then and later, ready-

mades tell the regardeurs they are not seeing the message, that the accumulation of Duchampiana and the view inside that alienating box will not reveal some secret message that tells all. We still have to do the work ourselves while others relax in their boxes. And if we do well, we might get a "Reading Certificate" like the one Duchamp composed and decorated with little readymades—drawings of a snow shovel, a bottle rack, a urinal, and a bicycle—jokes of their original selves as "absolute reality."[15]

Notes

1 Duchamp, Marcel, *Duchamp du signe: Ecrits,* 2d ed., ed. Michel Sanouillet and Elmer Peterson (Paris: Flammarion, 1975), 191, hereafter cited as *DDS* in the text. Translations are mine. For a broader discussion of the early readymades, see my "Duchamp's Early Readymades: The Erasure of Boundaries Between Literature and the Other Arts," *Perspectives on Contemporary Literature* 13 (1987), 24–32.

2 These include *Belle haleine* for a cover of *New York Dada* (New York, 1921), *Why Not Sneeze Rose Sélavy?* for the cover of *La septième face du dé* by Georges Hugnet (Paris, 1936), *Peigne* for the cover of *Transition,* no. 26 (New York, 1937), and *Wanted* for the poster of Duchamp's retrospective exhibition at the Pasadena Art Museum (Pasadena, California, 1963).

3 The motor that drives the waterfall mechanism of *Etant donnés* is located behind the waterfall and is contained in a cookie tin of the brand name "Peek Freans."

4 A hidden change made at some earlier time, usually to wreak havoc, in computer software by distant unknown users of electronic networks.

5 *Marcel Duchamp, Notes,* arrangement and translation by Paul Matisse, facsimile edition (Paris: Centre National d'Art et de Culture Georges Pompidou, 1980) n.p.; also (Boston: G. K. Hall, 1983), note 251. This note, written on standard American yellow legal pad paper, would appear to be quite late, probably from the fifties or sixties; color is not used in the Boston edition.

6 Unpublished letter to Jean Mayoux dated "8 mars 1956," quoted by Jean Clair, "Marcel Duchamp et la tradition des Perspecteurs," in *Marcel Duchamp: abécédaire, approches critiques,* ed. J. Clair (Paris: Musée d'Art Moderne, Centre National d'Art et de Culture Georges Pompidou, 1977), 155.

7 *DDS,* 49. This temporal definition of the readymade process seems, however, to be limited to the *Rendez-vous du dimanche 6 février 1916.* The text has a first draft [*brouillon*] (*DDS,* 254). The ordinary post office cards are, to be sure, readymade, and finding a text on them is to be expected. The cards do, however, turn the text into part of an artifact.

8 "Contributions to a Poetic of the Ready-Made," in *Marcel Duchamp: Ready-Mades, etc. (1913–1964)*) (Paris: Le Terrain Vague, 1964), 13–36.

9 To paraphrase Paul de Man: "it is not necessarily the literal reading which is simpler than the figurative one" (*Allegories of Reading* [New Haven: Yale University Press, 1979], 11). Duchamp even further complicates reading by inserting the visual object as well as its name or text.

10 Marcel Duchamp, *Approximation démontable exécutée entre 1946 et 1966 à N.Y. . . . : ETANT DONNÉS: 1° LA CHUTE D'EAU 2° LE GAZ D'ECLAIRAGE.* Handwritten manuscript with drawings, diagrams, and numerous photographs. The Philadelphia Museum of Art has published a book-form facsimile edition (Philadelphia, 1987). Included is a separate brochure, "Manual of Instructions for Marcel Duchamp *Etant donnés: . . . ,*" with text by Anne d'Harnoncourt and several photographs. This publication completes our current illusion of the completeness of the Duchamp oeuvre.

11 These were to accompany limited editions of Schwarz, *The Large Glass and Related Works,* vols. I and II (Milan, 1968). See Schwarz, *The Complete Works of Marcel Duchamp* (New York: Abrams, 1969), 563–577, for details.

12 Quoted by Schwarz, *Complete Works,* 576.

13 "Signature Event Context," *Glyph* 1 (Baltimore: Johns Hopkins University Press, 1977), 179–180.

14 Interview with Katherine Kuh in *The Artist's Voice* (New York: Harper and Row, 1962), 83.

15 A lithograph with printed text and four sketches made as an illustration to a collection of poems by Arturo Schwarz, *il reale assoluto* (1964) (*DDS,* 276).

Discussion

Moderated by Dennis Young

FRANCIS NAUMANN

I don't really know how to ask this question, but doesn't the word "rose" in French also mean "pink," not just "Rose," as in a proper name? I mean, does it translate as "pink," in the vulgar sense of the word?

CAROL JAMES

Yes.

FRANCIS NAUMANN

Pornography shops have books and magazines organized according to the classification of "pink," meaning that they contain images that show women with their legs spread, revealing the color pink. In the case of Duchamp, this makes an obvious reference to *Étant donnés*. I've never seen this connection established. Has anyone?

CAROL JAMES

Are you referring to pornography shops in France or elsewhere?

FRANCIS NAUMANN

Both. I address this question to the floor, because I don't really want to ask any one of you specifically. And I would rather none of you ask me how I came to know the meaning of the term.

CAROL JAMES

I think there could be a connection with the *messageries roses*. When I was in Paris this year there were many Métro advertisements for these services. For instance, the subway corridors, poster advertisements are done in series, never just one but maybe ten in a row, presumably because as you walk by the effect is multiplied with each image. There are now multitudes of these advertisements, and they use the color, of course. In current pop culture the generic term is *messageries roses*. I don't know if there are specific *rayons* in French pornography shops, but that's the same sort of connotation.

THIERRY DE DUVE

I liked the way your talk started with the *messageries roses* as a sort of

Derridean tangent, somehow. Then I was pleased to see you tackle the issue of nominalism, since you and I are, apparently independently of one another, responsible for having dug up this expression "literal nominalism" that hardly any scholar of Duchamp had looked at before.[1] May I ask you whether we should not investigate the meaning of nominalism a little further? As you said, the word appears twice in Duchamp, once in the *White Box*, as "pictorial nominalism," and once in the *Notes*, as "literal nominalism." You said it's an oxymoron because "nominalism" would refer to the abstract and "literal" to the concrete, right?

CAROL JAMES

At first it seems that "literal" would refer to a simple representation, whereas "nominalism" involves a kind of conceptualization.

THIERRY DE DUVE

At first, yes. And then you developed it. But I'm not quite sure how familiar Duchamp was with the nominalist tradition in philosophy. Maybe you have information about this. I owe it to Jean Suquet to have attracted my attention to one little thing, namely, that "la liberté d'indifférence," which he mentioned yesterday, is an expression that is exemplified at the hand of the famous example from medieval scholastics, namely "l'âne de Buridan" [Buridan's ass]. A donkey is offered two bundles of hay, each equally attractive, and starves in the middle because it cannot make the decision from which one to eat. And the expression "liberté d'indifférence" was quoted as a heading to that story in a textbook which Jean Suquet has found and which Duchamp probably studied when he was a child. Now, Buridan was a nominalist philosopher. Whether that is the nominalism we should be looking for or not, I don't know. I'm not too familiar with Buridan, but in Ockham at least, nominalism has to do with both the literal and the abstract inasmuch as it claims that only names are general and that essences are particular, or if you prefer, that only essences are singular and generalities are just names. Objects can only exist as particulars so that "literal nominalism" seems to contradict, in the readymade, the idea of it as an *exemplaire*. The word *exemplaire* means one item out of a series, it also means "exemplary." Each of the readymades exists as one entity which is unique, despite the fact that it is repeatable.

CAROL JAMES

I don't know what Duchamp's specific sources were for nominalism. I presume he had a kind of idea that probably first came from his school experiences, from memorizing definitions. And then later it would seem to fit what he liked, what worked against the Cartesian. He was half mockingly looking for an -ism: "What am I? I'm a nominalist." It very much did fit the way he worked and wanted art to be understood. As for the difference between "pictorial" and "literal" nominalism, I don't think it's clarified or developed in Duchamp's writing. I used this as a distinction between earlier and later readymades, the later bearing more on verbal accumulation and a tendency in Duchamp's pictorial content to become less abstract.

THIERRY DE DUVE

Could you say something more about the readymade being a proper name?

CAROL JAMES

A proper name? A readymade is neither an "original" in the usual art history sense nor an "individual" like a person who may share a name with many others. An individual has a name and we consider an individual to be a one and only. But a name can become generalized. I think this works better in French where *nom* means name and noun and *nominalisme* could play on both the unique and the general. This seems to be contradictory, but if you think of the readymade as neutralizing the contradictions—not exactly in the same way as we were talking about yesterday—a name like Rrose could be an individual but it also becomes a category. It's nominalized. It becomes a concept. Rrose Sélavy, what is it? It's that person that Duchamp concocted, the words he used and the objects he made, which become a *messagerie*, in a sense an open network of possibilities beginning with a name.

THIERRY DE DUVE

But then does it become a category through repetition? How does the proper name become a category?

CAROL JAMES

I'm not sure whether repetition of the name is what we have or repetition of the process of naming.

TAMARA BLANKEN

When writing the word "readymade," I often wonder how it should be spelled. Is it two words hyphenated, is it capitalized? If it is hyphenated, there is a possible connection to *Mirrorical Return*, the etching you believe to be a readymade. To "make-ready," as I understand it, is to prepare the plate from which prints are drawn. Thus, a positive make-readying would yield the reverse readymade *Mirrorical Return*. Has anyone ever thought about this?

CAROL JAMES

I'm not familiar with that process of printing, make-readying.

TAMARA BLANKEN

In commercial printing, the make-readying is when you are preparing the plate. And on the plate the image is backwards.

THIERRY DE DUVE

That's actually quite interesting.

CRAIG ADCOCK

I can answer the question about how to spell "readymade." Michel Sanouillet showed me a letter he received from Duchamp during the preparation of *Marchand du sel*. Sanouillet apparently asked Duchamp how he preferred it spelled. And the little letter says that he wants it "*Ready-made*." That's how Duchamp . . .

THIERRY DE DUVE

And then he adds, "et cela s'accorde." That is, in the plural it gets an "s."[2]

WILLIAM CAMFIELD

But in the early sources it is spelled in different ways: without a capital, abbreviated, with hyphens, without hyphens. If you want to look for some authorization or authority you have several choices. I myself would not rely wholly on this statement made to Sanouillet much later.

CRAIG ADCOCK

No, I agree with that.

THIERRY DE DUVE

I'm not an authority, but if you just care to know how I use it, I never hyphenate it if it's a noun, I always hyphenate it if it's an adjective. I would say "a ready-made urinal," with a hyphen, but "a readymade," as a noun. But that's personal.

CAROL JAMES

I never hyphenate it, and I never capitalize it, either as a noun or an adjective.[3]

WILLIAM CAMFIELD

Carol, I was interested in your idea about the different stages the concept of the readymade goes through, before and after Rrose Sélavy, for example. And if I understood you, the image is relatively less important at that stage than earlier, and the play on sounds, or puns, or inscriptions is more important. Did I follow that correctly?

CAROL JAMES

I put the second stage where the name "readymade" was given, or discovered, or came about, whatever you want to say. In other words, there were things already made, ready-made, waiting for the word "ready-made." And I generally put the Rrose Sélavy things there. Once the naming of "readymade" as a category became a fait accompli, the naming process was reapplied as self-renaming with all the Rrose things like the *Wanted* poster which says, "alias, alias, alias." Of course you can say, "Well this was at such-and-such a date and doesn't fit into your category," and I agree. I'm not terribly interested in making phase one, phase two, phase three as strictly limited chronological sets. I think that the third phase, which I started with the *Boîte-en-valise,* started with Duchamp's leaving France after assembling these versions of things he had been making for decades. It took a long time to collect these miniatures, to gather the materials. If there's any chronological rule to any of this, it's that as the material, visual and verbal, grows, the cumulative possibilities of punning grow. There are only a few, if any, Duchamp things that seem to have no sort of inscription or verbal factor at all, and the punning explosion came with "Rose" multiplied as "Rrose."

THIERRY DE DUVE

I happen to believe that the naming issue is absolutely capital for the

understanding of Duchamp, although in a quite different sense. But I do also believe that we should distinguish names of things and names of people, like signatures. Rrose Sélavy is a signature, and then there is the name of the thing. And sometimes even, as you hinted at but didn't develop, there is a distinction between the title of the thing, rather between what Duchamp calls it's "inscription," and its name. For example, the comb has this sentence on it, "*3 ou 4 gouttes de hauteur n'ont rien à faire avec la sauvagerie*," and its name is *Peigne*. So . . .

A N D R É G E R V A I S (F)

But it can also be said that for the readymade *Peigne* [*Comb*] there is no title in this sense, in that it's not inscribed on the readymade and it's known from another angle. There's an inscription ("*3 ou 4 gouttes* . . .") and there's a signature ("M.D."). It seems to me that distinctions must be made between the title, the inscription, and the signature, which can be Duchamp or one of his pseudonyms. Moreover, I'll say that during all the periods of "readymadization" there's play with language, even well before Duchamp came to the United States and learned another tongue. It's there as early as the *Roue de bicyclette* [*Bicycle Wheel*]. This play didn't wait for the choice of a generic English word to make itself evident or indeed to be authorized. Besides, this word "readymade" designates a certain number of works made from 1913 onward.

T H I E R R Y D E D U V E (F)

Yes, but if one's concerned about dates, all the same one must proceed from facts: the word "readymade" was invented in 1915 as a generic name for a certain number of objects. As to signatures, the first work signed by Rose Sélavy is *Fresh Widow,* and it's signed "Copyright Rose Sélavy." The signature is not an authentication in the graphological sense, it's a copyright.

A N D R É G E R V A I S (F)

And the other work signed Rose Sélavy—maybe in fact it's the first, we don't know exactly—is the *Témoins oculistes* [*Oculist Witnesses*]. That being said—and I don't know if I'm too Duchampian—I would tend to reduce the number of readymades . . .

THIERRY DE DUVE (F)

Yet it's you who's made the longest list of them: fifty.[4]

ANDRÉ GERVAIS (F)

That's right, but it's not as long as the one I heard in Carol's presentation. In my book I made a list by scanning all the catalogues, verifying everything exactly. There are around fifty, if I have counted correctly. But I had the impression, when I was listening to you, Carol, that the *Box-in-a-Valise* ensemble contained sixty-five or sixty-eight readymades. It seems to me that extending the notion of the readymade to this point nullifies it. Would you like to comment?

CAROL JAMES

I think that once "readymade" becomes an art category associated with Duchamp, as his "field," he wants to change and shift it, move the name into something else. The *Boîte-en-valise* has in it all those ready-made things, ready to go. They are ready-made in the simple literal sense that they already exist. Things are reproduced, miniaturized, renamed, repeated, remade but in an always altered way. Once done, ready-made, they are ripe to be redone. From this point of view, anything done is ready-made. Something like a salesman's box, these are sample copies, such that having one or many replicas, having originality or derivation, the proper or common noun is placed into question by each and every one of these "reproduced" things.

JEAN SUQUET (F)

It should be said that Duchamp made the *Box-in-a-Valise* in the momentum of the *Green Box*. The *Large Glass* broke; he learned about this three or four years later. But he didn't leave for New York in order to repair the *Large Glass*, instead he took all the manuscripts that he had saved and published them in the *Green Box*. He spent two years making the *Green Box*, from 1932 to 1934, and with this momentum he conceived the *Box-in-a-Valise*, which he began to fabricate two years later, around 1938. So it seems to me that if the *Box-in-a-Valise* is a collection of readymades, then more or less the same thing would have to be said of the *Green Box*, where he reproduced his own texts. But I believe that a readymade isn't the reproduction of a thing made by oneself, it's really an object removed from its context in the outer world and signed. Hence,

I don't believe that we can say that the *Box-in-a-Valise* is made of ready-mades, even if it contains replicas of readymades like the typewriter cover and the urinal. You can prove to me the opposite, but I don't think that the reproduction of the *Large Glass* in the *Box-in-a-Valise* is a readymade.

C A R O L J A M E S (F)

The *Large Glass?*

J E A N S U Q U E T (F)

Yes, the *Large Glass* reproduced in the *Box-in-a-Valise*. It can't be called a readymade.

C A R O L J A M E S

Just one thing. I want to make it really clear that I don't know what Duchamp specifically thought about these things in the *Valise,* and that is not my concern. My concern is for the regardeur and what had become of this term "readymade." It's part of art history. I'm sure the term was in books and exhibition catalogues with definitions, definitely by the sixties. But these things are ready-made from our point of view now. What Duchamp may have thought we can only surmise. My point is that, for the regardeur, for the subsequent theorizations or conceptualizations, for art historical, literary, or critical dialogues and discourses like the one we are engaging in, these things are readymades just because they participate in some aspect of Duchamp's self-replication.

R O S A L I N D K R A U S S

I tend to agree with those on the panel who seem to find your notion (that the *Boîte-en-valise,* or the things in it, are readymades) sort of counterintuitive. And I guess in light of the statement you just made I'm curious about whether it would matter to you if all of us here said, "We, everyone in this room, the regardeurs of Duchamp's work, resist this notion."

C A R O L J A M E S

Shall we vote?

R O S A L I N D K R A U S S

Yes! I'm wondering how you view other viewers of Duchamp's work.

CAROL JAMES

I guess I would then be asking how you think that is "counterintuitive."

ROSALIND KRAUSS

Well, André has come up with a reason. Jean has come up with a reason. My reason is that I think that if there's anything ready-made operating in the *Box-in-a-Valise* (and this at a very conceptual level), it has to do with the box projecting a bizarre way of thinking about a museum as an institution that is itself ready-made. But I really resist the idea that Duchamp's reproductions of his own work are readymades. And there are several of us who have now attested to our disbelief. So . . .

CAROL JAMES

No, I guess I don't understand why you don't think that this collection is . . .

ROSALIND KRAUSS

Do you understand why Jean Suquet doesn't think so?

CAROL JAMES

Yes, because he doesn't think that it was Duchamp's intention over it.

ROSALIND KRAUSS

No, as I understood it, he said he thinks the readymade is something that Duchamp takes that's made by someone else.

CAROL JAMES

But there are so many things that aren't made by someone else.

ROSALIND KRAUSS

Like what?

CAROL JAMES

What about the window?

ROSALIND KRAUSS

I don't think it's a readymade.

CAROL JAMES

You don't think it's a readymade. OK . . .

ROSALIND KRAUSS

In other words, I find your designation of lots of these things as ready-
mades kind of bizarre. I mean, the designation of *Etant donnés* as a
readymade seems absolutely hallucinatory.

CAROL JAMES

What I meant was that part of the critical thrust on art (I hate that
expression) of Duchamp's late work, the effect of *Etant donnés*, has been
that no one wants to accept it. People want to keep it aside because it's
somehow not classic Duchamp. It's not a readymade, and it's not *The
Bride Stripped Bare*. It's dismissed as part of an incomprehensible joke of
dotage, a trivial repetition. I want to get away from this sort of negative
idea of repetition and from the narrow concrete definition of "ready-
made," and try to understand both how the final work fits all that went
before and how and why it so sharply differs.

ERIC CAMERON

I can't remember all the quotations that come from the Oxford Diction-
ary's definition of the word "readymade," but the first one goes a very
long way back, and my sense from just going through them is that most
of them are negative in connotation. The very first one was that there was
a place "ready-made in hell" for us. That was a very long way back, I
think the fifteenth or fourteenth century, but there is another one from
the 1880s that says something about this being a "ready-made age."

FRANCIS NAUMANN

Unless I'm mistaken, the idea of a "readymade" belongs to the machine
age, in the sense that products were available that were "already made."
I mean, if you wanted a suit before the machine age, you had to have it
made by hand. Around the turn of the century, you could select your suit
from a book or a catalogue of ready-made items. That's where Duchamp
got the word, at least that's what I've always assumed.

THIERRY DE DUVE

The word "readymade" is in itself a readymade that he chose in New
York, together with his admiration for plumbing and bridges, etc. It per-
tains to his view of American art.

CAROL JAMES

But when you start definition arguments about what is and is not a ready-made, you get down to the level that there are maybe two readymades, bypassing the notion that "readymade" can go beyond individual items.

THIERRY DE DUVE

Pardon?

CAROL JAMES

If you want to identify objects, specific items, as readymades, you can construct a taxonomy but you cannot say, as I wish to, that "readymade" changes meaning. And I think that's the more interesting aspect. Rather than limiting "readymade," I believe expanding its possibilities of meaning is consonant with Duchamp's whole work.

THIERRY DE DUVE

Oh, in that case I feel compelled to remind you that Duchamp has said that all the paintings in the world are aided readymades because the painter starts with a tube of paint.[5]

CAROL JAMES

Right. So when you start limiting . . .

DENNIS YOUNG

Just one moment—there is someone wishing to speak from the floor.

UNIDENTIFIED

We've really just considered the *Valise* and the originals. Perhaps we should think about the question of the replicas that were made of the readymades in the sixties, and how they were made by sculptors from scratch, not as ready-made found or chosen objects, but as sculptures. Doesn't Duchamp reintroduce the notion of originality once again, and thus the notion of modernism?

THIERRY DE DUVE

Not today, of course, but some day, it will be necessary to make careful distinctions between "original" and "replica," not in order to put things in little boxes but to have concepts that are operative and therefore have some agreed-upon meaning. That's useful for scholars. I shall answer

your question by an anecdote, and the anecdote is, I believe, highly significant. As I think Carol's paper has at least suggested, the issues of replicas, repetition, etc., do matter, and they do introduce phases or shifts in Duchamp's work. And I believe that Duchamp, more than any artist I know—except Andy Warhol maybe, but he came much later—had an extraordinary awareness of what it means to be an artist "in the age of mechanical reproduction," to quote Walter Benjamin. He was very aware of what the "aura" had become once it was reproducible and he played with this, at times depriving objects of their "aura," at times restoring it—playing a very subtle game with that phenomenon. The anecdote is the following: I once had a discussion with Daniel Buren on Duchamp's importance as an artist. Are you familiar with Buren's work?

UNIDENTIFIED

Yes.

THIERRY DE DUVE

Good. Then you know that Buren paints the two white outer bands of his usual striped material white, when it's canvas, at least. It doesn't show unless you are very attentive. I asked him why he did that, and he said, "This is to indicate that it is not a readymade." And I said, "Oh, it's done by hand. So you want to make a point that you are not appropriating awning material but that you are producing painting, or at least a comment on painting in painting." And then I proceeded to challenge his understanding of the readymade. We finally got into an argument, wherein he said, "In any case Duchamp totally betrayed himself in 1964 when he allowed Schwarz to make replicas." Did you say ten copies this morning, Bill?

WILLIAM CAMFIELD

Thirteen readymades, ten copies of each.

THIERRY DE DUVE

OK. I thought it was eight, but . . .

FRANCIS NAUMANN

Eight in the edition, and two outside of it (one to be kept by Schwarz and another by Duchamp).

THIERRY DE DUVE

OK. So, in any case, Daniel and I thought at the time that the number was eight, so he said, "And he has allowed that edition of eight, so you see he has sold out to commercialism." Buren's career, at the beginning, evolved very much out of an anti-Duchampian stance. In the context it was very interesting. Then Buren went on to tell me that he once asked Duchamp why he had done that, and Duchamp's reply was, "The notion of original extends to eight . . . today."

DENNIS YOUNG

I think that is an excellent point on which to end the session.

1 Thierry de Duve, *Nominalisme pictural. Marcel Duchamp, la peinture et la modernité* (Paris: Minuit, 1984), trans. Dana Polan, *Pictorial Nominalism* (Minneapolis: University of Minnesota Press, 1991).

2 Michel Sanouillet cites this letter in a footnote on p. 49 of *Duchamp du signe.* Duchamp's answer reads: "Je préfère *Ready-made,* en italiques, et cela s'accorde."

3 Since Thierry de Duve is the editor of the present book and a consistent convention was needed, his spelling has been adopted throughout the transcription of the discussions, even in Carol James's interventions. Her spelling has been respected, however, in her own essay, as have the spellings of all participants in their respective contributions.

4 André Gervais, *La raie alitée d'effets,* 81–83.

5 "Apropos of 'Readymades'," in *Salt Seller,* 142.

Duchamp's Way:
Twisting Our Memory of the Past
"For the Fun of It"

When once asked about a detail of his artistic life, Duchamp replied that he did not have an "exact memory" of many early events and anyway that he sometimes twisted things "for the fun of it."[1] The implication of Duchamp's statement, made late in his life, is that he remained an inveterate dadaist and never became overly concerned with historical accuracy. As historians know, viewing the past is often contingent and sometimes permanently obscure. The method Duchamp used is more complex; it involves the conscious modification of history by disregarding "truth." Duchamp forgets some things and selectively modifies or misrecollects others, a technique that more honestly addresses the problematics of memory than typical historiography. In formal histories, the past is analyzed. Narratives about it are written down. Duchamp was not indifferent to the stories that were written about him. His interest, however, was somewhat ironical. He apparently thought that his own history was something he could either learn from or reconstruct; it was not a matter directly connected with reality. What he read about himself was never exactly true, in part because the writer had gotten something wrong or, perhaps just as often, had faithfully followed something Duchamp himself had twisted through faulty or perverse recollection. When asked by Pierre Cabanne what he thought about the various interpretations that were growing up around his work, Duchamp said that he was interested in them, that he read them and learned from them, but it is clear from his attitude that he was skeptical of their direct relationship with what had actually motivated or influenced him years earlier: "Each [critic] gives his particular note to his interpretation, which isn't necessarily true or false, which is interesting, but only interesting when you consider the man who wrote the interpretation, as always. The same thing goes for the people who have written about Impressionism. You believe one or you believe another, according to the one you feel closest to."[2] For Duchamp, the stories and actual past events were sometimes only loosely connected.

Coming into history is a generative process. The storytelling affects meaning, and interpretive modes affect what stories are told. Duchamp's history was necessarily incorrect. The "facts" themselves were open to question, but, more problematic, they entailed the shifting meaning and significance of his works through time—something that was further compromised through the retelling. What Duchamp seems to have done was to consciously accept the process of distortion and to try to make it part of his basic approach. He makes misinterpretation and misreading part of his meaning. Because final truth is inevitably distorted, he twists it further for himself for the fun of it. Moreover, he never corrects any of his interpreters. Duchamp goes beyond the straightforward reservation anyone would have about history and adopts history modification as a strategy. Reformation becomes a method of production. He gives the notion of memory—and faulty memory—a philosophical position. His twists of recollection become epistemological queries; they are probes that entail his aggressive approach to art and its various justifications—an interrelated system that is fair game for his relentless skepticism. He uses twisted memory on the one hand as a way of keeping interpreters off balance, of avoiding being boxed in, and on the other, as a way of keeping such matters within the bounds of his own system. In this last sense, his control of memory was a way of maintaining a consistent program.

Duchamp's approach to art making was articulated in part in mathematical terms. Throughout his life, he used metaphors derived from turn-of-the-century mathematicians, particularly Henri Poincaré and Esprit Pascal Jouffret, to talk about art.[3] The closed nature of mathematical systems gave him a model for his own self-contained artistic system. Furthermore, the mathematical models gave him a conceptual frame for writing his own self-contained history. During the course of his long career, Duchamp's oeuvre became canonical: such works as *Nude Descending a Staircase,* the *Large Glass,* and the Ready-Mades were all placed in their historically relevant positions. The artist himself took an active part in the way these matters were worked out, so much so that the self-reflection became part of the art. Also, Duchamp included historical references to himself in his own work. Several of the projects he was working on late in his life involve returning to themes he had worked out early in his career. Such reworkings are concrete references to memory, to the process of subsuming the pro-

visional nature of the past—or at least the recollection of the past—under the cultural climate of the passing present.

In this paper, I will deal with two specific—and interrelated—aspects of Duchamp's overall historical plan: his reworking of the *Large Glass* in his last piece and his long-term interest in stereoscopy. Both projects, as I see it, are involved with his epistemological uses of *n*-dimensional geometry. Perhaps the most famous of Duchamp's returns is the reworking of the imagery of the *Large Glass* in his last major work, *Given: 1. the Waterfall, 2. the Illuminating Gas*. In his last piece, the Bride shifts from an abstract grouping of two-dimensional, shadowlike forms into a fully round, three-dimensional female figure holding aloft a gas lamp (fig. 1.2). In the fixed-eye diorama, two important motive forces in the *Large Glass*, the waterfall and the illuminating gas, are made manifest. But more important, the piece conflates an early and a late facet of Duchamp's encompassing program. *Etant donnés* involves an historical or remembered kind of stereovision. For Duchamp, the visual metaphors involved methods of seeing in more than one way. Moreover, Duchamp himself apparently saw the last piece, and conceptualized it, in both late nineteenth- and late twentieth-century terms.

By the time Duchamp got around to the last piece, beginning it probably in 1946 when he was almost sixty, he had most likely forgotten the specifics of what he had been thinking about when he was working on the *Large Glass* thirty years earlier. But he had his working notes and his not so exact memory and his ability to twist things for the fun of it. In the last piece, he proceeded with a misrecollected reenactment. Perhaps the most intriguing aspect of the new decoding Duchamp gives to the *Large Glass*— thought of here as both a set of images and a group of written texts—is the change from abstract to representational imagery. The shift was conceptualized, or at least conceived, at an historical time and place (postwar America) when abstraction was dominant in high-art practice. Duchamp consciously chose a reactionary approach to his form, adding a shocking choice of style to his shocking choice of subject. The nude in the last piece was clearly intended to be indecent, but its shock value was essentially intellectual. The mannequinlike figure was so mildly offensive that Duchamp was obliged to rotate its meaning backward into an earlier his-

torical framework when avant-garde gestures still had some force.[4] That much he could remember.

Duchamp knew that he could not *really* shock his audience, that the systems of avant-garde transgression he had incorporated into the earlier Dadaistic aspects of the *Large Glass* had been culturally absorbed. He was getting at something even more shocking—the provisional nature of history and interpretation. By transferring the abstract imagery of the *Large Glass* into the realistic imagery of *Etant donnés*, he could couch his problems in reanalytical terms. One would expect the iconography of the *Large Glass* to be difficult and the normative forms of *Etant donnés* to be easily interpretable. Yet the *Large Glass* is the more clearly transparent work. It is *Etant donnés* that is irresolutely impenetrable, dark, and hidden from critical view. The *Large Glass* has its accompanying notes and its referential cultural attachments, its periodicy. *Etant donnés* is perplexing, opaque, dislocated, not part of a movement. It remains disconnected from its historical moment and arrives fully fractured, split away from the previous oeuvre of its maker, alienated. The disconnectedness of *Etant donnés*, however, becomes more comprehensible when Duchamp's historical purposes are taken into consideration.

Beyond the formal and mathematical perplexities entailed in the recasting of the two-dimensional *Large Glass* into the three-dimensional last piece, Duchamp incorporates self-references, bits and pieces of his own past, into his historical game—a game that often involved twisting his own memory. Memory works through time and interpreters apparently forget what is important. When they remember, the world changes. Images are reseen and art history is revised. Duchamp's own revisions were, to be sure, in many cases humorously intended, but they also had their serious side. He was posing difficult questions: How can knowledge be gained when it is complicated by our not being able to find a philosophical ground? Where do we stand to look for truth? Why do we shift our points of view through time?

Duchamp's own answers to such questions involved twisting his memory of the past for the fun of it. As everyone knows, memory does twist things. What distinguishes Duchamp's use of this simple fact is its unusually systematic nature. He was one of the first twentieth-century artists to see

the merits of revising one's opinions of earlier art historical moments. Further, he often made reference in his works to earlier periods that were, at the time he was working, art historically out of favor. By entailing in his overall project artistic forms that were considered "unworthy," Duchamp encouraged a reexamination of his own images. Not only faulty memory, but also the general calcification of aesthetic first principles forced him to recast his earlier ideas.

The notions of casting and recasting were fundamental to Duchamp's oeuvre. In several of his notes that deal with the distinctions between "appearance" and "apparition," he uses the metaphor of a cast and its imprint to turn things inside out—to give them a kind of geometrical twist.[5] The geometrical aspects of Duchamp's process have four-dimensional implications. The artist points out that the "appearance of an object is the sum of the usual sensory evidence enabling one to have an ordinary perception of that object" and advises his reader to consult the "psychology manuals" for more information.[6] By "usual sensory evidence," Duchamp is referring to such things as perspective, occlusion in the visual field, stereopsis, and the binocular disparity that helps the viewer to perceive the world in three-dimensional terms. Normal visual clues determine the "appearance" of an object, but its "apparition" is a different matter. The "appearance" is the actual look of a thing; its "apparition" is its pictorial analogue. In Duchamp's geometrical terms, an apparition is an $(n - 1)$-dimensional representation of an n-dimensional configuration—say, if $n = 3$, a flat perspective drawing or a photograph of a solid object. An "apparition" thus has geometrical implications.

In his notes, Duchamp discusses a number of such objects: "mirror images," "shadows," "linear perspective drawings," and "photographic negatives." He apparently conceptualized these flat, art-related objects in the specific geometrical terms of their being $(n - 1)$-dimensional, infra-thin molds for n-dimensional objects. Duchamp fully understands that a mold is a mirror-reversed, inside-outside version of the molded object, and the distortional aspects of the molding process were of interest to him. In the somewhat whimsical terms of casting chocolate, Duchamp points out that the mold of an object is the negative apparition of a surface. In the course of his exposition, he points out that all this should be couched "in the conditional tense: If one [could do so and so, then such and such would

be possible]."[7] Duchamp makes this proviso to remind his reader that his interests involve reconstructing an n-dimensional realm. In such discussions where $n = 4$, the terms are necessarily conditional. One speaks of the fourth dimension *as if* it were accessible to normal discourse, much as one speaks of art and art history.

The flavor of Duchamp's own discourse is revealed in the following sections from notes about casting chocolate geometrical objects: "the negative (in negative) apparition [is] determined for the colored form conventionally by linear perspective, for example, but always in an environment of $n - 1$ dimensions."[8] In Duchamp's terms, "there is the surface apparition (for a spatial object like a chocolate object) which is like a kind of mirror image looking as if it were used for the making of this object, like a mold, but this mold of the form is not itself an object, it is the image in $n - 1$ dimensions of the essential points of this object of n dimensions. The three-dimensional appearance comes from the two-dimensional apparition which is the mold of it (the external form)."[9] What is perhaps most intriguing here is the conflation of relatively straightforward geometrical processes with the loaded terminology of vision and visibility—of appearance and apparition.

Duchamp entails mathematical operations with the philosophical notions of what is visible and not visible and then goes on to explain his own peculiar geometrical processes: "By mold is meant: from the point of view of form and color, the negative (photographic); from the point of view of mass, a plane generating the object's form by means of elementary parallelism composed of elements of light (this light of equal intensity manifesting itself in color-source differences (and not colors subjected to a source of light exterior to the object.)"[10] As a substance, chocolate is plastic; it can be deformed in multiple directions; it can be stirred, mixed, ground up, while retaining its essential characteristics and colors. It can be molded in complex ways, and, conceptually at least, it can be translated and rotated from n-dimensional to $(n + 1)$-dimensional forms. Duchamp goes on to explain: "For example, the mold of a chocolate object is the negative apparition of the plane with several curvatures determined conventionally (perspectively for example in three-dimensional space) by its position in a space containing this object and an archetype."[11]

A number of Duchamp's works can be interpreted in terms of the geometrical relationships between an archetype, a ready-made manufactured object for example, and the multiple copies that can be developed from it. Through time, the archetype itself is lost; it dissolves in memory. The last piece is among the most important of Duchamp's works that deals with this idea. *Etant donnés* can be seen as an "appearance" of the "apparitional" *Large Glass*. As such, the *Large Glass* becomes, to use the words of the note just quoted, an "image in $n - 1$ dimensions of the essential points of this object of n dimensions. The three-dimensional appearance comes from the two-dimensional apparition which is the mold of it (the external form)."[12] In these terms, the *Large Glass* is a two-dimensional mold for the three-dimensional last piece. Duchamp's molding process is, however, conceptual and requires a number of topological distortions—for example, a "plane with several curvatures," as he calls it—in order to transpose the abstract forms of the *Large Glass* into the realistic forms of the last piece. The *Glass* is the apparitional mold that gives form to the last piece, which becomes the appearance or the analogue of a theoretical chocolate object. The specifics of the geometry are, as Duchamp says, "ad libitum" and "hypophysical."

Duchamp argues that an object's "physical appearance" is determined by pictorial conventions that become the "mold of the object." His "molds" are two-dimensional, infra-thin slices that can be used, at least conceptually, to generate higher-dimensional entities. They can engender an "object's form by means of elementary parallelism." In ways that echo his earlier uses of elementary parallelism in his Cubo-Futurist paintings, Duchamp conceptualizes the two-dimensional *Large Glass* as a photographic mold for the last piece. If moved toward the fourth dimension, it could potentially generate an even higher-dimensional form. Conceptualized this way, the last piece becomes a photographic "casting," a "camera obscura" or an $(n + 1)$-dimensional stereopticon, of the ideational complex outlined in the parametric jottings for the "mold"—the *Large Glass* itself—all generated by geometrical displacement. Under the vagaries of Duchamp's n-dimensional system, a translation from two-dimensional apparition (mold) to three-dimensional appearance (solid object) becomes possible. By implication, a similar operation could be carried out between three-dimensional molds and hypothetical four-dimensional objects.[13]

8.1
Jean-Léon Gérôme, *Le gardien du
harem* [*The Guard of the Harem*], 1859.
(Reproduced by permission of the Trust-
ees of the Wallace Collection, London.)

8.2
Etant donnés door, with spectator.
(Photo Philadelphia Museum of Art.)

8.3
Jules Lefebvre, *La vérité* [*Truth*], ca. 1859. (Musée d'Orsay, Paris.)

Given: 1. the Waterfall, 2. the Illuminating Gas is an element in a highly ramified *n*-dimensional pastiche in which an interplay between the ideas both projected and realized in the *Large Glass* comes to bear on questions relating to shifting between an "apparition" (a two-dimensional, glass-plate "mold") and an "appearance" (a three-dimensional "casting"). In metaphorical terms, shifting from two dimensions to three dimensions can stand for a complicated, and highly conjectural, displacement into the fourth dimension. In addition to the visual and spatial metaphors, Duchamp's transformations address broader aesthetic questions relating to judgment and evaluation. In the last piece, Duchamp shifts the "modern" form language of the *Large Glass* into the "moribund" form language of nineteenth-century realism. At least in part, his recasting represents an historical involution. By rotating the *Large Glass* into the past, Duchamp re-members it.

The exterior door in the last piece recalls Jean-Léon Gérôme's *Guard of the Harem* (fig. 8.1). The interior nude, holding her "Bec Auer" gas lamp, recalls not only the advertisements for that company, but also allegorical representations of *Truth* by such artists as Jules Lefebvre (fig. 8.3). Duchamp's geometrical shifts are conflated with historical shifts. By recasting his conception of the last piece into the associational matrix of nineteenth-century precedents, Duchamp illustrates his view that museums are not the final repositories of taste. He believed that the opinions that assigned works of art to prominent positions in history were suspect and argued that talking about "truth and real, absolute judgement" in regard to artworks was provisional at best: "I haven't been to the Louvre for twenty years. It doesn't interest me, because I have these doubts about the value of the judgments which decided that all these pictures should be presented to the Louvre, instead of others which weren't even considered, and which might have been there."[14] Duchamp's own allegorical figure of truth, a mannequin feebly holding her lamp aloft inside *Etant donnés*, symbolizes his opinion that the basic processes of art history were essentially debased and in need of being rethought. Art history was poorly illuminated and amounted to little more than faulty memory dimly recalled. Twisting his own memory of things for the fun of it was a delaying action. By now, this strategy too has become part of the academy.

Duchamp's geometry has art historical and aesthetic overtones. His $(n - 1)$-dimensional, infra-thin slices—his photographic negatives, mirror images, and perspective renderings—are two-dimensional configurations that contain n-dimensional objects. They are analogues for three-dimensional space, conceptualized as an infra-thin slice contained within the four-dimensional continuum. If a three-dimensional space, couched in these hypothetical terms, is translated according to the principles of elementary parallelism, it generates a four-dimensional configuration. Three-dimensional space then, in its turn, becomes an "apparition" (a mold) that generates an "appearance"—a hypothetical arrangement that is none other than the four-dimensional object. For Duchamp, there is more freedom of movement in the fourth dimension. The additional liberty was not only a matter of time and space, but also of aesthetic judgment. The fourth dimension was a metaphorical realm in which he could move away from established patterns of art making.

Duchamp twisted his memory of the past and, in the process, broke traditional molds of behavior and production. He re-formed standard aesthetic thinking by means of n-dimensional casting processes. In the early stages of his career, he had been obliged to shock his audience into taking fresh looks at art and art making. In the last stages of his career, he kept his work secret, and contradicted his own avant-gardism by using artistic methods that were easily accessible. The difficulties, however, remained. His accessible vocabulary was only ostensible. His dadaism had succeeded so well that it shattered even his own avant-garde windows. His artistic nihilism and attack on bourgeois culture had been tamed and brought within the establishment; to shock the artworld again, if only in terms that had lost their power through being so often repeated, Duchamp returned to the bourgeois forms of harem guards and nudes holding allegorical emblems high in the air. The false teeth of his new, albeit worn out, "avant-gardism" are suggested by his late "ready-made" *Wedge of Chastity* (fig. 8.4). This piece, completed in 1951–1952 and given to his wife Teeny as a wedding present in 1954, is related to *Etant donnés* and to casts that Duchamp had made from the interior nude: *Objet-Dard* (1951) and *Female Fig Leaf* (1951). His strange gift (or given) functions as an androgynous combination of these earlier erotic objects.[15]

8.4
Coin de chasteté [*Wedge of Chastity*], 1951–1952 (inscribed 1954). Galvanized plaster and dental plastic, 2³⁄₁₆ × 3⅜ × 1⅝ in. (Collection Mme Alexina Duchamp, Villiers-sous-Grez.)

Duchamp's project of reanalyzing, reexamining, recombining (remembering) the *Large Glass* involves not only recasting but also reseeing, and many of the notes deal with what he called four-dimensional vision. One particularly important aspect of this speculative kind of perception had to do with stereopsis and the related technique of stereoscopy. Stereoscopes and stereoscopic images were popular at the end of the nineteenth century, and, for Duchamp, they were a handy way of connecting his elaborate speculations concerning the fourth dimension with a commonplace and popular technique of transforming the three-dimensional into the two-dimensional (photography) and then, vice versa, of remapping the two-dimensional back onto the three-dimensional (stereoscopic photography). His interest in stereoscopy informed both the *Large Glass* and the last piece and can serve as a kind of conceptual link between his two major works. In both of these pieces, Duchamp was concerned with the n-dimensional effects of stereovision; he was interested in the phenomenon for its own sake and appreciated its metaphorical usefulness in discussions of hypothetical ways of seeing—ways of seeing that could, in symbolic terms, allow the perception of four-dimensional figures.

In the *Large Glass*, the fourth dimension is a matter of notation. It exists as speculation in the more than 100 notes that deal in overt ways with n-dimensional geometry. The area of the oculist witnesses and the scissors seems to be about the differences involved in looking at something with one eye and then looking at it with two eyes (fig. 8.5). This iconographic detail is transformed into the more specifically "stereoscopic" peepholes in the old door of the last piece. Duchamp's interest in seeing with offset eyes is related to the fact that stereopsis in the human visual system enhances the perception of three-dimensional objects. In and of itself, vision with two eyes is a way of going from the two-dimensional images projected by the lens systems of the eyes onto the surfaces of the retinas to the three-dimensional world of actual perception. Stereoscopy is a mechanical technique that enhances the effects of three-dimensional seeing. Looking at two separate two-dimensional photographs taken by two cameras at slightly offset angles (angles analogous to the displaced angles of the eyes) through a restoring device—the stereoscope—can create a dramatic spatial world. Duchamp produced his *Handmade Stereopticon Slides* (fig. 8.6) in 1918–1919 and was working on a related work, *Anaglyphic Chimney* (fig. 8.7),

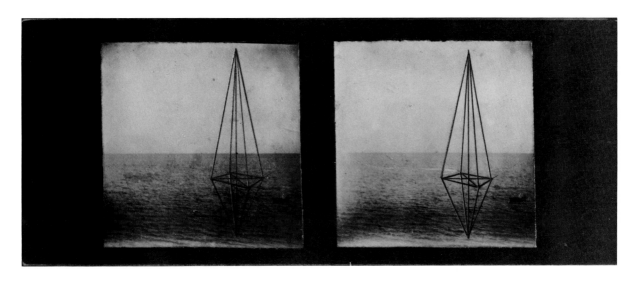

8.5
"Oculist Witnesses," detail of *The Large Glass*, 1915–1923. (Philadelphia Museum of Art; Katherine S. Dreier Bequest, 1953.)

8.6
Stéréoscopie à la main [*Handmade Stereopticon Slide*], 1918–1919. Pencil on stereopticon slide (two photographs mounted on cardboard), each 2¼ × 2½ in. (The Museum of Modern Art, New York; Katherine S. Dreier Bequest, 1953.)

8.7
Cheminée anaglyphe [*Anaglyphic Chimney*], 1968. Red and blue ink on white paper, approx. 9¹⁵⁄₁₆ × 7¹⁵⁄₁₆ in. (Collection Vera and Arturo Schwarz, Milan; photo Bacci.)

at the time of his death fifty years later. The fact that the kinds of space seen in these images, particularly when they are viewed through a stereoscope or the red and green lenses of anaglyphic glasses, were unique and not really like normal three-dimensional space was of interest to Duchamp. Isolating the effects of stereopsis enhances the three-dimensional look of such images. In other words, there are two kinds of three-dimensional vision: the normal spatial perception of the surrounding environment and the enhanced three-dimensional perception involved in stereoscopy. The very unusualness and intensity of stereoscopic images could serve as a metaphor for the fourth dimension—it was the third dimension plus something.

Duchamp's geometrical methods are essentially the same as those used by his principle mathematical sources. Henri Poincaré, for example, often discusses geometry in visual terms. The mathematician points out that "the sense of sight, even with a single eye, together with the muscular sensations relative to the movements of the eyeball, would suffice to teach us space of three dimensions. The images of external objects are painted on the retina, which is a two-dimensional canvas; they are *perspectives*." For Poincaré, the perceiver constructed the three-dimensional world in terms of movement: "But, as eye and objects are movable," he says, "we see in succession various perspectives of the same body, taken from different points of view. At the same time, we find that the transition from one perspective to another is often accompanied by muscular sensations."[16] Because changes in perspective are accompanied by proprioceptive sensations that are orderly and lawful (they behave like mathematical groups), the perceiver has a way of constructing an internal conception of space.

Poincaré goes on to say that "we understand thus how the idea of space of three dimensions could take birth from the pageant of these perspectives, though each of them is of only two dimensions, since *they follow one another according to certain laws*."[17] In his note from the *Green Box* that contains the title of the last piece (see figs. 5.1 and 5.2), Duchamp echoes Poincaré's remark: "We will determine the conditions of the instantaneous state of rest (or allegorical appearance) of a succession [of a set] of news items seeming to necessitate each other according to certain laws, in order to isolate the sign of agreement between, on the one hand, this rest (capable of innumerable eccentricities) and, on the other, a choice of possibilities

legitimated by these laws and also determining them."[18] Poincaré's analysis of moving geometrical projections also involves "instantaneous states of rest." His stop-frame projections provide him, and perhaps Duchamp as well, with an intellectual way of describing higher-dimensional spaces: as Poincaré puts it, "just as the perspective of a three-dimensional figure can be made on a plane, we can make that of a four-dimensional figure on a picture of three (or of two) dimensions."[19] These last remarks seem prophetic of Duchamp's method. The artist projected a hypothetical four-dimensional "Bride" in an instantaneous state of rest onto both a three-dimensional configuration, *Étant donnés*, and a two-dimensional configuration, the *Large Glass*.

Duchamp's projective techniques are not only related to those discussed by Poincaré, but are also similar to those used by his other primary source, Jouffret. The major parts of both Jouffret's books, *Elementary Treatise on Four-Dimensional Geometry* and *Mélanges of Four-Dimensional Geometry*, are concerned with systems of projective geometry in which various four-dimensional bodies are projected onto three-dimensional spaces and two-dimensional surfaces.[20] Such projections involve a number of visual complications. Many of Duchamp's geometrical notes deal with the problems of four-dimensional seeing. He argues that by moving around in a given n-dimensional space, the viewer can make (in a way reminiscent of Poincaré's combination of visual and muscular sensations) a "tactile reconnaissance" of any given n-dimensional object. Movement is a strategy through which *n-dimensional objects are perceived as being in fact n*-dimensional rather than $(n - 1)$-dimensional. Dimensional reduction occurs because of the projective characteristics of the visual system. Duchamp points out, following a rich tradition in the popular mathematical literature, that a hypothetical flat being would have to move around a circle drawn on its plane world to see the entire circumference of the circle. If the circle is considered as a portion of the plane, then the flat being sees an $(n - 1)$-dimensional projection of an n-dimensional object. In other words, from any given point of view the two-dimensional being sees the circular portion of the plane edge-on as a one-dimensional line segment equal to the diameter of the circle. With its eye fixed, the flat being perceives an infra-thin projection, but by moving around the circle, it can obtain, as Duchamp calls it, an "imaginative reconstruction" of the circle.

If such a strategy can help two-dimensional beings conceptualize the flat geometrical objects drawn on their plane world—and not fully visible from within that world—then a similar approach might work in the third dimension, and, *mutatis mutandis*, in the fourth dimension. As Duchamp explains it, "the same difference exists in the four-dimensional domain: there is a *tactile reconnaissance* in the four dimensions and three-dimensional visual perspective perception of the four-dimensional body." But Duchamp adds a proviso: "this three-dimensional visual perspective perception is only distinguishable by the four-dimensional eye. The three-dimensional eye will not distinguish it clearly (just as a two-dimensional eye only sees the projected segment of the circle)."[21] In this context, it might be pointed out that in the last piece, the viewer does not have a mobile, reconstructive view of the whole figure, but is forced to view it from a fixed position, a situation Duchamp explored as early as 1918 in *To Be Looked at (from the Other Side of the Glass), with One Eye, Close To, for Almost an Hour* (fig. 8.8). The similarity of this small work on glass to diagrams in Jouffret (fig. 8.9) illustrates not only Duchamp's reliance on the mathematician but also his artistic use of geometrical projection. Duchamp is concerned, as he says, with the "difference between tactile exploration, three-dimensional wandering by an ordinary eye around a sphere and the vision of that sphere by the same eye fixing itself at a point of view (linear perspective)."[22] This seems to be the experimental situation in both *To Be Looked at* and *Etant donnés*. In the last piece, the viewer's three-dimensional eye is not permitted to wander, but is fixed at a point of view at the peepholes in the exterior door. The last piece becomes a metaphor for our perceptual situation, vis-à-vis four-dimensional projections onto our space. If it is taken as a "three-dimensional visual perspective" of a four-dimensional object, then, as Duchamp reminds us, it is only "distinguishable by the four-dimensional eye."[23] A three-dimensional vision of the last piece conceptualized as a projection from a four-dimensional object, a situation suggested in the diagram from Jouffret, is analogous to looking at the projected line segments of a two-dimensional perspective drawing of a three-dimensional object from inside the paper it is drawn on. In his notes, Duchamp connects his notion of "infra-thin" with "fixed eye phenomena," and several of his works, particularly those dealing with stereopsis, are concerned with this idea.[24] Jouffret in his *Mélanges* refers to stereopsis in the context of a

discussion of the complications involved in the perception of projections from a four-dimensional figure—the polyhedroid.

This passage is worth quoting at some length, not only because it is so suggestive of Duchamp's geometrical method, but also because it evokes the artist's general system of overlaying and superimposing simple and complex meanings. The complexity of the mathematics is analogous to the complexity of the art. Jouffret explains:

When you examine the projection of a material polyhedron on a plane, you cannot always discern the projections of the diverse polygons which are the faces of the polyhedron. These projections have not only been more or less deformed and flattened, possibly even reduced to simple fragments of straight lines, but the individual projections of the polygons also partially cover one another, and all these superimposed thicknesses of planes *are blended into a single figure in the drawing.*

When one projects a polyhedroid (a multifaceted four-dimensional figure) onto a space, its diverse cases have polyhedrons for projections, which are also more or less deformed and flattened and can even be reduced to plane figures. But this is not all: these polyhedrons must be considered as being situated in many superimposed spaces more or less covering one another, and the thicknesses of spaces *blend into a single space in which we see the projection. In this space, the polyhedrons penetrate each other, and if one constructs them individually, it is necessary to carry out certain* suppressions *corresponding to these penetrations in order to realize the projection of the whole while reuniting them.*

This complexity explains why we cannot get past our view of the projected object to form a more complete conception of the four-dimensional figure. It would be easy for us to construct two polyhedrons which are the perspectives of a single polyhedroid taken from two different points of view. They would be the stereoscopic image *of it for two eyes placed at these two points. But the plane stereoscopic image gives us the sensation of a three-dimensional body only if we place our eyes in a plane different from the plane of the stereoscopic image, and the other could render us the same service vis-à-vis a four-dimensional body only if we could, in the same manner, place our eyes in a different space.*[25]

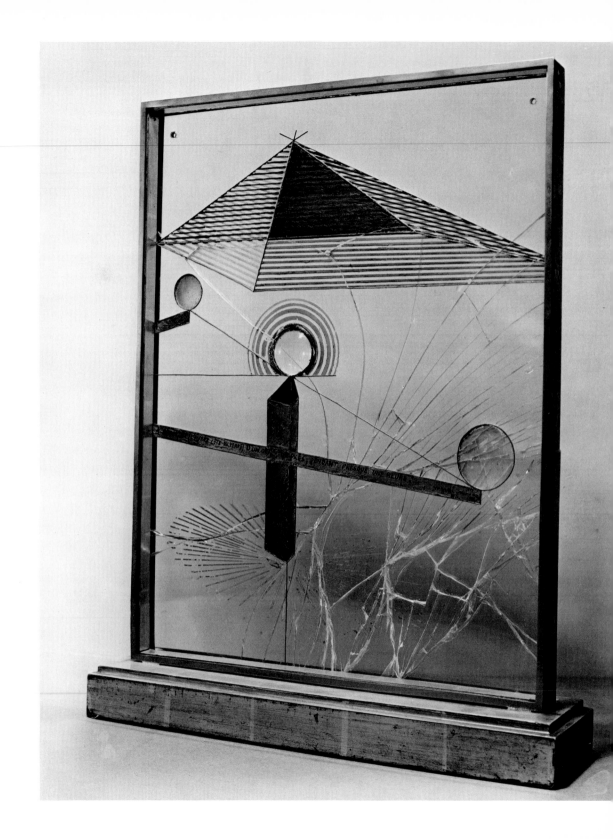

Duchamp's arrangement of the last piece is much like Jouffret's hypothetical four-dimensional stereoscope. The last piece also involves an attempt to deal with four-dimensional vision, but because Duchamp's speculations are about the essentially unseeable realm of the spatial fourth dimension, he needs a system of dealing with that realm in symbolic terms. Certain systems, for example stereoscopy, allow operators to transfer an n-dimensional configuration into an $(n + 1)$-dimensional configuration. Duchamp assumes that the process can be continued ad infinitum. He argues that, because $n = 3$ in the normal world and because this world can be represented in images where $n = 2$, there might be a way of inventing a kind of stereoscopy that would restore the fourth dimension. Using three-dimensional images, the operator could construct a four-dimensional vision. In terms of stereoscopy, the slides in the stereoscope would have to be spatial rather than planar. From this point of view, the last piece becomes a single three-dimensional image in a hypothetical four-dimensional stereoscope— or one half of a hypothetical three-dimensional stereopticon slide used in such a stereoscope. The physical characteristics that give a regular stereoscope its power are that each of the two eyes looks at one of two images from a stationary position that is offset from the other. The brain puts the two offset images together and interprets the differences as cues for depth; thus, the cognitive powers of the viewer change two-dimensionality into three-dimensionality. In a four-dimensional stereoscope, in order to get a

convincing restoration of a four-dimensional figure, the position of the eyes, or sets of eyes, would also have to be offset, but, much more problematic, they would have to be stationed in an entirely different *dimension*—a situation that would, of course, be extremely difficult to achieve.

The last piece is viewed through two peepholes that are analogues for the two oculars of a stereoscope. If the two-dimensional images of stereopticon slides are taken to be n-dimensional projections from $(n + 1)$-dimensional objects, then the last piece can be interpreted as a corollary in three dimensions. In other words, the last piece can be taken as a three-dimensional "slice" analogous to the two-dimensional "slice" of the stereopticon slide. While an interpretation of the last piece as four-dimensional stereoscopy is possible, it cannot be made to fully connect with reality. Duchamp's tableau represents only a portion of what would be necessary for a three-dimensional stereoscopic image of a four-dimensional "Bride." Most critical, there is no place for viewers to station their points of view. With their eyes fixed at the peepholes, they do not have an extra-dimensional point of view as would be required for a genuine four-dimensional perception. From their position in three-dimensional space, they are in a situation analogous to seeing a stereopticon slide from inside the slide.

The perception of three-dimensionality through a stereoscope is enhanced by the two eyes fixing themselves at a single position so that they can take advantage of parallax. From such positions, eyes can be fooled, as happens with stereoscopic images. Moving eyes are more difficult to fool. Moreover, in Poincaré's terms, it is the muscular sensations accompanying the movement of the eyes that allow the conceptualization of three-dimensional space. The perception of the fourth dimension is a much more complicated matter. Duchamp approaches it through metaphors that involve both movement and momentary, stop-frame glances. In philosophical terms, he goes from problems of seeing to problems of thinking, from problems of perception to problems of conception. He says, perhaps following Poincaré's discussion of the connections between mathematical groups and three-dimensional seeing, that "three equal, similar things are the group element that allows one to recognize a first, second, and third similar thing" and that there is a "uselessness of speaking of four or more."[26] This passage acknowledges the practical limitations of vision in the real world. A four-dimensional vision would require multiple viewpoints from multiple spaces;

and not only that, it would require multiple moving perceptions of multiple moving configurations—contingencies that are impossible to meet. In order to deal with these problems, if only in symbolic terms, Duchamp takes geometrical slices through the complexity. By using $(n - 1)$-dimensional projections or $(n - 1)$-dimensional sections of n-dimensional figures, Duchamp arrives at a way of referencing the contingency of modern life and modern art. He can relook and remember his own oeuvre in n-dimensional terms.

At the Philadelphia Museum of Art, the *Large Glass* can be looked at from any number of points of view. Any number of conceptual slices can be taken through and beyond it. As a metaphor for a four-dimensional projection, it has collapsed back upon itself and become completely flat. As Duchamp explains it, the forms have mapped themselves first onto solids and then onto planes. Like the *Large Glass*, the mysterious tableau of *Etant donnés* involves dilemmas of the fourth dimension. It too reminds the viewer that the fourth dimension cannot be seen from either moving or stationary positions from within three-space. Both the *Large Glass* and the last piece, appropriately offset from one another at 90 degrees, buttress Duchamp's philosophy of doubt. They go beyond their simple geometry. What cannot be seen is the work of art, because, like the place to stand to look back at the fourth dimension, a viewpoint for determining artistic value and meaning cannot be found in the real world.

In his mathematical speculations, Duchamp was involved with an epistemological project. His work with the *Large Glass* and its ancillary iconography of stereoscopy, his reiteration of the plane geometry of the early imagery of the *Large Glass* in terms of the last piece's solid geometry, and his related speculations involved in such works as the reinterpretation of his early *Handmade Stereopticon Slides* in *Anaglyphic Chimney* are all in keeping with his attempt to achieve an imaginative reconstruction of a four-dimensional world. Duchamp was remembering his own oeuvre in purposive terms. This supposition is given credence by his choice of mathematics. His use of stereoscopic metaphors, similar to the ones used by Jouffret when the mathematician was trying to explain the fourth dimension, have seeing as their subject. Duchamp's late works are antiquated avant-garde gestures, reseen; they are appropriated emblems of modernist practice. As such, they anticipate a number of strategies that figure prominently in

contemporary postmodernist practice.[27] From Duchamp's position, the flat can be recast into the round, the old into the new, the past into the present. He reinterprets and remembers his own oeuvre, twisting it into a complex pastiche. His images and his writings are superimposed thicknesses of texts. They exist as one work, partially recalled, changing through time. As he puts it in one of his notes, "in each fraction of duration, *all future and antecedent fractions* are reproduced. All these past and future fractions thus coexist in a present that is really no longer what one usually calls the instant present, but a sort of present in multiple continua."[28] By remembering his own oeuvre, Duchamp could create such a "present in multiple continua." By so doing, he could complicate his own assimilation into history.

Duchamp actively participated in the telling and retelling of his story. He was there at almost every turn, carefully overseeing what was being done to his memory. Presumably, there was considerable editing and twisting involved. The part that Duchamp played in the writing of his own history amounted to a way of coming back through his own oeuvre, adjusting it, honing it so that it would resay, and reinforce, his underlying analysis of the principles of art making. It was also a way of making all his works self-consistent. From this point of view, Duchamp's oeuvre shares characteristics with axiomatic systems such as mathematics. All of Duchamp's works are tightly related. The *Large Glass* and the Ready-Mades are mutually reinforcing; the last piece reiterates the *Large Glass;* the geometry entails reexamining history; the aesthetics are revealed by the geometry. Each of Duchamp's artistic gestures is related to his long-term endeavor to connect everything up. The connections were established, at least in part, by twisting memory for the fun of it. Perhaps most important, Duchamp sees to it that all of his works, including his earliest paintings, fall within the confines of his overall transgressive system. The works form a recursive loop that comes back around, turns on itself, and creates its own image. Duchamp's entire oeuvre reflects back upon itself, collapsing through the mirror surface it shatters, and, despite its anti-art tack, is remarkable for its artfulness. The art, and the anti-art, is self-consistent, bounded in terms of its intent, yet open-ended in its implications. Using such a recursive strategy was Duchamp's way.

Notes

1 Interview with Jeanne Siegel, "Some Late Thoughts of Marcel Duchamp," *Arts Magazine* 43 (December 1968–January 1969):22: "There is always a deformation, a distortion of [our understanding of the past] in souvenirs, and even, you know, when you tell a story about that, you, in spite of yourself, change the story as you saw it, because you have not an exact memory or you want to twist it anyway for the fun of it."

2 Pierre Cabanne, *Dialogues with Marcel Duchamp,* trans. Ron Padgett (New York: Viking, 1971), 42.

3 For discussions of Duchamp's mathematical sources, see Craig Adcock, *Marcel Duchamp's Notes from the Large Glass: An n-Dimensional Analysis* (Ann Arbor, Michigan: UMI Research Press, 1983), 29–39; also Linda Dalrymple Henderson, *The Fourth Dimension and Non-Euclidean Geometry in Modern Art* (Princeton: Princeton University Press, 1983), 117–130.

4 For a more detailed analysis of Duchamp's use of erotic imagery, see Craig Adcock, "Duchamp's Eroticism: A Mathematical Analysis," *Dada/Surrealism,* no. 16 (1988), 149–167.

5 Marcel Duchamp, *Salt Seller: The Writings of Marcel Duchamp (Marchand du Sel),* ed. Michel Sanouillet and Elmer Peterson (New York: Oxford University Press, 1973), 70, 84–85.

6 Ibid., 84–85.

7 Ibid., 70.

8 Ibid.

9 Ibid., 85.

10 Ibid.

11 Ibid.

12 Ibid.

13 For a more detailed discussion of Duchamp's casting processes in terms of photography, see Craig Adcock, "Marcel Duchamp's 'Instantanés': Photography and the Event Structure of the Ready-Mades," in *"Event" Arts and Art Events,* ed. Stephen C. Foster (Ann Arbor, Michigan: UMI Research Press, 1988), 239–266.

14 Cabanne, *Dialogues,* 70–71.

15 See Anne d'Harnoncourt and Walter Hopps, *"Etant donnés: 1° la chute d'eau/2° le gaz d'éclairage:* Reflections on a New Work by Marcel Duchamp," *Bulletin of the Philadelphia Museum of Art* 64 (April–September 1969):35; also Jean Clair, "Sexe et Topologie," *Abécédaire,* exhibition catalogue (Paris: Centre Georges Pompidou, 1977), 52–59.

16 Henri Poincaré, *Foundations of Science: Science and Hypothesis, The Value of Science, Science and Method,* trans. George Bruce Halsted (New York: The Science Press, 1921), 78.

17 Ibid. (Italics are part of the original.)

18 Duchamp, *Salt Seller,* 27–28; Thierry de Duve has pointed out that "faits divers," translated by George Heard Hamilton as "various facts" in the text used in *Salt Seller,* actually means "news items."

19 Poincaré, *Foundations of Science,* 78.

20 E. Jouffret, *Traité élémentaire de géométrie à quatre dimensions et introduction à la géométrie à n dimensions* (Paris: Gauthier-Villars, 1903); *Mélanges de géométrie à quatre dimensions* (Paris: Gauthier-Villars, 1906).

21 Duchamp, *Salt Seller,* 88.

22 Ibid.

23 Ibid.

24 Marcel Duchamp, *Notes,* ed. and trans. Paul Matisse (Paris: Centre National d'Art et de Culture Georges Pompidou, 1980), no. 5.

25 Jouffret, *Mélanges,* 42–43 (my translation).

26 Duchamp, *Notes,* no. 90.

27 In the version of this essay delivered at
the Halifax conference, this sentence read:
"As such, they anticipate and validate a
number of strategies . . ." (see note 4 to
the following discussion).

For a more detailed discussion of this
point, see Craig Adcock, "Why Marcel
Duchamp's Old Hat Still Addresses the Sit-
uation to the Nines," *Arts Magazine* 59
(March 1985):72–77.

28 Duchamp, *Notes,* no. 135.

Discussion

Moderated by Thierry de Duve

FRANCIS NAUMANN

You made several references to a hypothetical experience of the fourth dimension. I know it's not possible, but could you explain what it would be like to be translated into the fourth dimension?

CRAIG ADCOCK

The fourth dimension is essentially ninety degrees from everything else. If there were movie cameras trained on you from all eight corners of the room and you were translated into the fourth dimension, each camera would show you just going off into the distance straight away until you disappeared. From every direction, that's where you would go if you were translated into the fourth dimension. Does that help at all?

JEAN SUQUET (F)

Thank you, Craig Adcock, for having so well illuminated that which is after all the source for the *Large Glass* and which is forgotten a little too often. You have given us an interpretation of the *White Box* notes which is generally left in the dark by Duchamp commentators, even though these notes are at the origin of all his speculations. Please allow me to emphasize two points of your demonstration and pardon me for doing it in a much more pedestrian manner. I will begin with one of these "as if" situations in the manner of Thierry de Duve. Duchamp imagines that the page upon which he writes is inhabited by flat beings who have no possibility of rising above the page; thus they can't perceive the form of an A, a B, or a C. From their totally horizontal perspective, letters inevitably appear to them as a dash more or less compact. The only way that the page's flat inhabitants can realize the form of letters is to wander around them in a tactile exploration. They finger the lapses of the pen, the down- and the upstrokes, as blind beings who grope their way around. Does a sphere pass through the page like a rising sun? The natives (Duchamp called these flat beings *indigènes*) inhabiting the page are going to first feel a point which appears, then a circle which opens up, little by little vanishing again: all they are going to grasp of the three-dimensional sphere that passes through their two dimensions is a zero,

growing then fading away. They merely suspect the superior dimension, and that with the help of time, duration. They can describe the sphere only through a chronological account, a story. However—and I insist because I'm going to restage a character who is dear to me—the two-dimensional natives who aren't familiar with verticality nevertheless experience, in the region of the stomach, the sensation of gravity. And this bodily weightiness gives them the *idea* of the superior dimension which they cannot see but which they imagine. Would the Tender of Gravity be the gatekeeper to the inaccessible fourth dimension? I hope I haven't betrayed you.

CRAIG ADCOCK

That's not a bad idea—having a sort of intuitive perception of the fourth dimension. That's what Jouffret does essentially, although I don't recall the analogy of the sphere coming through the plane in Jouffret. There is a lot of discussion of flat beings in Jouffret but mostly in terms of shadows.

JEAN SUQUET (F)

Ah, then it's not there.

CRAIG ADCOCK

Jouffret takes slices through various four-dimensional figures seen from various points of view. If we can somehow put these slices back together, we can have an imaginative reconstruction of the four-dimensional figure. So, this process does have a temporal component, I think. There is time in there.

JEAN SUQUET (F)

That's it. Time, time . . .

CRAIG ADCOCK

As moderns, we are more used to thinking of time as the fourth dimension because that's what it is in the theory of relativity, of course. But Duchamp's fourth dimension, as we were saying earlier, was mostly a spatial fourth dimension. For him it's this parallel or, I should say, perpendicular domain.

HERBERT MOLDERINGS

I would like to contradict both of you. I don't think that in Duchamp's

speculations the sense of gravity in the region of the stomach helps in any way to further the understanding of his concept of the fourth dimension. As I understood his speculations and analogies, the only way for somebody to imagine a higher-dimensional world is through a mental construction. To address what Jean Suquet has said about the sphere penetrating the plane, I'd say that the flat "native" would have to observe the movement of the sphere second by second and measure it with this method: first the point, then a small circle, then a larger circle, then the smaller circle again, and so back to the point. And then he must unite all these observations by thinking. And so, to address what Craig Adcock has said, I would come to the conclusion that the fourth dimension in Duchamp's speculation isn't a geometrical method, as, for example, linear perspective was a geometrical method for Leonardo. My opinion is that, first, the fourth dimension is nothing but a novel description, in geometrical terms, of the process of imagination; and second, that the experience of this higher dimension, which entails going beyond the retinal image and imagining something which can't be seen, can only be achieved by a mental effort and not at all by a sensory experience like gravity.

JEAN SUQUET (F)

You might not agree with me, but I agree with you. I said that gravity gives the *idea* of the superior dimension. You're right, we can only imagine the fourth dimension, just like the flat beings who in experiencing gravity feel and ponder over the verticality which escapes them.

HERBERT MOLDERINGS (F)

I don't believe that a flat being has a sensation of gravity. I've never heard this said.

JEAN SUQUET (F)

I believe it. In any case, it seems to me that it's so in Abbott's *Flatland*.

HERBERT MOLDERINGS (F)

I have problems imagining that a two-dimensional being has a sensation of gravity.

JEAN SUQUET (F)

I understand that there's a problem imagining this, but we are after all in

science fiction here. Beware though, I'm being extremely prudent, not having my apparatus of footnotes and relying only on my memory. In any case, it's certain that in Duchamp's note on the fourth dimension he talks about giving an idea of it. So I agree with you.

CRAIG ADCOCK

To answer Herbert Molderings's question about Duchamp's geometrical method . . . Actually I agree that his purposes are exactly as you say, to transport matters away from the retinal into an imaginary world that can only be dealt with in terms of the mind. That's quite right. And I think I mean something like that by his "geometrical method." I'm talking about his use of everything from topological transforms in the *Three Standard Stoppages* to his intermixing of various geometries—not just four-dimensional geometry but other geometries too which he was clearly aware of. And also, he is pretty freewheeling in the things that he does, so it's not unreasonable to imagine that Duchamp may have done something like conflate gravity with these other systems. He defines four-dimensional lines as nested spheres; he defines a pseudo-sphere as a spherical projection toward a center—things that aren't really defined that way in geometry. So, he makes up his own rules. I don't think he is particularly concerned with the geometrical method in terms of, say, just using projective geometry for his perspective drawings, although he does that too. He goes beyond this method, which is only one aspect of his chosen geometries.

ERIC CAMERON

I would just like to ask a factual question about the dates of the various documents you quoted relating to the fourth dimension, by Duchamp, and how many of them overlap the period of construction of *Etant donnés*.

CRAIG ADCOCK

I think the earliest dated ones are about 1915 or so, and I presume that a lot of the ones dealing with seeing must have been done around the time he was working on the *Oculist Witnesses*, so: 1918 to 1920.

ERIC CAMERON

So, how many of those references to the fourth dimension or to *n*-dimen-

sional space come closer than that to the production of *Etant donnés*, beginning in '46 wasn't it?

CRAIG ADCOCK

The *"inframince"* notes go back to the thirties, so those ideas were on his mind in the decade before he began work on *Etant donnés*.

ERIC CAMERON

My sense is, from the late interviews, that whenever he speaks of the fourth dimension he speaks of it as a speculation that was very much in the past for him.

CRAIG ADCOCK

There are a lot of strange things in those late interviews. Duchamp was keeping things secret, I think. He wasn't talking about *Etant donnés* or the fact that he was incorporating geometrical metaphors into its construction. But, you know, in a certain sense you're right. I mean, he does say, "I was not a mathematician at all, I knew virtually nothing" (which wasn't true; he did know quite a lot). When he makes reference to mathematicians, he says he was reading Riemann and Lobatchevski, mathematicians whose difficulty probably precludes his having actually read them but probably not his having read about them in sources like Poincaré.

ANDRÉ GERVAIS (F)

Duchamp wrote responses to about a hundred questions from Serge Stauffer in 1961. Stauffer asked him something like this: "Robert Lebel, whose book I'm in the process of translating into German, writes that sex is the fourth dimension and you have affirmed it. Is it really you who said that or is it Lebel extrapolating on your declarations?" Duchamp responded with the same thing as he would with Schwarz a little later: "Sex is sex. Sex is not four-dimensional." But here he begins to explain himself—and that becomes particularly interesting precisely due to the crude and realistic nature of *Etant donnés*—and by a certain number of language nuances he works the thing to his total advantage by maintaining that sex and the fourth dimension are two different things![1]

CRAIG ADCOCK

Those kinds of statements are part of Duchamp's system of contradiction,

where at one moment he will say that sex is four-dimensional and then in another interview say that it is not. But he clearly entails sexual kinds of situations in his four-dimensional operations. If my hypothesis is correct, that there's an *n*-dimensional geometrical aspect to his translation of the *Large Glass* into *Etant donnés*, there alone he's got some kind of sexual metaphor working. There are many other instances: the way he rotates the *Fountain* that we were talking about earlier, or the *Mirrorical Return*. The urinal can very easily be used as a rotational object and stand as an example of an inside-outside transformation. If you rotate something through the fourth dimension, it's like putting it up against the surface of a mirror. The object is mirror-reversed. If you try to rotate something around a line, you can rotate it. But if you try to do a comparable four-dimensional rotation, you have to have a stationary plane in place of the line and then rotate the three-dimensional object around the plane while keeping everything perpendicular. And, of course, you can't do this operation in normal 3-D space. You have to rotate the object through the fourth dimension, and you can't really imagine how you would do that. But if you could do it, the object would be turned inside-out. The analogy that geometers always use involves gloves. If you rotate a glove through the fourth dimension, a right glove is changed into a left glove. There's an H. G. Wells story, "The Plattner Story," in which Mr. Plattner is accidentally translated into the fourth dimension and comes back mirror-reversed. After he returns, he is left-handed, his heart is on the right side of his body, etc. I think that some of Duchamp's works can be interpreted along these lines, and there are many clues in Duchamp's notes that he was thinking about these kinds of geometrical transformations. But, you know, they are three or four steps removed from what's actually possible in the real world.

MOLLY NESBIT

I have a quick practical question. I suspect I'm not the only one who wants to ask it. And I don't mean to be impertinent because I've learned a lot from your book, and I think we're all grateful to you for working on the fourth dimension for us. But do you think you need to know about the fourth dimension in order to get the *Etant donnés*?

CRAIG ADCOCK

No, probably not, because most of the transgressive system that I per-

ceive the work to be—its being another thumbing of Duchamp's nose at the public there at the end of his life—can be understood without the geometry. In other words, the main points of the *Etant donnés* don't require the fourth dimension at all.

MOLLY NESBIT

And we really don't need to know about the tradition or the history of the nude to get the point about the *Etant donnés* either, do we?

CRAIG ADCOCK

In his work? You mean the tradition of the nude in Duchamp's work?

MOLLY NESBIT

No, no. I mean the nineteenth-century one.

CRAIG ADCOCK

Oh, no. The reference to nudes like Lefebvre's is just an odd thing that he must have had in the back of his mind, those kinds of images, everything from the Statue of Liberty on down.

MOLLY NESBIT

Tell me more about Francis's "pink" zone—can we not talk more directly about it when dealing with Duchamp's work? It seems to be missing from your reading.

CRAIG ADCOCK

It's missing from my reading, yes. Well, I figured it had been talked about enough, I didn't really have anything to add beyond what has already been said on the subject. Some of the things that Camfield was saying vis-à-vis the *Fountain* would hold in this context. If you want to take the pink zone in *Etant donnés* as a late manifestation of Rrose Sélavy, I think you would be in the ballpark of what Duchamp was getting at. There are all kinds of male-female involutions involved in the last piece.

FRANCIS NAUMANN

I've always been mystified by the fact that in its installation at the Philadelphia Museum, you are forced to enter into a cubical space before seeing the work itself. It bothered me because I was conditioned to seeing works of art in museums against a wall, and they could very well

have installed the door of *Etant donnés* against the surface of a wall. As you said, it's like being inside a slide and looking out. Thus, my impression of looking at this work is to have seen it from the inside out. Do you know if it was Duchamp's idea to have us placed into a cube?

CRAIG ADCOCK

I tried to find out. That's a very good question to which I wish I knew the answer because that was what I thought of, too: that he had intentionally made people make a ninety-degree turn, which is a very four-dimensional operation.[2] One of the drawings that I had on the screen (fig 8.9) is a *perspective cavalière*, and that's both a chess-related term and an *n*-dimensional perspective system. If you noticed down at the bottom of the diagram, there were the normal three axes of a Cartesian coordinate system with an added dotted line meant to indicate a fourth perpendicular direction. In a *perspective cavalière*, this direction, like a knight or a *cavalier* on a chessboard, takes a ninety-degree turn in the perspective system in order to get at the fourth dimension. So I thought, "Well, a ninety-degree turn in *Etant donnés* would be nice." But I tried to find out, and nobody at the museum seemed to know if that antechamber was part of Duchamp's original conception or not. So, I don't know. But I agree with you. *Etant donnés* has no exterior. It only has an interior, from which you look into another interior.

ERIC CAMERON

I wanted to introduce the fact that in the development of the notion of the fourth dimension—well through the nineteenth century—in many respects it had to do with mystical, spiritualist, theosophical notions. As I come to the late statements of Duchamp that are not specifically about the fourth dimension—what he says in the James Johnson Sweeney interview about art being "an outlet toward regions which are not ruled by time and space," for example, and also, from "The Creative Act": "To all appearances, the artist acts like a mediumistic being who, from the labyrinth beyond time and space, seeks his way out to a clearing"—I wonder how far that is the old prophetic view of the artist claiming a higher view of the order of things.[3]

CRAIG ADCOCK

Well, of course, the implication that you have got that kind of realm on

your hands when you are dealing with the fourth dimension was picked up by many of its mystical interpreters, Gaston de Pawlowski for example. I mean, this fourth dimension is essentially the realm of the Platonic ideal. It's a very mystical something, and many popularizers of the fourth dimension take that tack. And that's my reason for assuming that these people were probably not Duchamp's sources. Mysticism doesn't strike me as something Duchamp was really involved with, but I may be wrong. Many people see Duchamp in precisely such terms. But to me, that he could be speaking of "regions which are not ruled by time and space" is okay because the fourth dimension is essentially beyond our time and space. There's nothing wrong with Duchamp's seeking suprasensible realms—that would not necessarily align him with these other mystical traditions at all.

THIERRY DE DUVE

We have talked about the fourth dimension, its mythology, its mathematics, etc., and whether it's the source for Duchamp or not. We haven't talked about your idea of twisting memory yet. I think that was the most intriguing and interesting part of your presentation. I made a comment yesterday about "subsidized symmetries," "mirrorical return," etc., and you have elaborated on that too. So I'd like to ask you what is at stake, now, in terms of an historical rereading of Duchamp's work, when you say that he brings us back to Gérôme, etc., and on the other hand, when you say that he anticipates and validates a number of postmodern strategies of today, turns his own work into a pastiche, etc.

CRAIG ADCOCK

I was just trying to get at the idea that I perceive the last piece to be a precursor to certain kinds of contemporary work. It's a work that is very contrary, very difficult and noninterpretable (or interpretable in so many different directions that it contains within itself its own contradiction). That kind of strategy seems to me to echo many approaches that I see being taken at the present moment. The business of going back to Gérôme—that was just a minor aside. I do think that Duchamp did *Etant donnés* at a moment when it was exactly the opposite thing you should have done. I just wanted to reinforce the idea that the nude in *Etant donnés* is a contrary and a contradictory work of art.

ROSALIND KRAUSS

I'd like to continue the direction of Thierry's questions. First of all, I'd be curious to know which work you have in mind when you say *Etant donnés* seems to anticipate current work.

CRAIG ADCOCK

I haven't really pursued the idea in those terms. I'm sure I can think of a few if you'll give me a half a second.

ROSALIND KRAUSS

Second, as I understand the notion of "pastiche," it involves lifting bits out of the past and entering them into a work in the present. Often pastiches have the problem that eclecticism has, which is to say, that they become stylistically incoherent because bits from different styles start to get collaged together. Now, if we're going to take seriously your saying that *Etant donnés* is a pastichelike reworking of the *Large Glass*, it seems to me that there has to be a visual connection between the elements that occur in the *Large Glass* and the form in which they reappear in *Etant donnés*. And if you're talking about pastiche in terms of its echoing past art—and I assume that's why you showed us the Gérôme and other academic examples—I find that not terribly convincing because *Etant donnés* is a diorama, which is to say, it's a form of experience that really wasn't admitted into the traditional aesthetic realm. It was what was repressed in the nineteenth century. Insofar as it is dioramalike, it's a kind of return of the repressed that isn't operating at the level of pastiche so much as at the level of a transgressive form of realism.

CRAIG ADCOCK

Before we get too far, that's not what I said. What I said was that the last piece is an element in an n-dimensional pastiche, which is a very different thing. It's an element in his whole pastiche. It's one odd-looking work. The *Large Glass* is another odd-looking work. The readymades . . .

ROSALIND KRAUSS

So everything he is doing is pastiche?

CRAIG ADCOCK

I think his oeuvre has a pastiche quality to it, yes.

THIERRY DE DUVE

You obviously don't mean the same thing as Rosalind when you use the word "pastiche." Well, do you accept her definition?

CRAIG ADCOCK

That's certainly not too far off. And getting back to the other point about *Etant donnés* having fractured fields that don't really mesh stylistically, certainly that seems to be what Duchamp was doing. That's the problem Jean Suquet has with the last piece, isn't it? The last piece doesn't seem to be a coherent part of what we thought of as Duchamp's oeuvre before that moment. That was one of the reasons he did it. And that seems like a pastiche strategy to me. Someone like Ross Bleckner, I think, would be a contemporary artist who presents work that's very difficult to know exactly what to do with; it contains its own contradiction. The same with Philip Taaffe.

THIERRY DE DUVE

Do you see the work of Ross Bleckner or Philip Taaffe as validated by *Etant donnés?*

CRAIG ADCOCK

No, no.

THIERRY DE DUVE

Because the word "validated" was in your talk, and that struck me. You said *Etant donnés* anticipates and validates some postmodern work. I don't know, I'm just trying to understand what you mean.

CRAIG ADCOCK

I wouldn't mind editing out the "validate." I see what you mean. I don't know that I'd want to go that far. In fact I know I don't want to go quite that far.[4] But *Etant donnés* seems to be a work that anticipates that kind of approach. Duchamp was one of the first to use it, and the reasons he used it are the same reasons these contemporary artists are using it, I presume. They are similar, at least. Duchamp was emerging into the same period that produced postmodernism.

HERBERT MOLDERINGS

Between 1947 and '54, Duchamp was very busy making things for the

sense of touch, from *Prière de toucher* to all these strange tactile objects, *Objet d'art* and *Coin de chasteté*, for example. And in the *White Box* he arrived at the conclusion that a higher dimensional perception is a "hypo-hyper circum . . . ," how do you say it?

CRAIG ADCOCK

He said, "hyper-hypo circumscription" . . .

HERBERT MOLDERINGS

. . . Like . . .

CRAIG ADCOCK

. . . Grasping a pocket knife . . .

HERBERT MOLDERINGS

. . . Yes, like a penknife.[5] You don't see it, but you hold the knife in your hand. It's like the object in *A bruit secret* [*With Hidden Noise*]. What to me is an enigma is how these tactile objects might be part of the construction of *Etant donnés*, which starts in 1946 too, because I feel that in the end he fell back into voyeurism again. The last piece doesn't rely on the sense of touch at all, as in *Prière de toucher* . . .

CRAIG ADCOCK

Well, in all his notes on the visual he has this notion of the tactile reconstruction of the four-dimensional figure, and it goes right back to notions he derived from Poincaré, that is, that the act of seeing is accompanied by certain muscular sensations. I'm sure that Poincaré's ideas were among his main sources because the parallels are so close. The visual-tactile objects that you're talking about have to do with casting. You know, it's the idea of a two-dimensional cast generating something three-dimensional.

HERBERT MOLDERINGS

Yes, he had the visual-tactile analogy, but we, as viewers, don't. We can only see. The touchable object in *Etant donnés* is at a distance from us; there is a wall, there is a dark room in front of it. And what is three-dimensional comes to us like an image on our retina. I don't understand his development in this period, and I'd like to ask whether you have some ideas about this.

CRAIG ADCOCK

Only insofar as those cast objects seem to be directly in line with the translation of the two-dimensional *Glass* into the three-dimensional last piece. If you're asking why Duchamp didn't go ahead and make a "feelie," or something, I think he was clearly smart enough to know that that kind of art wouldn't be very interesting. There is no such thing as tactile art.

HERBERT MOLDERINGS

We had that in the sixties.

CRAIG ADCOCK

But I don't think successfully.

JAKE ALLERDICE

I would just like to make one observation. Your discussion of the fourth dimension strikes me as being a lot like a group of theologians trying to talk about Heaven or God. Had you, or any of us, ever experienced the fourth dimension, not only would you not remember it but you wouldn't recognize it. Of course, there is no way of knowing. And yet, there is this sort of exquisite faith in the existence of the fourth dimension which allows you, and allows Duchamp, to carry on in their work. As I'm sitting here listening to this, I can't help thinking that perhaps $n + 1$ is to our age what God and Heaven were to the Renaissance.

ERIC CAMERON

Perhaps the parallel fits. If the fourth dimension was for Duchamp a way of saying that art was "an outlet toward regions which are not ruled by time and space," then we have a similar-sounding terminology in the concept of eternity and the notion of the way St. Augustine defines eternity as being that God exists in a province outside time. And because of existing outside time, God is able to be omniscient and to perceive the action of cause and effect throughout the universe.

CRAIG ADCOCK

I don't think that Duchamp for a moment thought the fourth dimension really existed. It was a metaphor for discussing something that you couldn't see. He certainly wouldn't have compared it with any concepts like God and other metaphysical things. The fourth dimension is mathe-

matically completely straightforward. It does exist mathematically. For any *n*-dimensional object, you just have to have *n* real-valued parameters continuously determining the points of your configuration. What gets to be a problem is trying to visualize the stuff, like the diagrams in Jouffret's books, those kinds of reconstructions which are just evocative. And I think they must have been so for Duchamp too. It was that aspect of the game that was of interest to him. The reason I talk about it is because Duchamp did. A large chunk of his notes takes a straightforward approach to these things, and I'm curious why in the world he would have done that. That's my interest in it.

JEAN SUQUET (F)

I would like to respond to this young man who rightly accuses us of taking pleasure in Byzantine discussions, as Byzantine discussions all the same had an enigma to resolve: what was the sex of angels? With Duchamp it's a little bit of the same thing: if he paid such attention to the fourth dimension, even if he "believed" in it during the years 1911–13, perhaps it's because this unknowable dimension allowed him to evade the prohibition that Freud illuminated at that time with another analysis. Duchamp exiled the Bride to the fourth dimension. *Noli me tangere*. The fourth dimension allowed Duchamp to cast this untouchable Bride whose bachelor he wanted to be from our world into an inaccessible realm. If the fourth dimension is treated only as a mathematical question, if one forgets to color it with the sentiments at the heart of Duchamp's endeavor, then it becomes a Byzantine speculation indeed. But if sex is involved, if not an angel's at least a Bride's, a little flesh is returned to the skeleton of the *cosa mentale*.

1 In a letter dated May 10, 1961, where he cited Robert Lebel as saying that Duchamp thought that "the erotic act is the essential four-dimensional situation," Serge Stauffer asked Duchamp whether Lebel might have quoted him verbatim. Here is Duchamp's reply, dated May 28, 1961: "Without using those words, this is an old idea of mine, a pet idea explained by the fact that a tactile sensation wrapping all the sides of an object *approximates* a four-dimensional tactile sensation—for of course none of our senses has a four-dimensional application except perhaps the sense of touch; thus the love act, as tactile sublimation, might give a tiny glimpse, or rather a tiny touch, of a *physical* interpretation of the fourth dimension." [". . . et par conséquent l'acte d'amour comme sublimation tactile pourrait faire entrevoir ou plutôt entretoucher une interprétation *physique* de la 4me dimension."] Marcel Duchamp, *Die Schriften,* trans. and ed. Serge Stauffer (Zurich: Regenbogen-Verlag, 1981), 265–266. As to Duchamp's reply to Schwarz, its exact phrasing is: "Sex is only an attribute, which can be transformed into a fourth dimension, but it is not the definition or the status of the fourth dimension. Sex is sex." Arturo Schwarz, *The Complete Works of Marcel Duchamp,* 36, note 4.

2 When entering the room in the Philadelphia Museum of Art where *Etant donnés* is installed, the visitor has to turn left to approach the door, which is the only work of art in the room, and even so, hardly identifiable as such.

3 *Salt Seller,* 137 and 138.

4 Accordingly, Craig Adcock has edited out the "validate" from his talk. See his contribution, note 27.

5 The expression "hyper-hypo circumscription" is not in Duchamp's notes as such. In a note from the *White Box,* he actually says: "l'objet[3] est *à l'embrasse circhyperhypovu* (comme *pris avec la main* et non pas vu avec les *yeux*)" (*Duchamp du signe,* 126), which has been translated as: "the object[3] is seen *circumhyperhypo-embraced* (as if *grasped with the hand* and not seen with the eyes)." (*Salt Seller,* 89.) The analogy with "a penknife clasped in one's fist" is made in two other notes (*Salt Seller,* 93).

la chute d'eau

le gaz d'éclairage

Progrès (amélioration)

Moules _____ métliques.

Progrès (amélioration) (allégorique)

les 24 donc furent chargés

à se déguiser en 24 aiguilles

qu'elles deviendront en se réunissant

un siphon, un brouillard

mentionner la qualité de nourriture à

Emploi du mica

les étamines

The Language of Industry

Line lay, somewhat oddly, behind all the activity in Duchamp's *Large Glass*. His first drawings (fig. 9.1) drafted the principals into ur-lines, orthogonals, ellipses, and loose spirals, perhaps platonic skeletons; whatever, the line itself was identifiable. It was geometrical; as such, steady and knowable, capable of being plotted into quadrants and measured to scale.[1] At least that was how the line began. Then it sped off. It indulged itself in complex gyrations, flipped between dimensions, combined to make machine parts and then an apparatus, one for some bachelors, one for a bride. The parts spun, like motors, with desire; the bride was stripped bare, unfolded; she bloomed. The end. No recognizable body had fallen into view. All by itself the geometry had touched off a sexual plot.

Duchamp could not leave this progression from geometry to desire like this and he did not. He took some care to provide it with a text—a long full title, *La Mariée mise à nu par ses célibataires, même*, and a battery of notes. The unseen body would at least be written in. Even with added detail though the plot was thin, offering precious little romance and no particular end, not even a kiss, only a stalemate, a splashing breeze, a surfeit of desire, several digressions on the fourth dimension, and that famous last indifferent *même*. Withal, Duchamp claimed, hilarity would ensue.[2] Laughter would make quite a difference. It would smooth over the strangeness in the linear desire, it would make light of the technical passages, and it would distinguish the picture from the usual easel painting, which was not and is not normally intended to be funny.

In some ways the *Glass* followed from Duchamp's early work in cartoons, a highly conventional genre based on flagrant incongruity, structural oddness, and broad comedic slips between the name of the cartoon, its caption, and its image. Generally the joke was made at the expense of bourgeois sexuality. But Duchamp called the *Glass* a painting, a *peinture de précision*, which is painting and not painting, a nameless alternative of his own devising that was supposed to support the logic that started with line and ended, laughing, with desire.[3] The precision in Duchamp's idea of painting will concern us in due course, not yet. It would be precipitous to jump too quickly ahead; besides, jumping to precision means glossing over vulgarity

9.1
La Mariée mise à nu par ses célibataires, même [*The Bride Stripped Bare by Her Bachelors, Even*], 1913. Pencil on tracing cloth, 12⅛ × 10 in. (Collection Jacqueline Monnier, Paris.)

and the vulgarity is the best part, the *"vulgarité indispensable,"* Duchamp called it in 1913, saying as well that it was neither poetic nor technical, nor (heaven forbid) picturesque.[4]

First things first. Line in its manifold vulgarity is at once tied to the body and different from it, at once sexually attached and very precisely Other. The road from line to desire was paved with historically determined and unimpeachable contradictions. Duchamp's progression is repeating another just as riven, in fact it is part of a series of cycles, banal cycles that managed not to echo but to bend and catch and swell. This vulgarity will not be crude, nor will it display its contradictions openly. It will appear to be progress.

Duchamp had been taught his lines. In the late 1870s and the early 1880s, when the Ferry reforms of the national school system were being made and a curriculum that was free of charge, secular, and compulsory for all children was set into place as the cornerstone of the new Third Republic, programs for drawing instruction in the French public schools were elaborated. Drawing proved to be controversial, and in the course of the debate around it, line and body were pitted against each other as if they were savagely opposite poles. The question before the government was which one, line or body, would provide the classroom model and then the controlling image for French public culture, which would be the formative one, which would be imitated until it became second nature, like reading and writing, and forever after done automatically, like breathing or speaking. Each had a clear set of references and recommendations. The body was understood to be nothing less than the body as it had been rendered by the old masters of high culture, the classical sculptors and the men of the Italian Renaissance. Line was geometric line, which carried with it a wholly different tradition, the functional, technical culture of machine production. The debate between the defenders of body and the advocates of line was long and passionate, too long to outline here. Suffice it to say that geometric line won out. It was taught as part of a visual language, what was called at the time the language (*langue*) of industry.[5] It was a language of forms designed for modern life, a language that lay at the beginning of the common modern picture, and a language that carved the opposition between line and body deep into the common sense of the image. Line was to lead France straight to the commodity.

APPLICATION

Porte

9.2
V. Darchez, *Nouveaux exercices de dessin à main levée d'après les derniers programmes officiels. Cours élémentaire* (Paris: Belin, 1883), 4e cahier, application, porte.

For the next thirty years, geometric drawing was taught as the objective root of all representation and the body was put away. The programs for drawing instruction, elaborated by the sculptor and director of the Beaux-Arts, Eugène Guillaume, and set out in the decree of January 25, 1881, gave geometry a specific progression. In the elementary course (to be used with students aged 6 to 9 years) one began with the straight line, the first principle; one learned that all things could be reduced to their essential, geometrically grounded lines; inversely and tautologically one was taught that these lines were the building blocks with which all things were to be drawn. And so classroom instruction started with the straight line and then elaborated upon it. The line was divided into equal parts, the relations between a group of straight lines were scrutinized, angles were constructed and from them simple figures like doors (fig. 9.2). From there one went on to the first principles of ornament, learned how to make a regular polygon and a circle and how to make stars. The programs were not illustrated and they did not always specify models, but the manuals produced by enterprising teachers and textbook companies soon settled into a more or less standard set of their own, giving the culture of line an alphabet. Knowledge,

APPLICATION

Roue de voiture

La roue est composée d'une partie centrale appelée moyeu, réunie par des rais ou rayons à une partie circulaire qui est formée de pièces de bois nommées jantes et qui est recouverte d'une bande en fer.

9.3
V. Darchez, *Nouveaux exercices de dessin à main levée d'après les derniers programmes officiels. Cours élémentaire* (Paris: Belin, 1883), 6e cahier, roue de voiture.

like the image, was built up in consecutive layers that would reenact the progress made by modernity. The middle and advanced steps of the program unveiled the direction progress would be taking.

In the middle course (for ages 9 to 12) one studied what were called ordinary curves, ellipses, and spirals (fig. 9.3). One looked at the curves borrowed from nature, stems, leaves, and flowers; though what this really meant was that the curves had to be extracted from the model before they could be given to the student; at most the student saw these curves after they had been translated into printed models. One studied low relief sculptures showing patterned friezes. One was given the first notions of mechanical drawing and perspective. Then one moved into three-dimensional figures, first geometric solids, then simple objects of everyday life, all of which were drawn in cross section and elevation and then drawn again in perspective. The conventions of shadowing were taught. The techniques of drawing using ruler, compass, protractor, and T-square were introduced; up until then all drawing had been done by the unaided hand, *"à main levée."*

In the advanced course (from 12 to 14 years) one learned a purely geometric repertoire of ornament, which was developed into moldings, egg and dart, pearls, denticules, etc. Palmettes were a favorite. The basic notions of the architectural orders were given. Measured mechanical drawing, the *croquis coté*, was done from geometric solids and then from objects of everyday life, the instruments used for wood construction, the tools of stone and metal working, and the most ordinary pieces of furniture. The conventions of wash were taught in order to give the technical description of architectural surfaces, tiles, parquets, windows, paneling, ceilings, but color was only allowed to indicate the material composition of the object (the parts that were stone were greyed, the parts that were wood were tanned) and to color the random map.[6] All of this would have served the building industry's needs very well. Then an intrusion: at the last minute, almost magically, the human head appeared and was drawn. But only the head. Below the neck the body remained in shadow, *acéphale*, invisible, suppressed.

Still more programs were elaborated for those last optional years of schooling in *lycée* or *collège*, where the student was introduced to the drawing of the body, both human and animal, and to the study of landscapes, though these would by and large be studied through the imitation of works of art. Only here, at the end, at the point well beyond the schooling of the average citizen, did the fine art tradition make a timid entrance. The curriculum did not really need it especially, in fact it did not need it much. The programs did not proceed from it, nor from the imitation of nature, nor from the imitation of the ancients: the public culture of the Third Republic was based on mechanical drawing, *sans* color, *sans* nature, *sans* body, *sans* the classics, some would have said *sans* everything. Still, the survivor, the measured mechanical drawing, worked as a visual language in a way that the others could not. It allowed for the communication of specific visual properties of objects and it enabled the worker and the designer, not to mention the consumer, to speak accurately and well to one another by means of indexical signs, numbered pictures. By and large this was a language meant for work, not for leisure, and certainly not for raptures or poetic, high cultural sighs. This language was *preaesthetic*.

Guillaume always argued for the value of his system by claiming that after graduation primary line drawing could be taken to professional ends as

different from one another as art and engineering. Before advancement, however, there was a primary (read working-class) level of linear competence that had to be achieved, there was a single glowing language of industry. The other segments of the population, notably the petit and grander bourgeois, would be educated to their respective classes in the secondary schools, where some drawing after fine art models, as we have seen, did occur. Different relations to line and to the economy would perforce emerge, as would different relations to art. But, Guillaume would have argued, the primary and secondary school programs had been designed in concert, secondary was built from primary, and drawing in all cases began with the concept that line was the basis for one universal language that could serve the entire nation whatever one's class. Yet not everyone could be allowed to advance. What looked cumulative had been cannily designed to ration knowledge. Even in its most mystical form, when it was only a political idea, this language of line promoted neither equality nor unity. The glow was smoky and uneven.

The idea of language did not end with the indexical line. This language was more than a form. It proclaimed itself to be more than formal. Drawing and seeing where to be taught together. The drawing programs were meant to inculcate *precision* seeing, by which was meant an appreciation of the geometrically grounded outlines of the things of this world. (The development of good taste was to be an outgrowth of this precision.) In the culture of line, the line of sight was singled out and ultimately became the most important line of all, far more important than any plumb line or ground line, since it set the horizons of expectation. As it happened, there was more than one horizon.

Along the way the programs had divided drawing into two: geometric, which is to say the more technical, mechanical drawing based on projection, what in French was called the *géométral*, was taught as a separate sequence alongside freehand, to our eyes still fairly geometric, line drawing based on perspective. The child of the Third Republic learned to expect that objects could be rendered in perspective and in projection, in other words, any child knew that there was such a thing as representation, double representation. An explanation was given: the world was in essence linear but its image was multiple, multiplied according to one's point of view. One was the reproduction of the way things appeared to the eye (a per-

spective) (fig. 9.4) and the other a representation of the way "things really were" (a measured mechanical drawing) (fig. 9.5), which took the same object into protosimultaneity. One was supposed to learn to see both kinds of image in a given object, to see surfaces clearly and to see beyond them, beyond the perceptual domain of the eye. This distinction between apparent and true representation, between the retinal and the nonretinal image seemed fundamental to Guillaume and his supporters; they repeated it like a litany over and over again. In the words of Guillaume:

In effect, if we consider drawing in and of itself, we see that its object is to represent things in all their truthfulness or things as they appear. In the first case, it is a matter of giving the figure of the object to scale, respecting its dimensions and giving its measurements. This is the drawing used by architects for their plan, elevations, and cross sections; with this engineers make their trace projections whose lines give the final word in precision, impossible to obtain with subjective drawing. It is, in a word, that which is used by all the crafts and professions in order to direct the labor of the worker. It is, finally, the graphic means by which the master craftsman expresses his ideas, transmits them and renders them intelligible to those who are charged with their execution. This kind of drawing, called plane [géométral] is the writing proper to all the arts and the entire building industry, to all the professions that practice in the world of form. On the other hand, if it is a question of rendering the appearance of things and fixing them as they seem to be in space, perspective intervenes and permits one to secure a representation that is perfectly lifelike, a mathematical truth. If one adds to the preceding that geometry also gives us the laws of tracing cast shadows and that to the domain of form, of which it makes us masters, it adds thus the domain of the effect, one sees that this science contains and constitutes all of drawing.[7]

The distinction between the retinal and the nonretinal did not, in other words, trouble his idea that there was one national language being drawn, one hovering above regional dialects just like the mythical national French. The sixty-four word version of the litany, which Guillaume worked up for a speech in 1882, attached the idea of the unity of drawing to an entire apparatus of law and reason: "Drawing by its very nature is exact, scientific, authoritative. It images with undeniable precision (to which one must submit) things such as they are or things as they appear. Not one of its

9.4
V. Darchez, *Nouveau cours de dessin géométrique à l'usage des élèves de l'enseignement primaire supérieur des écoles normales primaires et de l'enseignement secondaire rédigé conformément aux derniers programmes officiels* (Paris: Belin, 1896), 1ère partie, feuille 45.

9.5
V. Darchez, *Nouveau cours de dessin,* 1ère partie, feuille 46.

configurations could not be analyzed, verified, transmitted, understood, realized. In its geometrical sense, as in perspective, drawing is written and is read; it has the character of a universal language."[8] Explanations like this brought the double image back again and again to a single one. Little matter that the unevenness in the curriculum was being seconded by a doubling of representation and a split line of sight. All difference was circumvented by reducing space to drawing, that is to say, to a universal line.

Mercifully the fine points of language theory were not retailed in the classroom manuals. However, what was syllable, word, and letter of this language was not critical; only the *idea* of language ever counted. It was enough for the idea to stand quietly unchallenged behind the lesson plans and classroom exercises. The idea of language, or better, the desire for language would provide a coherence, legitimation, and universality for what was really just a visual means of industrial production. Line was to be a form that spoke well for reification. It would not and should not be questioned. That, after all, was the thrust of its claim to truth. And so with no great justification, no theoretical ado, teachers and students seized the purest form of language imaginable and mobilized it.

Thanks to them Guillaume's ideas and the curriculum models were caught up in classroom repetition, peculiarly annual, sequential, massive, staggered across the years of youth, and reaching every province of France. A gigantic net had been thrown over the nation's consciousness. Lines were repeated, reinforced, reviewed, woven slowly into a temporary coherence, dispersed, and sunk. The lines acquired their full significance through use. As they began to move, the play of difference in this language widened; the net could tear. The line was strong but not omnipotent, not a grid or a table of representation. Its march toward the commodity was in practice halting, its capabilities unclear.

Second things second. Where and how to see a language when it has ceased to exist as a theoretical object? By drawing lines out of the dense and common ground of historical material, ground where there are always several horizons and uneven glow, ground that does not submit to a single idea of nature. No one case can suffice to show the things said and done

with this language; they will be accumulated to show how such a language piled up and spread. Only then can we return to the question of its strength.

Line emerged slightly worse for wear in the notebook of a student named Jean Baron, born in 1873 and educated in the Ecole spéciale de garçons at Challuy in the Nièvre. The notebook gives his progress for the school year 1886–1887 when he was doing the *cours supérieur,* though the preparation in drawing is still at the level of the *cours moyen.*[9] Jean Baron drew a little knife on Monday, November 15, 1886. "*Trop petit,*" remarked his teacher. "*Bien,*" wrote someone else (fig. 9.6).[10] All through the year, once a week, just as the official instructions specified, Jean Baron made a pen drawing: a measured French window on Saturday November 20, a wine pitcher on Monday December 6, on January 8 a vase, a bookcase on Wednesday January 12, on Saturday December 11 a pruning knife, still "*Mal. trop petit.*" Young Jean was far from a prize student in drawing; he had had to add the measurements to his bookcase and more than once he was admonished to work on his taste and his attitude. And yet, reluctant though he was, he got enough of the point to be conversant: he might have trouble adjusting his proportions but he knew all about inflection: he could make the line tremble or make it small. Ernestine Thomé, born 1872 and attending the École communale du Mériot in the Aube, was the kind of prize student who flaunted her control. In April 1883 she penciled a hatchet blade wide across the entire page, giving it the added regulating rectangle, the sort of geometric trace recommended by the textbook author Armand Cassagne (fig. 9.7). She got a bit farther along in the program, did a good latticed door in June, and a huge, slightly fatuous stoic head in July. One of her notebook pages from 1884 contained a pen and ink frieze of interlocking rings. She lacked a fear of knives. These notebooks show that lines were never abstracted altogether from particular experience. They were understood to represent it.

Not all experience could or would be taught; the teacher is a case in point. This subject, needless to say, was more cultural than natural; it too had been schooled so as to know its place. It had also been examined. Teachers, the *instituteurs* and *institutrices* who were sent respectively to direct the boys' and girls' schools (the Ferry schools separated the girls from the boys in all but the smallest villages), were carefully monitored and trained.[11]

9.6
Jean Baron, cahier journaux, lundi 15 novembre 1886. (Collection of the Musée national de l'éducation, Mont Saint-Aignan.)

Right away the programs in drawing set out in 1881 were accompanied by a stricter set of complementary programs to be used in the teachers' colleges. Teachers were expected to pass a certification examination, the *brevet élémentaire*. The components of the *brevet* were constantly being adjusted by the government, even after the founding decrees of 1884 and 1887, but in all cases the *brevet* examination required proof of competence in drawing.[12] By 1908 there were more than 100,000 certified teachers.[13] The *brevet* program condensed and rearticulated the primary school stan-

9.7
Ernestine Thomé, cahier, 29 avril 1883.
(Collection of the Musée national de
l'éducation, Mont Saint-Aignan.)

dards for drawing, but it also clarified them: as it separated the two drawings, it distinguished male and female parts. The teachers were to understand right away that the unity of the language was premised upon a knowing silence and upon a duality that turned back to the unseen body.

At the *brevet* level, the two kinds of drawing were not taught in equal measure to each sex. The *brevet* program gave males their training in perspective but it went on to give them a better lesson and further drilling in mechanical drawing and it asked for tutoring in the technique of ren-

9.8
V. Darchez, *Nouveaux exercices de dessin à main levée. Cours supérieur et cours complémentaire suivi d'un complément spécialement destiné aux aspirants et aux aspirantes au brevet de capacité* (Paris: Belin, 1888), pl. XVIII.

Complément · OUTILS Planche N.° XLVIII

Une pioche, une pelle, un râteau, une bêche, sont appliqués contre un mur oblique au tableau. — On voit, au bas de la feuille, la trace du mur sur le sol. — Le plan de l'horizon est au niveau du tranchant de la bêche. — Remarquer que les dents du râteau ont leur point de fuite à gauche, dans le bas de la feuille.

9.9
V. Darchez, *Nouveaux exercices de dessin à main levée. Cours supérieur et cours complémentaire suivi d'un complément spécialement destiné aux aspirants et aux aspirantes au brevet de capacité* (Paris: Belin, 1888), pl. XLVIII.

dering to scale things like building parts and the organs of machines (its phrase). Female teachers could content themselves with perspective drawing and then turn to designing for embroidery, lace, and tapestry; they needed only to master enough projection to make and measure a sewing pattern. The split in the program followed the split in the two kinds of representation, with the result that a hierarchy of drawing was established according to gender. The man had to master the drawing of things as they were, the nonretinal mechanical drawing; he had to learn to see these lines in objects, seeing through the object to its plan; he saw what passed in those days for truth. The woman had to work further on her perspective, on seeing things as they appeared; she had to learn how to apply what she saw to cloth. He mastered both perspective and projection, however, while she mastered only enough projection to know what it was she was missing. Projection was principally a male space. Perspective was common ground.

In the language of industry the image of the body, be it draped or clothed or fig-leaved or nude, could not be the engine of gender in the picture. Gender was placed in the eye of the beholder, who would return it to the image through the identification of the privileged mode, the revealing flat projection. According to this line of reasoning, gender was told by the ability to see beyond appearances, beyond perspective too, into the bodiless, abstract space of industrial production; it was told by the declaration of a specifically masculine space and by a split in the look. Gender was defined through the masculine. Femininity had no space or look of its own, it was identified by its limitation to perspective *tout court*. Eyes in the classroom were divided and conquered, socialized to follow from the lines.[14] Some eyes would penetrate, others would settle. The language of industry was variable and dependent, alternately hostile and hospitable, open and closed.

Ris-Paquot told his female readers that they could stop after plate 19 of his manual for the *brevet*, stop after the culmination of the lesson on the cube in two and three dimensions. His male readers continued on to master the differences between the flat projection and the perspective drawing, which he demonstrated for them on the coffee grinder (fig. 9.10). The gendering of these lines was typically done like this—without much fuss, and without much concern that a significant if invisible body had crept into

the line. The separation was considered so obvious, so natural, that this body was neither justified nor discussed, not even at the congress on drawing held in 1908 at the Musée pédagogique, which examined virtually every other element in the program but this.[15] The most that was said there was that the exam subjects asked on the drawing question of the *brevet* needed to be varied a bit: Mlle Rehm, a teacher at the Ecoles communales de la rue de Tolbiac (Paris 13ᵉ), complained about the lack of variation in the *brevet* objects of everyday life; one prepared always the same thing, she remarked, "*des pots, des arrosoirs, et l'année suivante on recommence.*"[16] Her complaint could have triggered a discussion of the bodily differences in the programs. For one did not prepare the same objects if one were a woman as one did if one were a man.[17]

The ministerial order of 1887 set out the subjects to be examined on the *brevet*, including for the drawing question a list of neutral objects and gender-specific ones. Every candidate had to be ready to draw the first fifteen objects on the list:

1 Stool (for sitting) made of wood
2 Stepstool
3 Stepladder
4 Pail (in wood or zinc)
5 Tub (in wood or zinc)
6 Flowerpot
7 Music stand
8 Barrel
9 Bushel (double decaliter)
10 Wooden chest
11 Guéridon (simple)
12 Small square table
13 Trestle
14 Sawhorse
15 Mason's trough

Then the labor of studying was divvied up. The male candidate (*aspirant*) took column A; and the female candidate (*aspirante*) was diverted to column B:

Aspirants:

16 Small bench (in wood)
17 Footstool
18 Table drawer

19 Saltbox or spice box
20 Abacus (school model)
21 Copy-press table (without the drawer)
22 Basket for wood
23 Saddle rack (in wood)
24 A double liter in metal
25 Cast-iron weight of at least 5 kg.

Aspirantes:

16 Lamp and lampshade
17 Basket (choose a fairly big one)
18 Umbrella (open and placed on a table)
19 Stewpot (large size)
20 Frying pan
21 Garden rake

22 Shovel
23 Pick
24 Spade
25 Watering can

26 Saucepan (metal)
27 Pitcher
28 Jug
29 Cookstove
30 Sieve
31 Chair[18]

When Darchez put together his manual for use by candidates, he responded to their different situations by producing two sets of sample problems, one for men and one for women.[19] Gender became graphic. The man did the *croquis coté*; the woman did the imitation drawing. When the man saw the kitchen table, it was made to look like an arrangement of numbered unfolding squares; when the woman looked, the table came back with its feet on the ground. The man's eye dissected the saltbox (fig. 9.8). The woman's merely registered the tools (fig. 9.9). These separations were meant to be silently passed on to the students.

The great cycles of repetition in which teachers and students participated spun differently: eyes, lines, and bodies combined according to prescribed procedures and possibilities. Jean's little knife and lopsided bookcase were not absolutely comparable to Ernestine's hatchet and lattice door. Their horizons were being separated; even the object of everyday life would not look quite the same to each.

It therefore amazes us that well-meaning critics explain the remarkable difference between the forms attributed to nature and those of modern painting, by a desire to represent things not as they appear, but as they are. And how are they? According to them, the object possesses an absolute form, an essential form, and, in order to uncover it, we should suppress chiaroscuro and traditional perspective. What naïveté! An object has not one absolute form, it has several; it has as many as there are planes in the domain of meaning. The one which these writers point to is miraculously adapted to geometric form. Geometry is a science, painting is an art. The geometer measures, the painter savors. The absolute of the one is necessarily the relative of the other; if logic is alarmed at this, so much the worse! Will it ever prevent a wine from being different in the retort of the chemist and in the glass of the drinker?[20]

The voices are familiar but the words marshaled in support of ever more modern positions: Gleizes and Metzinger were writing on Cubism. By then other cycles of repetition had entered in to thicken the original idea of a language of industry, but those artists pointing to the virtues of abstract line had hardly discovered it; it might be more accurate to say that they could hardly avoid it. Geometric abstraction, the form fundamental to our definition of twentieth-century modernism, carried within itself the basic, industrial and masculine view of culture of the republican school; it was supported by the base and superstructure of common sense; it was founded upon a split in the look that did not require special theorizing in order to be known, though it might be renamed so as to appear aesthetic. The drive toward abstraction was, among many other things, a drive toward an immanent industrial masculinity. For the breakthrough of abstraction occurred at the point where the sexes were separated, at the break in the surface of appearance. The drive saw no difference, except that of painting, which would now occupy the place of the ordinary projection, claiming the new site of truth for its own, besotted with horizon wine.[21]

Another voice is heard. "Problem: trace a straight line on 'Rodin's the kiss' as seen from a view-finder."[22] It belongs to Duchamp and it is later, 1918. His line's progress was not so aesthetic and yet not trained either, *comme il a fallu*, on the commodity.

340^{bis}

341

342

343

R. P.

344

345

Ligne d'Horizon

P

G

H

F

Elévation

D

E

A

B Ligne de Base

Carré
mis en
Perspective

Plan Géométral

346

9.10
Ris-Paquot, *Enseignement primaire. Dessin d'imitation. Cours préparatoire aux examens pour les brevets de capacité de l'enseignement primaire* (Paris: Laurens, 1887), pl. 21.

9.11
Moulin à café [*Coffee Grinder*], 1911. Oil on cardboard, 13 × 4¹⁵⁄₁₆ in. (The Tate Gallery, London.)

9.12
In Advance of the Broken Arm, ready-made, 1915 (lost). 1945 replica bought for Katherine Dreier, 47¾ × 18 in. (Yale University Art Gallery, New Haven; gift of Katherine S. Dreier for the Collection Société Anonyme.)

The line Duchamp proposed to draw through the kiss was no ordinary line and yet it was so innately ordinary, merely masculine. Next to such a line, "Rodin's the kiss" seems strangely redundant, overstated and archaic. Duchamp's lines began and ended in common culture. They were first sketched in 1911 in his painting of the coffee grinder (fig. 9.11), that loophole onto something else he would say later. Like the signs of the language of industry, they did not try to rise to the level of symbol, for they did not harbor any single meaning; rather they made a rat's nest of referents, assumptions, and dim memory traces.

Duchamp did not refer to the language of industry exactly or self-consciously, he simply used it logically enough when he decided it would be important to try to make a work that was not a work of art. It gave him a significant form to express the separation of his work from traditional painting, the separation that produced his precision painting. Duchamp began to play with the language of industry on its own terms. The ready-mades took objects, some of them from the *brevet* set, and liberated them from the image, reinstalling the image of the shovel, for example, as a new thing, banal but newly enunciated, and sometimes newly named, *In Advance of the Broken Arm* (fig. 9.12). The readymades were very much part of the project for precision painting, as Thierry de Duve has argued.[23] But the readymades called up not painting but an *image*, the preaesthetic image; they filled the lines in with solid form; they repossessed the model; they made language objects. The line was stopped before it arrived at a manifestly commodity form. The tension between language and commodity was fundamental to Duchamp's concept of the readymade; the tension worked like a philosophical critique of the system in which these things were supposed to run together. Duchamp kept them apart. He kept his schoolboy drawing manual, a manual for the *brevet*, authored by Eugène Forel and titled *Guide pratique de dessin et de perspective à l'usage des instituteurs, des institutrices et spécialement des aspirants et aspirantes aux brevets de capacité* (1897).[24]

Duchamp worked the limits to the authority of this language. The usual signs of the language were there to be seen: not only the *brevet* objects of everyday life but the obsession with projection. The notes for the *Glass* are full of schemes for putting out a projection without recourse to the regular mechanical drawing. Sometimes, as in the *combat de boxe* or in the plan

to make the Wilson/Lincoln effect shimmer between a perspective and a projection image, the mechanical drawing makes an entrance, but Duchamp was more interested in conceiving a better, higher form of projection, as if to reassert the masculinity in the image, pushing the sexual power of the line into ever more spectacular, ever more superior kinds of pictorial form. So we have gunshots, virtuality in a fourth dimension, native colors that give us bachelor chocolate. At some point Duchamp decided that the bride had to live in the fourth dimension, appearing only as a three-dimensional projection of a fourth-dimensional being.[25] There she was accessible only to those with extremely powerful eyes; she, the sexual female awaiting the act, could really only be seen by an extremely male line of sight, the one capable of seeing clear through the objects to the lines to the body, the one that, looking at the bachelors, could capture their "polygone imaginaire du sexe."[26]

Projection, the *géométral*, was the means to the end of the *Large Glass:* it alone could express the eruption of male desire in the lines. This was a scenario fraught with consequences, not to say pitfalls. Somewhat later Jacques Lacan analyzed them, but by setting another such scene. Lacan was teaching a seminar on the gaze; he pointed to the anamorphic death's head tilted across the foreground of Holbein's painting *The Ambassadors*. The *apparition* returned. "Comment ne pas voir ici," Lacan finally asked, and the French here speaks worlds, "immanent à la dimension géomé-trale—dimension partiale dans le champ du regard, dimension qui n'a rien à faire avec la vision comme telle—quelque chose de symbolique de la fonction du manque—de l'apparition du fantôme phallique?"[27] How indeed can one not see, immanent in the projection's dimension—that dimension only partially accessible to the gaze, that dimension that has nothing to do with vision as such (it is nonretinal)—something symbolic of the function of the lack—of the apparition of the phallic ghost? That same phantom of the phallus haunted the *Large Glass*, making law and making lack. The phantom did not stem from a natural order of things, it should gently be said; the phantom sprang from common sense.

Duchamp's great accomplishment in the *Glass* was to bring the two kinds of modern male looking, the scopophilic and the projection, together and to leave them together to hang. Male vision and desire were dissipated, unfocused, scattered all around the *Glass*, aimless in a carnival atmosphere

of mechanical tricks, painted ladies, puffs of smoke, and candy. This male desire was to be the object of great hilarity. Laughter was Duchamp's response to the phantom, there would be no thoughts of little knives.

There were other sides to his study that were concerned not so much with lack as with the blanks in this language of line, notably the problems that Thierry de Duve has analyzed so elegantly, the twin problems of nominalism and color.[28] Finally in 1920 came the invention of Rrose Sélavy. She had been latent in Duchamp's idea of *apparition*. The painting, he noted, meaning the *Large Glass*, was in general "the *apparition* of an *apparence* . . . *Peinture de précision, et beauté d'indifférence*."[29] *Apparition* was not then within the purview of perspective; it was that peculiarly male sight, the pot of gold, the truth at the end of the projection. Put together with another note, this one datable to 1914, we see its gender better. The note is the famous

$$\frac{\text{arrhe}}{\text{art}} = \frac{\text{merdre}}{\text{merde}}$$

or grammatically:

L'arrhe de la peinture est du genre féminin.[30]

So the *arrhe* (downpayment) of painting is feminine. Painting taken to full term, we may assume, was different, and its difference would also be expressed by another. *Peinture de précision*, as Duchamp was elaborating it, broke increasingly with the feminine when it moved to figure the *apparition*. Precision ended pointedly with masculinity. Femininity was relegated to the purgatory of the imprecise. Rrose provided an image for that imprecision, a nonaesthetic image.

Her first two pieces set up the possibilities: *Fresh Widow* (fig. 9.13) and a drawing for the *Oculist Witnesses* (fig. 9.14). The one closed off the view through the French window, a standard schoolroom model, its opacity macabre and hard on the war widows. The other, the drawing, belonged to the higher order of visual experience Duchamp hoped to represent in the *Glass*. But Rrose quickly assumed a more traditional female role. By 1923 it would have been unthinkable for her to sign the *Large Glass*.[31] She

developed along the lines of the first possibility: accordingly she had things made, like the *Fresh Widow*, and she had them copyrighted, even if they were not technically copyrightable; she could collaborate with Duchamp, or she could lend her name to his titles and commercial ventures rather like his friend and collaborator on the Société Anonyme, Katherine Dreier; but by herself Rrose was fragile and not especially assertive; by herself she did not work very much at all; she was really just a creature of surfaces, starting with her own disguise. She did not wield a line and she did not have a body of her own. She existed in order to establish gender in the first place. The first place would never be hers. In 1925 Rrose made one of her rare drawings, a quick caricature called *Nous nous cajolions* (fig. 9.15) that stopped at the edge of a lion's cage, caught the surface appearances well enough, and then attached a photograph of a swell spread of graffiti (drawn by the likes of "Happy the kid from Willianburg Bklyn") from the public rest room (the men's room it would appear) of the Lincoln Arcade. The drawing summarizes her (and women's) limitations: she could never be "Happy."

Rrose Sélavy supposedly specialized in precision optics, but when it comes down to it, she almost never diagramed or drew; her work was mostly written. One of her puns targeted *aspirants* and spirals (*L'aspirant habite Javel et moi j'avais l'habite en spirale*) but with a pun that played on the sexual power of the word, not the line.[32] The drama of Rrose's existence was the conflict between her expressed desire to see, the gaudy rhetoric of her business card, *Oculisme de précision / Rrose Sélavy / New York–Paris / poils et coups de pieds en tous genres*, and her inability to kick up much of a look.[33] From time to time she was given the chance to try the higher orders of projection, but over the years she was gradually, then repeatedly and radically withdrawn. In 1926 she took credit for the film *Anémic Cinéma*, all spirals and puns, but by the time the rotoreliefs were issued in 1935, she was no longer participating in the project, perhaps because her words were no longer needed. In the end she was withdrawn both from projection and from perspective. Rrose Sélavy loved vulgarity but finally it was expressed without benefit of line, expressed through abstinence from precision optics, abstinence from the problematic surface, abstinence from the image. That discipline seemed to declare her femininity best of all: for perspective was in fact the sexes' common visual ground; a specifically

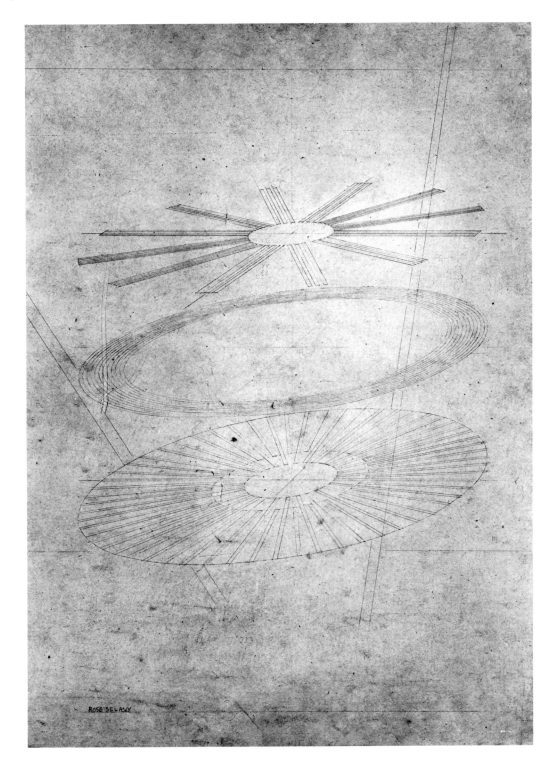

female image would therefore have to be defined as no image at all; technically a female line of sight would not exist.

Rrose stood outside the language of industry as a female. She stood for a part of the preaesthetic that was every bit as necessary to Duchamp as the *apparition* or the *n*th dimension. Through her behavior she became the better way to show sexuality without the body. She called attention to the surfaces where women languished; she was always a she, never an I. Like the greater projections in the *Glass*, she marked the scope of gender in the single universal language of industry, mostly by virtue of the fact that she was not part of its One.[34] Yet because she took so much distance from the language, she could show the extent of its strength. For there are two ways to read this distance, as exile or negation.

Last things last. One thing is clear. Rrose Sélavy speaks to the fact that the idea, or was it a dream, of language had broken down. Not everyone would speak in that way. Line's power was weakening; soon it would be marginalized and then treasured as art. Meanwhile industrial progress would find its true image in the advertisement.

NOUS NOUS CAJOLIONS

Notes

1 For example this note for the *Large Glass*: "Les *formes principales* de la machine-célibataire sont imparfaites: rectangle, cercle, parallélépipède, anse symétrique, demi-sphère = c'est-à-dire elles sont mensurées (rapport de leurs dimensions entre elles et rapport de ces formes principales à leur destination dans la machine-célibataire). Dans la mariée, les *formes principales* sont *plus ou moins grandes ou petites,* n'ont plus par rapport à leur destination, une mensuration: une sphère, dans la mariée, sera de rayon quelconque (le rayon donné pour la représentation est fictif et pointillé)." *Duchamp du signe. Ecrits,* ed Michel Sanouillet and Elmer Peterson (Paris: Flammarion, 1975), 66–67. (Herafter cited as *DDS.*)

2 *DDS,* 45–46. For the full story of the *Glass,* see the work of Jean Suquet, *Miroir de la mariée* (Paris: Flammarion, 1974) and *Le guéridon et la virgule* (Paris: Bourgois, 1976).

3 *DDS,* 46.

4 Note 82, dated 1913, in the collection of Duchamp notes edited and translated by Paul Matisse, *Marcel Duchamp, Notes* (Paris: Centre National d'Art et de Culture Georges Pompidou, 1980), is eloquent. The first part of it reads as follows:

Difficile de:
présenter un Repos en termes ni techniques ni poétiques: trouver la vulgarité indispensable telle qu'elle perde sa teinte vulgaire
1—Emploi de mots vulgaires éviter les mots métaphoriques ou généraux (les mots en caoutchouc, à équivoque). Mais pas recherche du mot vulgaire pour son pittoresque (la vulgarité indispensable seulement)
2—Idée prédominante et langage seulement comme son instrument (de précision)
a—idée elle même de précision et
b. langage transparent

5 See, for example, Antonin Proust's speech to the Chambre des Députés in March 1879, reprinted in the *Manuel général de l'instruction primaire. Journal hebdomadaire des instituteurs et institutrices,* vol. 15, no. 16 (April 19, 1879), 182. The debate over the programs took place between Eugène Guillaume and Félix Ravaisson and its essence was recorded in their entries for "Dessin" in the *Dictionnaire de pédagogie et d'instruction primaire,* ed. Ferdinand Buisson (Paris: Hachette, 1882–1883). The confrontation has been recounted by Christiane Mauve in her two articles, "L'art à l'école?," *Esthétiques du peuple* (Paris: Editions la découverte and Presses universitaires de Vincennes, 1985), 131–144, and "Les yeux du peuple," *Les sauvages dans la cité. Auto-émancipation du peuple et instruction des prolétaires au XIXe siècle* (Seyssel: Champ Vallon, 1985), 128–135.

6 *Manuel général,* partie générale, vol. 48, no. 6 (February 5, 1881), 113–114.

7 My translation. All translations in this paper are mine unless otherwise indicated. Eugène Guillaume, "Dessin," *Dictionnaire de pédagogie,* pt. 1, p. 684:

En effet, si nous considérons le dessin en lui-même, nous voyons qu'il a pour objet de représenter les choses dans leur verité ou dans leur apparence. Dans le premier cas, il s'agit de donner la figure des objets suivant leurs dimensions et avec leurs mesures par des délinéations exécutées en vraie grandeur et réduites proportionnellement. C'est le dessin qu'emploient les architectes pour leurs plans, élévations et coupes; dont, avec eux, les ingénieurs font usage pour les traces d'épures qui fournissent avec la dernière rigueur le développement de lignes qu'il serait impossible d'obtenir avec le dessin de sentiment. C'est, en un mot, celui qui est en usage dans toutes les professions ou métiers plastiques pour diriger le travail de l'ouvrier. C'est, en résumé, le moyen graphique par lequel le maître de l'oeuvre, quelle qu'elle soit, exprime ses conceptions, les transmet et les rend intelligibles à ceux qui sont chargés de les exécuter. Ce genre de dessin, qui est dit géométral, est l'écriture propre de tous les arts et de toutes les industries du bâtiment, de toutes les professions qui s'exercent dans le monde de la forme. D'autre part, s'il s'agit de rendre l'apparence des choses et de les figurer telles qu'elles semblent être dans l'espace, la perspective intervient et

permet d'obtenir des représentations avec une sûreté telle que la vraisemblance, qui est parfaite, devient une vérité mathématique. Si l'on ajoute à ce qui précède que la géometrie nous donne aussi les lois du tracé des ombres et qu'elle ajoute ainsi au domaine de la forme dont elle nous rend maîtres, le domaine de l'effet, on voit que cette science contient et constitue le dessin tout entier.

8 L. Charvet et J. Pillet, *Enseignement primaire du dessin à l'usage des écoles primaires (cours élémentaire et une partie du cours moyen d) et des lycées et collèges (classe préparatoire, huitième et une partie de la septième). Livre du maître. Première partie* (Paris: Delagrave, 1883), 65: "Le dessin, de sa nature, est exact, scientifique, autoritaire. Il représente, avec une précision irréfragable et à laquelle il faut se soumettre, les choses telles qu'elles sont ou telles qu'elles nous apparaissent. Pas une des figurations qu'il trace qui ne puisse être analysée, vérifiée, transmise, comprise, réalisée. Dans son acception géométrale, comme sous la forme perspective, le dessin s'écrit et se lit; il a le caractère d'une langue universelle." The reconcilation of this language of line to traditional high culture was always worrisome, and the problem especially nagged at those of Guillaume's men who had been trained as fine artists. The fine arts with their high culture of the body, they decided, following Guillaume, could be built upon the geometric base, and never alienated. As Paul Colin, government inspector of drawing and a painter as well, the one charged with writing the report on the state of drawing education for the 1889 World's Fair, reiterated: "Il ne s'agit pas, en effet, de sacrifier tel ou tel grand maître au cube et à la perspective pas plus que le développement du goût à l'etude des procédés techniques; non, il ne s'agit de rien de tout cela. Les programmes ont en vue de donner à l'élève les moyens de reproduction des choses dans leur verité absolue ou dans leur absolue vraisemblance. Il n'y a pas deux dessins; il n'y a pas le dessin des artistes et le dessin des gens du monde, il n'y a qu'un art unique, soumis à des règles dont on ne peut s'affranchir." Paul Colin, *Rapports du Jury International. Exposition Universelle Internationale de 1889 à Paris. Classe 5bis. Enseignement des arts du dessin* (Paris: Imprimerie Nationale, 1890), 11.

9 Each student was required to keep a monthly notebook to record their progress in the required republican subjects; at the end of the school year the teacher was supposed to collect them and keep them on file for use by the government inspectors. After a time they were chucked, though a few have survived and are available for consultation at the Musée national de l'éducation. They seem to have come mostly from family collections of student work. The museum has separated them into two groups, *cahiers de dessin* and *cahiers primaires;* the group, though not large, composes a random sample from both Paris and the provinces.

10 M Baron, who drew his own picture at the end of the notebook and dated it 1912, is probably also responsible for the trail of blue and brown Bs (for *bien*) in the margins.

11 Normal school programs were given in the decree of August 3, 1881. A. Fallières, then minister, in his "Circulaire relative à l'inspection de l'enseignement du dessin dans les ecoles normales primaires 6 février 1884," explained the top-to-bottom principle in no uncertain terms to the *inspecteurs d'académie:* "l'étude du dessin a pris et méritait de prendre une place beaucoup plus large qu'autrefois dans les écoles normales primaires, d'où elle doit se répandre jusque dans les moindres écoles primaires." *Circulaires,* vol. 8, p. 329. There is considerable evidence of the seriousness with which the teacher took up this mission. See *Nous les maîtres d'écoles. Autobiographies d'instituteurs de la Belle Epoque,* ed. Jacques Ozouf (Paris: Gallimard, 1973), and Francine Muel-Dreyfuss, *Le métier d'éducateur* (Paris: Minuit, 1983).

12 The decree of May 11, 1881, specified a drawing exam only for the *brevet supérieur;* the Ministry's circular of December 30, 1884, specified it for the *brevet élémentaire;* see also the decree of January 18, 1887, where the subject matter of the exam is elaborated in more detail.

13 For those who would become special teachers of drawing in the *lycée* or *collège,* there was yet another test. By 1908 there were 2,000 of these special teachers of drawing. *Conférences de Musée pédagogique 1908. L'enseignement du dessin par MM. L. Guébin, A. Keller, G. Quénioux,*

P. Cathoire, L. Francken (Paris: Imprimerie Nationale, 1908), 99.

14 On this matter of socialization see especially Teresa de Lauretis's essay "The Technology of Gender," in her book *Technologies of Gender: Essays on Theory, Film, and Fiction* (Bloomington: Indiana University Press, 1987), 1–30, and Mary Kelly, *Post-Partum Document* (London: RKP, 1983).

15 *Conférences du Musée pédagogique 1908,* 201, lists the differences in the program without comment.

16 *Conférences du Musée pédagogique 1908,* 212. See L. Malaval, *Le vrai dessin* (Paris: Nouvelle librairie classique, 1888), 159, on the umbrella as the object most feared by the *aspirantes.*

17 The list that follows is given in Darchez, *Nouveaux Exercises, partie complémentaire,* pp. i and v. In 1882 the Ministry put together a *Musée scolaire de l'art* with different reproductions, plasters, engravings, and photographic reproductions from antiquity and the Renaissance-Baroque. Schools for boys were proposed a set featuring bas-reliefs from the Parthenon, Holbein and Leonardo heads, portraits of Poussin, Colbert, Racine, and Turenne, and landscapes by Claude; with the exception of the Venus of Arles, all subjects were male. Schools for girls were proposed a shorter list of completely different works that included a cherub's head by Manni di Banco [sic], a Holy Family by Raphael, and portraits of Mme Vigée-Lebrun, Mme de Sévigné, Fénelon, and La Fontaine. With the exception of the portraits of Fénelon and La Fontaine, all subjects involved the depiction of women and children. The list is given in Colin, *Rapport 1889,* 41.

18 In French:

1. Tabouret (siège) en bois
2. Marchepied
3. Escabeau
4. Seau (en bois ou en zinc)
5. Baquet (en bois ou en zinc)
6. Caisse à fleurs
7. Pupitre de musicien
8. Baril
9. Boisseau (double décalitre)
10. Coffre à bois
11. Guéridon (simple)
12. Petite table carrée
13. Tréteau

14. Chevalet à scier le bois
15. Auge de maçon

 Aspirants
16. Petit banc (en bois)
17. Tabouret de pied
18. Tiroir de table
19. Boîte à sel ou boîte à épices
20. Boulier compteur (modèle des écoles)
21. Table de presse à copier (sans le tiroir)
22. Chargeoir (pour le bois)
23. Porte-selles (en bois)
24. Un double litre en métal
25. Un poids en fonte (de 5 kg. au moins)

 Aspirantes:
16. Lampe avec abat-jour
17. Panier (le choisir assez grand)
18. Parapluie (ouvert et placé sur une table)
19. Casserole (de grande dimension)
20. Poêle à frire
21. Râteau de jardin
22. Pelle
23. Pioche
24. Bêche
25. Arrosoir
26. Marmite (en métal)
27. Broc
28. Cruche
29. Four de campagne
30. Tamis
31. Chaise

19 For another example of this see E. Armand, *Le dessin dans l'enseignement primaire* (Paris: Henry Paulin, 1905).

20 Albert Gleizes and Jean Metzinger, *Du Cubisme* (Paris: Figuière, 1912), 30–31: "Aussi nous étonne-t-il que des critiques bien intentionnés expliquent la différence remarquable entre les formes attribuées à la nature et celles de la peinture actuelle, par la volonté de représenter les choses non telles qu'elles paraissent mais telles qu'elles sont. Comment sont-elles? D'après eux l'objet posséderait une forme absolue, essentielle, et ce serait pour la délivrer que nous supprimerions le clair obscur et la perspective traditionnels. Quelle simplicité! Un objet n'a pas une forme absolue, il en a plusieurs, il en a autant qu'il y a de plans dans le domaine de la signification. Celle que signalent ces écrivains s'adapte comme par miracle à la forme géométrique. La géométrie est une science, la peinture est un art. Le géomètre mesure, le peintre savoure. L'absolu de l'un est fatalement le relatif de l'autre; si la logique s'en effarouche tant pis!

empêchera-t-elle jamais un vin d'être dif-féremment parfait dans la cornue du chimiste et dans le verre du buveur?" I have used Robert Herbert's translation, which appeared in his anthology *Modern Artists on Art* (Englewood Cliffs: Prentice-Hall, 1964), 13.

21 The classic texts here are: Linda Nochlin, "Why Have There Been No Great Women Artists?'" in *Women in a Sexist Society,* ed. Vivian Gornick and Barbara K. Moran (New York: Vintage, 1971); John Berger, *Ways of Seeing* (Harmondsworth: Penguin, 1972); Carol Duncan, "Virility and Domination in Early Twentieth Century Vanguard Painting," *Artforum* 12 (December 1973), 30–39; Laura Mulvey, "Visual Pleasure and Narrative Cinema," *Screen* 16, no. 3 (1975), 6–18; T. J. Clark, *The Painting of Modern Life: Paris in the Art of Manet and His Followers* (New York: Knopf, 1985), chapter "Olympia's Choice"; and Carol M. Armstrong, "Edgar Degas and the Representation of the Female Body," in *The Female Body in Western Culture,* ed. Susan Suleiman (Cambridge: Harvard University Press, 1986), 223–242.

22 Note 184 in Matisse, ed., *Marcel Duchamp, Notes.* In French: "Problème: tracer une ligne droite sur le 'baiser de Rodin' vu d'un viseur."

23 Thierry de Duve, "The Readymade and the Tube of Paint," *Artforum* 24 (May 1986), 110–121.

24 Duchamp's copy is from the fourth edition of Forel and is now in the collection of Mme Marcel Duchamp. Forel's *Guide* would have been appropriate for Duchamp's drawing class at the Lycée Corneille in Rouen, where he was a student from 1897 to 1904. The surviving archival material does not specify which texts were used in those classes. The inspections done at this elementary school in Blainville-Crevon do mention drawing, but nothing specific about the manuals used when he was attending the school (Archives départementales de Rouen, 7TP63). Forel started with the straight line, namely the plumb line. He did not overly concern himself with the *brevet* questions themselves; rather he bent himself to explaining the fundamentals of representation that everyone, male and female, needed to understand, which is to say, perspective drawing, and he insisted that the point of such study was the develop-

ment of vision, not the training of artists: "Nous avons cherché, en nous servant d'exemples que le lecteur a sans cesse sous les yeux, à éveiller son attention, à l'inciter à l'observation et à l'analyse des faits, à lui apprendre, en un mot, à voir et à comprendre ces phénomènes, ces faits qu'une habitude quotidienne lui rend insensibles ou plutôt indifférents. Voir est, en effet, tout le secret du dessin" (p. 4). He concluded with an invocation to practice his lessons; the rules of perspective, he assured his reader, will then come automatically in the act of drawing "en quelque sorte d'une manière inconsciente, machinale" (p. 162). Duchamp learned and returned to such ideas. He dropped the plumb lines to make the stoppages; he went along with precision seeing; when he decided that indifference was beautiful, he pulled back to a pre-preaesthetic level of culture that Forel would have condemned. Forel also authored two other manuals, *Méthode de dessin conforme aux programmes officiels de l'enseignement primaire. Livre du maître. Première partie* (Paris: Hatier, 1899) and *Méthode de dessin conforme aux programmes officiels. Cahiers d'application A à F* (Paris: Hatier, 1910).

25 Duchamp's use of the fourth dimension has been the focus of much scholarly work, all of which implicitly argues for the importance of projection per se, fourth-dimensional or not, in Duchamp's work: Linda Henderson, *The Fourth Dimension and Non-Euclidean Geometry in Modern Art* (Princeton University Press, 1983), especially the chapter "Duchamp and the New Geometries"; Jean Clair, *Marcel Duchamp ou le grand fictif* (Paris: Galilée, 1975); John Dee, "Ce façonnement symétrique," *Marcel Duchamp: tradition de la rupture ou rupture de la tradition. Colloque de Cerisy* (Paris: Union générale d'éditions, 1977), 351–402; Craig Adcock, *Marcel Duchamp's Notes from the Large Glass: An n-Dimensional Analysis* (Ann Arbor: UMI Research Press, 1983).

26 Note 134 in Matisse's edition. See also Duchamp's observation that perspective drawing was "à la portée de toutes les intelligences," note 104.

27 Jacques Lacan, *Le séminaire de Jacques Lacan. Livre XI. Les quatre concepts fondamentaux de la psychanalyse 1964,* text established by Jacques-Alain Miller (Paris: Seuil, 1973), 82.

28 Thierry de Duve, *Nominalisme pictural.
 Marcel Duchamp, la peinture et la moder-
 nité* (Paris: Minuit, 1984). Thierry de Duve
 has taken this name-of-the-color study to
 be the key to Duchamp's transition from
 painting to readymade and the means of
 explaining how the readymades were part
 of a project of painting. To catch the cul-
 ture of line lying behind the color study, or
 for that matter to see the textbook image
 in the readymade, only reinforces de
 Duve's argument. See also his article "The
 Readymade and the Tube of Paint."

29 *DDS,* 45–46. See also 120–122.

30 *DDS,* 37.

31 In 1965 when Duchamp made an engrav-
 ing after the drawing of the oculist wit-
 nesses, Rrose's signature did not survive.

32 *DDS,* 161. Duchamp, notes Sanouillet,
 disavowed authorship of this pun, but it
 was part of the *Anémic Cinéma* copy-
 righted by Rrose in 1926 and as such can
 be allowed to remain as part of Rrose's
 oeuvre.

33 *DDS,* 153.

34 On the domain of the one, see Luce Iri-
 garay, *Ce sexe qui n'en est pas un* (Paris:
 Minuit, 1977).

Discussion

Moderated by Thierry de Duve

THIERRY DE DUVE

I am very impressed by the scope and the precision of your historical inquiry, and by its relevance to the study of Duchamp's work. Yet it seemed to me that what you were also doing was laying the ground for an even more spectacular analysis of Duchamp's "common sense" treatment of this body/line gendered problem. I suspect there is more to come. And I'm sure I'm not alone in thinking that we would like you to elaborate beyond the ideology whose reality you now have established, at least as far as Duchamp's education is concerned. As far as his work is concerned, we are still a little "hungry" maybe. Could you please go on?

MOLLY NESBIT

It needs to be said that, yes, one could use this whole system to work out an interpretation of Duchamp, factored according to common sense. However, this would not amount to letting common sense bleed through the *Glass*, to the point where it would become the controlling image for it. Common sense exists as a term only, a pole orienting us and showing us where the *Glass* is located: outside regular aesthetic production. Now, that culture outside regular aesthetic production was very complicated. It included gentlemanly science, the kind of learned physics that Herbert talked about yesterday, and the kind of mathematical fad that Craig talked about today. It also included going to performances of plays by Roussel, and lots of other activities. And so when we move common sense, or nonaesthetic culture, into our discussions of Duchamp, we need to keep the idea of many different possibilities active. We do not need to move toward a single answer or interpretation. How's that?

THIERRY DE DUVE

That's fine. Rosalind had a question.

ROSALIND KRAUSS

Looking at those lesson plans, I was struck by a parallel with an earlier example of that kind of drawing done plate by plate in relation to an instructional system, namely the *Encyclopédie*. At the end of the eighteenth century, in the Encyclopedia, one also encounters a kind of dem-

onstration through the medium of line. I take it that, however, one of the important differences between the Guillaume system and the Encyclopedia is that at the end of the nineteenth century line is now being reinvented within high capitalism, within a much more advanced process of commodification. I was wondering if you could expand on that.

MOLLY NESBIT

The Guillaume system was instituted because the French felt that they had to beef up their production in order to meet the international competition. Earlier in the nineteenth century there were other reforms, not so wide-reaching, which gave workers' education pretty much this same idea of drawing, though less extreme. Nature was allowed, color wasn't banished altogether. But it was always about establishing this other culture of work. The language of industry was a language of and for labor. But beginning around 1880, it definitely became a public culture, not just a professional one, as women had to learn it, for instance. Those who would become gentlemen amateurs also had to learn it. It was supposed to set up the zero degree of state-sponsored public culture that was oriented toward industry, not toward "art" (unlike the old history painting). It should be said that the industry in question is really the building industry—architecture, the decorative arts—and as modernism developed a decorative arts agenda of its own, the language of industry became very useful. To purism, for example. Commodification is at the heart of it all.

DENNIS YOUNG

To purism, and then also perhaps to De Stijl? I wonder if anyone has ever applied him- or herself to the decoding of the geometric pattern on Rrose's hat (fig. 2.1). If you look at Rrose's hat, you see a Van Doesburg, as it were, which if turned through ninety degrees makes an extremely obscene image, not unlike those in the graffiti photograph appearing in *Nous nous cajolions*. It seems to me that in the context of what you say, this is something like a triumph of the process of appropriating the male domain. I would be interested to know whether anyone would agree or whether I am simply revealing my talent for responding to Rorschach tests.

ANDRÉ GERVAIS (F)

It's the hat of Germaine Everling, Picabia's girlfriend.

MOLLY NESBIT

Where?

DENNIS YOUNG

If you look at the checkerboard pattern and you turn it to the left through ninety degrees, you surely get the image of a male and female in the act.

THIERRY DE DUVE

We finally got to see some pink—although in black and white.

AARON BOURGUIN

Speaking of pink, in connection to a tradition of technical drawing, and going back to the Encyclopedia, I have been given to understand that while Duchamp was working at the Sainte-Geneviève library, not only was he reading texts but he was uncovering drawings by an architect by the name of Lequeu, drawings that the Bibliothèque Nationale had put away, a series of what were called *figures lascives*. And apparently it's also rumored that these drawings went missing from the library, that he himself had taken them, returned them later, and may have, in fact, done work on the drawings themselves.[1] Somewhere in all of this . . .

MOLLY NESBIT

Well, there's drawing and drawing, isn't there? The *Méthode Guillaume* is not a prescription for Duchamp's method. It merely sets up a kind of structure in which we understand a little bit better what the limits of nonaesthetic culture were, in visual terms, in terms of representation. But that doesn't preclude him from fooling around with somebody else's dirty drawings, right? I mean, why not? You know, all of this is sunk into somebody's life. Duchamp's work as it goes from beginning to end is not an abstract mathematical problem. And so, to look for too much consistency, I think, would be false.

JOHN KLEIN

When you speak, Molly, of the need for precision in drawing and of France's need to compete in the international marketplace for consumer goods, it occurs to me to consider the history of machine tooling as something that could be talked about in this context. There the need for greater precision is connected to the need for professional operators—a highly specialized professional class of operators of machine tools. This

is where the precision is really needed—less so in the building trades. You might have responded to this already in saying that these manuals were primarily for the building trades, but the really masculine line is a professional class line, not a line of labor.

M O L L Y N E S B I T

I haven't studied the distinction between factory and *atelier* to see if they present two different degrees of masculinity. I suspect that basically male workers are male workers. But the French sense of industry, it should be emphasized, revolved around a revival of the decorative arts industry and was tied to a hoped-for revival of the *artisanat*. That's one of the reasons, by the way, that taste was such an important goal of the drawing programs, since the tradition of "Louis" styles was considered to be tasteful, and a taste worth preserving. Their "precision optics" was connected to tasteful seeing.

S T E W A R T A P P L E G A R T H

I was wondering if I was going to accept your approach to the gender differentiation evident in Duchamp's own education. I think that the traces of da Vinci's work could have been considered as important in talking about gender roles, linear perspective, and so on.

M O L L Y N E S B I T

All right, but my question to you is: Can we talk about the kind of culture that's needed to see all this in da Vinci as common sense? There are basic distinctions to be made.

S T E W A R T A P P L E G A R T H

Well, I guess when you talk to me about common sense, I'd say it's common sense for me to refer also to his other sources.

M O L L Y N E S B I T

Hang on, hang on. I don't want to explode this idea of common sense. I use it not as a source but very precisely as a kind of historical notion. And I think that to look at da Vinci connoisseurship as a source for Duchamp's handling of gender is just . . . not vulgar enough.

V E R A F R E N K E L

I just have some simple points of clarification. I found the paper fascinat-

ing, and I found myself longing to draw both genders into the exercises provided. I'm not sure where we are left, however. I understand Thierry's comment about it being an elaborate preparation for the very important point with which you ended. But I still don't understand what this interpretation of the vernacular or the industrial model tells us. Is it a sort of double negative that you're presenting? Is Duchamp, in the *Large Glass*, subverting the genderizing of the line and by that subversion subverting assumptions about so-called "high art" meanings? Where are you leaving us with this?

MOLLY NESBIT

All I really want to say here is that this business with appearance and apparition is gendered, even as it turns around and around in the notes. Finally we are left with a picture which seems to settle on the idea of projection, to settle in a male domain, period. I'm going to leave you with that, admittedly not a big satisfying academic analysis, only a simple point. I might add that perhaps this was Duchamp's way of taking a position on abstraction in painting, by rendering it through a literal projection. I don't think I'd want to go much further than that, Vera.

VERA FRENKEL

I'm not asking for closure. I think you've answered me. Thank you very much.

BRUCE BARBER

Thank you very much for an interesting presentation, especially for the second section of your paper which allowed me to at least get a glimpse of what a feminist reading of the early work of Marcel Duchamp might look like. However, in the first part of the paper I had to attempt to rescue, in a sense, to formulate in my own mind, the differentiation between what a feminist reading might be and what a conventional art historical reading might be. I heard a series of oppositions between low and high culture, between line and sex, line as opposed to body, and this Marxian notion of common sense. However, the notion that line may be male and female conjured up the specter of an aesthetician whom I'm sure you're familiar with, Wölfflin. His notion of the culturally received extends not far beyond a simple duality between linear and painterly. So

the aesthetic and the nonaesthetic—which you began to rhetorically introduce in the second part of your paper, in a kind of blossoming into scopophilia and the politics of the gaze—seem to me to be a critical basis for a feminist reading of Duchamp's work. But it also seems to me that the practice doesn't necessarily follow the theory in this instance. I'm not sure whether you want to comment about that or not.

MOLLY NESBIT

I don't think I did only a feminist reading . . .

HERBERT MOLDERINGS

Ha! That's true.

MOLLY NESBIT

. . . And I don't think there's any contradiction between the first and second parts of my paper. In the second part I merely continued, separating the boys from the girls. You might think of the whole paper as pragmatic. It is concerned with the terms in which everyday French culture was laid out (for example the terms of patent and copyright—that's where the line-body stuff really comes from), and examines the two traditions those terms oppose. You know, what I did is social history of art, that's what it is. It's not traditional art history, mind you, because in traditional art history we would take the model shovel from the drawings, for example, and use it as a source for Marcel Duchamp's shovel. End of problem. The analysis would go from point A to point B; we would smile and go home. But in fact, if one looks at this paper carefully, the historical model is different. It opens up problems and concludes with the restatement of a problem.

BRUCE BARBER

Will you forgive me if your paper asked for an act of faith on my part?

MOLLY NESBIT

That's all right.

HERBERT MOLDERINGS

I want to explain my outburst of a minute ago. Your starting point and thinking may be feminist, I don't know, but to me your paper was very convincing for its art historical contribution in relation to the *Large*

Glass. Coming at it from a very different angle I always had the impression that the *Large Glass* was divided into two domains along the lines of a very common-sense notion of male and female. And I didn't know that there actually existed in these manuals a daily training in sexual differences through drawing. If you see the development of the *Large Glass* plastically and literally, as I tend to see it, you would be astonished by one thing. Right at the beginning, in July 1912, the image of the Bride was there. And then over the years, with words and literary metaphors, Duchamp translated her into all kinds of machines, automobiles, and other combinations of mechanical devices. Then, finally, he rejected all that. He came back to the very first image, to the Bride as he had painted her in July 1912 in Munich. I always had the impression—and your contribution convinced me—that Duchamp's ideas on sexuality were condensed down to very basic lines separating the sexes, deeply rooted in elementary school education, family, and social experience. So I don't think your paper is a question of feminism or, for that matter of "male-ism"? I think it's really a very historical contribution, because it fits the historical evolution of this work of art.

CAROL JAMES

There was a sort of break early in your paper, about a quarter of the way through, where you began to talk about language, and you used *langue* in French several times. Were you using a *langue/langage* distinction?

MOLLY NESBIT

This is part of another paper—I should maybe say—in which I went in quite some detail into the debate over line and body and set up the idea of language in much more detail than I could do here.[2] The point really was that there was an idea of a visual language that sort of approximates Saussure's idea of *langue,* but as a kind of utopian form—the idea, you know, that there is an ideal system up there somewhere that gets put into use somehow. It's not technically Saussure, I know, but, as I was trying to explain it in my other paper, the Saussurian illusion made some sense because it spoke. Anyway, the point is that this notion of drawing as a language was not worked out. It was simply conjured with. So that when you get attempts to systematize that kind of instruction, some toady of Guillaume might say: well, you know, a line could equal a syllable, and

angles could be words. It doesn't make real sense. But there was this attempt to turn all this into a system of communication which finally communicated really in mechanical drawing. That's where you got a clear proposition.

CAROL JAMES

Is there some correlation between the lines, the shapes in the drawings, and language in the verbal sense? I'm asking this because in the second book you showed, the manual that has less emphasis on the male/female difference, there is a lot more text.

MOLLY NESBIT

Oh, that's explaining the technical "how to's" of perspective. Generally these texts are not terrifically meditative. They get down to straight lines or given plumblines, and off you go.

JOHN BENTLEY MAYS

The proto-feminism of this presentation is seductive to all of us, and it maybe inclines me to forgive you for certain things that I've decided not to forgive you for. Two things. One of them is a simple point that's been made before but that maybe needs to be underscored. This discussion of art education is fascinating—about the way in which people actually learn about a relationship between the visual world and representation— and yet it seems to me that the social and industrial matrix in which all of this is taking place is the ballast that I found lacking in your argument. As far as I'm concerned, to talk about sex differences is banal. Sex differences are obvious. To talk about how sex differences are constituted becomes really interesting. And that is where, in your account of the industrial changes in late nineteenth-century France, I found a lack and somewhat of a heartbreak because other things that you were doing were so beautiful. And that leads me to the second thing which was the cash value of your analysis, the payoff at the end of the analysis. Again, it seems banal to say what is so obvious, that the *Large Glass* is male and female. It seems interesting to be talking about the way that maleness and femaleness, at that pictorial level, or line level, have been generated by a reconsideration of history within the culture of the line that you've been talking about. True, if Duchamp reflects back upon the history of sexuality in the contemporary era as a cultural issue, then you

provided a very interesting touchstone, or strategy, for dealing with that. Only, its development didn't happen. The complex—as opposed to the simple—demonstration of how we all grew up through school and we all eat and internalize our teachers, and of how that somehow becomes a psychoanalytical crisis for the rest of our careers as people who look, and finally of how that, in turn, turns out to be culturally productive, that's the part I was looking for. And when it comes out, I will read your book for that reason, just to find out the thoroughly last chapter.

MOLLY NESBIT

It seems to me that the missing link is consumerism, or better the culture of consumerism, isn't it? Now consumerism is being defined through advertising, some of it pitched to male viewers, some to female viewers. The question becomes "how does the image help the pitch?" There are historical developments in the French advertisement which I haven't mapped in great detail, but I can tell you generally that the French advertisement is being modified according to the American model from about 1910 onwards. But in the end Duchamp was not responding to the brute formulations of the model, whether it be the schoolroom model or the admen's model.

JOHN BENTLEY MAYS

It seems to me, though, that it's not so much consumerism which is the missing link. What you began to elucidate but then left dangling was the other readymade, the other "found object" that's lurking here, which is the institution of art education. To begin looking at it the way you did— to my mind as an art critic—has the most interesting implications for thinking about contemporary art right now. I mean, what you've done is suggest a strategy that is not only useful for the period of Duchamp's training but also for the later and continuous institutional problem.

VERA FRENKEL

I think I finally have what I was trying to say earlier, and that is that there's a guile attached to saying, "These things have to do with common sense and are pragmatic." I think you have presented an array of exoticism that is remarkable. And I'll just leave it at that. I think your paper is a big tease.

1 Aaron Bourguin is referring to the rather far-fetched (perhaps mischievously misleading) thesis defended by Philippe Duboy in "J. J. Lequeu (1757–?), Duchamp," *XXᵉ Siècle* 47 (December 1976), 13–18, and in his book, *Lequeu: An Architectual Enigma* (Cambridge, Mass.: MIT Press, 1987).

2 Molly Nesbit, "Ready-Made Originals: The Duchamp Model," *October* 37 (Summer 1986), 53–64.

ANDRÉ GERVAIS

Connections: Of Art and Arrhe

Translated by Joanne Prout
and the author
Translation revised by Daniel Sloate
and Thierry de Duve

All modernity is provided by [the] reader.

The hat—etc.

Stéphane Mallarmé, *Le "Livre"* (published in 1957)

If it is shoes that you want, I'll give you shoes that you will admire to such an extent that you will lame yourselves trying to walk in them.

Marcel Duchamp (quoted in Julien Levy, *Surrealism,* published in 1936)

These two epigraphs (which have no relationship, given the difference in dates) were placed at the beginning of this paper to suggest that the onlooker is involved literally from head to toe in analyzing and interpreting Duchamp's oeuvre.[1] From head to toe, from hat to shoe, that is to say, the entire body of Duchamp's visual and, especially, literary work is mapped onto the onlooker's body. Here are two examples:

For the hat, let us take *Pulled at Four Pins,* which, as recalled by Gabrielle Buffet-Picabia, is "a kind of medieval helmet that was really just a weathercock"[2] (fig. 10.1). A familiar sight in the New York skyline, it shows that Duchamp, who had arrived there in 1915, was already at home in Manhattan—but also at war, "to expose the basic antinomy between art and readymades" (*SS,* 142). As for the shoe, let it be socks, or rather, stockings, as in the aphorism "Des bas en soie . . . la chose aussi" [i.e., la chose en soi] (1924). Whether socks or weathercock prompted the erotic innuendo, investigating the literary body that is in between can only lead to a debate involving "French letters."

The second example presents two readymades from 1917: *Hatrack* and *Trébuchet [Trap].* The one has been removed from its base and suspended in the air like the snake-haired, phallic head of Medusa, the mortal Gorgon whom Perseus decapitated. (Use a readymade as a *raidie Méduse.*) The other is a coatrack nailed where it was to the studio floor, as a tribute paid to laziness but also evoking a trap toward the end of a game of chess. (Trip over the *Trébuchet.*) This is to expose the basic antinomy between art and chess.

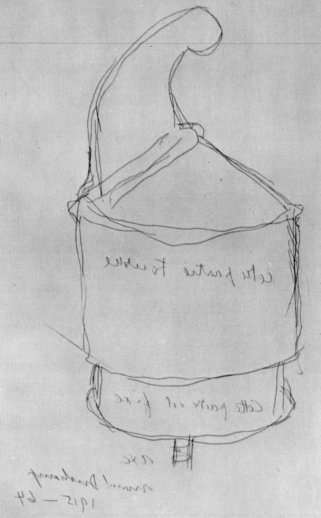

PULLED AT FOUR PINS

TIRÉ À QUATRE ÉPINGLES

60/100

10.1
Pulled at Four Pins, 1964. Etching,
12⅝ × 9 in. (Collection Francis Nau-
mann, New York.)

So, we have art and readymades on the one hand and art and chess on the other.

We remember that "the creative act" is what happens during the osmosis of three "isms": the author's "ism" of affirmation, which Duchamp called ironism, the onlooker's "ism" of precision, which he named oculism, and last but not least, eroticism, the sexual act or the "thing itself" (la chose en soi), which he explicitly said he wanted to turn into an artistic "ism."[3] This osmosis of isms—or ismosis—implying a "little game between 'I' and 'me,' "[4] only possible to an individual who has achieved complete separation between "the man who suffers and the mind which creates," is basically the erotic exchange between an author and an onlooker who responds to ironism with oculism. The *viewer* becomes a *voyeur* or "voyeuvriste,"[5] the *reader* becomes a writer.[6] From this "ismosis," I find my authorization to proceed.

We also remember that Duchamp provided a complete statement on the interaction between artist and onlooker in his brief and well-known speech entitled "The Creative Act" (*SS*, 138–140), written in January 1957 and delivered in April 1957, and that T. S. Eliot's phrase "the man who suffers and the mind which creates," which Duchamp quoted therein, was taken from a 1917 text. This is the same year that Duchamp took a stand with "The Richard Mutt Case," showing that he was already at that time interested in this cleaving—at once osmosis and antinomy—between artist and onlooker, the two poles of the creative act. Indeed, as early as 1915, in what was probably the first interview he gave in the U.S., he had already observed that "People give more to pictures than they take from them."[7] He constantly referred to the 1910s as a remarkably fertile period for his pictorial and literary works, since it was then that he made the *Large Glass*, the readymades, and the notes and inscriptions accompanying them. His almost systematic way of exposing at least two locations, two languages, or two sexes through pictorial and literary texts could be called the restricted teleintertext of his oeuvre: "inter" because it makes use of at least two texts; "restricted" because these texts were written by the same person; and "tele" because they are often several decades apart.

Duchamp was the ultimate bilingual artist who fertilized, with *angrais*, the field [le champ] he relentlessly ploughed with his *machine agricole* and

sowed with the seeds of his *rymes*. In contrast to the bastardization of French which Etiemble has disparagingly called "franglais," what I call *angrais*, punning on "engrais" [manure] and "anglais" [English], is Duchamp's peculiar cross-fertilization of tongues. And what I call *ryme*, crossing the French "rime" with the English "rhyme," is the infra-thin unit of his poetry, the often subliminal interplay of tiny signifiers crisscrossing the larger textual units constituted by his notes, aphorisms, puns, anagrams, and titles of works, whether in French or English.

Science avec patience/Le supplice est sûr
[*Science with patience/The ordeal is bound to be*]
Rimbaud, *L'Eternité*

This leads me directly to the first topic of my paper: the attempt to follow one of the connections or chains of signifiers addressing the question of art, a question that was almost certainly debated in Puteaux in 1911–1912,[8] reformulated by Duchamp from 1913 onward, and worked into the insistent textuality of his puns, hypograms, and various other propositions. Here are five examples:

1 In a note from the *Green Box*, Duchamp wrote: "Employer 'retard' au lieu de tableau ou peinture; tableau sur verre devient retard en verre—mais retard en verre ne veut pas dire tableau sur verre." ["Use 'delay' instead of picture or painting; picture on glass becomes delay in glass—but delay in glass does not mean picture on glass."] (*SS*, 26.) On the level of the signified, he wants to make a clear demarcation between painting and delay. On the level of the signifier, however, a contamination subsists since "retard" borrows "re" from "peinture" and "ta" from "tableau," while the last syllable, "ard," writes down its mute difference from "art."

2 *Musical Erratum* (1913) contains twenty-five notes drawn from a hat in three draws (one for Yvonne, one for Magdeleine, one for Marcel), accompanied (with minor deletions) by the Littré dictionary definition, containing three infinitives, of the word "imprimer" [to print]. In addition to hearing the ryme "tiré [drawn]/Littré"—which points at the missing "L" (i.e., "elles," the two young sisters)—and the ryme "raturé [deleted]/erratum"—which points at an extra "m" (i.e., Marcel)—one can also listen to this unlikely musical air—"air rare," or Erra-rd, or is it "erre art"?—on an Erard piano.

3 One readymade appeared at the same time as the generic name "ready-made": the snow shovel entitled *In Advance of the Broken Arm* (1915). The original, New York version had the title engraved on a thin metal band wrapped around its shaft, bringing to mind a hospital bracelet or the leg band used on birds. Intertextually, this readymade recalls the sonnet by Mallarmé (the "male, armed" or "ill-armed" poet) in which we encounter a "swan of bygone days" ["cygne d'autrefois"] stuck in snow and ice. Duchamp's banded shovel/bird can be called, via the name Mallarmé, a mallard or drake [canard mâle] and seems to echo his "speculation" from 1913, "Can one make works which are not works of art?" by contracting the beginning and the end of this sentence, supplying an answer "in advance," canard, to a question "en retard": Can art?

4 The ready-made answer to the question "Can art?" might, furthermore, be "Has art," Duchamp's interest in chance [hasard] dating from the same period. From *Musical Erratum* (1913) and *Three Standard Stoppages* (1913–1914) to *Rendezvous of Sunday, February 6, 1916* (1915–1916) (fig. 10.2), chance acts as "a subjective 'creator' which appears at the point where the psychological subject fails, that is, at the place where it accumulates defenses and intentions, where it claims decision instead of surrendering it," as Thierry de Duve has argued.[9] By the time Duchamp went to his rendezvous with "has art," canned chance [hasard en conserve] had already provided "the idea of fabrication" (*SS*, 22) that allowed a one-meter-long thread to distort itself "as it pleases" and to "measure" whether art "can."

5 In Paris, immediately following World War I, another readymade, *L.H.O.O.Q.* (1919), spelled out the "commands of the Bride." Carried out to the letter, and beginning with the letter "L" as a link between Leonardo and (Mona) Lisa, these commands direct the reader from the imperative "lis ça" [read this] to the realization that Lisa may be a good lay—on art (a good Léonard).

Later, the question of art was explicitly restated in the new context that emerged after World War II: *Objet-dard* [ard object] (1951) is the title of a readymade that should be called reciprocal since it came about in view of a certain internal antinomy between the region of *Etant donnés*, underground at the time, and the region of the readymades, overground. And in February 1954, the surrealist magazine *Médium* published part of a letter from Duchamp containing the following:

-toir. On manquera,à la fois,de
moins qu'avant cinq élections et
aussi quelque accointance avec q-
-uatre petites bêtes; il faut oc-
-cuper ce délice afin d'en décli-
-ner toute responsabilité. Après
douze photos,notre hésitation de-
-vant vingt fibres était compréh-
-ensible; même le pire accrochage
demande coins porte-bonheur sans
compter interdiction aux lins: C-
-omment ne pas épouser son moind-
-re opticien plutôt que supporter
leurs mèches? Non,décidément,der-
-rière ta canne se cachent marbr-
-ures puis tire-bouchon. "Cepend-
-ant,avouèrent-ils,pourquoi viss-
-er,indisposer? Les autres ont p-
-ris démangeaisons pour construi-
-re,par douzaines,ses lacements.
Dieu sait si nous avons besoin,q-
-uoique nombreux mangeurs,dans un
défalquage." Défense donc au tri-
-ple,quand j'ourlerai ,dis je,pr-

-onent,après avoir fini votre gê-
-ne. N'empêche que le fait d'éte-
-indre six boutons l'un ses autr-
-es paraît (sauf si,lui,tourne a-
-utour) faire culbuter les bouto-
-nnières. Reste à choisir: de lo-
-ngues,fortes,extensibles défect-
-ions trouées par trois filets u-
-sés,ou bien,la seule enveloppe
pour éte-ndre. Avez vous accepté
des manches? Pouvais tu prendre
sa file? Peut-être devons nous a-
-ttendre mon pilotis,en même tem-
-ps ma difficulté; avec ces chos-
-es là,impossible ajouter une hu-
-itième laisse. Sur trente misé-
-rables postes deux actuels veul-
-ent errer,remboursés civiquement,
refusent toute compensation hors
leur sphère. Pendant combien,pou-
-rquoi comment,limitera-t-on min-
-ce étiage? autrement dit: clous
refroidissent lorsque beaucoup p-
-lissent enfin derrière,contenant

-este pour les profits,devant le-
-squels et,par précaution à prop-
-os,elle défonce desserts,même c-
-eux qu'il est défendu de nouer.
Ensuite,sept ou huit poteaux boi-
-vent quelques conséquences main-
-tenant appointées; ne pas oubli-
-er,entre parenthèses,que sans l'
-économat,puis avec mainte sembl-
-able occasion,reviennent quatre
fois leurs énormes limes; quoi!
alors,si la férocité débouche der-
-rière son propre tapis. Dès dem-
-ain j'aurai enfin mis exactemen-
-t des piles là où plusieurs fen-
-dent,acceptent quoique mandant
le pourtour. D'abord,piquait on
ligues sur bouteilles,malgré le-
-ur importance dans cent séréni-
-tés? Une liquide algarade,après
semaines dénonciatrices,va en y
détester ta valise car un bord
suffit. Nous sommes actuellement
assez essuyés,voyez quel désarro-

porte,dès maintenant par grande
quantité,pourront faire valoir l-
-e clan oblong qui,sans ôter auc-
-un traversin ni contourner moin-
-s de grelots,va remettre. Deux
fois seulement,tout élève voudra-
-it traire,quand il facilite la
bascule disséminée; mais,comme q-
-uelqu'un démonte puis avale des
déchirements nains nombreux,soi
compris,on est obligé d'entamer
plusieurs grandes horloges pour
obtenir un tiroir à bas âge. Co-
-nclusion: après maints efforts
en vue du peigne,quel dommage!
tous les fourreurs sont partis e-
-t signifient riz. Aucune deman-
-de ne nettoie l'ignorant ou sc-
-ié teneur; toutefois,étant don-
-nées quelques cages,c'eut une
profonde émotion qu'éxécutent t-
-outes colles alitées. Tenues,v-
-ous auriez manqué si s'était t-
-rouvée là quelque prononciation

10.2
Rendez-vous du 6 février 1916 à 1 h. ¾ après-midi [Rendezvous of Sunday, February 6, 1916, at 1:45 PM], 1916. Typewritten text on four postcards taped together, 11¼ × 5¹¹⁄₁₆ in. (Philadelphia Museum of Art; The Louise and Walter Arensberg Collection.)

It is a pleasure for me to see that there is more than "arassuxait" ["art à succès" or "successful art"] in Paris. By plagiarizing Jarry we can put "patArt" up against the current pomposity.

Unfortunately Picabia is no longer here to patArder and I see from the different articles on him that the kick from an ass [le coup de pied de l'âne] can take on the shape of a pat on a dog's head.[10]

Duchamp's pleasure in pitting "patArt" against the current pomposity, and his regret at seeing a pat on a dog's head substituted for the kick from an ass, bring forth a string of naughty associations with animals recalling the expression "stupid [bête] as a painter":[11] *pétarder* is to expose one's bottom [pétard, cul], i.e., to cause a scandal, a fuss, as if kicking up one's heels like a donkey, while *pétarader* is to raise a stink by letting off a series of farts. Bottom and donkey are both asses.

"PatArt" is a two-syllable word with three letters in each—like Marcel— and begins with the same initial as Picabia, thus showing the bond uniting the two "inseparables" even beyond death. So as to follow the textual implications of "patArt" further, another furrow will have to be ploughed in this field.

We should probably go back to 1912 and link three events. The first is the flight to Chartres that Gabrielle Buffet-Picabia took sometime before March, sitting on a bicycle seat in a small plane piloted by Henri Farman, the champion cyclist and one of the pioneers of European aviation.[12] The second is a wash drawing entitled *Aéroplane*, which Duchamp did at the end of his trip to Munich, in August-September. And the third is what he said to Brancusi and Léger at the Salon de la Locomotion Aérienne in Paris, in October or November: "Painting's washed up. Who'll do anything better than that propeller? Tell me, can you do that?"[13] Dated from the crucial year 1912, these three authenticated events show the stake that Duchamp had in art in general, and in painting in particular. Not only can we see in these related events a prefiguration of the first readymade (*Bicycle Wheel*, 1913), but we might also want to associate the shape of a propeller blade to that of a tube of paint, or of two tubes of paint—let's say, red and blue— since a propeller blade [une pale d'hélice] textually evokes a minimal palette.[14] Duchamp chose the complementary colors red and blue for *Fluttering Hearts* (1936) and later used them to "explain" the origin of ready-

mades in the long interview he gave to Georges Charbonnier in 1960–1961.[15] The fact that both the wooden airplane propeller and the bicycle wheel—mounted on a kitchen stool also made of wood—turn and fan the air only accentuates the rift (painting/nonpainting, art/non-art) brought about by the substitution of readymades for painting. But in French a palette is also a paddle: *Glider Containing a Water Mill (in Neighboring Metals)* (1913–1915) proposes a mill wheel with eight paddles. It is also the first work (with *Three Standard Stoppages*) to use glass as a support. Duchamp spoke about this in 1966:

Cabanne: *How did the idea of using glass come to you?*

Duchamp: *Through color. When I had painted, I used a big thick glass as a palette and, seeing the colors from the other side, I understood there was something interesting from the point of view of pictorial technique. . . . The glass, being transparent, was able to give its maximum effectiveness to the rigidity of perspective. It also took away any idea of "the hand," of materials. I wanted to change, to have a new approach.*[16]

At the very moment when, in New York, *The Bride Stripped Bare* was first being transferred onto two large panes of glass, *In Advance of the Broken Arm* spoke of this "hand." Since "palette" is etymologically derived from *pelle* [shovel], should we not accept that this shovel replaces the palette in its peculiar way, implicitly stating the simple but radical definition that Duchamp would give of the readymade in 1963: "a work of art without an artist to make it,"[17] that is, without the artist's hand or arm (which is now broken).

The use of two complementary colors appears for the first time in *Pharmacy* (1914), calling to mind both the green and pink colors of the pear- or egg-shaped bottles once displayed in drugstore windows and the colors of the anaglyphic process. In *Pharmacy*, however, the image does not appear in relief; the stereoscopic picture necessitating complementary colors has been replaced by one industrial reproduction of a winter landscape, with the addition of 2 × 3 touches of green and pink paint. Note the double equivalence: anagly*ph*/*autography* (photography) and anagly*ph*/*art, ma cie* (pharmacie), both articulated by the cleaving "ph" (two graphemes for one phoneme: the "f" of relief).[18]

A well-known aphorism signed "Rrose Sélavy" should be analyzed here: "On demande des moustiques domestiques demi-stock pour la cure d'azote sur la Cote [sic] d'Azur" [Wanted: domestic mosquitos demi-stock for the nitrogen cure on the Côte d'Azur]. Appearing on the poster entitled *Monte Carlo Bond* (1924) (fig. 10.3) is a partial version of this text ("moustiques-domestiquesdemistock"), and in *Anémic Cinéma* (1925–1926) the complete text can be seen spinning around. Concerning the first segment of the aphorism, is it necessary to recall that only female mosquitos are hematophagous (i.e., depend on blood as a source of protein for their eggs), and are able to double their own weight (note the double "r" in Rrose) with just one meal? In order to prevent the blood from coagulating when they puncture their victim's skin, they inject a small amount of their saliva, which contains allergenic proteins that cause itching. Concerning the last segment of the aphorism, let me quote a recent book on sea water therapy:

It was only at the end of the nineteenth century that different sea water therapeutics achieved a certain prestige through the works of René Quinton. René Quinton published his major work, L'eau de mer, milieu organique, *in 1904. In this he set forth the hypothesis that the first living cell came out of the marine environment. He is probably the first to compare blood plasma with sea water. . . . The first International Association for Sea Water Therapy was founded in France in 1913, and they held their first convention in 1914, in Cannes.*[19]

Whether the association of blood plasma with sea water prompted the connection mosquitos/French Riviera, or whether the name of the place, Côte d'Azur, prompted the spoonerism "cure d'azote," the nearly paradise-like climate of the region between Menton and Toulon seems to have offered only phonic torture (-ote/-ure) inflicted by a demi-stock of biting mosquitos.[20] For the mosquitos were domesticated, clustered on the poster as a "fond de sûreté" [fond/background, fonds de sûreté/security fund] that was really meant for the stockholders of the *Monte Carlo Bond*.[21] Between the beginning of 1924 and the end of 1925, Duchamp made several trips to Monte Carlo to try "a cumulative system which is experimentally based on one hundred thousand rolls of the ball" (*SS*, 185). In a letter to Picabia (April 17, 1924), he wrote:

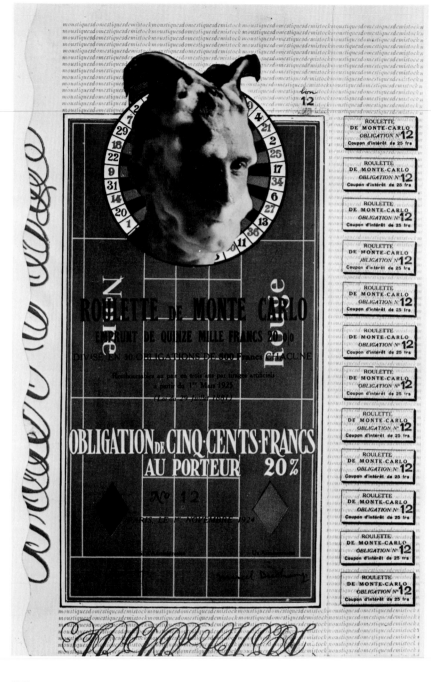

10.3
*Obligations de la roulette de Monte
Carlo* [*Monte Carlo Bond*], 1924, photo
collage on colored lithograph, 12¼ × 7¾
in. (The Museum of Modern Art, New
York; gift of the artist.)

It's delicious monotony, without the least emotion. Moreover, the problem consists in finding the red and black figure to set against the roulette. The winning formula [martingale] is without importance. They are all equally good and bad. But with the right figure, even a bad formula can work. And I think I've found the right figure. You see, I haven't quit being a painter; now I'm sketching on chance.[22]

Lovingly,

Rrose Sélavy

He returned to the same subject in a letter (January 16, 1925) to fashion designer and art patron Jacques Doucet:

I have studied the system a great deal, basing myself on my bad experience of last year. Don't be too skeptical since in this case I believe I have eliminated the word chance. I would like to force the roulette to become a game of chess. A claim and its consequences: but I would like so much to pay my dividends.

In another letter to Doucet (probably June 1925), he drew up a sort of inventory:

The temperature that the local people find hot is simply bearable. Beautiful sun peeking through the clouds. So I hope to be here for 3 months. I have begun to play; and the slowness of my progress in more or in less is a test of patience. I'm breaking about even, and I'm marking time in a disturbing way for the said patience. Well, whether I'm doing that or something else . . . I'm neither ruined nor a billionaire and will never be either.

The shift from painting (positive element) to chance (negative element) to chess (positive element) is obvious enough. The winning formula [martingale] is perhaps without importance, but it suggests an even richer polysemy: referring to garments, a *martingale*, which in French is also called *une patte*, is a half belt, a band sewn horizontally on the back of an overcoat or a jacket; referring to roulette, a martingale is a tactic of doubling the stake after each loss. So, roulette becomes the underground link between painting and chess, *la patte* (the painter's hand or "paw") linking via *la patte* (or *martingale*) to *le pat* (or stalemate), a position in chess where no move can be made without putting the king in check, and which determines an automatic draw.[23] Whereas the *martingale* is without importance, chance

(le has*ard*) should be eliminated by exploiting the inexhaustible "mines" and "figures" on the French Riviera. From the beginning of the venture to its end in a stalemate, the transformation of roulette into chess bears a discrete signature: who but Duchamp, Marcel could hide in *d*elicious *m*onotony and *d*omestic *m*osquitos?

And the roulette [wheel], hypogram of *ROUe de bicycLETTE*, turns! Once more, the small ivory ball would fall into the bowl.[24] Duchamp probably recalled this a quarter of a century later when he wrote to a group of Surrealists gathered in a café around André Breton, proposing *Retour d'ivoire* as a title for a magazine that never came out.[25] This title, starting with the notion of *tour d'ivoire* [ivory tower]—a state of withdrawal and refusal to compromise oneself—and promising a clearer look [d'y voir plus clair] by reviewing the review's title and turning it on itself, seems to identify Duchamp himself. His unwillingness to compromise was skillfully described by Michel Sanouillet in the preface to *Marchand du sel*, written in 1958:

Helped by a friendly nature, Duchamp has known how to cultivate the friendship of painters and writers of very different persuasions who leave no doubts about their mutual antipathies. He sees one group, listens to another, and speaks out with his courteous authority. It is no doubt this talent of committing himself without compromising himself which has earned him the high esteem of the American art circles.

And what does "committing oneself without compromising oneself" mean if not to place oneself in a critical situation (by exposing oneself to the onlooker) without putting oneself in danger? In 1919, Duchamp had already proposed a title for a magazine that was to have been run by Céline Arnauld but that never appeared either: *M'amenez-y*. Here he seemed to be saying: take me along to that point of amnesia [amenez-moi à l'amnésie], that point of no return where I could put into practice the rule that I set myself in the *Green Box*: "To reach the Impossibility of sufficient *visual* memory, to transfer from one like object to another the *memory* imprint" (*SS*, 31). Between *M'amenez-y* and *Retour d'ivoire*, that is, between the time when Dada had not yet reached Paris and the time when the Surrealists had already returned from their exile in the U.S., Duchamp went from one extreme (the no return) to the other (the return), while in both cases

maintaining contact with the onlooker, by way of the imperative in the title of the first magazine and the infinitive in the title of the second.

It is therefore not surprising that at some time Duchamp should show his hand, despite his litotes and even his silence, as he did in this letter (March 8, 1956) to Jehan Mayoux regarding the onlooker and (his) language:

All of these twaddles, existence of God, atheism, determinism, free will, societies, death, etc., are but pieces in a game of chess called language and are only amusing if we are not preoccupied by "winning or losing this game of chess." As a good "nominalist," I propose the word Patatautologies, which will, through frequent repetition, create the concept that I have tried to express by these execrable means: subject, verb, complement . . . , etc.

With "Patatautologies," the shift language/chess (already seen in 1952: "while all artists are not chess players, all chess players are artists")[26] receives a more general and radical expression. In this game, amusement is what Duchamp designated elsewhere as humor, and the probable outcome is a situation in which one is not preoccupied by winning or losing, ending in a stalemate [pat]. "Patatautologies" borrows its first syllable, as "patArt" had, from "stalemate" in the game of chess and fuses it to "tautologies," as "pat" and "art" were fused together or, in 1959, as "an" and "artist" were fused together into "anartist." With "Patatautologies," Duchamp distanced himself from "the philosophical clichés reworked by each generation" (as he said in the letter quoted above), just as he had distanced himself from the "current pomposity" with "patArt."

It is also by borrowing the prefix pata- that he coined the two neologisms. He was plagiarizing Jarry and, like all good plagiarizers since Lautréamont/ Ducasse, appropriated him to his own advantage. Though a study of the perhaps misleading analogies between Jarry's Pataphysique and Duchamp's oeuvre remains to be done, it is my feeling that the artist who said "There is no solution because there is no problem" would not accept Pataphysics— which is, as Jarry said, "the science of imaginary solutions"—at face value.[27] And when Duchamp wrote in the 1950s "Bien pataphysic à vous" ["Yours pataphysically"] on a photograph of himself, hair loose and pipe in hand, he undoubtedly changed the spelling to make it fit certain words from his work (like mâlic and anémic), but he also left the reader on an ambiguous *sic*.[28]

Thus the common denominator between "patArt" and "Patatautologies" is art as tautology, *sic*. This is a rather negative view of art. According to Duchamp the nominalist, there is only one word that fits a thing, and that's its name; all one can say of this thing is that it is what it is. "Patatautologies" is, by ironical nominalism, the metatextual name of the twaddles of the onlookers, just like "pode bal" [balls], a 1921 telegram, was the name of the non-activity of the artist. Everywhere we find tautologies, the same taste for clichés, repetition, and death: et patati, et patata [and so on and so forth]. But the epitaph "Besides, it's always the others who die," an aphorism suggesting a similarly boring repetition, is a more euphoric version of Duchamp's nominalism. Empty words regain their meaning, as in this unpublished letter (December 5, 1964) to Alain Jouffroy: "I read *Une révolution du regard* eagerly since your lucidity reconciled me 'tremendously' with the (written or spoken) word."[29] This redistribution, perpetually renewing the cleavage art/ard, finds its humorous validation in the creative act. On the author's side, the constantly hidden signature (Mar-cel Duchamp and its heteronyms) tends to turn all areas of his work into a vast auto(bio)graphical country, an immense but scattered self-portrait. On the viewer's side, there is my testimony, my way of answering the question of the construction of an object (whether painting, art, readymade, aphorism, for example), fueled by the ardor [ardeur] of the onlooker [regardeur].

Art, or "the personal 'art coefficient' contained in the work" (*SS*, 139), has the same pertinence for this writer as ardor has for the onlooker. The signifier "tr," which Duchamp told Pierre Cabanne was "*très* important,"[30] may well embody his personal art coefficient and offer a link between the signifiers "art" and "ard" that can be spotted throughout the works from 1910 onward, indelibly marking *The Bride Stripped Bare* (Boîte Verte/ Grand Verre and reta*rd*, *tr*ois /mè*tr*e and hasa*rd*, for example) as well as the readymades (*tr*ébuchet and ha*tr*ack, cana*rd* and Leona*rd*o, for example). However, it was only at the beginning of the 1950s that the cleaving art/ ard became explicit, displayed in *Objet-dard* (by way of "dart" in English, one meets "d'art" in French) and in patArt/patArder (by way of "tarder" [to be late], one meets "retard"). This "tr" is nevertheless the most hidden feature of "Lits et ratures" [beds and deletions], which, in one 1922 number, replaced the title of André Breton's magazine *Littérature*. Indeed, read anagrammatically, "Lits et ratures" yields: *tr + it + les autres*. The

mysterious *it* is to the author's personal art coefficient what *les autres* [the others], the onlookers, are to posterity forever reviewing *it*. Between them, the mute, unpronounceable signifier *"tr"* is engendered and eliminated through writing, a surge of creation and annihilation, something partaking of both Eros and Thanatos.

In a letter (February 6, 1950) to Michel Carrouges, Duchamp wrote the following about the *Large Glass*:

As to the rest, I can swear to you that I never considered introducing a basic theme explaining or provoking certain "actions" on the part of the Bride and the bachelors. However it is probable that my ancestors made me "speak" like them, of what my grandchildren will also say.

In 1963, on the other hand, he replied to William Seitz: "There won't be any difference between when I'm dead and now, because I won't know it."[31] Doesn't the equivalence drawn between "my ancestors" and "my grand-children" establish that "there won't be any difference between 'now' and 'when I'm dead'"? It is up to others to reestablish that difference "apropos of Marcel—or of my-R-self."[32] Since *it* only happens to others, the onlooker is on his own as a subject. As in the case of the "family" seen in the rebus *Nous nous cajolions* (1925), "ancestors" and "grandchildren" are gathered at the zoo: au zoo-tr/aux autres.

Will patArt [stalemate art] keep death at bay? Will "échecs-art" [chess-art, but also failure-art] elude checkmate? Duchamp's solution is to let roulette become, like chess and of course like art and language, a game between two people, the artist and his posterity. This is "a game," says Hubert Damisch, "in which the problem is not to succeed in blocking the system but rather in trying to keep the machine working as long as possible without giving up the fight."[33] This stalemate is like the ultimate and perhaps pathetic equilibrium where the failure to attain the freedom not to die is humorously acknowledged, a reading that is suggested by Duchamp's 1958 aphorism, "et qui libre?" [and who [is] free?].

The same stalemate is symbolized by the opened-closed *Door, 11 rue Larrey* (1927) with its two 1s joined in the address pointing out this equivalence.[34] I might add, without concluding, that the only game of chess that Duchamp made a fuss about was a draw that he played against Tartakover in 1928.

Une cinq chevaux qui rue sur pignon.

Il y a celui qui fait le photo-graphe et celle qui a de l'ha-leine en dessous.

La mode pratique, création Rrose Sélavy : la robe oblongue, dessinée exclusivement pour dames affligées du hoquet.

Étrangler l'étranger.

À charge de revanche ; à verge de rechange.

Du dos de la cuiller au cul de la douairière.

Abominables fourrures abdominales.

Parmi nos articles de quincaillerie paresseuse, nous recommandons un robinet qui s'arrête de couler quand on ne l'écoute pas.

Ovaire toute la nuit.

Paroi parée de paresse de paroisse.

Il faut dire :
La crasse du tympan, et non le Sacre du Printemps.

Le système métrite par un temps blennorragieux.

Des bas en soie... la chose aussi

M'amenez-y.

Lits et ratures.

10.4
Morceaux moisis [*Written Rotten*], 1920–1939. Lithograph, two of four pages, black on violet-lined music paper, each 12⅝ × 9⅝ in. From the *Box-in-a-Valise* (fig. 7.1).

The 44 moves—two 4s like the two 1s in the address—are listed, in two columns of 22 moves each, on a page that Arman sandwiched between two sheets of polyester. The title is simply *Chess Score* (1965). It is a bit like a detached object, like a D.-chess [D.-échecs, déchet/waste] shrouded in transparency—much like that of the *Large Glass*.

Là tu te dégages/Et voles selon
[There you free yourself/And fly accordingly]
Rimbaud, *L'Eternité*

From 1912 onward, Duchamp sought to devalue at any cost the idea of *la patte*, to "discredit the idea of the hand-made" ["démonétiser l'idée de la main"], as he told Otto Hahn in 1966.[35] I want to put the emphasis not on *la patte*, this time, but on the associations with money that the word "démonétiser" conveys. Duchamp wrote in the 1914 *Box:* "the arrhe of painting is feminine in gender" (*SS*, 24), substituting the five-letter feminine word "arrhe," in the singular ("arrhes" [deposit] is a word that exists only in the plural), for "art," a three-letter word that is masculine in French. Such a substitution is an example of what he called "subsidized symmetry" (*SS*, 49), that is, symmetry funded by the economy of the text.[36] Now this text, which when read in full contains the equation "arrhe/art = merdre/merde," has a surprise in store for the reader, revealing what may be called its infratext.[37] If one handles the equation like one would an ordinary division problem, crossing out all the common letters found above and under the division line, one is left with the letters *h*, *e*, and *t* forming the equation *he = t*. If these letters are read aloud in French, as in *L.H.O.O.Q.*, one pronounces "acheter" [to buy], or "acheté" [bought]. In the infinitive, it is an instruction; in the past participle, it is a fact, a fait accompli.[38]

Without its first letter, "merdre" is a five-letter palindrome, as "Ubu" is a three-letter palindrome. So amputated, King Ubu's favorite expression would leave behind the letter "M," which is also the first in "Munich" [m'unique, me only, me single], where Marcel went on an important trip in the summer of 1912. Perhaps this trip was recalled in the aphorism "J'offre et l'allemande" (*N*, 252) that was written probably around 1960. "J'offre et l'allemande" [I supply and the German woman] is an exact spoonerism on "l'offre et là je mande" [the supply and there I summon]. Thus, this individual (je), whose particulars [signalement] are to be read

from some "signe allemand" [German sign], summons someone whose initial is necessarily D so as to reestablish the law of supply and demand (l'offre et la *demande*), which is the infratext of the spoonerism. The summoning happens on the marketplace where the arrhe of (his) painting is exchanged for liquid currency. Liquidity should be understood in the light of such Jarryesque neologisms as "merdre" and "phynance." "Phynance," which is to "finance" what "merdre" is to "merde," and thus what "arrhe" is to "art," refers to liquid excrement, as was pointed out by Michel Arrivé:[39] indeed, the Duchampian neologism "arrhe" is a hypogram of "diarrhea." Finally, to complete the set of associations, "liquid" should also be understood as echoing another note from the 1914 *Box:* "On n'a que: pour *femelle* la pissotière et on en vit" [One only has: for *female* the public urinal and one lives by it] (*SS*, 23).

Anagrammatically, the letters *h, e, t* form the definite article, "the" (one of the most frequent words in the English language), which is the object of Duchamp's first text in English, precisely entitled *The*, written in the fall of 1915 (fig. 10.5). In this text, "the" is replaced thirteen times by a five-sided asterisk, and all thirteen times it is used in the singular, being therefore translatable only into "le" or "la," and not into "les."[40] The first and last sentences in this text allude to writing (linen/line, ink, wood) and to listening (listening-place). As a signifier, the word "asterisk" can be read out of the first sentence as an anagram (ink + a sister = asterisk in) and is understood as a signified in the last sentence, which speaks of four dangers (= has the risk). But whereas the asterisk replaces the definite article, these four dangers are introduced by the indefinite article; there is one in each sentence but the last, reading in this order: *a sister, a chance, a great many cords, a wife*. The first and the last of these four dangers are family-related—a sister and a wife—while the two in the middle concern the work—a chance (as in the *Three Standard Stoppages* and the *Monte-Carlo Bonds*), and a great many cords (as in *With Hidden Noise* and the aphorism "electricity breadthwise" [*SS*, 23]).

These dangers, so gathered two by two, are undoubtedly evoked in the title of a readymade that appeared at the end of 1915: *Emergency in Favor of Twice*.[41] The object attached to this odd title is unknown (at present) but the title itself, coined by someone who was then learning English and who might have looked up dictionary examples of phrases using the word

<u>The</u>

If you come into ✶ linen, your time is thirsty because ✶ ink saw ~~some~~ wood intelligent enough to get giddiness from a sister. However, even it should be smilable to shut ✶ hair ~~of~~ whose ✶ water writes always plural, they have avoided ✶ frequency, mother in law; ✶ powder will take a chance; and ✶ road could try. But after somebody brought any multiplication as soon as ✶ stamp was out, a great many cords refused to go through. Around ✶ wire's people, who will be able to sweeten ✶ rug, ~~that is to say~~ why must every patents look for a wife? Pushing four dangers near ✶ listening-place, ✶ vacation had not dug absolutely nor this likeness has eaten.

remplacer chaque ✶ par le mot: the

"emergency," seems to say that he ought to be ready for every emergency, that he must meet the emergency, or that he must rise to the emergency. These phrases are useful in understanding what was at stake in this "danger," this "crise" [crisis], two words that Duchamp himself proposed as a quick translation of "emergency."[42] Was the missing object perhaps the readymade corresponding to the note, "Make a sick picture or a sick Readymade" (*SS*, 32), or was it the remedy for such sick readymades? *Pharmacy* (1914) and *Why Not Sneeze . . .* (1921) indicate that Duchamp certainly explored such directions.[43] According to Littré, a crisis is etymologically "the action or faculty of distinguishing" [l'action ou la faculté de distinguer] the path toward the denouement, the final cathartic phase. It wouldn't be surprising should *Emergency in Favor of Twice* untie a particularly tight knot pertaining to Duchamp's very personal relation to painting and to the readymades. About the replicas of Duchamp's works in general, and of the readymades in particular, Robert Lebel has said that they "are not so much works as they are attributes," and that they "mediatize bonds too intimate to be bearable."[44]

In 1912, *Nude Descending a Staircase* was the first painting not to conform to the expectations of the art scene; in 1915, *In Advance of the Broken Arm* was the first readymade to coincide with the generic name "readymade." In the case of the *Nude*, only when the painting was rehabilitated, during the Armory Show in 1913, did a question arise that Duchamp had in fact already resolved: was this nude masculine or feminine?[45] Both. The *Nude* already embodied a way of using "le" and "la" not as definite articles (the) but as personal pronouns and complements (him/her): him-hergency. In the case of *In Advance of the Broken Arm*, it is not only both snow and the shovel [la pelle], but also, intertextually via Mallarmé, the call [l'appel] to the swan stuck in ice, that lead us to the verb "to ice." In the infratext lying under the expression "to rise to the emergency" and the expression "to ice," "twice" can be heard: this goes from the double *h* in "him-hergency"[46] to the double *u* in "twice." The snow shovel is, in the etymological sense, a provocation (pro + vocatio), in other words, "an anticipated call to the recognition of the subject."[47] An upper limb and a weapon are both arms. By inadvertency (in advance + hurt), the arm got broken. Hence an "emergency in advance of twice": the subject's anticipated call for recognition is engraved in the 2 × 3 grooves on the blade of the shovel,

designating the 2 × 3 letters in Duchamp's first name, Marcel. Hence also, "reciprocally," an "inadvertency in favor of the broken arm": the subject's first name gets repeated in the acknowledgment of the cleavage splitting it: MAR/CEL.

"Find inscription for Woolworth Bldg. as readymade" (*SS*, 75) is another project, dated January 1916. Craig Adcock has called attention to the fact that this building, erected between 1913 and 1918, would become the tallest skyscraper in New York at the time.[48] In the very first (?) interview that Duchamp gave, published in September 1915, he spoke of its (neo)Gothic appearance and of its immensity. The conflation of Gothic art— the epitome of religious art—with the biggest of all five-and-dime stores brings to mind the "indispensable vulgarity" that Duchamp valued. The pun on "art gothique / argotique" [Gothic art / slang] perhaps allowed him to consider that the building's height—like the height of a Gothic cathedral—was not an end in itself but a means of reaching elsewhere, higher and farther, making this potential readymade, whose immensity rose above the immense city, worthy of becoming art. As you would say a "book worth reading," it would be a "wool worth building."[49]

Eventually, the Woolworth Building became the cathedral of capitalism, and its construction took five years. To turn it into a cathedral of art, Duchamp was content to call it a readymade. This extreme reduction of activity has everything to do with the laziness of the "inhabitants of the infra thin" (*N*, 34) as well as with inertia, i.e., etymologically, with the absence of art.[50] The most laconic of all of Duchamp's works is a print bearing the rather spiritual, almost religious title *Première lumière* [*First Light*], but simply stating the bluntest negation: "NON" (fig. 10.6) This short palindrome is written in one direction and can be read in the other, and is also the least expensive way to call on the onlooker (the Other) to complete the work, to turn non-art into art. Where M(arcel) says "no," it is left to the Other to negate that negation in turn, and thereby to produce in the infratext the word "mother." From the very beginning of Duchamp's career as an "arrhetist," mother had been the metaphor for the arrhe of painting which, as we remember, is feminine in gender. When the lazy artist abandoned it in favor of readymades, he perhaps performed what a 1922 aphorism would later prescribe: "Un incesticide se doit de coucher avec sa mère avant de la tuer" ["An incesticide must sleep with his mother

before killing her"]. And in the infratext we find "l'autre" as an anagram of "la tuer." The ruse is thus also the conclusion, as on the epitaph: "Besides it's always the others who die." One must travel by *M.E.T.R.O.* (1963) from one end of the work to the other to realize that *M.E.T.R.O.* is the anagram of "morte" [dead]. Meanwhile you, the onlooker, must "love your heroes" [aimer tes héros]. Who are they, if not the MARiée and the CELibataires, namely, Marcel? At this point, there is no longer any question of the artist or even of the "arrhetist": "There is no solution because there is no problem." Exactly so.

Tel qu'en Lui-même enfin l'éternité le change

This verse by Mallarmé, placed here as a closing epigraph, can be endorsed in the brief but implacable framework of the creative act only if "l'éternité" is heard as *L'Eternité*, the already twice quoted poem by Rimbaud, only if modernity as understood by Rimbaud and, before him, by Baudelaire, is taken literally—that is, to the letter in the phonic and graphic sense. This implies an infinite number of ruses, intertextual calls, and transformations.[51] Here is, for the rest of *eternullity*,[52] the game of this nulArt, a

10.6
Première lumière [*First Light*], 1959.
Etching, 4¹³⁄₁₆ × 5⅞ in. (Private collection; photo Philadelphia Museum of Art.)

"nothing perhaps . . . capable of all the eccentricities" (*SS*, 28)—an intertextual gamble. It goes without saying that I have taken care to be *tiré à 4 épingles* [dressed to the nines] in order to *pull* this text *at four pins*.

10.7
Tiré à 4 épingles [*Pulled at 4 Pins*], 1959. Etching, 4½ × 4½ in. (Galleria Schwarz, Milan.)

Notes

The texts by Marcel Duchamp are from the following editions: *Duchamp du signe,* cited here as *DDS* (Paris: Flammarion, 1975); *Salt Seller,* cited here as *SS* (New York: Oxford University Press, 1973); *Marcel Duchamp, Notes* cited here as *N* (Paris: Centre National d'Art et de Culture Georges Pompidou, 1980). The texts quoted from unpublished letters come from the manuscripts. The texts quoted from letters already published have been revised using the original sources.

Several analyses that appeared in André Gervais's *La raie alitée d'effets. Apropos of Marcel Duchamp* (Montreal: Hurtubise HMH, 1984), abbreviated here as *La raie . . . ,* have been revised, reformulated, and reorganized in the present paper.

1 Duchamp's quote is preceded by the following comments (by Julien Levy): "An *ideal* shoemaker no longer makes shoes, but ideas in his medium. He is divorced from his material objective and, like a madman, he would cut leather and sew leather and choose leathers like a runaway engine, except that he has an idea." As in *Fresh Widow* (1920), the leather calls for the letter. And as in *In Advance of the Broken Arm* (1915), injury will result from ideas divorced from material objectives (you will aim/you will lame).

2 Gabrielle Buffet-Picabia, *Rencontres avec Picabia, Apollinaire, Cravan, Duchamp, Arp, Calder* (Paris: Belfond, 1977), 232.

3 To Pierre Cabanne, in 1966, in *Dialogues with Marcel Duchamp,* trans. Ron Padgett (New York: Da Capo Press, 1987), 88.

4 To Katharine Kuh, in 1961, in *The Artist's Voice: Talks with Seventeen Artists* (New York: Harper & Row, 1960–1962), 83.

5 Pierre Sterckx and Vincent Baudoux, "Marcel et mat," in *Marcel Duchamp* (Galerie Charles Kriwin, Brussels, October 1974), 15.

6 For a more detailed account, see *La raie . . . ,* 3–12, and also my article, "D'une proposition la même, par cette part en elle de l'autre," *Protée* (Chicoutimi) 14, no. 1–2 (issue entitled *La lisibilité*) (Spring-Summer 1986), 127–131.

7 "A Complete Reversal of Art Opinions by Marcel Duchamp, Iconoclast," *Arts and Decoration* (September 1915); reprinted in *Studio International* 189, no. 973 (January/February 1975), 29.

8 Although one might express some doubt about this if one judges from the letter (February 11, 1962) Duchamp wrote to Marc Le Bot: "The few polemic discussions were probably the same as those of fifty years ago, using different words. Picabia and I already had developed our attitude of opposition to the very idea of any valid theory, knowing how far it is from the lips to the grey matter." In Marc Le Bot, *Francis Picabia et la crise des valeurs figuratives* (Paris: Klincksieck, 1968), 51.

9 Thierry de Duve, "Le temps du ready-made," *Abécédaire. Approches critiques,* third volume in a four-volume set devoted to *L'oeuvre de Marcel Duchamp* (Paris: Centre National d'Art et de Culture Georges Pompidou, 1977), 181. See as well (p. 183): "Humor outwits death in the death instincts and makes chance sparkle in wit and spoonerisms. Humor is what places chance at the base of repetition, like a positive principle." Which approaches what Duchamp said to Otto Hahn ("Marcel Duchamp," *L'Express,* no. 683 [July 23, 1964], 23): "I have the greatest respect for humor, it is a safeguard that allows one to pass through all mirrors."

10 *Médium,* no. 2 (February 1954), 12. Picabia died on November 30, 1953. There is a twofold reference to Jarry that is relevant for those years: on the one hand the *Expojarrysition* at the Jean Loize bookstore in 1953 (see the review by André Pieyre de Mandiargues in *La Nouvelle nouvelle revue française* 1, no. 6 [June 1, 1953], 1130–1132), and on the other hand Duchamp's presence since August 1952 at the Collège de Pataphysique where he would join the Satrapes group in May 1953; Man Ray, Leiris, Ernst, and Queneau, for example, also belonged to the group.

11 In 1946, for example, Duchamp said to James Johnson Sweeney: "This is the direction in which art should turn: to an intellectual expression, rather than to an animal expression. I am sick of the expression 'bête comme un peintre—stupid as a painter' " (*SS,* 126). Although this expression is not found in dictionaries, Jacques Cellard (whom I met in Paris in July 1986) told me that it was probably to be found in Balzac and therefore dates back to the first half of the nineteenth century. Duchamp himself traces it back to the time of *Scènes de la vie de bohème* (1848) by Henri Murger (see *DDS,* 236). According to the *Dictionnaire des locutions françaises* by Maurice Rat (Paris: Larousse, 1957), "bête comme une oie" [silly as a goose] is one of its variants. This prompts me to add that Apollinaire in *Le poète assassiné* wrote: "*Pata,* which means goose, or the male organ, as one wishes" (Paris: Gallimard, 1916, p. 21). The fact that gander [jars, in French] recalls the name Jarry, who initiated Pataphysics, the fact also that a goose describes a silly person and that the male organ is also called, among many other names, a "bite," all refer back to the ryme "bête comme . . ." Finally, let me add that in Spanish "pata" means both paw and (human) leg, "patada" kick, and "pata de gallo" stupidity, blunder, or—lo!—asinine.

12 This important flight (which she recalled in an unpublished interview, recorded in October 1978 by Pierre André Benoit, and which he was kind enough to play for me at his home in November 1984), took place in 1912 before Marcel painted *Two Nudes: One Strong and One Swift* (March 1912). She remembered this as being followed by long discussions between her and the three Duchamp brothers. In her opinion, these discussions, more than the Roussel play Duchamp attended some months later, would lead to a change in Marcel's personality.

13 The declaration to Brancusi and Léger was reported by Fernand Léger in an interview with Dora Vallier, which took place in 1955 and appeared in one of the issues of *Cahiers d'art* (dated 1954, but in fact published in June 1955), and which was later republished in Dora Vallier, *L'intérieur de l'art. Entretiens avec Braque, Léger, Villon, Miro, Brancusi (1954–1960)* (Paris: Seuil, 1982), 63.

14 Concerning the first readymade, see André Gervais: "*Roue de bicyclette.* Epitexte, texte et intertextes," *Les Cahiers du Musée national d'art moderne,* Paris, no. 30 (Winter 1989), 59–80.

15 I rely on Thierry de Duve's demonstration in *Nominalisme pictural. Marcel Duchamp. La peinture et la modernité* (Paris: Minuit, 1984), 234–277. The passage from the unpublished interview with Charbonnier is quoted on p. 247.

16 Pierre Cabanne, *Dialogues,* 4l–42. See also pp. 105–106: "I often repair objects. . . . It's fun to do things by hand. I'm on guard, because there's the great danger of the 'hand,' which comes back, but since I'm not doing works of art, it's fine."

17 In an interview with Francis Roberts: " 'I Propose to Strain the Laws of Physics,' " *Art News* 67, no. 8 (December 1968), 47.

18 I repeat here, with what appears to me to be an important variation, Ulf Linde's decisive play on words ("MARiée CELibataire," *Marcel Duchamp/Ready-mades, etc. (1913–1964)* [Milan: Galleria Schwarz, and Paris: Terrain vague, 1964], 56): *Pharmacie/*Phares, ma Cie [Lights, my Company]. It is at the meeting point between "-cie" and "vert" [green] that one must place the winter [h*iver*] landscape; at the meeting point of "*vert et rose*" [green and pink] that one must place the st*éréos*cope; at the meeting point of "anagl*yphe*" and "*phot*ographie" that one must place the inverted first name of the Swiss painter who painted this landscape: *Sophi*e de Niederhausern (in spite of Duchamp's most probable ignorance of it). It is at the meeting point between the two lights seen "on the horizon," at "dusk," through the train window [*vitre* du *train*] that brought Duchamp to Rouen, and the bottles in the front window [*vitrine*], that one must place the bachelor component (bottles that bring to mind the malic molds and invoke the illuminating gas). In a note from the *White Box* (*SS,* 76), Duchamp briefly refers to the assisted readymade *Pharmacy* as being "the painting of Dumouchel," Duchamp's friend since his lycée days in Rouen (where this reproduction was chosen at an art supply shop). Another meeting point is thus established between canvas and readymade on the one hand, between *Pharmacy* and Dr. Dumouchel on the other.

19 Jacques-Bernard Renaudie: *La thalasso-thérapie* (Paris: Presses universitaires de France, 1984), 10.

20 In the restricted teleintertext, this torture is exerted from head to foot: "Aiguiser l'ouïe (forme de torture)" [Sharpened hearing (form of torture)], says an aphorism published in 1939; *Torture-morte* is the title of a 1959 cast of a foot.

21 See Robert Lebel, *Sur Marcel Duchamp* (Paris: Trianon Press, 1959), 50. The translation "background of the bond" (by George Heard Hamilton, *Marcel Duchamp* [New York: Grove Press, 1959], 50) misses the pun [fond/fonds].

22 In a letter (July 16, 1866) to Théodore Aubanel, Mallarmé uses an analogous formula (*Correspondance 1862–1871,* ed. Henri Mondor and Jean-Pierre Richard [Paris, Gallimard, 1959], 222): "As for me, I have worked more this summer than in my entire life, and I can say that I have worked for my entire life. I have laid the foundations for a magnificent work. . . . I work on everything at once, or what I want to say is that everything is so well organized in me now that as soon as a sensation comes to me it is transfigured and finds its place in this book or that poem all by itself. When a poem is ripe it will detach itself. You see I am imitating the natural law." Mallarmé was twenty-four years old at the time. Duchamp was the same age upon his arrival in Munich, and his stay there—during which he turned twenty-five—was a determining one in the continuation of his work, "the scene of my complete liberation," he said in *Apropos of Myself.*

23 The "neither-nor" of the draw is inscribed in the text of the letters through equivalents: "all equally good and bad" and "neither ruined nor a billionaire," for example.

24 Ulf Linde ("La roue de bicyclette," *Abécédaire. Approches critiques,* 35–41), has established the relationship between the bicycle wheel and *The Monte Carlo Bond,* as well as with the "handler of gravity" in the *Large Glass* and the canvas entitled *Tu m'* (1918).

25 This title was mentioned for the first time (?) by Pierre Demarne, *Art Artistes. 1947–1977 trente ans d'écrits et conversations sur les arts plastiques contemporains* (Paris: UNPF, 1977), 85.

26 In a speech at a New York State Chess Association banquet (August 30, 1952), cited by Kynaston McShine, "La vie en Rrose," *Marcel Duchamp,* 131.

27 Duchamp's aphorism is in Harriet and Sidney Janis, "Marcel Duchamp: Anti-Artist" (*View,* March 1945), republished in Joseph Masheck, ed. *Marcel Duchamp in Perspective* (Englewood Cliffs: Prentice-Hall, 1975), 37. See *La raie . . . ,* 203 and 392–393. Jarry's definition is in *Gestes et opinions du docteur Faustroll, pataphysicien* [written in 1897–1898, published in 1911], edited by Noël Arnaud and Henri Bordillon (Paris: Gallimard, 1980), 32. Regarding the word "Pataphysique" and its schoolboyish formation, see Noël Arnaud, "Jarry à son ombre même," *Revue des sciences humaines,* no. 203 (July-September 1986), 121–122 and 123.

28 The photograph in question was reproduced to illustrate Michel Leiris's article on the *Green Box* entitled "A propos d'une oeuvre de Marcel Duchamp" (1936) and republished by the *Dossiers acénonètes du Collège de pataphysique* (Paris, 1959), 77.

29 Alain Jouffroy's book, *Une révolution du regard,* was published in October 1964 (Paris: Gallimard).

30 *Dialogues with Marcel Duchamp,* 29 (p. 47 in the French edition).

31 The manuscript of the letter to Carrouges is printed in Jean Clair and Harald Szeeman, eds., *Les machines célibataires* (Venice: Alfieri, 1975), 48. The title of the interview with Seitz is "What's Happened to Art?," *Vogue* 141, no. 4 (February 15, 1963), 113.

32 See *La raie . . . ,* 27.

33 Hubert Damisch, "La défense Duchamp," in Jean Clair, ed., *Duchamp. Colloque de Cerisy* [1977] (Paris, UGE, 1979), 105 (during the discussion following the presentation of his paper). See in particular pp. 70 and 86 of his paper (on the chess/art relationship), pp. 86–87 and 95 (on the chess/roulette relationship), as well as p. 95 and, further on, p. 115 (on the unconscious/ruse relationship).

34 For the relationship that this readymade maintained with the stalemate [pat], see Ronald W. Jones, "Temporal Metaphors and Endgame Theory: Samuel Beckett's *Endgame* and Marcel Duchamp's *Door, 11 rue Larrey*," doctoral dissertation, Ohio University, 1981. Duchamp and Beckett met, almost certainly through Mary Reynolds, at the beginning of the 1930s (see pp. 97–103). Duchamp (in collaboration with Vitaly Halberstadt) wrote a treatise on certain endgames entitled *Opposition and Sister Squares Are Reconciled* (1932), and in 1954–1956 Beckett wrote (in French) a play entitled *Endgame* (first performed in 1957) in which there is reason to believe that he staged some of the proposals from this treatise. See Jones's Chapter IV (especially pp. 219–229).

35 Otto Hahn: "G255300," *Art and Artists* 1, no. 4 (July 1966), 10.

36 In addition to the economy of the text, we might add that of the biotext, a term introduced in 1982 by Jean Ricardou (*Le Théâtre des métamorphoses* [Paris: Seuil, 1982], 188) and which designates the biographic elements required by the act of writing and obeying those rules of the text. Thierry de Duve (*Nominalisme pictural,* 56): "There will be other occasions later on to notice to what extent Duchamp's life and work would have complied with this principle of subsidized symmetry. Duchamp was often the sponsor of a deferred action that came back to him in symmetry from his future."

37 The "infratext" is a term introduced in 1975 by Jean-Pierre Vidal. See his "L'infratexte, mode du génotexte ou fantasme de lecture," *La Nouvelle barre du jour* (Montreal), no. 103 (issue entitled *L'infratexte*) (May 1981), 19–54. See also *La raie . . . ,* 287–297. This term and over seventy others have been collected by Renald Bérubé and André Gervais: "Petit glossaire des termes en 'texte,' " *Urgences* (Rimouski), no. 19 (issue entitled *Le tour du texte*) (January 1988), 7–74.

38 The "solution" to the equation was discovered by a student of Thierry de Duve's, who passed it on to me in 1982.

39 Michel Arrivé, *Les langages de Jarry. Essai de sémiotique littéraire* (Paris, Klincksieck, 1972), 218–223 (article "merdre") and 238–247 (article "phynance").

40 The five-sided asterisk (or star) appears once in *Why Not Sneeze . . .* (1921) on the fastener of the cage door, once in *Tonsure* (1921), and forty-four times in *Rrose Sélavy* (1939), whose subtitle is "Precision Oculism/Rrose Sélavy/New York–Paris/hairs and kicks/of all types." It is a small volume containing forty-four aphorisms separated by an asterisk and framed by two larger asterisks (one at the beginning pointing downward and one at the end pointing upward). Further, the asterisk appears thirteen times in *Genre Allegory* (1943) and, indirectly, three times in the star-shaped tomato leaf in *Sculpture-morte* (1959). For someone with an angrais ear, the asterisk, which also became "asstricks" (*N,* 217), sounds like "arse et attrapes," a hypogram for "assorted tricks" [farces et attrapes], itself short for "ass-oriented tricks." All these puns invoke "Oculism" or, if you prefer, "au cul l'isme" [in the ass the ism].

41 This title, which does not appear in catalogues, is known only through a letter that Duchamp wrote around January 15, 1916, from New York, to his sister Suzanne. The letter, published in 1982 by Francis M. Naumann ("Affectueusement, Marcel," 5), is a good example of the kind of specifics that can be obtained from an exhaustive knowledge of what I call the "parlés" [speakings] (interviews, conversations, discussions, debates), of the correspondence, and of the notes made in diaries and correspondence by the various people who knew Duchamp. I am currently involved in preparing a publication of these "parlés."

42 In order to give his sister Suzanne—who was a nurse during the war—some idea of his work in the U.S., Duchamp proposed to roughly translate *Emergency in Favor of Twice* as "Danger (Crise) en faveur de 2 fois." Should one not read danger as "*deux en jeu ai*" [have two at stake] as proposed by Jean-Pierre Brisset (*Le mystère de Dieu est accompli* [1890; Paris: Navarin, 1983], 91)?

43 On illness, see Carol P. James, "Duchamp's Pharmacy," *Enclitic,* no. 3 (Spring 1978), 65–80.

44 In a text entitled "Dernière soirée avec Marcel Duchamp" (*L'Oeil,* November 1968), republished in *Marcel Duchamp* (Paris: Belfond, 1985), 134.

45 "The search for the nude was on, as if dis-
covery would reveal some great secret.
The *American Art News* offered a $10
prize for the best solution. The winning
entry was a poem called 'It's Only a
Man.'" Milton Brown, *The Story of the
Armory Show* (New York: The Joseph
Hirshhorn Foundation, 1963), 110.

46 The couple "him-her" can be understood
following the model of Marcel-Suzanne,
given the fact that Suzanne was the
addressee of the letter in which Marcel
announced the existence of *Emergency in
Favor of Twice.*

47 Thierry de Duve, *Nominalisme pictural,*
188.

48 Craig Adcock, "Marcel Duchamp's
Approach to New York," 55.

49 Via a series of puns on "la laine," "l'hal-
eine," "là l'aine" [wool, breath, there the
groin], Duchamp picked up the strand of
wool quite often, as in the aphorism
"Opalin, ô ma laine," or in the readymade
Belle haleine (1921) as well as in the
aphorism that comments on it ("Il y a
celui qui fait le photographe, et celle qui a
de l'haleine en dessous").

50 See Jacqueline Picoche, *Dictionnaire
étymologique du français* (Paris: Le Rob-
ert, 1979), 34.

51 One of such transformations on "moder-
nité" is the Jarryesque anagram "merdon-
ité," proposed by Michel Leiris (*Le ruban
au cou d'Olympia* [Paris: Gallimard, 1981],
248). See the entire section (pp. 221–248
and especially 240–241), which discusses
modernity.

52 "Eternullité" was Jules Laforgue's port-
manteau word, to be found in the collec-
tion of poems entitled *Les complaintes:*
see his *Poésies complètes,* ed. Pascal Pia
(Paris: Gallimard and LGF, 1970), 31.

Discussion

Moderated by Thierry de Duve

THIERRY DE DUVE (F)

If you'll allow me André, I need to get this off my chest. I'm rather crushed. You know very well that your work has inspired me tremendously and that I return to it all the time, as I return to that of Jean Suquet, because in it I see someone who wanders, not within the cracks of the *Large Glass* as does Jean, but in the cracks of the text's intertextuality. And I also know as do all of us that the spectators make the pictures, and that therefore we all project ourselves into Duchamp's work—I don't see why I would exempt myself from this sin which is mortal but also absolutely vital. However, I want to remind you of a phrase by Lacan which might be familiar to you. Lacan, if I remember correctly, said somewhere, "les écrits volent, les paroles restent." [Written words fly away, spoken words remain.] That is to say, he has inverted the common adage "verba volant scripta manent." And that's a little like the feeling—if I may tell you as a friend—that I had listening to you. Yesterday you told me, "what makes a reading pertinent is its overdetermination."

ANDRÉ GERVAIS (F)

Right.

THIERRY DE DUVE (F)

I think you're correct. But there's this: when this overdetermination that you've exploited so well is put into writing, the reader—who also makes the text, don't forget—can nibble at it, taking and leaving some. I myself very much taste your book in small bites. Presented orally, the same overdetermination is oppressing though, because there isn't time to let it trigger our own reverie, our unconscious, our own thread of flowing metonyms . . . Excuse me everyone, maybe this wasn't a very elegant way to engage the discussion, but now I'm a little relieved. Can words begin to fly again?

HERBERT MOLDERINGS

Would your approach allow us to describe, in a general sense, the field

in which we have to look for the readymade *Emergency in Favor of Twice?*

ANDRÉ GERVAIS (F)

I don't know much about this readymade. All I know is that Duchamp mentions it in the letter published by Francis.[1] So, in order to try to determine a bit more about it, I simply went to an English dictionary to see what the word "emergency" meant. Proceeding from the dictionary there is a series of interlocking elements. I probably did something similar to what Duchamp might have done when he was learning English (this is the end of 1915–beginning of 1916): looking in dictionaries and finding ready-made expressions with, for example, the word "emergency." So, I have cited some of them which, as chance would have it (but you know what that means), allude to what could be heard from the readymades of this time—made on a new continent and with a language new to him— and even allude to the choice of the word "readymade." If there hadn't been all these resonances of the title *Emergency in Favor of Twice*, I wouldn't have talked about it. But maybe everything that I've proposed is going to be proven false when we have the object associated with this title, if we ever have it.

THIERRY DE DUVE (F)

Personally, I can't help but think that *Emergency in Favor of Twice* is a title provoked, through "commissioned symmetry," by *In Advance of the Broken Arm*. This is, incidentally, the connection that you yourself have established and for which you have given the intertext. And that takes me to the question of titles, or names of readymades, which you spoke about yesterday in relation to Carol's demonstration. In this case the title isn't really the object's name, it's a phrase. Can we imagine that intertextuality extends to the objects themselves, in which case one could perhaps try to reconstitute or guess what this lost readymade could have been?

ANDRÉ GERVAIS (F)

That I don't know. Lévi-Strauss talks about readymades in his interview with Charbonnier, and although he attributes their paternity to the Surrealists in general, he said some things rather precise, like: "it doesn't matter what object nor how," and "it's the 'sentences' made with objects

that make sense." He said "sentences" or "propositions," he didn't say "names."[2] There are propositions, there are objects, and not just any objects; the objects and the propositions are linked, but not within just any sort of context. In this sense it's rather precise. But whether this is license to intertextualize the objects themselves I don't know. Although Linde has shown some "kinship" between the *Large Glass* and the three readymades accompanying it in the *Box-in-a-Valise*, I would tend to think that the *Box-in-a-Valise* isn't an assembly of readymades, as Carol has said, nor a sentence like those Lévi-Strauss might try to construct from some of Duchamp's objects, but rather a museum installation, an installation within a very restricted museum, in the sense that Butor said this museum is the museum of a refugee who prepares for his exit (because he sensed World War II coming), reducing everything to a traveling salesman's briefcase.[3]

THIERRY DE DUVE (F)

And how do you set into play the name "readymade" itself with the fact that Duchamp found it precisely ready-made, at the time when, as you have pointed out, he was learning the English language?

ANDRÉ GERVAIS (F)

My first remark is that the word "readymade," one should not forget, is perhaps a noun with Duchamp, but in English it's a past participle, of which there is a rather good number elsewhere in Duchamp. One says "ready-made garments," and I found "ready-made doors" in a 1916 magazine advertisement. Everybody knows the importance of clothing and doors with Duchamp. A good number of other objects could probably be found, whether of an everyday type or not, which are ready-made in this way. It's a past participle, like "mise à nu" [stripped bare], and therefore enters the paradigm of this grammatical tense fundamentally implied by Duchamp's titles and his wordplay. A second remark is that it's difficult to interpret Duchamp's "spoken declarations" other than in a textual way, as I do.[4] As sources, one must be wary of them. When looking at the Duchamp interviews where he speaks of the *Bicycle Wheel*, the "first" readymade, one realizes that in certain interviews he doesn't say, for example, that it's the first readymade even though in others he says it clearly. Therefore, there's a certain sway in his way of choosing frag-

ments of an ideal response that one could compose from all the propositions that he supplies within the collection of interviews. One realizes that with certain people or under certain conditions he chose to say this rather than that. In the fifties and sixties, when he gave a large number of interviews, he maintained this ambiguity, a variation on "a little game between I and me."

FRANCIS NAUMANN

I'm not really sure I have a question; it's more an objection. I didn't quite understand why the eleven from 11 rue Larrey and the forty-four moves in a chess game were related. I can't imagine that such a coincidental relationship tells us anything.

ANDRÉ GERVAIS (F)

The relation that can be made is textual, in the sense that I hypothesize that the inscriptions, titles, notes—not forgetting even the name Duchamp and his pseudonyms—are fragments of non-narrative texts (although a narrative reading can be made as Jean Suquet has done with the *Large Glass* notes). It's therefore possible to show that from one domain to the other, or even from one work to another in the same domain (I mean the spaces and times of the *Large Glass*, *Etant donnés*, the readymades, and the aphorisms, for example), there are analogies, repeats, inversions, metaphors, and metonyms which deal with the fabrication of a literary text. Whether Duchamp himself declared this as literary or not isn't the problem. It is in this way that the fact that he chose the 1928 chess draw becomes significant. He could of course have chosen games he had won or lost against this or that great master. He chose instead a game which on the one hand was a draw and which, on the other hand, contained forty-four moves (a number consisting in two identical numerals), which he transcribed into two columns of twenty-two moves each. And twenty-two, it's two times eleven. Then he published or exhibited the game vertically, between two plates of plastic, like the *Large Glass* repaired between its two plates of glass. He accumulates relations to all sorts of elements already present among his works and within their intertext, and that justifies my choosing the relation to which you refer.

FRANCIS NAUMANN

All right. Just one minor thing: I think Duchamp must have been proud of the results of his game with Tartakower. Anyone who could manage to pull off a draw against such a renowned chess master should be proud of his or her accomplishment. If I were so honored, you can be sure that I'd have posters made, I'd advertise the event everywhere.

VERA FRENKEL

I had some difficulty with your presentation. It reminded me of a friend of mine who is a theater director and a Shakespeare fetishist. He takes all the words of Shakespeare and puts them into a computer and watches how they come out, and then re-directs Shakespeare according to this new disposition of parts. There are many other kinds of Shakespeare fetishists, and I'm not suggesting that you are a Duchamp fetishist. I'm just saying that this came to my mind, as you were speaking: why Duchamp and why not Shakespeare? I mean, I don't expect you to answer this now in the thirty seconds we have left, but I'm just telling you, as a colleague, what the impact was on me. Here is an act of divination at work, and I'm not quite sure what it is divining.

ANDRÉ GERVAIS (F)

To pose the question "why Duchamp, why not anybody?" is a way of preventing an answer from ever happening. If I began to give some personal answers, we would be moving away from Duchamp. But I could simply reply by saying that one meets someone on the road, by chance: his name happens to be Duchamp, and instead of allowing him to pass, one speaks "with him."

1 This letter was written to Suzanne Duchamp around January 15, 1916, and appears on page 5 in Francis Naumann's "Affectueusement, Marcel: Ten Letters from Marcel Duchamp to Suzanne Duchamp and Jean Crotti."

2 "Let's say that it isn't *any* object in *any* way; not all objects are necessarily so rich in these latent possibilities; the objects we choose will be particular ones in particular contexts. . . . In readymades . . . , it is the 'sentences' made with the objects that have a meaning and not the object alone—whatever the inventor intended to do or say." Claude Lévi-Strauss, in Georges Charbonnier, *Entretiens avec Lévi-Strauss* (Paris: Union Générale d'Editions, 1969), 113, 115; English translation quoted by Arturo Schwarz, *The Complete Works of Marcel Duchamp*, 38. Another translation was published by Joseph Masheck, ed., *Marcel Duchamp in Perspective* (Englewood Cliffs, N.J.: Prentice-Hall, 1975), 77–83.

3 Michel Butor, "Reproduction interdite," *Critique* 334 (March 1975), 269–283.

4 "*Les parlés de Duchamp,*" as opposed to "*les écrits.*" Gervais has the project of gathering all of Duchamp's spoken declarations (interviews, etc.) as partaking in a literary genre distinct from his writings.

Chute d'eau.

une boîte de petit eau arrivant
de coin en demi cercle
par dessus les moules malic

(vue de côté)

Where's Poppa?

Fais dodo
'Colas mon petit frère;
Fais dodo
T'auras du lolo;
Maman est en haut,
Qui fait du gâteau;
Papa est en bas,
Qui fait du chocolat.

If I begin, epigrammatically, with this lullaby, it is to remind us that it is not only in the realms of alchemy and Neoplatonism that the Bride is depicted as above and the bachelors below. It is also in the world of the infant that this distribution may occur.

This does not mean, of course, that in displaying the program of that domestic machine laboring toward his happiness, the baby's lullaby portrays a world any less systematic than that of the various metaphysical orders we might wish to name. It only means that the signifiers through which the song operates to generate its particular transcendental signified are much closer to the object world of the body from which they sprang. And thus it is no accident that in the very act of projecting this milk and cake and chocolate into the rhythms of sleep, the lullaby seems to stumble over its own feet, as it were, and, tripping, to perform that break in the tune's order through which the body can reclaim and rescatter these objects. For its final line, by disturbing the five-syllable rhythm with the addition of a sixth, suggests—at the edge of consciousness—a substitute rendering that would restore the song's metric evenness and thereby reconstitute the slow regularity of the breath of sleep. "Qui fait du chocolat" is too long and must be hurried past by singer as well as listener; "qui fait du caca" is both rather more like it and rather more to the point.

This paper is indeed concerned with the body's relation to the signifier, but this at the level of the natural rather than the conventional sign. For I want to address the status of vision and visuality within Duchamp's enter-

prise, and that, I suppose, means coming to terms with Duchamp's own tendency to describe the vector of his progress as an artist as something that turned, above all else, on the issue of resisting the claims of the "retinal." Responding to Michel Carrouges, for example, on the publications of his *Machines Célibataires*, Duchamp expresses polite, if noncompliant, interest in the thematic issues raised by Carrouges's analysis, insisting that for his own part the concerns that led him to the *Large Glass* operated on a different level. The problems toward which his conscious painterly intentions were directed, he said, were ones whose "aesthetic validity" was acquired "primarily in the abandoning of visual phenomena, as much in terms of retinal relationships as of anecdotal ones."[1] In interview after interview this is repeated.

To Pierre Cabanne he characterized his attitude as "antiretinal" and therefore opposed to a preoccupation with "visual language," open instead to matters that are "conceptual."[2] In talking to others this opposition between retinal and conceptual, or the world of material sensation and the world of ideas, would be described as an opposition between the retina and the gray matter, as in this entirely typical statement to Alain Jouffroy:

I believe there is a difference between a kind of painting that primarily addresses itself only to the retina, to the retinal impression, and a painting that goes beyond the retina and uses the tube of paint as a springboard to something further. This is the case of religious artists of the Renaissance. The tube of paint didn't interest them. What interested them was to express their idea of the divinity, under one form or other. Thus, without doing the same thing, there is this idea of mine, in any case, that pure painting is not interesting in itself as an end. For me the goal is something else, it is a combination, or at least an expression that only the gray matter can succeed in rendering.[3]

This mention of the gray matter has, as we know, grounded a tradition of Duchamp interpretation in which visuality on Duchamp's terms is understood as a condition of intellect, of the diagrammatic mastery of a reality utterly disincarnated into what Jean Clair has called the "purely ideal" status of the perspective image.[4] And indeed perspective is thought to be at one and the same time the vehicle through which painting is remade into a *cosa mentale*, and the historical medium that links Duchamp to both

past and future. It ties him, as Clair puts it, to "a family that extends from Leonardo to Seurat by way of Vermeer,"[5] even while it opens him onto the future of that completely ideational space, the fourth dimension.[6]

Yet all those viewers and/or readers of Duchamp's work who have ever focused on its courting of the conditions of obscenity, on its obvious connecting of the mental to the carnal—as in his notorious remark "I want to grasp things with the mind the way the penis is grasped by the vagina"[7]— on its constant recycling of the bodily fluids by means of an infantilized corporeal machinery, on its lodging the moment of visuality right at that fold between body and world where each seems to occlude the other—as when he describes the *Bottle Rack* as something that one doesn't even look at, "that one looks at *en tournant la tête*"[8]—for this part of Duchamp's audience the destiny of vision as *idea* will seem peculiar indeed. For, one would have to object, doesn't this interpretive notion of classical perspective or of the *cosa mentale* act to short-circuit that connection—forged again and again in Duchamp's world—by which vision is inevitably hooked up to the mechanisms of desire?

Let us then think of exemplary twentieth-century voyeurs. Surely one of them is the Sartre of *Being and Nothingness*, the Sartre who depicts himself poised at the keyhole that has become nothing but transparent vehicle for his gaze to penetrate it, a keyhole that, as he says, "is given as 'to be looked through close by and a little to one side.' "[9] And if, in this position, hunched and peering, Sartre is no longer for-himself, it is because his consciousness leaps out beyond him toward the still unseen spectacle of lasciviousness that unfolds behind the as yet unbreached opacity of the door. Yet in this scenario, as we know, what comes next is not the realization of the spectacle but the interruption of the act. For the sound of footsteps announces that the gaze of someone else has taken him both by surprise and from behind.

It is as this pinioned object, this body bent over the keyhole, this carnal being trapped in the searchlight of the Other's gaze, that Sartre thickens into an object for himself. For in this position he is no longer pure, transparent intentionality beamed at what is on the door's far side, but rather, simply as body caught on *this* side, he has become a self that exists on the level of all other objects of the world, a self that has suddenly

become opaque to his own consciousness, a self that he therefore cannot *know* but only *be*, a self that for that reason is nothing but a pure reference to the Other. And it is a self that is defined by shame. "It is shame," Sartre writes, "which reveals to me the Other's look and myself at the end of that look. It is the shame . . . which makes me *live*, not *know* the situation of being looked at."[10]

To be discovered at the keyhole is, thus, to be discovered as a body; it is to thicken the situation given to consciousness to include the hither space of the door, and to make the viewing body an object for consciousness. As to what kind of object, Sartre defines this only in relation to the Other—the consciousness of the one who discovers him, and in whose look he ceases totally to master his world. As for himself, this thickened, carnal object produces as the content of *his* consciousness the carnation of shame.

The voyeur that Duchamp prepares for us is rather different. He (or she) too is positioned at the peephole, penetrating the door of the assemblage of *Etant Donnés*, all attention focused through this funneling of the gaze toward the waiting spectacle. But nothing, in this case, breaks the circuit of the gaze's connection to its object or interrupts the satisfaction of its desire. Having sought the peephole of *Etant donnés*, Duchamp's viewer has in fact entered a kind of optical machine through which it is impossible *not* to see (fig. 11.1).

Jean-François Lyotard has characterized that optical machine as one that is both based on the system of classical perspective and maliciously at work to lay bare its hidden assumptions. For the perspective system is, as we know, constructed around the theoretical identity between viewpoint and vanishing point, an identity that undergirds the geometrical symmetry, securing the image on the retina as a mirror of the image propagated from the point of emanation of the rays of light. Now if, in the *Etant donnés*, the vertical plane that intersects the visual pyramid of classical perspective is materialized not by a picture surface but by a brick wall—the transparency of which is not a function of pictorial illusion but of the literal breaching of the wall by a ragged opening—the two other parts of the system—viewpoint and vanishing point—are similarly incarnated. Vanishing point, or the goal of vision, is manifested by the dark interior of a bodily orifice, the optically impenetrable cavity of the spread-eagled

"bride," a physical rather than a geometrical limit to the reach of vision. And viewing point is likewise a hole: thick, inelegant, material. "The dispositif will be specular," Lyotard writes. "The plane of the breach will be that of a picture that will intersect the focal pyramids having for their summits the viewing- or peepholes. In this type of organization, the viewpoint and the vanishing point are symmetrical. Thus if it is true that the latter is the vulva, this is the specular image of the peeping eyes; such that: when these think they're seeing the vulva, they see themselves. *Con celui qui voit*," Lyotard concludes, "He who sees is a cunt."[11]

Now this viewer, specified thus by Duchamp as essentially carnal, caught up in a cat's cradle of identification with what he sees, is also—like Sartre at his keyhole—a prey to the intervention of the Other. For Duchamp, leaving nothing to his old buddy Chance, willed that the scene of *Etant donnés* be set within a museum, which is to say, within an unavoidably public space. And this means that the scenario of the voyeur caught by another in the very midst of taking his pleasure is never far from consciousness as one plies the peepholes of Duchamp's construction, doubly become a body aware that its rearguard is down.

11.1
Perspective schema of *Etant donnés*, as if seen from the side, reproduced from Jean-François Lyotard, *Les TRANSformateurs DUchamp* (Paris: Galilée, 1977).

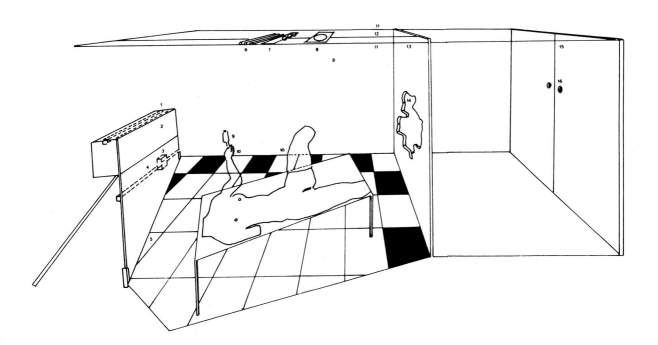

When Kant displaced the space of beauty from the empirical realm to the wholly subjective one, declaring taste a function of a judgment stripped of concepts, he nonetheless preserved the public dimension of this subjectivity by decreeing that such judgments are necessarily, categorically universal. Their very logic is that they are communicable, sharable, a function of the concept of the "universal voice." Aesthetic experience's pleasure, diverted from the exercise of desire, is channeled precisely into a reflection on the possibility of universal communicability. It is only this, Kant says in the Second Moment of the Analytic of the Beautiful, "that is to be acknowledged in the judgment of taste about the representation of the object."[12] Doubly paradoxical, then, such experiences of the beautiful are conceived as pleasure disincarnated because without desire, and as pure individuality that can only act by assuming the assent of others.

This space of cognitive access to the universality of the language of art describes, of course, not just a theory of aesthetic judgment, but its institutionalization in the great museums that are part of the development of nineteenth- and twentieth-century culture. For the museum as we know it was constructed around the shared space of visuality founded on the collectivization of individual subjects. It is the system of this museum, however, that *Etant donnés* enters only to disrupt by "making strange." For, threatened by discovery on the part of his fellow viewer, the purely cognitive subject of Kant's aesthetic experience is redefined in this setting as the subject of desire, and subjectivity itself is taken from the faculty of cognition and reinscribed in the carnal body.

Twice over, the vision of this viewer is hooked up to that glandular system that has nothing to do with the pineal connection, and everything to do with the secretions of sex and of fear. Descartes's notion of the bridge between the physical and the mental carefully preserved the autonomy of the latter. But the optic chiasma that Duchamp suggests is unthinkable apart from a vision that is carnal through and through. *Con,* as they say, *celui qui voit*.

Lyotard is alone, as far as I know, in pushing this notion of the carnality of vision deep into the heart of Duchamp's production, which is to say, onto the very surface of the *Large Glass*. For by carnality one wants to be

quite specific here. And Lyotard is talking about the body as a psychophysiological system. Speaking of Duchamp's statement that the *Glass* is intended to "isolate the sign of accordance between a state of rest" and a series of possible facts, Lyotard continues, "Now, the Glass is indeed this isolated sign, this immobile sensitive surface (the retina) onto which the diverse facts of the account come to be inscribed according to the possibilities scrupulously chosen by Duchamp and such that the viewer will literally have nothing to see if he disregards them."[13] And, going even further than this, Lyotard characterizes the *Glass* as a display, not of the facts of the event but of the physiological surfaces onto which they are registered. "What the viewer sees on the Glass," he concludes, "is the eye and even the brain in the process of forming its objects; he sees the images of these imprinting the retina and the cortex according to the laws of (de)formation that are inherent to each and that organize the screen of glass. . . . The Large Glass, being the film, makes visible the conditions of impression that reign at the interior of the optical chamber."[14]

That the *Glass* was conceived as a surface of impression such that its figurative marks would in the main bear an indexical rather than an iconic relation to their signifieds,[15] this is borne out not only by what the *Glass* now contains—mirrored fields, accumulations of dust,[16] shapes transferred from photographic imprints—but also by Duchamp's initial desire that part of the upper half of the *Glass* be coated with a bromide emulsion. Had this plan been feasible, the whole lascivious unfolding of the Bride's blossoming would have been materialized through the registration of a photosensitive plate.[17]

Further, in entertaining Lyotard's suggestion, we can point to other features of the *Glass* that allude to the neurophysiology of the optic track. The sieves, for example, through which the illuminating gas is processed are referred to in Duchamp's writing as cones, and he is explicit that it is in the labyrinthine passage through these cones that a transformation of the gas takes place.[18] For what he calls the "spangles of the illuminating gas"—which we might interpret here as light in its form as a pulsion from the visible band of the electromagnetic spectrum hitting the retinal field—these spangles get "straightened out" as they move through the sieves; and due to this straightening, "they lose their sense of up and down."[19]

11.2
Cols alités [Bedridden Mountains], 1959,
pen and pencil on paper, 12⅝ × 9⅝ in.

Now the fact that the image on the retina is inverted with respect to reality, top and bottom, right and left, was emblematic of the larger problem facing the physiological optics of the late nineteenth century, namely, the question of the transmission of information from eye to brain. At the heart of physiological inquiry into vision was the problem of just how the (geometrical) optical display, focused by the lens of the eye onto the retina, is transformed to an entirely different order of signal through which information is transmitted to the higher neurological centers where, in the "reading" of the signal, the conditions of the body's real orientation to the world are synthesized. Duchamp's words place both illuminating gas and sieves (or what he calls the "*labyrinth of the 3 directions*") within this problematic. "The spangles dazed by this progressive turning," he writes, "imperceptibly lose . . . their *designation* of left, right, up, down, etc., lose their awareness of position." But in relation to this loss, Duchamp adds the qualification "*provisionally*," for, as he reminds himself, "they will find it again later," that "later" being suggestive of the level of cortical synthesis.

It is possible to fill in other terms of the neurooptical system in relation to the *Glass*. Electricity, the form of the body's nerve signals, is of course continually invoked by the notes describing the bachelor apparatus. But even more explicitly, in the late drawing *Cols alités* (fig. 11.2), where Duchamp returns to the *Glass*, we are shown a telegraph pole on the right, hooked up to the apparatus itself, telegraphy having served as a useful analogy in nineteenth-century discussions of nerve transmission, as in Helmholtz's remark: "The nerve fibres have been often compared with telegraphic wires traversing a country, and the comparison is well fitted to illustrate this striking and important peculiarity of their mode of action."[20]

Although one could go on multiplying the symptoms through which the *Large Glass* manifests itself as conditioned by physiological optic's understanding of embodied vision, the point of this analysis is certainly *not* to add yet one more totalizing explanatory schema to the considerable number now in contention for the title of *key* to the mysteries of the *Large Glass*. One is not attempting to substitute the laws of physiological optics for any of those other master codes—such as the practices of alchemy, or the rituals of courtly love, or the incestuous secrets of a possible psychobiography, or the rules of *n*-dimensional geometry—codes that have been

proposed as a hermeneutic for Duchamp's work. Attending to these features is meant instead to bring us up against a kind of interpretive paradox, through which, in the light of Duchamp's vehement and insistent rejection of the "retinal," we have nonetheless to acknowledge the presence of physiological optics at work within Duchamp's thinking and production. This presence, as we shall see, is not just manifested by the *Glass*, but also by that whole cycle of objects from the '20s and '30s to which Duchamp referred when he described himself on his business card as Rrose Sélavy, specialist in "Oculisme de Précision."[21] The whole of "Precision Optics"— the *Rotoreliefs* (fig. 11.6), the *Rotary Glass Plates* (fig. 11.3), and the *Rotary Demisphere* (fig. 11.4), but also stereoscopy and anaglyphy as well as the pure exercise in simultaneous contrast of *Coeur volant*—all of this reaches back into the experimental and theoretical situation of the psychophysiology of vision. And none of it seems to concur with Duchamp's professed antiretinalism. Since what could "retinal painting" be if it is not exemplified by the turn that painting took in the grip of the discoveries of Helmholtz and Chevreul, the discoveries promulgated by Charles Blanc and Ogden Rood?

Indeed, Duchamp was explicit that he had Impressionism in mind as a premier example of the retinal. "Since the advent of Impressionism," he told an interviewer, "visual productions stop at the retina. Impressionism, Fauvism, Cubism, Abstraction, it's always a matter of retinal painting. Their physical preoccupations: the reactions of colors, etc., put the reactions of the gray matter in the background. This doesn't apply to all the protagonists of these movements. Certain of them have passed beyond the retina. The great merit of Surrealism is to have tried to rid itself of retinal satisfaction, of the 'arrest at the retina.' I don't want to imply that it is necessary to reintroduce anecdote into painting," Duchamp then cautions. "Some men like Seurat or like Mondrian were not retinalists, even in wholly seeming to be so."[22]

The distinction Duchamp makes at the end of this statement is important to keep in mind as we try to come to terms with the critique he is launching on the whole system of the visual as that is put into place by mainstream modernism—the line that moves from Impressionism to Abstraction by way of Cubism. Because those terms cannot be arrived at by assuming Duchamp's rejection was simply a wholesale condemnation of all those

11.3
*Rotative Plaque verre (Optique de préci-
sion) [Rotary Glass Plates (Precision
Optics)]*, 1920. Motorized optical device:
five painted glass plates, wood and
metal braces, turning on a metal axis,
electrically operated, 47½ × 72½ × 40
in. (Yale University Art Gallery, New
Haven; gift of Collection Société Ano-
nyme, 1941.)

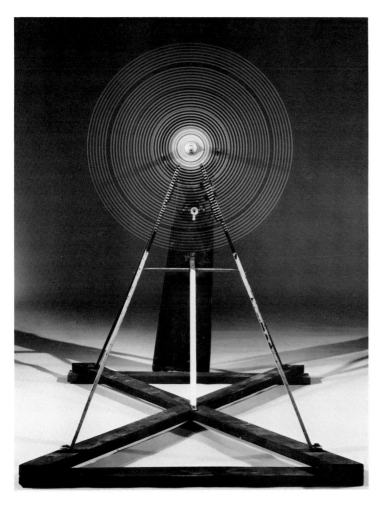

11.4
*Rotative Demisphère (Optique de préci-
sion) [Rotary Demisphere (Precision
Optics)]*, 1925. Motorized construction:
painted wood demisphere, fitted on
black velvet disk, copper collar with
plexiglass dome, pulley, motor, metal
and wood stand, 58½ × 25¼ × 24 in.
(The Museum of Modern Art, New York;
gift of Mary Sisler and purchase, 1970.)

11.5
Image of a spiral, reproduced from R. L. Gregory, *Eye and Brain* (New York: McGraw Hill, 1977), 107, accompanied by the following comment: "When this spiral is rotated, it appears to shrink or expand, depending on the direction of rotation. But when stopped, it continues to *appear* to shrink (or expand), in the *opposite direction*. This cannot be due to eye movement, since the apparent shrinkage or expansion occurs in all directions at once. The effect is paradoxical—there is movement, but no change in position or size."

11.6
Rotorelief n° 8 (Cerceaux) [*Rotorelief No. 8 (Hoops)*], 1935. One of a set of six cardboard disks, printed by offset lithography on both sides, each 7⅞ in. diameter. (Philadelphia Museum of Art.)

11.7
Disques avec inscriptions de calembours
[*Disks Inscribed with Puns*], 1926. Two of
the nine disks used in Duchamp's 1926
film *Anémic Cinéma*. (Collection Robert
Shapazian, Fresno.)

aspects of science that modernism had thought to appropriate. Rather, judging from the exception he makes of Seurat, he was fully admiring of real rigor in the application of the principles of modern optics. More precisely, what he objects to is the "arrêt à la rétine," the stopping of the analytic process at the retina, the making of the interactions between the nerve endings—their coordinated stimulation and innervation—a kind of self-sufficient or autonomous realm of activity. The result of this was, within the development of modernist painting, the reification of the retinal surface and the conviction that by knowing the laws of its interactive relationships, one then possessed the algorithm of sight. The mapping of the retinal field onto the modernist pictorial plane, with the positivist expectation that the laws of the one would legislate and underwrite the autonomy of the operations of the other, is typical of the form in which high modernism established and then fetishized an autonomous realm of the visual.

This is the logic that one hears, for example, in Delaunay's pronouncements that the laws of simultaneous contrast (as formulated by Young and Helmholtz) and the laws of painting are one and the same. "Color," he frequently declared, "colors with their laws, their contrasts, their slow vibrations in relation to the fast or extra-fast colors, their interval. All these relations form the foundation of a painting that is no longer imitative, but creative through the technique itself." What makes this possible, he would reiterate, is a scientifically wrought understanding of "simultaneous contrast, [of the] creation of profundity by means of complementary and dissonant colors, which give volume direction. . . . To create," he insists, "is to produce new unities with the help of new laws."[23]

It was the idea of the self-sufficiency and the closed logic of this newly conceived retinopictorial surface that gave a program to early abstract painting such as Delaunay's and a coherence to much of modernist theory. It is this logic that refuses to "go beyond" the retina to the gray matter, and it is to this refusal that Duchamp objects.[24] But the gray matter, as I will argue, though it undoubtedly refers to the cerebral cortex, does not thereby invoke a disembodied faculty of cognition or reflection, does not propose the transcendental ego's relation to its sensory field. The cerebral cortex is not above the body in an ideal or ideated remove; it is, instead, *of* the body, such that the reflex arc of which it is part connects it to a whole field of stimuli between which it cannot distinguish. These stimuli

may come from outside the body, as in the case of normal perception, but they may also erupt internally, giving rise, for example, to what Goethe celebrated as "physiological colors," or those sensations of vision that are generated entirely by the body of the viewer. The production of sensory stimulation from within the body's own field, the optical system's porousness to the operations of its internal organs, this fact forever undermines the idea of vision's transparency to itself, substituting for that transparency a density and opacity of the viewing subject as the very precondition of his access to sight.

Duchamp's view of the gray matter—that part that exists beyond the retina—cannot be separated from other kinds of organic activity within the corporeal continuum. For to do so would leave one, for example, with no way of interpreting the visual activity projected within the domain of the Bride in the upper half of the *Large Glass*. Duchamp describes the Bride's blossoming—which is to say the orgasmic event toward which the whole mechanism of the *Glass* is laboring—as an ellipse with two foci, an ellipse through which the circuitry of the bachelor machine connects to that of the Bride. The first of the foci, which he designates as the stripping by the bachelors, seems to relate to the perceptual part of the arc he is mapping. But the second focus, the Bride's "voluntarily imagined blossoming," connects the reflex arc of this ellipse to an organically conditioned (productive) source of the drive, an organ that Duchamp says "is activated by the love gasoline, a secretion of the bride's sexual glands and by the electric sparks of the stripping."[25]

If the mechanism of the *Large Glass* obeys Duchamp's dictum of "going beyond" the retina, it does so not to achieve the condition of vision's transparency to itself—which is suggested by the model of classical perspective when applied to the *Glass*—but rather, quite obviously, to arrive at the threshold of desire-in-vision, which is to say to construct vision itself within the opacity of the organs and the invisibility of the unconscious.

With these two notions—desire-in-vision and the unconscious as the condition of invisibility—I have obviously brought this discussion to a point where the status of the subject of consciousness that Duchamp is projecting is directly at stake. Arguments about the subject of the *Large Glass*—as about the subject put in place by the rest of Duchamp's work—and whether

it can be conceived of as a transcendental subject, or whether, like the subject of psychoanalysis or of associationist psychology, it cannot, are obviously brought to a head by the conflict between the two models of vision that two different interpretive traditions want to bring to bear on the *Glass*. The first is a geometrical model accountable to a higher logic, a model that operates in either the classical perspective discussions of the *Glass* or in the *n*-dimensional ones; the second is a psychophysiological model that has entirely different implications for the epistemological status of the Duchampian subject.

The difference between these two models is extremely clear, as are the implications that follow from them for Duchamp's historical position. What continues to vex the attempt to sort out their respective claims, however, is that, in order to prove its point, each of these opposed positions has recourse to Duchamp's exploitation of photography. The psychophysiological model feels itself buttressed by the *Glass*'s condition—both in theory and in actuality—as a light-sensitive surface of impression, thus simultaneously a sensory field and a photogrammatic one. The geometrical-perspective model, on the other hand, sees itself strengthened by the obvious connection between photography and optics, a connection that seems to situate the photographic camera as the modern descendant of the camera obscura, and photographic vision as an extension of all those models that tied the analysis of seeing to the understanding of image formation performed by seventeenth- and eighteenth-century optics. According to this argument the *Glass*'s condition as a kind of mammoth photographic plate only binds it that much more closely to the model of the camera obscura and its a priorism with regard to sight.[26]

But the evolutionist view that the photographic camera is just one more version of the camera obscura, and that as such it performs a kind of technological mediation between the optical models of a nineteenth-century analysis of vision and those of the seventeenth, this view cannot stand up to a rigorous archaeological analysis that would examine its specific historical grounds. And indeed, a recent study by Jonathan Crary strongly contests this position, arguing that "the camera obscura and the photographic camera, as assemblages, practices, and social objects, belong to two fundamentally different organizations of representation and the observer, as well as of the observer's relation to the visible."[27]

Beaming light through a pinhole into a darkened room, the camera obscura focuses that light on the opposite wall, allowing the observer—whether it is Newton for his *Opticks* or Descartes for his *Dioptrique*—to view that plane as something independent of his own powers of synthesis, something that he, as a detached subject, can therefore observe (fig. 11.8). It was due to this structural disconnection between plane of focus and observing subject that the camera obscura came, in the seventeenth century, to function as an epistemological model. Richard Rorty, for example, characterizes both Descartes's and Locke's use of this model in terms of "the conception of the human mind as an inner space in which both pains and clear and distinct ideas passed in review before an Inner Eye. . . . The novelty was the notion of a single inner space in which bodily and perceptual sensations . . . were objects of quasi-observation."[28]

Now this epistemic subject, Crary argues, is only made explicable insofar as he is the observer of a projection onto a field exterior to himself. So that,

> whether it is Berkeley's divine signs of God arrayed on a diaphanous plane, Locke's sensations "imprinted" on a white page, or Leibniz's elastic screen, the eighteenth-century observer confronts a unified space of order, unmodified by his or her own sensory and physiological apparatus, on which the contents of the world can be studied and compared, known in terms of a multitude of relationships. In Rorty's words, "It is as if the tabula rasa were perpetually under the gaze of the unblinking Eye of the Mind . . . it becomes obvious that the imprinting is of less interest than the observation of the imprint— all the knowing gets done, so to speak, by the Eye which observes the imprinted tablet, rather than by the tablet itself."[29]

But at the end of this period, the single most evocative image of the camera obscura's having ceased to serve as the model of vision is Goethe's direction, in the *Farbenlehre* (1810), that in the darkened room the subject, after looking at the bright point of light entering through an opening, close off that fissure so that the phenomenon of the afterimage might appear. With this severing of the dark room's relation to the external field, Goethe initiates the study of a physiology—and no longer an optics—of vision, a physiology that understands the body of the viewer as the active producer of optical experience. It is this shutting of the room, Crary maintains, that

11.8
Schooten, etching illustrating René Descartes's *La Dioptrique*, first published in Leyden in 1637.

signals a "negation of the camera obscura as both an optical system and epistemological figure."[30] Color, which can simply be produced by electrical stimulation of the optic nerve, is henceforth severed from a specifically spatial referent. Color, the form of the body's registration of light, is thus conceived as always potentially "atopic" so that the natural sign's necessary connection to the visual field can no longer be maintained. And now, fully embedded within the nervous weft of the body's tissues, color as well comes to be understood as something subject to the temporality of the nervous system itself, to its access to fatigue, to its necessary rhythm of innervation, to that which causes color to ebb and flow within experience in an infinitely mutable evanescence.[31]

In taking over from the camera obscura as the conveyor of the image, the body, solid and dense, becomes instead the producer of that image, a producer who must forge a perception of the real from a field of scattered signs. "None of our sensations," Helmholtz explained in 1867, "give us

11.9
Schema of the optical pathways of the brain, reproduced from R. L. Gregory, *Eye and Brain* (New York: McGraw Hill, 1977), 45.

optic chiasma

area striata

lateral geniculate body

anything more than 'signs' for external objects and movements," so that what we call seeing is really learning "how to interpret these signs by means of experience and practice." With regard to the signs provided by retinal excitation, he added, "It is not at all necessary to suppose any kind of correspondence between these local signs and the actual differences of locality [in the empirical field] which they signify."[32]

Typically, in this lecture presenting "The Recent Progress of the Theory of Vision" Helmholtz brings home these facts by the example of the stereoscope's capacity to use two flat pictures to simulate, with uncanny convincingness, the depth perception of normal binocular vision. What the stereoscope demonstrates, he says, is that "two distinct sensations are transmitted from the two eyes, and reach the consciousness at the same time and without coalescing; that accordingly the combination of these two sensations into the single picture of the external world of which we are

11.10
The Wheatstone stereoscope, reproduced from Warren and Warren, eds., *Helmholtz on Perception* (New York: John Wiley & Sons, 1968), 116. The observer looked with the right eye into the mirror *b*, and with the left into the mirror *a*. Both mirrors were placed at an angle to the observer's line of sight, and the two pictures were so placed at *k* and *g* that their reflected images appeared at the same place behind the two mirrors; but the right eye saw the picture *g* in the mirror *b*, while the left saw the picture *k* in the mirror *a*.

conscious in ordinary vision is not produced by any anatomical mechanism of sensation, but by a mental act."

The specific stereoscopic instrument to which Helmholtz refers his audience could not make his point more graphically. For the Wheatstone stereoscope, a product of physiological research in the 1830s, was constructed to produce its experience of depth in a way that proved to be much more powerful than later devices such as the Holmes or Brewster stereoscopes (fig. 11.11), a way, indeed, that Duchamp would later capture by the coinage of his term "miroirique." In the Wheatstone apparatus (fig. 11.10) the viewer would actually look—each with one eye—at two mirrors set at a 90-degree angle to one another, onto which would be reflected the two slightly divergent images, these held in slots at the sides of the device such that they were actually parallel to his line of sight and totally out of his field of vision.

Nothing could more effectively shatter the idea projected by the camera obscura model, in which the relationship between viewer and his world is pictured as fundamentally scenic, than this literal dispersal of the stimulus field. "The stereoscopic spectator," Crary writes,

11.11
The Brewster stereoscope, reproduced from Warren and Warren, eds., *Helmholtz on Perception* (New York: John Wiley & Sons, 1968), 117.

sees neither the identity of a copy nor the coherence guaranteed by the frame of a window. Rather, what appears is the technical reconstitution of an already reproduced world fragmented into two nonidentical models, models that precede any experience of their subsequent perception as unified or tangible. It is a radical repositioning of the observer's relation to visual representation. . . . The stereoscope signals an eradication of "the point of view" around which, for several centuries, meanings had been assigned reciprocally to an observer and the object of his or her vision. There is no longer the possibility of perspective under such a technique of beholding. The relation of observer to image is no longer to an object quantified in relation to a position in space, but rather to two dissimilar images whose position simulates the anatomical structure of the observer's body.[33]

The stereoscope's relevance is limited, of course, to the observation of objects in near vision. The importance of binocular difference is only felt where the optic axes are forced to converge and thereby to register a different perspective on each eye; for a distant scene the optic axes are so nearly parallel that the appearance to the two eyes is the same as if it had been viewed by only one eye. Duchamp's *Handmade Stereopticon Slide*

(1918–1919; fig. 8.6), with its looming foreground figure made extremely disjunct from the distant background, reflects these differing consequences of near and far for the stereoscopic production of volume. And indeed, one can imagine that in penciling in the figurative event of the double pyramid against a photographically wrought empty sea, Duchamp is maintaining the distinction between the stereoscopic phenomenon—which was explored before the invention of photography and is independent of it—and stereoscopy's subsequent mass marketing as an exclusively photographic medium. Made in Buenos Aires at the same time as this, the work *To Be Looked at (from the Other Side of the Glass) with One Eye, Close To, for Almost an Hour* (fig. 8.8) seems to maintain this same specificity of attention to the *point* of the distinctions that physiological optics was making within the apparatus of vision.

It is, however, within the phenomenon of what Duchamp was to call "Precision Optics" that one feels closest both to the experimental ground of psychophysiological research and to a connection between this ground and vision's relation to desire, which is to say, the operations of the unconscious in vision. For on the one hand, it is extremely hard to consider Duchamp's different projects for spinning discs apart from the various devices that were used to explore optical mixing and subjective color. Both the spiral-inscribed discs suggested for the latter and the pedestaled stands on which to mount Maxwell's discs in order to rotate them to produce the former are illustrated in O. N. Rood's *Modern Chromatics*, perhaps the most widely disseminated manual on optical color.[34] And indeed, Duchamp spoke of the production of the illusion of three-dimensionality achieved by the rotation of his discs as something achieved "not with a complicated machine and a complex technology, but in the eyes of the spectator, by a psychophysiological process."[35] But on the other hand, it is equally hard to view the *Rotary Demisphere* (1925) or the *Discs Bearing Spirals* (1923) activated into motion by the film *Anémic Cinéma* (1925), without witnessing that, by adding a virtual third dimension, Duchamp has simultaneously defined the vision in question as erotic. One of Duchamp's critics describes this effect of turning through space as "an oscillating action of systole and diastole, screwing and unscrewing itself in an obsessional pulsation that could be associated to copulatory movements."[36] And another agrees that in some of the discs, "the indication of the central cavity through the

11.12
The Müller-Lyer or "arrow" illusion
(top), and the Ponzo or "railway" illusion
(bottom), reproduced from R. L. Gregory,
Eye and Brain (New York: McGraw Hill,
1977), 138–139.

volutes of the spirals clearly evokes vaginal penetration. The fact that the eye, by means of optical illusion, perceives an in-and-out motion, establishes at an abstract level a literal allusion to the sexual act."[37] The sexual innuendos of the texts that accompany the discs in *Anémic Cinéma* thus only double at the level of language what is already evoked within the realm of vision.

That the erotic theater of Duchamp's "Precision Optics" in all its various forms is staged within the space of optical illusion places this enterprise at a kind of threshold or bridge moment between a nineteenth-century psychophysiological theory of vision and a later, psychoanalytic one. For the phenomenon of the optical illusion was an important, because troubling, issue within the associationist explanatory model to which physiological optics had recourse. Helmholtz's famous positing of "unconscious inference" as the psychological ground of all perception—unconscious inference being a process of subconscious, inductive reasoning from the basis of past experience—was continually brought up short by the obvious exception of the optical illusions. "An objection to the Empirical Theory of Vision," he admitted, "might be found in the fact that illusions of the senses are possible; for if we have learnt the meaning of our sensations from experience, they ought always to agree with experience."[38] The possibility of false inductions rendered by these "unconscious judgments" urgently needed to be accounted for if the theory were to be viable.

Attempts to provide purely physiological explanations having failed, Helmholtz had recourse to an associationist psychological one.[39] "The explanation of the possibility of illusions," he maintained, "lies in the fact that we transfer the notions of external objects, which would be correct under normal conditions, to cases in which unusual circumstances have altered the retinal pictures." Specifically, in the case of those famous optical illusions spawned by physiological research's attempts to solve the perceptual puzzle—the Müller-Lyer illusion, the Ponzo illusion (fig. 11.12), the Zöllner or Hering illusions—unconscious inference reasons from the inappropriate application of perspective cues. Memory is seen as three-dimensionally contextualizing these figures so that in the acute arrow part of the Müller-Lyer pair, for example, what is supplied through association is the past experience of retinal images obtained when the vertical line is the closest part of a three-dimensional figure, such as the edge of a building

nearest the observer; while for the obtuse arrow half, the context provided
refers to images projected when the vertical line is the most distant part,
such as the far corner of a room in which the viewer stands. The Ponzo
figure, sometimes called the railroad track illusion, is similarly referred to
the mistaken inference of perspective convergence and the resultant mis-
cuing of the viewer with regard to relative size.

The fact that the physiologist Helmholtz breathed the word "unconscious"
into the discourse of empirical science raised a storm of protest that would
dog him all his life. But for Sartre, later assessing the theoretical grounds
of the associationist psychology Helmholtz was advocating, it was obvious
that such an explanatory model would be utterly incoherent did it not posit
(no matter how covertly) an unconscious. The memory image sitting in the
brain below the threshold of consciousness, a sensory content waiting to
be revived and newly animated by thought, Sartre maintained, was not only
the very picture of the unconscious but as such was theoretically untenable.
Sartre's famous rejection of the concept of the unconscious applied not only
to the Freudian version but to the associationist one as well. Whereas, he
held, there can be only two types of things (the in-itself of objects or the
for-itself of consciousness), the idea of the unconscious posits the ontolog-
ically impossible condition of an in-and-for-itself. There can be nothing *in*
consciousness that is unavailable to it, that is not already in the *form* of
thought. Once thought is "hypostatized and hardened into the notion of an
unconscious," Sartre argued, "such thought is no longer accessible to
itself."[40]

Although Sartre insisted that there was no distinction to be drawn between
the unconscious of perceptual psychology and that of psychoanalysis, and
indeed the former's "laws of association" had already put in place the
relations of metaphor and metonymy, or condensation and displacement,
long before Freud availed himself of these terms, associationism obviously
veers off from psychoanalysis in that it posits no mechanism of repression.
The unconscious on which Helmholtz's theory of vision relies is, like that
of associationism in general, a store of memory, and thus a reserve of
consciousness. It is psychoanalysis that would view the unconscious as
divisive, as the turbulent source of a conflict with consciousness. The only
point of recognition within associationist theory that consciousness might
be shot through by unconscious conflict, and that this occurred at the very

heart of perception, was when it had to confront its own peculiar laboratory rat: the optical illusion. And there it found itself staring at something like an "optical unconscious."

It is in that languidly unreeling pulsation, that hypnotically erotic visual throb of Duchamp's "Precision Optics," that one encounters the *body* of physiological optics's seeing fully enmeshed in the temporal dimension of nervous life, as it is also fully awash in optical illusion's "false induction." But it is here, as well, that one connects to this body as the site of libidinal pressure on the visual organ, so that the pulse of desire is simultaneously felt as the beat of repression.

The rhythm of the turning discs is the rhythm of substitution as, at an iconic level, various organs replace one another in an utterly circular associative chain. First there is the disc as eye, an eye that, in Lebel's words, is "animated by a rotary movement, a sort of gigantic cyclops whose pupil serves as the screen for suggestive metamorphoses."[41] Metamorphosis then transforms eye into breast, a soft mound surmounted by a slightly trembling nipple. This then gives way to the fictive presence of a uterine cavity and the implication of sexual penetration. And within this pulse, as it carries one from part-object to part-object, advancing and receding through the illusion of this three-dimensional space, there is also a hint of the persecutory threat that the object poses for the viewer, a threat carried by the very metamorphic rhythm itself, as its constant thrusting of the form into a state of dissolve brings on the experience of formlessness, seeming to overwhelm the once-bounded object with the condition of the *informe*.

Writing about "psychogenic visual disturbance" in 1910, Freud speaks of the various bodily organs' accessibility to both the sexual and the ego instincts: "Sexual pleasure is not connected only with the function of the genitals; the mouth serves for kissing as well as for eating and speaking, the eyes perceive not only those modifications in the external world which are of import for the preservation of life, but also the attributes of objects by means of which these may be exalted as objects of erotic selection."[42] The problem for the organ can arise when there is a struggle between these two instincts and "a repression is set up on the part of the ego against the sexual component-instinct in question." Applying this to the eye and the faculty of vision, Freud continues, "If the sexual component-instinct which

makes use of sight—the sexual 'lust of the eye'—has drawn down upon itself, through its exorbitant demands, some retaliatory measure from the side of the ego-instincts, so that the ideas which represent the content of its strivings are subject to repression and withheld from consciousness, the general relation of the eye and the faculty of vision to the ego and to consciousness is radically disturbed." The result of repression is then, on the one hand, the creation of substitute formations at the level of the libido and, on the other, the onset of reaction formation within the operations of the ego.

The sequence of substitutions within "Precision Optics" and the sense of perceptual undecidability projected through the object's condition as a state of perpetual disappearance, all this rehearses the Freudian scenario of the unavailability of what is repressed and the structural insatiability of desire. For desire-in-vision is formed not through the unified moment of visual simultaneity of the camera obscura's optical display, but through the temporal arc of the body's fibers. It is an effect of the two-step through which the object is eroticized. Freud's theory of eroticization (or anaclisis), as set forth by Jean Laplanche, accounts among other things for the scopophilic impulse.[43] It is a theory of the two-step. According to the anaclitic model, all sexual instincts lean on the self-preservative or ego instincts, but they only come to do so at a second moment, always a beat after the self-preservative impulse. Thus the baby sucks out of a need for sustenance, and in the course of gratifying that need receives pleasure as well. And desire occurs at this second moment, as the longing to repeat the first one understood not as milk but as pleasure, understood, that is, *as* the satisfaction of desire. Thus it searches for an object of original satisfaction where there is none. There is only milk, which can satisfy the need but cannot satisfy the desire, since it has become something that the little hiccup of substitution will always produce as insufficient. What this model clarifies is the way the need can be satisfied, while the desire cannot.

In relating this psychoanalytic model of desire's longing for a lost origin and a structurally irretrievable object to the experience of "Precision Optics," I am attempting to capture the effect of this projection of desire into the field of vision. And I am trying to hold onto that field as something that is both carnally constituted and, through the activity of the unconscious, the permanent domain of a kind of opacity, or of a visibility invisible

to itself. That oscillation between the transparent and the opaque, an oscillation that seems to operate in Duchamp's work at all the levels of his practice, is revealed here, I am suggesting, as the very precondition of any visual activity at all.

I am aware of course of all those discussions of "Precision Optics" that describe them in terms of "elementary parallelism" and thereby fold them into the general problematic of the fourth dimension.[44] But Duchamp's preoccupation with *n*-dimensional geometry must itself, I think, be seen as a way of thematizing the problem of invisibility raised by the unconscious, just as his speculations on the *infra-mince*, no matter how much they invite an invocation of the mathematical theory of limits, were always maintained by Duchamp himself in relation to the invisible fold of the body's relation to itself. "Infra-thin," he wrote, "The warmth of a seat (which has just/ been left) is infra-thin." Or again, "Velvet trousers—/ their whistling sound (in walking) by / brushing of the 2 legs is an / infra thin . . ."[45]

There is no way to concentrate on the threshold of vision, to capture something *en tournant la tête*, without siting vision in the body and positioning that body, in turn, within the grip of desire. Vision is then caught up within the meshes of projection and identification, within the specularity of substitution that is also a search for an origin lost. *Con*, as they say, *celui qui voit*.

Notes

1 Jean Clair and Harald Szeeman, eds., *Les machines célibataires* (Venice: Alfieri, 1975), 49.

2 Pierre Cabanne, *Dialogues with Marcel Duchamp,* trans. Ron Padgett (New York: Viking Press, 1971), 43.

3 Alain Jouffroy, *Une révolution du regard* (Paris: Gallimard, 1964), 115. "Je crois qu'il y a une différence entre une peinture qui ne s'adresse d'abord qu'à la rétine, qu'à l'impression rétinienne, et une peinture qui va au-delà de la rétine, et se sert du tube de peinture comme tremplin pour aller plus loin. C'est le cas des religieux de la Renaissance. Le tube de peinture ne les intéressait pas. Ce qui les intéressait c'était d'exprimer leur idée de la divinité, sous une forme ou une autre. . . . Donc, sans refaire la même chose, il y a cette idée, chez moi, en tout cas, que la peinture pure n'est pas intéressante en soi comme but. Pour moi la fin est autre, c'est une combinaison, ou du moins une expression que seule la matière grise peut arriver à rendre."

4 See Jean Clair, "Marcel Duchamp et la tradition des perspecteurs," *Marcel Duchamp: Abécédaire* (Paris: Musée National d'Art Moderne, 1977).

5 Jean Clair, *Duchamp et la photographie* (Paris: Chêne, 1977), 82.

6 Clair makes this argument in both *Duchamp et la photographie* and *Marcel Duchamp ou le grand fictif* (Paris: Editions Galiliée, 1975). The most systematic discussion of Duchamp's relation to the concept of the fourth dimension is in Craig E. Adcock, *Marcel Duchamp's Notes from the Large Glass: An n-Dimensional Analysis* (Ann Arbor: UMI Research Press, 1981).

7 Lawrence D. Steefel, Jr., "The Position of *La Mariée Mise à Nu par Ses Célibataires, Même* (1915–1923) in the Stylistic and Iconographic Development of the Art of Marcel Duchamp," Ph.D. dissertation, Princeton University, 1960, 312.

8 Jouffroy, *Une révolution du regard,* 119.

9 Jean-Paul Sartre, *Being and Nothingness,* trans. Hazel E. Barnes (New York: Washington Square Press, 1966), 348.

10 Ibid., 352.

11 Jean-François Lyotard, *Les TRANSformateurs DUchamp* (Paris: Galilée, 1977), 137–138. "Le dispositif serait spéculaire. . . . Le plan de la brèche serait celui d'un tableau qui couperait les pyramides visives ayant pour sommets les trous du voyeur. Dans une organisation de ce type, le point de vue et le point de fuite sont symétriques: s'il est vrai que le second est la vulve, celle-ci est l'image spéculaire des yeux voyeurs; ou: quand ceux-ci croient voir la vulve, ils se voient. Con celui qui voit."

12 Immanuel Kant, *Critique of Judgement,* trans. J. H. Bernard (New York: Hafner Press, 1951), 51.

13 Lyotard, *Les TRANSformateurs DUchamp,* 133. "Or le Verre est bien en effet ce signe isolé, surface sensible (rétine) immobile où viennent s'inscrire les faits divers du récit selon des possibilités minutieusement choisies par Duchamp, et telles que le regardeur n'aura littéralement rien à voir s'il les néglige."

14 Ibid., 134. "Ce que le regardeur voit sur le Verre, c'est l'oeil et même le cerveau en train de composer ses objets, il voit les images de ceux-ci impressionner la rétine et le cortex selon des lois de (dé)formation qui sont les leurs et qui organisent la paroi de verre. . . . Le Verre, étant la pellicule, donne à voir les conditions d'impression qui règnent à l'intérieur de la boite optique."

15 See my "Notes on the Index," *October,* no. 3 (Spring 1977); reprinted in *The Originality of the Avant-Garde and Other Modernist Myths* (Cambridge: MIT Press, 1986).

16 The various studies comparing Duchamp to Leonardo da Vinci refer to the note in Leonardo's sketchbooks where he directs himself to collect dust on a plate of glass as an index of the passage of time, and make a connection between this and the

Dust Breeding project of the *Large Glass*. See Jean Clair, "Duchamp, Léonard, la tradition maniériste," *Duchamp: Colloque de Cerisy*, 10/18 (Paris, 1979), 128; and Theodore Reff, "Duchamp & Leonardo: L.H.O.O.Q.—Alikes," *Art in America* 65 (January 1977).

17 Marcel Duchamp, *Duchamp du signe: ecrits*, ed. Michel Sanouillet (Paris: Flammarion, 1975) 57–58; an English translation appears in *Salt Seller: The Writings of Marcel Duchamp (Marchand du Sel)*, ed. Michel Sanouillet and Elmer Peterson (New York: Oxford University Press, 1973), 38. That the *Large Glass* is itself conceived as an enormous photographic plate, a "delay in glass," is the argument Jean Clair makes in *Duchamp et la photographie*, 44–62. It is my argument also in "Notes on the Index."

18 Arturo Schwarz, *La Mariée mise à nu chez Marcel Duchamp, même* (Paris: Editions Georges Fall, 1974), 160. This is the text on a 1914 full-scale sketch for the bachelor machine: "Sur chaque cône: neuf trous correspondant aux neuf sommets des formes maliques, c'est-à-dire représentant, dans une demi-sphère conique au-dessus du plan, la disposition géographique des neuf sommets des formes maliques (voir le grand tableau du Réseau). (Pour déterminer la position exacte du cône des points-sommets, construire un disque de caoutchouc plat; transcrire sur ce disque la disposition géographique plane des neuf sommets—puis pousser le caoutchouc afin d'obtenir un cône et photographier dans les sept positions des Tamis)."

19 *Duchamp du signe*, 73–74; *Salt Seller*, 49.

20 *Helmholtz on Perception*, ed. Richard Warren and Roslyn Warren (New York: John Wiley & Sons, 1968), 83.

21 *Duchamp du signe*, 153; and *Salt Seller*, 105.

22 Jouffroy, *Une révolution du regard*, 110. "Depuis l'avènement de l'impressionnisme, les productions visuelles s'arrêtent à la rétine. Impressionnisme, fauvisme, cubisme, abstraction, c'est toujours de la peinture rétinienne. Leurs préoccupations physiques: les réactions de couleurs, etc., mettent au second plan les réactions de la matière grise. Cela ne s'applique pas à tous les protagonistes de ces mouvements. Certains d'entre eux ont dépassé la rétine. Le grand mérite du surréalisme, c'est d'avoir tenté de se débarrasser d'un contentement rétinien, de l' 'arrêt à la rétine'. Je ne veux pas dire par là qu'il faille réintroduire l'anecdote dans la peinture. Des hommes comme Seurat ou comme Mondrian n'étaient pas des rétiniens, tout en ayant l'air de l'être."

23 Robert Delaunay, *The New Art of Color*, ed. Arthur Cohen (New York: Viking Press, 1978), 35, 41, 63.

24 Thierry de Duve has situated Duchamp's "nominalist" relation to color and his conception of the readymade within the history of abstract painting's reception of nineteenth-century optical and color theory. His argument, which describes two separate theoretical traditions, Goethe's *Farbenlehre* which fuels a symbolist/expressionist practice and Chevreul's *De la loi du contraste simultané* which founds a more objective and ultimately structuralist one, emphasizes the need on the part of modernist artists to legitimate abstraction, to defend it from the arbitrariness of "mere" decoration. See Thierry de Duve, *Nominalisme pictural* (Paris: Editions de Minuit, 1984), 211–227.

25 *Duchamp du signe*, 64–65; and *Salt Seller*, 42–43.

26 Jean Clair, works cited above.

27 Jonathan Crary, *Techniques of the Observer: On Vision and Modernity in the Nineteenth Century* (Cambridge: MIT Press, 1990), 32. The following discussion of the archaeology of the camera in relation to nineteenth-century optics is indebted to this study.

28 Richard Rorty, *Philosophy and the Mirror of Nature* (Princeton: Princeton University Press, 1979), 49–50, as cited in Crary, "Modernity," 40.

29 Crary, *Techniques of the Observer*, 55.

30 Ibid., 68.

31 For Goethe's relation to this notion of the transience of vision, see Eliane Escoubas, "L'Oeil (du) teinturier," *Critique* 37 (March 1982), 233–234.

32 Warren and Warren, eds., *Helmholtz on Perception*, 110.

33 Crary, *Techniques of the Observer,* 128.

34 Ogden N. Rood, *Modern Chromatics with Application to Art and Industry* (London, 1879); French translation, *Théorie scientifique des couleurs* (Paris, 1881).

35 Hans Richter, *Dada: Art and Anti-Art* (London: Thames and Hudon, 1965), 99.

36 Steefel, "The Position of *La Mariée,*" 56.

37 Toby Mussman, "Anémic Cinéma," *Art and Artists* 1 (July 1966), 51.

38 Warren and Warren, eds., *Helmholtz on Perception,* 129.

39 See Richard Gregory, *Eye and Brain* (New York: World University Library, 1978), 142–143.

40 Jean-Paul Sartre, *Imagination, a Psychological Critique,* trans. Forrest Williams (Ann Arbor: University of Michigan Press, 1962), 71. For an important discussion of Sartre's relation to associationism and to Charcot, see Joan Copjec, "Favit et Dissipati Sunt," *October,* no. 18 (Fall 1981), 21–40.

41 Robert Lebel, *Sur Marcel Duchamp* (Paris: Editions Trianon, 1959), 52: "un oeil animé d'un mouvement de rotation, sorte de gigantesque cyclope dont la prunelle sert d'écran à de suggestives métamorphoses."

42 Sigmund Freud, "Psychogenic Visual Disturbance According to Psychoanalytical Conceptions" (1910), 55.

43 Jean Laplanche, *Life and Death in Psychoanalysis,* trans. Jeffrey Mehlman (Baltimore: Johns Hopkins University Press, 1976), chapters 1 and 5.

44 See Adcock, *Marcel Duchamp's Notes,* 179–186.

45 Marcel Duchamp, *Notes,* trans. Paul Matisse (Boston: G. K. Hall, 1983), notes 4 and 9.

Discussion

Moderated by Thierry de Duve JEAN SUQUET (F)

I would like to thank Rosalind Krauss for having begun with a song which cheered us up. A brief commentary on this song: she sang that "Maman est en haut, qui fait du lolo" ["Mom is upstairs making milk"] while "Papa est en bas, qui fait du chocolat" ["Dad is downstairs making chocolate"].[1] Once again they are separated, she and her milk, he and his chocolate, unless one lends an ear to Duchamp who added: "the chocolate would deposit itself after grinding, as milk chocolate."[2] So, I return to my catechism: upstairs and downstairs get mixed. Long live the song!

ROSALIND KRAUSS

I just want to say that I used that song because it's very amusing and because it helps me express my own frustration with the kind of litany one finds in Duchamp scholarship about master keys for unlocking or decoding the work—keys like alchemy, à la Schwarz, or courtly love, à la Octavio Paz[3]—in which the arguments always stress the situational parallels with the Bride above and the bachelors below. For me the song has the ironic effect of pricking this hermeneutic bubble. For if we're going to embark on all this source business, well, why not the lullaby? Duchamp could certainly have heard it sung to him and could have sung it himself. The other thing I like about it is the double entendre of the line "Papa est en bas, qui fait du chocolat." Chocolate is not just the attribute of the bachelor, it's something else as well. French friends of mine with children say that when they actually sing it they change the line to: "Papa est en bas, qui fait du caca." So I just liked that. It's all about the body.

DENNIS YOUNG

There is a version of the nursery rhyme which says: "Papa est sur l'eau qui fait du bateau" ["Dad is at sea sailing his boat"]. If it is this version that Duchamp knew then it is not perhaps such a destructive instrument as you are claiming it to be.

ROSALIND KRAUSS

Are you asking for a history of lullabies? I just used this as an epigraph. It was not a piece of serious scholarship.

DENNIS YOUNG

But you proposed it as a kind of extremely potent weapon, in demolishing people like Schwarz and Paz.

ROSALIND KRAUSS

I was talking autobiographically; it did it for me. Schwarz and Paz self-destructed long ago, as far as I'm concerned. What I hope is that the demonstration I then went through, having to do with nineteenth-century science, the nature of physiological optics, the status of illusion within psychophysiology, would change the way part of Duchamp's practice is looked at. We have the fact that Duchamp spent fifteen years of his life doing something called "Precision Optics."

DENNIS YOUNG

I admire your paper immensely, but I didn't want to let you perpetuate what, to me at least, is a contentious interpretation.

CRAIG ADCOCK

Just a comment since we are on the point of alchemy. You listed, I think, four categories in the "hermeneutic bubble" you wanted to prick: alchemy, the courtly love tradition, incest, and then n-dimensional geometry. The first three arguably are not in Duchamp. I would argue that they were read in there by his interpreters. But there is no doubt about the n-dimensional geometry. It's there, and Duchamp put it there. It's in the notes. So those categories are not exactly the same.

ROSALIND KRAUSS

Yes, it's true that n-dimensional geometry is in the notes. I'd just say that you and I don't agree about the status of n-dimensional geometry, about the role it plays in Duchamp's actual work. Obviously he was interested in thinking about it, making these notes, solving these equations. Yet I think that that interest was something he knew he could never translate visually into art. And he read Jouffret saying over and over again that you simply couldn't render the fourth dimension visually. In a way, it is the essence of the modern experience of the invisible. And

so for me it becomes a kind of emblem of a realm of invisibility. I just don't see it happening in the *Large Glass*. I respect enormously the archaeology you have done and the way you have unpacked those notes in relationship to the various sources like Jouffret and Poincaré. But I find the ultimate connection to what goes on in the work unconvincing.

CRAIG ADCOCK

But Duchamp's oeuvre is an illuminated manuscript. So the *n*th dimension is in the work; it's in the manuscript. Just one other minor point about the concave and convex corners you used in your explanation of the Müller-Lyer illusion (fig. 11.12). You'll notice that the line that's perceived as the longest is the one that's in the far corner, and the one that's perceived as the shortest is the one on the corner that would be read nearest to you. So it's just the opposite of what you'd expect from the perspectival argument, which is a serious problem for that particular explanation of the Müller-Lyer illusion, and something for which R. L. Gregory has been criticized. It's just a minor point that you might want to look into.

THIERRY DE DUVE

Your talk gave me lots of food for thought. It's mainly your dialectics of models that has interested me. But it's difficult to react immediately, so . . . Let me throw in just two questions. One: why Sartre? Why have you brought in this Sartre business? Was it simply a foil? And two: why the first Freudian model and not the second? I mean, why the first theory of drives—that is, the opposition between ego-drives and sexual or object-drives—and not the Eros-Thanatos model, the one from *Beyond the Pleasure Principle*. These are tough questions, maybe.

ROSALIND KRAUSS

As for Sartre, I guess I have two explanations. One of them is that in Sartre's rejection of the idea of the unconscious he is attacking not only Freud but the "unconscious" of nineteenth-century associationist psychology. That was very useful since I'm trying to talk about a model of carnal vision that operates in relation to both these things: psychophysiological optics on the one hand and a notion of the psychoanalytic on the other. The other explanation is that I just really loved Sartre's scenario—him standing in front of the door and getting looked at—as a way of imagin-

ing the carnalization of vision. As for the issue of which model of Freud I used, the first model, the model of the drives, has more to do with eroticization and with the relation of the spinning disks to the kind of erotic throb that's there: the strange vision, the pulse of what seems to me to be a series of eroticized objects, which are also very scary. If you could tell me why you think I should use the second model, I would be very interested . . .

THIERRY DE DUVE

No, no, I'm not suggesting at all that you should use the second model.

ROSALIND KRAUSS

No, but when I talk about the *informe* and you talk about Thanatos, there's obviously some reason to think about the second model.

THIERRY DE DUVE

Yes, I have a few reasons of my own, and they have been prompted by what you have said. One is the photographic model that is also part of your discourse, that is, the indexical model by which to look at the *Large Glass*, and the magnificent demonstration that you have made of the unsatisfactory simple association of the *camera obscura* and photography. On several occasions Freud has played with optical models in order to describe the unconscious—I'm sure you are familiar with this. And he never chose photography. He compares the unconscious to an optical machine, however never one that records an image. It's like an empty camera with no film in it. Thus, apparently, Freud was not satisfied with an indexical model of the unconscious and settled for an optical one. I happen to believe, very naïvely, that an indexical model would be historically a more appropriate model at the hand of which to describe the modern unconscious (I don't know about the unconscious at large). In a way Freud remained too faithful to the Cartesian *camera obscura* model. The turning point, you said, came with Goethe's *Farbenlehre*, when things such as the afterimage, and then later on optical illusions, indicated that perception could also be generated from within the body. There are impulses that come from the outside and impulses that come from the inside. That is precisely the issue around which *Beyond the Pleasure Principle* hinges, where Freud switches from his first theory of the unconscious to the second theory. He encounters war trauma as a

theoretical enigma for psychoanalysis, and what he can't understand is precisely repetition. We have been discussing this man, Duchamp, who wants never to repeat himself but does repeat himself all the time, and obviously the *Opticeries* are all repetitive machines. They are erotic bachelor machines but, as you said, they are also scary, slightly traumatic. Now, in *Beyond the Pleasure Principle*, but also later on in *Symptom, Inhibition and Angst*, Freud says that the body or the organism (he is still an organicist at that time) is prepared to receive shocks from the outside and is protected by a sort of barrier which he calls "ein Reitzschutz." The trauma occurs when the energy or the impulse is such that this protective barrier is broken, so that the organism cannot distinguish between an aggression that comes from the outside and one that comes from the inside and replays, repeats, the traumatic event in an attempt to protect itself from it, only too late. And it is this compulsive repetition that leads Freud to the theory of the death drive, otherwise incompatible with the ego drive. So that is why I asked the question. But I don't want to be too long.

ROSALIND KRAUSS

No, I welcome that, and I have to think about it.

THIERRY DE DUVE

What I also find fruitful, just as a sort of side effect of your talk, is that it allows us to reopen the case of "Op" art and "Kinetic" art, of which not everything was garbage. I was a fan of that twenty years ago because I was deeply interested in that kind of experimentation with optical illusion, etc. And then I went through a personal phase where I rejected all that because the art was bad, on the one hand, and because the ideology behind that kind of endeavor was deemed positivistic. But there was, in some of that work, the search for a new, alternative model of vision. I think it's very interesting that you bring it up again in terms that allow us to cope with what some of these artists have tried to do. I even think it's very up to date, given the fact that the Ross Blecknersand the Philip Taaffes are reappropriating this without really knowing what they're doing.

ERIC CAMERON

When you referred to Sartre looking through the keyhole, I was reminded

not only of Henri Barbusses's novel, *L'enfer*, but also of the fact that
Colin Wilson used this novel, about somebody who comes into a hotel
room and watches a woman through a crack in the wall, to develop his
whole theory of the outsider and a particular notion of existentialism from
that situation.[4] At the same time, granting that there's a parallel with
Etant donnés, I'm disinclined to accept an existentialist interpretation of
Duchamp. And I suppose the thing that weighs most heavily with me is
his statement, "I don't believe in being." Also, in referring to "appear-
ance" and "apparition," he identifies reality with appearance, whereas
apparition seems to be more something which has to be hypothetically
supposed in order to coordinate specific appearances. What we have is
not an existence given anywhere. I think as well of the way he describes
chess as being a plastic thing. What I believe he is concerned with
visually is not the sensuous appeal of paintings like Matisse's but a sort
of order that he perceives within things visual as he perceives the plastic
order of chess. It's an order which is perceived between appearances, not
existences.

R O S A L I N D K R A U S S

I hope it was clear that I was not making Duchamp into an existentialist.
I was saying that Duchamp's voyeur is very different from Sartre's. First
of all Sartre's voyeur never sees what's on the other side of the wall.
Duchamp's does. That's the whole point, we do see. It's in the seeing
that his particular carnality of vision is experienced. I would feel very
unhappy if my paper were to be taken as an argument about Duchamp
the existentialist.

H E R B E R T M O L D E R I N G S

You said that you don't see the *n*-dimensional speculation in the *Large
Glass*. I think that's because the *Glass* is glass. All these figures painted
on glass could have been painted on canvas. We would then have a very
traditional painting fitting into late Cubism in a certain way. At first
Duchamp thought of such a painting in the format of the *Large Glass*.
And then he began his *n*-dimensional speculations. You have a dozen
notes where the conclusion of these complicated rotations and mirrorings
is simply using glass as a support for painting. The sensation of looking
through a compact body is an experience which Duchamp thought was
characteristic of a four-dimensional vision. Now, the *Large Glass* is a

work with a multitude of meanings. But when I look back on our discussions of the last three days, I realize that we, as scholars or as viewers who think and try to analyze all these interwoven meanings, all tend to push one, sometimes two, levels of meanings as far as we can, maybe losing sight of the objects somewhere along our way. In the end, there is a tendency for scholars to substitute the part for the whole. I include myself in the group, since I pushed the point of view I presented yesterday. So I would question your model, not the model as such, but in relation to the *Large Glass*. True, Duchamp dealt for at least eighteen years—from 1918, with *A regarder de près*, to 1936, with *Coeurs volants*—with "Precision Optics." But I have some problems in mapping those concerns back onto the evolution of the *Large Glass* because I have always understood them to be a kind of break in his artistic development. Suddenly he's doing this very cool, distant, almost positivistic work: no soul, no affection, no psychic disturbances, no desires, none of the things that went into the elaboration of the *Large Glass*. In 1920 the first machine appears. And at the same time the slogan, *"Eros c'est la vie,"* appears too. but apparently it doesn't play a role at all in his work with "Precision Optics." And for me, that's the reason why "Rrose Sélavy" appears at the beginning as a riddle cut off from the earlier period, when he was dealing with desire, erotic experience, sex.

ROSALIND KRAUSS

Several things. For one, I was extremely interested in what you said in the discussion about the blueprints Jean Suquet reconstituted of the working machinery of the *Glass*. As I remember, you said, "But he didn't finish the *Glass*, and what seems to have been the last thing he actually did on it was the *Témoins oculistes*. What happens in 1918 in Buenos Aires is that he starts working with the idea of Precision Optics, so that a mechanical model seems to be supplanted by an optical model." That was enormously helpful to me; I thought, "Yes, that's it. Something happens, something intervenes." So that's my answer to the first thing you said, which is that my topic only relates to the *Glass* in a rather eccentric way, or on the bias as it were. I would agree with you. But I would say then, in relation to this onset of both Precision Optics and Rrose Sélavy, that in both of them we find cool positivist science coupled with hot psychoanalytic desire. Both are connected. For example, the spiral repro-

duced in *391* is inscribed *"Rrose Sélavy et moi . . ."* So I think the idea that the optical works only open onto precision—that is to say, that they are only what Molly was referring to as a male-gendered vision—would be too limited. Rrose Sélavy is a widow, a castrator, a tease, and she identifies herself on her business card as a specialist in "Precision Oculism."

M O L L Y N E S B I T

I'd like to ask you to talk a bit more about the sight of the two-step, the pulse in the revolving spirals, particularly in light of the fact that Duchamp takes the *Rotoreliefs* off to the fair.[5] I'd like to hear you talk about what it means to sell the optical unconscious.

R O S A L I N D K R A U S S

That's a very good question and I don't think I can answer, right here at this moment. That phenomenon obviously has to be dealt with. I also agree with Herbert, that in a way we are, all of us, trying to sell our own little theory. I mean, we are all these traveling salesmen, each of us with his or her little "Boîte-en-valise" with a little theory in it that we're trying to sell.

H E R B E R T M O L D E R I N G S

We don't get rich.

R O S A L I N D K R A U S S

No, we don't get rich. It's too bad. But I agree that there's a way that we're all addressing different facets of the same thing that don't really contradict one another. But what we have consistently excluded from it (you haven't, Molly, but many of us have), is what is actually inscribed in the readymade and in Duchamp's interest in commerce, namely, money. In this connection I want to enter another reading of the equation Thierry has been analyzing: *"arrhe is to art as merdre is to merde."* *"Arrhe"* is the singular of *"les arrhes,"* which is about money; it means "down payment." So there's already this monetary thing in that equation. And I did leave it out of my thinking.

T H I E R R Y D E D U V E

André didn't leave it out. He had a whole paragraph on this, where he

made the connection between Jarry's *"merdre"* and Jarry's *"phynance."* Anyway the money affair remains to be studied. That will probably be an even more explosive subject than sex for the next conference, for Duchamp's bicentennial, I suggest.

JOHN BENTLEY MAYS

I think that everybody has been a salesman and saleswoman trying to sell a product here. But I find Rosalind Krauss's product very interesting because of its dynamic. As I understand it, Rosalind, and correct me if I'm wrong, you produced the possibility of a comprehensive hermeneutic about the *Large Glass* based on optics and psychoanalysis as they meet in the site of photography. This seems to me to produce a field of solution for a number of the problems that have been raised here earlier. In the first place, have I heard you correctly? And in the second place, I'd like to know if you can speak a bit more about photography as the site of the psychoanalytic and optical?

ROSALIND KRAUSS

I am not proposing a hermeneutic for the *Large Glass*, I am opposing one. Even Lyotard's notion that the *Glass* can be decoded as a retinal field doesn't go very far. I don't think there is a consistent key because Duchamp was moving through various phases and even though he was repeating himself, he was repeating himself as he moved through different fields of experience. If I wanted to do anything through my demonstration it was to remind us that one of the fields through which he moved was that of eroticism, as he has put it. He moved through the field of sex, he was interested in the groin, he was interested in what it means to be "hot," he was interested in Rrose, and I wanted to take that seriously and to see what that meant in relation to one phase I think we simply can't forget.

THIERRY DE DUVE

Can I drop in just one thing? Maybe then there is a danger, not that you would have done hermeneutics, but that you would have made the invisibility on which you have concluded visible. Have you had the feeling that you have made this invisibility visible, and if so, have you offered a clue?

ROSALIND KRAUSS

I would have to think about that. What would it mean to make the invisibility visible?

THIERRY DE DUVE

You have explained it. You spoke of the folds of the body, of the body's invisibility to itself to be found in its own folds—which is almost a paraphrase of Merleau-Ponty, whom you did not cite but who was certainly at the back of your mind as well. It's like having accounted for this invisibility and therefore having explained it. Let me be a little blunter: do you feel you have explained it, do you wish to explain it away?

ROSALIND KRAUSS

I certainly don't think you can explain it away. Psychoanalysis doesn't explain anything away either. The unconscious becomes visible but in a strange way, in a way that remains invisible nonetheless.

THIERRY DE DUVE

But do you see what I mean? I don't mean to criticize what you have done, which I find fantastic. I'm afraid that it could be read as another psychoanalytical deconstruction, demystification, like saying: "Now we have explained art by bringing it down to its material constituents or conditions." The reductivist reading of your text is what I fear. And what do you do with that, with the effect, or the illusion, of a sort of materialistic enlightenment, like saying, "Oh, that was it, now we have the ultimate reduction: it all boils down to real things like the groin," which I don't deny. It's just that art starts where these reductions fail.

ROSALIND KRAUSS

What I'm saying doesn't explain lots of other things. The whole textual production that André was involved with and the readymade production that Carol dealt with. I haven't directed my attention to any of that. I'm really just saying, look there's also the body. You know he was busy producing these images of genitals and these bodily fluids. He liked bodily fluids: sweat, semen, the whole thing (fig. 11.13). Good for him.

THIERRY DE DUVE

Good.

11.13
Paysage fautif [*Wayward Landscape*],
1946. Seminal fluid on Astralon, 8⁵⁄₁₆ ×
6⅜ in. The original work from *Boîte-en-
valise* No XII/XX, inscribed to Maria
[Martins]. (Collection Tokoro Gallery,
Tokyo.)

HERBERT MOLDERINGS

I understood that you said that in the last piece, *Etant donnés*, we, the viewers, are made part of a scenographic machine. Is that right, that we are the retina in this *camera obscura?* And if that is right, I am very much against this piece.

ROSALIND KRAUSS

For me, one of the really interesting things that happens as a result of that piece (which Duchamp insisted on installing in a museum) is that it cuts through the idea that a museum is a public space within which one is disincarnated, one where carnal conditions don't count, an ideal space—the one of Kant's condition of the sharable, communicable "universal voice"—which is not one where you have to go to the bathroom or where you have to leave your galoshes. The fact that Duchamp turns every single viewer into this carnally thickened three-dimensional being is very important. I don't know how you felt looking through that peephole, but I thought, "My God, who is seeing me doing this?" I've never felt uncomfortable looking at anything in a museum except for that.

THIERRY DE DUVE

But certainly you didn't feel ashamed. You brought shame up in your talk. I found that very interesting. But I don't think anybody can experience shame when looking at *Etant donnés*, whereas a real voyeur . . .

ROSALIND KRAUSS

I said Sartre experiences shame.

THIERRY DE DUVE

Yes, the real voyeur caught in the act experiences shame. But *Etant donnés* doesn't arouse shame.

ROSALIND KRAUSS

We, each of us speaks for herself or himself. I think it's embarrassing.

THIERRY DE DUVE

It's very embarrassing.

ROSALIND KRAUSS

Embarrassment and shame are pretty close in feeling.

T H I E R R Y D E D U V E

Oh no, oh no.

D O U G S T E P H E N S

I want to go on with your Sartrian situation. Duchamp is not, the way I
see him, the existential viewer but the person coming around the corner,
seeing the person viewing. What he has created with *Etant donnés* and
the *Large Glass* seems to me a kind of invitation to gaze and to enact that
voyeuristic desire. And even at a secondary level, where the critics and
the art historians respond to that invitation, I think that he would be
watching them with amusement. So I guess that even the proceedings of
the last three days could be added to his oeuvre as his most recent
posthumous work.

R O S A L I N D K R A U S S

I agree with you. Duchamp really does set up the viewer as the voyeur.
Sartre, in describing himself, enters that situation and plays it off against
himself. Duchamp doesn't. And in answer to Herbert's previous question
about whether we become retinal at that point, I was really quoting
Lyotard who says we don't become retinal, we become "vulvular."

T H I E R R Y D E D U V E

My impression when I went to see *Etant donnés* the first time was, of
course, that I was caught in the act but also (it's very subjective, you
can't explain this) that it was the Bride's gaze that went around the cor-
ner and caught me from behind. This is a strange topology, but the fact
that her head is turned away and then hidden behind the wall is what
made me feel that way. She doesn't stare back like, for example, Manet's
Olympia (who was probably seen as equally obscene in her own day),
and yet the piece is not a simple defacing of woman, that is, a represen-
tation of woman as a sheer object of desire that cannot respond, as you
would have in Wesselman's paintings where women have no eyes at all.

D E N N I S Y O U N G

The notion that Duchamp, or maybe the female inside the piece, is look-
ing at us reminds me of an aspect of Duchamp which has not been raised
during the conference, his relation to dandyism. I recall, for instance,
that the *Comb* has written on it, "*3 ou 4 gouttes de hauteur . . .*," and I

suggest that the "hauteur" is in fact the dandy's gaze—that of the aloof, detached individual, the "bien peigné" who indeed, in the case of *Etant donnés*, has trapped us in that gaze. Incidentally, I would defend Rosalind Krauss's view of the image she borrows from Sartre: for even if we don't *experience* shame because we are protected by the museum, nevertheless *Etant donnés* sets up a metaphor for that experience. But if one is seeking some sense of how the self comes into being—something which is at stake in the Sartrian reference—then Duchamp's identification with the dandy, it seems to me, is an alternative. I'm thinking of, for instance, Domna Stanton's book, *The Aristocrat as Art*.[6]

R O S A L I N D K R A U S S

I couldn't really go into a textual analysis of the Sartre passage in the context of this presentation. But in that passage from *Being and Nothingness*, just before the part about the keyhole, he describes the way the advent of the Other robs him of possession of the world as his. And when he talks about this world no longer being his world, the world that he sees through his eyes, but suddenly being the world as it's seen through the eyes of the Other, he talks about the world leaking away as though into a drainhole—about the world hemorrhaging, bleeding away. Then he moves himself to the keyhole, and once again he talks about his world hemorrhaging away. And what's fantastic about this moment is the way that in becoming carnal, becoming ashamed, he also becomes a woman. This is not at all analyzed by Sartre in the text. But it's involved in his language.

D E N N I S Y O U N G

But wouldn't you agree that in any social situation (the sociological dimension is conspicuously lacking, I think, from our colloquium), the question of who can outstare the other is greatly at stake? To some degree it even plays into the confrontations that we indulge in on the panel. And the question of shame is not simply one that focuses upon this kind of very specific illustration of the Peeping Tom. It's a much broader question and it has very much to do with social situations in which the signifiers of superiority are displayed. I hesitate to introduce Lacan in front of people who I know are really deeply read in him. But still, am I not right in feeling that as far as he is concerned the uncon-

scious comes into being in a rather different way from Freud's, and that it has something to do with signifiers of the self?

ROSALIND KRAUSS

In other words, why didn't I bring in Lacan instead of Freud?

VERA FRANKEL

That wasn't Dennis's question. I just wondered if you were going to address it or not.

ROSALIND KRAUSS

First of all, I am thinking historically—in relation to the history of psychoanalysis. Freud's theory is based on an organic model of the unconscious. He studied with Brücke, who came out of Helmholtz's laboratory. And so there are two facts. The first is the very specific historical tie between Freud's psychoanalytic position and that of physiological optics, and the second is the date of *Instincts and Their Vicissitudes*, which comes from the teens. Lacan is an historically later phenomenon. I don't see either the heuristic or the historical reason to bring him in at this point. But I may be wrong . . .

THIERRY DE DUVE

You're very much to the point. There are also strategic reasons to leave out Lacan from your demonstration. I think it's very intelligent.

JAKE ALLERDICE

I just have one thing to observe about this question of shame. There are works of art which create shame in the viewer. Take the experience of seeing the *Mona Lisa*. Standing in front of it, in the crowd, I think that the experience of identifying yourself with a gaggle of people who are observing it is in fact an experience of shame. I think that if we want to talk about Leonardo and Duchamp, we may one day start saying that to see the *Large Glass*, or to talk about the *Large Glass*, also brings shame to us.

ROSALIND KRAUSS

I welcome that. I think what it addresses is the historical transformation of the museum, which existed in relation to a certain kind of aesthetic that was developed in the eighteenth century and that can no longer be

supported in the twentieth. Duchamp seems to have been one of the first to say, "We are now ashamed in these institutions." And your example, or that of someone's being on a conveyor belt to be moved past Michelangelo's *Pieta*, all of those things are bases for experiences of shame.

T H I E R R Y D E D U V E

It's past seven o'clock. I was certainly not going to either conclude or close the conference. The conference is declared definitively unfinished, as it should be.

1 Perhaps "twisting his memory for the fun of it," Jean Suquet misquotes the nursery rhyme Rosalind Krauss cited at the beginning of her talk, conflating two sentences: "Fais dodo, t'auras du lolo. Maman est en haut, qui fait du gâteau." "Lolo" being baby talk for milk, Suquet's preference for it is quite transparent, as is shown by what he says next.

2 *Salt Seller*, 68.

3 Arturo Schwarz, *The Complete Works of Marcel Duchamp;* Octavio Paz, *Marcel Duchamp, or, The Castle of Purity* (London: Cape Goliard, 1970).

4 Colin Wilson, *The Outsider* (London: Gollancz, 1956).

5 In 1935 Duchamp, who had just published a cheap edition of 500 sets of *Rotoreliefs,* rented a stand at the Concours Lépine to show and market them. The Concours Lépine was the annual fair of the Association des inventeurs et fabricants français, instituted in 1902 by the Préfet de police Louis Lépine to allow small entrepreneurs, inventors, even simple *bricoleurs,* to display their creativity and feed the French industry with prototypes of sometimes the most farfetched practical contraptions. Henri-Pierre Roché recalls that Duchamp's stand was *"frappé d'invisibilité"* and that not one of the visitors of the fair stopped to look at the *Rotoreliefs,* so obviously devoid of any practical use. ("Souvenirs sur Marcel Duchamp" in Robert Lebel, *Marcel Duchamp,* 84.)

6 Domna Stanton, *The Aristocrat as Art* (New York: Columbia University Press, 1980).

"D'ailleurs c'est toujours les autres qui meurent" ["Anyway, it's always the others who die"]. Epitaph on Marcel Duchamp's grave in the cemetery of Rouen. (Photo Philadelphia Museum of Art.)

Contributors

Craig Adcock teaches art history at the University of Notre Dame, Indiana, and specializes in nineteenth- and twentieth-century art. He has published essays about Dadaism and its influence and several essays about Marcel Duchamp, including a book-length study entitled *Marcel Duchamp's Notes from the Large Glass: An n-Dimensional Analysis* (1983). His monograph on James Turrell was recently published by the University of California Press.

Eric Cameron is an artist and presently head of the Department of Art at the University of Calgary. Born in 1935 in Leicester, England, he emigrated to Canada in 1969. Since 1979 his art has centered on his "Thick Paintings (to be continued)," sixteen of which are presently touring Canada in an installation entitled "Divine Comedy." His theoretical writings include *Bent Axis Approach* (1984) and a book also entitled *Divine Comedy*, published by the National Gallery of Canada in conjunction with the initial showing of the installation there in January 1990.

William A. Camfield is professor of the history of art at Rice University, Houston, Texas. His publications include a book on *Francis Picabia* and exhibition catalogues on *Francis Picabia, Marcel Duchamp / Fountain*, and *Tabu-Dada; Jean Crotti and Suzanne Duchamp*.

Thierry de Duve, born in Belgium in 1944, has taught art history and theory at the University of Ottawa and is now working in Paris. He is author of *Nominalisme pictural. Marcel Duchamp, la peinture et la modernité* (1984), translated as *Pictorial Nominalism* (1991), *Essais datés. 1974–1986* (1987), *Au nom de l'art* (1989), *Résonances du readymade* (1989), and *Cousus de fil d'or. Beuys, Warhol, Klein, Duchamp* (1990).

André Gervais, born in Montréal in 1947, is professor of literature at the Université du Québec à Rimouski and director of the magazine *Urgences*. His most recent book of poems is entitled *La nuit se lève*. He has published numerous articles on literature, some of them on Duchamp, in *Protée* (Chicoutimi), *Moebius* (Montréal), *Etudes littéraires* (Québec), and *Les Cahiers du Musée national d'art moderne* (Paris). He is author of *La raie alitée d'effets. Apropos of Marcel Duchamp* (1984).

Carol Plyley James has recently taught in the Department of French and Italian at the University of Wisconsin at Madison and now concentrates on writing about current cinema from France and Canada. She has written about Duchamp since her graduate studies at the University of Minnesota, where she completed her dissertation on "The Writings of Marcel Duchamp in the Development of His Poetics" (1978). Her articles on Duchamp have appeared in *The French Review, Enclitic, Sub-Stance, Visible Language, Perspectives on Contemporary Literature,* and *Dada/Surrealism*.

Rosalind Krauss is Distinguished Professor of Art History at the Graduate Center, City University of New York, and editor of *October* magazine. Her books include *Passages in Modern Sculpture* (1977) and *The Originality of the Avant-Garde and Other Modernist Myths* (1985).

Herbert Molderings, born in 1948, has studied art history, philosophy and sociology. He is at present professor in the history of modern art at the Ruhr-Universität in Bochum, and lives in Cologne. He was director of the Westfälischer Kunstverein in Münster between 1975 and 1978. He has organized exhibitions on the photography of the Neue Sachlichkeit and the Bauhaus, on Man Ray, Apollinaire, Sarkis, Jochen Gerz, Charles Simonds, Florence Henri, August Sander, Tina Modotti, Erich Mendelsohn, and others. His works on Duchamp include a Ph.D. thesis (1973), an essay, "Film, Fotographie und ihr Einfluss auf die Malerei in Paris um 1910. Marcel Duchamp, Jacques Villon, Frank Kupka" (*Wallraf-Richartz Jahrbuch,* 1975), and a book entitled *Marcel Duchamp. Parawissenschaft, das Ephemere und der Skeptizismus* (1983).

Francis M. Naumann, Ph.D., is an independent scholar who has written extensively on the subject of Dada and American art. His articles have appeared in *Artforum, Arts Magazine, Art Bulletin,* and *Archives of American Art Journal.* He is author of *The Mary and William Sisler Collection* (Museum of Modern Art, 1984) and coeditor of *Marcel Duchamp: Artist of the Century* (MIT Press, 1989).

Molly Nesbit was educated at Vassar College and Yale University and is assistant professor at the Department of Art History, Barnard College, Columbia University. Her book *Atget's Seven Albums* is forthcoming from Yale University Press.

Jean Suquet, born in Cahors (France) in 1928, is a poet and a photographer (Prix Niepce, 1963) who lives in Paris. He is author of *Le scorpion et la rose* (1970), *Histoire de l'alchimie* (1970), *Une chimie greffée de chimères* (1972), and three books on Marcel Duchamp: *Miroir de la Mariée* (1974), *Le guéridon et la virgule* (1976), and *Le Grand Verre rêvé* (1990).

Index